AUSTRALIAN PAINTING

. . . by making art the perfect expression
of one time and one place it becomes art
for all times and of all places.

TOM ROBERTS, July 1890

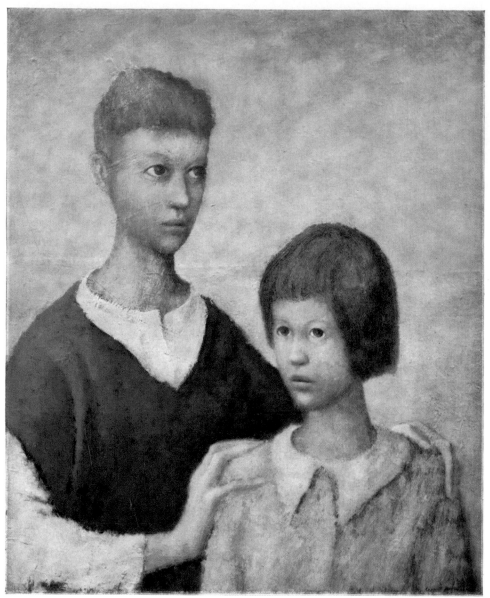

Frontispiece RUSSELL DRYSDALE, *Two Children*, canvas, 23½ x 19½, 1946, Melbourne

AUSTRALIAN PAINTING

1788 - 1970

Bernard Smith

MELBOURNE

OXFORD UNIVERSITY PRESS

LONDON WELLINGTON NEW YORK

*Oxford University Press, Ely House, London, W.*1

GLASGOW NEW YORK TORONTO MELBOURNE WELLINGTON
CAPE TOWN IBADAN NAIROBI DAR ES SALAAM LUSAKA ADDIS ABABA
DELHI BOMBAY CALCUTTA MADRAS KARACHI LAHORE DACCA
KUALA LUMPUR SINGAPORE HONG KONG TOKYO

Oxford University Press, 7 Bowen Crescent, Melbourne

© *Oxford University Press 1971*

First published 1962
Reprinted 1965
Second edition 1971
Reprinted 1974

ISBN 0 19 550372 4

PRINTED IN AUSTRALIA BY BROWN PRIOR ANDERSON PTY LTD

CONTENTS

INTRODUCTION

WHEN compared with that of other nations the story of Australian art is a comparatively short one, but it is, nevertheless, full of fascination and interest. For the Australian nation, though young, has been fashioned by people from the older nations of Europe (at first, mainly from Britain) and Australian art has naturally drawn quite constantly upon European traditions throughout its short history. Indeed, in one sense, it may be said that Australian art is a European art flourishing in the South-East Asian world. But that is not the whole truth. From the beginning of settlement in 1788 the physical environment of the country and, later, the social character and composition of the new nation have influenced the course which art has taken in Australia. In consequence Australian art has gradually acquired qualities as distinctive as the social attitudes and speech of Australians. To observe how these peculiarities have asserted themselves is one of the fascinations of the study of Australian art.

But it is by no means the only satisfaction. Australian artists have constantly returned to refresh themselves from the deep fountains of European culture and civilization. And it is equally fascinating to study the ways in which traditional links have been preserved, especially when the points of view of local artists and critics of art have tended to become insular, ultra-nationalistic, or narrow in their range of sympathies.

And there is yet another fascination. The study of Australian art is the study of an art in its beginnings. A national tradition always matures slowly and in the arts very slowly indeed. So in this book we study a seed-time, the harvest being still beyond knowledge. How rich that harvest will be it would not be wise to conjecture. One thing is certain, however: Australian art will not emerge fully formed until it has produced masterpieces which fashion from the Australian experience of life something of lasting value for the whole field of human experience. And masterpieces are not produced without an awareness of tradition. For the Australian artist there are two traditions of special importance, the European tradition itself and the local Australian tradition which is itself a variant of the European tradition. Strangely enough, it is the local tradition which is less well understood by Australian artists today. To clarify the Australian tradition and to make it more widely understood is one of the main aims of this book.

Four additional chapters bring this account of Australian painting to 1970. They constitute an early attempt to bring the varied activities of the decade into historical perspective. Doubtless, later, more detailed investigations will lead to modifications of the present account.

ACKNOWLEDGEMENTS

ALTHOUGH it covers a somewhat similar field this book is in no way a second edition of my earlier *Place, Taste and Tradition* (1945), from which only two or three paragraphs have been incorporated. Apart from a few critical comments which have already appeared in *Meanjin*, x (1951), in *Nation*, 18 June 1960 (whose respective editors I thank for permission to reprint) and in the John Murtagh Macrossan Lectures for 1961, the material herein has not been published previously.

It is not possible here to thank everyone individually who has helped me in preparing this book during the past six years but I wish to record my thanks to them all. A book of this nature could not possibly be published in Australia in its present form without financial and personal assistance from many quarters. Both the publishers and I wish to express our thanks to the Australian Humanities Research Council and the Commonwealth Art Advisory Board for the co-operation and assistance they have provided. We are also indebted to the Bank of New South Wales and Mr G. A. W. Robertson, the editor of the *Etruscan*; Dr Norman Behan of Brisbane; the Clarendon Press, Oxford, and the Art Gallery Society of Victoria for their assistance in providing blocks.

It is my duty to thank the Trustees of the Art Galleries of New South Wales, Queensland, South Australia and Western Australia; of the National Gallery of Victoria; of the Tasmanian Museum and Art Gallery, Hobart; of the Queen Victoria Museum, Launceston; of the Castlemaine Art Gallery; Mr Brian Johnstone of Brisbane for permission to reproduce work in their collections. I wish also to thank the directors of these institutions for their co-operation and assistance.

I wish to express my deep appreciation to those artists and relatives of artists who have answered my questions and provided me with reliable information. To several people I owe a special debt of gratitude: to Mr Daniel Thomas, of the Art Gallery of New South Wales, for his prompt and never-failing attention to innumerable inquiries over two or more years and his many helpful suggestions, including his invaluable assistance in reading and correcting the proofs; to Mr Brian Finemore, the Assistant Curator of the Australian Collection at the National Gallery of Victoria, for his patient and helpful replies to my many queries; to Mr Robert Campbell, the Director of the National Gallery of South Australia, for his friendly co-operation and personal interest in the book; to Professor A. D. Trendall, the Master of University House in the Australian National University, for reading the manuscript and making helpful comments; and to Professor

R. M. Crawford for allowing me to read his unpublished article on Tom Roberts and Alfred Deakin. I also want to thank the librarians of the Mitchell and Dixson Libraries, the National Library of Australia and the Art Gallery of New South Wales for their constant good service. I must express also my gratitude to all those people who have kindly allowed me to reproduce works of art in their possession.

This book was completed before it was possible to take advantage of some valuable research work completed by Honours graduates of the School of Fine Arts in the University of Melbourne, during 1961, but I wish to acknowledge here the value of work by Miss Virginia Spate on Tom Roberts and his times, and Mr Eric Thacker for his work on *art nouveau* in Australia. I also wish to thank Professor Burke and my colleagues in the Fine Arts Department of the University of Melbourne for their encouragement and patience, and the University itself for providing financial assistance for research in the subject.

I am deeply indebted to Dr Ursula Hoff, the Keeper of the Prints at the National Gallery of Victoria, who has given me invaluable help in reading and correcting the proofs. The errors that have survived the scrutiny of my friends are indeed my own. Finally I wish to thank my publishers and their printer for the great care they have taken in the production of the book.

SANDRINGHAM, VICTORIA B.S.
DECEMBER 1961

As with the first edition the directors and staffs of the leading state libraries and galleries have been unfailingly helpful. For this second edition I am also indebted to the following dealers' galleries for their courtesies and their invaluable co-operation: in Sydney, Bonython Art Gallery, Gallery A, Holdsworth Galleries, Macquarie Galleries, Rudy Komon Art Gallery, Watters Gallery; in Melbourne, Gallery A, Mr John Reed and the Pinacotheca; in Perth, the Skinner Galleries. I thank too Mrs Hazel de Berg and many of the artists she has interviewed in recent years for permitting me to make use of the material now held by the National Library, Canberra; I must also thank Miss McGrath who kindly helped me to revise the Note on Books and Periodicals. And once again I owe a special debt of gratitude to Dr Ursula Hoff, the Assistant Director, National Gallery of Victoria, and to Mr Daniel Thomas, the Curator, Art Gallery of New South Wales, for the trouble they have taken in helping me to eradicate errors which crept (would that they would stand and be more visible) into the first edition.

GLEBE, SYDNEY B.S.
JANUARY 1971

ABBREVIATIONS

AA	*Art in Australia*, 1916-42: the Sydney art quarterly
AE	*The Australian Encyclopaedia*, 10 vols, Sydney, 1958
Brit. Mus.	British Museum (Natural History), London
(Nat. Hist.)	
Burl. Mag.	*The Burlington Magazine*, London
CAO	*A Catalogue of Australian Oil Paintings in the National Art Gallery of New South Wales*, Sydney, 1953
C.A.S.	The Contemporary Art Society of Australia
DAB	Percival Serle, *Dictionary of Australian Biography*, 2 vols, Sydney, 1949
DNB	*Dictionary of National Biography*, 22 vols, London, 1960
EVSP	Bernard Smith, *European Vision and the South Pacific*, Oxford, 1960
Journ. RAHS	Journal of the Royal Australian Historical Society, Sydney
N.L.A.	National Library of Australia, Canberra
PTT	Bernard Smith, *Place, Taste and Tradition*, Sydney, 1945

The State Galleries are indicated by the name of the capital cities in which they are located, thus:

ADELAIDE	The Art Gallery of South Australia
BRISBANE	The Queensland Art Gallery
HOBART	The Tasmanian Museum and Art Gallery
MELBOURNE	The National Gallery of Victoria
NEWCASTLE	The Newcastle City Art Gallery
PERTH	The Western Australian Art Gallery
SYDNEY	The Art Gallery of New South Wales

To KATE and KATE

THE FIRST ARTISTS

1788 - 1824

. . . the whole appearance of nature must be striking in the extreme to the adventurer, and at first this will seem to him to be a country of enchantments.

THOMAS WATLING, *Letters from an Exile at Botany Bay to his Aunt in Dumfries* (1794)

WHEN Lieutenant James Cook discovered the eastern coast of Australia in 1770 in the *Endeavour*, the ship's company included Joseph Banks, a young gentleman of considerable wealth and social standing, who possessed keen scientific interests and was especially devoted to the study of botany. Young men of his class usually made a tour of the European continent, often lasting two or three years, in order to complete their education and improve their taste. The tour was known as the grand tour and its high point was the ancient towns of Italy. But Banks liked to do unusual things. The Royal Society had helped to sponsor the *Endeavour's* voyage and through its recommendation Banks, who was a member of the Society, was allowed by the Admiralty to travel with Cook to the South Seas. When his friends asked him why he did not make the far safer trip to Italy he replied: 'Every blockhead does that; my Grand Tour shall be one round the whole Globe'.[1]

In order to obtain permanent graphic records, grand tourists often included artists among the suite of servants who attended them. Banks included two young artists, Alexander Buchan and Sydney Parkinson (*c.* 1745-71), in his party, Buchan was to make drawings of native peoples and natural scenery; Parkinson, drawings of plants and animals. The voyage, unfortunately, ended in tragedy for both artists. Buchan, who was an epileptic and a very bad sailor, died soon after the *Endeavour* reached Tahiti in 1769. Parkinson, who made many drawings of plants, animals, natural scenery and native peoples in the Society Islands, New Zealand and Australia, and also compiled a splendid journal of the voyage,[2] proved himself a most able and observant artist-traveller. But he too died (from malaria) shortly after leaving Batavia where so many had fallen ill.

Some of the drawings made by Buchan and Parkinson were used to make engravings to illustrate John Hawkesworth's *Voyages* (1773),[3] which contained the first official account of Cook's discoveries. Several of Parkin-

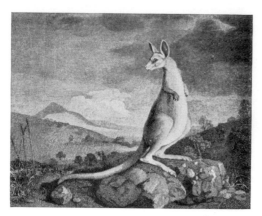

1 *An Animal of New Holland*, engraving after George Stubbs, 7¾ x 9⅝, Hawkesworth's *Voyages*, vol. iii, 1773

son's drawings were also engraved for his *Journal of a Voyage to the South Seas*, which was published by his brother, Stanfield Parkinson, in 1773, but was not made available to the public until 1784.[4] By means of such engravings the British public was introduced to the Australian scene. The engraving of a kangaroo (1) in Hawkesworth's *Voyages* after a painting (from a specimen) by George Stubbs helped to establish the country's reputation as a wonderland of natural curiosities. Another engraving, entitled *Two of the Natives of New Holland Advancing to Combat* (2), was intended to depict the Australian Aboriginal, but was accurate only in the rendering of the tattooing and the bone ornaments. Everything else: the shield, sword, dart, the pose of the figure and method of dressing the hair, owes far more to the engraver's knowledge of classical sculpture than to his knowledge of the Australian Aboriginal.

This is not surprising. The two natives who defied Cook at his landing with such primitive weapons were rightly regarded as men of courage. Artists of the time made a practice of using poses and gestures selected from well-known pieces of classical sculpture in order to represent heroism and nobility in the figures they drew. In this engraving the native holding the shield is posed rather like *The Borghese Warrior*, a well-known piece of Hellenistic sculpture by the Ephesian sculptor Agasias. Furthermore, many educated people of the time firmly believed that all primitive people were naturally noble and heroic because their lives were lived close to nature free from the complexities and temptations of civilization. They considered them, in other words, to be noble savages.[5] And quite

2 *Two of the Natives of New Holland advancing to Combat*, engraving by T. Chambers after Sydney Parkinson, 8⅞ x 7½, from *Voyage to the South Seas*, 1784

the best way to represent a noble savage was to cast him in the mould of a Greek hero or a Greek god. So it came about that the first engraved illustrations of Australian Aboriginals depict them as noble savages.

The Voyage of Governor Arthur Phillip to Botany Bay, which was published in 1789, sixteen years after the printing of Parkinson's *Journal*, continued to illustrate Australian Aboriginals in this fashion, though one contemporary reviewer of the book, William Wales, criticized the tendency to depict native peoples after the manner of classical sculpture and to

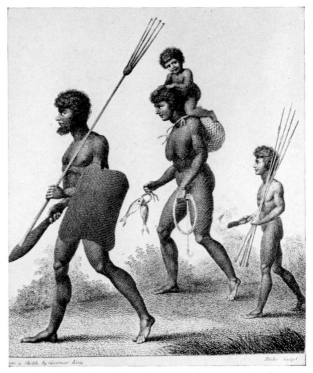

3 *A Family of New South Wales*, engraving by William Blake after Governor King, 7½ x 6⅜, from John Hunter's *Historical Journal*, 1793

make their huts look like booths in English fairs.[6] The convention, however, lingered into the 1790s; and the finest of all the engravings which render the Aboriginal as a noble savage was also one of the last. This was William Blake's *A Family of New South Wales* (3), which was engraved from a drawing by Lieutenant P. G. King and published in John Hunter's *Historical Journal of the Transactions at Port Jackson and Norfolk Island* (1793).

Cook's voyages were undertaken to promote the cause of science and geographical discovery, and to advance Britain's position as a maritime power. Governor Arthur Phillip's task was more mundane. He had to establish a penal settlement upon an unknown coast. The Admiralty did not supply him with artists as they had Cook on his second and third voyages. But drawing played a significant part in a naval officer's training. He was expected to be able to draw maps, charts and profiles of coasts, and to keep a journal, when visiting unknown or outlandish countries, which would contain an accurate record of all interesting and curious observations. Furthermore, many naval men shared the current enthusiasm for collecting and describing new plants and animals; others, with some skill in drawing,

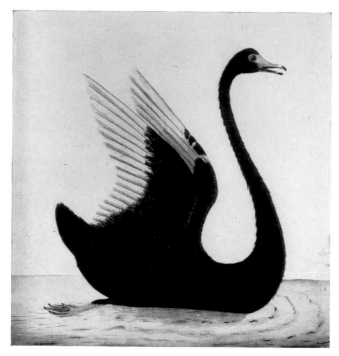

4 THE PORT JACKSON PAINTER, *Black Swan*, water-colour, 9 x 7½, *c.* 1790, 'Watling' Drawings, Brit. Mus. (Nat. Hist.)

were well aware that specimens and drawings of 'non-descript' products of natural history sent back home to scientists and collectors with influence in official circles often led to preferment or advancement.

In this connection no one had more influence than Sir Joseph Banks who, as a young man, had collected plants in New Holland in 1770 and had become, by 1788, the President of the Royal Society, the most important and influential body of scientists in the world.[7] Banks had done more than anyone else to interest the British Government in the establishment of the penal settlement at Botany Bay. But he also had a deep personal interest in the place, for he hoped to obtain from there many rare specimens for his magnificent natural history collection. And few things delighted him more than a fine illustration of an exotic plant carefully drawn and coloured from nature.

Governor Phillip was well aware of Banks's interests and sent him many specimens and drawings of plants and animals found in the neighbourhood of Port Jackson.[8] But Phillip was no draughtsman, so he employed someone to make drawings for him. It is not possible to say for certain who this person was. Yet since most of the drawings made were illustrations of the plants, animals and native people of the Port Jackson neighbourhood, it will be convenient to call him the Port Jackson Painter.[9]

The Port Jackson Painter's known work consists of over 250 water-colour drawings, most of which are now in the British Museum (Natural History)

at South Kensington. The drawings include maps and coastal profiles, and illustrations of birds, snakes, insects, fish and other animals collected in the neighbourhood of Port Jackson and Norfolk Island. There is also a number of drawings of Aboriginals, and of incidents which took place at the settlement during Phillip's governorship (1788-92). A painting of a black swan (4) provides a good example of the Port Jackson Painter's natural history drawings. An elegant silhouette is used to convey the essential qualities of the bird with a minimum of fuss and detail. The subject was a matter of unusual interest for Europeans. The Roman poet Juvenal declared black swans to be as rare as good wives,[10] and

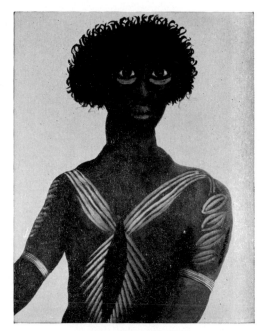

5 THE PORT JACKSON PAINTER, *Balloderree*, water-colour, 9¾ x 8, *c.* 1790, 'Watling' Drawings, Brit. Mus. (Nat. Hist.)

writers had recalled his words down the centuries. Their discovery by the Dutch navigator, Willem de Vlamingh, in Western Australia in 1697, aroused great interest. The black swan, like the kangaroo and the platypus, came to be cited as evidence that in Australia (a country itself at the antipodes of Europe) the laws of nature were somewhat upside down.

The Port Jackson Painter did not depict Aboriginals as noble savages in the way English engravers (who had never seen them) did. Consider, for example, the portrait of Balloderree (5), a young native well known about the settlement, who upon one occasion visited the Governor bedecked in war paint to inform him that he proposed to revenge himself upon some white men because a party of convicts had destroyed his canoe. The Port Jackson Painter has portrayed him with a naïve realism which is tinged with kindly sentiment and a hint of amused superiority. He did not, it would seem, dislike the Aboriginals, nor did he represent them idealistically in the manner of Greek heroes. His drawing sought rather to record their customs and habits, as in the fine drawing called *Method of Climbing Trees* (6) which depicts their methods of obtaining food. 'The Hunted Rushcutter' (7) which records, doubtless, an actual incident, reveals the lively sense of humour so often present in his work. But it was the country's curiosities, its plants, animals and people, which held the centre of the

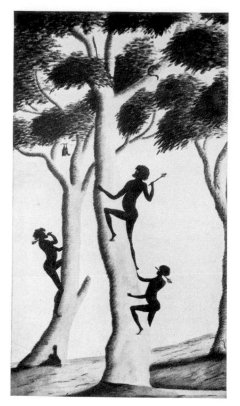

6 THE PORT JACKSON PAINTER,
Method of Climbing Trees, water-
colour, 11 x 6¼, *c.* 1790, 'Watling'
Drawings, Brit. Mus. (Nat. Hist.)

artist's interest. The local landscape as a whole yielded no such fascination, being drawn in a rudimentary fashion. And this is true in general of the work of the other naval draughtsmen who accompanied Phillip to Sydney Cove: George Raper, John Hunter, William Bradley and Arthur Bowes.[11] A professional painter would certainly have attempted to render the character of the local landscape.

Governor Phillip had not been provided with professional artists because his was not a voyage of discovery and scientific investigation. The practice of providing professional artists for scientific expeditions was, however, continued by the Admiralty when preparing for Matthew Flinders's exploration of the Australian coastline in the *Investigator* (1801-3). William Westall (1781-1850) was appointed as a landscape and topographical artist, and Ferdinand Bauer (1760-1826) as a natural history draughtsman.

Westall had been trained as an artist, first under his brother Richard Westall, and later at the Royal Academy Schools. Benjamin West, the President of the Academy, recommended him for the position when William Daniell, who later became famous for the scenes he painted in India, declined to accept the position.

As was usual among artists attached to surveying voyages, Westall made many off-shore drawings of coastal and harbour views. These, when engraved in the atlases to the published accounts of such voyages, were an aid to later navigators. Westall's coastal profiles and harbour views are among the finest ever made by a professional artist attached to a voyage of discovery and survey. He also made drawings of natives encountered upon the voyage. In most of them something of the neo-classical conventions in which he had been taught to draw still lingers. Westall, that is, could not help seeing Aboriginals to some extent as noble savages. He also painted a number of particularly fine water-colour landscapes, such as his *King George's Sound from the Isthmus Below Peak Head*[12] which is treated with

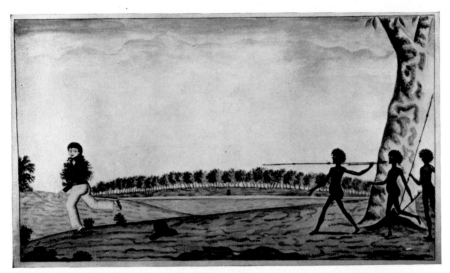

7 THE PORT JACKSON PAINTER, 'The Hunted Rushcutter',
water-colour, 6⅝ x 11¾, c. 1790, Banks MS. 34, Brit. Mus.
(Nat. Hist.)

great breadth and fluency. As the expedition proceeded, however, Westall
became increasingly concerned with the peculiarities of Australian vege-
tation. This led to individual studies of trees and shrubs, and a more careful
and precise treatment of foreground vegetation in his landscape. It is likely
that such interests were developed by Ferdinand Bauer.

Some of the oil paintings which Westall executed for the Admiralty after
his return to England reveal him grappling with the problem of depicting
the light, atmosphere and vegetation of the tropics; a novel problem in
landscape painting at that time, but one which, under the stimulus of the
great German geographer, Alexander von Humboldt,[13] was soon to occupy
the attention of many travelling artists. In Westall's *View of Cape
Townshend*, he is clearly seeking to render the visual effect of a tropical
morning shortly before sunrise; in his *View in Sir E. Pelew's Group*
(8), the blinding sunlight of a tropic noon; and in his *View of Malay Road
from Pobasso's Island*, the dramatic effects of a tropical storm.

The *Investigator* circumnavigated Australia and was finally abandoned
at Sydney in 1803 because of its unseaworthy condition, the ship's company
transferring to the *Porpoise* and *Cato* which were, however, wrecked in
northern Queensland waters. After the party was rescued, Westall made
his way to China and thence to India, drawing scenes wherever he travelled.
He arrived home in England in 1805, but the island of Madeira had
attracted him on the journey out and thence he returned in the same year,
later making a trip to Jamaica. By 1807 he was back in England again and
held an exhibition of paintings from drawings made on his extensive travels.

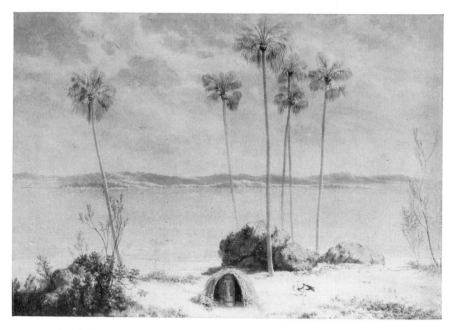

8 WILLIAM WESTALL, *View in Sir E. Pelew's Group, Gulph
of Carpentaria*, canvas, 23 x 33½, c. 1802, The Admiralty, London

But his exotic subjects did not appeal to the buying public, and in the years
following he turned to sketching in Worcestershire, the Wye Valley and
the Lake District.

Westall held a very poor opinion of the Australian landscape as a subject
for painting. But his work and travels are of considerable value for an
understanding of the beginnings of Australian art. Improvements in the art
of navigation, Britain's growing mastery of the high seas and the desire for
a life of adventure all helped to attract many young artists to engage upon
long voyages whenever the opportunity presented itself. Sometimes, as in
Westall's case, they gained a paid position as a topographical or landscape
artist to a scientific expedition; at other times they had to content them-
selves with gaining a passage as best they could. They were assisted by the
fact that during the first half of the nineteenth century many fine travel
books, magnificently coloured by means of aquatint engraving, were pub-
lished both in London and Paris. Illustrations for such books were provided
by artists prepared to journey to the ends of the earth in order to paint lands
and peoples no European artist had painted before.[14]

The Austrian artist, Ferdinand Bauer, Westall's companion on the
Investigator, was one of the greatest of all botanical draughtsmen. Few, if
any, natural history painters have equalled the beauty, accuracy and sen-
sitivity which Ferdinand and his brother, Francis, achieved in their draw-

ings of plants and flowers. Indeed, Ferdinand Bauer's work evoked the praise of the poet Goethe, who said that it revealed that the service both of art and science, though difficult, was still possible. Bauer was born in Vienna and was the son of a painter to Prince Liechtenstein. The Abbot of Feldsberg, recognizing his ability at the age of fifteen, engaged him to paint flower studies which later passed into the Prince's collection. In 1786 Bauer journeyed to Greece with John Sibthorp, the Sherardian Professor at Oxford, and returned with him to England where the two men collaborated in the production of the now famous *Flora Graeca* (1806-40). Francis followed him to England and, through Sir Joseph Banks's patronage, became draughtsman to the Royal Botanic Gardens at Kew. And it was through Banks's recommendation that Ferdinand Bauer became Flinders's natural history draughtsman, with a salary of £300 per annum including rations for himself and his servant.

When Bauer arrived in Sydney on the *Investigator* in February 1802 he was so impressed with the great wealth of botanical material awaiting classification that he decided to remain in Australia longer than he had first intended. From Sydney he made many successful botanical excursions including a visit to Norfolk Island in August 1804. He arrived back in England in 1805 with Robert Brown, the great English botanist who was another member of Flinders's expedition, and began to prepare the plates for his *Illustrationes Florae Novae Hollandiae* (1813). But the time was not favourable for flower books and, after the issue of fifteen plates, the project was abandoned (9). Disappointed, Ferdinand left England and bought a small house in Vienna where he completed his drawings of Australian plants, animals and flowers before he died there in 1826. A large number of his drawings of Australian plants are now in the collection of the British Museum (Natural History), South Kensington, many more in the Natural History Museum, Vienna, and others at Göttingen University.[15]

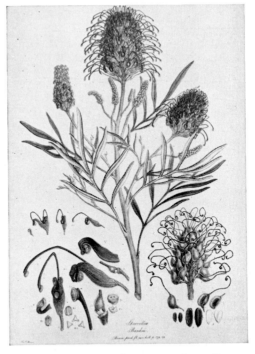

9 *Grevillea Banksii*, engraving after Ferdinand Bauer, from his *Illustrationes Florae Novae Hollandiae*, 12½ x 10, London, 1813

Bauer's achievement was possible because men like Sir Joseph Banks combined a keen interest in science with a delight in fine drawing. Few men of his time had wider or more varied interests than Banks, but the central passion of his life was his botanical collection. Running through years of correspondence with the early governors of New South Wales there is one dominant theme, his tireless interest in the 'non-descript' productions of New Holland. He used his influence with the British Government to provide special facilities for the safe transport of specimens of Australian flora to England. Botanists and horticulturalists were keen to obtain floral rarities from New Holland, and the colony benefited because Banks was equally interested in transmitting useful plants from England to Australia. Indeed the need to transplant Australian specimens to England and to acclimatize English plants in Australia led to the early establishment of botanical gardens in the colony. Amateur collectors like John White, the surgeon of the First Fleet, and Philip Gidley King, the Governor of New South Wales (1800-06), were aware of the great interest in Australian natural history and did all they could to maintain a constant supply of specimens and illustrations from the colony.

But amateurs were not able to cope with the increasing demands of botanists, nurserymen and the directors of botanical gardens. For this reason professional collectors were sent to the country. Among the first to arrive was George Suttor (1774-1859) and George Caley (1770-1829), both sent out by Banks in 1800. Suttor brought a collection of grape vines, apples, pears and hops with him. He proved to be an excellent colonist and forty-three years after his arrival was able to publish *The Culture of the Grape-Vine and Orange in Australia and New Zealand* (1843). Caley also established a botanical garden for the transmission of plants to and from the colony and made several botanical excursions to the south and west of the settlement at Sydney.

Australian plants were received with great interest and enthusiasm in England. The Linnean Society, a scientific society specially devoted to the study of botany, had been founded in 1788, a few months after the foundation of the settlement at Port Jackson. This society from its beginnings took a special interest in Australian flora. James Edward Smith, the President and a close friend of Banks, published his *Specimen of the Botany of New Holland* (1793-4) less than six years after the foundation of the settlement. The book reveals how the propagation of Australian flowers was becoming quite a fashionable pursuit in England. We learn that the Dowager Lady de Clifford was the only lady in Europe who had a waratah growing in her garden, though up to the time of publication it had not flowered. Lord Viscount Lewisham's *pimelia*, however, had flowered, in February 1794. *Mimosa* had been raised plentifully from seeds brought from Port Jackson,

and, wrote Smith, 'is not uncommon now in our greenhouses'. The enthusiasm for Australian plants continued for many years. In 1828 Robert Sweet, another Fellow of the Linnean Society, published *Flora Australasica: or a Selection of Handsome, or Curious Plants, Natives of New Holland, and the South Sea Islands; containing coloured figures and Descriptions of some of the choicest species most proper for the conservatory or greenhouse, and many which will endure the cold of our climate, in the open air, with very little protection; with magnified dissections of their most essential parts, their names, descriptions, a full account of the best method of cultivation and propagation. The greater part are handsome evergreen shrubs, and many produce sweet-scented flowers; as they are generally of free growth, and easily managed, they may be considered as the most desirable plants for cultivation.* The title of the book alone is sufficient to indicate that the interest in Australian plants arose partly from scientific curiosity, partly from a fashionable desire among gardeners to possess exotic rarities from the antipodes.

In any case, the interest in the 'non-descript productions of New Holland' stimulated the production of hundreds of drawings of Australian plants and animals during the early years of settlement. Most of these drawings found their way to England. Some were used to illustrate voyage and travel books relating to Australia, others books and journals associated with the study of natural history. The naval and natural history draughtsmen who first worked in Australia were more interested in depicting its natural curiosities, such as its plants, birds, fish and insects, than in depicting the landscape as a whole. Reactions to the landscape itself varied. Some, noting the lack of undergrowth and the open forest character of the vegetation, compared it with an English nobleman's park. Early engravings representing Australian scenery often resemble an English park, though tropical plants, such as palm and the grass tree (*Xanthorrhoea*), are usually added for local colour. Others, oppressed by the bushland stretching away on all sides, spoke of its monotonous effect.[16] In such country the eye could not look far into the distance; it was trapped, as it were, in a foreground of primeval bushland which offered little variety from its dull evenly-toned olive-grey. Furthermore, early settlers had reason to fear the natives and the danger of getting lost in forests which lacked edible fruits, and in which water was often difficult to find. However fascinating and curious the plants and animals, the landscape as a whole was felt to be drab, fearsome and melancholy. This attitude to Australian nature may be studied in more detail in the work of Thomas Watling, the first landscape painter to work in Australia.

Thomas Watling (*b.* 1762) was a young coach-painter of Dumfries, Scotland, who was transported at the age of twenty-six for forging guinea

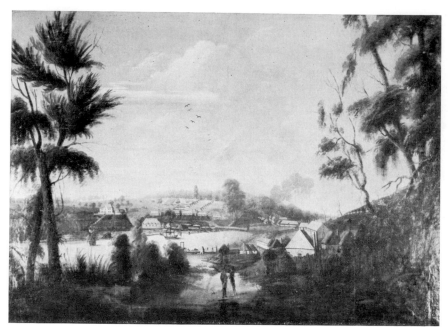

10 THOMAS WATLING, *A Direct North General View of
Sydney Cove . . . in 1794*, canvas, 36 x 51, Dixson Galleries

notes of the Bank of Scotland. He appears from his work to have been
professionally trained and he either taught or was prepared to teach
drawing, for among the documents exhibited at his trial there was a drawing
sheet, which read: 'Ladies and Gentlemen taught Drawing at Watling's
Academy. Admission per month One Guinea'. Watling, though to all
accounts a somewhat shifty young man, received a good Scottish education
and imbibed a great deal of the picturesque taste and romantic sentiment
current during his day. He arrived in Sydney in October 1792 and remained
in the colony until at least 1796, when he received a conditional pardon.
During the period of his conviction he spent a good deal of his time making
drawings of birds, native people and views of the settlement for officials
like John White, the Surgeon-General, and David Collins, the Judge-
Advocate. A number of his drawings have been preserved in the British
Museum (Natural History) at South Kensington, and some of his letters
home were published in *Letters from an Exile at Botany Bay, to his Aunt
in Dumfries* (*c.* 1794). This book enables us to appreciate his reactions to
the Australian scene.

Watling had been trained in the picturesque mode of landscape painting,
a mode which made much use of old and gnarled trees, winding mountain
paths, peasant cottages, jagged and rocky cliffs. Consequently the local
scene depressed him. 'The landscape painter', he wrote to his aunt, 'may in

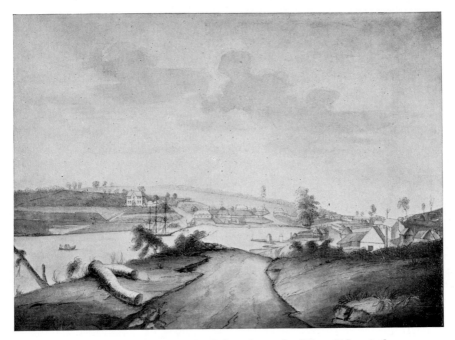

11 THOMAS WATLING, *Taken from the West Side of the Cove,* pen and wash, 15 x 20, *c.* 1794, 'Watling' Drawings, Brit. Mus. (Nat. Hist.)

vain seek here for that kind of beauty which arises from happy-opposed off-scapes. Bold rising hills, or azure distances would be a kind of phaenomena. The principal traits of the country are extensive woods, spread over a little varied plain'.[17] This was an accurate enough description of the Sydney neighbourhood in its virgin state. But Watling knew well enough that picturesque paintings were not simply transcripts of nature but that they were painted by selecting and combining motifs drawn from a number of sketches. So he proceeded to outline to his aunt a programme for painting the local scenery.

I confess that were I to select and combine, I might avoid that sameness, and find engaging employment. Trees wreathing their old fantastic roots on high; dissimilar in tint and foliage; cumbent, upright, fallen or shattered by lightning, may be found at every step; whilst sympathetic glooms of twilight glimmering groves, and wildest nature lulled in soft repose, might much inspire the soul.[18]

How Watling selected and combined to avoid the 'sameness' of the landscape and render it picturesque may be seen by comparing his oil painting *A Direct North General View of Sydney Cove . . . in 1794* (10) with the wash drawing (11) from which the larger work appears to have been painted. Picturesque painters preferred serpentine curves to even

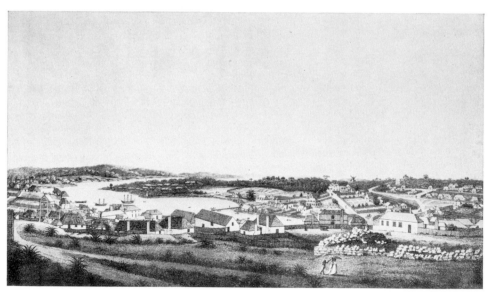

12 W. S. BLAKE, *A View of the Town of Sydney*, aquatint, 9⅜ x 16½, 1802

curves, dark foregrounds to light foregrounds, and a generalized treatment to sharp details. A comparison of Watling's painting with his drawing reveals the following: the horizon line of the drawing curves in one long shallow arc; in the painting the line has been softened, broken by verticals and altered to a shallow serpentine curve; the foreground of the painting is much darker than the foreground of the drawing and is also more generalized in its treatment; large trees have been introduced into the foreground of the painting as side-screens to the view; a group of natives gathered around a fire, and a naval and military man conversing on the high road add a touch of local colour. All these alterations helped to transform a topographical drawing into a picturesque painting. The painting was intended to be what Watling himself called a 'picturesque description', and was probably sent back to England by an official to indicate the growth of the settlement at Sydney after seven years.

Some of Watling's views and drawings of natives were used to illustrate Collins's *Account of the English Colony in New South Wales* (1798-1802). Watling was himself anxious to publish an illustrated book on the colony, for in a projected advertisement which he sent in one of his letters to his aunt in which, incidentally, he calls himself 'Principal Limner of New South Wales', he proposed: 'the Execution of a Picturesque Description of that Colony; in an highly-finished Set of Drawings, done faithfully upon the Spots, from Nature, in Mezzo, Aqua-tinta, or Water Colours'.[19] But the project came to nothing. Watling received a conditional pardon in 1796 and nothing is known of his work after that date. He may, however, have gone

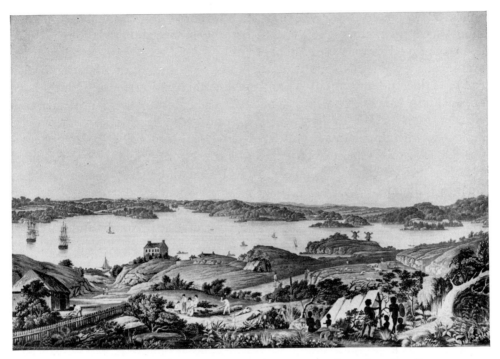

13 *Part of the Harbour of Port Jackson*, aquatint by Robert Havell
after James Taylor

to Calcutta where a Thomas Watling was practising as a miniature painter
between 1801 and 1803.[20] But by 1804 he was definitely back in Dumfries,
for in that year he is alleged to have forged five-pound notes of the Bank
of Scotland. He was tried in January 1806, but the witnesses emitted their
depositions viva voce, contrary to Scottish law, and Watling obtained a
verdict of 'not proven'. In 1806 Watling was forty-four years of age, but
what happened to him after that date remains unknown.[21]

Watling had sought to combine the topographical view and the pic-
turesque landscape in his 'picturesque descriptions'. Though the need for
topographical views of the colony continued, by 1800 there was in England
an influential body of opinion opposed to the fashionable affectations of
the picturesque mode of landscape painting. For instance, Edward Dayes
(1763-1804), a well-known water-colour painter and mezzotint engraver,
published a scathing criticism of picturesque painting in his *Essay on
Painting* (1805). 'We must give up our understanding', he wrote, 'if we
call that landscape fine which represents dirty, rugged grounds, scrubby
bushes, poor scraggy ill-formed trees, shapeless lumps of antiquity, and
muddy pools peopled with gypsies and vagabonds, dirty beggars clothed
with rags . . . or nasty swine on filthy dunghills'.[22] In 1804 Dayes had himself

engraved a *View of Sydney Cove*[23] which is more topographical in approach than Watling's picturesque view of *Sydney in 1794*, though it may have been engraved from an original Watling. Another representative topographical view of this time is W. S. Blake's engraving of Sydney in 1802 (12); its documentary precision and spick-and-span appearance would have appealed to Dayes. The layout and situation of the town are indicated clearly; such details as houses, roads, cultivated land and wharves are indicated with appealing simplicity and welded into a well-balanced composition. A similar manner of working is to be found in the topographical drawings of the convict, John Eyre (14), and the surveyor and explorer, George William Evans.

John Eyre (*c*. 1771-1812), the son of a woolcomber of Coventry, was transported to New South Wales for seven years for breaking and entering. He arrived in Sydney in June 1801. As a convict he was paid from the Police Fund to paint numbers on Sydney's houses at 6d per house. Several of his topographical views (14) were published in D. D. Mann's *Present Picture of New South Wales* (1811) and A. West's *Views in New South Wales* (1812-14).[24] George William Evans (1778-1852) was born at Warwick and articled to an engineer and architect. He arrived in Australia in October 1802 and was appointed acting Surveyor-General of Lands in August 1803. Evans drew several topographical views of Sydney, and also of Hobart after he had taken up the post of Assistant-Surveyor of Lands at Port Dalrymple in 1812.[25] Others followed Eyre and Evans; and many topographical views of Australian colonial towns were drawn and engraved during the next forty years. For this was the great age of picturesque topography. In both London and Paris superb travel books lavishly illustrated with coloured aquatint engravings were being published. One of the greatest of the British publishing houses of the time was Robert Havell and Sons, which published, among other things, the great bird books of John Audubon, the famous American ornithological artist. Havell also published three views of Sydney (1823) drawn by the military surveyor, Major James Taylor, a section of which is illustrated (13).

Taylor arrived in the colony in 1817 as a member of the 48th (Northamptonshire) Regiment and left for Madras in 1824. Unlike Eyre, whose paintings are rather devoid of life, Taylor animated his precisely-drawn panorama with a wealth of local activity. We see a man ploughing a field; a group of men idly gossiping while two doze in the afternoon sun, leaving a third to chop wood—the first illustration on record of what has always been known in Australia as the Government stroke![26] We see travellers on the road; a field full of sheep and cattle; ships at anchor in the harbour; many yachts and native craft. In the middle ground we may note the natural parklands which early travellers so frequently commented upon as

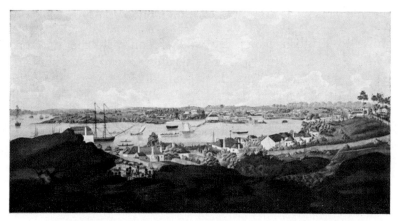

14 JOHN EYRE, *View of Sydney from the West Side of the Cove*, water-colour, 13½ x 25½, 1806, Dixson Galleries

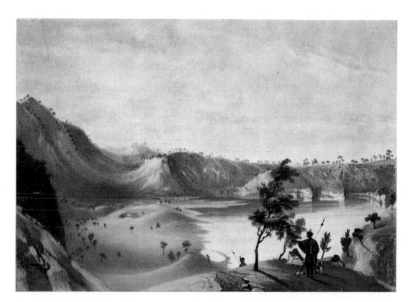

15 *Interior Mount Gambier*, hand-coloured lithograph, 9¾ x 14, by J. W. Giles after George French Angas from *South Australia Illustrated*, 1847

being similar to English parks. By way of contrast, the horizon line is crowded with trees, a feature which gave the landscape that shut-in quality which Watling and many travellers complained about. Into the scene Taylor has carefully inserted two native camps, and has fringed his foreground with native flowers, such as the waratah, the grass tree and the wild iris. In another part of the panorama, Taylor draws English plants growing in the garden of the military hospital. The panorama is clearly not intended to be simply a transcript of nature but seeks to satisfy three allied yet distinct interests: an interest in the progress of the settlement, in the contrast between savage and civilized life, and in natural history.

Panoramas were a specialized development of topographical landscape. One painting was attached to another until the running set provided a graphic description of a large area as seen from one vantage point. The first mechanical panorama was invented by Robert Barker (1739-1806), an Irish painter resident in Edinburgh, who conceived the idea of painting a completely circular view of the city and placing it on a revolving drum. It met with great success and Barker took it to London in 1789 and exhibited it at the Haymarket.[27] It was so successful that a permanent panorama was set up which continued for many years. Panoramas became popular both in England and America during the first half of the nineteenth century, and several panoramic views were painted in the Australian colonies at that time with the ultimate intention of providing material for this highly popular form of entertainment. Robert Burford (1791-1861), for instance, painted panoramas of Sydney and Hobart from drawings made by Augustus Earle in 1825 and 1827. They were shown in London in 1829 and 1830. Several others were painted before 1850: but in the second half of the century the panorama steadily declined in popularity. A highly popular form of art, it reduced pictorial topography to its most hybrid and least satisfactory form.

The topographical view recorded urban progress. It looked in towards the centre of the town, not out into the primeval wilderness flanking the frontiers of settlement. By 1813, however, the Blue Mountains to the west of Sydney were crossed. In Tasmania, where Hobart had been established in 1804, movement into the interior of the island, slow at first, made rapid progress under Governor Arthur following his appointment in 1824. The opening up of the interior confronted artists with new types of landscape. And the first man to paint them, indeed, we might say the first man to paint Australian landscape with a vision unsullied by current artistic conventions, either picturesque or topographic, was John William Lewin (1770-1819).

Lewin was a natural history draughtsman and field naturalist who came of a family of ornithologists. He arrived in Sydney in January 1800 with a

recommendation from the Duke of Portland, who was then the Home Secretary, and he also had an undertaking to collect Australian insects for Dru Drury, a well-known London naturalist who was a friend of Banks and possessed the finest entomological collection in Britain. During 1803-4 Lewin drew, engraved and coloured plates for his *Prodromus Entomology: Natural History of Lepidopterous Insects of New South Wales*, which was published in London in 1805. His second book, *Birds of New Holland*, was published in London in 1808. During these years Lewin also painted many views of Sydney.

Governor Macquarie took a special interest in Lewin

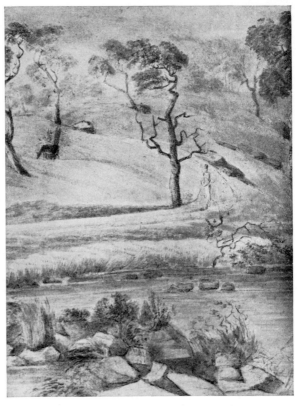

16 JOHN WILLIAM LEWIN, *Cox's River*, water-colour, 8¾ x 7, 1815, Mitchell Library

and helped him in several ways. In 1815 he accompanied the Governor when he made his famous progress over the Blue Mountains to Bathurst. On this progress, Lewin made a number of water-colour paintings of scenery through which the company passed. These paintings constitute the first successful attempt to paint the local scenery with an eye unfettered by current artistic conventions. Lewin's work as a naturalist had enabled him to acquire an honest eye for visual facts. A naturalist, he succeeded in painting a naturalist's landscape; his water-colours are, to the best of his ability, transcripts of nature. In his *Cox's River* (16), for instance, the foreground is light in tone, and contains nothing more than a collection of rocks, grasses and trees, honestly seen and drawn. There are no side-screens of picturesque foliage, no noble savages. Lewin has grasped the nature of the eucalyptus, its light translucent foliage through which the horizon may be seen, and the nature of the slender and feathery grasses of the interior. He succeeded, too, in portraying an authentic bush atmosphere. In *Springwood* (17), for example, we see Macquarie's party preparing to camp among tall

c

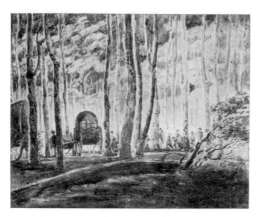

17 JOHN WILLIAM LEWIN, *Spring-wood*, water-colour, 8¾ x 10¾, 1815, Mitchell Library

gum saplings as the raking light of the evening filters through the foliage to cover everything with a rosy tone. The horses have been unharnessed from the wagons and men are standing about or sitting in groups yarning under the trees. In *Sidmouth Valley* (Mitchell),[28] a family is seen camped in the bush, their chattels spread out around their wagon and tents. A woman prepares an evening meal while a man sits on a chest and watches. In Lewin's Blue Mountains paintings the landscape is no longer seen, as it was by the Port Jackson Painter, as an assemblage of curiosities, or as Thomas Watling saw it, as a vehicle for picturesque treatment; it is being seen as a whole. And Lewin succeeded not only in portraying the landscape truthfully, but also in capturing something of the adventurous life of the frontier. New themes became prominent in Australian art soon after the Blue Mountains were crossed. By 1825 illustrations of the adventurous lives of early squatters, explorers and bushrangers in the antipodes were beginning to interest British people quite as much as the pictures of the platypus, the black swan, the lyrebird and the kangaroo.[29]

Illustrations of the Australian scene published in England during the 1820s reveal these new interests. Engravers, however, continued to modify Australian scenery according to picturesque and topographic conventions. This is revealed in the work of the convict painter and engraver, Joseph Lycett (*fl.* 1810-25).

Lycett was, like Thomas Watling, a convict strongly addicted to forgery. He was a native of Staffordshire who had resided for some time in the town of Ludlow when convicted at the Shropshire Summer Assizes on 10 August 1811 of uttering forged and counterfeited bank notes. Sentenced to transportation for fourteen years, he arrived in Sydney in the *General Hewitt* on 7 February 1814; among his fellow prisoners was the architect, Francis Howard Greenway. Evidence concerning Lycett's early life is conflicting. The file of indictments relating to his trial describes him as a labourer, but the *General Hewitt's* list of convicts describes him as a portrait and miniature painter. Lycett certainly possessed skill as an engraver for, sixteen months after his arrival, he was caught in the Police Office, Sydney, where he was employed, forging Commissariat notes. A *Sydney Gazette* notice of 3 June 1815 records how

A Mr Lycett, who, unfortunately for the world as well as for himself, had obtained sufficient knowledge of the graphic arts to aid him in the practice of deception, in which he has outdone most of his predecessors. The bills of Mr Thrupp he has imitated by a means that has not in this colony been before resorted to by the ingenious. The printing type used in such bills has been imitated in copper plate as to deceive the eye upon a slight glance.

For this further lapse Lycett was sent to Newcastle, a place of secondary punishment. There his abilities were put to better use when he was engaged to paint the altar piece of the new church. It is possible that he was responsible for the plans of the church as well. Mrs Macquarie certainly made use of his services to copy drawings from her books on architecture. Governor Macquarie, too, took an interest in Lycett, employing him between 1819 and 1821 to make drawings of views in New South Wales and Tasmania. In these years he seems to have had a better and happier time. His two daughters came out to Sydney as free settlers and returned with him in 1822 after he had received an absolute pardon from Lord Bathurst, to whom Macquarie had sent three of his drawings. In England, Lycett busied himself with engraving his views, appropriately dedicated to his emancipator, Bathurst, for publication. They were issued in thirteen monthly parts, both plain and coloured, under the title *Views in Australia,* during 1824 and 1825.

If Macquarie intended that Lycett's *Views* should indicate the progress of settlement during his administration, his wishes were certainly realized. For the *Views*, each of which is provided with an accompanying text, provide a graphic survey of the colonies in New South Wales and Van Diemen's Land during his term of office: the chief centres of settlement; smaller towns which had been established or had grown considerably under Macquarie; the residences of wealthier colonists to which were added several picturesque and romantic views. The *Views* also testify to the changing life of the times. The expansion of settlement into the interior wrought considerable changes in colonial life. Until Macquarie's time, Sydney and Hobart had been small penal settlements clinging to the coast and surrounded by hostile bushland. But by 1820 attention was beginning to turn to the frontier. So Lycett's *Views* introduced new pictorial motifs that were to have a long life in Australian art: the hunter chasing kangaroos and emus across the wide grassy plains of the interior; the stockman with his dogs; the sundowner with his swag; the bushrangers—or banditti, as Lycett called them—around their camp fire. The inclusion of such typical embellishments to add local colour was characteristic of picturesque landscape and Lycett's engravings are not, like Lewin's Blue Mountains water-colours, honest transcripts of things seen.

After his arrival in England, Lycett prepared a series of water-colours

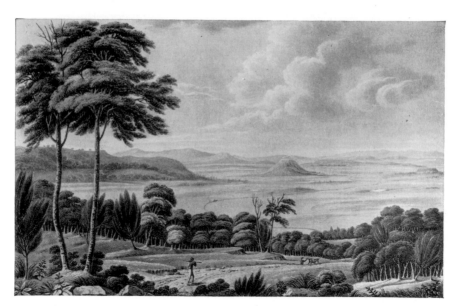

18 JOSEPH LYCETT, *Salt Pan Plain, Van Diemen's Land*, engraving,
6¼ x 10⅝, from his *Views in Australia*, 1824

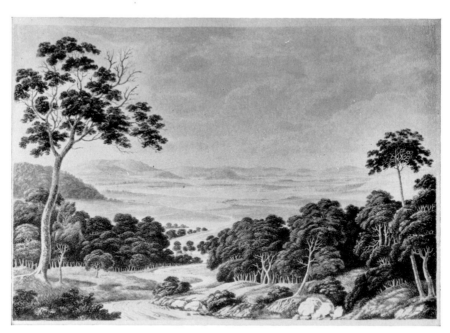

19 JOSEPH LYCETT, *View of the Salt Pan Plains, Van Diemen's Land*,
water-colour, 14 x 19¾, 1824, Dixson Galleries

of his Australian views by way of preparation apparently for his engravings. A comparison of these drawings with their corresponding engravings reveals that in the process of engraving Lycett tended to make the scene correspond to conventional ideas of the picturesque landscape. In the engraving of *Salt Pan Plain, Van Diemen's Land* (18), for example, the eucalypt in the left foreground of the corresponding water-colour drawing (19) has been transformed into two picturesque trees of an indeterminate species, and the open tracery of the foliage has been turned into opaque and laterally-disposed foliage reminiscent of an oak. Figures have been introduced and the engraving as a whole looks more like a piece of English countryside than a land into which Europeans had recently entered. This was due, to some extent, to the sway of picturesque convention in landscape drawing. But the alterations may have been due also in some measure to quite practical reasons. Lycett's was the first important illustrated book to hold out a direct appeal to the prospective migrant to settle in Australia. Such literature has always sought to depict the country in the 'most favourable' light. Lycett was transported to Australia for forging English bank notes. How many migrants he induced, by forging landscapes, to settle freely in the country will never be known.[30]

NOTES

1 EDWARD SMITH, *The Life of Sir Joseph Banks*, London, 1911, p. 16

2 SYDNEY PARKINSON, *A Journal of a Voyage to the South Seas, in his Majesty's ship, The Endeavour*, London, 1773

3 JOHN HAWKESWORTH, *An Account of the Voyages undertaken by the Order of His Present Majesty for Making Discoveries in the Southern Hemisphere . . .* , London, 1773

4 Because of a legal injunction granted to Hawkesworth restraining publication of Parkinson's *Journal, see* SIR MAURICE HOLMES, *Captain James Cook, R.N., F.R.S. A Bibliographical Excursion*, London, 1952, pp. 25-6, 53-5

5 *See* H. N. FAIRCHILD, *The Noble Savage*, New York, 1928

6 *See* L. FITZHARDINGE, 'Some "First Fleet" Reviews', *Hist. Stud. Aust. and N.Z.*, ix (1959), 88

7 Banks was elected President in 1778

8 Now better known as Sydney Harbour

9 The Port Jackson Painter may have been Henry Brewer, *see EVSP*, p. 118 n.

10 JUVENAL, *Satire VI*, 165

11 Accounts of the art work of these men will be found in: MOORE, i, 10-11; *EVSP*, pp. 117-20

12 In the Royal Commonwealth Society Library, London

13 For Humboldt and nineteenth-century landscape painting *see EVSP*, pp. 151-7

14 On Westall *see also Drawings by William Westall, Landscape artist on board H.M.S. Investigator during the circumnavigation of Australia by Captain Matthew Flinders, R.N., in 1801-1803* (ed. T. M. Perry and D. H. Simpson), London, Royal Commonwealth Society, 1962.

15 On Ferdinand Bauer *see also* W. BLUNT, *The Art of Botanical Illustration*, London, 1950, pp. 195-202, *passim*

16 For a more detailed account of these reactions *see EVSP*, pp. 133-4, *passim*

17 WATLING, *Letters from an Exile*, Penrith [n.d.] (1794), pp. 8-9

18 *ibid.*, p. 9

[19] *ibid.,* p. 26

[20] WILLIAM FOSTER, 'British Artists in India', *Walpole Soc.,* xix (1931), 88

[21] On Watling *see also* HUGH S. GLADSTONE, 'Thomas Watling Limner of Dumfries', *Transactions of the Dumfriesshire and Galloway Natural History and Antiquarian Society,* 3rd ser., xx (1935-6), 70-133

[22] *op. cit.,* p. 225

[23] *See* W. DIXSON, 'Notes on Australian Artists', *Journ. RAHS,* v (1919), 231

[24] On Eyre *see also EVSP,* pp. 162-4

[25] On Evans *see also* article in *AE,* vol. iii

[26] i.e. a lazy method of working

[27] On Robert Barker *see also* article in *DNB,* vol i, p. 1129 ff.

[28] *See EVSP,* pl. 112

[29] On Lewin *see also* PHYLLIS MANDER JONES, 'John William Lewin: a Memoir', *Biblionews,* Sydney (Nov. 1953), 36-46, and bibliography (Dec. 1953); *EVSP,* pp. 158-62, *passim*

[30] On Lycett *see also* article in *AE,* vol. v

CHAPTER TWO

ARTISTS ON THE PASTORAL FRONTIER
1821 - 51

*New South Wales is a perpetual flower garden, but there is
not a single scene in it of which a painter could make a
landscape, without greatly disguising the character of the trees.*
BARRON FIELD, *Geographical Memoirs*, 1825

PRIOR to 1821 settlement in Australia was confined to areas around Sydney,
Hobart and Launceston. But after the recall of Macquarie expansion into
the unoccupied areas of New South Wales proceeded apace, and under
the able administration of Colonel George Arthur (1824-36) the struggling
settlements of Van Diemen's Land were transformed into a flourishing
colony. From 1820 onwards both colonies, despite a minor slump in New
South Wales in 1827, experienced boom conditions, based upon the expan-
sion of the pastoral industry, which continued until the depression of 1843.

The rapid expansion of the pastoral frontier brought a greater variety of
scenery to the notice of travellers and artists. In New South Wales men
came to realize that Australian scenery was far more diversified than the
visual monotony of the Cumberland Plain, in its virgin state, had led the
first settlers to believe. They became acquainted with the sub-tropical cedar
brush of the Illawarra and Port Stephens districts, the precipitous sandstone
scarps of the Blue Mountains, the open forest and savannah lands beyond
the Great Divide.

Settlement in the interior also introduced a greater variety of human
experience. Before 1821 the main occupation of artists in Australia had
been to portray the curiosities of nature, the life of the Aboriginals and the
progress of the small settlements. Indeed the new settlements founded
during the period now under consideration, at Brisbane (1824), at Perth
(1829), at Melbourne (1835) and at Adelaide (1836), stimulated both
amateur and professional artists to recapitulate the graphic interests of
Sydney's first artists, each settlement recording its local fauna and flora, its
native peoples and its own progress. But in the older colonies a new range
of subjects, already foreshadowed in the work of John Lewin and
Joseph Lycett, illustrating frontier life, became increasingly popular.
Colonials on horseback hunting the emu and kangaroo, bivouacking around
an evening camp fire, or attacked by Aboriginals or bushrangers: these were

25

the themes which came to symbolize the adventurous colonial life and to attract migrants to the country.

During the period Australia began to experience some of the effects of the romantic revival in arts and letters. Certainly, elements of romanticism can be found in Australian work before 1820, but they are exceptional. Distance and isolation from Europe created a noticeable time-lag in taste and fashion, a lag emphasized by the fact that the colonial economy was never affluent enough to support the arts in any but the smallest degree. The neo-classical taste of the late eighteenth century persisted in Australia well after 1820. Barron Field (1786-1846), who claimed, not without justification, to be Australia's first poet, wrote poetry and prose in the 1820s, still governed largely by Augustan conventions; and John Glover's paintings of the 1830s, as we shall see, echo the pictorial tastes of eighteenth-century England.

It should be realized, too, that the Australian colonist was cut off from one of the most important sources of romantic sentiment and inspiration, the veneration of the past, especially the Christian medieval past of the northern nations of Europe. As John Ruskin wrote in 1856:

. . . the charm of romantic association can be felt only by the modern European child. It arises eminently out of the contrast of the beautiful past with the frightful and monotonous present; and it depends for its force on the existence of ruins and traditions, on the remains of architecture, the traces of battlefields. . . . The instinct to which it appeals can hardly be felt in America.[1]

He might equally have said Australia, for Australia as so many at the time remarked, possessed no ruins: she could not dream about her past, only about her future.

There were, however, two sources of romantic sentiment available in the new colonies; the love of the simple and adventurous life freed from the conventions of civilized life, and the closely associated delight in wild, mountainous scenery. The noble savage itself was, at heart, a romantic symbol; and as the century progressed it shed its classical associations. Such a painting as Captain James Wallis's *Corroboree at Newcastle* (20) admirably expresses the romantic interests of the time. Here is that love of primitive man, wild scenery and moonlight which the romantics adored. And yet, for all its romantic interest, the image of the noble savage was quickly replaced in the second and third decades of the century. Even in the eighteenth century, despite a wide currency, it had appealed only to a limited number of educated people. It ill accorded with colonial experience. For the great majority of the colonists the natives represented the lowest condition of human existence. Contact with Europeans debauched their intricate tribal structure and shattered the economic basis of their existence. Clad in old rags to hide their nakedness from the eyes of the newcomers,

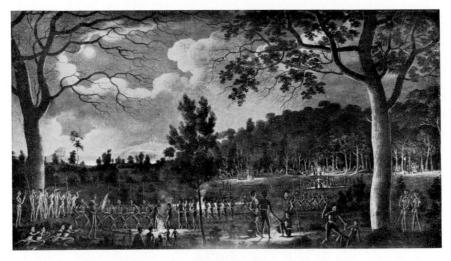

20 JAMES WALLIS, *Corroboree at Newcastle*, oil on wood, 28 x 48,
c. 1817, Dixson Galleries

the Aboriginals became, during the 1820s and 1830s, the butt of a cruel and insensitive colonial humour.

The moral values of the convicts, such as they were, were still largely responsible for determining the moral values of colonial society at large.[2] And for the convicts the Aboriginals were a species of human being who belonged to a social class lower even than their own. Much of the cruelty which convicts experienced from their masters during the period of their servitude was visited upon natives with whom they came in contact on the pastoral frontier where so many became shepherds and stockmen in the years following their emancipation. T. R. Browne, a convict stationed at Newcastle in the years 1812-13, was among the first to caricature the Aboriginal. He produced comical silhouettes of well-known natives called by nicknames such as Long Jack, Pussy-Cat, and Hump Back'd Maria (21). Caricaturing the Aboriginal was carried on into the 1830s by W. H. Fernyhough (1812-49), a surveyor and architectural draughtsman, who lithographed *Twelve Profile Portraits of the Aborigines of New South Wales* in 1836. The grotesque gestures of his *Native Dance* (22) afford a sharp contrast with James Wallis's *Corroboree at Newcastle*. The Aboriginal is no longer conceived as a romantic figure performing his strange rituals under the light of the moon. He has become the colonial clown. Even more striking is the contrast between John Carmichael's besotted and debauched *Male and Female Black Natives* (23) of 1839 and William Blake's idyllic *Family of New South Wales* (3) of 1793. Such contrasts testify to the decline of the idea of the noble savage, an idea which did much to humanize relationships between Europeans and native peoples during the second half of the

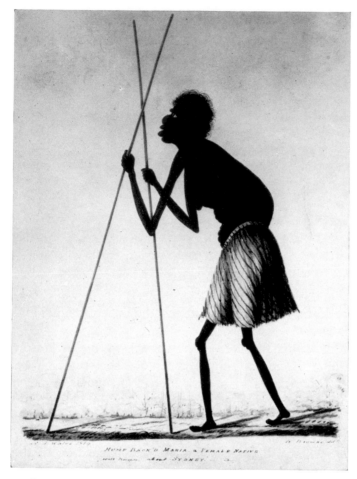

21 T. R. BROWNE,
Hump Back'd Maria, a
Female well known about
Sydney, water-colour, 11½
x 9½, *c.* 1819, Nan Kivell
Collection, Commonwealth
of Australia

eighteenth century. In place of the noble savage, the nineteenth century
evolved the idea of the ignoble savage, a concept crystallizing largely out
of the attitudes formed by evangelists and evolutionists. For, to the
thoroughgoing evangelist, Aboriginals were pagan savages who (saving
Christian conversion) were destined to perdition; to the evolutionist they
were creatures but one step above the brute creation, destined to extinction
by the immutable laws of natural selection.

To replace the eighteenth century's black noble savage the nineteenth
century produced a white one: the noble frontiersman. He became the
new representative, the new symbol, of a life freed from the restricting
conventions of civilized life. His was a life lived close to nature, dangerous,
adventurous and often heroic. The image arose in the art of many pioneering
communities in the second decade of the century; in America, for instance,
in such forms as Natty Bumppo, the hero of several of James Fenimore
Cooper's novels. In its Australian context, the graphic image is fore-

shadowed in pictorial embellish-
ments to Joseph Lycett's engrav-
ings, but it is better expressed in
the work of Augustus Earle (1793-
1838), an artist himself greatly
given to a life of wandering and
adventure.

Augustus Earle was the son of
James Earle (1761-96), and the
nephew of Ralph Earle (1751-
1801), a well-known American
portrait painter. Augustus's father,
who was himself a painter, travelled

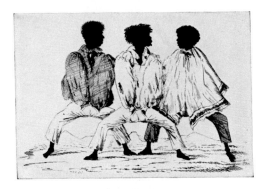

22 W. H. FERNYHOUGH, *Native
Dance*, lithograph, 8½ x 11, 1836

to England as a young man, and his son studied at the Royal Academy.
After completing his studies, Augustus travelled in the Mediterranean
(1815-17), spent two years in the United States (1818-20) and four more
in Brazil (1821-24). In 1824, on his way to India, Earle was wrecked on the
south Atlantic island of Tristan da Cunha. After an adventurous eight
months on the island he was taken off by the *Admiral Cockburn* bound for
Van Diemen's Land, and arrived in Hobart in January 1825. He later visited
New Zealand and India, and in 1831 embarked as topographical artist
aboard the *Beagle*, where he made the acquaintance of Charles Darwin.

Earle only remained in Australia until October 1828, and there was an
intervening visit of nine months to New Zealand. He was, therefore, only
a bird of passage; but he worked with great industry and covered a large
part of the country. He also became quite well known as a portrait painter
in New South Wales. His best-known portrait is the full-length standing
figure of *Captain John Piper* (1773-1851), the Naval Officer of Port Jackson
(24). Piper is presented in his uniform of office, standing upon a southern

point of Sydney Harbour, beside a
gum tree. His splendid residence,
'Henrietta Villa', the scene of many
of the colony's most lavish enter-
tainments during the twenties, is
portrayed behind him. Earle also
painted portraits of Governor Bris-
bane and Governor Darling, and a
number of the notables of New
South Wales.

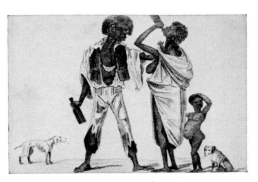

23 JOHN CARMICHAEL, *Male and
Female Black Natives*, etching, 4½ x 7,
1839

Earle made many excursions into
the newly-opened regions of New
South Wales, including the Illa-

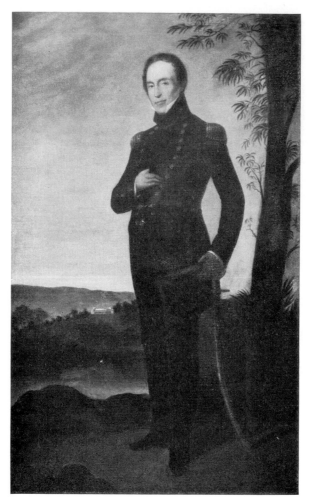

24 AUGUSTUS EARLE, *Captain John Piper*,
canvas, 75¾ x 47½, *c.* 1826, Mitchell Galleries

warra, Port Stephens, Port Macquarie, the Bathurst Plains and Wellington Valley—at that time the most westerly of all the settlements of the colony. On these excursions he sought to portray natural curiosities of the landscape, especially geological curiosities, the life of the native people and the activities of the regions recently opened up by European settlement. Like many of the roving artists of his time, Earle was anxious to visit regions 'hitherto unvisited by any artist'. In the early years of the century before the invention of photography (1839), when the perfecting of the coloured aquatint and the lithograph was making illustrated travel books popular, there was a great need for illustrations of little-known parts of the world. Earle was only one of a great number of artists who wandered widely about the world seeking to provide them.

Many years after his visit to Australia Augustus Earle, back in England after his work on the *Beagle*, exhibited a painting at the Royal Academy of 1838, made from drawings executed in the Illawarra district of New South Wales. He called it *A Bivouac of Travellers in Australia in a Cabbage Tree Forest, Day Break* (25). The painting seeks to present something of the life of the colonial frontiersman, which was now beginning to impress itself upon the European imagination. The scene is set in a landscape highly exotic to English eyes. A group of travellers, accompanied by their native guides, are seen about their camp fire, which has been kept blazing all night. Around them are strewn saddles, rifles and dogs, and the results

of the previous day's kill. Two men are preparing to break camp; another is about to place a quart-pot on the fire in preparation for breakfast. One traveller stretches himself on awakening; another is still asleep. By means of such paintings the image of the noble frontiersman was transmitted. It was just the kind of picture calculated to stir the imagination at a time when migration from the old world to a new was exercising the thoughts of thousands.

The noble savage had inhabited a romantic wilderness. The noble frontiersman entered, like Abram, into a land of sweet pastures. During the 1820s and 1830s, as sheep runs were pushed farther and farther into the interior, the pastoral imagery of the Bible rose constantly in the minds of travellers. It was the land of Canaan. 'O I congratulate you', exclaimed the Reverend Samual Marsden, as he encountered a family of settlers negotiating the precipitous passes of the Blue Mountains. You are all going to the land of Goshen.'[3] And when Barron Field in 1822 rode into the Bathurst Plains (to which Marsden had been referring) he found, as he had never found upon the coast, a country his heart could warm to:

I could hardly believe I was travelling in New Holland this day, so different, so English—is the character of the scenery—downs, meadows and streams, in the flat—no side scenes of eucalyptus. . . . You may see as far as the eye can reach. Stockmen, cattle and sheep occasionally form your horizon, as in old Holland— a Paul Potter or Cuyp effect rare in New Holland. At sunset we saw wooded hills, distant enough to display that golden glow which landscape painters love.[4]

And another traveller a year later wrote:

The fatigue of the journey was now over, and we were really in a Christian country—the climate mild and delightful, the prospect cheerful and extensive— the sheep returning to the fold seemed healthy and happy, and awakened thoughts of abundance—of content—of thankfulness. The gorgeous sun was setting in a robe of gold, over that undiscovered country west of the Macquarie, and the scene was altogether worthy of a Claude.[5]

Throughout the 1820s and 1830s some of the best pastoral land of eastern Australia was opened up by squatters and explorers. Their reports resounded with a note of optimism and hope for the future. In 1836 Major Mitchell found, in the Western District of Victoria, the land of Australia Felix:

As I stood, the first European intruder on the sublime solitude of these verdant plains, as yet untouched by flocks or herds, I felt conscious of being the harbinger of mighty changes there for our steps would soon be followed by the men and the animals for which it seemed to have been prepared.[6]

It is not surprising that the new pastoral country opened up should suggest to some the possibility of a new and independent school of landscape paint-

ing in Australia. Dr John Lhotsky, a Polish scientist who made a visit to the Southern Alps in 1834, wrote a few years later:

Australian sky and nature awaits, and merits real artists to pourtray it. Its gigantic gum and acacia trees, forty feet in girth, some of them covered with a most smooth bark, externally as white as chalk; the enchantment—like appearance of forests, the foliage of which is pruinose and mellow, in a way defying description— mornings and evenings so pure and serene that the eye is absorbed as it were, in the depths of the azure of the horizon. . . . All this and more . . . will produce a Daniell, and in succession a Salvator Rosa, and, perhaps, such as will even succeed them.[7]

Lhotsky wrote his comment in 1839. By that time John Glover, a very well-known English artist who knew and revered the work of Claude and Salvator Rosa, had already been working for nine years in Australia seeking to render as ably as he could the characteristic features of the country's landscape. Augustus Earle had been a bird of passage, but Glover (1767-1849), who arrived in Hobart in February 1831, came to stay. He was the son of a Leicestershire farmer who first established himself as an artist and drawing master in Lichfield. In 1805 he began to practise in London and rapidly became one of the most successful artists and art teachers in the kingdom. He was elected President of the Old Water-colour Society in 1807, and exhibited regularly at the Royal Academy and the Society of British Artists, holding one-man shows in London in 1823 and 1824. In 1830, however, at a time when Van Diemen's Land was receiving considerable publicity in England as a desirable home for migrants with capital, and when Glover was sixty-four years of age, he decided to leave England to paint the little-known scenery of the new colony and to settle his family upon the land.

In 1832 he obtained an extensive grant of land in north-eastern Tasmania on the northern slopes of Ben Lomond. There he built a fine two-storeyed stone house, and called his property 'Patterdale', after Patterdale in Cumberland where he had lived for some time before migrating to Van Diemen's Land. Here, as his family proceeded to farm, he continued to paint prolifically, as he had done throughout his life, and was able to prepare an exhibition 'descriptive of the scenery and customs of Van Diemen's Land' which he held in Bond Street, London, in 1835.

Glover's style was formed in the last decades of the eighteenth century, and he retained a great affection for those landscape masters, such as Claude Lorraine, Salvator Rosa and Gaspard Poussin, whom the connoisseurs of the time revered. Indeed, he owned two Claudes himself. It is not surprising, therefore, that his interpretations of the Tasmanian landscape should at times recall these masters. Glover's son, John Glover junior, remarked once that the rocks along the Tamar River reminded him of the rocks in Gaspard

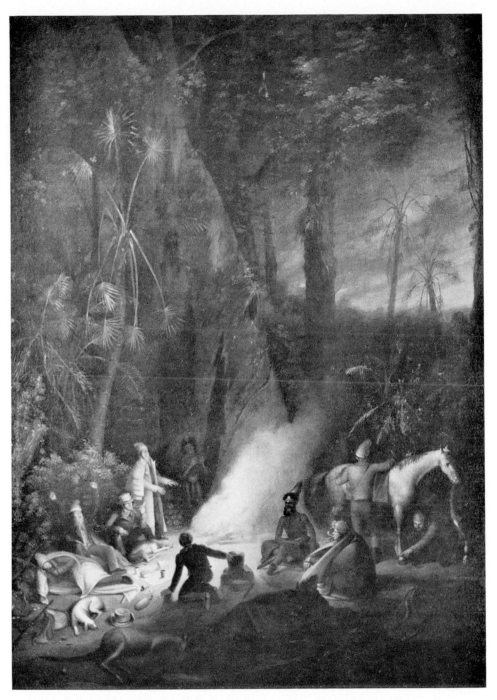

25　AUGUSTUS EARLE, *A Bivouac of Travellers in Australia in a Cabbage Tree Forest, Day Break*, canvas, 41½ x 32¾, *c.* 1838, Nan Kivell Collection, Commonwealth of Australia

26 JOHN GLOVER, *Australian Landscape with Cattle*, canvas, 30 x 40,
c. 1835, Nan Kivell Collection, Commonwealth of Australia

Poussin's paintings;[8] and John Glover's painting of a hunting party on Ben Lomond (N.L.A.)[9] recalls the banditti scenes of Salvator Rosa and Gaspard Poussin. This is not to say that Glover was incapable of catching the character of the local landscape. There need be little doubt that he had come to the colony with that intention very much in mind. Some of the remarks which he wrote into the catalogue of his 1835 exhibition are most perceptive, as when he observes: 'There is a remarkable peculiarity in the trees in this country; however numerous they rarely prevent you tracing through them the whole distant country'.

Such observations were also expressed in his drawings and paintings, as in his *Australian Landscape with Cattle* (26). This fine landscape concedes nothing to later artists like Louis Buvelot, Tom Roberts, Arthur Streeton and Hans Heysen in the unmistakable clarity of its vision. Here is no Englishman painting the landscape with English eyes nor interpreting it by means of the ideal formula of Claude. The light and open foreground untidily strewn with fallen logs and branches, the translucent screen of trees in the middle distance, the pale blue hills beyond: such typical features of the local landscape are seen and depicted lucidly. In such paintings Glover established himself as one of the pioneers of Australian landscape painting. Yet in those optimistic years of the pastoral expansion everything seemed possible, and the reality often faded imperceptibly into the ideal.

In *My Harvest Home* (27) the old blends with the new.[10] A bountiful harvest has sprung from what was once an antipodean wilderness. The

27 JOHN GLOVER junior, *My Harvest Home*, canvas, 30 x 46½,
c. 1840, Hobart

eucalypt forest glows in the mellow light of Claude. It is a vision of a
pioneer's paradise. But the sense of plenitude and physical well-being which
the painting figures forth is no mere pictorial device, for it expressed the
living experience of the Glover family as Australian farmers. Northern Tas-
mania became a granary for the mainland in the early 1830s and played
an important part in the growing prosperity of the island. 'We sow, plant,
fence and break up new ground in progressive order', wrote John Glover
junior to his sister in England, 'and our crops thank goodness turn out
equal to most, our wheat in particular often surpasses most of our neigh-
bours . . . Mr Glover continues painting'.[11]

Glover continued painting until the last few years of his life when he
became something of a patriarch on his splendid agricultural and pastoral
property, surrounded by his children and grandchildren. He impressed all
who met him in the closing years of his life with his natural dignity and his
strong religious convictions. One of his English pupils wrote of him:

Though he was a very plain man and uncouth in appearance he was one of the
most interesting persons I ever met with. He could not, I imagine, have been a
highly educated man, but his mind appeared to us as innately elegant, poetical
and refined, and when he spoke of the beauties of nature he seemed to conduct
his hearers into a world of his own so deeply did he feel and appreciate.[12]

In his deep feeling for nature, Glover was closely akin to the early
romantic poets. It is likely that he knew Wordsworth, for they lived less

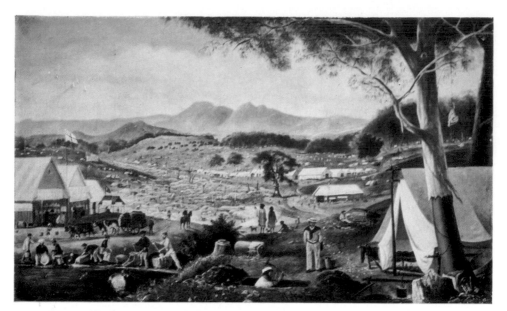

28 E. ROPER, *Gold Diggings, Ararat*, canvas, 17½ x 29½, 1854,
Dixson Galleries

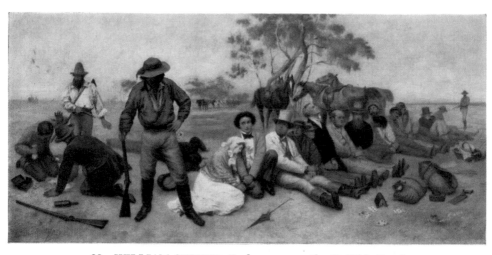

29 WILLIAM STRUTT, *Bushrangers on the St Kilda Road*,
canvas, 29¾ x 61½, *c.* 1887, Lady Grimwade

than ten miles apart in the Lake District for some years. In several of his Tasmanian landscapes, Glover's lucid observations of natural forms were mingled with a delight in capturing the transient effects of sunlight, mist and cloud. He was the first artist working in Australia in whom the effects of the romantic revival may be observed at work.[13] But others were soon to follow. In 1835, the year in which Glover held his exhibition of Tasmanian landscapes in London, Conrad Martens (1801-78), a pupil of that highly romantic water-colour painter, Copley Fielding, arrived in Sydney.

Martens's early life serves to remind us that the practice of using professional painters as artists upon voyages of survey and discovery, which Joseph Banks had done so much to inaugurate when he travelled with Cook in the *Endeavour,* was still very much alive. Martens was the son of a German who had come to England as Austrian consul and later settled as a merchant. Both his brothers were artists; and when his father died in 1816 Conrad studied landscape painting under Fielding, later making many sketches along the Devon coast after he and his mother had moved from London to live at Exeter. Late in 1832 or early in 1833 he accepted the offer of a trip to India, but while his ship was at Rio de Janeiro Captain Fitzroy offered him the post of topographical draughtsman on the *Beagle,* as Augustus Earle was about to vacate the position because of ill health.

Martens remained with the expedition from November 1833 until the *Beagle* and the *Adventure* arrived at Valparaiso where, in October 1834, it became necessary to sell the *Adventure* to reduce the expense of the expedition. This forced Martens to leave the expedition; or, as Charles Darwin, who had become a friend of the painter, put it in a letter to his sister, 'to leave our little Martens to wander about the world'.[14] As it happened he only wandered across the Pacific; first to Tahiti, for a few weeks, then to the Bay of Islands, New Zealand, for a few days, and then on to Sydney, where he arrived in April 1835. There he remained until his death in 1878.

Like Augustus Earle, Martens travelled widely in New South Wales shortly after his arrival and it seems that at first he intended to move on as Earle had done. By 1835, however, there was a small but influential circle of people in the colony, including Sir Richard Bourke, the Governor of New South Wales from 1831 until 1837, Alexander and William Macleay, General Sir Edward Macarthur, and Captain P. P. King, all of whom were interested in the promotion of science and the arts in the colony. They were able to provide Martens with some initial support and bought his paintings. Local patronage was fitful and unpredictable, however, and, when the depression of 1843 hit the colony, Martens and his family (he had married in 1837) were reduced to straitened circumstances for several years, though he received a little financial help from his family in England from time to time.

D

Lithographic views of Sydney, the first of which he produced in 1842, also helped to tide him over the worst of his difficulties. Finding it impossible to live on the sales of his painting despite a prolific output, he was pleased to accept the position of Assistant Librarian of the New South Wales Parliamentary Library. In 1843 he had built a cottage at North Sydney, then called St Leonards, and there he lived with his family until his death at the age of seventy-seven.

Martens was the most prolific, if not the most important, of Australia's colonial painters. His early work, as revealed in his Devonshire water-colours, is based on the practice of his master, Fielding, which consisted in broad, fluently-handled renderings of picturesque aspects of sea and shore, moorland and country road, renderings which delighted in making use of accidental effects of light and shadow and the visual drama of storm and rain clouds. The work which he executed during the months aboard the *Beagle* was, and had to be, more precise, documentative and empirical. For he was in the company of men whose capacity for observing the world of nature was penetrating, analytical and precise: not only Darwin himself, whose powers of observing nature have never been surpassed, but also men like Captain Robert Fitzroy, a pioneer meteorologist, from whom Martens clearly learned much of use to him in the observation of clouds and other atmospheric conditions.

The paintings which Martens produced in the years immediately following his arrival in Sydney are still conceived in the traditions of picturesque topography which he had employed while an artist on the *Beagle*. As the years passed, however, he became more interested in the elevation of his themes above the level of topography and sought to capture effects of romantic grandeur (30). His *North Head, Sydney Harbour* (Adelaide, 1854) is still largely a picturesque composition, with its side-screens of trees and its heavy dark foreground. But there is much insistence upon the documentation of foreground detail, and he exaggerates the size of his trees to endow them with dignity and grandeur. All this is most Turnerian. And, like Turner, and the landscape painters of his generation, Martens was fascinated by the problems involved in the depiction of light.[15] Light, as the great romantic painters conceived it, was the most dramatic element in the involved drama of nature. And Martens became a master in rendering vivid effects of light, cloud and storm over Sydney Harbour (30). Entries in his notebooks reveal how he studied the heavens like a meteorologist. He also made water-colour sketches of moonlight and dawn over the sea. From such researches came paintings like *Sydney from Vaucluse* (31). Here the close-up precision of urban topography is replaced by a romantic vision of the city as a small world of man encompassed by the larger world of nature. It is a splendid study in atmosphere and light, highly reminiscent of Turner.

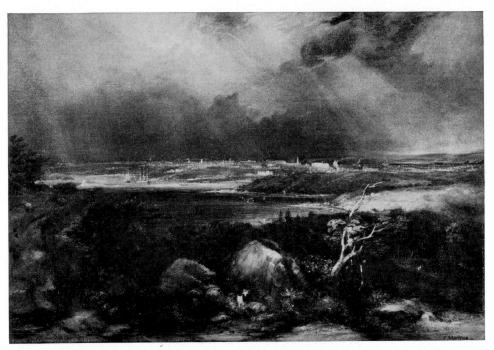

30 CONRAD MARTENS, *View from Neutral Bay*, water-colour, 17¾ x 25¾,
c. 1857/8, Mr K. R. Stewart

31 CONRAD MARTENS, *Sydney from Vaucluse*, water-colour, 17½ x 26,
1864, Dixson Library

Only rarely did Martens reach such heights, and then only in his finest water-colours. He had been trained as a water-colour painter and his oils tend, by comparison, to be heavy in treatment and flat in colour. It was a medium he never fully mastered.

Although Martens will always be remembered for his romantic interpretations of Sydney Harbour, the plains of the interior attracted him as they had Barron Field. In the early 1850s he sailed to Brisbane, travelled across the Great Divide to the Darling Downs, and made his way down the New England Tableland painting landscapes and the residences of squatters. The district had been occupied during the 1820s and 1830s, and Martens found some hospitality (and an occasional patron) in the homesteads he drew and painted. His Darling Downs landscapes have certain similarities with the Mills Plains landscapes of John Glover in the way the pictorial elements are assembled. Foregrounds have a sense of spaciousness, groups of trees tend to be placed in the middle distance, and there is a further emphasis upon treeless spaces in the depths beyond. The emphasis is upon openness, flatness and bigness. But the Australian savannah, which was to prove such a compulsive image to the painters of later generations, was not Martens's true *métier*. At heart a romantic, he was more at home painting the gorges and sandstone battlements of the Blue Mountains, and those foreshores of Sydney Harbour from which there sprouted in Martens's own day many Gothic Revival mansions whose battlemented heads, rising above the gum trees, served to remind their owners in exile of the ancient northern origins from whence they had sprung.[16]

Until the end of the 1820s colonial art in Australia was produced almost entirely for an English audience; though there was always some local demand for portraits and miniatures. The period from 1830 to 1851, however, witnesses the emergence of local patronage in New South Wales and Van Diemen's Land. Artists became aware that a small local market for their work existed. It depended very largely upon the interests of professional people: the higher civil servants, Army and Navy officers, doctors and lawyers, together with some members of the older pastoral families, such as the Macarthurs, as distinct from the newer class of squatters who, during those years, were too fully occupied establishing themselves upon their holdings to have any time or money for the cultivation of the arts.

One indication of the rise of local patronage is the publication from time to time of engraved and lithographic views of Sydney and Hobart. Sometimes these were brought together in book form. Thus Charles Atkinson published his *Views through Hobart Town* in 1833, in which he made some concession to contemporary taste by featuring himself standing before a Gothic ruin. In 1836 J. G. Austin published his *Lithographic Drawings of Sydney and its Environs,* and two years later J. Maclehose published his

Picture of Sydney. Similar publications followed during the 1840s. Such books rarely rose above the level of modest topography but they were produced for a local market not an English one.

Another indication of the growth of colonial taste and patronage is to be found in the emergence of amateur art circles and the organization of the first art exhibitions. In early Victorian England the ability to sketch in water-colours was an elegant accomplishment suited alike to ladies of fashion and gentlemen of taste. And among a small and select circle of Van Diemen's Land society water-colour painting became quite fashionable during the 1830s and 1840s. From the time of John Glover's arrival in 1831 an amateur interest in painting flourished. During the 1840s the amateur painters included G. T. W. B. Boyes, the Colonial Auditor; Dr F. R. Nixon, the first Bishop of Tasmania; George Frankland, the Surveyor-General of Tasmania (1828-38); Lieutenant F. G. Simpkinson, the nephew of Lady Franklin, and Samuel Prout Hill, a journalist, lecturer and poet.

Some of the work possessed distinction, notably that of Boyes, who also wrote an outstanding personal diary invaluable for the study of his life and times, which has never been published.[17] Rallying points for those like Boyes and others who were interested in raising standards of public taste were provided by the establishment of Mechanics' Institutes, first in Hobart in 1827, then in Sydney in 1833. By 1851 the capital of every Australian State had its own institution. These Institutes provided among other things a forum for public lectures and the exchange of ideas concerning the fine arts and standards of public taste.[18]

Art exhibitions also helped artists and potential patrons to come together. An exhibition of his own work which Augustus Earle held in Sydney in July 1826 aroused considerable interest; but little appears to have been done until many years later. John Skinner Prout (1806-76) awakened considerable interest in painting through his lectures at the Sydney Mechanics' Institute when he arrived in 1840. Seven years later a Society for the Promotion of Fine Arts was established under the presidency of Sir Charles Nicholson, and held its first exhibition in the Australian Library, Sydney, in June 1847. In Hobart, which he visited in 1843, Prout's lectures and teaching aroused widespread interest. 'The prevalent fashionable epidemic, instead of betraying symptoms of the ancient Berlin wool influenza or the knitting disorder, had taken an entirely new turn', wrote Louisa Ann Meredith, 'and that a landscape-sketching and water-colour fever raged with extraordinary vehemence'.[19] The enthusiasm led to the organization by Prout, Boyes, Nixon and others, of the island's first exhibition, which was held in the Legislative Council Chambers in January 1845. An art exhibition in which John Glover participated was held at the Launceston Mechanics' Institute in 1848.

32 JOHN SKINNER PROUT, *Grass Trees, Richmond Road, Van Diemen's Land*, water-colour, 10 x 7, 1844, Nan Kivell Collection, Commonwealth of Australia

Apart from Conrad Martens, the two most important artists working in the Australian colonies during the 1840s were John Skinner Prout and George French Angas (1822-86). Both of them, however, like Augustus Earle were birds of passage, and both had gained experience in picturesque travel before arriving in Australia. John Skinner Prout was a nephew of Samuel Prout, an artist greatly admired by John Ruskin for his renderings of medieval architecture. Largely self-taught, he had obtained considerable experience in England sketching ancient buildings, a practice then much in vogue. He could also write with facility about his travels and had experience in handling a lithographic press. Prout published some of his drawings in his *Castles and Abbeys of Monmouthshire* (1838). Early in 1840, however, finding it difficult to obtain a living in England, he migrated with his family to Australia where he threw himself with vigour into the task of promoting an interest in water-colour painting in the colonies.

Like Earle, Skinner Prout travelled widely. His paintings, however, are much less of a documentary and topographical nature than Earle's. For he sought out picturesque effects seeking to capture them swiftly with a few deft washes and telling strokes. His work is much lighter in treatment than the more heavy and finished work of Martens (32). Prout possessed considerable facility and it is clear that he was appealing to that early Victorian taste for breadth, charm and simplicity in water-colour which was to be shattered by the geological, botanical and moral thunderings of John Ruskin. But Prout lacked Martens's capacity to study nature with patience and humility.

Prout, none the less, worked with great industry. After a sojourn in Tasmania he visited the Port Phillip District and sketched there. Before he returned to England in 1848 he had published by means of his own lithographic press: *Sydney Illustrated* (1844), *Tasmania Illustrated* (1844), and *Views of Melbourne and Geelong* (1847). He had, however, arrived in the

colonies at a most unfortunate time and lived through the 1841-43 depression in the eastern States. On his return to England he held an exhibition of dioramic views of Australia based on his drawings. The scenes he chose, such as a *Bivouac of Emigrants in the Blue Mountains,* were those likely to interest prospective migrants. After returning to England he lived first in Bristol and then in London, where he was a member of the New Water Colour Society for many years. He died in 1876.[20]

The work of George French Angas is closely connected with the foundation of South Australia and a programme to induce migrants to settle there. He was the son of George Fife Angas (1789-1879), the banker, shipowner and philan-

33 RICHARD READ senior, *Mrs Macquarie,* miniature on ivory, 3¾ x 2¾, c. 1819, Hobart

thropist who did so much to found the colony. George French Angas first studied art under Waterhouse Hawkins, a natural history painter; and, like Skinner Prout, travelled in search of the picturesque, having published some travels before journeying to Australia. At the age of nineteen he made a trip to the Mediterranean and in 1842 published *A Ramble in Malta and Sicily in the Autumn of 1841.* In September 1843 he sailed for South Australia where he travelled widely about the colony, sketching the scenery and the Aboriginals. Both his art and his programme recall those of Augustus Earle, and are more documentary and factual in their approach than those of Prout.

From South Australia, Angas visited New Zealand and then paid a short visit to Sydney, returning home to hold an exhibition of his work in the Egyptian Hall, Piccadilly, in 1846. He then set about publishing his travels: *Savage Life and Scenes in Australia and New Zealand* (1847); *The New Zealanders Illustrated* and *South Australia Illustrated* (1847) (15). These books contained large coloured lithographs and were based on the scale and manner of publication of John Gould's *Birds of Australia* (1841-48). Such books and the exhibitions of his work helped to publicize South Australia and New Zealand to prospective migrants. Angas next visited South Africa (1848) and on his return published *The Kaffirs Illustrated* (1849).

He then returned to Australia and for seven years (1853-60) was the Secretary of the Australian Museum, Sydney. By that time he had become as interested in science as in art, and published several papers on conchology and zoology. His work provides yet another example of the close association of art and science during the first half of the nineteenth century. He returned to London in 1861 and died there in 1888.[21]

Early Colonial Portrait Painting

The history of portrait painting in colonial Australia is a field which awaits special investigation, and will only be treated here briefly. The first portrait painter of any standing was Richard Read senior, who was active in Sydney between 1814 and 1826. Read painted portraits of Governor Macquarie and Mrs Macquarie (33) and local notables such as Dr

34 AUGUSTUS EARLE, *Mrs Piper and Her Children*, canvas, 76½ x 47¾, c. 1826, Vaucluse House, Sydney

Bland and Michael Massey Robinson. Read's portraits are of historical interest only.[22] Richard Read junior, a miniaturist who advertised that he 'had no connection whatever with any other person in the same profession', was active in Sydney between 1819 and 1849.[23] Other early Sydney miniaturists include T. B. East, Samuel Clayton and Josiah Allen. Charles Rodius made engravings of Paris streets prior to his arrival in Sydney in 1823. Apart from making a number of portrait drawings of well-known citizens he also executed a series of portraits of Aboriginal 'kings' and their wives, which were published by J. G. Austin in 1834.[24] The portraits which Augustus Earle painted in Sydney between 1825 and 1828 of such people as Governor

Brisbane, Governor Darling, Mrs. Blaxland, Captain John Piper (24) and Mrs Piper and her children (34), though by no means the work of an accomplished portrait painter, are of a better quality than the work of the men before him, and possess a primitive colonial charm.

The first portrait painter to practise professionally in Tasmania was Thomas Bock (1790-1857), born at Sutton Coldfield and probably apprenticed to the Birmingham engraver, Thomas Brandard. Bock practised engraving in Birmingham between 1815 and 1823. In April 1823 he was sentenced to fourteen years' imprisonment at the Warwick Assizes for administering drugs to a young woman. He appears to have been an exemplary convict and received a conditional pardon in June 1832 and a full pardon in November 1833.[25] Bock practised as an engraver in Tasmania, engraving the colony's first bank notes. Apart from drawing and painting (mainly in crayon or water-colour) portraits and miniatures of local citizens, Bock also painted a series of studies of Tasmanian Aboriginals for Lady Franklin, now in the collection of the Tasmanian Museum.

The second portrait painter to practise in Hobart was Benjamin Duterrau (1767-1851), of French Huguenot descent, who was born in London and apprenticed to engraving there. In 1790 he engraved two colour plates for G. Morland. Later he turned to portrait painting, exhibiting six portraits at the Royal Academy between 1817 and 1823, and three genre pieces at the British Institution. Duterrau, like John Glover, migrated to Australia rather late in life. In his sixty-fifth year he arrived in Western Australia but decided to transfer to Hobart, arriving there with his daughter in August 1832. Miss Duterrau became governess to Governor Arthur's children, and Duterrau himself began to practise as a portrait and landscape painter. In 1835 he etched some portraits of Tasmanian Aboriginals, probably the first executed in Australia.[26]

In November 1837 Thomas Griffiths Wainewright arrived in Hobart, having been transported for life for forgery. Wainewright was a talented littérateur and artist, a spendthrift, and probably a poisoner. His colourful life has received much attention from many writers, including Oscar Wilde and Mario Praz, and need not be considered here. Suffice to say that Wainewright studied painting under Thomas Phillips and became an associate of that circle of English pre-romantic artists which included Fuseli, Blake, Stothard and Flaxman. During the early 1820s he exhibited at the Royal Academy regularly and contributed to literary magazines like *Blackwood's* and the *London Magazine* for which he wrote art criticisms and literary essays under various pseudonyms. His literary interests gave him access to the literary circle around Charles Lamb. Although in his English work Wainewright echoes the mannerist extravagance and voluptuousness of Fuseli whom he much admired, in Tasmania, as Robert Crossland has

35 THOMAS GRIFFITHS WAINEWRIGHT, *Frances Maria
Brodribb*, crayon, 20½ x 16½, *c.* 1840, Adelaide

pointed out, he produced a series of portraits 'almost monotonous in their
insistence on the domestic virtues of grace, elegance and refinement'. Such
sensitive portraits as *Francis Maria Brodribb* (35) and *Dr Frederick John
Clarke* (G. R. F. Nuttall) reveal him as the most accomplished portrait
draughtsman at work in Australia during the colonial period.[27]

NOTES

1 RUSKIN, *Works* (ed. E. T. Cook and A. Wedderburn), London, 1903-12, vol. v, p. 369

2 *See* R. WARD, *The Australian Legend*, Melbourne, 1958, pp. 66-99, *passim*

3 MRS HAWKINS, 'Journey from Sydney to Bathurst in 1822', quoted from G. Mackaness, *Fourteen Journeys Over the Blue Mountains of New South Wales, 1813-41*, pt. ii (1950), p.30

4 BARRON FIELD, *Geographical Memoirs on New South Wales*, London, 1825, pp. 430-1

5 Article in *The Australian*, 24 March 1827

6 T. L. MITCHELL, *Three Expeditions into the interior of Eastern Australia . . .* London, 1838, p. 158

7 J. LHOTSKY, 'The State of Arts in New South Wales and Tasmania', *The Art-Union*, London (July, 1839), pp. 99-100

8 John Glover junior to his sister Mary, 20 February 1831, Glover MSS., Mitchell Library, Sydney

9 *EVSP*, pl. 133

10 This painting is usually attributed to John Glover but is more likely to be by his son John Glover junior.

11 John Glover junior to his sister Mary, 12 July 1839, Glover MSS., Mitchell Library, Sydney

12 MS. note on the artist by a former pupil, in the possession of Dr W. L. Crowther, Hobart, Tasmania

13 On Glover *see also* B. S. LONG, in *Walker's Quarterly*, xv (1924); FARINGTON, *Diary*, iii, 87 and v, 53; T. S. R. BOASE, *English Art 1800-1870*, Oxford, 1959, p. 42, *passim*; *EVSP* 194-201; Glover MSS. in the Mitchell Library, Sydney

14 NORA BARLOW, *Charles Darwin and the Voyage of the Beagle*, New York, 1946, p. 108

15 Martens acknowledged his debt to Turner in his 'Lecture upon Landscape Painting', delivered at the Australian Library, 21 July 1856, Mitchell MS., C. 338.

16 On Martens *see also* LIONEL LINDSAY, *Conrad Martens the Man and his Art*, Sydney, 1920; M. H. GRANT, *Dictionary of British Landscape Painters*, Leigh-on-Sea, p. 124; *EVSP*, pp. 232-40, *passim*; J. GRAY, Conrad Martens, B.A. Thesis, University of Melbourne

17 The Diary of G. T. W. B. Boyes, Royal Society of Tasmania, Hobart. Some extracts from the Diary are printed in the *Papers and Proceedings of the Royal Society of Tasmania*, 1946 (1947), pp. 35-50.

18 On the Mechanics' Institutes and Schools of Art in Australia, *see* G. NADEL, *Australia's Colonial Culture*, Melbourne, 1957; *PTT*, pp. 88-94

19 L. A. MEREDITH, *My Home in Tasmania*, London, 1852, pp. 326-7

20 *See also* J. S. PROUT, *Journal of a Voyage from Plymouth to Sydney, in Australia, on board the Emigrant Ship Royal Sovereign*, London, 1844; W. DIXSON, 'Notes on Australian Artists', *Journal RAHS*, vii (1921), p. 379; MEREDITH, *op. cit.*, pp. 326-7

21 *See also* EDWIN HODDER, *George Fife Angas*, London, 1891; and MOORE, i, 61, *passim*

22 On Read senior *see* W. DIXSON, 'Notes on Australian Artists', *Journ. RAHS*, v (1919), 245-7

23 Quoted by DIXSON, from the *Sydney Gazette*, in his article on Read junior, art. cited

24 *See* DIXSON, art. cited

25 Tasmanian State Archives; Report of the Warwick Assizes, *Birmingham Gazette*, 14 April 1823

26 On DUTERRAU *see also* the article in *DAB*; MOORE, i, 37-8

27 On Wainewright *see also* JONATHAN CURLING, *Janus Weathercock*, London, 1938; ROBERT CROSSLAND, *Wainewright in Tasmania*, Melbourne, 1954

CHAPTER THREE

THE LATE COLONIAL ARTISTS
1851 - 85

. . . *in Australia alone is to be found the Grotesque, the Weird, the strange scribblings of nature learning how to write.*

MARCUS CLARKE, Preface to *Poems of the late Adam Lindsay Gordon,* 1880

PAYABLE gold was discovered in Australia in 1851 and wherever it was in quantity a community of tents and shanties sprang up rapidly. Life at these diggings was both vigorous and exacting. A spirit of energy and bustle prevailed which did much in the end to provide Australian life with a new fund of resource and an independence far finer than, though in many ways related to, the dull-spirited and sub-literate modes of resistance inherited from the convict 'founding fathers' of New South Wales and Van Diemen's Land. Life in these new mining communities is expressed with a simple charm in E. Roper's *Gold Diggings, Ararat,* 1854 (28). Nothing is known about Roper, but he was clearly an observant man capable of seeing the amusing and incongruous side of things quickly. How different this painting is from the rural peace of Glover's *Harvest Home* (27); and the contrast provides a sharp indication of the marked difference of life on the old pastoral frontier of Tasmania and the new mining frontier of Victoria. A bearded miner is busily digging for gold while his mate, his hands in his pockets, quietly looks on. The billy is on the boil and the evening's joint of mutton has been securely slung from a tree, where it swings safe from ants, if not from the flies. Below them men are panning and cradling gold by the creek. A team and jinker is halted by a group of stores—the nucleus of the rising town—the cosmopolitan characters of their occupiers denoted by the flags which surmount the buildings. The stores have been roofed with the new corrugated iron then being exported in considerable quantities to Melbourne by such iron foundries as the Clift manufactories, Bristol. In the middle distance, a group of Aboriginals, dressed in European cast-offs, gaze at the diggings which spread out in the distance into the hills. This painting is the work of an artist with little or no professional training—a primitive painter. It succeeds none the less in conveying a very good idea of life on the Victorian diggings during the mid-fifties.

48

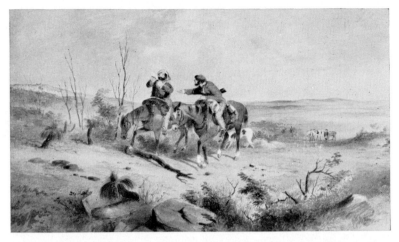

36 SAMUEL THOMAS GILL, *Overlanders*, water-colour, 13¼ x 23⅛,
c. 1865, Sydney

As the frontiers of settlement moved from the coastal regions to the interior, artists tended to interest themselves increasingly in subjects drawn from life outback. New themes, of great importance in the growth of Australian national sentiment, began to emerge both in literature and art. The life of drovers and stockmen who moved large flocks and herds over vast stretches of arid and semi-arid country provided one such theme. For the open-air life of freedom and adventure, in the saddle by day, and camped out under an open sky by night, held a great appeal especially for city-dwellers. The heroes of the colonial frontier, whether they were honourable men like the explorers Burke and Wills or dishonourable men like the bushranger Ned Kelly, exercised an enormous emotional appeal. The first poet of the Australian frontier to become well known in England was Adam Lindsay Gordon (1833-70), who described the frontier life of the stockrider in glowing terms:

> 'Twas merry in the glowing morn, among the gleaming grass,
> To wander as we've wandered many a mile,
> And blow the cool tobacco cloud, and watch the white wreaths pass,
> Sitting loosely in the saddle all the while.
> 'Twas merry 'mid the blackwoods, when we spied the station roofs,
> To wheel the wild scrub cattle at the yard,
> With a running fire of stockwhips and a fiery run of hoofs;
> Oh! the hardest day was never then too hard![1]

While Gordon was writing his bush ballads, the artist, Samuel Thomas Gill (1818-80), became well known both in Australia and England for his lithographs depicting the open-air life of the Australian diggers and bushmen. Gill had migrated with his parents to Adelaide in 1839 at the age of

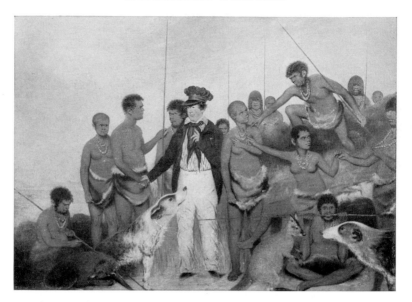

37 BENJAMIN DUTERRAU, *The Conciliation*, canvas, 47 x 66,
1836, Hobart

twenty-one and, as a young man, soon established his reputation as an
illustrator and cartoonist before moving to the Victorian diggings in 1851.
For the next five years he produced many series of lithographic views on
various goldfields. They were widely circulated in England where the desire
to emigrate in search of gold was at its height. Later, Gill turned his
attention to life in the rapidly expanding cities of Sydney and Melbourne.
Taken together, his drawings form a most valuable commentary upon the
life of the times, a commentary which is expressed with much gusto and
great humour. Gill is the first artist whose work expresses a distinctly
Australian attitude to life; the sardonic humour, the nonchalance and the
irreverent attitude to all forms of authority, so frequently remarked upon
by the students of Australian behaviour, are all present in his work.

In his lithographs Gill succeeded in popularizing the image of the
frontiersman, as Gordon had done in his ballads. In his *Overlanders* (36)
two men are sitting 'loosely in the saddle', as they move slowly across a great
flat of semi-arid country with their dogs and pack-horses behind them. One
stockman drains a flask while his companion spins a yarn. The dead and
fallen timber, the stunted grass-trees (favoured by early colonial artists as
the typical emblem of the country's vegetation) had long been used to
stress the melancholy of the Australian scene. And the melancholy is here
increased by a further reduction of the traditional divisions of landscape,
foreground, middle distance and background, to minor components of little
importance. What is perhaps new, however, is the presentation of the

dramatic in a primeval setting: the comical, the banal, and often the tragic being enacted either in a semi-arid desert setting studded with exotic flora or an open forest of unrelieved monotony.[2]

Linked with the desire to paint visual records of Australian life was the desire to paint events of historic significance. The conventions of history painting, however, differed from the less elevated conventions of genre painting. History paintings were not normally painted by eye witnesses of the events depicted and they were confined to events of great significance. During the eighteenth century the painting of history was regarded by most artists and critics as the highest form of painting, but for them history was the painting of events from the Bible and classical antiquity; and even when the events depicted happened to occur in more recent times, a classical form of dress and a dignified presentation of heroes noble of bearing and expression were considered essential to this elevated form of art.

The American artist, Benjamin West, who became President of the Royal Academy, was largely responsible for breaking down the authority of these conventions with his painting of the *Death of Wolfe* (1771), which depicted an event which had occurred only twelve years before. West still invested his figures with an air of great dignity and nobility, but he clothed them in their contemporary dress; and his choice of a subject with great patriotic appeal transformed history painting from a highly academic to a highly popular form of art. As a result of West's innovations, nineteenth-century artists adopted a less stylized approach to the painting of history than eighteenth-century artists. Even so, it was still assumed that a history painting should depict an event of major significance, the figures being drawn and composed in a heroic and dignified manner.

It is not surprising that the desire to execute paintings which would record events of national significance was felt by several artists working in Australia during the second half of the century. For the country was expanding rapidly, and social and political events of a decisive nature for the future history of the nation were taking place. How much better it would be to record the events of history as they were enacted under the eyes of the artist, or at least before the actual events had passed out of living memory. In 1869 the Trustees of the Public Library of Melbourne, thinking along these lines, commissioned S. T. Gill to make forty water-colour paintings of the events he had witnessed on the Victorian diggings over fifteen years before.

Such paintings were social documents rather than history paintings in the accepted sense of the word. History painting in Australia had begun, however, over thirty years before when Benjamin Duterrau painted *The Conciliation* (37). It shows George Robinson, the Methodist bricklayer who became a protector of Aboriginals, conversing with a group of Tasmanian

Aboriginals to pacify them and induce them to leave their wild life and go with him.[3]

History paintings of a much finer quality than Duterrau's *Conciliation* were painted by William Strutt (1825-1915), who migrated to Victoria in 1850, and remained in the colony for eleven years before returning to England to continue his career. Strutt came from a family of artists and received a thorough professional training, first from his father, William Thomas Strutt, a miniature painter, and later in Paris where he studied at the atelier of Michel Drölling (1786-1851) and then at the Ecole dex Beaux Arts. There he had the advantage of instruction from, as he claimed, such masters as Ingres, Delaroche and Vernet, and several other well-known teachers. Certainly Strutt became an able draughtsman, and his closely-finished, precise paintings are closely related to the neo-classical manner then favoured by the teachers at the Beaux Arts. Strutt remained in Paris for some time after completing his training and illustrated several books, including Anna Jameson's *Sacred and Legendary Arts* and Ferdinand Seré's *Le Moyen Age et la Renaissance* (1848). This last work strained his eyesight and he migrated to Australia in 1850 bent upon an open-air life. The trip restored his health and he decided not to abandon his profession. When he arrived in Melbourne he began working as a lithographer. Strutt's teacher, Drölling, had been a history painter, however, and it was clearly Strutt's own intention during the eleven years in which he resided in Australia to execute history paintings which would commemorate historic and typical events of colonial life in a dignified and memorable fashion.

William Strutt's largest and perhaps most impressive painting of an Australian subject was his *Black Thursday* (39). In February 1851, soon after he arrived in Victoria, a tremendous bushfire swept across the State. Melbourne was covered in a black pall of smoke and dust that completely obscured the sun, and the temperature rose to 117 degrees. After the fire, Strutt traversed the devastated areas and made many sketches. From these he painted his *Black Thursday* which he worked on for three years. It was first displayed at the Royal Academy, then at the Crystal Palace, and later taken on a tour of the capital cities of the Australian States.

In October 1852 another event occurred which attracted Strutt's attention. Early one afternoon a number of travellers were held up and robbed by bushrangers on St Kilda Road, a short distance from Melbourne. The captives were tied together in twos and threes, a man being posted over them with orders to fire if anyone stirred, the ringleader explaining to him that 'if you miss one, you are sure to hit some of the others'. The bushrangers remained for two hours adding seven more travellers to the original group. Then towards sunset they all galloped off into the bush in the direction of South Yarra.

38 WILLIAM CHARLES PIGUENIT, *The Upper Nepean,* canvas,
35⅞ x 51, 1888, Sydney

In *Bushrangers on the St Kilda Road* (29), Strutt has directed his atten-
tion not to the violence of the incident, but to the reactions of the par-
ticipants. We are presented with a quiet moment at the height of the
outrage when the victims are all safely trussed up and the bushrangers are
dividing the booty. The prisoners reveal the most varied emotions: fear,
defiant disgust, despair, resignation; one handsome young man even seems
to be calculating the possibilities of escape. The painting is an admirable
social document of the time, revealing the varied types and costumes to be
found on the Victorian high-roads during the height of the gold-rushes;
for Strutt, like his contemporary, Holman Hunt, was painstakingly accurate
in the rendering of detail. The landscape, too, is of interest. Strutt, like Gill,
portrays a wide, flat, open expanse, broken only by a few trees. The sun-
drenched scene is capably suggested by the high tones used throughout
and the lack of cast shadows. Clearly Strutt was not seeking merely to
record an incident which had momentarily caught the public's attention.
In *Black Thursday* and *Bushrangers on the St. Kilda Road,* he was seeking
subjects that would typify Australian colonial life as a whole.

Consider Strutt's bushfire theme. Throughout the nineteenth century
when virgin forest stretched far more extensively across the country than it
does today, and when safety precautions were virtually non-existent, the
menace of the bushfire was always present in the minds of settlers. It
became a popular subject in colonial literature and the graphic arts. In
Black Thursday Strutt sought to bring the elevation and dignity of history
painting to a theme already well established in colonial art and life. The

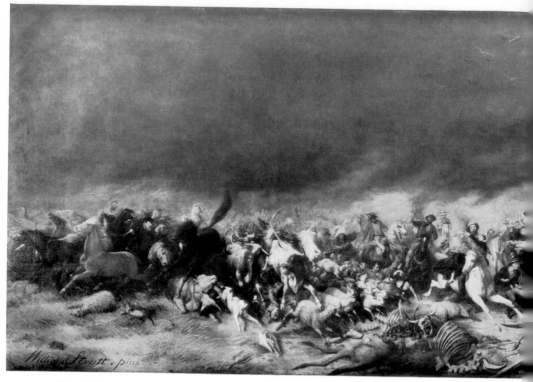

39 WILLIAM STRUTT, *Black Thursday*, canvas, 42 x 135, 1862-64, State Library
of Victoria

bushranger theme, too, had become a well-established emblem of colonial
life. For the deeds of the bushranger were no less fascinating nor of less
romantic appeal because they were outside the law. Joseph Lycett intro-
duced bushrangers into his *Views in Australia* as early as 1824, describing
them as 'a sort of banditti who live in the woods', and in the years inter-
vening the bushranger had become a well-known figure in colonial poetry,
prose and illustration.

 All of Strutt's major works of outdoor Australian life tend to stress the
hardships and dangers of colonial life. Holdups, bushfires, droughts, the
death of explorers: these themes are in keeping with the strand of melan-
choly that runs right through colonial art and literature in Australia. Indeed
in one of his water-colours painted in 1852, entitled *Martyrs of the Road*
(40), Strutt paints the carcasses of horses lying in an open waste of land-
scape: a painting which both in its theme and treatment foreshadows the
drought and erosion scenes of Drysdale and Nolan.[4]

 Although William Strutt was essentially a history and portrait painter, his
grim interpretations of the Australian environment find fitting contemporary
parallels in the melancholy bush ballads of Gordon and the equally melan-

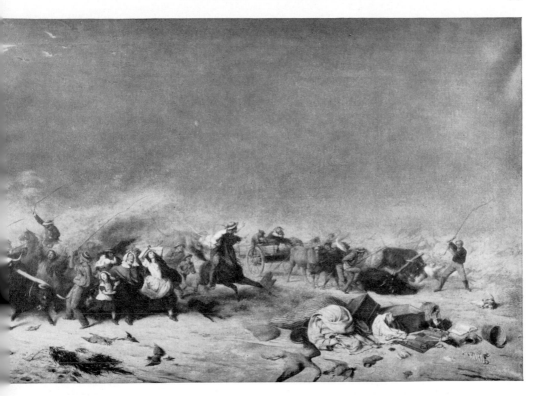

choly stories of Marcus Clarke (1846-81). It was Clarke who gave the most complete expression to the prevalent attitude of the writers and artists of the time towards nature in Australia: 'What is the dominant note', wrote Marcus Clarke, 'of Australian scenery?'

That which is the dominant note of Edgar Allan Poe's poetry—Weird Melancholy. A poem like 'L'Allegro' could never be written by an Australian. It is too airy, too sweet, too freshly happy. The Australian forests are funereal, secret, stern. Their solitude is desolation. They seem to stifle, in their black gorges, a story of sullen despair. No tender sentiment is nourished in their shade. In other lands the dying year is mourned, the falling leaves drop lightly on his bier. In the Australian forests no leaves fall. The savage winds shout among the rock clefts. From the melancholy gum strips of white bark hang and rustle. The very animal life of these frowning hills is either grotesque or ghostly. Great grey kangaroos hop noiselessly over the coarse grass. Flights of white cockatoos stream out, shrieking like evil souls. The sun suddenly sinks, and the mopokes burst out into horrible peals of semi-human laughter.[5]

The writers and artists of the 1860s and 1870s found Australia no paradise of sunshine and adventure; it was a weird, grotesque, melancholy land. The convention dominated both art and writing. It is not to be assumed,

E

40 WILLIAM STRUTT, *Martyrs of the Road*, water-colour, *c.* 1852, Parliamentary Library of Victoria (*Reproduced by permission of the Library Committee, Parliament of Victoria*)

however, that artists and writers adopted the convention in order to express their dislike of the local landscape and to reject it. The best of them, indeed, tended to identify themselves with the weirdness and melancholy they found in the landscape. Marcus Clarke, for instance, in the passage quoted above, continues:

. . . In Australia alone is to be found the Grotesque, the Weird, the strange scribblings of nature learning how to write. Some see no beauty in our trees without shade, our flowers without perfume, our birds who cannot fly, and our beasts who have not yet learned to walk on all fours. But the dweller in the wilderness acknowledges the subtle charm of this fantastic land of monstrosities. He becomes familiar with the beauty of loneliness. Whispered to by the myriad tongues of the wilderness, he learns the language of the barren and the uncouth, and can read the hieroglyphs of haggard gum-trees, blown into odd shapes, distorted with fierce hot winds, or cramped with cold nights, when the Southern Cross freezes in a cloudless sky of icy blue. The phantasmagoria of that wild dreamland termed the Bush interprets itself, and the Poet of our desolation begins to comprehend why free Esau loved his heritage of desert sand better than all the bountiful richness of Egypt.[6]

William Strutt did not, however, identify himself with his adopted country in the way Marcus Clarke did. That is not surprising, for his sojourn in Australia was a comparatively short one, and the large historical paintings of Australian subjects were painted in England and exhibited at the Royal Academy. They were, indeed, very much an Englishman's impression of Australia. Nevertheless they strongly appealed to colonial taste, which is not surprising either, since colonial taste was determined by educated Europeans—British people, mainly, though gold had brought a sprinkling of cultivated Europeans—not by the native-born. William Strutt was not personally involved in the colonial situation. An artist of the time far more involved, though he, too, painted with the Royal Academy in mind, was Robert Dowling.

Robert Dowling (1827-86) was brought to Tasmania by his father, a

41 ROBERT DOWLING, *Group of Natives of Tasmania*, canvas, 60 x 120,
1859, Queen Victoria Museum and Art Gallery, Launceston

Baptist minister, in 1831. His first art lessons came from Thomas Bock, and
in 1856 he was able to leave for London where he exhibited sixteen pictures
at the Royal Academy between 1859 and 1882. Like Strutt he was primarily
a portrait, genre and history painter. Though thoroughly trained in the
Academy Schools, the scenes of his boyhood in Tasmania left a deep impres-
sion upon him. In his *Early Efforts—Art in Tasmania* (Melbourne), which
he exhibited at the Royal Academy in 1860, an admiring family are gathered
outside a hut set amid sylvan surroundings of Tasmanian bush and moun-
tain. A young artist is seen in the act of painting a group of Tasmanian
Aboriginals posed statuesquely before him. The choice of subject is sig-
nificant. After George Robinson had 'conciliated' the Tasmanian Aboriginals
they were all placed on Flinders Island in Bass Strait where they slowly
pined away and died. When Dowling painted his picture there were only
a few left. Dowling came from a deeply religious family and it is clear that
the tragedy of the Tasmanian Aboriginals left a lasting impression upon his
mind, for he returned to the subject on several occasions, and he chose it
for his most important work, *Group of Natives of Tasmania* (41).

Dowling handles a subject which might have fallen quite easily into a
sentimental treatment with a fine restraint. He identified himself with the
subject and succeeded in evoking an atmosphere of tragic melancholy
brooding over the doomed race. The natives are seated—emblematic of
their situation—around the dying embers of a burnt-out log near a great
blackened stump, and in the far left corner there is a leafless tree with
shattered branches. The figures themselves are disposed in a closed and
classically-ordered composition but there is no communication between

them; they neither converse nor look at one another, but stare stonily in front of their own faces, like the doomed. Only the fisherman and his wife moving up from the lake show any signs of life, and they seem to be staring with some perplexity at the petrified circle. Dowling worked from drawings made by Thomas Bock. The foreground natives, though with their backs to us, are painted with their faces in profile, a device which brings a frieze-like severity to the foreground. The composition, a history painting in the full sense of the word, not only provides a valuable record of the last members of 'the most primitive people in the world' but also serves to celebrate yet another death of the noble savage—that enduring symbol of civilized man's guilty conviction that he is at heart far more savage than the savages. Two or more years before, Dowling had painted a smaller *Tasmanian Aborigines* (Melbourne) in which many of the same natives are represented. The figures in this painting have a greater sense of community, but the firmly-closed frieze-like composition is already present.[7]

Landscape Painting

The most important landscape painters of the period were Eugène von Guérard, Nicholas Chevalier, William Charles Piguenit and Louis Buvelot. In the work of the first two we may study late examples of the 'typical' landscape that had been developed during the previous hundred years by artists, travellers, geographers and critics. Typical landscape developed out of the picturesque and topographical forms of landscape. It may be defined as a kind of landscape the component parts of which are carefully selected in order to express the essential qualities of a particular type of geographical environment. The typical landscapist introduced into his paintings rocks, plants, animals, people and so forth that he felt to be most representative of the country or region he was depicting.

Eugène von Guérard (1811-1901) was an Austrian painter whose father had been the court painter to Francis I. Eugène had studied at the Düsseldorf Academy and travelled in Italy. His landscapes, however, owe most to the Austrian Biedermeier School, especially to Ferdinand Waldmüller (1793-1865), whose work von Guérard would certainly have known. Waldmüller sought absolute naturalism in his landscapes, painting detail with a close-focus vision like the Pre-Raphaelites. At the age of forty-two von Guérard emigrated to Australia and made a number of sketches on the Ballarat diggings. Later, in 1870, he was appointed the Curator of the National Gallery of Victoria and Principal of its Art School. He retired in 1881 when he sailed for Europe. During his twenty-eight years in the country he painted many landscapes, mainly in Victoria.

Von Guérard worked in a highly finished topographical style, seeking to render details of vegetation and terrain with a polished accuracy. He sought

to depict plants and rocks with detailed precision. Indigenous animals were often added to further identify a scene. But von Guérard was no colourist; the olive-green of Australian foliage escaped him, and the subtler colours of the atmosphere (42). His great expanses of virgin forest, however, amply convey the depressing effect so frequently mentioned by travellers and settlers.[8]

Nicholas Chevalier (1828-1902), like Eugène von Guérard, obtained a thorough professional training in European art schools prior to migrating to Australia. He was born at Moscow, the son of a Swiss overseer of the estates of a Russian prince, but received his training in painting in Switzerland, studied architecture for a time in Munich, and moved to London in 1851. There he worked as a lithographic illustrator and exhibited paintings at the Royal Academy of 1852. Then followed a period of study in Rome. He appears to have gained some access to Royal patronage for he is said to have designed a fountain for Osborne, and the setting for the Koh-i-noor diamond in the British crown. In 1855 he arrived in Australia to attend to some of his father's investments. In Melbourne he became the first cartoonist on the *Melbourne Punch* (1856-61). Later he visited New Zealand (1867-68), accompanied the Duke of Edinburgh on a world tour (1868), and held an exhibition of his work at South Kensington on his return to London (1871).

Chevalier's large painting, *The Buffalo Ranges* (43), won him a £200 prize offered by the Trustees of the National Gallery of Victoria in 1864 for a local landscape. Its alpine character and geographical grandiosity is characteristic of late romanticism. It also seeks to celebrate the innate dignity of pioneering labour. Such themes possessed an immediate popular appeal and continued to attract Australian artists until the end of the century. But as a painting *The Buffalo Ranges*, with its large areas of unresolved tone, its laboured detail and drab colour is rather pompous and dull stuff. By contrast, the artist himself appears to have been a pleasant and sociable person, always upon the best of terms with the British Royal Family and a keen amateur musician. In the orchestra on H.M.S. *Galatea*, Nicholas Chevalier, it is said, played second fiddle to the Duke. Later, he was commissioned by the Queen to paint historical pictures of her reign and, for the twenty years prior to his death in 1902, was the London adviser to the Trustees of the National Gallery of New South Wales.[9]

William Charles Piguenit (1836-1914) was a native-born Tasmanian of French descent who, like so many of the artists who worked on the American, New Zealand and Australian frontiers, began life as a surveyor. Piguenit received some lessons from Frank Dunnett, a Scottish painter, and in 1872 retired from surveying and devoted himself to landscape painting. His approach to landscape may be compared with Strutt's approach to history painting. Like Strutt, he sought dramatic and exciting subjects which

would be typical of the country at large. An explorer by nature, he made long journeys into little-known country in search of natural scenery both sublime and typical. His approach was, indeed, essentially romantic, but it was that late and rather grandiose romanticism of artists like F. E. Church, the American artist who also sought the sublime and dramatic in nature: illimitable plains, snow-covered volcanoes violently erupting, impenetrable tropical jungle. Piguenit himself delighted in mountain scenery (38), especially the central Highlands of Tasmania (44); but he had an eye for the typical, and one of his finest canvases, *Flood in the Darling* (45), depicts floods covering the vast river-flats of the interior of New South Wales. The first Australian-born landscape painter of any consequence, he was also the last of the colonial painters who occupied themselves with painting the Australian landscape in its primeval condition, and an element of desolation and melancholy invests most of his paintings.[10]

The work of Louis Buvelot (1814-88) heralds a significant change in the approach to landscape painting in Australia. Like John Glover, he did not arrive until towards the end of an active painting career. Born at Morges, Switzerland, he studied first under Arlaud at Lausanne, and later with Camille Flers, a landscape painter, in Paris. For eighteen years he lived and painted in Brazil and then returned to Switzerland. In 1858 he visited the East Indies; and it was not until he had again returned to Switzerland that he decided, because of the cold winters, to migrate to Victoria, where he arrived in 1865 at the age of fifty-one. He first set up as a photographer in Melbourne, but the success of his wife as a teacher of French enabled him to give his whole attention to landscape painting until his death in 1888.

It is not at all unlikely that Buvelot's earlier landscape work in Brazil belongs to that class of topographical and typical work favoured by those nineteenth-century artists who travelled about the world a good deal in search of unusual subjects. By the time Buvelot had reached Australia, however, his work bore a close affinity with the landscapes of the Barbizon school: it should be compared with the paintings of Daubigny and Theodore Rousseau. Unlike Chevalier and Piguenit, Buvelot was not ambitious to paint large canvases depicting sublime mountain scenery or the great open spaces of the interior. Like the Barbizon painters themselves, he was attracted by homely, rural scenes usually painted in the warm light of the late afternoon or early evening. He was not a young man, and he did not wander very far afield, but spent most of his time painting in and around the Port Phillip District. Consequently his landscapes tend to portray a settled rural countryside, not a primeval wilderness. It is quite untrue to say of him, as is often said, that he was the first artist to paint the Australian landscape with a clear vision unsullied by memories of European landscape. Indeed the scenes which he painted, having been modified by European

42 EUGÈNE VON GUÉRARD, *Valley of the Mitta Mitta, with
the Bogong Ranges*, canvas, 26½ x 41¼, 1866, Melbourne

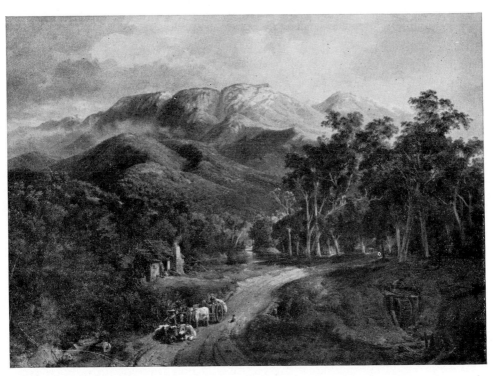

43 NICHOLAS CHEVALIER, *The Buffalo Ranges, Victoria*, canvas,
51 x 71, 1864, Melbourne

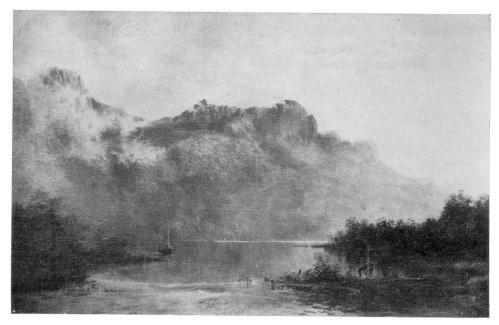

44 WILLIAM CHARLES PIGUENIT, *Mount Olympus, Lake St Clair, Tasmania*, canvas, 27⅛ x 42⅛, 1875, Sydney, gift of 50 subscribers, through the New South Wales Academy of Art

settlement, were in fact more European in quality than many of the scenes painted by earlier men like Lewin, Earle and Glover; men intensely interested in the curiosities of the landscape and quite capable of depicting its characteristic forms. Buvelot, much as he enjoyed the eucalypt, saw the tree against a background of European recollections. 'It is so poetic', he once said. 'It can take so many shapes. Sometimes it has the breadth and strength of a venerable oak and another time it is slight and graceful like the poplar and birch.'[11] And it may be noted that in his *Summer Evening, Near Templestowe* (46) his taller gums are slightly reminiscent of Lombardy poplars, and the two large trees in his *Waterpool at Coleraine* (47) give the distinct impression of being a kind of cross between eucalypt and oak. Nevertheless, Buvelot's contribution to the evolution of an Australian school of painting was very great indeed, for he began to work in Australia at a most crucial time for the development of art here, and his perception of colour, schooled as he was in *plein-air* methods, was far superior to that of his predecessors. Before Buvelot very little attempt had been made, despite some interesting water-colour paintings by Earle and Angas, to analyse the local and atmospheric colour of Australian scenery.

We may gain some idea of the changes which Buvelot introduced from his *Summer Evening, Near Templestowe*, painted in 1866 (a year after his arrival) in a district which is now a suburb of Melbourne. Human interest

45 WILLIAM CHARLES PIGUENIT, *Flood in the Darling*
1890, canvas, 48¼ x 78½, *c.* 1895, Sydney

here replaces the interest in nature's curiosities. We are introduced to a
settled countryside of high roads and fenced paddocks. A drover has just
driven his flock across a small bridge and they move up the road slowly
towards us throwing up a golden dust into the warm mellow light of the
summer evening as they come. To the right, a herd of cows has just been
driven into the home paddock of a farm and waits to be milked. In the
distance, men are still at work in the fields. All these details have been
drawn together and unified by the artist's keen sensitivity to tonal values.
Foreground details have been suppressed in the dark shadow which falls
across the road. The people and cattle in the central mid-ground have been
painted with broad patches of colour; the shadows on distant trees are of
purple and grey-blue; blue smoke issues from the chimneys of slab huts
at the right; a rosy afterglow is beginning to rise in the evening sky. Every-
thing in the landscape is for Buvelot a problem in tone and colour. The
characteristic form and colour of the tall eucalypts is, for instance, admir-
ably realized; but it is a homely and rather European scene for all that,
with its flocks and herds, fields and cottages, with none of the forbidding
antipodean melancholy that haunted the vision of earlier colonial artists and
writers. It is in fact a scene of peace and rural plenty, a variant on the
pastoral classical landscape traditional to European painting, and one full
of nostalgia for Europeans exiled like Barron Field in the Antipodes.
Buvelot's *Waterpool at Coleraine* is even closer in spirit to the Barbizon
school with its huge oak-like gums, its lawny meadows, ducks and village
pond all seen by the light of the sunset.

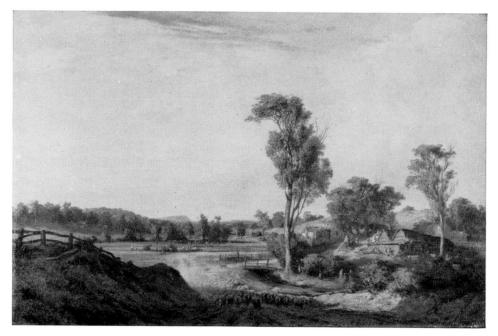

46 LOUIS BUVELOT, *Summer Evening, Near Templestowe,*
canvas, 30 x 46, 1866, Melbourne

Louis Buvelot, through his teaching, wide influence and example may be said to have created a school. For this reason he has been rightly called the Father of Landscape Painting in Australia. The artists who worked before him worked in isolation. Some, of course, like Martens, took pupils. John Skinner Prout established a flourishing art school in Hobart during the forties, and made water-colour painting quite popular in fashionable circles. But what influence they had did not last; did not make any permanent contribution to the growth of a local tradition. Many artists, however, who came to play a very important part in the foundation of the Australian school of painting came to know Buvelot during the formative years of their lives. He influenced as a result not only a number of artists who continued to apply the *plein-air* tradition of the Barbizon school to the Australian landscape, but also the men who were to create the Heidelberg School of Australian impressionist painting.[12]

Four painters may be noted here, all of whom were influenced by Buvelot and helped to continue the *plein-air* methods which he had introduced. Two were Englishmen, Julian Ashton and Walter Withers, and two Scots, John Mather and John Ford Paterson. They are typical of the new situation in Australian art. Professionally trained abroad they migrated to Australia in early manhood and made their reputations here. The country was still too young and still not sufficiently interested in the arts to maintain a com-

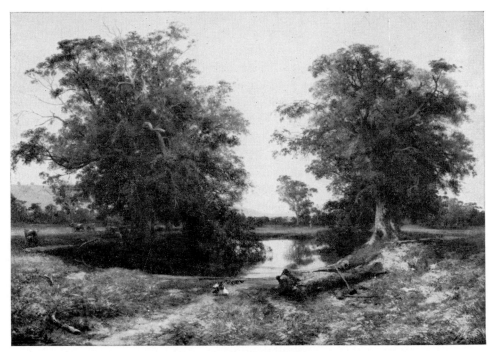

47 LOUIS BUVELOT, *Waterpool at Coleraine*, canvas, 42 x 60,
1869, Melbourne

munity of professional artists. But there were a number of trades and callings flourishing in Melbourne, and to a lesser degree in Sydney, that could provide some form of economic support for young men interested in the arts, such as photography, printing, lithography, and especially newspaper and magazine illustration. And the newly-formed art schools created a small demand for art teachers. Julian Ashton (1851-1942), who had trained in London and Paris, arrived in 1878 to draw for the *Illustrated Australian News*. Walter Withers (1854-1914) arrived in Melbourne in 1882 to farm, but soon left the land to obtain a position as a draughtsman to a firm of printers. John Ford Paterson (1851-1912), who had attended the Royal Scottish Academy Schools in Edinburgh, arrived in Melbourne first in 1872, stayed three years, and then returned to Scotland. In 1884 he came out and remained.[13] John Mather (1848-1916) also studied in Edinburgh, migrating to Victoria in 1878. He helped to decorate the dome of the Melbourne Exhibition Building and later became well known as a teacher.[14]

The newcomers were not entirely of British origin. By 1885 Melbourne's art community had taken on a continental flavour. The Portuguese artist, Arthur Loureiro (1860-1932) had been awarded the *Prix de Rome* by the Royal Academy, Lisbon, and had studied at Rome and Paris, exhibiting for

three years at the Old Salon, before arriving in Melbourne in 1884, where he began to teach and paint. His work became known for its broad, free handling, and fresh out-of-doors feeling which was attributed, by one Melbourne critic of the time, to his French training. Both Ugo Catani and Girolamo Nerli (1863-1926) studied at the art school in Florence under Antonio Ciseri before arriving in Melbourne in 1885. Nerli, an Italian *marchese*, was born at the Palazzo Pieri Pecci in Siena. His mother was the daughter of Thomas Medwin, the biographer of Shelley and the author of *Conversations of Lord Byron.*

Nerli, like Loureiro, became well known for his freer style of painting. Although his Melbourne work does not appear to have been noticed by contemporary critics he began to exercise an influence upon Sydney taste (following his arrival there in 1886), according to James Green. Green, who had been a journalist on the *Building News* (London) before he arrived in Sydney, was widely travelled, widely read and a voluminous writer. He exercised a considerable influence upon local opinion both in art and architecture in Sydney during the 1890s. The first of his many articles for the *Australasian Builders' and Contractors' News* was published on 1 January 1890, and he may have been in the country some time before that date. Green, who often signed himself 'De Libra', was an ardent and extremely vocal follower of John Ruskin. His early articles are, not surprisingly, extremely critical of anything slightly savouring of impressionism. But such attacks weakened as his sympathies broadened. He may, therefore, have been recording his own early reactions when he wrote in 1899 that:

The Marchese Nerli, an Italian by birth, and with a thorough European training, was the first to introduce to New South Wales the daring independence of Southern neo-continentalism . . . in its disregard of generally accepted trammels and its frequent substitution of the mere sketch for finished works. . . . His wildly sketchy 'Bacchanalian Orgie', *à la Monticelli*, was 'caviare to the general', and the audacity of his Salome—suggesting, black and yellow symphony, 'Repose', with what a critic called *un tantino troppo di bravura* about it, took the Sydney public's breath away.[15]

During the early eighties many of these young artists began to spend their week-ends sketching in the countryside around Melbourne. Favourite sketching-grounds were discovered to which artists returned again and again. The habit of week-end sketching in the open air spread. Buvelot, like most of the Barbizon painters, sketched, but did not paint finished canvases, in the open air. In France it appears to have been the Barbizon painter, Daubigny, who promoted the practice of completing his landscapes in the open. It is difficult to say just when the practice began in Australia. But Julian Ashton[16] claimed that his painting, *Evening, Merri Creek*, painted in 1882 and now in the Sydney Gallery, was the first. In the following year

48 JULIAN ASHTON, *Sentry Box Reach, Hawkesbury River*,
water-colour, 22⅛ x 36, 1884, Sydney, gift of Howard Hinton

Ashton moved to Sydney where he drew for the *Picturesque Atlas*. During
the early 1880s Julian Ashton, Frank P. Mahony and A. H. Fullwood spent
week-ends painting in the bush around Sydney Harbour at such places as
Sirius Cove, Mosman, on ocean beaches like Coogee, or in the country at
such places as Richmond or favoured spots along the Hawkesbury River.
George Collingridge (1847-1931) and his brother, Arthur, had already dis-
covered the Hawkesbury River District as a sketching-ground in 1879.
Here Ashton worked with A. J. Daplyn (1844-1926) in 1884 and painted
a large water-colour *Sentry Box Reach, Hawkesbury River* (48) which
brings a new feeling for light and space to the treatment of Australian
landscape and points directly towards the spring freshness of his delightful
little *Solitary Ramble* (50).

Daplyn was another pioneer of *plein-air* painting in Australia. Born in
London, he had studied under Gérôme and Carolus-Duran in Paris, painted
landscapes at Pont-Aven and exhibited in the Old Salon, before migrating
to Australia in 1881. Here he applied himself immediately to the problems
peculiar to Australian *plein-air* painting and years later brought the fruit of
his researches together in a manual entitled *Australian Landscape Painting*.
In 1882 the *Argus* critic described Daplyn's *Boat Builders* as 'painted in
low tones after the French method and in the style of the "impression-
ists" . . .'.[17] It is possibly the first occasion on which the word was used in
an Australian context. Not that Daplyn was an impressionist, his *plein-air*

manner consisted simply in a greater truth to tone and a method of handling broader than the landscapes of Piguenit, Chevalier, von Guérard and even Buvelot, all by the 1880s somewhat old-fashioned. Daplyn became the first instructor at the (Royal) Art Society classes in Sydney when they were established in 1885. Nor is it without significance that this French-trained Englishman who had painted landscapes at Pont-Aven was Charles Conder's first teacher.

Meanwhile, in Melbourne, John Mather had discovered Healesville as a sketching district, and had worked along the eastern shores of Port Phillip Bay. Such artists drew others about them. Consequently, in the years between 1880 and 1885, we may see a new pattern emerging in Australian art. A number of young migrant artists, some from Britain and some from the Continent, settled in the rapidly-expanding cities of Sydney and Melbourne. The illustrated Press of the day helped in one way or another to support most of them. During the week-ends they sought out picturesque spots in the countryside and made *plein-air* sketches. It was the masters of the Barbizon School and the English water-colour painters whom they most admired. Their works painted before 1885 were still low in tone, generally speaking, and rather like those European scenes to which they were still accustomed. Like the Barbizon painters they preferred the evocative hours: early morning, evening, sunset, twilight. But, like Buvelot, they continued to analyse the true values of colour as seen through an envelope of atmosphere. In consequence they came, despite the lowness of the tones in which they customarily painted, to a more faithful depiction of the colours of the Australian landscape than any of the painters before them.

Study Abroad

The practice of leaving Australia to study art in Europe did not become a feature of Australian cultural life until the 1880s, but began somewhat earlier. The first Australian-born artist to study abroad was Adelaide Ironside; and she was followed by two British-born artists whose families had settled in the country in their youth, Robert Dowling and Edward a'Beckett.

Miss Ironside (1831-67) was a Sydney girl with good connections, delicate health, and a highly nervous sensibility. A citizen's fund enabled her to leave for study in Europe with her mother in 1855. Settling in Rome she became well known for a time as a painter and spiritualistic medium, painting visions she saw in crystal balls. Joseph Severn, the artist-friend and companion of John Keats, took an interest in her. Perhaps it was Severn who brought her to the attention of John Ruskin, for when Miss Ironside settled in London in 1865 she struck up a curious friendship with the critic

49 ROBERT DOWLING, *A Sheikh and his son entering Cairo
on their return from a Pilgrimage to Mecca,* canvas, 54 x 96,
1874, Melbourne

who gave her private lessons in drawing, largely confined, it would seem, to drawing shells and the flower of the convolvulus.[18]

Adelaide Ironside's paintings were inspired by the religious paintings popularized by the Nazarenes in Rome and the Pre-Raphaelite Brotherhood in England. She exhibited *The Marriage in Cana* and *The Pilgrim of Art* in the New South Wales Court of the London Exhibition of 1862, and there appears to have been some contemporary interest in her work. Both the Prince of Wales and William Charles Wentworth are said to have bought paintings worth £500 each from her. But though *The Marriage in Cana*, *The Pilgrim of Art* and the *Presentation of the Magi* eventually found their way back to St Paul's College, in the University of Sydney, her work had no influence upon the subsequent development of Australian painting.[19]

In 1856, a year after Adelaide Ironside had left Sydney with the help of a citizen's fund, a similar fund was raised by Launceston citizens to enable Robert Dowling to study abroad. Dowling studied at Leigh's Academy, and exhibited sixteen paintings at the Royal Academy between 1859 and 1882. A large subject painting. *A Sheikh and his son entering Cairo on their return from a Pilgrimage to Mecca* (49), was shown at the Academy of 1875.

In 1851 Edward a'Beckett, a nephew of Sir William a'Beckett, arrived in Melbourne at the age of seven with his parents. After completing his formal education at Melbourne Grammar, he left in 1867 for England in order to study at the Royal Academy Schools. On his return to Melbourne

he painted a number of portraits of Melbourne citizens. One of his best is that of Dean Macartney, the first Dean of Melbourne, in the Chapter House of St Paul's Cathedral, Melbourne.

But these three cases were exceptional. It was not until the development of technical education during the 1870s and of art schools in particular, especially the art school of the National Gallery of Victoria, that art students began to emerge who were sufficiently well trained to benefit from study in Paris and London.

NOTES

[1] From 'The Sick Stockrider', *Poems of the late Adam Lindsay Gordon*, Melbourne, 1880

[2] On Gill *see also* A. W. GREIG, 'Gill, the Artist of the Goldfields', *Vic. Hist. Mag.* (Mar. 1914), pp. 133-42; MOORE, i, 59-61, *passim*; ii, 142-5, *passim*; W. DIXSON, *Journ. RAHS*, ix (1923), pp. 162-3; W. S. CAMPBELL, *Journ. RAHS*, xv, 21; ALAN MCCULLOCH, 'The Art of S. T. Gill', *Meanjin*, x (1951), 27-32

[3] On Robinson *see also* the article in *AE*, vii, 470

[4] On Strutt *see also* GEORGE MACKANESS (ed.), *The Australian Journal of William Strutt, A.R.A. 1850-1862*, Sydney, 1958, 2 vols; A. CHESTER, 'The Art of William Strutt', *Windsor Magazine*, no. 215 (Nov. 1912), 611-26; MOORE, i, 124-5, *passim*. The Parliamentary Library of Victoria possesses Strutt's *Exploring Expedition Sketch Book*, and his *Victoria the Golden Sketches and jottings from nature 1850-62*. The Dixson Library possesses several other sketch-books of a similar nature.

[5] *The Poems of the late Adam Lindsay Gordon* (preface by Marcus Clarke), London [n.d.], pp. iv-v

[6] *ibid.*, pp. v-vi

[7] On Dowling *see also* MOORE, i, 36-7, *passim*; article, *DAB*; N. J. B. PLOMLEY, 'Pictures of Tasmanian Aborigines by Robert Dowling', *Annual Bull. National Gallery of Victoria*, iii (1961), 17-22

[8] On von Guérard *see also* MOORE, i, 52-3

[9] On Chevalier *see also* F. A. FOREL, *Nicholas Chevalier, Peintre Vaudois*, Lausanne, 1908; MOORE, ii, 166; *CAO*, pp. 42-3

[10] On Piguenit *see also* W. V. LEGGE, the *Tasmanian Mail*, 6 May 1915; MOORE, i, 89-90, *passim*; article in *AE*, vii

[11] Quoted by MOORE, i, 88

[12] On Buvelot *see also* S. DICKINSON, *Catalogue of Oil Paintings in the Collection of T. W. Stanford Esq. of Melbourne*, Melbourne, 1892, pp. 20-1; article in *DAB*

[13] On J. F. Paterson *see also* MOORE, 1, 91-2, *passim*, ii, 213, *passim*; *Argus*, Melbourne, 1 July 1912

[14] On Mather *see also* the *Argus*, Melbourne, 21 Feb. 1916

[15] DE LIBRA (JAMES GREEN), *Australasian Art Review*, 1 June 1899, pp. 23-4

[16] On Ashton *see also* his autobiography, *Now Came Still Evening On*, Sydney, 1941; The Julian Ashton Book, *Art in Aust.*, Sydney, 1920; *CAO*, pp. 16-17

[17] *Argus*, 25 March 1882. Quoted by V. SPATE, Art criticism in the Melbourne Press 1880-1900, B. A. Thesis, Hon. Schools of History and Fine Arts, University of Melbourne

[18] RUSKIN, *Works*, ed. cit., xxxvi, 484-8

[19] On Adelaide Ironside *see also* MOORE, ii. 1-4

GENESIS

1885 - 1914

Australian sky and nature awaits, and merits real artists to pourtray it . . . there is a whole system of landscape painting of the most striking character, yet available for human art. . . .
JOHN LHOTSKY, 'The State of Art in New South Wales and Tasmania', *The Art-Union*, July 1839, pp. 99-100

The Formation of the Heidelberg School

BETWEEN 1885 and 1890 a distinctive Australian school of painting sprang into existence. Its creation was due mainly to the vision, energy and persistence of Tom Roberts (1856-1931) who, with his widowed mother, had migrated to Australia from Dorchester, England, in 1869 at the age of thirteen. The family settled in Collingwood, Melbourne, where they lived for some years in difficult and somewhat straitened circumstances. Roberts became a photographer's assistant and rose to be senior operator at Richard Stewart's studio in Bourke Street, Melbourne. On Friday evenings he attended drawing classes at the old Court House, Collingwood. This was one of the Artisans' Schools of Design set up in the later 1860s. The evening classes were the first attempt to provide schools of art in Victoria, and though instruction was elementary and facilities primitive, they succeeded in attracting some able men as teachers, such as Thomas Clark and Louis Buvelot. Clark, who became instructor in figure-drawing at the Carlton School of Design, had studied at the Royal Academy, and had been a master of the School of Design, Birmingham, and Director of the Nottingham School of Art prior to his arrival in Melbourne in 1857. At Birmingham, Clark is said to have taught Burne Jones. Buvelot was also a master at the Carlton School. Roberts owed much to both Clark and Buvelot.

In 1875 Roberts went on to the evening classes of the National Gallery which had been established five years before. There he studied drawing under Clark (who had become drawing master at the school) and painting under Eugène von Guérard, the curator of the Gallery and master of the art school from 1870 to 1881. Clark urged his best pupils to study abroad, advising Roberts to save in order to study at the Royal Academy, London, and at Julian's in Paris. Although working as a photographer by day and an art student by night, Roberts also managed to contribute drawings to

50 JULIAN ASHTON, *A Solitary Ramble*, water-colour,
13¼ x 9¾, 1888, Sydney

the local Press. After six years' study at the Gallery he had learnt enough
and had saved sufficiently to sail for England in 1881. There he studied at
the Royal Academy school and continued to draw for newspapers like the
Graphic.

In 1883 he embarked upon a walking tour of Spain in the company of
three Australian friends, John Russell, a Sydney artist, Sydney R. Russell,
his architect brother, and Dr William Maloney. It was planned that the
artists should sketch, the architect study the architecture of Spain seen on
the trip, and that Dr Maloney should keep an account of the tour. They
sailed to Bordeaux, walked through southern France into north-western
Spain, and on to Madrid and Granada.

At Granada, Roberts met two artists, Laureano Barrau and Ramon Casas,

whose talk and work appear to have acted as an illumination to him. Both artists had studied in Paris and had gained some knowledge of the aims of the French impressionists.

Casas was a pupil of Carolus-Duran (1838-1917) and, like his teacher, was primarily a portrait painter who adopted a naturalistic and painterly technique. A portrait which Casas made of Roberts at Granada in 1883 makes use of the informal pose, and the 'truth in tone' values so much discussed by students at the time. It may owe something to the influence of Manet; and Casas, a student in Paris during the later 1870s, may have seen some of the work of the French impressionists. Some small oil paintings which Roberts painted in Spain in 1883, though by no means impressionist and painted within the limits of academic naturalism, suggest that during the Spanish tour he came to acquire a keener interest in colour and light, true tones, and the importance of keeping painterly values. It was natural enough, therefore, that the influence of Whistler should appear in some small oil paintings which he executed in London in 1884.

Roberts, nevertheless, had been trained as a portrait painter and always retained an interest throughout life in the subject picture. It is not surprising, therefore, to find that he was also greatly influenced by the work of Bastien-Lepage (1848-84), a great hero of the art schools of the time. Lepage had specialized in the painting of rural and peasant scenes which, though visualized in the *plein-air* manner, were usually tinged with melancholy and sentiment. His *Potato Gatherers* (Melbourne, 1878) is typical. In this way he continued the realist tradition established by Millet and Courbet in French painting during the mid-nineteenth century. It was from such artists as Bastien-Lepage and Courbet that Roberts gained a heroic conception of rural labour.

In 1885 Roberts returned to Australia with his new ideas and some paintings in his new manner. By this time *plein-air* sketching was, as we have already seen, a well-established local practice and, a year after his return, Roberts and Frederick McCubbin, an old fellow-student from the Gallery School, pitched their tent near Housten's farm, Box Hill, and began to paint. Roberts sought to apply the new principles he had learned abroad to painting the light and colour of the Australian bush. At Box Hill in 1886 he painted *The Artists' Camp* (51). There is no attempt to render a large expanse of countryside as there is in the work of the earlier men, Piguenit, von Guérard and Buvelot; nor any attempt at this stage of Roberts's development to dignify a rural theme. The scene depicted is quite small— nearly all foreground—and quite casual in its human interest. Roberts has adopted a palette of richly modulated browns and greens (faintly reminiscent of Manet's landscapes) in order to capture the colour of eucalypt saplings seen in the crisp blue light of morning; 'French methods of land-

F

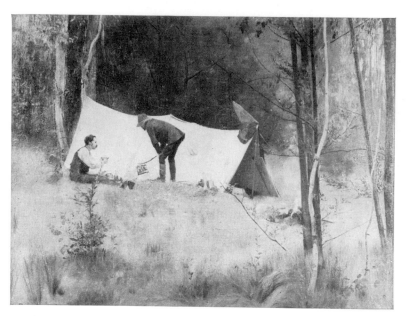

51 TOM ROBERTS, *The Artists' Camp*, canvas, 17½ x 23¼,
1886, Melbourne

scape painting', a contemporary critic remarked, 'their avoidance of too much definition of form and their disposition to secure striking effects by colour laid on in broad masses'.[1] There was, as yet, no strong critical opposition to the new methods. In 1886, too, he painted *A Summer Morning's Tiff* (Ballarat) and, in 1887, *Reconciliation* (Castlemaine), in which a slight human interest is introduced into paintings which are, however, essentially studies in light and colour.

Friends joined Roberts and McCubbin at Box Hill. In 1886 they rented a cottage at Mentone on Port Phillip Bay and there met Arthur Streeton, a young lithographer's apprentice who was studying drawing in the evening classes at the Gallery School. Streeton was out on the rocks painting a free study of the sea and shore. He became a close friend. Then in 1887 Roberts visited Sydney, met Charles Conder (1868-1909) and discussed impressionist painting with him. Like Roberts himself, Conder was born and educated in England.[2] He also learned something about *plein-air* painting from Girolamo Nerli (1863-1926). Nerli's *Wet Evening* (Hinton, Armidale) reveals the broad effects for which he became known. He was also a capable portraitist. Nerli's influence on Australian art was, however, short-lived, for after a four-year sojourn in this country he moved on to Dunedin, New Zealand, to become the director of the art school there and one of the first teachers of Frances Hodgkins.[3]

In 1888 Conder painted *The Departure of the* s.s. *Orient* (52), a work

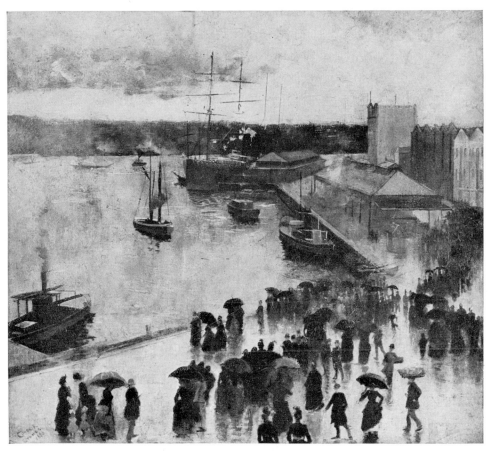

52 CHARLES CONDER, *The Departure of the* s.s. *Orient—Circular Quay,*
canvas, 17¼ x 19¾, 1888, Sydney

similar in its breadth, low tones and subject-matter to Nerli's *Wet Evening.*
Though he was only nineteen at the time, this picture is one of the finest
Conder painted in Australia. Its rich low tones embrace passages of
exquisite painting resonant with colour and admirably controlled. When
Conder exhibited it at the annual exhibition of the Art Society of New South
Wales in 1888, local critics remarked upon the quality of the painting and
the Trustees of the National Gallery of New South Wales purchased it for
their collection. It was the first occasion upon which the new school of
Australian painting had received official recognition.

The Departure of the s.s. *Orient* owes perhaps as much to Nerli as to
Roberts, but Conder was greatly impressed by his conversations with
Roberts, and in October 1888 he moved to Melbourne. Roberts's visit to
Sydney indicates a new freedom of handling in his own work. His *Holiday
Sketch at Coogee* (53) reveals the use of colour harmonies more subtle and

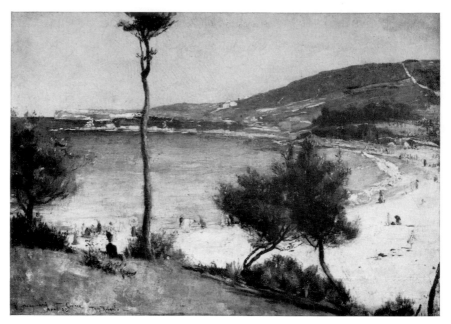

53　TOM ROBERTS, *Holiday Sketch at Coogee,* canvas, 15⅞ x 22, 1888, Sydney

gradual than before, more adapted to the expression of distance and light, looser and bolder colour and stronger contrasts of tone.

In 1888 Roberts, Streeton and Conder established themselves in a large weatherboard house at Eaglemont which Streeton had discovered during the previous summer. It was set upon a hill above the Yarra and surrounded by a fine but neglected garden. Here the three artists camped, sleeping on sacks tied between saplings with only candles to light the house at night. To ease the financial strain, Streeton and Conder began a school in land-scape and still life, which was attended by about a dozen girls, mostly during the week-ends. Roberts spent several days each week working on portraits in a Collins Street studio. Eaglemont soon became a rendezvous for many artists who had thrown in their lot with the new movement.

At Eaglemont, Roberts and his friends made many impressionist oil sketches on cigar-box lids, working deftly and rapidly with colour broadly applied. From these experiments came Australia's first impressionist exhibi-tion—the most famous art exhibition in the country's history. It was called the Exhibition of 9 × 5 Impressions and was opened at Buxton's show-rooms, in Swanston Street, Melbourne, on 17 August 1889. One hundred and eighty-three paintings were shown: Roberts exhibited sixty-two; Streeton, forty; Conder, forty-six; Frederick McCubbin, five; C. Douglas Richardson, twenty-six (of these six were sculptured impressions); R. E. Falls, three; and Herbert Daly, one. The exhibition, quite a large one for a group of local

artists to stage, was cleverly managed and gained a good deal of publicity. Prices were low and most of the paintings sold. There can be no doubt that it was a direct challenge to prevailing taste which favoured the English and German schools, distrusted French methods and held the moral and didactic values of John Ruskin in high regard. These values had been amply demonstrated in the large Centennial Exhibition held only the year before in which accepted academic values prevailed. The 9 × 5 Exhibition may well have been stimulated by the great success of the Centennial, but it was certainly a local reaction to the values which its pictorial exhibits enshrined.

The 9 × 5 Exhibition appears to have sharpened critical reaction for a time against local impressionist work, which hitherto had been treated tolerantly, being misinterpreted as sketches for more finished work. Indeed the *Age* critic (17 August 1889), in a sympathetic review, still thought of the paintings in the show as charming 'shadows of coming events'. The *Daily Telegraph* critic (17 August 1889), however, whilst admitting the presence of an educated taste and much to admire, complained nevertheless that impressionism left too much to the imagination. 'The lazy artist will be prone to dash off dauby work and expect his admirers to see the production with the mind's and not the body's eye . . . leaving the spectator to do the hard work of detail and elaboration mentally'. It was left, however, to James Smith of the *Argus* to condemn the exhibition in the most trenchant terms. Smith, as much as anyone, embodied the received cultural values of colonial Melbourne. He had written books on Wilton and its associations, on English poetry and rural life, before he migrated to Melbourne in 1854. He wrote plays, including one on Garibaldi (produced in 1860), interested himself in the *Alliance Française* and became President of the Dante Society. He was a Trustee of the Public Library and the National Gallery of Victoria and, for fifty-six years, worked tirelessly for the improvement of local culture. But on 17 August 1889 he made it indubitably clear that he did not like impressionism in any form:

Such an exhibition of impressionist memoranda as will be opened today at Buxton's gallery by Messrs Roberts, Conder, Streeton, and others, fails to justify itself. It has no adequate *raison d'être*. . . . The modern impressionist asks you to see pictures in splashes of colour, in slapdash brushwork, and in sleight-of-hand methods of execution leading to the proposition of pictorial conundrums, which would baffle solution if there were no label or catalogue. In an exhibition of paintings you naturally look for pictures; instead of which the impressionist presents you with a varied assortment of palettes. Of the 180 exhibits catalogued on this occasion four-fifths are a pain to the eye. Some of them look like faded pictures seen through several mediums of thick gauze; others suggest that a paint-pot has been accidentally upset over a panel nine inches by five; others resemble the first essays of a small boy who has just been apprenticed to a house

painter; whilst not a few are as depressing as the incoherent images which float through the mind of a dyspeptic dreamer. . . . A few afford something agreeable to the eye to rest upon, but the exhibition, viewed as a whole, would leave a very painful feeling behind it, and cause one to despond with respect to the future of art in this colony, did we not believe with Mr W. P. Frith, R.A., that 'Impressionism is a craze of such ephemeral character as to be unworthy of serious attention'.

To all such criticisms Roberts, Streeton and Conder replied in a joint letter to the *Argus* about a fortnight later (3 September 1889), which reveals that they were aware of the impressionist approach to painting, the perceptual problem involved in it, and were already thinking of themselves as the pioneers of an Australian school:

We will not be led by any forms of composition or light or shade. . . . Any form of nature which moves us strongly by its beauty, whether strong or vague in its drawing, defined or indefinite in its light, rare or ordinary in its colour, is worthy of our best efforts. . . . We will do our best to put only the truth down and only as much as we feel sure of seeing (but) the question comes, how much do we see and how much are our ideas and judgements of works made up by comparison with those we have already known . . .? We believe that it is better to give our own idea than to get a merely superficial effect which . . . may shelter us in a safe mediocrity which . . . could never help towards the development of what we believe will be a great school of painting in Australia.

In 1890 a second artists' camp was established at 'Charterisville', not far from Eaglemont, by Walter Withers (1854-1914), who had returned from study in Paris the previous year. 'Charterisville' was an old stone house with a large barn, gardeners' lodges and stables, and was set in a magnificent but neglected garden. It had been the former home of David Charteris Macarthur, a pioneer banker of Melbourne. Following his death in 1887 the purchaser, a dairy-farmer, let portions of the house and the garden lodges to artists, the collapse of the land boom making it impossible to retain the house in its former state. Many artists lived for a time at 'Charterisville' and many more visited it. In 1893 Phillips Fox and his friend, Tudor St George Tucker, both of whom had returned from Paris the year previously, established a Summer School there as a section of their Melbourne Art School in the city.

From these two Heidelberg camps the new approach to painting spread among a widening circle of artists and students. It is to be stressed that in the years between 1888 and 1893, when they were exercising a most vital influence upon Australian painting, the members of these camps were by no means cut off from a knowledge of artistic developments in Paris. The impressionist painters of the Heidelberg School were not ignorant of the existence of French impressionism, or of the broad principles upon which it was based. John Russell corresponded with Roberts from France from

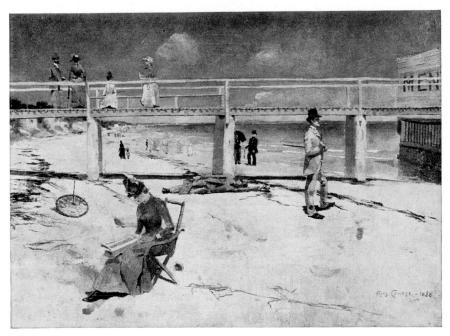

54 CHARLES CONDER, *A Holiday at Mentone*, canvas, 17¼ x 23,
1888, Mr and Mrs M. S. Atwill

October 1887 and he seems to have had some knowledge of impressionist techniques from at least 1886. Conder discussed Monet's methods in a letter to Roberts from Paris in February 1891 and said that he agreed with those who said Monet was 'the greatest landscapist in his way'.[4] On the other hand, the school was not a provincial attempt to copy the technical methods of Monet and his associates. It was an original attempt to apply impressionist principles to a different set of visual and social conditions.

The close association of Roberts, Streeton and Conder terminated shortly after the 9 × 5 Exhibition though they remained friends and corresponded with one another for the rest of their lives. Conder left for Europe in April 1890, Streeton went to Sydney in the same year, shortly after the National Art Gallery of New South Wales purchased his *Still Glides the Stream* (55), and was followed there by Roberts in 1891. In Sydney, Roberts and Streeton established Curlew Camp on Little Sirius Cove, Mosman, in a picturesque spot on Sydney Harbour. The camp became a well-known rendezvous for artists and their friends during the 1890s when many Sydney artists were feeling the effect of the economic depression. Later, Roberts established a teaching studio in Vickery's Chambers, Pitt Street, Sydney.

Both Roberts and Streeton made many oil sketches and small paintings around the coves of Sydney Harbour and at such ocean beaches as Coogee.

55 ARTHUR STREETON, *Still Glides the Stream and shall Forever Glide*, canvas, 32¼ x 60¼, 1889, Sydney

In these paintings the impressionist aspects of their work were contained and in some ways developed. Streeton's paintings became somewhat higher in key, more summary in handling, and often richer and brighter in colour. His harbour and beach scenes were severely criticized, when he exhibited them in the 1890 Exhibition of the Art Society of New South Wales, by James Green (de Libra), probably the most influential critic of the 1890s in Sydney:

Can Mr Streeton's 'Study for Colour' be characterized as other than a kaleidoscopic nightmare? What of the splotchiness of 'Sunlight Sweet, Coogee', the smudginess of 'From McMahon's Point', or that dab of paint in the left-hand corner of the 'Sunny South' (where probably a tree would grow), like nothing in the heavens above, the earth beneath, or the waters under the earth? . . . I contend that treatment of this kind has no place in an exhibition of finished works of art.[5]

During the same period, however, Streeton travelled inland to the Blue Mountains and the Hawkesbury River to paint on a more heroic scale. The desire to paint landscapes which would suggest the immensity and grandeur of Australian nature never left him. In 1892 he had returned to Melbourne, but it is clear that the idea of painting landscapes of the interior still meant much to him. As he wrote to Roberts in 1892:

I want to stay *here*, but not in Melb. If I can raise the coin I intend to go straight inland (away from all polite society), and stay two or three years and create some things entirely new, and try and translate some of the great hidden poetry that I know is here, but have not seen or felt it.[6]

Now although the interior certainly exercised its fascination, the attraction of London and Paris was, if anything, greater. Indeed the main reason Streeton had not gone earlier was due largely to the fact that he could not afford it. But in 1896 he held a one-man show in Melbourne, from which he did rather well. A letter which he wrote to Roberts *c.* 1896 reveals his divided state of mind.

I picture in my head the Murray and all the wonder and glory at its source up towards Kosciusko . . . and the great gold plains, and all the beautiful inland Australia, and I love the thought of walking into all this and trying to expand and express it in my way. I fancy large canvases all glowing and moving in the happy light and others bright decorative and chalky and expressive of the hot trying winds and the slow immense summer. It is *immense,* and droughts and cracks in the earth, and creeks all baked mud.

But somehow it's all out of reach, and all sorts of damn'd little things in the way. Two-thirds of the year I have a feeling of dependence on other people, indebtedness, etc. It carries you off your work and holds thought that should play in a good current on to many canvases and be strong. The current gets weakened.

I love Australia (yet have seen so little) and shall be beastly sorry to go away . . .

But I can't sit here thinking, 'tis waste of time. I want to hurry up and *move* somehow. So first opportunity and I'm off . . .

Of course, my troubles are, no doubt, small—we hear of good artists who starve all their lives, and so on. I don't grumble a bit, but it's unfortunate. This country is full of wealth, but somehow can't afford artists yet. Why, dammit, bricklayers, scene-shifters, office boys, all get their work recognized and are able to go on—and if I were recognized more I could *paint more.* Perhaps I'd have the same trouble in Europe, but I must risk it. . . .[7]

The Art of the Heidelberg School

Two main interests may be observed in the work of the artists of the Heidelberg School: their interest in depicting effects of light and colour and their interest in creating a distinctively Australian art. These two interests, as we shall see, were closely related.

Their first interest was clearly expressed in the catalogue which they prepared for the Exhibition of 9 × 5 Impressions.

An effect is only momentary: so an impressionist tries to find his place. Two half-hours are never alike, and he who tries to paint a sunset on two successive evenings must be more or less painting from memory. So, in these works, it has been the object of the artists to render faithfully, and thus obtain first records of effects widely differing, and often of very fleeting character.

It was with this programme in mind that they had already begun to solve many of the problems involved in rendering the effects of light and colour peculiar to Australian atmosphere and vegetation. Although they were most certainly indebted to Europe for the sources of their inspiration these

problems were their own, and the technical solutions which they found to them were also largely their own. The Heidelberg School, therefore, is rightly considered as the first distinctive Australian school of painting. That does not mean, as is so often assumed, that little of an Australian character was produced by the men who came before them—rather the reverse. The work of the Heidelberg painters had its roots in an Australian as well as in a European past. It represented the culmination of a century of colonial endeavour. For the colonial painters, as we have seen, had already done much to portray the special qualities of the Australian scene, the shape and form of a great deal of its typical topography and vegetation. Indeed, some of the best of them, like John Glover, Conrad Martens and William Charles Piguenit, had gone farther and reacted sensitively to the moods and sensations which Australian landscape evoked.

To say, as it is so often, that the artists before Buvelot and Roberts saw the Australian scene with English or European eyes is to falsify the history of Australian art. The great contribution which the Heidelberg School *did* make to the history of vision in Australian art was to produce, for the first time, a naturalistic interpretation of the Australian sunlit landscape. They analysed with skill, enthusiasm and sensitivity the appearance of eucalypt and *melaleuca*—and such dominant forest types—in the full blaze of sunlight. They depicted the colour and luminosity of the pale shadows of midsummer—blue, turquoise, pink and rose-violet; the atmospheric effects of dust, heat-haze and afterglow. But they loved most the warm coloured stillness of summer evenings.

This great love of the sun did not spring simply from a desire to state visual facts truthfully, though the desire to be truthful to appearances was certainly there. The image of the sun came to be used increasingly in Australian literature and art during the last two decades of the century as a symbol of Australia itself. The sun, that is, came to occupy a key place in the *mystique* of Australian nationalism, and when, in 1915, the Anzacs stormed the Dardanelles, they wore it emblazoned upon their slouch hats. It had been making its way as a characteristic symbol of Australian life and nature since the 1830s. In the work of writers of that time, John Dunmore Lang and Charles Harpur, for example, the clear, sunny skies of Australia were already seen as emblems of hope beckoning the European migrant. The symbol had been increasing in popularity in the face of that other and quite different attitude to Australian nature which we have already discussed in connection with the work of William Strutt and Marcus Clarke; namely, the conviction that Australian nature was monotonous and melancholy. In order to understand the new sense of optimism, joy, and love of the sun which the Heidelberg School brought to Australian nature we must appreciate the historical conditions in which the school arose.

By the 1880s both Sydney and Melbourne were great cities containing hundreds of thousands of people. The young Heidelberg artists were city-dwellers: Roberts began life as a photographer, Streeton as a lithographer's apprentice, McCubbin as a baker. Conder, who spent two years surveying in the country, was the most urban-minded of the four, and soon found a place as an artist on the *Illustrated Sydney News*. In the week-end they escaped into the bushlands which still, in much of their pristine splendour, surrounded the new cities. The suburban bushlands afforded them refreshment and recreation after their week of routine work in the city; and the new vision of Australian landscape which they brought into existence with such success was a vision of city-dwellers who had chosen to identify themselves with the sunshine and colour of the bush, its vibrating blue hills and rosy skies; a vision which lifted the youthful spirits of the Heidelberg painters far above the lonely, monotonous and melancholy back yards of Collingwood and Carlton.

It must be stressed, however, that they did not give all their attention to landscape painting. Roberts spent only a portion of his time at camps such as Eaglemont and 'Charterisville'. For at the time he was establishing himself, and supporting himself, as a portrait painter in the city. In 1887 or 1888 Grosvenor Chambers, a three-storey building, had been erected in Collins Street East 'expressly for occupation by artists', the whole of the top floor being designed as studios on principles, so it was claimed, 'laid down by Reynolds'. Roberts occupied one of these studios and a number of artist-friends, such as George Walton, the English portrait painter who had studied at the Royal Academy with Roberts and had come out for the sake of his health, occupied others. Conder also rented studios in the city.

It is not surprising, therefore, to find that urban scenes form a significant part of the work of the Australian impressionist painters. Tom Roberts's *Bourke Street* (59) affords an impression of one of Melbourne's main city streets exuding the heat and light of an Australian summer. In its informality and directness of handling—the figures, for instance, are suggested with great breadth and simplicity—it recalls French impressionist composition. But the colours are paler, more opalescent—faint rose-pinks and purples, dusty yellows and the palest of blue skies. Indeed, the Australian character of the work of the members of the Heidelberg School is most apparent in their sensitive apprehension of local colour. The lights and reflections upon city streets after rain were a special interest. Nerli's *Wet Evening* and Conder's *Departure of the* s.s. *Orient* have already been discussed, and Streeton's *Redfern Station* (56) is another fine essay on the same theme.

The new impressionist vision of the Australian city can be traced in contemporary prose writing. To take but one example, the descriptions of Sydney in Ada Cambridge's novel, *A Marked Man*, published in 1890, are

56 ARTHUR STREETON, *The Railway Station, Redfern,* canvas, 16 x 24,
1893, Sydney, gift of Lady Denison

directly inspired by her personal knowledge of Curlew Camp, established
in that year by Tom Roberts at Little Sirius Cove. An evening on Sydney
Harbour is described in terms closely equivalent in colour and feeling to
the oil sketches of the Harbour painted in the early 1890s by Streeton:

The rosy afterglow lingered yet, but the Moon was rising over the North Head
—they turned round to look at it whenever they reached a point that gave them
a clear view. The great cliff was black as the blackest night, but the waters of
Middle Harbour were softly shining and tumbling, every moment growing whiter
and brighter. And the shores were veiled in that exquisite pinky-blue haze which
never seems so ethereal and dreamlike anywhere as in Sydney Harbour at the
close of a sunny day.[8]

It was, however, images of the country and of country life, not of the
city, which finally captured the public imagination and brought the greatest
fame to the members of the Heidelberg School. It could not have been
otherwise. By 1889 (the year of the 9 × 5 Exhibition) the greater propor-
tion of Australians already lived in the cities. But these city-dwellers came
to identify themselves increasingly with the life and attitudes of the
Australian rural worker during the later decades of the century, as Aus-
tralians sought to fashion a national identity of their own. The frontier
exercised an enormous influence upon the imagination of all Australians.
To some extent this idealization of rural labour was a world-wide pheno-
menon of the later nineteenth century. As liberalism transformed itself into

democratic socialism and labour parties arose in the European world, the image of the noble peasant invented largely by the romantic writers became an increasingly popular figure in art and literature, and was enshrined in the paintings of artists like Millet, Bastien-Lepage and Van Gogh. In older countries humanists and socialists stressed the patience and the endurance of the peasant. Young countries like Australia had had insufficient time to develop such a noble class of patient plodders. The bushman was the closest type to the noble peasant which the life of the country had produced, but he was characterized by his independence and an egalitarian collectivism which crystallized in the ideal of mateship.

> They call no biped lord or sir,
> And raise their hat to no man.[9]

Thus it was that the outback came to exercise a powerful influence upon the emergence of Australian culture. As Dr Russel Ward has put it:

. . . even as they faded from the workaday world, the value and attitudes of the nomad tribe (that is, the rural workers) were embalmed in a national myth, thence to react powerfully, as they still do, upon thought and events. The extinct bushman of Lawson and Furphy became the national culture-hero on whose supposed characteristics many Australians tend, consciously or unconsciously, to model their attitude to life.[10]

Three of the members of the Heidelberg School, Frederick McCubbin, Tom Roberts and Arthur Streeton, each after his own fashion, made a significant contribution to the growth and diffusion of this national myth.

Frederick McCubbin appears to have been the prime mover in promoting the distinctly national quality of the Heidelberg School. Already at the Box Hill camp, as Roberts recalled years afterwards, he would wax philosophic around the evening camp-fire. For such reasons the others dubbed him 'The Prof'. Doubtless, much of his philosophizing concerned the growth of a national school of painting. McCubbin had studied at the Gallery School under G. F. Folingsby (1830-91), a product of the Munich School. It was Folingsby who transmitted to the young McCubbin that school's romantic interest in the painting of history pieces with a national flavour. The National Gallery of Victoria possesses some of Folingsby's sketches for history paintings, and his *Bunyan in Prison*.

When Julian Ashton arrived in Melbourne in 1878, already an advocate of *plein-air* painting, he found McCubbin engaged upon a *Death of Semiramis*. 'Why bother about a lady so long deceased?' Ashton asked. 'Why not paint the life about you?'[11] The remark probably left an impression for, in 1886, prompted by Roberts's interest in the work of Bastien-Lepage, McCubbin began a series of paintings in which *plein-air* methods were applied increasingly to subjects redolent with local history. The

need for a school of Australian *history* painting had been discussed in the *Melbourne University Review*, two years before, in an article which claimed that there were 'some pages of Australian *history* worthy of treatment'.[12] The introduction of European life into new surroundings, the discovery of gold, Eureka, and inland exploration were mentioned. McCubbin began his series of social *history* paintings with a well-known theme. The death of children who wandered away into the bush was one of the most common tragedies of Australian frontier life, and had already found frequent literary expression, notably in Kingsley's *Geoffry Hamlyn* and Marcus Clarke's melodramatic little tale of *Pretty Dick*. McCubbin's *The Lost Child* (58) sought to incorporate this old colonial theme into the new pictorial methods. He followed it with his *Down on His Luck* (57), another well-known folk-image of the unsuccessful gold-digger, and *Bush Burial* (Geelong, 1890). The figures were painted from models posed in the open air and set in grey landscapes undisturbed by changing effects of sunlight and shadow. These paintings were quite different from the small impressions shown at the Exhibition of 9 × 5 Impressions. But that exhibition never at any time summed up the whole programme of the Heidelberg School.

In McCubbin's case, though not in Roberts's and Streeton's, the large national subject picture introduced a note of melancholy into the work of the school, a melancholy in sharp contrast to the sun-drenched optimism and gaiety of spirit which animated the landscape impressions of Roberts

57 FREDERICK McCUBBIN, *Down on His Luck*, canvas,
45 x 60, 1889, Perth

58 FREDERICK McCUBBIN, *The Lost Child*, canvas,
45 x 28½, 1886, Melbourne

and Streeton. It was akin to the older colonial melancholy from which the paintings of the Heidelberg School, in other respects, afforded such a dramatic rupture. Indeed, McCubbin's work forms a bridge here between old and new. He was the means whereby older colonial fears and attitudes were carried on into the new school. Nevertheless, McCubbin's history paintings reveal, after 1890, the impact of impressionist techniques. In his *Bush Burial, Wallaby Track* (Sydney, 1896) and *The Pioneer* (Melbourne, 1904), the figures are covered with loose flecks of paint in which the palette knife has been used freely. By such means McCubbin sought to 'keep' his figures more naturally within their atmospheric space. Thus 'historic genre, Victorian sentiment, open-air realism, and a certain impressionism of technique intermingle in the same work'.[13]

McCubbin had painted his tragic depictions of colonial life in the comparative peace and tranquillity of his surburban home, and at Macedon. Roberts was, by his nature and training, more of a realist. His interest in painting subjects of Australian interest dates, like McCubbin's, from 1886 when he painted his fine picture, *Coming South* (72) based, doubtless, upon drawings he had made on the voyage back from London. It is clearly, with its careful study of different types, an essay on the theme of migration. He hung it in the Indian and Colonial Exhibition, London (1886). It was described by the *Age* critic as 'a very careful and well-drawn work full of character and very tender and harmonious in colour. The influence of the French school is clearly seen as it is evident that he has attained his present proficiency by a careful and exhaustive study of drawing . . .'.[14] Roberts followed this painting a few years later with a fine series of paintings devoted to the pastoral industry.

In order to paint *Shearing the Rams* (60), Roberts visited Brocklesby Station, in the Riverina, New South Wales, during two successive shearing seasons, where he made a large number of sketches and drawings, and set up his easel for a time in the shearing shed itself, later finishing the painting in a city studio. He adopted a similar practice when painting *The Breakaway* (61) and *The Golden Fleece* (Sydney, 1894). In such paintings, Roberts sought to give a heightened and ennobled expression to the life of the rural worker. It was a subject in which his own feelings were deeply involved. In explanation of his choice of *Shearing the Rams* as his subject, he wrote:

. . . one of the best words spoken to an artist is, 'paint what you love, and love what you paint', and on that I have worked; and so it came that being in the bush and feeling the delight and fascination of the great pastoral life and work I have tried to express it. If I had been a poet . . . I should have described the scattered flocks on sunlit plains and gum-covered ranges, the coming of spring, the gradual massing of the sheep towards that one centre, the woolshed

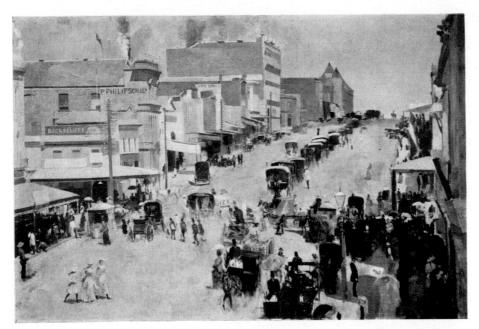

59 TOM ROBERTS, *Bourke Street,* canvas, 19½ x 29⅜,
1885-86, N.L.A.

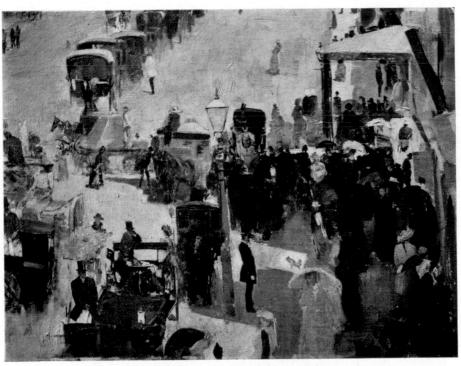

59a TOM ROBERTS, *Bourke Street* (a detail), 10 x 15

. . . the shouts of the men, the galloping of horses and the barking of dogs as the thousands are driven, half-seen, through the hot dust to the yards . . . but being circumscribed by my art it was only possible . . . to give expression to one portion of this . . . it seemed that (in the woolshed) I had the best expression of my subject, a subject noble enough and worthy enough if I could express the meaning and spirit of strong masculine labour . . . and the great human interest of the whole scene . . . I believe . . . that by making art the perfect expression of one time and one place, it becomes art for all time and of all places.[15]

Roberts possessed an easy and natural manner and appears to have been quite at home among shearers. We cannot in fairness say that his paintings are romantic or that he was painting a world unfamiliar to his experience. Certainly he may never have himself observed a genuine holdup or break-away, but such things still happened, though much less frequently, and Roberts did all he could to reconstruct such situations as realistically as possible. Both *The Breakaway*, with its informal composition, and *Bailed Up* (Sydney), with its lack of histrionics, are splendid examples of this. Of course, Roberts thought out and carefully composed his larger figure compositions. But this is a feature of all large work of this kind, including many examples by the French impressionists. To come nearer home, a painting like *Shearing the Rams*, which combines careful formal artistry with a high degree of realism, may be compared with the similar craftsmanship that went to the writing of Henry Lawson's short stories.

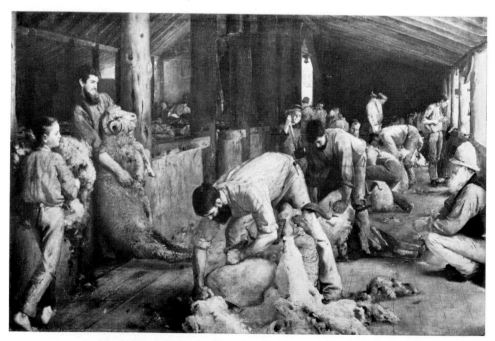

60 TOM ROBERTS, *Shearing the Rams*, canvas, 47 x 71,
1889-90, Melbourne

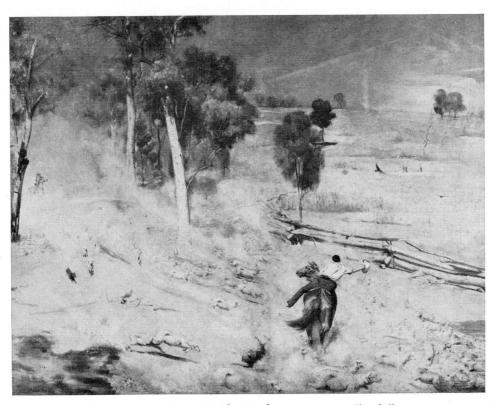

61 TOM ROBERTS, *The Breakaway*, canvas, 53½ x 65½,
1891, Adelaide

Unlike Roberts and McCubbin, Streeton was neither a portrait nor a figure painter. But he, too, felt their desire to paint large paintings typical of the Australian scene. In his case, they had to be produced within the limitations of landscape painting. In such works as *Fire's On* (62) and *Purple Noon's Transparent Might* (Melbourne, 1896) Streeton sought to paint his hymn of praise to the Australian sun. And he set about it in the same methodical manner that Roberts adopted when painting his pastoral pictures. In 1891 he painted *Fire's On* at Glenbrook, in the Blue Mountains, New South Wales. A letter which he wrote to McCubbin at the time provides a better insight into his methods and existing state of mind than anything else, and is therefore worth quoting in detail:

I follow the railway line for three-quarters of a mile through a canyon or gully where big brown men are toiling all the hot day excavating and making a tunnel, which will cost thousands . . . but will save wearing out a great number of engines on the first Zig Zag. I've passed the west mouth and now am arrived at my subject, the other mouth, which gapes like a great dragon's mouth at the perfect flood of hot sunlight. There is a cutting through the vast hill of bright sandstone; the walls of rock run high up and are crowned by gums bronze-green, and they look

G

quite small, being so high up, and behind is the deep blue azure heaven, where a crow sails along like a dot with its melancholy, hopeless cry—long drawn, like the breath of a dying sheep. Right below me the men work, some with shovels, others drilling for a blast. I work on the W. colour drying too quickly and the ganger cries, 'Fire, Fire's On'; all the men drop their tools and scatter and I nimbly skip off my perch and hide behind a big safe rock. A deep hush is everywhere—then, 'Holy Smoke', what a boom of thunder shakes the rock and me. It echoes through the hills and dies away 'mid the crashing of tons of rock; some lumps fly hundreds of feet sometimes and fall and fly everywhere among the trees. . . . All at work once more—more drills; the rock is a perfect blazing glory of white, orange, cream and blue streaks here and there where the blast has worked its force!

By the following day Streeton had developed an acquaintance with the men working on the tunnel.

. . . I sit down, drink tea and eat a bit, rest, and then yarn all the afternoon with my friends, the big, stalwart men. Sitting on a gunpowder keg at the tent door, I hand round the ruby twist; we smoke, and I listen to long yarns and adventures —diggers, prospectors, and so on. One old chap, but energetic; tales of coal, gold, and discussions on the present hard 'bullocking' they have to do in the broiling sun. I like these men. They're like a 'roaring camp', big and bronzed. I say 'Good-bye' to my friends and move off. My path lies towards the west, which is a flood of gold. I felt near the gates of paradise—the gates of the west.[16]

In such passages as these Streeton echoes the same feeling of respect for the dignity of manual labour which Roberts sought to express in his paintings of shearers and drovers.

Purple Noon's Transparent Might was another attempt to paint a large landscape under full sunlight. It is, indeed, an interesting essay in the painting of atmospheric colour over the great expanse of a wide river valley. Streeton's sensitive perception of colour values is here remarkably well sustained throughout the whole canvas. There are few paintings as large as this one which are so consistently based upon the careful painterly assessment of retinal impressions. In later years Streeton came to rely too greatly upon the tricks and sleight-of-hand of a fluent style; the hand working on from habit when the eye had become lazy. His style, that is, became mannered. But in such early paintings visual perception and painting technique are wonderfully balanced.

The romantic element in the work of the Heidelberg School is present not only in their desire to paint typical Australian life and landscape; it is also to be found in their affection for the lyrical moods of nature. The true impressionist—if there ever was such a person—was an objective painter. He was not concerned with the moods of nature or with literary values. It was his business to depict a fragment of the world in a moment of time with all the conditions of light, atmosphere, temperature, wind and shadow peculiar to the moment. Only upon occasion—and then only in their

62 ARTHUR STREETON, *'Fire's On', Lapstone Tunnel,* canvas,
72⅜ x 48¼, 1891, Sydney

sketches in oil—did the Heidelberg painters attain such objectivity. Musical and literary associations are by no means an uncommon feature of their early work. Roberts's *Bourke Street* is realistic enough in its apprehension of light and colour, but it is illuminating to find that he associated its colour values with music and first called the painting *Allegro con brio*. An increasing interest in the ideal as opposed to the real, and in the ways in which poetry and music might be associated with painting, appears in 1889. The new interests are perhaps best revealed in a letter Streeton wrote to Roberts from Sydney in 1890. Already he was waxing nostalgic over the summer of 1889 at Eaglemont, dreaming of the time before Conder had left for Paris, and 9 × 5 Impressions were still being painted. As the years passed, that summer became the lost golden age of their lives to which all three looked back with varying degrees of nostalgia.

The enjoyment of the 'last summer at Eaglemont' was to me more intense than anything I have up to the present felt. It would surprise you how often I think of it, and, oh it is a great comfort. Its suggestion is a large harmony, musical, rose. Fancy if you could grasp all you feel and condense your thought into a scheme which would embrace sweet sound, great colour and all the soft slow movement, sometimes quick with games, and through all the strength of the great warm and loving sun. . . . How we made sketches of the girls on the lawn. The lovely pure muslin, and gold, sweet grass-seeds and the motherly she-oak, with its swing spreading a quiet blessing over them all. Behind this splendid tree was the deep gold of the summer gates of the west sunset, and the whole gem was framed, yes, with oleander on the east with the two tropical sleepy round bushes, and on the south pittosporum, and north the big solemn pine. They seemed to keep guard as the silver dusk of night simplified the group of quiet, happy boys and girls.[17]

Streeton is here writing about an experience which has touched him deeply. Precision of observation is linked with a mood Watteauesque in its ineffable dreaminess. Here nature, Australian nature, is seen as a happy idyll; the mention of a swing even calls to mind a faint image of Fragonard's famous painting. The Eaglemont camp has become a *fête champêtre*— a neo-Rococo vision that will play an increasingly important part in Australian art during the following decades. The dreaminess and air of reflection in the description had already been expressed in one of Streeton's last paintings at Heidelberg, *An Australian Gloaming*. It is the romantic light of the afterglow and moonrise which attracts him. The painting is closer in spirit to Claude and the later paintings of Corot than to the French impressionists. Streeton later changed the title to *Still Glides the Stream and Shall Forever Glide* (55)—a line taken from Wordworth's sonnet, 'After-thought'. Thus he sought to invest the painting with poetic associations. And he was not alone in this. Charles Conder's paintings in the 9 × 5 Exhibition already in 1889 indicated a cleavage between transcripts

of nature and an impressionist's dream of ideality. To such works as *Impressionist's Camp, Prince's Bridge,* and *Burning Off* there may be opposed *Arcadia, A page from Herrick, A Dream of Handel's Largo, Old Time is Still A-Flying.* Streeton's descriptions of the Eaglemont camp, his interest in Wordsworth's 'After-thought', which has for its theme the transience of man and the permanence of art, together with Conder's interest in Arcadia as a subject, and in the work of Herrick, all suggest that Streeton and Conder had become interested in transience as a theme suited to artistic expression.

In Conder's work, the movement away from the objective depiction of impressions was heralded by the emergence of a decorative element in his work. Even when painting beach scenes directly from nature with Tom Roberts at Coogee in 1888 it is clear that Conder's interests were more decorative, less realistic than Roberts's. Characteristic was Conder's use of silhouetted foreground figures, reminiscent of Whistler's etchings, and shown in casual but decorative positions, and he also made great play with coloured parasols and gaily-striped costumes to enhance the richness of his colour schemes. Such little masterpieces as *Cove on the Hawkesbury* (78), at once decorative and impressionistic, have a Japanese air about them. There is in this trend away from the immediacy of sensation towards the decorative, the lyrical, and the wistfully melancholic already a suggestion of the *fin de siècle* and symbolism.

Symbolism began to appear in Conder's work in August 1889, in his cover design for the catalogue of the Exhibition of 9 × 5 Impressions (63), in which he sought to express a personal philosophy of art. The figure 9 is shown upon a circular wooden plaque which is cut with the grain, but the figure 5 is depicted upon a plaque cut against the grain. This is a reference to the wooden cigar-box lids on which the 9 × 5 impressions were painted, the length of a lid being normally cut with the grain and the width across it. The grain of the lower plaque, however, bursts forth at its base into curious root-like tentacles. On one side they are connected to the antennae of a dragon-fly and on the other to the root-like forms which sprout from an oddly-shaped figure, the lower half of which is in the form of a tree-trunk and the upper half in the form of a classically-posed female figure. Conder seems to be suggesting how the impressionists draw upon the transient beauty of life (symbolized by the petals which fall from the blossoming tree and the dragon-fly which lives but a day) and embody its variety in the permanent forms of art (symbolized by the classical figure). But art forms are themselves transient. When they cease to draw upon life (symbolized by the broken branch and the figure beside it), they become bound by convention and assume cold, academic forms. Yet even the apparently lifeless traditions of art may give rise to new forms of beauty. An image,

63　CHARLES CONDER,
Catalogue Cover Design, Ex-
hibition of 9 x 5 Impressions,
August 1889

64　CHARLES　CONDER,
Catalogue Cover Design, Vic-
torian Artists' Society Winter
Exhibition, March 1890

long bound by convention, may still hold a living flame to a newer and higher form of beauty. Yet even these new forms must take on conventions of their own (signified by the ribbon of convention as it floats through the blossoming tree) in order to become art.

Such ideas varied in certain important respects from the impressionist programme. It is true, of course, that in many of the great French impressionist paintings we may hear at times beneath the bright harmonies a solemn chorale upon the transience of earthly beauty, but Conder here is making direct use of classical imagery and neo-classical notions about the nature of art. The direction of his thought may be traced also in his cover design for the Catalogue of the Winter Exhibition of the Victorian Artists' Society held in March 1890 (64). Again the dragon-fly and falling petals appear as symbols of transience, and the symbol of art is again shown in the form of a dual image, a female head into which a tree has been incorporated. On this occasion it may signify nothing more than figure and landscape painting but it is, it will be noted, even more closely identified with the notion of transience, being linked by ribbon bands to the symbols of time (stars and sickle) and death (pomegranate and the waning moon).

Conder's growing interest in symbolism is accompanied by a significant change in his style. The 9 × 5 Exhibition catalogue reveals Conder as a pioneer of the *art nouveau* style in Australia. The new linear emphasis which he gives to his design, his use of plant forms, and the lettering which

itself suggests plant growth, are all features which foreshadow the *art nouveau* style. The decorative emphasis in his work, his interest in symbolism and the stylistic forms of *art nouveau* all indicate Conder's knowledge of the aesthetic movement prior to his return to Europe. An aesthetic taste in Whistlerian mode is also observable in the furnishings of his Melbourne studio. It was fitted with soft drapes of liberty silks, madras muslin and other light fabrics, and sketches by his Sydney friends Phil May, F. B. Schell, Frank Mahony, B. E. Minns, Nerli and Madame Constance Roth, together with his own pictures, were scattered about the walls among fans and curious odds and ends. Conder probably saw the Whistler exhibited in Sydney in the Anglo-Australian Exhibition of 1885 and it is possible that he gained information concerning the art of Whistler and the aesthetic movement from two young Englishmen: Blamire Young, a schoolmaster from Cambridge who arrived to accept a post as mathematics master at Katoomba College, New South Wales, in 1885, and Phil May who arrived in 1886 to accept a position as a black and white artist on the *Bulletin*.

Young had studied classics and mathematics at Pembroke College, but his artistic interests, both practical and critical, had been roused by his association with the Cambridge Fine Art Society, from which the critic, Roger Fry, had graduated to connoisseurship. At Cambridge, Young had begun to sketch and paint in water-colour. In 1887 he induced the Head-master of Katoomba College to help him to build a studio in the school grounds. This, in imitation of Whistler, he decorated with Mirzapore rugs, a Persian Wilton carpet, and a blue-tiled fire-place. Wrought-iron lamp frames, painted scarlet, hung from the ceiling, and the windows were curtained at one end with silk madras muslin and at the other with floral chintz. It was in this studio that he met Phil May who gave him his first instruction in drawing and painting. The studio became the centre of a little coterie which included May, Theodore Fink and Godfrey Rivers, who had studied at the Slade and emigrated to Australia in 1889. The studio, however, was destroyed by fire. May left for England at the end of 1888. Young resigned his teaching post in 1893 and followed him to London.

Whether or not the proto-*art nouveau* quality in his work was gained from May or Young, by 1889 Conder was making considerable use of symbolism in his painting. In that year he painted two pictures for the Victorian Artists' Society Exhibition: *Hot Wind*, in which a half-nude girl lies full-length upon sunburnt ground blowing upon a brazier; and *Victorian Idyll* (which has disappeared) wherein summer is depicted as a goddess robed in reddish draperies. Both paintings appear to have been inspired by Adam Lindsay Gordon's lines:

> Where with fire and fierce drouth on her tresses
> Insatiable summer oppresses

Sere woodlands and sad wildernesses,
And faint flocks and herds.

And it is probable that the great drought of 1888, one of the worst on record since Australian records began, may have helped to suggest the subject of at least the first painting.

Conder's use of nude and semi-nude female figures to convey symbolic meanings became popular. Aby Altson, for example, who won the Travelling Scholarship of the National Gallery of Victoria in 1890, painted *The Golden Age* (65) about 1893. It is a large, rather immature painting in which slender, lissom *art nouveau* youths and maidens disport themselves with music and dancing in a sunlit landscape; but it catches admirably the spirit of the time. In Sydney in 1894, Sydney Long (1871-1955), while still a student at Ashton's, painted his figured landscape, *By Tranquil Waters* (66), a remarkably fresh and broadly painted canvas with clear lights and bright blue shadows. It was purchased by the Trustees of the Sydney Gallery from the annual exhibition of the Art Society of New South Wales in 1894, and was criticized on moral grounds by a member of the New South Wales Legislative Council. It was the first occasion upon which a State gallery had purchased a painting containing youthful nude figures set in a naturalistic Australian landscape. Such purchases were still likely to create a furore in the Press and Parliament even in 1894.

On such matters Tom Roberts and Julian Ashton often found themselves in public opposition to the prudery prevalent in Australian society. About 1880 Tom Roberts and his friend C. Douglas Richardson, while still

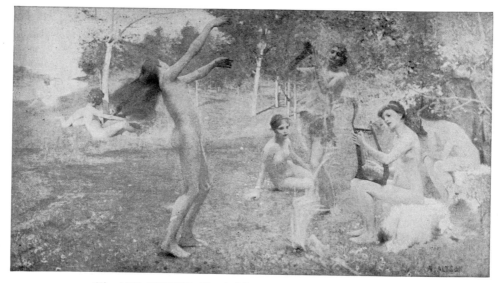

65 ABY ALTSON, *The Golden Age*, canvas, 54¼ x 98, 1893,
Melbourne

66 SYDNEY LONG, *By Tranquil Waters*, canvas, 43¾ x 72⅜,
1894, Sydney

students, succeeded in obtaining permission from Sir Redmond Barry and the Trustees of the National Gallery of Victoria to establish a life class in the Gallery school. Roberts's charming little *Sunny South* (67) must be one of the first, if not the first, studies of the nude in a *plein-air* setting painted in Australia. It is difficult, perhaps, to appreciate fully today the moral issues of the time. Surf-bathing in the open sea was proscribed by law, for example, and rigidly policed until 1902. Among writers and artists, however, the growing opposition to Victorian values expressed itself in an almost neo-pagan interest in nudity, sex and sun-cults, international in scope and significance.

Havelock Ellis's one essay in fiction captures this burgeoning neo-paganism of the time with success. Although not composed until 1885, six years after he had left Australia, his *Kanga Creek: An Australian Idyll* is clearly written from his own experience. In his *Autobiography* Ellis explained that:

In Australia I gained health of body; I attained peace of soul; my life task was revealed to me; I was able to decide on my professional vocation; I became an artist in literature . . . these five points covered the whole activity of my life in the world. Some of them I should doubtless have reached without the aid of the Australian environment, scarcely all, and most of them I could never have achieved so completely if chance had not cast me into the solitude of the Liverpool range.[18]

67　TOM ROBERTS, *The Sunny South*, canvas, 11⅝ x 23⅝,
1887, Melbourne

Kanga Creek is an imaginative reconstruction of those early years. Therein youth, love, a fullness of sensational experience, a pagan delight in mother nature, are the things worth while. On one occasion the young school-master, the hero of the story, 'flung himself down beneath a gum tree with an excess of joy in the presence of that glad warm earth, as though he would kiss the whole world'. Yet the land, for all that, still retained its melancholy emblems: 'the long-drawn cry of the curlew', 'the lagoon, a silent spot with an air of melancholy brooding over it'. The menace and dread of the bush to which Marcus Clarke had given voice is still there but it is now muffled. With Ellis, as with Streeton, the predominant tone is one of sensuous enjoyment linked with an awareness of the transience of earthly beauty. One summer evening the schoolmaster brings the young woman of his heart to Kanga Creek and sits her there naked upon a rock in the moonlight. 'I wanted to bring you here', he said suddenly; 'I wanted to seat you like a queen on this throne. It's been waiting for you thousands and thousands of years'.[19] In such writing the erotic is evoked indirectly, the nude seen idealistically through the diaphanous gauze of neo-pagan senti-ment. It is usually the same with the paintings which employ the nude figure during the last decade of the century.

Not only the nude was aetherealized. During the 1890s it happened to many of the motifs which had become traditional to Australian painting and writing. The bush came to be seen increasingly through a haze of romance. The changing tone of the popular ballad poetry is a clear indication of the new literary fashions of the time. For Lawson, Farrell, Edward Dyson and Barcroft Boake the bush retained a large measure of its traditional malevo-

lence. But for A. B. Paterson, who lived most of his working life in the city, the bush is a pleasant place for the city clerk to escape to during a vacation:

> And I sometimes rather fancy that I'd like to change with Clancy,
> Like to take a turn at droving where the seasons come and go,
> While he faced the round eternal of the cashbook and the journal
> For the drover's life has pleasures that the townsfolk never know.

The bush becomes a place of escape and recreation for the city man. Bush types are idealized. In Roderic Quinn's 'The Camp Within the West' the swagman becomes a Christ-like symbol bearing upon his shoulders the burden of the world's sorrow. A similar apotheosis of the sundowner occurs in J. Le Gay Brereton's *Landlopers*:

... the tramp can appreciate everything, and can find enjoyment even in misfortune. He is not stifled by conventional obligations. He wanders at large in a perfect atmosphere of love. He is on the common level; no social lies raise him to a pedestal or depress him in a cess-pit. He feels his fellowship with Nature. An individual he is yet merged in the universe. He recognizes his union with the Divine. He is a god ... he is so brimming with exultant joy that he would like to clasp the hand of every man he meets, and kiss the lips of every girl.[20]

Le Gay Brereton, however, was not a professional tramp himself, but a Professor of English Literature who enjoyed bush-walking.

Such then is the temper of much of the painting and writing of the last decade of the century. Sunshine has become a pervading presence enfolding youth and nature in a shimmer of joy. The new sensuousness was not due, of course, entirely to local circumstance. Conder read Whitman, and the poet probably inspired Le Gay Brereton's *Landlopers* in more ways than one. And then it was Verlaine's cult of faded things, not Edgar Allan Poe's melancholy which provided the keynote to Australian nature. A. G. Stephens, the critic, wrote a preface to the *Bulletin Story Book* in 1901 which reads like a reply to Marcus Clarke's preface to Gordon's *Poems*. 'Verlaine's cult of faded things, extolling the hinted hue before the gross colour, finds a natural home in Australia—in many aspects a Land of Faded Things—of delicate purples, delicious greys, and dull, dreamy olives and ochres.'

Through such followers of the Heidelberg School as David Davies and Walter Withers, the fashion for landscapes with luminous yet muted colours became popular. Evening effects, crepuscules and afterglows provided themes through which nature could be seen in a soft romantic haze (68). Ten years after Streeton had painted his *Still Glides the Stream*, the critic, James Green, was able to write that the poetic note which was first struck as the tone-key of Australian art in 1889 had become by 1899 the strongest element of national individuality. The popularity of poetic landscape was due, he said, to

68 DAVID DAVIES, *Moonrise, Templestowe*, canvas,
46 x 58, 1894, Melbourne

the dire prosaicism of Australian life in general. The landscape of a country **is**
the distilled aroma of her being, and, when truthfully translated upon canvas,
remains her esoteric own and essentially none others. . . . It is in this poetic
distillation of Australian Nature, apart from mere literal transcription or excel-
lence of technique, that our painters are now learning so specifically to excel.[21]

The new romanticism of faded things was making its own contribution to
the national *mystique*.

One sign of the increasing romanticism in landscape is to be found in
the conversion of the naturalistic nude into classical myth. Roberts's naked
young bathing boys are replaced by images of the god Pan. The transition
is marked in Long's *By Tranquil Waters* where a boy bathing in the fore-
ground plays a pipe. Henceforth the image of Pan in a bushland setting
becomes increasingly common in Australian painting and poetry. Long's
Pan of 1898 depicts two satyrs dancing with two young girls to the tune
of a pipe played by a Pan figure. The design reveals considerable move-
ment away from the decorative naturalism of *By Tranquil Waters* towards
a more purely decorative and *art nouveau* style. Yet Long continued to use
living models for his allegories. From D. H. Souter we learn that 'Pan was
an Irishman as far as the waist; the rest was studied from a Woolloomooloo
goat'. Long's *Spirit of the Plains* (69) is a fine piece of *art-nouveau* decora-

69 SYDNEY LONG, *The Spirit of the Plains,* canvas, 24 x 51,
1897, Brisbane

tion applied to an Australian setting. His attempt to populate the bush with
classical gods was followed by other painters, but had a much wider vogue
among poets. Long's *Pan* found an early parallel, for example, in Christopher
Brennan's poem 'Secreta Silvarum' written about 1901:

> . . . This is the house of Pan, not whom blind craze
> and babbling wood-wits tell, where bare flints blaze,
> noon-tide terrific with the single shout,
> but whom behind each bole sly-peering out
> the traveller knows, but turning, disappear'd
> with chuckle of laughter in his thicket-beard,
> and rustle of scurrying faun-feet where the ground
> each autumn deeper feels its yellow mound.
> Onward: and lo, at length, the secret glade,
> soft-gleaming grey, what time the grey trunks fade
> in the white vapours o'er its further rim.
> 'Tis no more time to linger: now more dim
> the woods are throng'd to ward the haunted spot
> where, as I turn my homeward face, I wot
> the nymphs of twilight have resumed, unheard,
> their glimmering dance upon the glimmering sward.[22]

But the bush could not be easily submitted to classicizing. In 1905 Long,
in a moment of self-criticism, admitted that artists in Australia would never
be able, unlike those of older countries, to people their country with
nymphs, naiads, pans and centaurs. Instead, he suggested, the Australian
artist 'will bid the aborigine blossom out in all his manly vigour, when
sufficient time has allowed us to forget his failings'.[23]

Art nouveau suggested new ways of depicting Australian tree-forms. The

thin, graceful stems and feathery branches of young eucalypt saplings and the sinuous lines of the tea-tree lent themselves splendidly to a decorative treatment. They are a feature of landscape and graphic art between 1895 and 1905, notably in the work of Ruby Lind (1887-1919) and Violet Teague (1872-1951). It was D. H. Souter (1862-1935), however, who made the most use of *art nouveau* in graphic art, though it affected the work of most Australian artists, to some extent, during the first decade of the century. In 1902, for example, Walter Withers, possibly influenced by Blamire Young's essays in history painting, executed six panels for the entrance hall of Purrumbete homestead at Camperdown, Victoria, in a fully-fledged *art nouveau* style. The panels depicted stages in the development of the property by the Manifold family. The paintings and sculpture of C. Douglas Richardson (1853-1932) were also strongly influenced by *art nouveau*.[24]

Ernest Moffitt (1870-99) was another pioneer of *art nouveau* in Australia. The pen drawings and woodcuts which illustrate Lionel Lindsay's *Consideration of the Art of Ernest Moffitt* (1899) are among the most delightful examples of the style produced in Australia. There is an echo of *Jugendstil* and the Austrian Secessionists in such woodcuts as his *Bathers* (70), transmitted, no doubt, through the early issues of the *Studio*, a most important vehicle from the time of its first publication in 1892 for the diffusion of

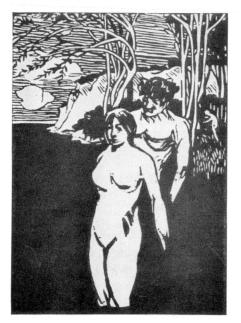

art nouveau in Australia and elsewhere. Moffitt, who died young and was interested in all the arts, was a spiritual force among the little confraternity of artists at 'Charterisville'. Lionel Lindsay has vividly depicted the man and his time in his *Consideration*:

The old garden at Charterisville, and everybody down the river, either swimming or lying on the rocks in the hot sun. Moffitt, his whole body sunburnt, as bronze as a faun, and some of us climb the bank, and binding flowers and vine leaves about us, dance on the short grass, or chase each other, shouting; and we think of happiness and pagan Greece, before Christianity came to throw its ominous shadow of melancholia and 'purity' upon the blytheness of life.

70 ERNEST MOFFITT, *The Bathers*, woodcut, 4 x 3, from L. Lindsay, *A Consideration of the Art of Ernest Moffitt*, 1899

The movement from impression to romance in Australian landscape was a product of aesthetic attitudes and

art nouveau. In both Blamire Young was a leading influence. He remained in England for two years after leaving his Katoomba school, married, and developed under the influence of the Beggarstaff Brothers, James Pryde and William Nicholson a consuming interest in the new poster. Returning to Melbourne in 1896, he formed with Harry Weston what may be called a co-operative group for the production of commercial posters. Between them Weston and Young succeeded in producing a series of remarkable *art nouveau* designs which vitalized poster art throughout the country. But Young, a man of varied and original talent, could not confine himself long to the constricting requirements of the commercial world. At that time Roberts and McCubbin were still engaged upon their cycle of social history paintings. Young contributed to the trend with two large water-colour paintings illustrative of Victorian history, *William Buckley* and *Fawkner's Printing Press* (both at Geelong) in the decorative manner of *art nouveau*. They were exhibited at the Exhibition of the Victorian Artists' Society, but their heavy decorative contours and bright flat colours found little favour with the critics. For some years Young and his family lived through the depression years of the nineties (like many of his Melbourne fellow-artists) in straitened circumstances punctuated by financial crises.

It was not until 1911 that a series of water-colours painted at Mount Buffalo and exhibited at the Guildhall, Melbourne, brought him, then in his fiftieth year, critical acclaim and public notice. Exhibitions in Adelaide and Melbourne (at the Athenaeum) followed, and Young later visited Tasmania with his family. The holiday left a permanent impression upon him and from it proceeded some of his finest paintings, which he exhibited in Sydney in 1912 prior to departing with his family for Europe. The fascination of Spain had touched him, as it touched many of his generation, and he made his way leisurely to England via the Canary Islands, Lisbon, Oporto, Madrid, Bourgos and Paris. In England he painted only for a few months on the Sussex Downs before the outbreak of war forced him back to his youthful skill with a rifle, as an instructor in musketry and machine gunnery. He did not return to Australia until 1923.[25]

Blamire Young handled water-colour with versatility, grace and, at times, with wit. But his light romantic gift, which gained much from Bonington, Watteau and the later paintings of Corot, often betrayed him into an excessive prettiness of design and sweetness of colour. He was romantic in his love of old buildings, in his devotion to atmosphere and light, and his love of the theatre. One of his plays, *Art for Art's Sake*, was produced in Melbourne in 1911, and another, *The Children's Bread*, was published in 1912. And the stage is never far from his work. Figures are often placed, in the manner of his friend Pryde, against a huge drape, or against the greater curtain of the sky. From Whistler he learned to assemble his tones

71 BLAMIRE YOUNG, *Dry Weather*,
water-colour, 21⅜ x 29½, *c.* 1912, Sydney

and masses in telling decorative areas, and from the Japanese, the value of open composition and bright, flat washes of colour. Young's decorative neo-Rococo manner is in sharp contrast to the *plein-air* realism of Roberts and McCubbin. He played with a dream-world behind the thin veils of his graded and granulated washes, though on occasion a note of mordant satire can appear. But usually even his droughts occur upon the hills of Arcadia (71).

The desire to interpret Australian landscape as a southern Arcadia of sunshine and lyrical colour reached the height of its expression in the later work of Frederick McCubbin. The last and perhaps finest phase of his art was presided over by Turner's genius. We know that McCubbin studied with great interest a special publication of the *Studio* for 1903-4, devoted to Turner's work. Thenceforwards he abandoned his large-scale figure pieces on Australian themes in favour of lyrical landscapes inspired by the later paintings of Turner (83). Colour is now flecked on brightly, loosely, with great freedom. McCubbin no longer seeks to provide a true impression of things seen but to paint a hymn in celebration of Australian light.[26]

Despite McCubbin's personal triumph late in life, the vision which had inspired the painters of the Heidelberg School was fading. J. J. Hilder's[27] slim, lyrical effusions manage somehow to avoid vulgarity (84); the same cannot be said of Elioth Gruner's early work. Trained under Julian Ashton, he combined his master's *plein-air* methods with an interest, then widely current, in the lyrical excursions of the later paintings of Corot. It is said that he made a special visit to Melbourne to study *The Bent Tree*. But there was something mundane about the quality of his imagination that does not fail to reveal itself even in his most lyrical evocations of spring blossom, morning light, or dappled cows and cow-sheds at dawn. True, like Max Meldrum, Gruner analysed tonal gradations with much devotion; but his mood is invariably sentimental, his composition stereotyped, and his colour lacks sensitivity. To compare any of Gruner's early beach scenes or spring landscapes with similar early paintings by Roberts, Conder or Strecton is to realize at once that Australian impressionism had lost the power to inspire creative art.[28]

Norman Lindsay and Hans Heysen

During the first two decades of the present century Norman Lindsay was the most controversial figure in Australian art and letters. His life spans the history of Australian art from its beginnings in the camps at Heidelberg (he spent some crucial early years at 'Charterisville') to the present day. His work represents, among other things, the full flowering of that school of graphic art which gained so much impetus from the *Bulletin* and other illustrated journals in the years between 1880 and 1914. Lindsay revealed himself to be the most talented, imaginative and prolific pen draughtsman in the country, and the effect of his work and thought extended eventually into the whole field of Australian culture.

In his work as an artist, whether in pen and ink, etching, water-colour or oil painting, Lindsay is a magnificent illustrator. Preoccupied, however, from the beginning of his intellectual life with literary, ethical and technical questions, his art has revealed a complete lack of interest in the formal and constructive elements of design, especially in painting. Not surprisingly, therefore, his influence upon Australian painting has been of no great importance. It is in the realm of letters, especially in poetry, that his ideas and attitudes have found the most responsive audience.

During the first two decades of the century Norman Lindsay became a liberating force of considerable power in Australian culture. Far more than any of his contemporaries, he helped to widen the range and deepen the curiosities and interests of Australian artists and writers. From the beginning he opposed nationalism and brought a most salutary breadth of interest in the masterpieces of European literature, art and music, to the local scene. His own art became a lifelong protest, arising first in his own family, against the strict code of Christian morality. Deeply impressed at an early age by the writings of Nietzsche, he acquired a profound belief in the overwhelming importance of the artist's role in society as a creator aligned against the forces of a Philistine establishment habituated to hypocrisy, wowserism and corruption. The conception of the dedicated artist alienated from society was not familiar to Edwardian Australia; and the spectacle of its enactment in real life created, on the one hand, a series of crises with officialdom and, on the other hand, standards of behaviour for professional artists and writers which involved relationships with the 'art-loving public' less compromising than hitherto.

Norman Lindsay was born in the small mining township of Creswick, Victoria, in 1879. His father, Dr Robert Lindsay, a graduate of Trinity College, Dublin, was a general physician in the town, and his mother was the daughter of the Reverend Thomas Williams, a Wesleyan missionary who had settled in Fiji in 1839 and retired to Creswick in the later 1850s. The Lindsays had ten children, five of whom, Percy, Lionel, Norman, Ruby

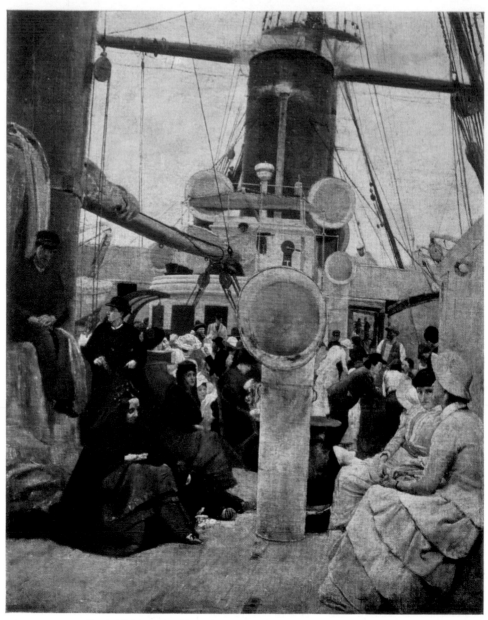

72 TOM ROBERTS, *Coming South*, canvas, 24¾ x 19½, 1886,
Melbourne

and Daryl, became well known as artists: Lionel and Daryl also achieved knighthoods for their services to art and connoisseurship in Australia.

Norman's early education and interests owed a good deal to his missionary grandfather who encouraged and criticized his first drawings, read Shakespeare to him, and took him regularly to the Ballarat Art Gallery, where Solomon J. Solomon's painting *Ajax and Cassandra,* with its exciting and dramatic nude, Cassandra, left a permanent impression. A persistent illness troubled his youth and he read widely from childhood. His home provided him with some books of germinal significance: an illustrated Bible with 'embattled hosts and charging charioteers', *Tales from Homer,* and Knight's *History of London.* By the age of twelve he was acquainted with Shakespeare, *Don Quixote, Gil Blas* and *The Three Musketeers.* The Creswick library furnished reproductions of Dürer's prints, and drawings by Edwin Abbey, from *Harper's.* Norman Lindsay first attended the State School and later the Grammar School at Creswick where he revived the school paper, the *Boomerang.* At the age of fourteen he made a series of drawings inspired by *Hamlet* and *The Three Musketeers.* But his drawings soon began to reflect the interests and curiosities of pubescence and he came violently into conflict with his mother's Calvinistic morality.

Meanwhile, Norman's elder brother, Lionel, had obtained employment in Melbourne upon a weekly paper, the *Hawklet,* a kind of police gazette specializing in sensational news; and Norman came to Melbourne at the age of sixteen at his brother's request to help him with his work. Drawing for the *Hawklet* brought Norman into direct contact with the carnal and violent aspects of Melbourne life: prize-fights, the music hall, saloons, brothels, the scenes of murders. He also contributed drawings to the *Tocsin* and the *Freelance,* and became art editor of the short-lived *Rambler.* Black and white illustrations from old copies of such journals as *Once a Week, Good Words,* and the *Cornhill Magazine,* containing reproductions of the work of Millais, Frederick Sandys and Whistler, appear to have been the most important influences upon his art at this time. 'We were all', Sir Lionel Lindsay has written, 'ardent collectors of the illustrators of the sixties'.

About 1897 Lionel and Norman with their friend, Ernest Moffitt, settled in one of the lodges in the old garden at 'Charterisville'. Norman, captivated by the drawings of Sandys, drew the trunks and branches of the old trees in the garden with the 'fervid care of a Pre-Raphaelite'. Moffitt, who had studied art, and music under Marshall Hall, became secretary of the Conservatorium of Music at East Melbourne. It was Moffitt who transferred to Lionel and Norman his passion for the Greek authors; and at 'Charterisville' Norman began his practice of making sets of illustrations to books that appealed to him, beginning with the *Idylls* of Theocritus, and following with illustrations to *Boccaccio.* He was also reading widely:

H

Rabelais, Balzac, Pepys, Gautier, the letters of Byron, Rossetti and Swinburne. About 1898, at the age of nineteen, he read Nietzsche's *Anti-Christ* and *Zarathustra*, which had appeared in an English translation.

In Melbourne, during the later 1890s, Norman was associated with his brothers, Percy and Lionel, in membership of the Prehistoric Order of Cannibals, a club of young artists founded in 1893, which also included among its members Miles Evergood, Max Meldrum, Will Dyson, Hugh McCrae, Ernest Moffitt and Harry Weston. The life of the Club later provided him with material for his novel *A Curate in Bohemia* (1913). At this time, too, Norman regularly attended life-classes, organized by George Coates, and there he met Raymond Parkinson, whose sister Kate he married in 1899.

About this time the *Hawklet* failed and Norman Lindsay, at the age of twenty-one, succeeded in obtaining a permanent position on the *Bulletin* staff in Sydney, after J. F. Archibald had been shown his *Boccaccio* drawings. During the following nine years (1901-9) he produced an enormous amount of work for the *Bulletin*: political cartoons, joke blocks, comments on national life. He settled in Sydney, at Lavender Bay, with his wife and son, Jack (*b.* 1900), and opened a studio in Bond Street. A few years later, in 1903, his brother Lionel, after some years in Spain and England, joined him in Sydney. Norman continued to feed his imagination upon translations from the classics: Catullus, Horace, Petronius and Plautus, and on one occasion wrote a Roman play in the vein of Plautus, which he called *The Pink Butterfly*.

In Sydney, too, Lindsay gradually freed his drawing from the decorative elements and precise detail which he had inherited from *art nouveau* and the Pre-Raphaelites. Contrasts of sunlit flesh and white togas against the brilliant blacks of foreground shadows and heavy foliage brought a more tonal and painterly quality to his drawings. His brother Lionel has suggested that the 'deep metallic tones' of the Moreton Bay fig trees at Lavender Bay inspired him in this new interest in dappled and heavily contrasted lights. During the next ten years or so Norman made an important series of imaginative drawings expressive of his philosophy of life and art, the most notable being: *The Scoffers* (1903), which was purchased by Bernard Hall, the first buyer and one of the earliest admirers and champions of Lindsay's work; *Pollice Verso* (1904), *Dionysus* (1905) and the *Crucified Venus* (1912). In the *Pollice Verso* (73), nude Roman warriors and their women gesture violently with their thumbs down at the Crucified Christ as they surge forward in a Bacchanalian procession inspired by Titian and Rubens. The influence of the latter, gained first from the book by Max Rooses, became in the opinion of Lionel the most momentous and abiding influence upon Norman's art. The Trustees of the National Gallery

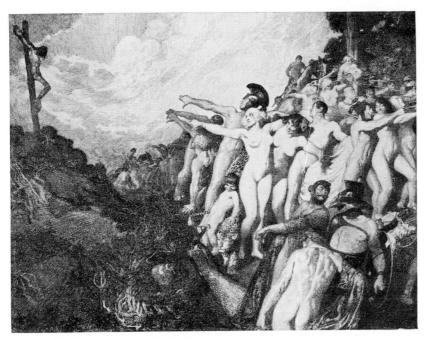

73 NORMAN LINDSAY, *Pollice Verso*, pen drawing,
17¾ x 22⅞, 1904, Melbourne

of Victoria purchased *Pollice Verso* from an exhibition held in Melbourne
in 1907, but so great was the public outcry which followed that the drawing
was hung for the remainder of the exhibition with its face to the wall.

In 1906 Norman Lindsay turned from line to wash drawing, and began
to illustrate the *Memoirs of Casanova*. In order to gain historical accuracy in
setting and costume he read widely and studied contemporary prints care-
fully, the task taking him three years to complete. In 1909 he set off for
London in search of a publisher but failed to find one. However, one
hundred illustrations for the *Satyricon* of Petronius, which he had begun
at Naples with Pompeii at hand, were published in a limited edition, with
text and translation. Lindsay remained in London for fifteen months, and
visited Paris several times. Among the European masters he most admired
Rubens, Delacroix, Manet, Goya, Degas and Turner. But London affected
his health and he returned to Australia, suffering from pleurisy, to accept a
new contract on the *Bulletin*. During his convalescence at Leura in the
Blue Mountains the First World War broke out. For the next four years
Lindsay, sharing the current war fever, produced full-page cartoons for the
Bulletin and hundreds of cartoons for Government war posters. They were
critical years for the artist personally. He separated from his wife and three
sons, Jack, Raymond and Philip, who went to live in Brisbane; his health
was not good; his brother Reginald was killed at the Somme in 1916; and

his sister Ruby, married to his friend, the artist Will Dyson, died from pneumonic influenza in 1918. Lindsay became increasingly critical of war-time patriotism, turned away from the carnage of war and became deeply interested in spiritualism. His thoughts on life and art, which underwent a thorough reappraisal at this time, were published in *Art in Australia* in February 1922, and more fully in *Creative Effort* (1924).

Prior to the First World War, Norman Lindsay's art and thought exercised a stimulating and civilizing effect upon Australian culture. The bent of his genius lay not in formal experiment or formal construction, though technical problems and their solution delighted him; it lay in his use of art as a moral weapon to create an apotheosis of the *élan-vital* he believed in, and to belabour orthodoxy. But the war brought to Sydney forms of art with which Lindsay found himself entirely out of sympathy and, during the post-war years, this *enfant terrible* of Edwardian times was gradually transformed into a kind of Australian institution himself. His later work is discussed in a later chapter.[29]

As early as 1903 the great majority of Australia's most talented artists were in London or Paris, and exhibitions in the eastern States were dominated by minor artists and semi-amateurs who worked for the most part in a sweet and popular romantic-impressionist manner spiced with *art nouveau* sophistication. In South Australia, however, in the same year, an artist of originality and power returned from studying abroad. Hans Heysen (*b.* 1877) did not confine his art to the limitations imposed by impressionism and *art nouveau*. Although he has himself admitted that Streeton's high-tone landscapes came as a revelation to him (and his work may be seen in more ways than one as a development of Australian impressionism), his mature work differs markedly from the painterly impressions of the Heidelberg School and the colour poems of Young, Hilder and the later paintings of McCubbin.

Born in Hamburg, Germany, Heysen was brought to Adelaide by his parents at the age of six. Early training at Norwood and the School of Design, Adelaide, was followed by four years abroad, during which he studied at Julian's and the Beaux Arts, and painted in Italy, England and Holland. On his return he married and settled at Hahndorf in the Mount Lofty Ranges, amid a rich and beautiful agricultural country first settled by a community of Evangelical Lutherans who had migrated from Prussian Silesia, to avoid religious persecution, in 1839. His early work such as *The Coming Home* (Sydney, 1904), with its soft evening glow, crepuscular effects and emphasis upon decoration, reveals his link with *art nouveau*. But his response to nature was too deep to be long confined to decorative mannerisms.

From the Hahndorf country Heysen fashioned an image of the Australian

landscape which has come to occupy a permanent place in the national imagination, to be the delight of ordinary people and the despair of the sophisticated. Yet his vision was not commonplace. It acquired nobility, as did Constable's, through a lifelong devotion to the countryside of his boyhood. He chose, like the Barbizon painters to whom he was undoubtedly indebted, simple rural themes: haystacks, turkeys, barns, and country work such as ploughing and droving. The magnificent charcoal and chalk drawings which he made of such subjects reveal the power and integrity of his drawing. The eucalypt forests of the Mount Lofty Ranges provided him with a subject he made his own, and a generation of Australians came to see the gum tree as he saw it. This creation of a popular landscape convention was not the achievement of a second-rate painter. But, unfortunately for Heysen's reputation, a tangled scrub of little gum tree painters has grown up around the roots of his achievement to obscure the originality of his own work.

Nowadays dislike of the work of his imitators makes an unprejudiced approach to his work difficult. And so it must be stressed here that Heysen's landscapes have never at any time been 'mere imitations of nature'. They are certainly realistic in their firm, disciplined drawing and love of simple things. But Heysen's vision is cast in a heroic mould. There is baroque magnificence in the amplitude of his scale, something of the plenitude of Rubens in his pastorals, and his gum trees achieve a dimension larger than life (74). At times, indeed, they are almost Piranesian in their grandeur. Heysen was perhaps the only Australian painter of the Edwardian years to handle the big landscape with success, though many attempted it. He continued to explore the problem after Streeton and McCubbin had moved on to other interests, and his achievement, all things considered, was more successful than theirs. Streeton's *Fire's On*, to take an example, for all its excitement of colour and light, retains the quality of a sketch. It is essentially a blown-up impression: informal in composition, swift and broad in handling. The figures in McCubbin's rural genre pieces never quite belong to their setting. There is something of the lamp about them, with their studio poses and literary associations. But Heysen's control of breadth and detail in drawing and of figures in landscape was sure, for he drew more thoroughly than either Streeton or McCubbin upon the figure and landscape tradition of the European masters. The echoes of Turner, Constable and Rubens which recur in his work help to give his large paintings the authority of accumulated knowledge which theirs lack. Occasionally, however, in his large oils, his control of colour values deserts him and areas of flat, uninspired painting appear. Such weaknesses do not appear in his water-colours, a medium which he handled with power, clarity and vigour.

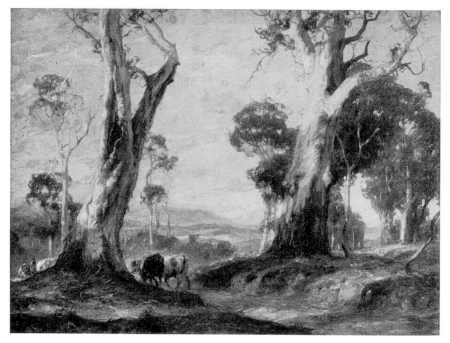

74 HANS HEYSEN, *Red Gold*, canvas, 50 x 67½, 1913, Adelaide

Heysen's vision of Australia was his own, but it was not narrow in range. The country was not for him all sunlit plain nor all melancholy desert. He painted the hot summers, the spring mists, the fruits of autumn, and the dry, dead Centre. One of his finest drawings depicts an approaching storm seen through a bushfire haze (75). It is based upon an effect seen near Hahndorf during the great bushfires of 1912, and it possesses the freshness and authority of an old master. He also painted pastorals drawn from the rich farmlands of the valleys among the Mount Lofty Ranges. But in 1925 he began to travel north into the desert country; and in his drawings and paintings of such places as the Aroona Valley in the Flinders Range, and Oratunga in the Centre (76), he foreshadowed an interest in the desert landscape to be made much of by Drysdale, Nolan and others in the 1940s.

His comments of his experience of Central Australia, written in 1932, carry a prophetic ring.

The far Northern interior of Australia with its stern reality of desert country holds a peculiar fascination for many who have come under its spell, and I must confess to having fallen a victim. I have seen it at various times over a period of years but always when the country was in the throes of severe drought. Yet those who have lived there longer have told me that there are years when its surface is covered with an abundance of grass and wild-flowers and this desert is converted into a veritable paradise. I have not seen it under these conditions. My experience makes this paradise sound like an impossible dream. . . . Again

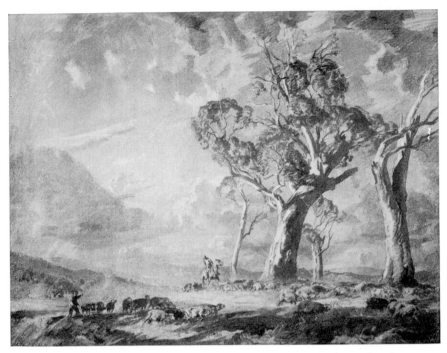

75 HANS HEYSEN, *Study for Approaching Storm*, charcoal and
wash, 22½ x 29½, 1913, Adelaide

I have seen it on calm days of crystalline purity when the eye could travel, as it were, to the end of the world, bringing with it that wonderful sense of infinity that a land of moist atmosphere could never give. There is an undeniable call about this interior which covers by far the greater portion of Australia, and offers, for the artist, a wide field as yet practically untouched.[30]

And where Heysen pioneered, others followed.[31] Rex Battarbee, for example, whose work and enthusiasm has helped to create a Central Australian group of painters grounded upon Heysen's vision: the most notable painters of the group, apart from Battarbee himself, being Albert Namatjira, and the two brothers, Edwin and Otto Pareroultja.[32]

Nationalism, Taste and Patronage, 1880-1900

The Heidelberg School effected a revolution in Australian taste. Here again Tom Roberts was a leader, though his achievement was equalled in Sydney by Julian Ashton, who became an outstanding champion of the new movement for the recognition of Australian art in its own right. One important aspect of the battle for recognition lay in the struggle for power within the existing art societies. The early art societies owed their existence more to enthusiasts for cultural improvement and well-meaning amateurs than to professional artists. When Roberts returned from overseas in 1885,

76 HANS HEYSEN, *The Land of the Oratunga*, water-colour,
19 x 25, 1932, Adelaide

amateurs were in control of the Victorian Academy of Art, the only import-
ant art society in Victoria. Largely due to his leadership, a group of profes-
sional artists broke with the Academy and formed the Australian Art
Association. It included Roberts, Streeton, Conder, Mather, Ford Paterson,
W. B. Spong, Percival Ball, Arthur Loureiro and Ugo Catani.

The name of the new society was significant, for it implied the recog-
nition of Australian art in its own right. During the 1870s, exhibitions of
local works were invariably called exhibitions of *colonial* art. The New
South Wales Academy of Art, for example, held annual exhibitions of
colonial art during the 1870s to which local professionals and amateurs
alike contributed. Local taste was determined by a more or less cultured
British-born minority who could not bring themselves, for fear of allowing
their standards to become provincial, to take the work of local artists
seriously. They were not well served, however, by their London advisers.
To take but one example: while Sir Charles Eastlake enriched the National
Gallery of London with many fine early Italian masterpieces, he advised the
Trustees of the National Gallery of Victoria to purchase large paintings
from the Royal Academy Exhibitions of the 1860s and 1870s which
possessed no more than a popular and sentimental appeal and are now
comparatively worthless. He can hardly be blamed, however, for the taste
of Australia's educated minority was more provincial than it knew. It

derived directly from the taste of Victorian England in its more popular aspects. Sentimental and narrative genre, grandiose canvases both in history and landscape deriving from the Munich and Düsseldorf schools, and the melodrama and linear naturalism of the Pre-Raphaelites were the order of the day. These values were filtered through to the Australian colonies by means of newspaper reports of exhibitions of the Royal Academy and the Paris Salons and, to a greater extent, by means of the loan works and reproductions shown at those intercolonial and international exhibitions so frequently held in Australia during the second half of the nineteenth century. Paintings were expected to possess an immediate and popular appeal and were improved by the incorporation, either implicitly or explicitly, of a moral message of some kind. After 1880, the evangelical earnestness and high-mindedness of John Ruskin began to dominate local criticism, and is reflected in the writings of the leading critic of Sydney, James Green (de Libra), and the leading critic of Melbourne, James Smith. It was against their popular Victorian values that Tom Roberts and Julian Ashton rose in order to champion art for its own sake rather than for the sake of morality, *plein-air* and impressionist painting rather than Victorian academic painting, and the right to existence of an independent Australian school of painting.

Julian Ashton became President of the Art Society of New South Wales in 1887. From that time he campaigned vigorously for the recognition of Australian art. In 1888 he made the acquaintance of Sir Henry Parkes, then the Premier of New South Wales for the fourth time. Though decidedly mid-Victorian in his tastes, Parkes was genuinely interested in the arts. Ashton became his friend, painted his portrait in 1889, and gained his support in his campaign for Australian art. At the Annual Dinner of the Art Society in 1888, which Parkes attended, Ashton spoke vigorously to the toast, 'Australian art', and criticized the buying policy of the Trustees of the National Gallery of New South Wales. In the following year Parkes appointed Ashton and Bernhard Wise, his Attorney-General, as Trustees. They were responsible for the purchase of Streeton's *Still Glides the Stream* in 1890. As a result of Ashton's tireless advocacy, the work of the Heidelberg School met with greater favour from the Trustees of the Sydney Gallery than it did from those of the Melbourne Gallery.

Meanwhile, in Victoria, the difference between the professional artists and the Victorian Academy was resolved in 1888, mainly through the efforts of Roberts, Streeton and Conder, the Australian Art Association and the Academy amalgamating to form a new society called the Victorian Artists' Society, which still exists today. A similar disagreement between the professional and lay members of the Art Society of New South Wales took place in 1895, when no professional artists were elected to the Selection Committee for the annual exhibition of that year. Under the leadership of

Roberts (then in Sydney) and Henry Fullwood, a new Society, entirely confined to professional artists, was formed and called the Society of Artists, Roberts being elected its first President. These changes in the art societies of Sydney and Melbourne brought a greater measure of recognition to impressionist and *plein-air* painting.

Roberts, Streeton and Conder all exhibited a lively interest in literature, music and the theatre, and won their first friends and patrons from among people actively interested in these associated arts. The Mannington Caffyns, for example, encouraged Charles Conder and introduced him to their friends. Mrs Caffyn, whose portrait he painted *c.* 1888, encouraged him to lead, as he himself put it, 'a fashionable existence'. Both Dr Caffyn (*b.* 1851), the English physician who migrated to Australia in 1881 and practised at Brighton and South Yarra, and his Irish wife, were writers. He wrote two novels, contributed to the *Bulletin* frequently, and wrote articles for the *Pall Mall Gazette*, under the pseudonym, 'The New Philosopher'. Mrs Caffyn contributed to the local Press and wrote *A Yellow Aster* (1894) in Australia, the character of Charles Brydon, the painter, being modelled on Conder. The Caffyns were interested in social and moral reform. In Mrs Caffyn's books there are frequent contrasts between the 'Victorian' woman and the 'new' woman. When the Charringtons produced a series of plays by Ibsen in 1890, 'the new woman' became a topic of cultivated conversation. Conder and Streeton were friendly with Charles Charrington and his wife, Miss Janet Achurch, who starred in Ibsen's 'Doll's House'. Conder painted Miss Achurch's portrait, and Streeton presented her with his *Coogee Bay*, the first picture he painted in New South Wales.

One of the earliest, and in some ways the most influential and important, patron of the Heidelberg School was G. W. L. Marshall Hall, the London-born musician, poet, teacher and dramatist, who became the first Ormond Professor of Music in the University of Melbourne in 1890. After ten years of inspired teaching during which he established the Melbourne Conservatorium of Music and exercised a deep and lasting influence upon the intellectual and cultural life of Melbourne, the University Council refused to renew his second five-year term appointment to his chair 'because of his blasphemous and mildly sensual poems and utterances'. He thereupon created his own conservatorium and orchestra, both of which he conducted successfully until 1912. Hall became a friend of Roberts and Streeton and many other artists shortly after his arrival in 1890. He associated closely with painters, and was a frequent visitor to their camps in Sydney and Melbourne. It was at the Curlew camp that he wrote his 'Hymn to Sydney', published in 1897.

Another influential friend and patron was Theodore Fink (1855-1942), the politician and educationalist who was born in the Channel Islands and

educated in Australia, qualifying as a solicitor at the University of Melbourne. Fink was interested in journalism and was able to provide the Heidelberg School with influential support at a time when it was most needed, through his association with the *Herald* and *Weekly Times* newspapers, of which he became a director in 1889. A keen Federationist, Fink became closely associated with the Australian Art Association during the brief period (1886-88) of its existence, and usually chaired its 'smoke' nights. He remained a lifelong friend of Roberts and Streeton.

Among other early patrons of the Heidelberg School are to be included Dr Felix Meyer and Dr J. W. Springthorpe, who both became well known for their liberal patronage of art; Carl Pinschof, the Consul-General for Austria, whose hospitality was always extended to representatives of the arts; and Sir Baldwin Spencer (1860-1929), the famous English-born anthropologist, who became Professor of Biology at the University of Melbourne at the age of twenty-seven. Spencer formed one of the first large collections of Australian painting and was one of Streeton's close friends.

In Sydney, one of the most valued patrons of the new Australian school was Eadith Walker, the daughter of Thomas Walker, a public benefactor who had amassed a considerable fortune as a general merchant. Thomas Walker was a member of the first elected Legislative Council of New South Wales; his daughter Eadith was created a Dame of the British Empire for her varied philanthropic activities. In 1898, at the suggestion of Julian Ashton and Bernhard Wise, she covered the cost of sending a representative exhibition of Australian art to London. It contained three hundred and seventy-one works by members of the Heidelberg circle of painters and those grouped about Julian Ashton in the Society of Artists, Sydney. Among the exhibits were such representative paintings as Roberts's *Breakaway*, and *Golden Fleece*; Conder's *Departure of the s.s. Orient*; Streeton's *Golden Summer* and *Purple Noon's Transparent Might*; McCubbin's *On the Wallaby Track* and W. C. Piguenit's *Flood in the Darling*. It was shown at the Grafton Gallery and was received not unfavourably by English critics.

It may be said, generally speaking, that during its emergence in the decade between 1885 and 1895, the Heidelberg School found its earliest supporters from an educated minority among the artistic, musical and literary circles of Sydney and Melbourne, and from medical men, academics and some journalists. Born and bred in the cities themselves, the Heidelberg painters gained their first support from an urban intelligentsia. The movement was not, at the beginning, considered by the educated public at large or by art critics as a national movement in art; it was seen rather as a minority expression, an *avant-garde* group. And indeed, that is how the artists, despite their strong national sentiments, tended to regard themselves.

For though Roberts, McCubbin and Streeton certainly sought to paint large canvases redolent with national sentiment, this was only *one* aspect of a varied programme. Success in Paris and London was what they all desired most—but such success, as they were all to find, was not achieved easily. They never embraced nationalism as a desirable end in itself. It was not until the 1920s that the Heidelberg School came to be identified by critics and the informed public alike as a purely national expression in painting. The national element was played up at the expense of the purely artistic element in the works of the School. This distorted interpretation of their work was used both as an excuse and a precedent for the highly nationalistic and isolationist tendencies which developed among many Australian artists during the 1920s and 1930s. In reality a genuine expression of Australian nationhood, launched by men who in youth were curious and open-minded to all forms of contemporary artistic expression which came within their ken, the Heidelberg School and its associated derivatives came to serve the pathological nationalism of the 1920s and 1930s—a nationalism which sought, not without success, to insulate Australian art from contact with artistic expression abroad. Created by city-born artists in a thoroughly urban *milieu*, the Heidelberg School came to be accepted by its friends and its foes alike by the late 1930s as a school which specialized in the creation of an up-country *mystique* based upon the apotheosis of the pastoral industry and the gum tree. It was more than that.

None of the leaders of the Heidelberg School committed themselves to political activity. Indeed, the Australian painters of the time were far less closely associated with the Australian Labor Movement than were the writers. Nevertheless, during the eighties and nineties it is fairly clear that the sympathies of Ashton, Streeton and Roberts lay with the Labor Movement. Such sympathies are clearly revealed in the comments which Roberts wrote concerning *Shearing the Rams* and Streeton wrote concerning *Fire's On*. Julian Ashton numbered William Lane and J. F. Archibald (a fellow-voyager with Tom Roberts on the s.s. *Lusitania* in 1885[33]) among his friends. Dr Maloney, one of the pioneers of the Socialist Movement in Victoria, was one of Tom Roberts's oldest companions. They toured Spain together in 1883. Quite a large number of black and white artists were brought into direct contact with the Labor Movement through their contributions to the *Bulletin*, J. F. Archibald's great radical and republican weekly, which came to be known as 'the Bushman's Bible'. The *Bulletin* between 1880 and 1900 trained a generation of black and white artists, and its regular contributors included Phil May, Frank Mahony, George Lambert, B. E. Minns, Norman Lindsay, Lionel Lindsay, David Low, Will Dyson and many others.

The association of artists and the Labor Movement rested mainly upon broad humanitarian sympathies rather than economic ties. In the years

following the economic collapse of 1893 it is possible to trace a certain change of heart and attitude in Roberts's relation to the Labor Movement, and of the artists whose attitudes he influenced. His series of large history paintings of pastoral life came to an end with his *Mountain Muster* (H. O. Vary) painted in 1898. These paintings were essentially gallery paintings and were painted in the hope that they would be purchased by public galleries in Australia. But however well they expressed the Australian *ethos*, they were not easy paintings to sell. Roberts, always a realist, acknowledged that it was desirable that artists should be upon friendly and easy terms with the people from whom they expected support. This side of Roberts was vividly described by D. H. Souter, the brilliant artist and journalist who drew for the *Bulletin* for over thirty-five years.

Tom Roberts had everything. Chief among his sartorial possessions were a crush hat and a dress cape lined with red satin. Neither was new when he brought them to Australia, and they were still serviceable when he took them to England in the early years of the Commonwealth. He was our sole Society Bohemian and wore his crush hat and red cape with more dignity than many a king wore his coronation robe and crown.

He represented the successful artist with the entrée to Government House, and was on the dining list of most people who had over a couple of thousand a year. Before he came we never dreamt of calling on Royalty's representative. We set no store on State levées or gubernatorial garden parties. We possessed no society clothes and were criminally indifferent to the nice distinctions or the etiquette of social functions. Tom Roberts showed us the error of all that: 'There is no occasion, dear boy', said he, 'for an artist to be a boor. A man may be able to paint decently well and also know how to comport himself in good society. Besides, you don't usually sell your stuff to people who rent cottages at seventeen and six a week: Business, my dear boy, business.'

So under the shadow of his tutelary wing we learned to shake Governors-General and State Governors by the hand as if to the manor born; exchange small talk with diamonded dames, and sip champagne and crack jokes with quite a lot of titled personages from Dukes to C.M.G.'s, and form ourselves into a select cult where brains were the only qualification and bluff was a goodly proportion of the entrance fee.[34]

Tom Roberts married in 1896 and during the last years of the century was engaged largely upon portrait painting. At this time he painted portraits of Sir Henry Parkes, Viscount Hampden (the Governor of New South Wales, 1895-99) and Earl Beauchamp (the Governor of New South Wales, 1899-1901). He had long been intending to return to England on a second visit and held a farewell one-man show with that intention in 1900. He was persuaded, however, to accept the commission to paint a picture commemorating the Opening of the First Commonwealth Parliament by the Duke of Cornwall and York in the Exhibition Building, Melbourne, in January 1901. The huge painting (77), which took him two years to com-

77 TOM ROBERTS, Oil sketch for his *Opening of the First
Commonwealth Parliament*, canvas, 12 x 18, *c.* 1901, N.L.A.

plete, was presented to King Edward VII, and hung for many years in
St James's Palace, London. In order to complete his picture Roberts painted
portraits from life of all the most distinguished personages concerned in the
ceremony.

'The Big Picture', as it came to be called, was a turning-point in Roberts's
career. In the fifteen years between his return from Europe in 1885 and
1900 he had been responsible to a greater extent than any other artist for
bringing an independent Australian school of painting into existence. In
his own work he had achieved distinction in painting both rural and urban
landscapes; he had made a reputation second to none in the country in
portraiture; and he had painted the most memorable history paintings of
Australian rural life. His personal influence upon his fellow artists had been
profound. Streeton, Conder and McCubbin all spoke of their great indebted-
ness to him. He had played a leading and creative role in the politics of the
art societies. In every way he had been a natural leader and a creative artist
in his own right.

'The Big Picture' has sometimes been looked upon as a most unfortunate
aberration in the middle of his career, from which his art never fully
recovered. Yet in one sense the painting is a summing-up of earlier work,
and may fairly be seen as the last of those national and historical paintings
which he began with *The Breakaway* in 1889, in which he sought to embody

what was most characteristic of Australian life. Present himself at the opening of the First Parliament, he responded deeply to this historic movement in the history of his adopted country. And the painting itself represented a personal triumph. 'So it came about', he wrote in a private memoir for his son, 'that this painter came into touch with some of the great ones of the earth, and the incongruity of it was the thought of the early days in Australia, and the poverty and hard times for us . . .'[35] Others, like N. Graves B. Jefferson, who represented the entrepreneurs who commissioned the painting, felt that it would bring him both success and honour. 'Roberts', wrote Jefferson, 'has been brought closely into touch with the Royal Family and the whole of the representative men of Australia and of foreign countries. Under all these circumstances, it is doubtful whether Tom Roberts will ever have to look back, and good luck to him.'[36] His own artist friends, however, were not so confident. '. . . there is a feeling with others and with me', wrote Streeton from London in 1902, 'that you are putting too much time into your big gem of the Opening . . .'[37] Conder was less complimentary: 'I hope the big machine will be a success, but it must be an awful job to do. I should think "Parliamentary Coves" are usually so beastly ugly'.[38]

Early in 1903 Roberts left for England in order to complete 'the Big Picture' in London.

NOTES

[1] *Argus* (Melbourne), 7 September 1886

[2] On Conder *see* FRANK GIBSON, *Charles Conder, His Life and Work*, London, 1914; JOHN ROTHENSTEIN, *The Life and Death of Conder*, London, 1938; URSULA HOFF, *Charles Conder: His Australian Years*, Melbourne, 1960

[3] On Nerli *see* MOORE, ii, 210, *passim*

[4] Conder to Roberts, 13 February 1891, *Smike to Bulldog*, Sydney, 1946, pp. 133-4

[5] JAMES GREEN, 'Imperfect Finish in Australian Painting', *Australasian Builders' and Contractors' News*, 29 November 1890, vii, 401

[6] *Smike to Bulldog*, p. 40

[7] *op. cit.*, pp. 63-4

[8] ADA CAMBRIDGE, *op. cit.*, p. 172

[9] HENRY LAWSON, 'Shearers', *Poetical Works*, Sydney, 1944, pp. 168-70

[10] R. WARD, *The Australian Legend*, Melbourne, 1958, p. 196

[11] LIONEL LINDSAY, 'Twenty-five Years of Australian Art', *AA*, ser. i, no. 4; quoted by U. HOFF, *Meanjin*, xv (1956), 302

[12] The *Melbourne University Review*, 27 September 1884

[13] U. HOFF, 'The Phases of McCubbin's Art', *Meanjin*, xv (1956), 304

[14] The *Age*, 19 January 1886; quoted by V. Spate, thesis cited

[15] R. H. CROLL, *Tom Roberts*, Melbourne, 1935, p. 340

[16] *Smike to Bulldog*, pp. 21, 23

[17] Streeton to Roberts, c. 1890; *Smike to Bulldog*, pp. 14-15

[18] HAVELOCK ELLIS, *My Life*, London, 1940, p. 139

[19] HAVELOCK ELLIS, *Kanga Creek*, Waltham St Lawrence, 1922, p. 53

[20] J. LE GAY BRERETON, *Landlopers*, Sydney, 1899, p. 25

[21] DE LIBRA (JAMES GREEN), 'The Poetry of our Painting', *Australasian Arts Review*, 1 September 1899, pp. 1, 2

[22] *The Verse of Christopher Brennan* (ed. A. R. Chisholm and J. J. Quinn), Sydney, 1960, p. 112

[23] SID LONG, 'The Trend of Australian Art Considered and Discussed', *Art and Architecture*, ii (1905), 8-10

[24] For several points made in this paragraph I am indebted to E. Thacker, Art Nouveau in Australia; B.A. Thesis, 1961, School of Fine Arts, University of Melbourne

[25] On Young *see also* J. F. BRUCE, *The Art of Blamire Young*, Sydney, 1921; MOORE, ii, 234, *passim*

[26] On McCubbin *see also The Work of Frederick McCubbin*, Melbourne, 1916; U. HOFF, 'The Phases of McCubbin's Art', *Meanjin*, xv (1956), 301-6; MOORE, various refs.; *CAO*, p. 137

[27] *See The Art of J. J. Hilder*, Sydney, 1918

[28] *See also Elioth Gruner* (Foreword by N. Lindsay), Sydney [n.d.]; *CAO*, pp. 79-80

[29] The literature on Norman Lindsay is extensive; two useful sources of biographical information are: *Norman Lindsay's Pen Drawings* (introd. by Lionel Lindsay), Sydney, 1931; *Norman Lindsay Water Colour Book* (with a biog. by Edmund Blunden), Sydney, 1939.

[30] AA, iii, 44 (1932), 19-20

[31] On Heysen *see* various references in *CAO*, pp. 90-1

[32] *See also* T. G. H. STREHLOW, *Rex Battarbee*, Sydney, 1956; C. P. MOUNTFORD, *The Art of Albert Namatjira*, Melbourne, 1944; and R. BATTARBEE, *Modern Australian Aboriginal Art*, Sydney, 1951

[33] I am indebted to Sylvia Lawson, who is preparing a biography of Archibald, for this point.

[34] Quoted by CROLL, pp. 40-1

[35] *op. cit.*, p. 63

[36] *op. cit.*, pp. 60-1

[37] Streeton to Roberts, 7 August 1902; quoted by CROLL, p. 203

[38] *Smike to Bulldog*, p. 137

78 CHARLES CONDER, *Cove on the Hawkesbury*,
panel, 14 x 8¼, *c.* 1888, Melbourne

EXODUS

1881 - 1919

His body dwells on Gander Flat,
His soul's in Italy.
VICTOR DALEY, *Correggio Jones*, 1898

ARTISTS as a distinct social group in the Australian community came into existence during the 1880s. Previously they had worked in isolation from one another and did not distinguish themselves in their manner of living and their social attitudes from the public in general. Indeed, artists like Conrad Martens, W. C. Piguenit, Robert Dowling and William Strutt were highly respected members of the colonial society, and helped to define rather than to criticize Victorian values in Australia. But as young men Roberts, Streeton and Conder, to name only three, differed considerably in their manner of living and personal values from the community at large. The camps established around Melbourne helped to underline this separation of the artist from the community. For the Heidelberg impressionists, as for their contemporaries in France and England, art became a way of life. If in such a painting as *Shearing the Rams* Roberts sought to hold up the mirror to Australian life, it must not be forgotten that he was also in one sense the Australian champion of *l'art pour l'art*.

The revolt of the artists was both timely and essential, for even the most intelligent and educated of the public looked upon art at best as little more than an elegant and polite accomplishment. When, in 1889, Conder's cousin and first love, Margaret Conder, described his art as his hobby, he gently reprimanded her:

. . . you must know that it is more than that, for a hobby is a fad which a man takes up probably to kill time. Unless it were more than a hobby to me I could never hope to do what I hope to. You are rather like my father in your way of looking at art—you don't feel it quite I fancy as many do—almost a religion it is to them and duffers like myself unless we regarded it as such would soon lose heart in it.[1]

Margaret Conder's attitude was one which generally confronted the local artist. It was criticized trenchantly by Sydney Dickinson in 1891:

In painting, as in other refinements, Australian opinion has not emerged from the embryonic condition wherein it is regarded as a light and graceful recreation which, when cultivated in a spirit of dilettantism, may evoke a languid interest, and give to ladies an opportunity to enjoy afternoon tea amongst attractive surroundings. Art for art's sake is an idea that finds little occasion for lodgement in the chinks of our busy day of money-getting; those who practise the cult are asked to amuse merely, and anyone who invades the sleepy circle of decorous self-satisfaction with an original idea, is viewed askance, and with the suspicion of lifted eyebrows. Such criticism as we have is judiciously tempered to these conditions. It babbles gently of commonplaces, and sets forth with an air of originality opinions which have begun long since to grow stale on the other side of the globe.[2]

The more serious artists sought to insulate themselves, so far as they could, from such philistinism. They rebelled against the conventional teaching of G. F. Folingsby at the National Gallery School; they foregathered in painting camps, in favourite pubs and cafes, like Fasoli's and the Maison Dorée in Lonsdale Street; and sought the company of writers, musicians and actors. During the 1880s, those who espoused the Bohemian life supported themselves more or less precariously in various ways. Some painted portraits, others provided drawings for the illustrated Press which flourished splendidly in those years, or were employed as lithographers, like Streeton, or as photographer's assistants, like Roberts. But with the onset of the economic crisis of 1893, the life of the Australian artist became increasingly precarious. 'There was a strange sense of unreality about the art life of those days', said Harry Weston. 'It was after the land boom had burst; and on the rare occasion you received a cheque, you rushed to the bank, feeling certain that it would be stopped. Living, however, was wonderfully cheap . . .'.[3]

The art life of Melbourne at this time has been described graphically by William Moore:

These bohemians were full of life and their ebullitions often startled the other customers. It was Ernest Moffitt who discovered Fasoli's in Lonsdale Street, whose interior had the rude simplicity of an old-time inn. The dinner, with wine *ad lib*, and *café noir*, cost a shilling. Work was difficult to get, and a frequent change of residence became a necessity. . . . Most of them had read about Bohemian life in Paris, and life's little difficulties never flurried them. The cares of the week were forgotten at the free and easies on Saturday nights, when enough was thrown into the hat to ensure an adequate supply of bread and cheese, and beer. At these functions they were joined by well-known musicians, journalists, and connoisseurs. . . .[4]

The Melbourne Bohemians foregathered in such clubs as the Cannibal Club and the Ishmael Club, both formed about 1893, the year of the collapse of the boom. The Cannibal Club was formed by a sociable and convivial spirit called Leon (Sonny) Pole, and included artists, poets and musicians. The

members of the club included Percy and Norman Lindsay, Max Meldrum, Will Dyson and Miles Evergood among the artists; Hugh McCrae, the poet; and Hermann Kühr, the Viennese French-horn player in the Marshall Hall orchestra.

The small Melbourne art market for original paintings barely survived the depression of the 1890s. As late as 1905 Moore wrote: 'The encouragement of art in Melbourne is practically non-existent'.[5] In the event, neglect was seen as an attribute of genius. Had not all the great artists starved in their day? Was it not true that a great artist was a man who could not sell his work during his lifetime? Therefore', said D. H. Souter, 'to accuse an artist of painting pictures which the public really buys during his lifetime, is to place an ineradicable blot upon his escutcheon'.[6] And Norman Lindsay has stated that during his early life he became so accustomed to the public not buying or even wanting to buy pictures, that it became very difficult to alter his original impression that the public was not interested in art.

It is not surprising that local indifference encouraged most artists with outstanding talent to leave the country for England and the Continent. There were only two chapters in the life of a Victorian artist according to Moore—'Genesis and Exodus'. 'No wonder there are so few of them left', he complained in 1905.[7] But the reasons for the wholesale departure of artists from Australia at the turn of the century springs, of course, from deeper reasons than public indifference.

The fact of the matter was that Paris and London were looked upon as the only cities in which an artist could hope to complete his professional training. To be exhibited upon the line at the Annual Exhibition of the Royal Academy, London, or to receive a *mention honorable* at the Old Salon (Société des Artistes Français) became the ambition of the art students of Melbourne and Sydney. This is not at all surprising, for the art world of Australia contained a large proportion of European-trained or European-born artists. The art schools were staffed almost entirely by teachers born and trained in Europe. Since its inception in 1870, the head of the Gallery School in Melbourne had received a continental training. Eugène von Guérard was trained at Düsseldorf; G. F. Folingsby, his successor, at Munich; and Lindsay Bernard Hall, who succeeded Folingsby in 1892, had been trained at the Royal College of Art, South Kensington, at Antwerp and at Munich, and was an original member of the New English Art Club, the society which pioneered the reception of impressionism in England. Phillips Fox, an Australian, and Tudor St George Tucker, an Englishman, had both studied at the Ecole des Beaux Arts prior to opening their own Melbourne Art School in 1893. In Sydney the New South Wales Academy of Art established an art school in 1875. Its instructors, Giulio Anivitti (1850-81), a painter and Achille Simonetti (1833-1900), a sculptor,

were both Italians trained in the Accademia di S. Luca, Rome. Lucien Henry became instructor at the Mechanics School of Art, Sydney, in 1881. He was a Provençal who had studied under Viollet-le-Duc and at the Beaux Arts. He was transported to New Caledonia for the active part he played in the Paris Commune and settled in Sydney following his release. Julian Ashton, who became instructor of the classes of the Art Society of New South Wales in 1892, and four years later established his own Sydney Art School, had been trained both in London and Paris. It was natural for such people to stress the importance of overseas study.

The emergence of the Australian school of painting is closely paralleled, therefore, during the 1880s by the movement of artists and art students to Europe in order to work and study. Most of them went, naturally enough, to Paris and London. It is true, of course, that isolated cases of students leaving Australia for study overseas do occur from the later 1850s onwards. The work overseas, for instance, of Adelaide Ironside and Robert Dowling, has already been discussed. But overseas training does not emerge as a persisting trend in Australian art until the 1880s. From that time forward it has continued to exercise a continuous influence upon the course of Australian art.

The artists who left Australia to study in Europe between 1880 and 1914 may be divided into two groups. There were, firstly, those who, like Roberts on his first sojourn overseas (1881-85), remained only a few years abroad and did not succeed in becoming known at all in French and English art circles during their stay. Secondly, there were those who, like Roberts on his second sojourn overseas (1903-19), remained long enough to attempt with greater or lesser success to identify their work and life with the art and life of France or England. The work of the first group, of course, lies entirely within the field of Australian art. But the work of the second group involves a problem both historical and psychological in its implications. For these people became *expatriate* artists. In their desire to find a place in the art world of Europe lay a respect for European tradition and a desire to measure themselves against the most widely accepted standards of the day.

Expatriation, however, involved a withdrawal from direct participation in Australian art and a break, more or less, with their Australian connections. But the break was rarely complete. For expatriate artists tend to return to the scenes of their childhood and adolescence either in the flesh or in the imagination. The break was not complete even in the case of Charles Conder, the one artist on record who, after beginning his career in Australia, succeeded in making a genuine contribution to European art, even though a minor one. Conder retained his connexions with his Australian friends, especially Roberts, intermittent though it was in his later years. But Aus-

tralia held him, as we shall see, in a more fundamental way. And it is precisely because the expatriate's break tends to remain a partial rather than a complete one that his work retains an importance for the art of his homeland. During the period between 1880 and 1914 (with which we are here directly concerned), expatriate artists maintained a connexion with Australia in various ways. Correspondence with artist friends remaining in Australia created a new and more personal channel by means of which knowledge of current developments in Europe became known to local art circles. Expatriates often sent work back for exhibition; some revisited Australia for short periods for the purpose of holding exhibitions of their work. Finally, most of them after remaining abroad for periods of between ten and forty-five years, returned to Australia permanently, where they exercised an effect upon local art which was often considerable, and was at times of decisive importance for the development of Australian art.

Of the more important artists who departed for Europe during the period between 1880 and 1900, Tom Roberts, C. Douglas Richardson and John Russell left in 1881, Bertram Mackennal, the sculptor, in 1883, Rupert Bunny in 1884, Phillips Fox and Walter Withers in 1887, John Longstaff in 1888, Charles Conder in 1890, James Quinn in 1893, George Coates in 1896, David Davies in 1897, Arthur Streeton in 1898, Hugh Ramsay, Max Meldrum and George Lambert in 1899. Already by 1895 the *Argus* in an editorial was beginning to criticize the practice of awarding overseas scholarships to the outstanding students of the National Gallery of Victoria. 'There can be no doubt that an Australian school is in process of birth. A certain indefinable something runs through the work of Messrs McCubbin and Streeton, Roberts, Withers and Paterson which marks them of the same class of inspiration . . .'. But, the editorial lamented, the Trustees (who awarded the scholarship), 'take away those who have shown their competency to join and lead this school and they send them to Paris to swell the ranks of a huge army who hope by tricks of technique or laborious skill to put new life into out-worn subjects. . . . Thus we observe that our own men who have never left us are each in their own individual manner recording their impressions of nature and humanity as they appear in Australia, while the men sent away . . . become stronger but less original; desert simplicity for mythology . . .'.[8] By 1900 the departure of artists from Australia was so frequent as to attract wide attention. It became a source of some resentment to artists and writers who either preferred to remain in Australia or could not afford to travel. In 'London Calls',[9] Victor Daley (the talented Irish-born poet and champion of national aspirations) criticized this wholesale desertion by painters (and writers) of their own country for what he considered to be nothing more than the flesh-pots of European culture:

> They leave us—artists, singers all—
> When London calls aloud,
> Commanding to her Festival
> The gifted crowd.

And in 'Correggio Jones',[10] another fine satirical poem, Daley created the comic figure of a potential expatriate painter:

> Correggio Jones an artist was
> Of pure Australian race,
> But native subjects scorned because
> They were too commonplace.

and ended his poem with an apt comment on Jones's distressing situation:

> He yet is painting at full bat—
> You'll say, if him you see,
> 'His body dwells on Gander Flat,
> His soul's in Italy.'

That was one way of viewing the situation. But it was not the only way. Australia, as we have already seen, was paying less attention to its artists than to its writers. For most Australians, art was a dubious luxury they could not afford. It was widely suspect as a form of cultivated affectation. The young Australian society of the 1890s was neither rich enough, nor populous enough, nor educated enough to support the fine arts. Closely associated with the desire to leave the country was the growing realization on the part of local artists that the very existence of art had always depended upon the existence of a privileged class. . . . you don't as a rule sell your pictures', remarked Tom Roberts, 'to people who rent cottages at seventeen-and-six a week'.[11] But the values of Australian society were determined largely by people who did. 'The rich an' educated', wrote Henry Lawson in 1893, 'shall be educated down'.[12] That was no programme for art or artists. It is not surprising that they left the country in large numbers.

A rich and educated Australian became our first important expatriate artist. He was John Russell, the friend and companion of Tom Roberts during his first visit to Europe. Russell, however, had nothing in common with the comic image which Victor Daley created in the person of Correggio Jones. Had Australian artists been able to follow the artistic interests of Russell they would have made contact with the Ecole de Paris half a century before they did, and the rich promise so evident in the early work of the Heidelberg School might have flowered magnificently. But as it happened, Russell died unknown in his own country.

Russell, who was born at Darlinghurst, Sydney, in 1858, was the son of John Russell and the grandson of Robert Russell, an ironmaster and engineer of Kirkaldy, Scotland, who had migrated to Hobart in 1832. The

business was later transferred to Sydney and carried on by his sons. It flourished for many years and built railways, bridges and ships, including gunboats for the Maori wars of the 1860s. As a young man, Russell discovered a passion for drawing while sailing in the Pacific where the family had many business interests. At the age of eighteen, he visited England to study engineering, and there his interest in art grew. Returning from England three years later on the death of his father, he set up a studio in Sydney and began to paint portraits. Realizing, however, that overseas study was essential, he set off for England in 1881, travelling, it is said, on the same boat as Tom Roberts. Russell settled in Paris and in 1886, seeking at this time to learn more about the methods of Puvis de Chavannes and Fernand Cormon, entered the latter's studio as a student. At the Atelier Cormon he met several brilliant young artists who were at that time engaged upon staging a full-scale revolt against the methods of their master and who were to play, in the years immediately following 1886, an important role in the creation of modern art.

There was Toulouse-Lautrec, the creator of the French *art nouveau* poster whose portrayals of the night-life of the Montmartre cafés are among the masterpieces of French post-impressionist painting; and there was Louis Anquetin, a tall, studious artist who was among the first followers of Seurat in his *pointilliste* experiments. Seurat was, at that time, developing a technique of painting by means of small dots juxtaposed upon the canvas in order to create a mixture of colour in the eye of the observer. This technique sought, by scientific means derived from colour theorists like Chevreul, to preserve the brilliant colours of nature by avoiding the mixture of colours upon the palette prior to painting. In 1886 Seurat was working on his masterpiece, *La Grande Jatte*. Anquetin began to champion *pointilliste* methods among the students at Cormon's, and Emile Bernard, the youngest student at the school but also one of the most brilliant, became his ardent disciple. Russell became a member of the Anquetin-Bernard set as did Vincent Van Gogh, who had also become a student at the school, on his brother Theo's advice, shortly after his arrival in Paris in February 1886.

Thus, in 1886, the year Tom Roberts and Frederick McCubbin were beginning their first essays in Australian impressionism at Box Hill, John Russell was establishing himself among the circle of Parisian painters who were pioneering the break from impressionism, and laying the foundations of modern art. He rented a studio for himself in the Impasse Hélène, in the Clichy quarter, which had become the centre of the *pointilliste* experiments. Cormon's was a select studio containing only thirty to thirty-five students, mostly French; American and English being rarely admitted. A. S. Hartrick, an English painter who gained entrance to Cormon's with Russell's help, describes him in 1886 as 'a big Australian who had become notable among

art students in Paris by his athletic prowess in a boxing circle he had formed'.[13]

Fernand Cormon was an academic history painter and was considered an arch-reactionary by the Anquetin-Bernard circle. He was strongly opposed to their experiments. Tension ran high, and when he attempted to dismiss Bernard for painting in the new manner pandemonium broke out in the school. Van Gogh went home to fetch his revolver, threatening to shoot Cormon. The master made off and the school was closed for several months.

About that time Russell met Mariana Antoinetta Matiocco, a young Italian whom Rodin claimed was the most beautiful woman in France. She read extracts from Dante's *Inferno* to him as she posed (1885) for his *Porte de l'Enfer*. Her face reappeared in his *La France* and his *Minerve sans Casque*. She also modelled for Fremiet's *Jeanne d'Arc*, now in the Place des Pyramides. Russell, later, married Mariana. Russell, himself, was at this time developing a select circle of friends among artists in Paris which included Fantin Latour; Guillaumin, the friend and pupil of Camille Pissarro; Paul Gauguin, whom Russell met shortly after Gauguin's return from Martinique in the winter of 1887; Alexander Reid, a Scottish painter greatly interested in the work of Monticelli; Dodge McKnight (*b.* 1860), an American painter; and Fabian de Castro (*b.* 1868), a Spanish painter.

Russell's friendship with Van Gogh lasted for several years. The Dutch painter was a frequent visitor to his studio in 1886 and about this time Russell painted the portrait of Van Gogh now in the Stedelijk Museum, Amsterdam; it was Van Gogh's favourite portrait of himself (79). Then in the winter of 1887 Russell left Paris for Sicily with his wife and baby son and painted landscapes there until the end of the spring. Van Gogh saw these paintings when Russell returned to Paris and they may have contributed to his own decision to leave for the south of France in 1888. Writing to Russell from Arles in the spring of 1888, he recalls them: 'I remain enraptured with the scenery here; am working at a series of blooming orchards. And unvoluntarily I thought often of you because you did the same in Sicily'.[14] He suggests that they exchange work—one of his Arles orchards for one of Russell's Sicilian studies, and continues:

You know I thought and think such a deal of those of yours I don't gainsay that your portraits are more serious and higher art but I think it meritory in you and a rare quality that together with a perfection as appeared to me the Fabian and McKnight portraits you are at the same time able to give a Scherzo the adagio con expressione the gay note in one word together with more manly conceptions of a higher order. And I so heartily hope that you will continue to give us simultanément both the grave and elaborate works and those aforesaid scherzos. Then let them say if they like that you are *not always* serious or that you *have* done work *of a lighter sort*—so much the worse for the critics and the better for you.[15]

This was praise indeed from a man like Van Gogh who always spoke his mind so frankly that he experienced the greatest difficulty in maintaining friendships. Russell agreed to send Van Gogh some of his Sicilian drawings and later received some of Van Gogh's finest Arlesian drawings, including *Le Zouave Milliet*, *Paysage d'Arles* and *Barques aux Saintes-Maries*.

Van Gogh, it is to be noted, wrote to Russell as a painter and as an equal giving full vent to his great enthusiasm for the paintings of Monticelli (gained in part from his conversations with Alexander Reid) and discussing the way in which the neo-impressionist techniques might be applied to paintings in the south.

Surely Monticelli gives us not neither pretends to give us local colour or even local truth. But gives us something passionate and eternal—the rich colour and rich sun of the glorious South in a true colourists way parralel [sic] with Delacroix' conception of the South viz. that the South he represented now by contraste simultané of colours and their derivations and harmonies and not by forms or lines in themselves as the ancient artists did. . . .

In another letter he again speaks of the paintings he is working on:

I have been to the seaside for a week and very likely am going thither again soon. Flat shore sands—fine figures there like Cimabue—straight stylish. Am working at a Sower. The great field *all violet*, the sky and sun very yellow, it is a hard subject to treat. Please remember me very kindly to Mrs Russell—and in thought I heartily shake hands.[16]

Shortly after his return from Sicily in 1887 Russell built a fine house at Belle Ile, Brittany, and, in the following years, he invited many of his artist friends there. It became known as the Englishman's castle. It was at Belle Ile that Russell met Claude Monet and a long friendship developed between the two men. It was while staying with Russell that Monet painted the portrait of Hippolyte Guillaume, who was a general handyman and model in the Russell household. Like Van Gogh, Monet had a high opinion of Russell's art, considering some of his landscapes superior to his own. Matisse met John Russell at Belle Ile in 1897. He was then a young artist still painting in a rather conventional manner in the studio of Gustave Moreau. According to his biographer, Alfred H. Barr, it was Matisse's two visits to Brittany in the summers of 1896 and 1897 which set him on the path towards becoming a leader of modern painting. While Matisse was in Brittany, Russell gave him two drawings by Van Gogh. 'His first acquisition of work', writes Barr, 'by a martyr of modern painting'.[17] It seems that Russell played a part in the growth of Matisse's appreciation of modern art. The Russells made many friends among some of the most famous artists of the day, including Sargent and Alfred Sisley, the impressionist. Rodin was also a great friend, and the sculptor held a high opinion of Russell's work.

79 JOHN RUSSELL, *Portrait of Van Gogh*, canvas,
23¾ x 17¾, *c.* 1886, Stedelijk Museum, Amsterdam

Although Russell numbered among his associates some of the most revo-
lutionary artists of France, his own work tended to combine an interest
in neo-impressionist techniques with the more traditional approach of a
portrait painter. This is especially true of his fine head of Van Gogh. Russell's
portrait of Dr William Maloney (86), with whom he toured Spain in 1883,
is dated 1887 and reveals the high palette and divisionist technique which
the students at Cormon's were then developing under the influence of
Anquetin and Bernard. It is, with its light pink and blue tones, a fine
sensitive portrait, vibrant with life and full of feeling.

Russell did not entirely lose contact with Australia. He continued, for
instance, to correspond with Roberts after the latter's return to Melbourne.
It would be interesting to know whether he ever mentioned the neo-
impressionist experiments at Cormon's in the years between 1886 and

1889 when the Heidelberg School was coming into existence. That he did indeed discuss painting techniques in his letters to Roberts is clearly suggested in a letter which Streeton wrote to Roberts in 1896. Streeton thanks Roberts for letting him read a letter from Russell, and continues: 'He seems to love the open air very much, and, therefore, must be a fine chap. . . . But he does seem to me to bother too much about the ways and means—really there's not time enough to do that'.[18] Streeton's distrust of theory is here apparent. That he did not employ divisionism in his own work may well have been due not so much to ignorance as to a dislike of methods based on theories. If, however, Streeton disliked the methods Russell had embraced, Russell disliked the lack of interest in art in Australia. 'J. P. Russell, my Australian friend in Paris, told me there was no appreciation of painting there', wrote Hartrick, 'for its inhabitants were at that stage of culture when thirty shillings would be considered a good price for a portrait; therefore he decided not to return to his native land, but abide in France'.[19]

There were doubtless other reasons why Russell remained in France. He had made many friends, he had married, and he possessed a private income of £3,000 a year. Hartrick tells us too that he had quarrelled with his people in Australia. Yet Russell maintained an interest in his own country. It is clear from his letters that he was contemplating the formation of a collection of contemporary painting to improve taste in Australia, and also advocated, later in life, the formation of a national museum. The idea was already present in his mind as early as 1890, for in January of that year Van Gogh wrote to him from the asylum of St Rémy: 'If ever you come to Paris take one of my canvases from my brother's place if you like, if you go on with the intention of making a collection one day for your country. You will remember that I have already told you that it is my ardent wish to give you one with this end in view'.[20] Russell also seems to have toyed with the idea of lecturing on modern art. But nothing came of these plans.

Russell's wife died before the First World War. He sold the house at Belle Ile, moved to Neuilly, and then to Portofino on the Italian Riviera. Later he moved to England. Then a return to Paris was followed by visits to the Côte d'Azur, Switzerland and Italy. At that time he made some experiments with cubist painting. Then, after the First World War, Russell returned to Australia to establish a home for his second wife, an American; and to settle another son by his first marriage on a farm in New Zealand. Finally, he bought a small house at Watson's Bay, Sydney, and lived there quietly until his death at the age of seventy-three in April 1930.[21]

John Russell was the first Australian expatriate artist to live in Paris, and his presence there formed a point of contact for other Australians coming over to study during the 1880s. One of the first to come was Bertram

Mackennal, who left Melbourne in 1883, two years after Roberts and
Russell, and he shared a studio in London with Roberts for a time while
attending the Royal Academy Schools. Mackennal appears to have become
a friend of Russell's even before his visit to Paris in 1884.

In 1888 John Longstaff and his young wife arrived in Paris, after he had
won the first travelling scholarship awarded by the National Gallery of
Victoria in 1887. Russell had been informed of their coming and booked
them in at the Hôtel de l'Univers et du Portugal in the Rue Croix des Petits
Champs. This hotel in the late 1880s became one of the small centres at
which Australian artists in Paris forgathered. A night or so after the Long-
staffs arrived in Paris, Russell had them to dinner with Rodin and his wife,
and it was arranged that Longstaff should enrol at Cormon's. There Longstaff
met Anquetin and Toulouse-Lautrec, as Russell had done before him. But
Longstaff, a conservative at heart and a man who surrendered rather quickly
to the chance of academic success, never allowed himself to become too
much involved in *avant-garde* experiments. He did, however, make some
experiments with impressionism. Not long after they had settled in Paris
an epidemic of black influenza broke out and Russell invited the Longstaffs
to stay with him at Belle Ile. There Longstaff was able to watch Russell
at work on his large impressionist paintings, and painted a number of land-
scapes in the impressionist manner himself (92). But the interest did not
last. At Belle Ile he painted a number of sunrise studies. On showing one
to student friends in Paris, they remarked, 'What a splendid sunset'. There-
upon he wrote to Russell: 'After this I paint any dawns I have to paint
comfortably at the end of the day instead of the beginning'.[22] He was,
however, keenly interested in the visual effects of moonlight (a Pre-
Raphaelite rather than an impressionist preoccupation). During his sum-
mer holiday at Yport on the Normandy coast in the year following the
Belle Ile visit he would rise at two in the morning to watch a late moon
rising; and upon one occasion he employed a fisherman to accompany him
in order to note the effect of moonlight upon flesh. The knowledge so gained
from these studies was used in painting his huge, melodramatic composition
The Sirens (80), which he exhibited with success at the Salon of 1892 and
the Royal Academy of 1893.

Despite the fact that this painting is a typical example of the pseudo-
classical manner favoured by French academic artists at that time, it also
reasserted those literary tendencies which Longstaff had first expressed
in his scholarship-winning picture, *Breaking the News* (Perth) of 1887.
Anecdotal, scrupulously faithful to detail in the manner of the Munich
school, which Longstaff had derived from his teacher, Folingsby, that paint-
ing revealed both his technical dexterity and artistic limitations. It gained
far greater popularity at its first showing than any of Roberts's or Mc-

80 JOHN LONGSTAFF, *The Sirens,*
canvas, 118⅜ x 82⅜, 1892, Melbourne

Cubbin's essays in Australian genre. That painting and *The Sirens* indicated
the direction Longstaff's career was to take. A gentle, uncomplicated man
with a sentimentally romantic nature and some talent for drawing, Long-
staff was, by all accounts, greatly handicapped by an extremely beautiful
but diffident wife whose personal values were even more banausic than
his own. In Paris she locked herself up in her hotel, refused to learn French,
or entertain Longstaff's student friends. In consequence she found the
French and French life most distasteful. After three years of it, Topsy (as
Longstaff called her), with one son and another on the way, left for home
with an aunt. Longstaff remained in Paris another three years and then
in 1894 moved to London. There he discarded the picturesque clothing of
the Paris art student, discovered a new interest in sartorial decorum, and
began to move in respectable circles. He became a friend of J. J. Shannon,
an American painter well known at the time for his portraits of fashionable
women. Sir Frederick Leighton, the President of the Royal Academy,
invited him to his studio; he became a friend of Frank Brangwyn; and the
Earl of Shaftesbury invited him to dinner. He was a frequent visitor at the
more informal gatherings at the home of Phil May (whom he had known

in Australia). There he met Melba and Tosti; and saw Isadora Duncan 'lolloping about in time to the music'.[23] He did a little teaching to sustain himself, but portrait commissions soon began to grow.

When Longstaff returned to Australia in 1894, Melbourne was in the depths of an economic depression. The times could not have been worse for an up-and-coming young painter of fashion. He was soon reduced to designing trade advertisements, and although one splendid whisky poster did call forth the praise of the Sydney *Bulletin*, that trenchant guardian of the Australian verities, he realized grimly that he should never have left Europe. Even in Australia, however, Longstaff's amiable personality and European training stood him in good stead. He had thoroughly mastered the faculty for catching a likeness fluently and investing it with a dignity or grace that delighted his sitters and often flattered them. So official portraits even in those penurious times were not long in coming his way. His important commissions of the period include: Sir Arthur Snowdon, the Lord Mayor of Melbourne; Sir Frederick Darley, the Chief Justice of New South Wales (1900), and Henry Lawson (81).

In 1886 William Gilbee, a prominent Melbourne surgeon, bequeathed £1,000 to the Trustees of the National Gallery of Victoria for a commission for an Australian history painting. By 1900 interest had accrued and the Trustees commissioned two paintings: one by E. Phillips Fox of *The Landing of Captain Cook*, and the other by Longstaff of the *Arrival of Burke, Wills and King at Cooper's Creek, Sunday Evening, 21st April, 1861* (82). A stipulation of the gift was that the work should be executed in England. With the assistance of an advance payment, therefore, Longstaff left for England in September 1901, taking his wife and fourth son with him. The painting, a huge and most melancholoy one, was completed and shipped out to Melbourne towards the end of 1907.

Longstaff's large paintings on Australian themes represent a curious survival into the twentieth century of that melancholy interpretation of Australian life and nature which we have already considered in discussing the work of Thomas Watling, Strutt and McCubbin. For Longstaff Australia was

81 JOHN LONGSTAFF, *Henry Lawson*, canvas, 35⅞ x 28¼, 1900, Sydney

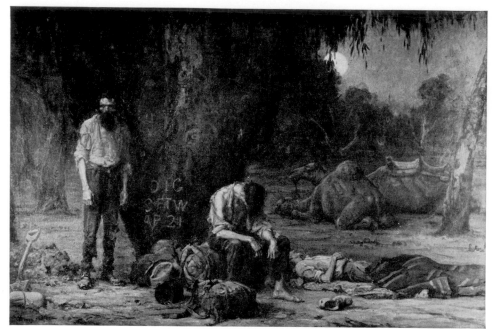

82 JOHN LONGSTAFF, *The Arrival of Burke, Wills and King
at the Deserted Camp at Cooper's Creek*, canvas, 111 x 169½,
1902-7, Melbourne

a land of flood, fire and famine, and he heightened his themes with melo-
drama. Yet they were always based in part upon personal experience. His
Breaking the News was based on a vivid childhood memory of a mining
disaster in his home town of Clunes; *Gippsland, Sunday Night, February
20th 1898* (Melbourne) was painted after a trip through the country which
the fires had devastated; *The Arrival of Burke, Wills and King at Cooper's
Creek* (1907) contained a landscape background based on sketches of desert
landscape around Port Augusta.

Longstaff did not take long to establish himself as a fashionable portrait
painter following his arrival in London in 1901. From the moment of his
arrival he never looked back. Shortly after landing in England, he had been
commissioned by the Imperial Colonial Club to paint portraits of the
Prince and Princess of Wales for their clubrooms. Then the young Lord
Beauchamp, freshly returned from his governorship of New South Wales
(1899-1901) commissioned a portrait of Edward VII for the National
Gallery of New South Wales, where he had acted for a short period as a
Trustee. The Trustees of the Gallery, on being informed of the gift
impending, resolved that a companion portrait of the Queen should be
commissioned. In consequence, through the good offices of Sir John See,
then the Premier of New South Wales, the 'Ladies of New South Wales'

humbly begged Queen Alexandra also to sit for Longstaff, and later paid for the portrait. In the event, however, Longstaff found that he was expected to paint the portraits almost entirely from photographs and other data. The King gave him an hour when the portrait was nearing completion; but he had to content himself with mental notes of the Queen's appearance while standing close to her during a court presentation.

It is not at all surprising that, in the circumstances under which they were painted, the two royal portraits are not to be numbered among the finest of Longstaff's work, or that now, suffering considerably from crackle and mould, they are rarely exhibited. Such commissions, however, helped to establish Longstaff quickly in London, and each year found him represented at the Academy. Some notable portraits of this period included: Sir Edmund Barton, the first Prime Minister of Australia; the Australian-born Countess of Darnley (1905); Mrs Breitmeyer, the wife of Louis Breitmeyer, the South African diamond merchant; Marjorie Williamson, a daughter of J. C. Williamson, the Australian theatrical impresario; Mrs Reginald Turner, Mrs Stewart Dawson, Miss Alice MacDonald, and the Countess of Eldon in her Coronation robes.

Longstaff possessed good looks, an easy and pleasant manner, and a punctilious regard for the social conventions of Edwardian England. 'Night after night', writes Nina Murdoch, his sympathetic biographer, 'he spent at dancing clubs, and week-end after week-end saw the successful portrait painter setting forth as one of a gay crowd bidden to one or another of England's country houses'.[24] In his seventies he declared himself that he had never known what it was to feel tired. By 1910 he had thoroughly established himself as a portrait painter of fashion with a large studio in St John's Wood which once belonged to R. W. MacBeth, R.A. In the following year he made a hurried trip to Australia to visit his ageing parents. The dutiful son of an affectionate mother, Longstaff had always written a weekly letter to her during his long years in Paris and London, outlining his experiences and successes. He returned to Melbourne on the *Grosser Kurfürst*, the Nord Deutscher Lloyd Company setting aside for him a five-berth cabin as a bedroom and an adjoining four-berth as a dressing room. On arriving in Melbourne he boarded the train for his parents' home at Shepparton to find, to his surprise—and doubtless to his delight—a cheering crowd awaiting him. The Shire President and Councillors made formal speeches of welcome, and the admiring crowd escorted him home, while the town band in front played 'See the Conquering Hero Comes'. They asked him if he felt glad to be home, to which he replied:

Am I glad to be home again? I cannot tell you how glad. The Australian landscape has always seemed to me the most beautiful in the world as well as the most mysterious. When I first saw the brown, hot earth from the ship's decks

at Fremantle I cannot tell you the emotion it gave me—after all that confounded sappy English green![25]

Unfortunately, however, he could not remain home for long. On arriving at Shepparton he found several important commissions awaiting him which he could not bring himself to reject. So, after a day or two with his parents, he was off to Sydney where, during the next two months he completed six portraits. By May he was on his way back to his family and the 'sappy English green'. Portrait commissions continued to flow steadily in England, too, and when the war came, Longstaff became an official War Artist with the A.I.F. in France.[26]

The third artist from Australia to study at the Atelier Cormon was Charles Conder, who arrived in Paris in August 1890. His uncle had agreed, shortly after the Exhibition of 9 × 5 Impressions, to allow him £120 a year in order to study abroad. Conder took a studio at 13 Rue Ravignan, a long low wooden building, high up in Montmartre above the Boulevard de Clichy. It was a centre of Bohemian life and housed many *avant-garde* artists and writers. Some years later Max Jacob christened it the Bateau Lavoir; and it was there that Picasso lived between 1904 and 1909 and executed some of his finest paintings.

Although it is not on record, it is almost certain that Conder knew Russell, who may have been responsible for his enrolment at Cormon's. Conder, however, also spent half his time working at the Académie Julian, where Julian Ashton had studied in the 1870s. Conder, tall and extremely handsome, like Russell himself, soon became a well-known figure in Montmartre. Louis Anquetin and Toulouse-Lautrec became his close friends and companions. Lautrec painted his portrait, and also included it in his painting of *Two Waltzers at the Moulin Rouge*.

Conder's work in France and England belongs to the art of the *fin de siècle* and does not need to be dealt with here. Yet the formative influence of his early years should be stressed.

Conder was a child of the British Empire. Born in London in 1868, he was the third son of a railway engineer who accepted a Government appointment in India two years after his son's birth. Conder's mother followed her husband to India but died when her son was five years of age. He was then sent back to England where he spent ten unhappy years attending, with his brother James, between 1874 and 1876, first a dame's school and then a boys' day school, and later, between 1877 and 1883, a boarding school at Eastbourne. Conder's relations with his father were not happy. He refused to become an engineer and was sent to Australia in 1884 to work under his uncle, William Jacomb Conder, an official in the Lands Department of New South Wales. Eight months in the Department's office was followed by two years (1884-85) in a Trigonometrical Survey

Camp. About 1887, apparently with the help of his uncle, he gained
employment as a lithographic apprentice with Gibbs Shallard, and became
an illustrator for their paper, the *Illustrated Sydney News*, to which he
contributed regular weekly drawings from April to October 1887. It was
not long afterwards that he met Roberts and joined the Heidelberg group.

In Australia Conder became an artist. In the survey camp he discovered
his passion for landscape painting, and about this time first fell in love—
with his cousin, Margaret Conder. The experience meant much to a
motherless and homeless youth, and his art became a kind of nostalgic
celebration of the transience of love. The *femme fatale* symbol, so much
a feature of his later work, was already present in his Australian drawings
and paintings. It was Roberts who introduced him to impressionism, and
Eaglemont which provided him with his first vision of Arcadia and of a life
dedicated to art. 'Give me', he wrote to Roberts later from Paris, 'one
summer again with yourself and Streeton—the same long evenings—
songs—dirty plates—and the last pink skies'.[27] It was in Australia that
he made his first contact with the aesthetic movement, decorating his
Melbourne studio with liberty silks and Madras muslins. And it was in
Australia, by all accounts, that he contracted the disease which slowly
killed him.

Australia fashioned the artist but it could not contain him, for Mont-
martre was his spiritual home. He was not, in his maturity, in the least
provincial like his friends, the Longstaffs. John Longstaff came to Paris to
learn how to become a successful painter; Conder came to learn how to
live. The Longstaffs, significantly enough, shortly after their arrival in Paris,
moved to a *ménage* in the Rue Notre Dame des Champs in Montparnasse,
at that time a quarter favoured by English and other foreign students,
quieter, more medieval and more academic than Bohemian Montmartre.
The difference in personality was reflected in different attitudes to art.
Longstaff was attracted to the more conservative art of the Old Salon,
Conder to the somewhat more experimental art of the New Salon. This is
revealed in Conder's letters to Tom Roberts, on 22 May 1891, for example,

Longstaff has a picture in the Old Salon and it seems popular with most of the
students at Cormons I think he may get a mention or medal on it—The Old
salon is most uninteresting I think and the New most charming I find so much
I like at the latter and the Whistlers—Puvis de Chavannes—Dagnans etc most
exciting and make one want to work.

Then, on Thursday 26 May, he continued, '. . . I am glad to say that
Longstaff has a mention . . . He was here yesterday and seemed very
pleased about it. Longstaff is a nice fellow and I'm glad of his success.
I feel little enough sympathy with him on art matters . . .'.[28]

83 FREDERICK McCUBBIN, *Golden Sunlight*,
canvas, 30 x 45½, 1914, Castlemaine Art Gallery

84 J. J. HILDER, *Landscape With Sheep*, water-
colour, 20½ x 17½, 1912, Sydney, bequest of
Dr and Mrs Sinclair Gillies

From Montmartre Conder moved, with the ease and grace natural to him, into English art circles and became, during the 1890s, one of the best-known artists of the *fin de siècle*. And as he became identified with the circle that included Aubrey Beardsley, Will Rothenstein, Oscar Wilde, James Pryde and William Nicholson, he became increasingly estranged from his Australian connections, and his contact with the colony of Australian artists in London grew more tenuous. The story told by William Moore is revealing. In 1905, at the suggestion of Tom Roberts, the Australian artists in London arranged an annual dinner at the Soho café *Au Petit Riche*, whose proprietor had once managed a café in Melbourne: 'One night Charles Conder appeared. He had been away from the group for some time and for some reason or other he was left alone. "Anyone going my way?" he asked as the party broke up. As no one moved, he went out alone'.[29] A complete and satisfactory explanation of the incident has never been given: but Conder had achieved fame by that time and with it, there need be little doubt, the jealousy of many of his former companions.

Australian artists yearned desperately for European recognition, but those who achieved it risked a double alienation: an alienation from those artists who had never succeeded in fleeing the country to work abroad, and made patriotism the virtue of their necessity; and an alienation from those who, having left their Australian *milieu* had never succeeded in arriving in any other, but remained exiles caught between two societies, cherishing a veneer of Australian anti-culture in Europe and a veneer of European culture in Australia. Conder was perhaps the first to be touched by such jealousies but others, returning to Australia after the First World War, Lambert, Longstaff, Bell, Quinn and Rupert Bunny, were to feel it, too—Bunny perhaps most of all. For Rupert Bunny lived for forty-seven years in France and became, like John Russell, to all intents and purposes, a French artist. Although his work was quite well known to Australian artists through works purchased by public galleries during his visits to Australia in 1911 and 1923, Bunny's work was not widely appreciated in Australia until a few years before his death.

Rupert Bunny (1864-1947), the son of a Victorian County Court judge, was born at St Kilda, Melbourne, and educated first at the Alma Road Grammar School, St Kilda, and later at Hutchins School, Hobart. Although he matriculated and enrolled at the University of Melbourne, he enrolled instead, in 1881, following what appears to have been a family dispute concerning his future career, in the School of Design, under O. R. Campbell, at the National Gallery, later joining the School of Painting under Folingsby in 1883. About a year later he travelled to Europe with his father and remained in England for eighteen months studying at Calderon's, St John's Wood, a preparatory school to the Royal Academy.

K

There he met Henry Tuke and T. C. Gotch who gave him letters to their former master, Jean-Paul Laurens. Bunny arrived in Paris in 1886 and studied under Laurens for two years. In 1888 he first exhibited with the Société des Artistes Français and, in 1890, became the first Australian to gain a *mention honorable*—for his *Tritons*.

During the early 1890s Bunny became associated with a group of English art students living in Paris. Among them were Alastair Cary-Elwes, a nephew of the Earl of Denbigh, a former Governor of South Australia; Douglas Robinson, a son of Sir William Robinson, who had given up the navy for art, and Harold Mostyn, the son of a Welsh baronet. At this time his work was still dark in tone, romantic in feeling, somewhat histrionic in gesture. His *Avant L'Orage* (1894) marked the beginning of a change; paint was used more heavily and there was a stronger feeling for volume. But allegorical themes persisted.

Between 1890 and 1910 Bunny made frequent trips to England and exhibited at the Royal Academy regularly. But following his marriage in 1902 to Jeanne Morel, the daughter of a French army colonel, his associations with French art and life deepened. His work became known: Gustave Geffroy, one of the most influential critics in Paris, held a high opinion of Bunny's decorative art. He became a member of the New Salon, the Autumn Salon, and the International Society of Sculptors, Painters and Gravers. The French Government purchased three of his works for the Luxembourg. Nine others were purchased for the French provincial collections. When he visited Australia in 1911 at the age of forty-seven he was at the height of his fame: the Felton Bequest purchased *Endormies*, and the Sydney Gallery bought his large *Summer Morning*. In the same year he exhibited work in the International Exhibition, Rome, and at the Carnegie Institute, Pittsburgh.

Bunny was a talented and sensitive exponent of the more conservative side of French painting at the turn of the century. Early in life he acquired the painterly methods of French realism as modified and developed by the *plein-air* painters. But his temperament, quiet, sensitive and restrained, was predisposed towards idealism. Not surprisingly, his early work contains a strong literary element drawn from classical literature and the Bible. There is evidence of Pre-Raphaelite influence in his earliest works, but more important was the example of artists like Arnold Böcklin, whose landscapes abound with symbols personifying the elements of nature. Bunny arrived as a student in Paris when the influence of Puvis de Chavannes was already at its height, and from his work learnt how to organize large compositions and simplify his forms. Doubtless it was Chavannes, too, who led him away from chiaroscuro and realism towards a more primitivistic, decorative style depending upon bright, flat, dry surfaces and simplified, monumental forms,

often drawn directly from classical
models. But Bunny, throughout his
life, drew upon varied sources. Al-
though deeply responsive to the
past he was tolerant of modern in-
novation when not pressed to excess
and extravagance. For a time *art
nouveau* strongly affected his work:
as in his fine *Rape of Persephone*
(93) with its vigorous rhythmical
conception, its highly-keyed colour,
and freely-flowing forms. Impres-
sionism, *Japonisme* and Gauguin
were among the contemporary
sources of his style; but it is clear
that he also learned much from
Delacroix, Rubens and Veronese.

No Australian artist ever painted
women more perceptively than
Bunny. There was something in
his gentle nature that led him to
idealize feminine grace and charm
with a becalming innocence of
mind. Among his most representa-

85 RUPERT BUNNY, *Returning from
the Garden,* pulpboard, 36½ x 25¾,
1906, Sydney

tive works are those conversation and genre studies of women talking
intimately among themselves, returning with flowers from the garden
(85), enjoying a walk, musing over tea (97) or upon a park bench.
In such paintings his rococo love of texture and light, his sensitivity and
good taste, are beautifully realized. Bunny indeed belongs in spirit, like
Pierre Bonnard (1867-1947), his greater French contemporary, to the
Indian summer of nineteenth-century naturalism—an *intimiste* and idealist
still in love with surfaces and the appearance of things. The First World
War ended his world. Tolerant though he was of modern painting, the
post-Cézanne experiments quite clearly meant little to him personally. His
late landscapes of southern France and the Pyrenees, for all their formal
simplicity and sensitivity of touch and colour, are remembrances of times
past. Many were painted after his return to Australia, following the death
of his wife in 1933, during the depths of the economic depression. He took
a flat in South Yarra and lived frugally and very much to himself, com-
posing music and spurning publicity, until his death at the age of eighty-
two in 1946. A few months before his death Sir Daryl Lindsay arranged
a retrospective exhibition of his work, at the National Gallery of Victoria,

which revealed for the first time to Australians the range and variety of his work. It was this exhibition and the smaller shows held at the Macquarie Galleries, Sydney, during the last decade of the artist's life, and later, that re-established Bunny's Australian reputation. Since his death his work has been held in the highest regard, and rightly so, some critics, Paul Haefliger and Clive Turnbull, for example, considering him the finest of all Australian painters.

Yet, in a very real sense Bunny, apart from the accident of his birth, was barely an Australian painter at all. He was, with John Russell and Emanuel Phillips Fox, one of the three Australian expatriates who assimilated the French tradition thoroughly and gained a modest reputation abroad. His work lies outside the development of Australian art much more completely, for example, than the work of Charles Conder. Bunny proved that the gulf could be bridged: that an Australian art student could become a French artist. But returning to his own country, like Russell, at the end of his life, he found himself an outsider, largely ignored by local artists and critics. In the end he was accepted by the champions of the modern movement as a kind of father-figure.[30] It was, indeed, not Rupert Bunny or John Russell, but the men who did not succeed in thoroughly establishing themselves as artists in Europe: Streeton, Lambert, Norman Lindsay and George Bell, who were, each in his own way, to influence the course of art in Australia in the years between the wars.

The work of Emanuel Phillips Fox (1865-1915) forms a natural comparison with that of Rupert Bunny, for he spent a good deal of his life in France and was attracted to subject pictures of an *intimiste* character; paintings with domestic and garden settings featuring people enjoying themselves, entertaining and relaxing. Fox, however, avoided the classicism, allegory and literary overtones so often to be found in Bunny's work, keeping more closely to impressionist subjects, and devoting himself single-mindedly to the painting of light and colour. Although, like all the Australian painters of his generation, apart from Russell, he refused to involve himself in experiments with broken colour and *pointillisme*, he is the Australian artist who in his best work came closest to the impressionist love of sunlight, colour and the good life. In such a painting as *The Art Students* (96), Fox reveals himself as one of the most sensitive, subtle and natural colourists in the whole field of Australian painting. The composition is splendid, the colour painted with feeling and superbly related to atmospheric and tonal values. But Fox was unequal. At times the clarity of his vision and his sensitivity failed and he produced paintings sentimental and somewhat vulgar in their claim upon popular appeal. Yet Fox's work, at its best, is more crisp, more sentient, more alive with light and colour than Bunny's, upon whom the academic manner often rests heavily.

86 JOHN RUSSELL, *Portrait of Dr Maloney*, canvas, 18½ x 13½,
1887, Melbourne

Phillips Fox was the son of Alexander Fox, a Melbourne photographer. He studied art first under O. R. Campbell and G. F. Folingsby at the Gallery School, and in 1886 went to Paris to study at Julian's, the Beaux Arts under Gérôme, and with Thomas Harrison. He first exhibited at the Old Salon in 1890, the year in which he returned to Melbourne, where he held a one-man show in December 1892. In the year following he formed the Melbourne Art School with his friend, Tudor St George Tucker, where *plein-air* and impressionist methods of painting were taught. A summer school section was conducted at 'Charterisville'. In 1901 Fox shared the Gilbee Bequest with Sir John Longstaff and repaired to England, according to the conditions of the will, to paint his history painting, *The Landing of Captain Cook*. In 1905 he married Ethel Carrick, a former Slade student, and settled in Paris where in 1908 he became an associate, and in 1910 a member of the Société Nationale des Beaux Arts. In 1912 he became a member of the International Society of Painters, Sculptors and Gravers, and travelled in Spain and Algeria. Fox visited Melbourne in 1908 and held a one-man show at the Guildhall. He came out again in 1913 and held successful shows in Melbourne and Sydney. The colourful paintings of the south of France which he exhibited on that occasion were well received by young art students, like Roland Wakelin, then becoming interested in the modern movement. The outbreak of the First World War found Fox in Tahiti still in search of sunshine and colour. He returned to Australia in 1915 to organize an art union for the Red Cross, but died on 8 October of that year.[31]

Streeton arrived in London in 1898 and remained for eight years that were the most difficult of his life. The Australian students who had preceded him to Europe, Roberts, Russell, Bunny, Fox, Mackennal and Conder, to name the more prominent, came as young men. They enjoyed the *camaraderie* of the art schools and gained lifelong friends. Furthermore, they were sustained during their early years abroad by scholarships or remittances from Australia. But Streeton arrived in London not as an art student but as a man with a colonial reputation. For much of the time he worked in loneliness and isolation. He had come without introductions, and, as he remarked ruefully to Roberts in a letter written from Hampstead three years after his arrival, 'K [i.e. Conder] was right when he said a long time back that you *must* have friends in London. I came without a letter and I knew only two men—Mackennal and Minns'.[32]

Shortly after his arrival he visited the Royal Academy of 1898 which had rejected one of his paintings, and continued to do so, with a single exception, during the eight years of his first sojourn in England. He found himself admiring the Sargent portraits, 'quite as fine as the great Rembrandt',[33] and the work of Greiffenhagen, Brangwyn and G. F. Watts. The atmosphere of

the Academy was, he felt, commercial rather than artistic, and he preferred the International Exhibition at Knightsbridge which included work by Rodin, Whistler, Conder, Rothenstein, Beardsley and Charles Keene. The distinctly romantic nature of Streeton's interests, discernible since the Heidelberg days, revealed itself sharply in London. Constable, Turner, Titian and G. F. Watts were the masters which excited him most. In his Chelsea studio it was Chatterton, the Lake Poets and the Brontës which he read. In 1902 he went to the Wye Valley to paint Chepstow Castle. Compared with Russell, Conder and Bunny there was something quaintly old-fashioned about Streeton's taste. Like Longstaff he possessed a simple transparency of mind, yearned for public success, and was cast down by indifference and loneliness. Certainly there was a lyrical impulse in Streeton's romanticism, but he was not at all drawn, either by curiosity or temperament, to the darker and tragic aspects of romanticism. It was a sweet vision of youth and happiness at Eaglemont which he recalled again and again throughout his life. 'Innocent Streeton' was Conder's description of him. And Streeton in turn, writing to Roberts, said of Conder, 'For me he's not healthy, tho' I like him very much as of old, and his work. He's a fine artist'.[34] Streeton's imagination, in short, did not contain the density and intelligence of Conder's. His rugged determination to show that he could equal the English landscape painters on their own ground reveals his naïvety about the nature of artistic success. In a letter to Roberts he said:

I heard lately that the boss of the New English (Steer, who is always amiable when I meet him) does not like my work: well I'm competing with him. I've been down this summer painting his favourite subject and painting it in my own way, and I begin to feel I'm all right. They'll have to accept me yet.[35]

But neither the New English Art Club nor the English art world as a whole ever accepted Streeton. His letters from London frequently reveal the poverty and isolation of his situation. He wrote, for example, in 1901:

I tried the R.A., New English, and International—with the usual result. I don't mind being hard up for years to come, save for the cursed waste of opportunity. These are my most precious years, and all last winter, spring and summer I was confined here—no coin for models. Just doing my best and hoping for the future, and eating my heart out to think of the sweet passing summer and the hills in the country.[36]

English criticism need not be blamed for its neglect of Streeton. All the best that he ever painted and wrote reveals how greatly he depended upon the Australian landscape for his inspiration. During his London years he sought to emulate Constable, Sargent and Steer to little purpose. The great landscape painters were not tourists in search of culture but men with a deep sense of intimacy with the scenes they painted; and there was little

intimacy between Streeton and the English landscape. It is clear from his letters, too, that he was thoroughly homesick. Sensing his misery Roberts, in 1902, sent him some gum leaves to burn in his grate, and Streeton wrote a little later:

Lord, how far back it all seems, yet how clear—every detail and trifle ingrained in my brain for life—the Houstons, the creek, the horehound patch, the black wattle, the messmate, the long open space up to the road, the hurrying up the hill on Sunday evenings with Prof. well to the fore: Heidelberg, the she-oak and sienna dust over all; the straw brown hills; pale Dandenongs; the Old England; College tennis; pines and coppery light; hazels, japonica; Impressionist Exhibition; gorse up the drive; girls; the picnics in the twilight and all the loveliness—all a dream![37]

But by that time Streeton was far from being the only artist in Chelsea with nostalgic memories of Australia. 'They all seem to be here', he wrote, 'Mackennal, Longstaff, Mahony, Fullwood, Spence, Norman, Minns, Fox, Tudor St George Tucker, Quinn, Coates, Bunny, Altson, K., Sonny Pole'.[38] Indeed, by 1902, the exodus to Europe was at full flood. It was in the Chelsea Arts Club that the Heidelberg School established its last and least distinguished camp.

In 1906 Streeton heard that his *Australian December*, which he had painted in 1887 and sold for £8, had exchanged hands for £75. Deciding that an exhibition in Australia would be timely, he gathered a collection of his paintings and arrived in Melbourne in December. With the help of his friend, Professor Baldwin Spencer, he put on a most successful one-man show at the Guildhall, Melbourne, in April 1907, following it with a show in Sydney, and a third in Melbourne shortly after. But he had no intention of remaining. A letter which he wrote to Roberts from Sydney on 5 October 1907, shortly before he returned to England, reveals his state of mind very clearly at the time:

The harbour and the long promontories look as glorious as ever, and I wish I could settle among it all. But I must get back. What is there for one here? I could paint a couple of years free and then be condemned to get half-a-dozen pupils at two or three guineas a quarter, as all the other chaps here do; and then if I got to London again, I'd have to serve *another* apprenticeship before I got into the shows there.[39]

Tom Roberts had arrived in England with his wife and son in March 1903, the task of completing his picture of the Opening of the first Commonwealth Parliament before him. He was provided with a studio at the Imperial Institute and completed the painting in November. The work had given him, he informed his friend, Alfred Deakin, 'a very happy time . . . and for the first time no anxiety about money'.[40] After completing 'the Big Picture', Roberts entered a difficult phase of his life which his son, Caleb,

has called his *black* period. He was uncertain as to the direction his art should follow; he suffered from gout and inflammation of the eyes; the Academy constantly rejected his paintings for four years; and he fared little better at the hands of the selection committees of the New English and other art societies. Roberts suspected that the Royal prerogative which had ensured the exhibition of the big picture at the Academy of 1904 would not endear him to the Academicians. '. . . they can't biff your painter in this effort though doubtless they'll be very careful to do it in others',[41] he prophesied to Deakin at the time. Nor did commissions flow from his contact with 'the great ones of the earth' as Mr N. Graves B. Jefferson had so cheerfully imagined. But in Roberts there was no bitterness and he remained throughout his life as equally loyal to his birthplace as to his adopted country:

England does not really *want* anybody; she has everybody and everything. The supply is in excess of the demand. She has the world to draw upon, and everyone comes here sooner or later. The only thing is to make her want you, and that is difficult, for she only really wants the exceptional in any line.[42]

With this realistic appraisal of the situation in mind he set himself to win a small place in the art world of England for himself.

It was a most modest place that he did win, but it was not failure. For Roberts, as for Streeton, however, the first five years were bleak and difficult. 'The Big Picture' completed, he took a studio first in Warwick Square, then in Harrington Road, South Kensington, while the family lived in a flat in Putney. The summers of 1905 and 1906 were spent in Holland, and of 1907 and 1908 in Mundesley, Norfolk. During that time he felt, knowing that recognition came late in England, that he had arrived ten years too late to gain it. The family was sustained very largely at this time through the efforts of Roberts's wife, who attended L.C.C. classes and became a skilled carver and gilder of frames.

Roberts, however, was not the kind of person to suffer isolation for long. Warm-hearted and sociable, he made friends wherever he went, and his house was open both to his English and Australian artist friends. He became a centre for the Australian artist community in London, which by 1903 was quite a considerable one; was responsible in 1905 for the establishment of an annual dinner among them (gum leaves were set alight with much ceremony at table in a censer); and was the originator of the large reception which Australian artists gave to the Australian and New Zealand Imperial Conference of 1911. He was also a very active member of the Chelsea Arts Club.

With his *Mundesley Barn* of 1908, Roberts appears to have emerged from a period of indecision. He had been more alive than Streeton to the dangers

of experimenting promiscuously with a diversity of styles. 'I'll have to stand very firm and be sure', he wrote to Deakin in August 1904, but referred more than once in the years that followed to the need for a 'new departure'.[43] In this search he was helped by his Australian friends, the portrait painters George Coates and James Quinn. He adopted a restricted palette, making much use of muted tones and subtle greys.

In 1910 Roberts moved with his family to Golders Green and entered upon a period of painting which gave him considerable satisfaction. In the summer of 1913 he worked in Italy and held a one-man show in Walker's Galleries, in February 1914, of paintings done in the neighbour-hood of Lake Como and the Splügen Pass. Criticism was, in general, favourable, the *Observer* noting the 'unity of vision, tact in selection, and a certain tenderness, not untinged with melancholy'.[44] Roberts returned to Italy the following summer and was there when war was declared. Back in England, he joined the R.A.M.C. in company with twenty-four other members of the Chelsea Arts Club and was posted to the Third London Hospital, Wandsworth, where he worked with a number of Australian artists including Streeton, George Coates, Miles Evergood, and A. H. Fullwood and the companion of his youth on the Spanish walking tour, Dr William Maloney.

George Lambert, who left Australia to study in Europe in 1900 and returned twenty-one years later, was one of the most talented of the Edwardian expatriates. Lambert's early years were in many ways like those of Charles Conder. Conder was the son of an English engineer employed upon the construction of railways in India; Lambert the son of an American engineer employed upon railway construction in Russia. Lambert spent his early years in Russia and Germany; Conder his first years in India. Conder's mother died when he was five; Lambert's father three months before he was born. Both of them were educated in England; both came to Australia in their youth; Conder at the age of sixteen, Lambert at the age of fourteen. Conder spent two years in the bush on a trigonometrical survey; Lambert spent his early years on his maternal granduncle's pro-perty at Eurobla, near Nevertire, New South Wales, where, as a station-hand, he was involved in post and rail fencing, branding and dipping sheep, horsebreaking and droving. Both Lambert and Conder developed their early passion for drawing and painting during their years in the bush, and both were drawn to Sydney in the hope of becoming professional artists with the Sydney illustrated Press. Conder became an illustrator on the *Illustrated Sydney News*, Lambert a regular contributor (of humorous illustrations of bush types and bush life) to the Sydney *Bulletin*.

Physically, too, they had much in common. They were both big men, and both, in their own ways, extremely handsome. But there the similarities

87 GEORGE LAMBERT, *A Bush Idyll,* oil on canvas,
19 x 30⅞, 1896, Sydney

ended. For their temperaments and early emotional experiences were quite different. The motherless Conder grew up to detest a father who had little affection for him and resisted his desire to become an artist, to resist also his father's profession as he experienced it in the rough masculine life of the survey camp. The fatherless Lambert, though always an affectionate son to his widowed mother, was drawn in a family of women (he had three elder sisters) to his maternal grandfather, the only male in the English household. Conder became the ladies' man, indolent, dreamy, highly sensitive and poetic, adding to good looks a charm and graciousness of manner irresistible to women. It was a prodigious indulgence in women and alcohol that destroyed his powerful, athletic constitution and finally killed him at the comparatively youthful age of forty-one. Lambert was the man's man, observant, energetic, realistic in all he undertook, attractive to women by the magnetism of his personality—a 'job-lot Apollo' one of his friends called him—but essentially a talented craftsman who gave his greatest love to his work and his horses.

Lambert's early work belongs to the *Bulletin* school of graphic draughtsmanship, with its incisive line and topical comment. His first oil painting of any consequence, *A Bush Idyll* (87), is painted with that loose breadth and informality of composition to which the *plein-air* manner of Julian Ashton gave currency among Sydney painters, but its muted grey-blue tones still owe much to the wash-drawing techniques favoured by the *Bulletin* school. In this regard the painting may be compared with the illustrations Lambert made for A. G. Stephens's edition of Barcroft Boake's *Where the Dead Men Lie* (1897).

A Bush Idyll was purchased by the Sydney Gallery from the 1896 Exhibition of the Society of Artists. The unexpected tribute encouraged

88 GEORGE LAMBERT, *Across the Black Soil Plains*, canvas,
35¼ x 120¼, 1899, Sydney

Lambert to exchange station work for employment as a grocer's clerk in the city, a position which enabled him to take the evening classes at Julian Ashton's studio. Soon, however, he was able to support himself entirely by means of his graphic work and become a day student. While with Ashton he painted *Across the Black Soil Plains* (88), a large picture in the manner of Roberts's heroic paintings of pastoral life. The dependence upon tone rather than colour reveals the continued influence of his wash-drawing work, and the lowness of tone that interest in *dark* painting then current both in Sydney and Melbourne. The broad and rather decorative treatment of the landscape contains an element of *art nouveau* that Lambert may well have gained from Ashton's other outstanding pupil, Sydney Long. The subject painting, *Youth and the River* (1900), painted for the Travelling Scholarship (first awarded in that year by the Society of Artists) is, with its strongly allegorical note, even more closely related to Long. Here a nude youth and girl are both mounted upon horses which are stepping into a dark river from which dim faces threaten and black swans glide, all quite in the manner of the *art nouveau* allegories of the time.

Lambert won the scholarship, befriended Hugh Ramsay on the voyage over and studied in Paris with him, first at Colarossi's and then at the Atelier Delécluse. He had married shortly before leaving Australia and both he and his wife settled in the Latin Quarter quite near a studio shared by the three Australians, Ambrose Patterson, J. S. MacDonald, and their friend, Ramsay.

During those early years abroad, Lambert's work was influenced by Ramsay's painterly style. Both of them painted *dark* in the current manner and came under the spell of Velasquez, at that time the idol of the studios. Lambert's *Equestrian Group* (89), in his Velasquez manner, is one of the most distinguished and painterly of all his compositions. His son, Maurice, has been posed in a manner reminiscent of Don Balthasar Carlos. *The Three Kimonos* (Sydney), painted a few years before, and shortly after the family left Paris and settled in Chelsea, added a touch of *Japonisme* to

89 GEORGE LAMBERT, *Equestrian Group*, canvas,
50¼ x 40, 1905, Sydney, gift of the artist, diploma
picture Society of Artists Travelling Scholarship

the interest in Velasquez. Lambert was an assiduous worker with a superb
sense of devotion to his craft, and sought to learn from the masters. In
The Bathers (90), for example, the influence of Rubens is also present,
and he himself confessed his deep interest in the work of Botticelli, Gior-
gione, Veronese, Van Dyck and, of course, Velasquez. Among the moderns
Puvis de Chavannes, Manet, Sargent and Orpen attracted him. The
influence of Augustus John, too, is often apparent, as in *The Belle of the
Alley* (Sydney). In the years immediately before, during and after the
First World War a light-toned, crisp and drier style owing much to the
influence of Orpen began to dominate his work. The painterly style of his
Velasquez phase was discarded for a linear style of wit and the studied
gesture. It was this style which he brought back to Australia when he
returned in 1921.

During the early war years Lambert was engaged upon a Home Office project felling timber in Wales, but in December 1917 he accepted a commission which required him to make sketches and drawings which were to serve as visual records of the part played by the Australian Light Horse in the Palestine campaign. He was also asked to paint a large battle piece of the Charge of the Australian Light Horse at Beersheba. This led to an association with Australian War Records which resulted in a very large number of drawings of the Eastern campaigns, many portraits of high-ranking military officers, and three large battle pieces, *The Landing at Gallipoli* (91), *The Charge of the Light Horse at Beersheba* and *The Surrender of Kazimain*. Most of his work for War Records is now gathered together at the Australian War Memorial, Canberra.

His war paintings called forth the best in Lambert. Essentially a man of action and a skilled horseman, he saw the Palestine campaign as a daring and perilous adventure, just as the young troopers of the Australian Light Horse must have seen it. The very first officer he reported to when calling at the base camp at Moascar in Egypt, upon taking up his duties, was none other than Major 'Banjo' Paterson. Truly, it must have seemed as though Clancy himself had brought his horse all the way from the Overflow to drive the infidel out of the Holy Places. But on this occasion there were to be no histrionics, though the flamboyant gesture was by no means uncom-

90 GEORGE LAMBERT, *The Bathers*, canvas, 36½ x 32, 1907, Adelaide

91 GEORGE LAMBERT, *Anzac—The Landing*, canvas, 78 x 145,
1920-22, Australian War Memorial, Canberra

mon either to Lambert's art or his personality. It was not his business to
allot praise or blame, depict the heroics or the tragedy of war. He had been
given the task of topographer, one of the most ancient of all commissions,
and he discharged it well.

His drawings possess the impersonality and brevity of a good military
dispatch. In his large battle pieces he depicts the forms of men and horses
in action, and the ground across which they fought and died, with an
unswerving grip upon reality. He saw a battle like a general, not like a
philosopher or a moralist, and that was what he had been called to do.
The dispassion and craftsmanship of such art is deprecated today by some
critics for whom art can never be more than the expression of personal
attitudes and private feelings. They forget that the artist still owes a duty
to the tribe. Lambert was called upon to preserve memories and record
events precious to the history of the nation. His own comments would have
been an impertinence. He had the good sense not to provide them.[45]

In 1892 Lindsay Bernard Hall (1859-1935) became the Director of the
National Gallery of Victoria and Head of its School. Although himself an
artist of no great merit he came to exercise during his long years of office,
both through his own teaching and through his students, an influence
second to none in the history of Australian art.

Born at Liverpool in 1859, Hall took up his post at the age of thirty-
three. He had studied at the Royal College of Art, South Kensington, and
later at Antwerp and Munich. A foundation member of the New English
Art Club (formed in 1886 as a challenge to the Royal Academy), he
brought to Melbourne that great enthusiasm for 'values' and the art of

92 JOHN LONGSTAFF, *The Cabbage Plot*, canvas, 10 x 17½,
1890, Castlemaine Art Gallery

93 RUPERT BUNNY, *The Rape of Persephone*, canvas, 21 x 31½,
1925, Mr Brian Johnstone

Velasquez shared by the New English Art Club's early members. Hall was an earnest, meticulous and methodical man, respected rather than loved by his pupils. Under him the Melbourne Gallery School became highly efficient in the training of portrait painters skilled in the art of illusionism. The programme left little place for the arts of design and colour nor were students encouraged to exercise their imagination or express their personality. The programme had its advantages and its weaknesses. It produced a generation of highly competent portrait and figure painters with narrow sympathies and a great distrust of the intellect and imagination. In a country whose citizens have always feared beauty and men highly endowed with creative gifts more than they fear God, portrait painters who could produce a good likeness have provided a welcome substitute for creative artists, so often eccentric and unpredictable in their productions. Bernard Hall's students, in short, and the students of his students, to the third and fourth generation, became an orthodoxy which closed its ranks firmly against experiment and innovation. Hall did his best work as a teacher during the first ten years of his life at a time when an appreciation of the methods of Velasquez, Manet and Whistler could still arouse in students a genuine sense of visual discovery.[46] During those ten years he produced his most able students: James Quinn, a sensitive portrait painter with a complete command of his craft whose achievement has not yet been fully recognized; Hugh Ramsay, the highly-talented young Scot; Max Meldrum, the teacher and theorist by whose influence tonal realism was transmitted deep into the twentieth century; and George Bell, whose classical instinct alone among all of Australia's tonal painters led him to Cézanne and, late in his life, to the leadership of the modern movement in this country.

James Quinn was awarded the Travelling Scholarship a year after Hall's arrival. In Paris he studied at Julian's and the Beaux Arts, married a French art student and remained in Paris for nine years before setting up in London as a portrait painter. Quinn, fortunately, had completed the greater part of his training before Hall arrived in Melbourne, and thus escaped a thorough grounding in Hall's muddy palette. He developed a technique which influenced the later manner of Tom Roberts—a richly colourful style in which greys were skilfully deployed. His *Portrait of a Young Girl* (1915, Melbourne) is a masterly example of his subdued yet sensitive manner. Quinn received a greater measure of recognition as a portrait painter in London than most of the Australian Edwardian expatriates, and did not return to Melbourne until 1936.[47]

Bernard Hall's most talented student, however, was Hugh Ramsay (1877-1906), a boy from Glasgow who studied at the School from 1895 to 1899 and then proceeded to Paris at Longstaff's suggestion and joined

Colarossi's studio. He spent much time in the Louvre studying the old masters and copying Velasquez but contracted tuberculosis in his Paris lodgings and was compelled to return to Australia in 1902. Back in Melbourne he continued to paint with great energy, feeling and versatility until his death at the age of twenty-nine in 1906.

Ramsay attained a mastery of values and a tonal technique unequalled by any Australian of his generation. But his work, despite its great technical virtuosity, remained that of an unusually gifted student. There was still much of the art school about his carefully arranged compositions with their studied posing, lighting and dress, nor had he emancipated himself entirely from the powerful influence of his teachers, Bernard Hall, Velasquez, Manet, Whistler and Sargent. At times his technical precocity betrayed him, and his surfaces developed an oily glitter, as in his *Sisters* in the Sydney Gallery. But he could paint with sensitivity, feeling for character and great beauty of tone. His portrait of *Jeanne* (94) reveals a Whistlerian mastery of rich and closely related greys.[48]

Arthur Streeton's successful exhibition at the Guildhall, Melbourne, in 1907, not only made the purchase of Australian paintings fashionable; it also stimulated a taste for paintings of European subjects by Australian painters. Local collectors maintained strong ties with Britain; the majority had probably travelled on the Continent. It must not be supposed that the emergence of a distinctly Australian art during the 1880s led to a subsequent decline in the demand for European views which had been present in Australia since early colonial days. For many a buyer, and for many an artist, England was still 'home'; and views of London, Paris, Florence and Venice, for example, recalled the joys and adventures of the European journey. Interest in such views grew in the years before the war, reached a peak during the 1920s and has persisted down to the present day. Although, of course, many Australian artists returning from Europe have found a ready

94 HUGH RAMSAY, *Jeanne*, canvas, 50 x 34, 1902, Mrs J. Wicking

local interest in pictures of European cities and the European countryside (the late work of Rupert Bunny has already been noted in this connexion), this continuing factor in Australian taste is best illustrated in the life and career of Will Ashton.

Will Ashton (1881-1963) was the son of a drawing master of the York School of Art who settled in Adelaide two years after his son was born. Will was educated at the Prince Alfred College, Adelaide, where his father had secured a post as a teacher of drawing. After leaving the College in 1897 he entered his father's studio for four years and was then sent abroad by his parents to study at St Ives under Julius Olsson and Algernon Talmage. There Ashton developed a liking for marine subjects rendered in free, vigorous impasto in an impressionist manner. From St Ives he went to the Académie Julian to work under Marcel André Baschet and François Schommer. In 1905, after exhibiting with the Cornish painters in London, and in the provinces, he returned to Australia, holding his first Australian exhibition in 1906. A show at the Guildhall, Melbourne, in 1907 established his reputation as a painter of European subjects. Henceforth, a great deal of Ashton's life was spent coming and going between Australia and Europe. After winning the Wynne Art Prize for an Australian landscape in 1908 he returned to England, coming back to hold exhibitions in 1912, and returning to England in 1913. The following year found him in Australia again; but the outbreak of war delayed his embarkation for Europe. Sailing for England, Ashton served for a time with the Y.M.C.A. and returned to Adelaide to enlist in the A.I.F., but was rejected on medical grounds. For five years after the Armistice he made his home in Sydney, returned to Paris in 1923 and came back the following year to hold highly successful exhibitions in Adelaide, Melbourne and Sydney. In 1925 he was back again in France but returned the same year to hold exhibitions in the three capitals that were even more highly successful.

Ashton was a robust, uncomplicated, out-of-door landscape painter with a firm masculine touch. His paintings, often of spots hallowed by generations of tourists—Notre Dame and the bridges of the Seine, Florence and the Ponte Vecchio, the canals of Venice, French and Mediterranean watering places—are picturesquely set down with a firm grasp upon fact and atmospheric colour (103). Ashton's popular and picturesque impressionism became quite a vogue in Australia during the years between the wars when *avant-garde* painting was regarded by most collectors with the deepest suspicion. Ashton himself, as an art adviser to the Commonwealth Government and a Director of the Art Gallery of New South Wales (1937-44) became, like so many of his generation, a sturdy and influential opponent of the post-Cézanne developments in contemporary painting.[49]

George Bell (1878-1966) studied under McCubbin and Hall at the Mel-

95 GEORGE BELL, *Portrait of Daryl Lindsay*, canvas, 40 x 30, 1924, Sir Daryl Lindsay

bourne Gallery School from 1895 to 1903 and in the Parisian studios of Julian, Colarossi, Castelucha and La Grande Chaumière from 1904 to 1906. In 1906 he visited Italy where the paintings of Titian and Tintoretto claimed his greatest interest. Then in 1907 he worked at St Ives at a time when the English painters, Stanhope Forbes, Algernon Talmage and Julius Olsson were at work there. In 1908 he settled in Chelsea, began to practise as a portrait painter, and became a member of the Chelsea Arts Club where his closest friends were the Australians, George Lambert and Fred Leist, and the English painters, Walter Russell, Philip Connard and Wilson Steer. In 1908 he became a foundation member of the Modern Society of Portrait Painters which included Glyn Philpot, Gerald Kelly, J. D. Fergusson and Lambert. At this time his portraits, such as his *Lady in Black* (Sydney), are still in the dark tonal manner favoured by so many portraitists at the time. Between 1908 and 1914 Bell exhibited work in exhibitions held in Munich, Düsseldorf and Paris, but it was not until he had lived in London for eleven years that the Royal Academy accepted one of his paintings. About 1910 his work became more colourful, more direct in handling, more assertive of planal construction, and his interest in composition grew. His *Lulworth Cove* (Melbourne, 1911) is typical of the new manner, and this is continued and developed in bright, flattish genre paintings of gypsy life painted in 1914. On visits to Italy in 1912 and 1914 he became increasingly interested in Botticelli and Piero della Francesca. During the war Bell taught in a boys' preparatory school, worked in Munitions, and was appointed an official war artist to the Fourth Division of the A.I.F. in 1918. This required the painting of the portraits of high-ranking officers and winners of the Victoria Cross.

After the Armistice he returned to Australia to complete his large battle picture, *Dawn at Hamel 4th July 1918* (War Memorial, Canberra). Unlike other battle pieces painted by Australia's war artists, it studiously avoids the depiction of dramatic action. In a calm but desolate landscape the

wounded are being brought in after a fierce engagement. The painting also reveals the beginnings of a tendency in Bell's work towards that cubic reduction of form which English war artists like C. R. W. Nevinson had already developed considerably. The incipient classicism of this work was prophetic. Certainly Bell's friend, Lambert, adopted a liberal attitude to the modern movement, but it was Bell alone among the Edwardian expatriates who came to reject academic realism wholeheartedly, to the distress and dismay of most of his former colleagues, and to reconstruct his art and aesthetic position in the light of Cézanne and what had followed. Trained in the old dispensation he became, having passed the age of fifty, the leader of the new. This phase of his career is discussed in the following chapters.

But of most of the expatriates Victor Daley spoke with the insight of a true poet. None of the artists who left Australia in those Indian summer years of the nineteenth century before the First World War achieved in their art either lasting worldly success or enduring artistic value. Correggio Jones did not reach the Promised Land of art either in the flesh or in the spirit. The history of modern European art can be written, apart perhaps from a passing reference to Conder, without mentioning the men who created the Australian school of painting. Nor are they forgotten only in Europe. Their failure was most fully realized in their own country. If the Edwardian excursion brought little or nothing to European art neither did it bring back much of lasting value to Australia. For the present generation of Australian artists, apart from Roberts and Bunny, perhaps, whose work can still arouse perfunctory gestures of respect from the young, the expatriates might never have lived at all. As to their failure to reach the highest achievement in art there can be no doubt, but the causes are not easy to assess. In refusing to be satisfied with the provincial and second-rate standards prevailing in Australia around 1900 their instincts were soundly based and their years abroad bravely asserted the fact that the world of art, at its best, is always an international community. Perhaps their failure lay in the motives which caused them to leave the country. Perhaps the European venture ceased too quickly from being part of a lifelong process of self-discovery and became, for most of them, a step on the road to success and public acclaim. In the end many of them did achieve success of a sort in the years after the First World War, but only by clinging to the image of a world that was quickly passing.

NOTES

[1] J. ROTHENSTEIN, *The Life and Death of Conder*, London, 1938, pp. 29-30
[2] SIDNEY DICKINSON, 'Wanted: A Standard in Art Criticism', *The Australian Critic*, i (1891), 217
[3] Quoted by MOORE, i, 166

L

[4] *op. cit.*, i, 166-7

[5] W. MOORE, *City Sketches*, Melbourne, 1905, 13

[6] D. H. SOUTER, 'J. J. Hilder, Water-Colourist', *Art and Architecture*, vi (1909), 142

[7] MOORE, *City Sketches*, p. 13

[8] *Argus* (Melbourne), 24 August 1895, *see* V. SPATE, thesis cited

[9] *See Creeve Roe* (ed. M. Holburn and M. Pizer), Sydney, 1947, p. 43

[10] *ibid.*, pp. 41-3

[11] D. H. SOUTER, 'Tom Roberts, Painter', *Art and Architecture*, iii (1906), 37

[12] In his poem 'For'ard', *see In the Days when the World was Wide*, Sydney, 1896

[13] A. S. HARTRICK, *A Painter's Pilgrimage Through Fifty Years*, Cambridge, 1939, p. 39

[14] H. THANNHAUSER, 'Van Gogh and John Russell: some Unknown Letters and Drawings', *Burl. Mag.*, lxxiii (1938), 96

[15] *ibid.*

[16] *op. cit.*, p. 98

[17] A. H. BARR, *Matisse, His Life and Art*, New York, 1951, p. 35

[18] *Smike to Bulldog*, p. 63

[19] HARTRICK, *op. cit.*, p. 21

[20] THANNHAUSER, art. cit., *Burl. Mag.*, lxxiii (1938), 103

[21] This account of Russell's life is drawn from the article by Thannhauser, cited above; from letters and conversations with Thea Proctor, the artist's niece; and from letters between Miss Proctor and the artist's son, Alain Russell.

[22] Quoted from NINA MURDOCH, *Portrait in Youth*, Sydney, 1948, p. 102, a book to which this account of Longstaff's life is greatly indebted.

[23] *op. cit.*, p. 159

[24] *op. cit.*, p. 198

[25] *op. cit.*, p. 210

[26] *See also The Art of Sir John Longstaff*, AA, iii, 37 (April 1931) and *CAO*, pp. 128-9

[27] *Smike to Bulldog*, p. 128

[28] ROTHENSTEIN, *op. cit.*, pp. 65, 68

[29] Moore, ii, 10

[30] *See also The Art of Rupert Bunny*, Sydney [n.d.]; and *CAO*, pp. 35-6. I am indebted to Mr L. Course for several points made here.

[31] On Fox *see also* D. H. SOUTER, 'E. Phillips Fox', *Art and Architecture*, v (1908), 88; and *CAO*, p. 68

[32] Streeton to Roberts, 8 January 1901; CROLL, p. 200

[33] *Smike to Bulldog*, p. 65

[34] *op. cit.*, p. 71

[35] Streeton to Roberts, 27 December 1902; CROLL, p. 207

[36] *Smike to Bulldog*, p. 73

[37] CROLL, p. 207

[38] *ibid.*

[39] *Smike to Bulldog*, p. 90

[40] Roberts to Deakin, 17 November 1903, Deakin Papers. I am here indebted to Professor R. M. Crawford's study of the Roberts-Deakin correspondence in *In Honour of Daryl Lindsay*, Melbourne, 1964.

[41] Roberts to Deakin, 4 February 1904, Deakin Papers

[42] CROLL, p. 99

[43] Roberts to Deakin, 4 August 1904, Deakin Papers

[44] CROLL, p. 102.

[45] On Lambert *see* AMY LAMBERT, *Thirty Years of an Artist's Life*, Sydney, 1938; and *CAO*, pp. 104-5

[46] On Hall *see also CAO*, p. 84

[47] On Quinn *see also CAO*, p. 166

[48] On Ramsay *see also The Art of Hugh Ramsay*, The Fine Art Society, Melbourne; and *CAO*, pp. 168-9

[49] On Ashton *see also CAO*, pp. 21-2

CHAPTER SIX

LEVITICUS
1913 - 32

*If we so choose we can yet be the elect of the world, the last
of the pastoralists, the thoroughbred Aryans in all their
nobility.*

J. S. MACDONALD, 'Arthur Streeton', *Art in Australia,*
October 1931

THE modern movement is a vague but useful term. It is here taken to
mean the movement which developed out of French impressionism under
the influence of Cézanne, Seurat, Van Gogh, Gauguin, Matisse and the
artists associated with their respective circles. Artists no longer sought to
imitate nature—an ideal the nineteenth century had cherished. Some
supporters of the modern movement maintain that the *avant-garde* artists
of the early twentieth century gave up attempting to imitate nature because
that was a simple matter having little to do with art. Today we know that
such arguments are naïve and indeed untrue. The impressionists did not
break with nature because its imitation was easy or irrelevant to good
painting. They gave up because they came to realize that it is not possible
to separate entirely what we see from what we know and what we feel. 'The
"Egyptian" in us', as Dr Gombrich has wisely put it, 'can be suppressed,
but he can never be quite defeated'.[1] All art, even the most naturalistic, is
to some extent conceptual. The artists of the modern movement became
increasingly aware of this. They also placed greater emphasis upon the
expression of the artist's personality in his work. Paintings were to express
the artist's moods and feelings. They also placed great emphasis upon
form, especially the arrangement of line, colour and mass in effective
artistic structures. Tone, the handmaiden of illusion, fell into disrepute.

In Australia the modern movement may be divided into two phases.
The first phase began in Sydney on the eve of the First World War and
ended in Melbourne on the eve of the Second World War, when the second
phase began and continued down to the present time.

During the first phase of the movement a group of artists, whose numbers
increased as the years passed, became influenced to a greater or lesser
degree, at times directly and at times indirectly, by the work of such artists
as Cézanne, Seurat, Van Gogh, Gauguin, Matisse and their associates. For

this reason they may be called Australian post-impressionists. But they remained a minority ranged against an academic establishment. This establishment, in the years between the wars, was led by the Edwardian expatriates and their wide circle of friends and patrons. Returning to Australia one by one after the Armistice the expatriates found to their surprise and joy a flushed economy and a receptive public awaiting them. For most, expatriation had meant years of struggle and disappointment, tempered by limited academic success. But the war brought them, often as official artists, in contact with the Commonwealth Government and they were welcomed back as artists who had achieved some measure of success in Europe and knew, in all things artistic, what was what. They became critics, connoisseurs, gallery directors, and advisers to the Government on art matters. Longstaff and Streeton received knighthoods. When news was received that Lambert had been honoured with an associateship of the Royal Academy, that carefully guarded preserve of English artistic ortho-doxy, he and his friends received the news with as much éclat as if he had been awarded the Order of Merit or the Nobel Prize. Australian society still had little knowledge or understanding of the life of the artist and scant respect for his integrity. But it was now rich enough to corrupt; and it did corrupt as it yearned for culture. The expatriates became the aesthetic mentors of this economically flushed but artistically naïve society, for they had earned by the fact of their expatriation the right to know.

But the irony of it was that they did not know. They rejected Cézanne, and what sprang from Cézanne, almost to a man. Most of them had seen original examples of modern art in Paris and London in the years before the war. It was, they said, the work of incompetents seeking fame through notoriety; a conspiracy among Parisian dealers, a Bolshevik ruse to under-mine the foundations of society. And they clubbed together to prevent the virus spreading to Australia.

Ironically, too, the erstwhile exiles, their wander years over, became champions of the Australian tradition. The expatriates became patriots. But the new nationalism of the twenties and thirties differed markedly from the nationalism of the eighties and nineties. Then, nationalism had been closely linked with revolt and innovation. Roberts and Streeton had fought as young men for the recognition of an Australian school of painting against a colonial establishment whose artistic notions, such as they were, were dominated by the moral exhortations of Ruskin and the history painting and didactic art of the English and German academies. But now nationalism allied itself with reaction. The achievements of the Heidelberg School, fostered by the ageing Streeton and his ageing friends, became a national legend. They alone had discovered how to paint the Australian landscape. Before them came the primitives who saw with English eyes

96 EMANUEL PHILLIPS FOX, *The Art Students*, canvas, 72 x 45, 1895, Sydney

97 RUPERT BUNNY, *The Cosy Corner*, canvas, 23 x 29, 1908, Dr Norman Behan

and after them came the decadents who saw with French eyes. Young
Australian artists were exhorted to build on the sound foundations laid by
Roberts, Streeton and Heysen, and eschew the decadent forms of con-
temporary art.

In consequence, stereotyped and debased forms of the Streetonesque
and Heysenesque landscape proliferated at the exhibitions of the art
societies. Portrait painters, with few exceptions, remained faithful to the
tonal illusionist tradition which Bernard Hall continued to disseminate
unceasingly at the Melbourne Gallery School from his arrival in 1892 until
his retirement in 1934. And under the influence of his pupils, and the pupils
of his pupils, the illusionist portrait lived on in declining vigour into the
second half of the twentieth century. Melbourne, at the antipodes of the
growing points of Western culture and highly conservative and orthodox
in all cultural matters, became a stronghold of nineteenth-century values
where the traditions of representational painting, however degraded,
persisted.

Not all the expatriates became howling reactionaries. Rupert Bunny,
long domiciled in Paris, was perhaps the most tolerant, but even he at the
beginning was cautious enough. As he remarked in a newspaper interview
during a short visit to Australia in 1911:

Van Gogh and the rest simply revolted against the deadness of work that was
merely a clever repetition . . . of work that had all been done before, and they
wanted to express their own individuality . . . some of them really succeeded.
Others did not, because they forgot that unless individuality itself is interesting
neither is the expression of it.

And to emphasize his point he added, 'I cannot consider Matisse, for one,
anything but a humbug'.[2]

But for the most part the Australian Press paid little attention to the
modern movement. Even the local cultural journals, such as *The Lone
Hand* and *Art and Architecture*, were mostly indifferent. True, the latter
reprinted a brief but sympathetic account by C. Lewis Hind of Roger Fry's
exhibition, Manet and the Post Impressionists, held at the Grafton Galleries,
London, in December 1910,[3] and a year later (when renamed the *Salon*),
featured an article by Fred J. Bloomfield (probably Broomfield) in which
the art of Van Gogh, Gauguin, Matisse, Picasso and others was discussed
sympathetically.[4] But this was exceptional. Neither books nor coloured
reproductions concerned with the art of the post-impressionists were yet
available in Australia, still less original works. The first original painting
by a French impressionist to be purchased by an Australian gallery on
Bernard Hall's recommendation was Camille Pissarro's *Boulevard Mont-
martre*, in 1905. But beyond the impressionists, public and private buyers
were not prepared to move.

The Beginnings of the Modern Movement in Sydney

In Australia the influence of post-impressionism first appears in the work of a group of Sydney art students trained by Dattilo Rubbo (1871-1955). Like Nerli, who did much to prepare Sydney for impressionism, Rubbo was an Italian. He had studied at Rome and Naples before migrating to Sydney in 1897. A year later he opened an art school in Bligh Street and also became an instructor in painting at the Royal Art Society of New South Wales School in Vickery's Chambers.

Rubbo was a colourful personality greatly loved by his students and, through his own school which flourished for forty-three years, brought a new interest in colour to art teaching in Sydney. His own work was devoted largely to portraiture and genre painting, much of it being sombre in tone and mood, for he was sensitive to poverty, destitution and the loneliness of old age. Yet his paintings could also be, like his own volatile personality, bright in spirit and highly colourful. Not surprisingly, he encouraged an experimental attitude in his pupils. One of them, Norah Simpson, introduced post-impressionist painting into Australia. She had begun her studies with Rubbo in 1911 at the age of sixteen, and left Sydney on a trip to Europe with her parents in the following year. During the few months they spent in London she attended the Westminster School of Art where Harold Gilman, Spencer Gore and Charles Ginner were teaching. All three were leading members of the Camden Town Group which had been formed early in 1911 and pioneered post-impressionist painting in England. Gilman and Ginner had been influenced by Van Gogh, Gore by Cézanne and Gauguin. Proceeding to Paris, Miss Simpson was able to see a considerable number of impressionist and post-impressionist paintings, including work by Cézanne, Gauguin, Matisse, Picasso and other members of the *Ecole de Paris* in the collections of Paris art dealers to whom she had received introductions through Gilman. In Paris and London she collected photographs and books dealing with post-impressionist and cubist work and brought them back to Sydney when she returned in 1913.[5]

Norah Simpson possessed, by all accounts, a bright, independent and attractive personality; and upon returning to Rubbo's classes in 1913, succeeded in influencing the work both of her teacher and some of his pupils, notably Roland Wakelin, Grace Cossington Smith and Roy de Maistre. She continued to work in Rubbo's classes until her return to England in 1915. The strong, simple forms and heightened, stippled colours of her *Studio Portrait, Chelsea* (98), painted about 1915, testifies to her links with post-impressionism and the Camden Town Group, especially Gilman; while the carving in the background reflects the interest in primitive sculpture then widely current in *avant-garde* circles in Europe.

98 NORAH SIMPSON, *Studio Portrait,*
Chelsea, canvas, 20 x 16, *c.* 1915-17, Sydney

Norah Simpson's influence upon Australian art, though crucial, was brief. In 1915, the year she returned to London, Australian paintings revealing the influence of post-impressionism were first publicly exhibited in Sydney by Roland Wakelin and Grace Cossington Smith, in the Annual Exhibition of the Royal Art Society of New South Wales. Wakelin (*b.* 1887) was a New Zealander who had studied at the Technical College, Wellington, under Henri Bastings and had exhibited in 1910 at the Academy of Fine Arts, Wellington, before coming to Sydney in 1912. In the following year he joined the Royal Art Society's classes conducted by Dattilo Rubbo and Norman Carter. His first interest in modern art was aroused upon seeing a reproduction of Marcel Duchamp's *Nude Descending a Staircase* in a Sydney newspaper, the painting being reproduced widely at that time as the most controversial work in the New York Armory Show (February 1913), the first exhibition of modern art to make a major impression upon the American public. Shortly afterwards Wakelin became interested in Miss Simpson's coloured reproductions and began to develop a deep interest in the work of Cézanne. An exhibition of Phillips Fox's work held in Sydney in 1913 after his return from southern France, high-keyed in colour and broadly handled, also affected Wakelin's style at that time.

Grace Cossington Smith studied at Rubbo's studio in Rowe Street from 1910 until 1912 and travelled abroad during 1912-14, studying first at the Winchester Art School and later at Stettin in Germany. It was not, however, until her return to Sydney and Rubbo's classes in 1914 that she, too, under Norah Simpson's influence, became interested in modern painting.

In 1915, with Dattilo Rubbo's encouragement, Wakelin exhibited three, and Grace Cossington Smith one painting at the annual exhibition of the Royal Art Society of New South Wales. Wakelin's *Fruit Seller of Farm Cove* (99) made use of stippled brushwork and a studied and blocky arrangement of the forms in the manner of Seurat. Grace Cossington Smith's sensitive colour sense is already apparent in her *Sock Knitter* (106), in which stippled brushwork is applied to flattish decorative forms reminiscent of Matisse.

Roy de Maistre (then de Mestre), the third and youngest member of the group, was a member of an old pastoral family of southern New South Wales. His father's horses won the Melbourne Cup five times, but the son's interests turned to music and art. In 1913 he came to Sydney to study the violin and viola at the Conservatorium and painting at the Royal Art Society classes under Carter and Rubbo. Here he struck up a friendship with Wakelin and Miss Simpson and started to work in the modern manner.

99 ROLAND WAKELIN, *The Fruit Seller of Farm Cove,*
canvas, 36 x 46, 1915, The Commonwealth Government

100 ROLAND WAKELIN, *Down the Hills to Berry's Bay*, canvas,
26¾ x 48, 1916, Sydney

By 1916 the students in Rubbo's classes who were experimenting with
neo-impressionism and post-impressionism had begun to arouse consider-
able local opposition and Rubbo had to defend their right to exhibit their
works in the Royal Art Society exhibitions. This he did successfully, and
Wakelin exhibited *Down the Hills to Berry's Bay* (100). Its greens, ochres
and terracotta pinks reflect Cézanne; and the massive simplicity of the
design Seurat. So enthusiastic was Wakelin for Cézanne's work at this time
that he called his own house at Carr Street, Waverton, 'Cézanne'. Local
critics were still not quite sure how to react to the new tendencies. One
wrote: 'Mr Dattilo Rubbo has joined the pointillists . . . and has dragged
two students at least, Mr Wakelin and Miss Tempe Manning, after him.
The three of them splash merrily with spots of crimson and green and
vermilion and yellow, and the results are certainly amazing'.[6] In the same
exhibition Grace Cossington Smith exhibited *The Reader* (the author),
more *pointilliste* in manner than her work of the previous year.

Between 1914 and 1916 Wakelin and Miss Smith had been concerned
largely with heightening colour, strengthening and simplifying forms and
experimenting with pure pigment applied with stippled brushwork. During
1917 and 1918, however, Wakelin, Grace Cossington Smith and Roy de
Maistre abandoned *pointilliste* effects in favour of flatter facets of colour.
This is apparent in Grace Cossington Smith's war-time paintings of crowds
and troop-embarkation scenes which are somewhat reminiscent of C. R. W.
Nevinson. Massive, cubic effects dominate Wakelin's *White House* (101),
and a flat, posterish manner of composing prevails in de Maistre's *Water-*

101 ROLAND WAKELIN, *The White House*, oil on pulpboard,
9⅝ x 11¾, 1918, Newcastle

front on Sydney Harbour (102). These paintings foreshadowed the first Australian essays in abstract art.

In 1916 de Maistre joined the A.I.F., but he was discharged nine months later suffering from tuberculosis. During convalescence he returned to painting and met Dr Moffitt of the Gladesville Mental Hospital, Sydney, who awakened his interest in the psychological effects of colour. At that time mental patients were often placed in wards painted in colours intended to stimulate or soothe. De Maistre persuaded the Red Cross to allow him to experiment with colour in the treatment of shell-shock cases and became so interested in his results that he raised sufficient money to establish the Exeter Convalescent Home; Moffitt became the Medical Director. Rooms were painted in colour-keys designed to provide the benefits of colour treatment without the retinal exhaustion and monotony of single colours.

Meanwhile two books, *Cubists and Post-Impressionists* by Arthur Jerome Eddy (1915), and *Modern Painting, its Tendency and Meaning* by Willard Huntington Wright (1915), had become available in Australia. The books were illustrated with works by Matisse, Picasso, Kandinsky, Boccioni and others, and there were colour illustrations of the work of such artists as Gleizes, Duchamp, Gris, Villon, Kandinsky and Picabia. Wright included in his book a long chapter on synchromism, a form of painting based upon the generation of form by pure colour. It had been developed during 1913 and 1914 by two Americans, Morgan Russell and MacDonald Wright.

Synchromism, said Huntington Wright, was 'the last step in the evolution of present-day art methods. . . . It now remains only for artists to create. . . . The era of pure creation begins wtih the present day'.[7] Eddy's book included a chapter on colour theory and had a good deal to say on the relation between painting and music, an aspect of aesthetics to which many of the early abstract painters, Kandinsky especially, devoted much thought and experiment. It also provided a detailed description of a colour organ invented by A. W. Rimington, a Professor of Fine Arts at Queen's College, London. Wakelin and de Maistre read these books. They became intensely interested in synchromism and in the possibility of painting pictures according to a chromatic notation analogous to musical notation. De Maistre, of course, had some knowledge of music and he and his friend Adrian Verbrugghen, the son of Henri Verbrugghen, the Director of the Sydney Conservatorium of Music, invented a colour music scale in which the spectrum colours were related to the notes of the diatonic scale. De Maistre and Wakelin also invented a colour disc which was designed to assemble colour schemes from a chromatic scale based on standard principles. It was patented later and used by de Maistre for producing harmonic colour schemes for interiors.

102 ROY DE MAISTRE, *Waterfront on Sydney Harbour*, cardboard, 12¼ x 10, *c.* 1918/19, Mr Daniel Thomas

In August 1919 Wakelin and de Maistre held an exhibition of synchromies at Gayfield Shaw's Gallery, Sydney, Wakelin showing six paintings and de Maistre five (111), together with exhibits illustrating the application of his colour theory to interior decoration. De Maistre also delivered a lecture on colour music at the exhibition, which was well attended, and aroused considerable discussion.

The synchromies exhibition, however, helped to alert and sharpen the reaction to post-impressionist painting. De Maistre's ideas were strongly criticized by Julian Ashton, the President of the Society of Artists and then still the most

influential man in the art world of Sydney, and also by Henri Verbrugghen. But the most vociferous critic of all was Howard Ashton, the son of Julian Ashton, a landscape painter and journalist who acted as art and music critic on the Sydney *Sun*. Ashton castigated the exhibition in an art review as 'elaborate and pretentious bosh'.[8]

Such adverse criticism was not without effect. By 1921 the impetus of this first phase of the modern movement in Australia was beginning to lag. In that year Max Meldrum visited Sydney and his tonal theory of painting, discussed below, influenced de Maistre and Wakelin for a time. By February 1922, Norman Lindsay, whose ideas were setting firmly against modernism, could see in the temporary eclipse of the movement reason for faith in the future of the Australian civilization:

Primitivism as an expression of mind has failed to get even a hearing here. Efforts have been made to introduce it, by a few idle busybodies, who think art is merely some 'new idea', some just invented fancy, something to entertain leisure in cultured gabble, but a little derision applied in time withered this noxious growth before it could take root.[9]

In Melbourne, Meldrum was attacking modernism quite as vehemently.

Meldrum and Tonal Realism

Like Roy de Maistre, working away assiduously for some years on the relation between painting and music, Max Meldrum was consumed by the desire to invent a rational theory of painting. Born in 1875, he arrived in Melbourne at the age of fourteen, and studied at the Gallery School under Hall from whom he acquired a preference for dark painting, a lifelong concern with tonal values and a predilection for the artfully designed lights of studio interiors. In 1899 he won the Travelling Scholarship and proceeded to Paris. There a dislike of the 'ineptitude and academic conventions of the schools' compelled him to study in 'the school of nature' which he found in the village of Pacé in Brittany. He exhibited frequently in Paris, however, and in 1908 was elected an Associate of the Société Nationale des Beaux Arts.

Meldrum lived in France at a time when the fauvist and cubist experiments were creating considerable excitement in art circles, and there he developed a violent dislike for modern art. After much study in the Louvre he came to the conclusion that great art had always been impersonal and concerned essentially with the objective depiction of appearance.

Meldrum returned to Melbourne in 1913, and in 1917 established a school in which he developed, practised and taught his theory. Painting, he claimed, was a pure science: the science of optical analysis or photometry. The artist's aim was to transfer to his canvas an exact illusion within the limitations of painting (wider, he asserted, than photography) of the

objects present in the act of perception. This was the central problem of painting as revealed in the work of Leonardo, Velasquez, Rembrandt, Canaletto and Corot. Art, said Meldrum, evolved, its advance depending upon the improvement of knowledge concerning the nature of perception. It followed that much academic teaching was quite irrelevant. Both classicism, with its preoccupation with unity and harmony of parts, and romanticism, with its emphasis upon the artist's individuality, were to be discarded in favour of a naturalism grounded in the objective analysis of tone.

Meldrum linked his theory of painting with a criticism of society. Social decadence, he claimed, brought with it a slackening interest in tone and proportion and an increasing interest in colour: modern art with its distortions and excessive interest in colour was a supreme example of social decadence. Meldrum owed much of his power and influence over two decades to thus linking a painting theory with a social theory. Whereas the great majority of the Australian artists of Meldrum's generation identified themselves with the establishment as they grew older, Meldrum remained a critic of society throughout life. When most of his colleagues were enlisting in the services, 'doing their bit' in military hospitals, or being enrolled as war artists, Meldrum, like Cézanne before him, held that the artist had no business with war. It was the only thing they had in common. His strong pacifist views had much to do with the success of his school. With the country split from top to bottom over the conscription issue many young art students preferred to study under Meldrum in a congenial atmosphere than risk being given white feathers at the Gallery School where an atmosphere of high patriotism prevailed.

In seeking to reduce painting to a science Meldrum chose to ignore the fact that the masterpieces of painting have always expressed the personality, temperament, ideas and attitudes of the men who painted them and of the times in which they were painted. He chose, in other words, to ignore the personal and social function of art and to explain art entirely in terms of the painting techniques evolved over the centuries to create pictorial illusion. Yet his theory, it must be stressed, cannot even be considered as an entirely satisfactory account of his own practice, for it was based upon an inadequate theory of perception. Meldrum maintained that the eye perceived tonal relationships 'naturally' whereas illusions created by lines alone required mental translation. But he did not take into account the fact that tone, too, is an abstraction for it occurs to the normal eye only in association with colour and can only be realized by a mental dissociation of tone from colour. Meldrum himself created highly artificial studio methods to aid these processes of dissociation. Further, there is an infinite number of tonal gradations in nature but the artist, because of the limitations of his medium, must reduce them to a very small number and

construct his painting out of them. A Meldrum painting is, in short, like all painting, conceptual and constructive. Meldrum's method, however, made it possible for his students to become skilled in capturing a likeness quickly and was greatly favoured by potential portrait painters, and the practical-minded common-sense type of student temperamentally suspicious of imaginative activity.

Among his pupils Meldrum's theory became something of a cult and craft mystery. The adulation of their teacher became uncritical. Some acclaimed Meldrum as the greatest among the masters; the man who had discovered the scientific laws underlying the age-old practices of his craft; the man who had once and for all placed painting upon a scientific basis. As Newton to physics and Darwin to biology, so Meldrum to painting. Such adulation found graphic expression in an odd device invented by Percy Leason, one of Meldrum's most influential followers. Western painting, argued Leason following Meldrum closely, rose and declined as certain factors expressed themselves in art. In order to explain what he had in mind Leason made use of a triangle; the left and rising side of which, holding the numbers 1 to 6, signified growth; the right and falling side, with the numbers 6 to 12, signified decline. Number 6 at the apex of the triangle represented the high point of art: the achievement of objective tonal truth. Some masters during certain phases of their careers, Rembrandt, Velasquez, Corot and Whistler, for example, had managed to achieve 6 during certain moments of their lives, but Leason also gave them less flattering numbers for concerning themselves with such things as expression, colour, and feeling, less important to good painting, in his view as a staunch Meldrumite, than tone. To Meldrum alone he awarded 6 during the whole of his career. In the history of painting Meldrum was the great cock of the roost. The master, like his devoted pupils, seemingly believed it, for he wrote a preface to the book in which his supremacy was so graphically demonstrated.[10]

Such pride and arrogance of mind was, perhaps not unnaturally, associated with intolerance. Meldrum could appreciate few forms of painting but his own and the masters he appealed to in order to justify his theory. The impressionists, for example, by turning to irrelevant scientific theories and by asserting their individuality through colour, had inaugurated the decline of modern art. In his teaching he rejected as useless the study of anatomy, composition, rhythm and the study of colour for its own sake. Meldrumism became an exclusivist doctrine: its truths could be revealed fully only to professional artists. Laymen were able to criticize and enjoy finished paintings but were not in a position to judge theories and methods of painting. Only painters, said Meldrum, could 'define the rhythm and order of ocula sensa'.[11] As so often in such cases, the pseudo-science became

103 WILL ASHTON, *Le Pont Marie, Paris*, canvas, 16¾ x 13¼,
c. 1930, The Rt Hon. Sir Robert Menzies

a craft mystery, the truths of which revealed themselves only to the initiated.

Yet Meldrum possessed the courage of his convictions. The loyalty he inspired in his pupils sprang as much from his personality as from the deceptive simplicity of his theories. For many his single-mindedness and resistance to personal corruption by social and financial success made him a symbol of artistic integrity in a philistine community where the idea of art as a way of life was a poor joke. In his own art he was a capable and honest but not an inspired craftsman. Much of it has the air of pedantry one finds in his writings. But an early portrait of his mother (104) reveals a precocious mastery of his craft and a truly superb impersonalization of sympathy reminiscent of the young Rembrandt. The latent humanism of such early works, however, did not survive the intellectual rigour which his arid theory imposed upon his own painting. In one sense, however, Meldrum's theory is of considerable interest: it is probably the last of those attempts, so characteristic of the nineteenth century, to deduce a naturalistic theory of painting from scientific or pseudo-scientific presuppositions. And yet, oddly enough, in his later work the very breadth with which Meldrum painted his planes of tones, and his refusal to add detail and polish, had the effect of introducing into his art a kind of tonal, cubic reduction akin in many ways to the modified post-impressionist methods adopted by many painters during the 1920s (115). Even Meldrum's art, despite the practice of a discipline designed to produce impersonal painting as rigorous and thoroughgoing as any in the history of art, was responsive to the imperceptible pressures of period style.

Meldrum exercised a strong influence upon painting in the years between the wars and his ideas were also diffused widely by his pupils, several of whom established schools of their own, notably: Archibald Colquhoun who, following a period of study overseas, established a school in Melbourne in 1927; Hayward Veal, who ran a Meldrum School of painting in Sydney between 1938 and 1950; and Percy Leason, who took Meldrum's ideas to America and taught them with modifications at the Staten Island Institute of Arts and Crafts, the Wayman Adams Summer School in the Adirondacks, and later at his own Summer School at Westport, Lake Champlain. Meldrum himself had done something to make his ideas known in America, however, in a lecture tour in 1931.

Compromise and Reaction

In Sydney, as we have seen, by 1920 the initial energy of the *avant-garde* movement which had begun in Dattilo Rubbo's art classes seven years before was beginning to flag. Wakelin and de Maistre failed to gain sufficient support from their fellow artists and local patrons in order to estab-

lish synchromism or any of the advanced forms of contemporary painting as viable artistic movements. Indeed, their concern with abstraction, though pursued with keen enthusiasm at the time, was a passing interest. De Maistre after his brief experiments with Meldrumism, reverted to a stylized form of representational painting based upon the formal analysis of figures and objects after the Camden Town manner. Wakelin, too, returned to less experimental painting. His *Conservatorium*[12] reveals a curious compromise between Meldrum and Seurat. In later work he came to combine an interest in design with a desire to express romantic feeling in landscape, and never returned to pure abstraction. Indeed, pictorial taste and technique in Sydney was not to be led during the 1920s by youthful *avant-garde* experimenters but by those Edwardian expatriates trained in the pre-war academies who returned to Australia in the years following the end of the war. Still deeply respectful of Royal Academy tradition, they nevertheless reflected the post-war interest in bright colours, crisp painting and decorative emphasis given currency by such British painters as Augustus John, Sir William Orpen, Eric Kennington, Gerald Kelly, Algernon Talmage, William Strang and Dame Laura Knight. The work of these artists was brought prominently before the Australian art public in an exhibition of European art brought out by Penleigh Boyd and exhibited in Sydney and Melbourne in the second half of 1923. But the man who did most to popularize the 1920 academy mode was George Lambert.

Lambert became the arbiter of 'progressive' taste. When he returned in 1921 to complete his war art commissions he was, at the age of forty-seven, at the height of his career, a man of unusual energy and great personal charm. His style, under the influence of Orpen and others, had become thin and dry in texture, pastel-like in colour, firm, and yet somewhat affected in manner and gesture. Although a skilled exponent of academic methods he saw himself as a champion of youth and was not intolerant of modernist experiments providing they were not 'excessive'. Hence his work and influence provided a compromise between the *avant-garde* and the old guard: bright enough to be daring, it was yet solid enough in constructive drawing to be eminently respectable. In 1921, the year of his return, he exhibited *Important People* (105) at the annual exhibition of the Society of Artists. Its dry paint surface, decorative manner and enigmatic subject-matter evoked widespread comment by no means unfavourable, and it marks a sharp break in Sydney taste from the flaccid tonal romanticism which had prevailed during the war years in genteel circles. Hilder was on the way out and Lambert on the way in. The power of the old gods of the art schools, too, was declining. The inspiration behind *Important People* was to be found not in Velasquez, Raeburn or Corot, but in the Italian primitives. Lambert's advice to students underlines this change from tone to design and

104 MAX MELDRUM, *Portrait of the Artist's Mother*, canvas,
23 x 18⅞, 1913, Melbourne

105 GEORGE LAMBERT, *Important People*, canvas,
53 x 67, *c.* 1914-20, Sydney

construction. They should observe closely, he said, and work hard at draw-
ing. 'Get your machinery first, learn how to do the tiresome, uninteresting
foundation work thoroughly.'[13] His influence upon the art students was
immediate and direct: upon Douglas Dundas, for example, who built his
art upon Lambertian lines; and Arthur Murch, who worked as Lambert's
assistant from 1928 to 1930.

Lambert's influence was increased by the support of his friend Sydney
Ure Smith, another Ashton student who had graduated to art publication
after establishing a successful practice in commercial art. In 1917 Smith
established the journal, *Art in Australia*, remaining its editor until 1938; this
was an achievement in art publication in Australia which has never been
equalled. Indeed Ure Smith's tireless devotion to the cause of Australian art
is comparable only to that of Julian Ashton and the young Tom Roberts.
He replaced Ashton as the President of the Society of Artists in 1921, and
as a result of his work the Society became the most influential circle of
artists in the years between the wars. In 1923 Ure Smith was largely respon-
sible for organizing an *Exhibition of Australian Art* held at the Royal
Academy, London. Although his own work was traditional, consisting largely
of topographical studies of old buildings in Sydney and its environs which
he etched, drew, or painted in water-colour with loving care, his policy as
President of the Society of Artists was tolerant and forward-looking. Under
Julian Ashton (1907-21) modernist tendencies of any kind had not been

106 GRACE COSSINGTON SMITH, *The Sock Knitter*, canvas,
24 x 20, 1915, Sydney

encouraged. Under Ure Smith, the influence of post-impressionist painting, although modified and diluted in its passage from Paris via London to Sydney, began to appear with decorous modesty in the annual exhibitions of the Society.[14]

Closely associated with Lambert and Ure Smith in the Society of Artists circle at this time were two women, Thea Proctor and Margaret Preston, whose drawings, paintings and designs evoke the peculiar quality and flavour of Sydney taste during the 1920s more vividly than the work of any of their contemporaries. Miss Proctor studied under Ashton prior to leaving for London where she became a close friend of the Lamberts, and was for a time his pupil. While abroad she fashioned an attractive decorative style out of her interest in Conder's fan designs, the Japanese print, and the drawings of Ingres, expressing it in elegant line drawings (107), tinted water-colours and woodcuts. Although by no means a modernist in her training or methods, an abiding interest in colour and form made her sympathetic to the aims of artists like de Maistre and Wakelin. It was the votes of Thea Proctor and Lambert that gave de Maistre the Society of Artists' Travelling Scholarship for 1923 and three years later she formed with him the (Sydney) Contemporary Group.[15] This exhibiting group brought together those Sydney painters who had been influenced in one way or another by post-impressionist doctrine. Margaret Preston, Thea Proctor, Vida Lahey, Adelaide Perry, Grace Cossington Smith, Aletta Lewis, George Lambert, Elioth Gruner, Roland Wakelin, Roy de Maistre and Kenneth Macqueen were among the earliest exhibiting members of the group which still exists.

107 THEA PROCTOR, *The Shell*, pencil and wash, 11 x 9½, *c*. 1923-24, Professor E. G. Waterhouse

Margaret Preston was a South Australian who had received a thorough continental training. From the Adelaide School of Design she had graduated to Bernard Hall's studio in Melbourne and thence to Munich and Paris. Her early work, tonal and realistic in the manner of the times, was exhibited at the Royal Academy, the New Salon, the International Society of Painters, Sculptors and Gravers and the New English Art Club. But she was a woman of great independence of mind, volatile in temperament, ardently patriotic and consumed by a passion for experiment-

ing in painting media and all kinds of graphic techniques. After she settled in Sydney following the First World War, she had discarded the tonalism of the schools and began to devote herself to colour design in strong, simple and blocky shapes (117), first only in oils, later in woodcut, lino-cut, masonite-cut, silk-screen, and monotype—and indeed almost anything else that could be cut and printed.

Margaret Preston has travelled widely about the world but no one, oddly enough, has advocated the creation of a distinctive national art in Australia more ardently both in her own work and in her writing and lecturing. It became the cause to which she dedicated her life. Much of her work in the early twenties, springing from such interests, was concerned, like Lucien Henry[16] before her, in arousing interest in the decorative qualities of Australian flora. Then she became aware of the aesthetic beauty of Aboriginal art and sought to gain from it a better insight into the nature of art itself. Her article, *The Indigenous Art of Australia*,[17] pioneered the appreciation of Aboriginal art among local artists, and she became the first of many practising artists to champion Aboriginal art as an independent art form, and to be influenced by it herself. She has, therefore, a fair claim to have been the first champion of the aesthetic quality of an art today known and admired throughout the world.

Elioth Gruner, another prominent member of the Society of Artists, was the typical Australian landscape painter of the period between the wars just as Lambert was the typical portrait painter. But his talent was smaller than Lambert's. Although he certainly possessed a keen and discriminating eye for fine tonal gradations, there is a neat and sweetly fastidious refinement about his work that lacks character. Many of his landscapes might not unfairly be described as Meldrum taken in the open air with milk and sugar. He had already, as we have seen, made a pre-war reputation painting spring blossom and misty mornings *au contre jour* in a sentimental *plein-air* style. In 1921 he spent four months painting *The Valley of the Tweed*, a large work which he executed as a commission from the Trustees of the National Art Gallery of New South Wales for a typical Australian landscape. It was painted entirely in the open air. In this commission for a landscape at once big and typical there lay a nostalgic desire to return to the past glories of the Heidelberg School. But the painting, despite its technical competence, is a pretty lifeless thing with none of the vitality and sense of visual discovery that characterizes Streeton's *Fire's On*. Sir William Orpen strongly criticized *The Valley of the Tweed* to Gruner himself while the latter was acting as manager of the Australian Exhibition in London in 1923, without knowing that Gruner had painted it. Though Gruner resented the attack, Orpen's advocacy of thin, dry paint and pastel-like surfaces was not altogether lost upon him. He did not attempt the big landscape again; and

M

108 ELIOTH GRUNER, *On the Murrumbidgee*, canvas,
40 x 48½, 1929, Sydney

later paintings such as *The Pines* (1926, Sydney) and *On the Murrum-bidgee* (108) contain less sentiment, more drawing, and a greater concern with composition and the anatomical structure of the countryside depicted. But even these later works still possess something of the prim tidiness of a coloured photograph.[18]

The new emphasis upon broad patterns, strong contrasts and sharp con-tours so characteristic of the painting of the time is reflected in changing fashions in the graphic arts. In this Sir Lionel Lindsay was a pioneer. In 1907 he had pioneered the local interest in etching. In the early twenties he awakened interest in wood engraving, organizing in 1923, at Tyrrell's Art Galleries, Sydney, the first exhibition in Australia devoted entirely to the medium. Lindsay's own cuts exploited to the full the rich tonal possibilities of the medium by his detailed elaboration of simple designs (109). The rendering of textures, such as the petals of flowers and the feathers of birds, fascinated him.[19] Other artists, like Margaret Preston, Thea Proctor, Adrian Feint and Raymond McGrath, more closely affiliated to the new movement in painting than Lindsay, made greater use of sharp contrasts and bold designs. Associated with wood engraving was the lino-cut, pioneered by Napier Waller about 1923. Both media were admirable for the production

of bookplates which became very popular during the twenties, Adrian Feint developing a considerable reputation in this field.

The artists associated with the Contemporary Group and the Society of Artists represented progressive and fashionable taste respectively. The Royal Art Society, however, became after 1920 increasingly the centre of conservatism and reaction. In 1922 it was reconstituted for the purpose of creating Fellows and Associates as in the Royal Academy, but it lacked social prestige and its standards of professional competence steadily declined. Under W. Lister Lister, a painter of huge uninspired studio-painted 'plein-air' landscapes, who

109 LIONEL LINDSAY, *Goat and Rhododendron*, wood engraving, 6¾ x 6, 1925

was the President for forty-one years from 1900, a group of ageing professionals increasingly irritated by contemporary forms of expression joined with aspiring but inept amateurs to champion exhausted forms of naturalism inherited from Bernard Hall, Julian Ashton, Arthur Streeton and Hans Heysen. The leaders of the Society claimed to be champions of sanity in art in a world of artistic decadence, and their paintings sold well.[20] In Melbourne optical realism based upon tonal values, introduced by Bernard Hall into the Gallery School in 1892, continued to dominate taste. Meldrum had codified it into a system during the war years. But in the hands of John Longstaff and W. B. McInnes, a pupil of Hall, it became a popular portrait style. Longstaff had returned in 1919 and his career moved inevitably towards its climax: the President of the Victorian Artists' Society, 1924-25; a Trustee of the National Gallery of Victoria, 1927; and knighted, 1928. For twenty years he became the hearty and complaisant embodiment of art officialdom in Australia. McInnes's portraits were often more flattering and oleaginous than Longstaff's, though he could produce a competent and characteristic likeness, as in his fine study of Sydney Ure Smith (110). Between them they virtually dominated official portraiture for a decade.

In 1919 J. F. Archibald, the sardonic and mercurial editor of the *Bulletin*, a man who had spent a lifetime exposing hypocrisy, pretension and status-seeking, died leaving a portion of his estate for an annual prize to be awarded for the best portrait 'preferentially of some man or woman dis-

110 W. B. McINNES, *Sydney Ure Smith, O.B.E.*, canvas, 37⅜ x 33⅛,
(before 1929), Sydney, gift of Sydney Ure Smith

tinguished in Art, Letters, Science, or Politics, painted by an artist resident
in Australasia during the twelve months preceding'. The notion implicit in
the will of a Pantheon, a Gallery of Great Australian Men and Women was
in perfect accord with the slightly sour nationalism of the time. McInnes
and Longstaff shared the prize between them nine times during the first
ten years of the award, McInnes winning it five times and Longstaff four.
And as it began so it continued. The Archibald Prize became the last strong-
hold of tonal illusionist painting in the country; a sleek, flattering, oleaginous

111 ROY DE MAISTRE, *Rhythmic Composition in Yellow Green Minor,*
cardboard, 34 x 45¾, 1919, Sydney

manner having been favoured by the Trustees of the Art Gallery of New
South Wales (who administer the award) down almost to the present day.
The most successful competitor of all has been William Dargie (116) who
has won the competition eight times. Dargie was the pupil of Archibald
Colquhoun, who had been the pupil of Max Meldrum, who had been in
turn the pupil of Bernard Hall. It is quite surprising at first to think of the
number of Australian portrait painters who have continued decade after
decade to hold Bernard Hall's old, dark mirror up to nature and man in
order to reduce them both to so many cream and brown patches: but it
is a levelling mode of portraiture which a society deeply egalitarian in its
sympathies and prejudices seems to have found curiously satisfying for the
portrayal of its most distinguished sons and daughters.

Post-Impressionist Painting in Melbourne

French post-impressionist painting began to influence art in Melbourne
about ten years after it had begun to influence art in Sydney. Although
the work of the gifted New Zealander, Frances Hodgkins, was favourably
received by critics as brilliant and daring examples of French modern
painting when she exhibited in Melbourne in November 1912 and in Sydney
in April 1913, she was at this time relying entirely upon a free, decorative
but quite impressionistic use of colour for her fluent effects.[21] The work of

112 HILDA RIX NICHOLAS,
Grand Mere, canvas, 31⅞ x
25¼, *c.* 1919, Sydney

Hilda Rix Nicholas, however, shown in Melbourne and Sydney in 1918, was indirectly influenced by Van Gogh and Gauguin. Miss Nicholas spent a good deal of time at Etaples during her years of study in Europe between 1909 and 1918, and there, doubtless, learned much about the new modes (112). Her paintings, though received favourably enough, do not appear to have had any effect upon Melbourne art, then still dominated by the teachings of Hall and Meldrum.[22]

In 1918, however, Dr Esmond Keogh, returning home from the Western Front, brought back to Melbourne with him some books he had obtained in France containing illustrations of paintings by Cézanne, Van Gogh and others. Keogh was acquainted with Marriott, whose *Modern Movements in Painting* appeared in 1920, and subscribed to early issues of Wyndham Lewis's *Blast*. In 1920 a friend brought back a book of Picasso's drawings. These books Keogh showed among his circle of friends who included Patrick Harford (who later married Keogh's sister, the poet, Lesbia Harford) and William Frater, who was at that time still much influenced by Max Meldrum.[23]

William Frater (*b.* 1890) had studied at the Glasgow Art School under Legros, Greiffenhagen and Anning Bell while serving his articles as a stained glass craftsman and designer. In 1910 he migrated to Melbourne and

obtained employment with Brooks Robinson's Stained Glass Studios in Elizabeth Street, where he gained a high reputation as a craftsman and designer. During 1911-12 Frater attended evening classes at the Victorian Artists' Society. The vigorous *alla prima* methods he was adopting at the time are to be seen in his fluent and sensitive *Portrait of a Girl* (113). In 1912, having resolved a family difference, he returned to Europe, studied for a short period in Paris and London and then for two further years at the Glasgow School. Then, in 1914, he returned to Melbourne and to his former post with Brooks Robinson's. Max Meldrum, who had returned the year previously, was developing his tonal theory at the time, and the two Scots became firm friends. Frater's portrait of his wife reading (the artist, 1915) and his *Self-Portrait* (the artist, 1916) reveal Meldrum's theory increasingly. A small portrait of his son, *Arthur* (*c*. 1922, A. Frater), however, reveals the beginnings of his interest in Cézanne.

Harford worked with Frater at Brooks Robinson's, where Arnold Shore was also serving his articles as a stained glass craftsman between 1911 and 1917, at the same time attending evening drawing classes at the Gallery School under McCubbin and Hall. In 1917 Shore transferred to Meldrum's evening classes. The post-impressionist movement in Melbourne came into existence as a result of the discussions between Frater, Shore and Harford. Frater became a champion of Cézanne's methods. Shore was drawn to Van Gogh's magnificent colour and expressive freedom. Van Gogh liberated him from the constrictions of Meldrum's realism. Both artists began to exhibit their first essays in post-impressionism with the Society of Twenty Melbourne Painters, a group founded in 1917, consisting largely of painters who worked in the Meldrum manner. Their efforts were so different from the rest of the Society that they were hung on an end wall and ignored by Melbourne critics for some years.

Both Frater and Shore have spoken of the stimulating effects of Pat Harford's questioning of the view then generally accepted in Melbourne that art was an imitation of nature. It was Frater, however, who provided some leadership to the small group of modernists in Melbourne during the early 1920s. In 1925 he delivered a lecture in the Queen's Hall in reply to one by Bernard Hall attacking modern art. 'Copying nature', he asserted, attacking Meldrum's position, 'is not an art; the cult at present is to copy effects of light' which, he added, 'tends to destroy form and colour'. Thinking artists organized form and colour. If they help their construction they are used, if not, they are ignored.[24] By 1923 many of Meldrum's former pupils were beginning to question his theory. On 16 March Percy Leason, an ardent disciple of his master, wrote to Frater:

With the wholesale repudiation of Meldrum that seems to be going on amongst his past pupils there is a serious possibility and a very good likelihood that the

113 WILLIAM FRATER, *Portrait of a Girl*,
canvas, 24 x 20, 1910, Melbourne

great school of art which Australia could develop is to become a hopeless ruin, and it is all being pulled down because each individual wants to gratify selfish desires.[25]

Both in Sydney and in Melbourne during the 1920s knowledge of the modern movement was obtained largely by means of coloured illustrations. John Young recalled how the early Sydney post-impressionists around 1919 consulted illustrations in the magazine *Colour*;[26] Frater has expressed his indebtedness, prior to 1925, to colour illustrations of the work of Van Gogh, Matisse and Cézanne in copies of *The Dial*;[27] Shore has described how the last fortnightly issue of Orpen's *Outline of Art*, to which he and Frater were subscribing, with its illustrations of work by Cézanne, Van Gogh, Gauguin and Matisse, came as a revelation to him.[28] But good colour reproductions were difficult to acquire until the establishment by Gino Nibbi, an Italian from Rome, of a book and curio shop in Bourke Street in 1928, materially altered the situation. Nibbi was keenly interested in the modern movement and began to import large Piper prints from Munich of the work of post-impressionist masters. From Nibbi, Frater purchased the large print of Cézanne's *Peasant in a Blue Smock*; and Shore bought copies of *Cahiers d'Art* and *Formes* in which he studied reproductions of work by Modigliani,

Soutine, Picasso, Dufy, Rouault, Chagall and so on. By 1930 Nibbi's book shop had become a rendezvous of artists and laymen interested in European contemporary art and literature. As a result of Nibbi's active advocacy the Melbourne interest in contemporary painting began to widen appreciably. In Geelong shortly afterwards, H. Tatlock Miller began to publish *Manuscripts* (1931-35), a little magazine which championed *avant-garde* thought in literature and art. It was, it would appear, the first Australian magazine to discuss cubism and surrealism without prejudice.

Meanwhile George Bell had become increasingly interested in the principles underlying post-impressionist painting. He saw its insistence upon form and design as a return to the basic principles of good art. His knowledge of the Italian masters had made him increasingly dissatisfied with the tonal illusionism taught by Hall and Meldrum. Settling in Toorak after his return to Melbourne in 1920 Bell had built himself a house and studio, and had begun to paint and take private pupils. In 1922 he taught drawing for a year while McInnes was abroad. By 1925 he had become dissatisfied with his own work and the principles upon which it was based. His interest in modern art grew and brought him in touch with Frater, Shore and others of their circle. Bell had already become respected as a leader of opinion for the prompt action he took when it appeared that the work of Victorian artists would be inadequately represented in the Exhibition of Australian Art organized in Sydney in 1923 by the Society of Artists for exhibition at the Royal Academy; and as art critic on the *Sun News-Pictorial* from 1923 he helped to encourage a sympathetic approach to the work of the younger and more experimental painters.

The Post-War Time-Lag and Reaction

Generally speaking, the decade from 1920 to 1930 was not a particularly creative period in Australian art. It is true that in those years the influence of the modern movement was first felt in the country: but post-impressionism did not bring the same sense of discovery and liberation to the artists of the time that impressionism brought to the men of Roberts's generation, or that expressionism, surrealism and abstract art were to bring to the artists who began to work in the years preceding the Second World War. William Moore called the years before 1900 the Genesis of Australian art, and the years after, the Exodus. And he might well have called the 1920s the Leviticus; for it was then that the old men of the tribe, their years of exile over, began to lay down the law for the guidance of the young. Let us keep Australian art healthy and sane, they said, and not allow the madness going on in Europe to sap the vitality of the true Australian art which we began.

The air was heavy with the arrogance and respectability of old men, old

and tired in spirit and in the handling of paint, if not yet quite old in years. When Tom Roberts, the best of them, returned to Australia in 1923 to end his life here he was sixty-seven. The long years he had spent in London seeking for a place on the line at the Academy had taken their toll. An honest and sensitive craftsman he remained, for he was not the kind of man to compromise his values for the sake of cheap success. But the energy, freshness and finer perception of his early work had gone, and he spent the last years of his life painting pale grey-green and saffron landscapes in which the sun never quite shines and the light is like cold steel. The paint is handled in a close, introverted way, and a wistful air hangs over the work. Roberts did not realize the promise of his youth: but neither did Streeton, nor Meldrum, nor Norman Lindsay.

Streeton returned in 1924 to find himself at the age of fifty-seven already a national legend, a legend which he began at once to document, embroider and consolidate. He began to prepare the Streeton history of Australian art designed, he told Roberts, to 'put everybody in their proper place'.[29] The project arose, it appears, partly out of jealousy of Julian Ashton whom someone had dubbed to Streeton's chagrin 'the father of Australian art'. Later he set himself the task of preparing the *Arthur Streeton Catalogue*. He handled his own exhibitions with the uninhibited assurance of a dealer handling a protégé's work. Melba opened the 1924 one-man show at the Fine Arts Gallery which announced his return to his homeland, and he prefaced his catalogue liberally with business puffs. Sales were splendid and continued to be so. Settling in Toorak and purchasing five acres in the Dandenongs he became more and more engrossed in painting and tending his suburban and country gardens. But he also travelled widely throughout the country painting for his one-man shows, visiting one tourist resort after another: Mount Buffalo, the Grampians, the Blue Mountains, the Barron Gorge in Queensland, to paint the beauty spots of Australia. The two most influential critics of the time, Lionel Lindsay and J. S. MacDonald, vied with one another in praise. His method, said Lindsay, was plastically finer than that of the French landscape impressionists; he had fixed the character of the Australian landscape for all time; he was one of the few great painters of landscape left to the world.[30] Indeed, Lindsay found in Streeton's work piercing beauty which stirred his patriotism to almost mystical depths. So, too, did James Stuart MacDonald. 'They point', he said in an ecstatic survey of Streeton's art, 'to the way in which life should be lived in Australia, with the maximum of flocks and the minimum of factories. . . . If we so choose we can yet be the elect of the world, the last of the pastoralists, the thoroughbred Aryans in all their nobility'.[31] That was written in 1931. By that time Streeton had become the great father-figure of Australian art and his paintings the manifest symbol of a pathological nationalism that had been

growing in the country since the Anzacs had stormed the Dardanelles. D. H. Lawrence quickly sensed it during his visit in 1923.[32]

But Streeton's later work did not receive universal approval from the critics. M. J. MacNally, the art critic for the *Age,* in his review of Streeton's 1924 show wrote: 'Streeton's art, instead of its old-time dignity . . . now echoed with the boom and bustle of arrogant commercialism'.[33] But already Streeton was something of a national institution; the *Age* editor did not approve and the criticism was not published. Blamire Young, with the discernment and discrimination so characteristic of his criticism, picked out the early Australian paintings and the small English landscapes painted under the influence of Constable as the best work shown in the Streeton Loan Exhibition held in 1932 at the Art Gallery of New South Wales. One of the few critics of the time who had some respect for international values, he concluded his comments with a timely warning: 'It is a problem whether the world of Art will ever again accept wholeheartedly an artist who has kept aloof in his work from the main stream of the tendencies of his time'.[34]

And as with Streeton so with Norman Lindsay. The prodigious energy and facility remained but contact with the living art of his time was lost. Life at Springwood, after the war and his second marriage, brought to his art a world full of satyrs and pirates, sailing ships and lovely ladies. In his *Garden of Happiness* (1920), a series of twenty pen drawings; his *Idyllia* (1920), a series of twelve etchings; his *Man and Hyperborea* (1927); and his illustrations to the poems of Leon Gellert and Hugh McCrae, Lindsay entered a realm of rococo-pagan fantasy. In the Nietzschean and neo-platonic philosophy of life expressed, in an odd kind of aphoristic turgidity in his *Creative Effort* (1924), the artist became, as his son Jack has put it, 'a member of a sort of Apollonian secret-society or blood-brotherhood spread over the ages and redeeming the hungry chaos of matter by the stabilizing Image'.[35]

After the war Norman Lindsay turned more to water-colour, following Blamire Young's methods, and in 1934, at the age of fifty-five, began to work in oil. The colossal output continued, but the paintings, like the pen-drawings before them, were dominated by deep-bosomed, heavy-hipped nudes luxuriating in exotic and bacchanalian settings. As illustrations they are technically superb but possess little, if any, aesthetic merit. Doubtless, Norman Lindsay's women are idealizations; the agents and progenitors of his life-force. But the conception was greater than the accomplishment: his *femme ideale* is quite unconvincing beyond the realm of adolescent erotica. After the war his critical writings, published in *Vision* (1923-24) and elsewhere became increasingly reactionary and he fulminated violently against modernism in literature and art; against the work of Pound, Eliot and Joyce; Cézanne, Van Gogh and Gauguin. His prestige among writers and some

artists undoubtedly assisted in creating the highly conservative and reaction-
ary temper of the time.

It is revealing to find, when one looks at the record, how much liberal
and progressive thought in the arts Australia owed during the 1920s to
women. There were, of course, talented artists like Ethel Stephens, the
portrait painter, and Alice Muskett, the flower painter, at work long before
the First World War and a few achieved some notice while studying over-
seas. But women, perhaps because of their status in Victorian and Edwardian
society and other reasons that need not be discussed here, did not figure
prominently in Australian art prior to the First World War. This was not
so in the 1920s. The introduction of post-impressionism to the country owed
much to women: Norah Simpson, Grace Cossington Smith, Thea Proctor,
Margaret Preston, Isabel Tweddle, Dorrit Black, Ada Plante, Aletta Lewis,
Vida Lahey and Mildred Lovett, to name only the more prominent. Indeed,
the contribution of women to post-impressionism in Australia appears to
have been corporately greater than that of men; and in individual achieve-
ment in every way comparable. This is unusual, for women do not normally
figure as prominently in the visual arts as do men. They have not found
painting, it seems, as congenial a form of expression as the novel. In the
visual arts they have achieved distinction more as patrons than as prac-
titioners. The reason for their unusually important contribution to Australian
art during the twenties and early thirties is to be found probably in the
occurrence of the First World War.

In this regard it is not without significance that the greatest figure in
Australian art in the period between the wars was Max Meldrum, a pacifist
who believed, like Cézanne and Picasso, that war was a soldier's business
not an artist's. Like the dadaists he opposed not only the war but also the
teaching of the academies. But, unlike the dadaists, Meldrum worked out a
theory of painting based upon a rational and personal reading of the achieve-
ments of the past. Had his opposition to the war and the French academies
taken the explosive and irrational form that gave birth to dada and surreal-
ism, the history of Australian art would certainly have been different. For
Max Meldrum, like Tom Roberts and George Bell, possessed the gift of
leadership, and might have led a successful revolt, had he so chosen, against
the values of the smug decade. But Meldrum chose to be rational and place
his faith in the past; and became a reactionary. Had he chosen to be
irrational and place his faith in the future he would have come much closer
to the spirit of the twentieth century.

All this is admittedly speculative but will serve to throw a sharp light on
the time. Meldrum's education as an artist was not interrupted by the First
World War, for he had already discovered by 1913 the position that he was
to maintain intractably throughout his life: but the education of a whole

generation of Australian artists certainly was. Australia sent 330,000 soldiers overseas and casualties totalled 226,000, of whom 60,000 were either killed in battle or died of wounds. Professor Crawford has recently pointed out that 60,000, though a small number beside the millions killed in the war, was not a small proportion of the Australian youth of that generation, and has suggested that 'there is reason to believe that it included a high proportion of those young men of promise who might have been expected to supply the new generation with its leaders'.[36] Just how many of those who enlisted were either intending to be or were art students, and were killed or did not return to the pursuit of art after the war has not been ascertained, and probably never will be. But the figures might well be revealing. It was no easy matter (the official war artists excepted) to turn, or to turn again, to art after the war. Rehabilitation made little provision (as it did after the Second World War) for ex-service training in the arts. And those who nevertheless did turn to art were in no position, as late starters, to influence art until the end of the decade. One typical case will serve to illustrate the position.

Rah Fizelle, born in Goulburn, New South Wales, in 1891, drew and painted from nature from an early age, but had no opportunity of entering an art school or of obtaining any tuition until 1919, following his demobilization. From 1919 to 1921 he attended the Sydney Teachers' College, taking a special course in art; and became, on winning a third scholarship in 1921, a day student at Ashton's. Then from 1922 to 1926 he continued as an evening student at Ashton's while teaching art at a demonstration school. During this period he became a regular exhibitor with the Society of Artists and a member of the Water-Colour Institute in 1924. About this time, while not quite understanding it, he became interested in cubism. He left teaching in 1927 for Europe, studied for a time at the Regent Street Polytechnic, then changed over to the Westminster Art School where he was taught by Bernard Meninsky and Walter Bayes, and gained from them ideas on composition and the solidity of form. Then he travelled in Spain, where he was deeply impressed by El Greco and Titian, and proceeded to move about over southern France and Italy during the next three years devoting his attention to museums, churches, palaces, Etruscan tombs, and finding his greatest interest in the *quattrocento*. Returning to Australia in 1931 he held one-man shows in Sydney and Melbourne; and from 1932 to 1937 conducted an art school with Grace Crowley based on modern principles, becoming increasingly interested in the geometrical organization of form (114).[37]

Meldrum had arrived in France at the age of twenty-four to study art in Paris; Fizelle arrived at the same age to serve in the trenches. Meldrum began to influence the course of Australian art in 1913 at the age of thirty-

114 RAH FIZELLE, *Morning*, canvas,
39 x 26, 1941, Sydney

eight; Fizelle, at the age of forty-one, in 1932. That Meldrum exercised a far deeper influence than Fizelle is, of course, indisputable. But what is significant in this context is that his work did not begin until 1932 and that probably no other artist who spent his student years on active service exercised as much influence as Fizelle, through his school and his presidency of the Contemporary Art Society of New South Wales, in introducing contemporary art to Australia. Sir Daryl Lindsay certainly played a part in developing a better appreciation of post-impressionist values in Melbourne but his essential contribution to Australian art has lain in the art museum field. It would seem, therefore, on the evidence at present available, that due to the First World War the impact of a whole generation of art students upon Australian art was tragically thin and long delayed. This generation might have been expected, in the normal course, to have introduced cubism and futurism to Australia: those movements so crucial to the evolution of the pictorial language of the twentieth century. But Australian art did not experience cubism, futurism and non-figurative art until about 1935; and even then, not deeply. The First World War isolated Australian art from its sources in Europe far more effectively than the economic depression of the 1930s or the Second World War.

It was not until about 1924 that a new generation of students was beginning to leave the country for study abroad: and by that time the old association with Paris had weakened. Students now tended to study at the Slade, the Regent Street Polytechnic and the Westminster Art School, and contented themselves with shorter periods of study in Paris, often confined to gallery visits, in contrast to the three or four years in a Paris art school that was usually considered minimal to students of the 1890s, even after several years of training in Australia. In this regard the Travelling Art Scholarships did not yield the promise that might have been expected of them. In New South Wales the system broke down after sending Lambert

abroad in 1899, and was not revived until de Maistre won the second scholarship awarded in 1923. In Victoria the triennial awards have been continuous down to the present day, but since Meldrum won his scholarship in 1899 no subsequent winner has returned to play an outstanding role in Australian art; a few have become reasonably well known as exhibitors in the annual shows of various societies, but most not even that. It would appear, furthermore, that the great majority of those students who were abroad between 1920 and 1930 had become too dominated by Ashton and Lambert in Sydney and Hall and Meldrum in Melbourne to make fruitful contact with the sources of twentieth-century painting during their years abroad.

The fact that post-impressionism made such a slight impact, and cubism and futurism no impact, upon Australian art and culture during the 1920s and early 1930s cannot, however, be explained entirely in terms of the solid resistance of the older generation, the heavy toll of the war itself, and the comparative failure of the student-body of the 1920s to make contact with *avant-garde* art in Europe. Until the 1940s the modern movement in Australia simply did not bring forth artists of stature sufficient to produce work that, regardless of time and taste, will stand comparison on its own merits with the best work of the Heidelberg School. Nor did it produce a leader of the calibre of Roberts with enough drive and creative ability to break through the thick rind of artistic complacency that encrusted the decade. One of the reasons for this must be found in the nature of post-impressionism itself. As a movement it was as much English as French. The term itself, which has little currency in French criticism, was invented at short notice by Roger Fry as a title to his Grafton Gallery Exhibition of 1910, 'Manet and the Post-Impressionists'. Moreover, as it was defined in the work of the Camden Town and London Groups, and the criticism of Roger Fry and Clive Bell, much of the aestheticism of Whistler and the New English Art Club hung about it. Post-impressionism and fauvism are essentially *fin de siècle*. It is true that extreme simplification, distortion and bright 'toneless' colour aroused the anger of critics whose approach was grounded in realism. But in Australia, Wakelin's and de Maistre's experiments of 1919 apart, post-impressionism never strayed far from the world of appearances. The post-impressionist innovators in Australia were perhaps too cautious; they did not push their experiments far enough to make a complete break with naturalistic painting. Nor is it surprising that in their insistence upon form and lack of interest in subject-matter for its own sake they were iconographically conservative. The still life, the interior, garden and back-yards, landscapes and portraits, a little figure-painting: the range of subject-matter made no advance upon that already treated with distinction by the impressionists. Consequently a great deal of post-impressionistic

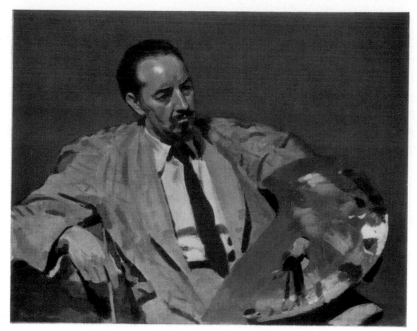

115 MAX MELDRUM, *Portrait of John Farmer*, canvas,
30⅛ x 38½, 1936, Sydney

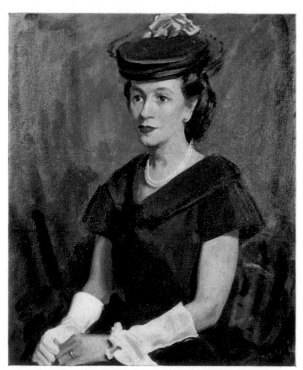

116 WILLIAM DARGIE, *Portrait of Mrs Behan*, canvas,
30 x 24, 1957, Dr Norman Behan

work in Australia tends to be on the light side in terms of real achievement: colourful, well-constructed, eminently decorative, but with an inherent tendency to revert to impressionist modes. Cézanne, Van Gogh and Gauguin were not aesthetes: and had Australia's post-impressionist painters been able to study their work in the original and at its source they might have come to realize that these three artists and their most intelligent followers were beginning to strike at sources of inspiration which had little to do with the polite world of significant form, classical or otherwise. As it was, they were most at home in the world of good taste: that moving limbo between the silent hell of creation and the catchpenny paradise of popular success.

NOTES

[1] E. H. GOMBRICH, *Art and Illusion*, New York, 1960, p. 395

[2] *Sydney Morning Herald*, 19 September 1911

[3] *Art and Architecture*, viii (1911), 278

[4] FRED J. BLOOMFIELD (probably Broomfield), 'The Modern Tendency of Art', *The Salon*, i (1912), 18

[5] *in litt.* Mrs Norah Cockren, 11 August 1960, 5 September 1960

[6] The *Sun* (Sydney), 1 September 1916

[7] W. H. WRIGHT, *op. cit.*, pp. 276-333

[8] ROLAND WAKELIN, 'The Modern Art Movement in Australia', AA, iii, 26 (December 1928), and verbal information from the artist; *see also* R. WAKELIN, 'Some Personal Recollections', *Art Gallery of N.S.W. Quart.*, January 1962; on de Maistre *see* JOHN ROTHENSTEIN, *Modern English Painters*, London, 1956, pp. 246-59, and R. DE MAISTRE, *Retrospective Exhibition of paintings and drawings from 1917 to 1960*, Whitechapel Art Gallery, London, May 1960

[9] NORMAN LINDSAY, 'The Inevitable Future', AA, ii, 1 (February 1922), 38

[10] *The Science of Appearance as formulated and taught by M. Meldrum* (ed. by R. R. Foreman), Sydney, 1950

[11] *op. cit.*, p. 219. On Meldrum *see also Max Meldrum: His Art and Views* (ed. by C. Colahan), Melbourne, 1917

[12] Illustrated in AA, ii, 1 (February 1922), 70

[13] 'A Painter's Advice to Students: A talk by G. W. Lambert to the Students of the Sydney Art School on his Return to Sydney recently', AA, ii, 1 (February 1922), 9-13

[14] On Sydney Ure Smith *see also Sydney Ure Smith, Memorial Exhibition*, 1950 (Mitchell Library of New South Wales); and *Sydney Ure Smith, Memorial Catalogue*, Sydney, 1950

[15] *See also Thea Proctor Number*, AA, iii, 43 (April 1932)

[16] On Henry *see* MOORE, ii, 186, *passim*; and R. T. BAKER, *The Australian Flora in Applied Art*, Sydney, 1915; and *Art and Architecture*, i (1904)

[17] AA, iii, 11 (March 1925). For a list of Margaret Preston's writings and further references *see CAO*, p. 164

[18] *See also Elioth Gruner*, Sydney [n.d.], and other references in *CAO*, p. 80

[19] On Lionel Lindsay *see also* MOORE, ii, 194, *passim*

[20] On the history of the Royal Art Society of New South Wales, *see* G. GALWAY, *Fifty Years of Australian Art*, Sydney, 1929

[21] On Frances Hodgkins in Australia *see* E. H. McCORMICK, *The Expatriate; a study of Frances Hodgkins*, Wellington, 1954, pp. 144-60; *The Works of Frances Hodgkins in New Zealand*, Auckland, 1954, pp. 88-91; 247

[22] *See The Art of Hilda Rix Nicholas. Exhibition of Paintings and Drawings.* Fine Art Society's Gallery (Melbourne), 1922; *Exhibition of Pictures of Life and Landscape of Australia and France*, Athenaeum, Melbourne, 1928

[23] *in litt.* 6 October 1960

[24] From a typescript of Frater's notes for the Lecture in the author's possession

[25] Holograph letter in the author's possession

[26] In his evidence before the High Court in Equity, New South Wales, in the case arising from the 1943 Archibald Prize award; *see* typescript, Art Gallery of N.S.W., p. 70

[27] From conversations with the artist

[28] A. SHORE, *Forty Years Seek and Find*, Melbourne, 1957

[29] *Smike to Bulldog*, p. 112

[30] LIONEL LINDSAY, 'Arthur Streeton', *AA*, iii, 40 (October 1931), pp. 9-11

[31] J. S. MACDONALD, 'Arthur Streeton', *AA*, iii, 40 (October 1931), p. 22

[32] In *Kangaroo*, 1923

[33] Quoted in *Smike to Bulldog*, p. 112

[34] BLAMIRE YOUNG, 'The Streeton Exhibition', *AA*, iii, 42 (February 1932), p. 19

[35] J. LINDSAY, *The Roaring Twenties*, London, 1960, p. 67

[36] R. M. CRAWFORD, *An Australian Perspective*, Melbourne, 1960, p. 62

[37] From notes supplied by the artist

CONTEMPORARY ART ARRIVES
1930 - 39

One does not necessarily go out and weep because our beliefs have been betrayed. The love-birds die in the cage, the rose mildews in the bud, but we live on. Forward the Rebels!
BLAMIRE YOUNG, the *Herald*, 17 August 1932

DURING the 1930s Australian art began to show signs of new vitality. Contact with contemporary European art was firmly established; the reactionary opposition in painting and criticism was challenged and defeated by a new generation of artists who broke completely with the traditions of academic naturalism; and a lively curiosity among artists and the public began to replace the complacency that had prevailed during the preceding decade. This curiosity revealed itself in many ways: in the great interest shown in exhibition work from overseas; in the formation of new art schools, centres and societies, in the sense of excitement and interest in experiment prevailing among local art students; in the return of a new generation of students from abroad keenly interested in contemporary work; and in the arrival of artists and scholars from Hitler's Europe.

Exhibitions from Overseas

During the 1920s anyone interested in modern art in Australia had to depend largely upon books and colour reproductions, and even these were scanty enough. During the 1930s, however, original work by contemporary European painters began to appear in loan exhibitions from abroad or in loan exhibitions from private collections in Australia. Following Penleigh Boyd's exhibition of 1923, which reflected the Royal Academy taste of the time, very little work from overseas, apart from gallery purchases, was exhibited for a decade. Critics, private collectors, and gallery purchasing tended to follow Royal Academy modes and reputations. Even the purchases made by Sydney Ure Smith and Sir James MacGregor in 1933 for the National Art Gallery of New South Wales were considered rather modern at the time by local critics, with paintings by John, Epstein, Duncan Grant and Spencer Gore, and drawings by Eric Gill and John Skeaping.[1]

However, the drift from academic taste, gradual during the early 1930s, quickened as the years passed. Probably the most 'advanced' works in the

collection brought out to Australia by Mrs Alleyne Zander in 1933 were paintings by Ben Nicholson, John and Paul Nash, Mark Gertler, Christopher Wood, Edward Wadsworth, Duncan Grant, Vanessa Bell, Stanley Spencer and Matthew Smith.[2] Noting public interest in modern work the Society of Artists began to include contemporary work by overseas artists in their annual exhibitions. In 1935 an Etretat landscape by Matisse, a portrait by Derain, and paintings by Pissaro, Utrillo and Dufresne were exhibited.[3] On the other hand, the Loan Exhibition of Contemporary British Art arranged by the Empire Art Loan Collections Society of London, which was shown in Australia and New Zealand in 1934-35 and was drawn mostly from private English collections, retained a strongly academic flavour.[4] July 1936, however, saw the opening in Sydney of a large Exhibition of International Art drawn partly from local collections and partly from work obtained by Sydney consulates from overseas collections, a good deal of conventional and academic work, paintings by Matisse, Marquet, Utrillo, Vlaminck and Munch. By this time the Press was becoming increasingly interested in the public response to contemporary work and the exhibition drew large attendances.[5] In Melbourne, the Loan Exhibition of Works of Modern Art by Artists Outside Australia, organized by George Bell for the National Gallery of Victoria from October to November 1937, was of considerable importance. This little exhibition of fifty-two items included a Picasso lent by Lady Casey, paintings by Van Gogh and Utrillo lent by Sali Herman, a Kisling lent by Gino Nibbi, a Marie Laurencin lent by Alan Henderson, and a Christopher Wood lent by Isabel Tweddle. Assembled at a time when interest in contemporary art was running high in Melbourne but little original work was yet available, this small exhibition aroused far more interest than its size might suggest.

The loan collections shown in Australia between 1933 and 1938 consisted mainly of contemporary British academic work, and even the advanced work, such as it was, came mostly from Britain. The first, and indeed the only exhibition at all representative of the work of the masters of the modern movement ever to be shown in Australia, was the Exhibition of French and British Modern Art shown in Australia during the second half of 1939. Assembled by Basil Burdett in Europe for Sir Keith Murdoch, the Managing Director of the Melbourne *Herald*, it contained over two hundred works, including paintings by Bonnard, Braque (four), Cézanne (seven), Chagall, Chirico, Dali, Derain, Dufy, Ernst, Friesz, Gauguin (seven), Gris, Laurencin, Léger, Lurcat, Marquet, Matisse (eight), Modigliani (two), Picasso (nine), Rouault (five), Seurat, Signac, Soutine, Toulouse-Lautrec, Utrillo, Valadon, Van Dongen, Van Gogh (eight), Vlaminck, Vuillard, Ben Nicholson, Graham Sutherland, Christopher Wood and Edward Wadsworth. The exhibition created great public interest wher-

ever it was shown and exercised an influence upon Australian taste in the visual arts difficult to exaggerate. It ended the dominance of the Royal Academy of London as the official arbiter of pictorial values in Australia, and was one of the first of three major events which led to the collapse of the authority of the academic establishment in art in Australia; the other two being the struggle against the Australian Academy of Art which led to the formation of the Contemporary Art Society and the lawsuit arising from the award of the 1943 Archibald Prize to William Dobell.

New Schools, Centres and Societies

In Melbourne the economic depression decreased the amount of work available to craftsmen and designers at Brooks Robinson's Stained Glass Studios and, in 1931, Arnold Shore, after discussing the matter with William Frater, approached George Bell with the idea that the two of them should start a new art school in Melbourne to teach the principles and practice of modern art. Bell, who already had a number of private pupils interested, agreed to the proposal. Frater found premises and the new school was opened in February 1932. The partnership between Bell and Shore continued until 1934 when Bell, feeling the need to study modern art at its source, travelled abroad for two years, working for a time with Iain McNab, at the Grosvenor School, London, and visiting France and Spain.

After Bell returned in 1936 the partnership with Shore lasted another year and then broke up, Bell continuing the school alone. Between 1936 and 1939 a group of unusually gifted and intelligent students, with a lively interest in all forms of contemporary art, attended the school. Among the more prominent were Wolfgang Cardamatis, Russell Drysdale, Sali Herman, Geoffrey Jones, Peter Purves Smith, David Strachan, Alan Sumner, Alan Warren, Frances Burke, Maie Casey, Frances Derham, Mary Alice Evatt, Anne Montgomery and Louise Thomas.

The influence of this important school runs parallel to the influence of the Contemporary Group of Melbourne. In 1931 Gino Nibbi wrote a frank and trenchant criticism of the work exhibited in the annual exhibition of the Australian Art Association (a body of professional artists founded in 1912) and of Australian art in general, which was published in the Melbourne Herald[6] and sparked off a Press controversy. Sir Keith Murdoch suggested an exhibition of colour reproductions of modern masters which was held in December 1931 in the Assembly Room of the Herald building, and opened by Mr Theodore Fink (aged seventy-six), the man who in his thirties had been such a staunch supporter of the Heidelberg School. Apart from colour reproductions of work by Cézanne, Van Gogh and Gauguin, the exhibition included original work by Matisse, Picasso, Utrillo, Dufy and Modigliani, all obtained from private owners. Lectures were given by Bell,

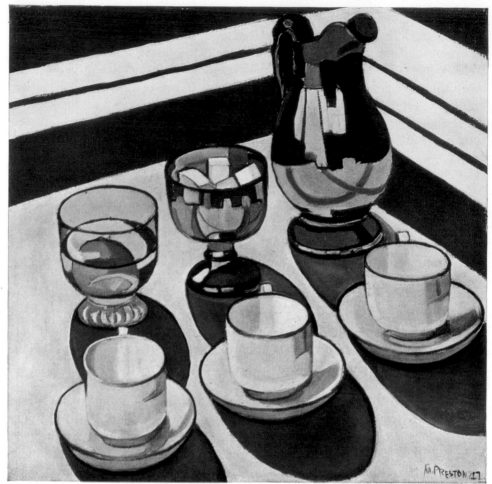

117 MARGARET PRESTON, *Implement Blue*, canvas, 16¾ x 17,
1927, Sydney, gift of the artist

Frater and Shore. The wide public interest in the exhibition played a part
in the creation of the Contemporary Group of Melbourne which was formed
by George Bell the following year. Its first exhibition, in August 1932, in-
cluded work by William Frater, Arnold Shore, George Bell, Adrian Lawlor,
Daryl Lindsay, Eric Thake, Isabel Tweddle, Ada Plante and Eveline Syme.

The work of most members of the new group was well known from their
participation in other exhibitions, but the group itself helped to make the
modern movement an articulate force in the Melbourne art community.
Critical reactions to the first exhibition varied. To Arthur Streeton, now aged
sixty-five and a critic on the *Argus*, the exhibition represented retrogression
rather than progress. His review traced what he believed to be the true
progress of Australian art from Buvelot through Roberts, McCubbin, Mel-

drum and others, to Ernest Buckmaster. 'Mr Buckmaster', said Streeton, 'is taking the lead . . .' But concerning the exhibitors in the first Contemporary Group exhibition he wrote: 'Some . . . seem to hide their gifts with misshapen representations of humanity, flowers, trees and architecture. . . . Much of this painting is done just to attract attention. . . . This exhibition expresses no fresh direction'.[7] But not all the artist-critics of the older generation had joined the ranks of reaction. Blamire Young, then aged seventy-eight and the art critic on the Melbourne *Herald*, wrote a sympathetic and discrimating review, and his concluding remarks are worth quoting in full.

We have been indifferent, and now the anaesthetic of indifference has been overcome, and we are on our way. Under the drug of academism we have perhaps painted with the mindlessness of the sleep-walker, but that is over. One does not necessarily go out and weep because our beliefs have been betrayed. The love-birds die in the cage, the rose mildews in the bud, but we live on. Forward the Rebels![8]

Four years later Young died having helped not a little in his quiet way, since his arrival in 1885, to civilize his adopted country.

The first exhibition of the Contemporary Group was devoted chiefly to work based on post-impressionist principles. Intimations of surrealism, however, appeared in some still life paintings by Eric Thake (118); Blamire Young in his review noted the influence of Chirico and Wadsworth. Thake was one of George Bell's most talented pupils and possessed a splendid sense of design, firm and lucid, sensitive in tone and colour. Australia has not produced a graphic artist with a finer feeling for pure line. His surrealism was predominantly English in its derivation and restraint; its light airy fantasy providing a delicate foil to the firm sensitive economy of his designs.[9]

A sense of adventure and experiment in art had arisen in Melbourne. Already in December 1930 Adrian Lawlor held a one-man show at the Riddell Gallery in Little Collins Street. He had arrived from England in 1910, studied drawing at the Gallery School and painting with A. D. Colquhoun, Frater, and later George Bell. The paintings, considerably more *avant-garde* than anything shown in Melbourne before, drew publicity,

118 ERIC THAKE, *Bluebells, Blue River, Upper Murray*, oil, 16 x 20, 1932, Miss Leslie Henderson

N

119 SAMUEL ATYEO, *Organized Line to Yellow,* canvas, 26¾ x 21¼, *c.* 1934, National Collection, Canberra

quickened interest and were adversely criticized by Streeton. At the Gallery, where Bernard Hall's long reign as Director, Head Teacher and Felton Bequest Adviser for forty-odd years was drawing slowly to an end, students were beginning to question the authority of tonal naturalism. In 1932 Samuel Atyeo, an able Gallery student expected to win the Travelling Scholarship, dramatically renounced academic art by submitting a painting of nudes in the modern manner. Hall, breaking an old tradition, refused to hang it in the Gallery with other entries. Atyeo thereupon had it displayed in a Little Collins Street shop window, where it aroused much discussion and Press publicity. Having broken with academic art Atyeo experimented in turn with Cézanne, Van Gogh and Picasso, moving increasingly towards non-objective art. His *Organized Line to Yellow* (119) was one of the first truly non-objective paintings produced in Melbourne. Atyeo left Australia a year or two later, making no further contribution to contemporary art in Australia. One of his fellow-students, Moya Dyring, also broke with her Gallery training and was, perhaps, the first artist in Melbourne to experiment with cubism. Her first one-man show was opened at the Riddell Gallery by Mr Justice Evatt, of the High Court of Australia, who was to become one of the most prominent and persistent supporters of *avant-garde* art in the country.

In Sydney an art school devoted to the principles and practice of contemporary art was also opened in 1932. It was run jointly by Grace Crowley and Rah Fizelle. Miss Crowley had been a student and later an assistant at Julian Ashton's school. Between 1927 and 1931 she studied abroad mostly in France under André Lhote and Albert Gleizes, from whom she gained some understanding of cubism and the post-cubist trends in painting (120). The Crowley-Fizelle school was more constructivist in its approach, more interested in the geometric organization of form and in dynamic symmetry than the Bell-Shore school. It was more *avant-garde,* but less influential in the training of artists and the formation of taste in Sydney than the Bell-Shore

school in Melbourne. But it did provide facilities for students seeking an introduction to the principles and practice of contemporary art. The establishment by Dorrit Black, a South Australian, of the Modern Art Centre in Margaret Street, Sydney, in the early 1930s, also helped to promote the abstract-cubist-constructivist trend in contemporary art in Sydney. Dorrit Black, like Grace Crowley, had studied under Lhote and Gleizes. The first exhibition of Ralph Balson, one of Australia's early abstract painters, was shown at the Centre (121). During the early 1930s, too, the exhibitions held at Ball Green, Turramurra, the home of Ethel Anderson, a writer and poet, also helped to widen the circle of interest in modern work.

120 GRACE CROWLEY, *Woman*, canvas, 29½ x 21½, c. 1936, Mrs H. V. Evatt

Exhibitions of work by Roland Wakelin, Grace Cossington Smith and others were held. Frank Hinder and his wife, Margel, became members of the circle of artists interested in cubism, constructivism and abstract art when they arrived from America in 1934. By that time it included Grace Crowley, Rah Fizelle, Dorrit Black, Frank Weitzel and Eleonore Lange. Frank Hinder, after two years at the East Sydney Technical College (1925-27), studied at the Art Institute of Chicago in 1927 and then between 1927 and 1929 at the New York School of Fine Arts and the Master Institute of Roerich Museum, where he was taught by Howard Giles and Emil Bisttram. Through these two teachers both Hinder and his wife were brought into contact with cubism, futurism, Kandinsky, the Bauhaus, and the murals of Rivera and Orozco. About 1934 the Sydney constructivist circle became deeply interested in relating movement to design; and was stimulated by such books as Jay Hambidge's *Dynamic Symmetry, The Greek Vase* (1920) and Irma Richter's *Rhythmic Forms in Art* (1932). They were, of course, as much interested in sculpture and three-dimensional construction as in painting, and Eleonore Lange's investigations into the problems of dynamic sculpture and light were closely related to the central interests of the circle. Miss

121 RALPH BALSON, *Painting*, wood panel, 30 x 40,
1954, University of Melbourne

Lange was a sculptor and art educationist from Frankfort-on-Main. During the 1930s and early 1940s she lectured and wrote a great deal, apart from her own work, bringing a keen, perceptive sympathy to her subject. She did much to raise the level of understanding in art in Sydney by asserting international values and the aesthetic equality of style, and played a most significant role in creating an informed audience for contemporary art, especially abstract and non-figurative painting and sculpture.

In 1937 Frank Hinder held a one-man show at the Grosvenor Galleries, Sydney, which reflected his New Mexican experience, his interest in dynamic symmetry, and contained a number of non-objective paintings. Then in August 1939, at Miss Lange's suggestion, the circle held an exhibition of work called Exhibition I at the David Jones Galleries, Sydney. It included paintings by Ralph Balson, Grace Crowley, Rah Fizelle, Frank Hinder and Frank Medworth; and sculpture by Margel Hinder, Eleonore Lange and Gerald Lewers. The exhibition, opened by Mr Justice Evatt, contained in its catalogue a foreword by Miss Lange. In neo-classical art, she asserted, colour was determined in area, tone, value and line by its capacity to suggest dimension, and the system of composition was fixed by the use of vanishing points. The impressionists used an order based on atmospheric perspective. It was Matisse who first offered a new system of order which replaced vanishing points and atmospheric perspective by the picture plane itself. Modern painters, Miss Lange added, 'used a scene or

122 ARNOLD SHORE, *The Vegetable Garden*, canvas, 19½ x 23½,
1939, Melbourne

123 FRANK HINDER, *Fishermen Hauling Nets*, egg tempera,
17 x 24, 1939, Dr and Mrs R. Stiel

a posed model only to elaborate its inherent colour sensations into an artistic theme of colour relations', and were 'abandoning the representation of objects in order to establish a new realm of visual existence'.

It was intended to follow Exhibition I with others annually but, with the formation of a northern division of the Contemporary Art Society and the outbreak of war, the idea was abandoned. Individual members of the circle continued their researches into geometric and abstract form. In 1944 Grace Crowley, Frank Hinder, Gerald Ryan and Ralph Balson held an exhibition of *Constructive Paintings* at the Macquarie Galleries, Sydney. Another exhibition of abstract paintings was held at David Jones Gallery in 1948; but group exhibitions of abstract work were infrequent prior to 1956.

The modern movement developed later in Melbourne than in Sydney, and in Sydney it revealed a greater tendency to experiment in constructivist and abstract or semi-abstract form. But in Melbourne the course of modern art through the 1930s became more of a public matter, was more fraught with disputation than in Sydney, and in Melbourne, too, it developed greater independence and greater vitality. When, in the late 1930s, the authority of reaction to determine the course of Australian art was successfully challenged, it was in Melbourne that the crucial battle was fought. That this was so is due perhaps more than anything else to the differing personalities of Sydney Ure Smith and George Bell. Ure Smith, friendly, cautious, and tolerant by nature, the statesman of the Australian art world as he was called by William Moore, did not allow his interest in new work to ossify or his taste to harden. As the President of the Society of Artists he was determined that it should not lose touch with progress, experiment and change. As the editor of *Art in Australia* he gave cautious but continuous support to the modern movement, and was more tolerant of *avant-garde* thought than the Sydney Press prior to 1938. He maintained a friendly liaison between the Contemporary Group and the Society of Artists; and during the 1930s artists who had contributed to the growth of the modern movement, Arnold Shore, Roland Wakelin and John D. Moore, for example, were elected to membership of the Society of Artists. Indeed the Society became under his presidency an Academy, the door of which was never completely shut to innovators who found the prestige of its status not unacceptable. This process of electing artists possessed of originality to membership of the Society was speeded up during the 1940s when the principles of the modern movement had become widely accepted by critics and the informed public. It prevented the emergence of influential individuals and groups likely to challenge the status of the Society. The Sydney constructivist circle of artists, absorbed and preoccupied by their experiments with form and design had, of course, no such intention. Had they done so, they would doubtless have been invited to become members of the Society.

That the Australian Academy of Art failed, as we shall see, was due in no small measure to the fact that it was superfluous. When the Australian Academy was founded in 1937 the Society of Artists had been operating as the *de facto* Australian Academy of Art for many years.

In contrast to Sydney Ure Smith, George Bell was more the artist, teacher and man of principle who had worked out his own aesthetic position, not without difficulty, during a lifetime. He was less of a tactician, less ready to compromise than Ure Smith, and more ready to challenge established views, whatever their authority, if he thought they were wrong. Like Meldrum, and the professional artists of his generation, he possessed a profound distrust of laymen claiming to be well-informed critics of art. Perhaps it is not surprising if, therefore, under Bell's leadership during the 1930s, the youthful modern movement in Melbourne developed a greater independence, a greater sense of adventure and more vitality than the corresponding movement in Sydney.

The Formation of the Australian Academy of Art and the Contemporary Art Society

The contemporary movement did not emerge as a force strong enough to challenge the authority of academic naturalism until 1937 when it united all elements opposed to the formation of the Australian Academy of Art. The Academy was formed at a meeting held in Canberra in 1937 at which Mr R. G. Menzies, then the Commonwealth Attorney-General, presided. The expressed aim of the Academy was 'the recognition of art in Australia as something significant for the whole of the Commonwealth and knowing no State boundaries'. It claimed to be a national institution with the sole purpose of furthering art appreciation and art education, and set itself up as a 'champion of the rights of individual and associated artists'.[10] Fifty foundation members from the leading art societies were appointed and a council of ten elected, five representing the northern division embracing New South Wales and Queensland, and five representing the southern, embracing Victoria and the other States. The inaugural exhibition was held in Sydney in April 1938 and the second in Melbourne a year later, in the National Gallery of Victoria.

The creation of the Academy created a sharp division among artists. It was felt by many that the real purpose of the Academy was to strengthen the power of the establishment and stifle contemporary forms of expression. Apart from this many, including several well-known academic painters, opposed the Academy on the principle that academies by their very nature stifle originality and progress in the arts.

There were strong grounds for suspecting that the Academy would be no friend to contemporary art. Its Council was composed of men who had

written sharp criticism of the *avant-garde* styles beyond post-impressionism, and included some moderates who spoke of including in academy exhibitions 'any and every point of view that was reasonably sound'.[11] But the Academy was, of course, to decide what was sound and what was not. It failed, however, to become a truly representative body even of the older and more conservative artists. Its membership did not include, for example, Julian Ashton, Sir Arthur Streeton and Norman Lindsay and it did include a large number of popular portrait and landscape painters who had made no creative contribution to Australian art whatsoever. Among well-known artists who were invited to join and refused were: Rupert Bunny, George Bell, Daryl Lindsay, Charles Wheeler and Napier Waller.

The key to the situation lay, to a large extent, with the leading post-impressionist painters who, by 1937, had become widely accepted by the older generation of Australian artists and the critics as 'sane' modernists, and were at the same time held in respect by the *avant-garde* as artists who had pioneered the break with academic naturalism. Most of them, however, together with artists once associated with Lambert and the Sydney Contemporary Group, accepted invitations to join, including Douglas Dundas, Adrian Feint, William Frater, Vida Lahey, Kenneth Macqueen, Arthur Murch, Margaret Preston, Thea Proctor, Arnold Shore, Grace Cossington Smith and Roland Wakelin. None of the pioneers of post-impressionism, however, was represented on the Academy's first Council. In April 1937, some months before the Academy was formed, James Quinn, then the President of the Victorian Artists' Society, an artist of the older generation who brought a tolerant mind to modern painting, asked Mr Menzies to open the Annual Exhibition of the Society, and on that occasion Mr Menzies said:

You all know of the proposal to form an Academy of Art in Australia. I must admit that I was the prime mover in this idea. I feel definitely that some authority and body should be formed here as in other countries. Every great country has its academy. They have set certain standards of art and have served a great purpose in raising the standards of public taste by directing attention to good work. This exhibition indicates that the Victorian Artists' Society is encouraging people in every type of painting. Experiment is necessary in establishing an academy, but certain principles must apply to this business of art as to any other business which affects the artistic sense of the community. Great art speaks a language which every intelligent person can understand. The people who call themselves modernists today talk a different language.[12]

Now James Quinn had invited members of the Melbourne Contemporary Group to exhibit, an entire wall was hung with their paintings and many were present in person. Mr Menzies' remarks naturally enough aroused considerable consternation among them and their friends. Quinn, who had himself been invited to join the Academy, publicly dissociated himself on

the spot from Mr Menzies' remarks on modernism. But the challenge had been given, and it was accepted.

The opening speech gave rise to a Press controversy. Norman MacGeorge, a landscape painter of the older generation who had long possessed a lively interest in contemporary art, began it by expressing the opinion in the *Argus* that Mr Menzies intended the Academy to be a disciplinary measure aimed at those whose conception of art was not his.[13] 'I realize', Mr Menzies wrote in a reply two days later, 'that an academy should find room in its member-ship for all schools of artistic thought, provided they are based on competent craftsmanship'.[14] Thereupon George Bell entered the lists:

What does a layman know of craftsmanship or draughtsmanship . . .? Just as it would be ludicrous for an artist to argue a knotty point of law, so it is ludicrous for Mr Menzies to lay down what is good drawing and good art. . . . Academies have been, throughout history, reactionary influences. Art is always growing. An Academy sets out to standardize art. As soon as that is done art is dead. An Academy sets out to be conservative in its very essence. It sets its face against a furthering of knowledge gained by experiment. Every great artist has been a 'rebel', as an experimenter is always called.[15]

To this Mr Menzies replied:

. . . Mr Bell cannot have it both ways. If the artists of Australia expect the educated public to display some interest in their work they must expect the same public to form some opinion of that work, and to express it. . . . As to the reactionary influence of academies, I can only repeat what I said when opening the Victorian Artists' exhibition last week. That was that the Royal Academy in London numbered among its members since 1778 Reynolds, Gains-borough, Hoppner, Turner, Sargent, Raeburn and Augustus John. I will be surprised to learn that these painters whose work is intelligible and, indeed, exciting, even to an individual like myself, are to be regarded as the reaction-aries of British art during the last one hundred and fifty years.

I am sorry that Mr Bell should have been so angry as to forget his customary good manners. No doubt he is quite correct when he says that I am not myself a painter. He might be right when he says that I have a pedestrian mind. But in spite of these disabilities the fact remains that I am a typical person of moderate education, I hope reasonably good taste, and a lifelong interest in the fine arts.

In other words, with all my individual defects, I represent a class of people which will, in the next one hundred years determine the permanent place to be occupied in the world of art by those painting today.[16]

The Press controversy continued vigorously for weeks, with Mr Menzies, Max Meldrum, J. S. MacDonald and Harold Herbert ranged on one side, and Norman MacGeorge, Adrian Lawlor, Basil Burdett, Sali Herman and Mr Justice Evatt on the other. Evatt, in opening one of Moya Dyring's exhibitions, made a plea for modern art. 'The Australian galleries', he said, 'should be induced to buy or borrow modern pictures'.[17] The Director of the

National Gallery of Victoria, J. S. MacDonald, a most vociferous opponent of modernism, attacked the suggestion. 'I don't think', he said, 'we should have modern art in the gallery at all. It is not liked by the art galleries of Australia'.[18]

The controversial atmosphere of the time was splendidly captured by Adrian Lawlor. Possessing wide interests in all the arts and an admirable contempt of self-appointed experts, Lawlor had opposed isolationism and provincialism in Australian culture since the days when he had written in *Vision* in the early 1920s. His pamphlets, *Arquebus* (1937) and *Eliminations* (1939), attacked the idea of an Australian Academy of Art with an explosive mixture of learning, buffoonery, pastiche and wit. They have become landmarks in the history of Australian taste.

The Contemporary Art Society

In July 1938 George Bell began to organize opposition to the Academy. He addressed a printed leaflet, entitled *To Art Lovers,* to a large number of sympathetic artists and laymen proposing the formation of 'a society which will unite all artists and laymen who are in favour of encouraging the growth of a living art, who are determined both to prevent any dictatorship in art and to nullify the effect of any official recognition acquired by a self-constituted Academy'. He suggested also that the new society should stimulate public interest in living art, broaden national policy to ensure the purchase of contemporary masterpieces, seek the removal of customs duties on art works, provide lectures and hold an annual exhibition of contemporary work by artist members. An inaugural meeting was held at the Victorian Artists' Society rooms on 13 July 1938 at which a new society, the Contemporary Art Society, was founded, with George Bell as the President, Rupert Bunny as the artist Vice-President, John Reed as the lay Vice-President, and Adrian Lawlor as the Honorary Secretary.

The Society proclaimed that its primary and paramount object was to encourage and foster contemporary art:

By the expression 'contemporary art' is meant all contemporary painting, sculpture, drawing and other visual art forms which is or are original and creative or which strive to give expression to progressive contemporary thought and life as opposed to work which is reactionary or retrogressive including work which has no other aim than representation.[19]

The new Society, which brought together all groups of opinion in Melbourne opposed to the formation of the Academy, was a heterogeneous body from the beginning, and soon developed three main groups of opinion. First, there were those who looked to George Bell as their leader. Their approach to modern art was based primarily upon post-impressionist prin-

124 WILLIAM FRATER, *Portrait of Adrian Lawlor,*
canvas, 29¾ x 17⅝, 1930, Sydney

ciples. Most of them would probably have agreed with Bell's definition of
modern art as 'an artist's personal experience expressed on a surface in
terms of his material—that is design in form—reinforced by colour, and pre-
senting a perfect balance of opposing forces which produces a work satis-
fying an eternal instinct in the aesthetically receptive mind'.[20] Most of the
artists to join the Society first, many of them Bell's students, belonged to the
group.

By 1938, however, the post-impressionism which George Bell stood for
did not represent the most advanced form of contemporary art in Australia.
Lively *avant-garde* groups influenced in various ways by dada, naïve paint-
ing, surrealism, cubism, social realism, expressionism and abstract art were
beginning to make their appearance in the years immediately prior to the
outbreak of war. They found a patron and champion in John Reed (*b.*
1901), a law graduate of Cambridge and Melbourne who began to take a
deep interest in the promotion of *avant-garde* art from the time he settled

in Melbourne in 1925. He and his wife, Sunday, assisted, encouraged and bought the work of many young and virtually unknown artists; and in so doing established an *avant-garde* circle of Melbourne painters, the most prominent of whom were Albert Tucker, Sidney Nolan, Arthur Boyd and John Perceval.

A third group in the Society, consisting of social realist painters, included Noel Counihan, V. G. O'Connor, Josl Bergner, Harry de Hartog and others. Sympathetic to socialism and communism they sought to engage the Society where possible in Popular Front political and cultural activity. During the early years of the Society's existence they maintained an uneasy alliance with John Reed and his circle (most of whom possessed left-wing sympathies) against George Bell and his supporters who were strongly opposed to the intrusion of politics into the Society.

Conflict arose early between Bell and Reed and their respective supporters over the question of the rights and powers of lay members. George Bell, like Max Meldrum, held no high opinion of laymen as critics or judges of art. The issue came to a head over the appointment of a selection committee. Some opposed the idea of any selection committee as being alien to the broad principles of the Society. Bell and his supporters desired a selection committee composed entirely of artists. This was agreed to, with the proviso that the laymen be allowed to submit any *one* picture rejected by the committee for reconsideration. Under this provision a painting by Sidney Nolan entitled *Rimbaud*, at first rejected, was hung in the first exhibition.

The exhibition which was held in the National Gallery of Victoria in June 1939, and opened by Mr Justice Evatt, gave rise to considerable controversy. It was also important in introducing a new generation of artists to the public; a generation that was passing beyond post-impressionism. Among the more prominent artists who exhibited some of their earliest work were: Sidney Nolan, James Gleeson, Russell Drysdale, Peter Purves Smith, Sali Herman, Albert Tucker, Noel Counihan, V. G. O'Connor and David Strachan. The success of the exhibition encouraged the Contemporary Art Society to establish branches in other States; and later in the year Mr Peter Bellew, a lay member of the Society, visited Sydney and helped to establish a branch there, with Rah Fizelle as the President.

Meanwhile, conflict over the rights of laymen in the Society continued. The constitution provided that not more than two-thirds of the Council of twelve should be artists, but no restriction was placed upon the number of laymen who might serve. Bell, disturbed at the possibility of an entirely lay Council, called a special general meeting to alter the constitution; but was defeated by John Reed's circle acting with the social realists and their lay followers. Bell, increasingly distressed by the growth of lay influence and communism within the Council and among the Society's members, resigned,

first from the Presidency, and (at the annual general meeting of 1940) from the Society itself, together with eighty-three artists.

The division that thus rent the Contemporary Art Society so soon after its foundation was not due entirely to a difference between personalities or to disagreements about the rights of laymen and the place of politics in the Society. Beneath the disagreements lay a fundamental difference concerning the role of the artist in society. The post-impressionists abhorred politics in art. But to the dadaists, expressionists, surrealists, and social realists, artistic revolt against established values tended to be viewed as but one part of a more general revolt that possessed psychological, social and political aspects. In one sense the departure of the George Bell group from the Contemporary Art Society foreshadowed the artistic character of the war years. During the 1920s and 1930s the modern movement in Australia tended to be classical and impersonal in its manifestations, pre-occupied with the achievement of significant form in one way or another. It did not believe that the artist should involve himself too closely with the problems of life, religion, society and politics. But during the war years the tenor of art and life changed remarkably. The temper of the contemporary movement in art changed from one of classical impersonality to one of romantic involvement. Post-impressionism and the burgeoning experiments with cubism, geometric and abstract form were overshadowed in the new situation by romantic forms of contemporary art such as surrealism, social realism, realistic expressionism and neo-romanticism that were to dominate the 1940s. The change was foreshadowed in the work of Danila Vassilieff.

Vassilieff (1897-1958) was born in Kagalinitskaia, Rostov-on-Don, into a family of Cossack farmers. At the age of twelve he entered a military academy at St Petersburg and fought on the Eastern Front during the First World War. The October Revolution found him in Denikin's army in which he attained the rank of Lieutenant-Colonel. Captured by the Bolsheviks with the remnants of his regiment in 1921, he was imprisoned at Baku but later escaped and lived for a time with nomadic Tartars in Azerbaijan, and later in Persia. From thence he made his way through India, Burma and Manchuria to China; living for a time in Shanghai. In 1923 he decided to come to Australia. In Darwin he gained a Government contract to construct fourteen miles of railway line near Katherine. From this venture he was able to buy some land near Tully in northern Queensland and clear it for sugar-cane and bananas.

In Australia in 1923 Vassilieff had begun to paint as a hobby, and in 1929, wishing to learn more about art, he left the country for Rio to join an old friend, Dmitri Ismailovitch, who had served in his Cossack regiment and later made a name for himself as an artist in Brazil. Vassilieff shared his friend's studio for two years, painting from plaster casts and

125 DANILA VASSILIEFF, *A Street in Fitzroy*, plywood
panel, 14⅞ x 17¾, 1937, Mr and Mrs John Reed

still life groups and learning to glaze, while employed as an engineering
draughtsman with the Anglo-Persian Oil Company. Becoming increasingly
dissatisfied with Ismailovitch's conventional approach to painting, he began
to experiment with more direct and expressive techniques that would bring
him into closer contact with life. He wrote later:

I worked like a slave . . . day and night, in every spare moment. And then I
realized after two years of nothing but apples and bananas and pumpkins and
plaster casts, that it was all a waste of time, it was meaningless to me, it was
not what I wanted to do at all. That was dead life and I wanted to paint living
life, life and nature and people in action and movement.[21]

He went on a painting excursion along the Amazon, and in 1932 painted
in British Guiana, Dutch Guiana, and Venezuela, holding his first exhibition
in the palace of the Bishop of Guiana at Georgetown. In 1934 he toured the
West Indies; Trinidad, Jamaica, Haiti, Santo Domingo, Puerto Rico, Mar-
tinique and Barbados, painting landscapes, seascapes, street, market and
slum scenes in a direct, lively and colourful manner. His exhibitions were
very well received and, encouraged by Alfred Mendes, a collector and
connoisseur, he proceeded to London where he held an exhibition of West
Indian paintings at the Albany Gallery in 1934. The following year he visited
Spain and Portugal. On returning to London he exhibited at the Wertheim

Gallery, and six months later at Prince Galitzin's Gallery. There his work was favourably received by several critics including Jan Gordon of the *Observer*.

Then he decided to return again to Australia. Arriving in Sydney in 1936 he worked as the foreman of a gang laying pipe-lines for the Water Board, and painted street scenes around Woolloomooloo and Surry Hills. He held two exhibitions of his work at the Macquarie Galleries in that year.

In 1937 Vassilieff moved to Melbourne, lived for a time in Fitzroy (125) and held an exhibition in September at Riddell's Gallery. It was opened by John Reed, who became a close friend and patron. Then he took up his post at the Nield School, Warrandyte, where he remained until it closed in 1946. Vassilieff continued to hold annual exhibitions in Melbourne until his death in 1958.[22] During the last eight years of his life he produced some notable sculpture.

Vassilieff possessed the prodigal creative energy and vitality of a natural expressionist and his work moved inevitably towards expressionism from the time he began to follow the bent of his own genius. He was passionately fond of Byzantine art, epitomized for him in the work of his compatriot, Rublev; and he held the work of Goya, El Greco, Turner, Rembrandt, Rubens, Soutine and Chagall in high regard. But he had little time for Constable, the impressionists (except Renoir) and the non-objective tradition represented by Kandinsky, Mondrian and the Bauhaus School. These artists represented for him what he called 'ghastly good taste'. His exhibitions in Sydney and Melbourne were always well attended by younger artists and students and there can be no doubt that he was a pioneer of expressionist painting in Australia. His painting of street scenes in Sydney and Melbourne also foreshadowed a theme prominent among social realists in Australia. The freedom, verve and immediacy which he brought to his painting exercised an influence upon Australian art, especially in Melbourne, which it is difficult to estimate. The fact that *avant-garde* art in Melbourne developed during the war years a character more thoroughly expressionistic than Sydney, tended to be more immediate in execution, lay greater score upon vitality and less upon the post-impressionist tradition, was probably due not a little to his work and example.

The 1930s were years of transition between one phase of Australian art and another. From the time Norah Simpson brought back some knowledge of the paintings of the *Ecole de Paris* to the art students of Sydney, local academic art had been modified by a steady intrusion of contemporary ideas. But the modifications did not penetrate deeply enough to influence the public taste profoundly. The art-buying public still remained, for the most part, faithful to the older ideals: Streeton, Heysen and Gruner continued to supply most Australians with the image of the country they had come to love, an heroic or Arcadian idyll into which neither tragedy nor any dark

126　NOEL COUNIHAN, *Portrait of William Dolphin, the Violinmaker*,
oil on hardboard, 40¼ x 34¼, 1945, Newcastle

passion of the spirit had entered. It was not until the eve of the Second
World War that a new generation, and the artists who were to speak for it,
found the Heidelberg dream out of touch with the reality of their lives. It
was from their quite different, and perhaps deeper, experience of life that
Australian art was reborn.

NOTES

1 SYDNEY URE SMITH, 'Recent Purchases for the National Art Gallery of New South Wales',
AA, iii, 55 (May 1934), pp. 8-12

2 See AA, iii, 48 (February 1933), p. 46; and iii, 49 (April 1933), pp. 6-8

3 As illustrated in AA, iii, 60 (August 1935)

4 LIONEL LINDSAY, 'The Loan Exhibition of Contemporary British Art', AA, iii, 58 (February
1935), pp. 60-2

5 ELEONORE LANGE, 'The International Art Exhibition at the National Art Gallery of New
South Wales', AA, iii, 64 (August 1936), pp. 29-36

6 The Herald (Melbourne), 7 November 1931

7 The Argus (Melbourne), 17 August 1932

8 The Herald (Melbourne), 17 August 1932

9 See also GEORGE BELL, 'Eric Thake', AA, iii, 64 (August 1933), pp. 39-40

10 Catalogue of the Second Exhibition, National Gallery of Victoria, April 1939

11 'The First Exhibition of the Australian Academy of Art', AA, iii, 71 (May 1938), 13-24

12 The Argus (Melbourne), 28 April 1937

13 The Argus, 1 May 1937

14 The Argus, 3 May 1937

15 The Herald (Melbourne), 3 May 1937

16 The Herald, 4 May 1937

17 The Herald, 3 June 1937

18 The Sun (Melbourne), 5 June 1937

19 Extract from the C.A.S. Constitution published in the inaugural exhibition (1939) catalogue

20 Quoted from LAWLOR, Arquebus, Melbourne, 1937, p. 55

21 From 'Soldier into Artist' (f. 21), notes in typescript for a biography of the artist by
Elizabeth Vassilieff, the artist's wife, to which this account is mainly indebted.

22 See also 'Daniel [sic] Vassilieff', AA, iii, 62 (February 1936), p. 70

REBIRTH

1939 - 50

*This is a period of transition; we are at the beginning of a
new cycle, and ours is a new spring.*
PAUL HAEFLIGER, *Angry Penguins*, December 1944

DURING the 1940s Australian painting reached a level of achievement it
had not previously attained. The Second World War, unlike the First, in-
vigorated the arts. The country was, it is true, cut off to some extent from
direct contact with Europe, but at this stage of the nation's development the
five years of partial isolation were profitable. Under the pressure and chal-
lenge of war Australian artists, like the nation as a whole, were thrown
more upon their own resources and were quickened in spirit by the events
they lived through. In Sydney a new generation of artists, fully trained and
with years of European experience behind them, began to work. In
Melbourne a group of young *avant-garde* artists brought vitality and a sense
of adventure to the art of a city noted during the present century for its
conservatism in matters of taste. Contact with the art world abroad, re-
opened during the previous decade, was sustained through books and the
movement of service personnel but most of Australia's leading artists were
at work in their own country. Artists and writers came to mean more to the
nation in this war than they had meant in the First World War or in the
peace between the two. Magazines like *Meanjin* and *Angry Penguins*,
indicative of the intellectual ferment of the time, sprang up and flourished.
Noting the decline in art publication in Europe, *Art in Australia* announced
in March 1941 with brave and touching ambition that it would now embrace
the art of the whole world. 'Art cannot die, and we in Australia can and will
carry on our efforts to preserve, encourage and foster the culture our enemies
would destroy.'[1] Art did not die; but *Art in Australia* did, after five more
issues in the year following, having overreached itself in a pyrotechnic dazzle
of luxury publication that covered everything from Masaccio and Sung
porcelain to Moore and Sidney Nolan. But after two decades of isolation
such ambition to reach international standards quickly was characteristic
of the intellectual adventuring of the time.

Though for most Australians the arts were still exotic curiosities of the

mind, there was, none the less, a widespread interest in all the arts among servicemen. *Salt*, the fortnightly magazine of the Army Education Service, did something to satisfy this interest and maintain contact between the arts and the services. Official war artists were not, as in the First War, chosen so largely from the ranks of the conventional portrait painters and illustrators, nor were visual war records confined to the portrayal of officers, war heroes, and the glorification of martial sacrifice. Life in the services and the industrial face of the nation at war was also included and produced some of the best work. Furthermore, despite the inevitable tragedies, irritations and frustrations of the time, most artists managed to draw and paint their way through the war years. The war, in short, brought with it a serious threat to the nation's independence which with the aid of its allies it met successfully: the challenge was great enough to stimulate, not great enough to suppress, artistic expression.

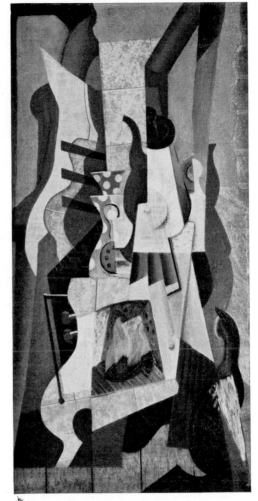

127 ERIC WILSON, *Stove Theme*, canvas, 36½ x 21, 1942, Brisbane

New Arrivals in Sydney 1938-40

Between 1938 and 1940 the whole climate of artistic opinion and practice in Sydney was affected radically by the return of a new generation of students from abroad, and the arrival of a number of important artists, teachers and designers from England and the Continent. During the 1920s and early 1930s Julian Ashton, towards the end of a long lifetime of distinguished teaching produced, together with his faithful partner, Henry Gibbons, a highly talented group of students. Among the most prominent were Grace Crowley, Rah Fizelle, William Dobell, John Passmore, Jean Bellette and Paul Haefliger. Crowley and Fizelle returned, as we have seen, during the early 1930s, to play a significant role in the early history of the

contemporary movement in Sydney. Passmore did not return until 1950. But Dobell, Haefliger and Jean Bellette all returned in 1939. Dobell had studied at the Slade, Jean Bellette and Haefliger at the Westminster School under Bernard Meninsky and Mark Gertler. The Westminster School had acquired a reputation for its teaching, was looking very much to Paris, but was also paying great attention to classical composition and the achievement of 'volumes'. The school attracted other Australian students, too, such as Eric Wilson, who had studied at the East Sydney Technical College and won the New South Wales Travelling Scholarship for 1937; and Donald Friend, who had studied under Dattilo Rubbo and Sydney Long. Wilson, a pioneer in Sydney of cubist and abstract painting, returned in 1939 (127); Friend returned in 1940, after he had worked for two years in Nigeria. Students from George Bell's school also moved to and settled in Sydney: Sali Herman in 1938, Russell Drysdale in 1940, Wolfgang Cardamatis and David Strachan a little later.

And there were others; artists, teachers and designers, who returned or arrived in the city on the eve of the Second World War. Desiderius Orban, a Hungarian artist and art teacher, and a foundation member of the group, *Nyolcak*, established in Budapest in 1908, settled in Sydney in 1939, and later opened an art school in which the role of the creative imagination in the practice of art was given first place. Frank Medworth, an English art master, engraver and painter, took charge of the East Sydney Technical College in 1939; and worked unceasingly both in the school and the city to introduce a more tolerant approach to contemporary forms of expression. Hal Missingham, a former student and teacher at the London Central School of Arts and Crafts, a graphic artist, designer, and water-colour painter, settled in Sydney the following year. Carl Plate, after several years abroad, arrived and opened the Notanda Galleries, a print and book shop intimately associated with the growth of the contemporary art movement in Sydney. Elaine Haxton, trained at East Sydney, returned after some years abroad in 1939, full of enthusiasm for the murals she had seen in Mexico on her way home. Dahl and Geoffrey Collings, R. Haughton James and Richard Beck began the slow and difficult process of introducing the principles of contemporary design into Australian industry.

Almost every one of these arrivals in Sydney was a professional artist, and most had received a complete academic training but had come to understand the broad principles upon which contemporary art was based. During the early 1940s, whether serving in the Forces or not, they were able to effect a radical change in the theory and practice of art in Sydney. An international outlook replaced a provincial one, while the pressures and urgencies of war brought a maturity and depth to art in Sydney that it had not experienced before. Two broad trends are observable during the 1940s,

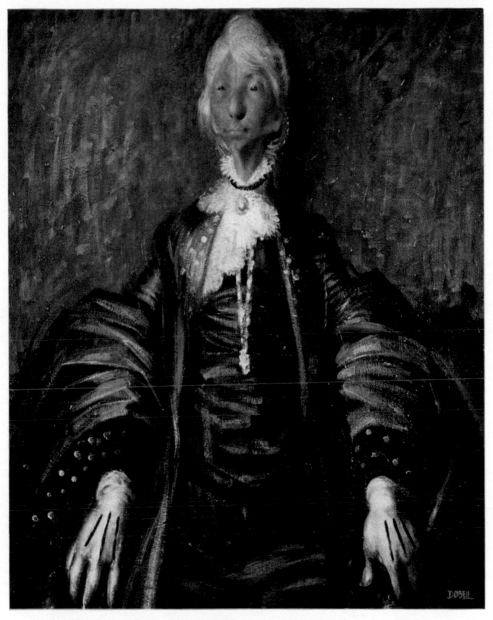

128 WILLIAM DOBELL, *Dame Mary Gilmore, O.B.E.*, hardboard, 36 x 29, 1955-57,
Sydney, gift of Dame Mary Gilmore

trends that sprang from the diverse interests and temperaments of the new arrivals. One trend might fairly be called realistic expressionism, and the other neo-romanticism. The realistic expressionists, who were equally if not more prominent in Melbourne, brought an expressionistic idiom to the interpretation of life about them. The neo-romantics, more prominent in the immediate post-war years, explored historical styles; especially the Byzantine, the *trecento*, the *quattrocento* and Persian art, with a new freedom deriving from contemporary principles.

Surrealism

The Sydney branch of the Contemporary Art Society was established late in 1939, and the new arrivals in Sydney joined it in force, so that oddly enough, despite the resignation of Bell and his eighty-two artist supporters, the second (1940) exhibition of the Society, which was held both in Melbourne and Sydney, was one of the most representative and important exhibitions the Society ever held. The exhibition introduced to the art public of Sydney a generation of artists who were to determine very largely the standards and taste of the city in the visual arts during the 1940s, and it represented a landmark in the history of Australian art in that the contributors both from Melbourne and Sydney revealed beyond all doubt the existence in both cities of a generation that had moved beyond post-impressionism.

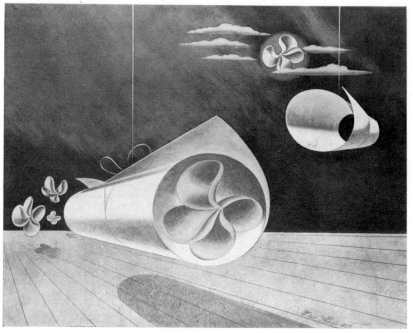

129 ERIC THAKE, *Salvation from the Evils of Earthly Existence*, cardboard, 16 x 20, 1940, Melbourne

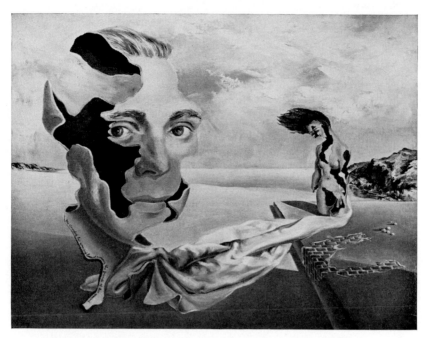

130 JAMES GLEESON, *We Inhabit the Corrosive Littoral of Habit,* canvas, 15¾ x 19½, 1941, Melbourne

Abstract work from Gordon Andrews, Dahl and Geoffrey Collings and Leonard Crawford was included; and the exhibition was notable also for its recognition of surrealism. An anonymous donor provided a £50 prize for the best picture 'showing new expression of thought in art'. Gino Nibbi, the judge, awarded the prize equally between Eric Thake's *Salvation from the Evils of Earthly Existence* (129), and James Gleeson's *We Inhabit the Corrosive Littoral of Habit* (130).

The two paintings were presented by the Society to the National Gallery of Victoria. Both artists had exhibited surrealist works before; Thake's being inspired by the more restrained English surrealism of Wadsworth, Paul Nash and John Tunnard, Gleeson's by Salvador Dali. Gleeson had studied at East Sydney and under May Marsden at the Sydney Teachers' College, who encouraged an experimental attitude in her students. Surrealist trends appeared in his student work in 1937, and he is the only Australian artist who has sought to develop his art pretty much upon surrealist lines. Possessed of poetical and critical interests he lectured and wrote a good deal during the early 1940s to make surrealism better understood. Gleeson first exhibited surrealist paintings in the inaugural exhibition of the Contemporary Art Society in June 1939; but it was the presence of Salvador Dali's *L'Homme Fleur* in Sir Keith Murdoch's exhibition of *French and British Modern Art* that brought surrealism fully to public notice in Australia. It

131 ALBERT TUCKER, *The Futile City*, cardboard, 17½ x 21½,
1940, Mr and Mrs John Reed

was the most discussed and publicized painting in the exhibition. The Cézannes were studied and respected but they did not arouse the same excitement among the younger artists. The 1940s were to be, in essence, romantic.

By 1940 quite a vogue for surrealist painting had arisen. It appeared in the work of Adrian Lawlor, always ready to experiment with *avant-garde* ideas; in the work of Herbert McClintock (Max Ebert), who held one-man shows of his surrealist work in Perth and Sydney but later turned to social realism; and in the work of Geoffrey Graham. It appeared in the work of Albert Tucker, in such paintings as *The Philosopher* (1939) and *The Futile City* (131). Tucker was also experimenting with social realism; and was to turn later to a more expressionistic style.

Following its brief period of popularity in the early 1940s surrealism did not, except in Gleeson's work, continue as a distinctive form of expression in Australian art. But it played an important part in the formation of the styles of Purves Smith, Russell Drysdale, Albert Tucker, Sidney Nolan, Arthur Boyd and the theatre designer, William Constable. Though not programmatic surrealists they have used surrealist and quasi-surrealist devices considerably in their work. The influence of surrealism was felt more strongly in poetry than in painting. *Angry Penguins,* the *avant-garde*

journal edited (1941-46) by Max Harris and John Reed, and *Comment* (1940-47), edited by Dorothy Crozier, published a good deal of surrealist and quasi-surrealist verse by Max Harris, Alistair Kershaw, James Gleeson and others. The much-publicized success of the Ern Malley hoax (1944) probably reduced the influence of surrealist *vers libre* in Australian poetry.[2]

Social Realism

Following the departure of George Bell and his supporters, the influence of social realism became more prominent in the councils and the exhibitions of the Contemporary Art Society. Social realism can be defined simply as the depiction of contemporary life from a left-wing point of view, and its prominence in Australian art during the early 1940s was due in large measure to the success of the Communist Party's united front against Fascism, and the entry of the U.S.S.R. into the war in 1941. But it must be stressed that the social realist painters were artists who believed that art and politics cannot and should not be separated. They were artists in politics, not politicians. If they found themselves, on the one hand, ostracized continuously by artists and critics who could not bring themselves to believe that it was possible to be involved in politics and paint good pictures at the same time, they also found themselves, on the other hand, continuously involved at one level or another in theoretical disputes with the members of the local Party hierarchy for whom the pronouncements of Zhdanov, and other leading communists, on cultural matters provided endless ground for discussion but none for disagreement. At its best social realism is a cathartic and moral art embraced by artists acutely aware, either through personal experience or imaginative feeling, of the existence in society of cruelty, injustice and suffering. By depicting the depressing, horrifying or squalid the artist seeks to alleviate his own sense of guilt and sharpen the feelings of others against social evil.

Social realism began in Australia as an interest in depicting street scenes and life in the inner industrial and slum areas of Sydney and Melbourne. It is foreshadowed in Danila Vassilieff's paintings in the back streets of Surry Hills, Sydney, during 1936 and 1937; and of Fitzroy and Carlton in Melbourne between 1937 and 1940. Slums and factories were the subjects mostly chosen by the short-lived Windsor Group (1938-39), Sydney, a circle of Fred Leist's ex-students.

Social realism flourished most strongly in Melbourne during the war years among a group of artists who were members of the Contemporary Art Society, the most prominent being Josl Bergner, V. G. O'Connor and Noel Counihan. Bergner was a member of a Viennese Jewish family who was taken by his parents to Poland at an early age and grew up among artists and writers. He migrated alone to Melbourne in 1937 and lived in a Carlton

attic where he began to paint street and market scenes, such as *The Pumpkin Eaters* (133), in a sombre, painterly style that owed not a little to his passion for Daumier, Van Gogh and the Picasso of the blue period. Bergner followed his street scenes with a series based on his reminiscences of life in the Warsaw ghetto and an important series of paintings of Australian Aboriginals which he completed in 1942 while employed with other aliens in an employment company. In 1947 he left Australia for Israel where he still paints.

Victor O'Connor qualified as a lawyer just prior to entering the Army in December 1941 and his training in art was confined to a short period in Bell's studio. During 1941-42, when the Melbourne social realists were producing some of their best paintings, O'Connor painted a splendid series of pictures in red-browns with a great sensitivity of touch, *The Refugees* (134), for example, on the theme of the Nazi persecutions. For another of the series, *The Dispossessed* (1942, the artist), he shared the Society's anonymous prize with Donald Friend.

Noel Counihan, the third member of the group, was a Press cartoonist and caricaturist for many years before he began to paint in 1941. He is a draughtsman of unusual skill and firm, masculine power and, though his art does not possess O'Connor's sensitivity of touch or Bergner's air of brooding tragedy, his painting has become a highly expressive instrument shrewd in its statements, deft and assured in handling. Some of his portraits, such as his magnificent portrait of the violin-maker, *William Dolphin* (126), possess great distinction.

A social realist, Harry de Hartog, succeeded George Bell as President of the Contemporary Art Society in 1940, and he was succeeded in turn by Victor O'Connor. It was at the suggestion of Noel Counihan that the Society decided upon an exhibition of anti-fascist art, which was held in the Athenaeum Gallery, Melbourne, late in 1942 and opened by J. D. Blake, the State Secretary of the Communist Party. It was intended to present a popular front among artists against fascism and ranged, therefore, from representational to abstract work. Sidney Nolan's contribution to the exhibition, *Dream of the Latrine Sitter*, created considerable consternation among some visitors who found difficulty in deciding for themselves whether an image of a private in a water-closet was a fascist or an anti-fascist gesture.

The Anti-Fascist Exhibition was also held in Adelaide by the South Australian section of the Contemporary Art Society, which had been formed in June 1942 as the result of a split between the Council and the Associates of the Royal South Australian Society of Arts on the question of contemporary art, which had culminated in a highly successful Associates' Contemporary Exhibition held in July 1942. The first annual exhibition of the South Australian C.A.S. was held in October 1943; and early exhibitions brought the

132 SALI HERMAN, *McElhone Stairs,* canvas, 26½ x 22, 1944,
Mrs H. V. Evatt

work of David Dallwitz, Douglas Roberts, Jacqueline Hick, Ivor Francis (135) and Jeff Smart to notice in other States.

Until the Anti-Fascist Exhibition, co-operation on matters of broad policy had been maintained in Melbourne between John Reed and his circle of artists and the social realists led by O'Connor and Counihan. But the exhibition deepened a rift already growing between the two groups. Reed took his stand on the fact that the Society had been brought into existence to oppose work which had no other aim but representation and disliked the inclusion of purely naturalistic work in the exhibition. The social realists, on the other hand, were highly critical of the very personal and expressionistic character of some of the work, especially Tucker's and Nolan's. Theoretically they had come increasingly to believe that most *avant-garde* art was expressive of the decadence of capitalist culture, and were seeking to unify artists against faccism whether they worked in naturalistic modes or not.

The rift became a public matter in the fourth issue of *Angry Penguins*, which appeared early in 1943 in a new format under the joint editorship of John Reed and Max Harris. It contained an article by Tucker entitled *Art, Myth and Society*. In the process of discussing the role of myth in society and the nature of the artist's freedom, he launched a trenchant but impersonal attack upon the Communist Party's approach, both in theory and practice, to art and artists:

The artist must be free from violence, regulation, coercion, want, and moral blinkers. If, in his role as a social being, he is to co-operate with any political movement, he must be assured of creative freedom at all times. Rest assured, his interpretations and beliefs will assert themselves through his work.[3]

Rejoinders, from Counihan and de Hartog, were published in the September issue of *Angry Penguins*; and the controversy which followed produced a complete break between the Reed-Harris group, which included the artists, Nolan, Boyd, Tucker and Perceval, and the social realists, Counihan, O'Connor, Bergner and de Hartog and their followers. The latter group turned increasingly to popular front activity and was largely responsible for the organization of the Australia at War Exhibition (1945) which sought to unite all artists, irrespective of their differences, in patriotic, anti-fascist activity.

A circle of realist painters that included James Cant, Roy Dalgarno, Herbert McClintock and Roderick Shaw became active in Sydney a little later than the Melbourne group. James Cant (*b.* 1911), after some art training in various Sydney studios, went to London in 1934, worked for a time with the London surrealist group associated with Roland Penrose, and painted in France and Spain before returning to Australia in 1939 to join the Army. Cant tends to take his themes from the simplest and least promising of things and paint them with a lucid spareness of vision. Street

133 JOSL BERGNER, *The Pumpkin Eaters*, hardboard,
31⅛ x 37½, *c.* 1940, National Collection, Canberra

134 V. G. O'CONNOR, *The Refugees*, cardboard,
16 x 20½, 1941, the author

135 IVOR FRANCIS, *Schizophrenia*, canvas, 32½ x 24½,
1943, Adelaide

scenes, massive and vacant; Aboriginal art; stray bits of landscape closely scrutinized and painted with a primitive sharpness of focus, as in *The Yellow Hill* (136), are characteristic of a style which is flexible and still in a process of development. It was Cant who suggested the formation of the Studio of Realist Art (Sora), established in March 1945 as an art school and artists' centre in Sydney. The other foundation members included Hal Missingham, Dora Chapman, Roy Dalgarno and Roderick Shaw. Dalgarno, who had trained at the Melbourne Gallery School, was commissioned by a group of trade unions to paint industrial life and activities; Roderick Shaw, an original member of the Windsor Group, was also a designer and book illustrator of ability who later turned to high-quality printing.

 The Sydney realists were less doctrinaire, but did not achieve the painterly quality or emotional depth of the Melbourne group. For the most

136 JAMES CANT, *The Yellow Hill*, hardboard, 36 x 48,
1959, Adelaide

part they confined themselves to industrial themes avoiding direct political comment.

Although individual artists like Counihan have continued to produce sound if not always inspired work, social realism as a creative trend in Australian art barely survived the war. In its programmatic form it has, like surrealism, ceased to interest the *avant-garde* or the post-war generation of students. The reasons are not far to seek. Social realists often begin as good artists and end as poor politicians; by putting more of their energy into politics than into painting they burn themselves out. Much more important, however, is the fact that the outlook of the post-war years did not favour a realistic approach to art.

Realistic Expressionism and Post-Impressionism, mainly in war-time Sydney

The realistic note in Sydney art during the war years was rarely associated with politics. The search for themes in the daily life of the city and the nation, foreshadowed in Vassilieff's street scenes, was augmented by the arrival in Sydney of Sali Herman in 1938 and Russell Drysdale in 1940— both Bell students. Bell admired Vassilieff's work and encouraged his pupils to find their subjects in the life about them. Realistic and satirical commentary on life is observable in the work of Peter Purves Smith, another of Bell's students. Indeed a frank observation of life combined with elements of surrealist fantasy, humour, dry and sardonic wit, and at times pure whimsy is often to be found in the work of Purves Smith, Russell Drysdale, Sali Herman, Donald Friend and William Dobell. These artists, together

with the more expressive and primitivistic *Angry Penguins* group in Melbourne, were largely responsible for establishing the mood and character of art in Australia during the war years. It is most desirable therefore to consider their work individually.

Peter Purves Smith (1912-49), after leaving Geelong Grammar School, spent a few years at the Jervis Bay Naval College but, with its reduction and transference to Westernport, Victoria, turned for a time to jackerooing in the country. When he decided to study art he left for London and worked first under Iain McNab at the Grosvenor School and then with Bell in Melbourne. Apart from his teachers, Modigliani, Henri Rousseau, Christopher Wood, Utrillo and surrealism appear to be the main contributors to his highly personal style, a style strong in formal organization yet droll, whimsical and, at times, sharply satirical. The elongated type of figure which he used with such expressive effect appeared in early student works such as *French Café* (1936, Mrs R. Drysdale), as did the influence of surrealism in *New York* (137). His most important paintings belong to the two years he spent in Paris and London prior to joining the British Army in 1940. To this period belong his poetic *Early Morning in Paris* (1939) and *Promenade* (1939, Mrs R. Drysdale), with its thinly scumbled and luminous blues and greens. A direct and refreshing awareness of life is present both in such colloquial observations as *The Park* (1938, Mrs D. Tooth) and *The Pond* (1939, Mrs D. Tooth), and in the political satires, *The Nazis, Nuremberg* (1938, Brisbane) and *The Diplomats* (1939, Lady Casey).

Purves Smith was thirty-seven when he died in 1949 after being invalided out of the British Army in Burma, where he had served with Wingate's Chindits. Despite the small amount of work which he left, it is of more than usual importance both for its own intrinsic quality and the fact that it foreshadowed a quite new approach to the interpretation of the Australian landscape, which his friend and fellow-student, Russell Drysdale, was to explore and develop. Purves Smith and Drysdale worked closely together both in Melbourne and in Paris, and learned much from one another. Two small drought landscapes by Purves Smith (138), painted in 1940, anticipate in more ways than one the new approach to the Australian rural scene which Drysdale was to announce in his Albury paintings a year later. Writing in 1939, Gino Nibbi remarked of Purves Smith's work, with considerable perception:

He aspires to decorative effects curiously hallucinatory, and utilizes some primordial visions . . . as did Rousseau le Douanier for whom the word *naïveté* was synonymous with high knowledge. Purves Smith seems one of the most qualified at the present time to give some allegorical interpretations of the virgin appearance of the Australian land.[4]

137 PETER PURVES SMITH, *New York*, canvas, 30 x 20,
1936, Sydney

138 PETER PURVES SMITH,
Drought, water-colour on paper,
18½ x 15, 1940, Lady Casey

But Purves Smith died young, and the allegories and primordial visions rose in the work of others.[5]

Russell Drysdale was born at Bognor Regis, Sussex, in 1912, into a family possessing Australian associations since the 1820s. The Russells, originally from Fife, Scotland, pioneered as pastoralists first in Tasmania, then in the Western District of Victoria, the Riverina and northern Queensland. Anne Drysdale, also from Fife, took up land near Geelong in the 1840s. Drysdale spent his early years in England but visited Australia with his parents twice before the family settled here in 1923. After completing his secondary education at Geelong Grammar School between 1923 and 1929 he spent a year in northern Queensland acquiring a knowledge of the sugar industry, in which the family was interested, and then returned to Boxwood Park, the pastoral property they had acquired in the Riverina. There he acted as an overseer while his parents were abroad in 1931, joining them in England for some months before they returned. Drysdale had always assumed that, in the family tradition, he would follow a life on the land, though drawing had been a hobby since his school days in England. During an illness in Melbourne in 1932 Dr Julian Smith, impressed by the quality of his draughtsmanship, introduced him to Sir Daryl Lindsay who advised him to study art under George Bell. The artists most discussed in the Bell-Shore school at the time were Cézanne, Gauguin, Van Gogh, Matisse and Picasso; and Drysdale, brought up to admire the Australian impressionists, at first found Bell's ideas and methods difficult to accept. During a second visit to England and the Continent in 1932, however, he was able to see for the first time original works by the impressionists and post-impressionists and the School of Paris; as well as painters such as Utrillo and Rouault less familiar to him. He began to think seriously of becoming a painter.

In 1935 he married Elizabeth Stephen, also of Scottish descent, and with the full support of his parents, decided to become a painter. He enrolled as a student at the Bell-Shore school, studying first under Shore while Bell was abroad in England, and then under Bell after his return in 1936 and Shore's resignation. At the school he met Peter Purves Smith, reviving a school friendship that was terminated only by Purves Smith's death in 1949.

Drysdale's early works were painted between 1936 and 1938 under the influence of Bell and the talented group of students which Bell attracted to his classes after his return in 1936. Their tonal key is high, the paint crisp in handling and dry in texture. A light palette of pinks, pale greens, blues and yellow-reds prevails, and the design tends to be flat and decorative. His early drawing of the figure, in rhythmical arabesques, owes something to Modigliani, Kisling and Ian Fairweather—all strong influences among Bell's students at this time.

Drysdale's skill and perception as a draughtsman underlies and fortifies the expressive power of his paintings. Not surprisingly, therefore, figure subjects —usually associated with manual labour in the city or country—appealed to him from the beginning. In one early painting of 1937 he depicts men mixing concrete in a city street, in another a group of figures symbolizing several aspects of farming. Appealing, too, was the life and architecture of the built-up inner suburbs of Melbourne. In one painting a young guitarist sits on a doorstep and plays to his friends, in another the decorative ironwork of hotel verandas and terrace houses is already beginning to exercise its picturesque appeal. But urban imagery soon gave way to those images of country life which were to form the staple of his style. No early painting is more revealing than *The Rabbiter and His Family* (139), where the random influences of the art school are already being put to the service of personal expression. The folksiness and sophisticated primitivism of Christopher Wood is its point of departure, but already present is Drysdale's abiding interest in the pose, air and gesture characteristic of country types.

He returned to Melbourne in June 1939, a few months before the outbreak of war, and worked in George Bell's private studio for a year where he became increasingly interested in themes concerned with life on the land. In 1940, unable to enlist because of defective vision in one eye acquired in 1929, unwilling to become involved in the art-politics of the Contemporary Art Society, and interested in working on rural themes, he moved from Melbourne to Albury where he acted for a time as overseer for shearing at a friend's property. Then, late in the year, he settled in Sydney and began to exhibit at the Macquarie Galleries.

1940 was for Drysdale a transitional year. His student work had been bright and decorative—essentially post-impressionist in structure, feeling and subject-matter. But as the war opened and deepened the mood of his art changed; and the reaction of people to hard and hostile environments aroused his interest increasingly. Soutine and the early Picasso might well have been partly responsible for those little studies in isolation or loneliness, such as *Study 1940* (Mrs H. V. Evatt) and *Newspaper* (Lord and Lady Casey), which he painted in that year; and they owe something perhaps, too, both in technique and style, to Dobell.

In 1941 Drysdale's personal style began to assert itself when he began to paint a series of studies of country life as he had experienced it in the Riverina at various times, but more especially during the previous year when the district had been hit by one of the worst droughts of the century. At once realistic and expressive, these paintings constitute a complete break with the naturalistic landscape which the Heidelberg School had established sixty years before and from which the local post-impressionist painters of the 1920s and 1930s, attached as they were to a structural and stylized naturalism, had never entirely departed. He began to formulate a new set of conventions grounded not upon naturalism but upon ideas drawn from realistic, expressionistic and surrealistic sources. But though he discarded the naturalistic element in post-impressionism, he retained its classicism. The classic quality is to be found in his preference for horizontals and verticals and the ordered, static quality of his compositions; the expressionist quality in his colour and figuration; the surrealist in his use of such devices as deep perspective, vacancy and disjunctive images to create absurd, whimsical or disquieting effects.

Drysdale's art does, in a general way, provide a parallel to the work of such American artists as Thomas Hart Benton and Grant Wood who, in the 1930s, rejected the formal adventures of the School of Paris and returned home to paint the American scene. Its sources, however, are not found

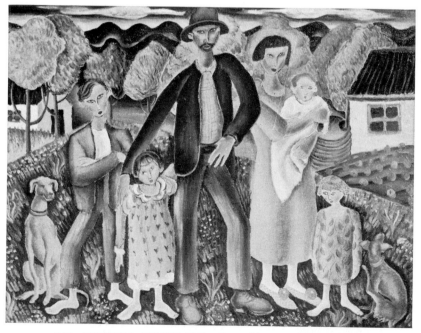

139 RUSSELL DRYSDALE, *The Rabbiter and His Family*,
canvas, 24 x 30, 1938, Lord and Lady Casey

140 RUSSELL DRYSDALE, *Sunday Evening*, asbestos cement,
23⅝ x 29⅞, 1941, Sydney

in such work but, as we have observed, in contemporary European painting.

Drysdale's interpretations of the Australian outback have often been criticized as ugly and grotesque. Certainly he does not seek beauty-spots in the manner of Elioth Gruner and the later work of Streeton. But the creative artist, it must be remembered, discovers and expresses the truth as he sees and feels it. He is not a manipulator of known and received forms of beauty. Drysdale revealed aspects of country life which the impressionists and their followers chose to ignore. As we have seen, the Heidelberg painters did not for long hold up the mirror to Australian nature with a steady hand. When their visual integrity and the enthusiasm which accompanied it failed them they began to idealize rather than to see. The hard edge of reality was softened by romance. So it was that Drysdale's art became an implicit criticism of Streeton's golden visions and Gruner's sweet pastures.

Although Drysdale's art has its source in twentieth-century European painting, it does not follow that it is unconnected with local tradition. There was, as we have seen, a long-established alternative to the fashionable convention of 'sunny Australia'. It arose from the experience of colonials as they subdued the land and occupied it. Australian nature, the older convention proclaimed, was monotonous, unpicturesque, idiosyncratic, alien and hostile to man, inducing either loneliness and melancholy or nonchalant resistance. It had already been asserted to some extent in the art of such

141 WILLIAM DOBELL, *The Billy Boy*, canvas, 28 x 21, 1943,
Australian War Memorial, Canberra

men as S. T. Gill, William Strutt and Frederick McCubbin. But its real strength lay in the literary tradition. Writers from Charles Harpur to Patrick White have not ceased to emphasize the tough, unyielding qualities of the environment. It was this alternative convention that reappeared with renewed vitality in Australian contemporary art in Drysdale's 1941 Riverina paintings (140).

Henry Lawson had first expressed the older convention realistically; and Drysdale finds his true literary parallel in Lawson; he is, indeed, a kind of twentieth-century Lawson of painting. He possesses Lawson's compulsion to tell the truth as he sees it, his sense of the absurd, his humour, his craftsmanly respect for form, his humanity and, though Drysdale restrains it more thoroughly, Lawson's sentiment. Like Lawson he has sought to cut down the over-romanticized and over-glamorized image of the Australian bush to true size. 'Draw a wire fence and a few ragged gums, and add some scattered sheep running away from the train. Then you'll have the bush all along the western line from Bathurst on',[6] Lawson wrote in his essay, 'In a Dry Season'. He might well have been describing a Drysdale painting half a century later. Drysdale, too, recalls Lawson by the economy with which he visualizes a scene. 'I have left out the wattle—because it wasn't there. . . . I have left out "the sad Australian sunset" because the sun wasn't going down at the time', wrote Lawson, in 'The Union Buries its Dead'.[7] Drysdale reveals a similar desire to reduce his imagery to essentials. Consequently, like Lawson, he was able to establish a convincing relationship between his 'characters' and their back country setting.

From 1941 the face of the nation at war began to occupy his attention increasingly. *The Medical Examination* (1941, C. F. Vine-Hall) and *Local V.D.C. Parade* (142) are still Lawsonesque in their search for the characteristic and their enjoyment of the absurd. But as the war crisis sharpened the humour and anecdotal element declined. Partly as the result of the influence of the work of English artists such as Graham Sutherland, John Piper, Paul Nash and, above all, Henry Moore, his compositions became more formalized and monumental and his colour deeper in tone, mottled in texture, sharper in its contrasts and edges, and began to free itself from constructional form. The mood also changed. It became far more dramatic, at times threatening and somewhat hallucinatory. Such changes are to be noted in his gouache (Miss C. Belbridge) and his oil studies of *Albury Platform* (1943, Melbourne), *Bushfire* (1944, Brisbane) and *Airport at Night* (1944, Melbourne). The likely influence of Dobell continues in his *Portrait of Donald Friend* (1943, James Fairfax) and his *Nude* (1944, Miss J. Stephen), in which a new interest in the painting of flesh appears.

During the severe drought of 1944, the *Sydney Morning Herald* commissioned Drysdale to record its effects in the Western Division of New

142 RUSSELL DRYSDALE, *The Local V.D.C. Parade*, wood panel,
17½ x 22½, 1943, Adelaide

South Wales. The series of paintings which he exhibited in 1945 based on his drawings at that time are conceived in a mood quite different from the Riverina paintings of 1941. Sheets of iron distorted by fire and twisted in the wind became symbols of the futility of human achievement. Dead trunks of trees, thrown at times into grotesque male and female forms, simulated life. In such country no fence divided the organic from the inorganic or the living from the dead. Oddly enough, however, the dramatic element in his work began to give way to a quieter, more classical mood, and was accompanied by a change of technique. In place of the mottled and sharp edginess of the early war paintings there appeared a manner based upon even transitions of tone and close modelling of forms over thick, white grounds. The mannered eccentricities of his earlier work, such as excessive figural elongation, were modified in order to achieve monumentality. What once appeared ludicrous began to acquire a heroic quality. The change both in mood and technique was revealed in *The Drover's Wife* (143), an image of fortitude, devotion and survival. Children began to appear frequently in these landscapes of drought and desolation, with the loneliness and melancholy of the landscape stamped upon them. Drysdale had begun his studies of loneliness in such paintings as his fine little *Two Children* (1941, University of New England) and his Picassoesque *Mother and Child* (1942, Mrs B. Niven), and the theme runs continuously through his work. At times it is the nostalgia

143 RUSSELL DRYSDALE, *The Drover's Wife*, canvas,
20 x 24, 1945, Mr Kym Bonython

of migrants, as in *Ennui* (1944, C. Swanton); at times it is the native-born who are alone. The theme appears in another painting of *Two Children* (frontispiece), one of the finest of his paintings and one of the few in the history of Australian art—so consistently romantic at heart—in which form and content achieve a classical ideality. By virtue of its formal perfection and profound but controlled feeling, the small painting reaches beyond the individual and the regional to express the consuming loneliness of human-kind.

In thus seeking to express universal values, Drysdale did not wander far from common life. His country town paintings are an example. It is not the contemporary Australian town with its naïve faith in cantilevered awnings and chromium plate which has exercised his imagination, but tumble-down, half-deserted gold towns like Hill End and Sofala (144). In some ways these paintings are like de Chirico's metaphysical paintings; but Drysdale has brought the metaphysics down to earth. In place of massive Roman arcades he substitutes the cast-iron verandas of boom-time Australia. Thus the fantastic element, not being forced, gains power as a threat dimly felt beneath the surface of the commonplace. Here we are confronted with one of the basic qualities of Drysdale's imagination. He seeks continually for what we might call a realistic correlative; in other words forms in real life which correspond to those more abstracted evocative forms given cur-

144 RUSSELL DRYSDALE, *Sofala*, duck on hardboard,
28¼ x 36½, 1947, Sydney

rency by *avant-garde* painters abroad. This matching of ideographs to
reality is often found in the work of artists who have retained respect for
the rational presentation of the visible world. Realistic correlatives are
present, for example, in Rembrandt's work; as when he places the body of
Christ before a candle to suggest, but not assert, a divine radiance without
infringing—by baroque haloes—the laws of optics.

Between 1946 and 1950 Drysdale produced a series of paintings classical
in mood and structure which he has not surpassed; but in 1950 he entered
upon a period of uncertainty and indecision marked by an increased interest
in technical experiment and greater receptivity to influences from the work
of his contemporaries. In that year he began to prepare for his first London
exhibition. Held at the Leicester Galleries in December 1950, it brought
together some of his finest paintings, but included others repetitious of early
work with a feeling of haste and tiredness about them. It may have been,
therefore, the desire to avoid repeating himself that caused him to enter
upon a phase of increased technical experiment during the early 1950s. At
times it is the influence of Graham Sutherland that reappears; at times the
primitive quality of early colonial work, or the equally primitive effects to
be seen in some amateur snapshots. Then, in 1951, Drysdale visited Cape
York and painted a series of studies of Aboriginals: the first time he had

entered that dangerous iconographical territory. It cannot be said, in all
conscience, that he has come through it unscathed. He adopted a highly
realistic treatment both of pose and expression in the rendering of his
Aboriginals that is at times out of keeping with the abstracted landscapes
into which they are set. In some ways these paintings are a compromise not
altogether satisfactory between the realism of the 1941 Albury paintings and
the classical landscapes of 1949. On the other hand, as the result of technical
innovations, his colour has achieved greater luminosity and is handled with
new freedom. In his recent paintings of Melville Island natives, Drysdale
tended to simplify and abstract the forms, and further heighten the colour
(146). Backgrounds are often reduced to flat decorative areas; and an off-
focus figuration has appeared; so too has the influence of Aboriginal art
itself. Here it is the romantic, hallucinatory and somewhat surrealist side of
his work which is predominant.

Drysdale is among the most original of all Australian landscape painters.
Few contemporary Australian painters of landscape have been able to
escape entirely from the broad terms of reference that his Albury paintings
of 1941 began to lay down: a landscape alien to man, harsh, weird, spacious
and vacant, given over to the oddities and whimsies of nature, fit only for
heroes and clowns, saints, exiles and primitive men. It was a radical break
with anything that had been painted since the days of the Heidelberg
School, but it also testified to the survival of an old vision of the antipodes
that had long since sunken deeply into the European imagination.[8]

In sharp contrast to Drysdale's work, the art of Sali Herman transmits a
radiant and sensuous enjoyment of common things. Born in Zurich in 1898,
Herman was an art dealer in Europe before becoming an artist in Australia.
He thus brought a well-informed mind to his own art when he began to
study under George Bell in 1937. Although he learnt much from Bell, his
sense of control and his painterly quality owe not a little to a close and
extensive association with painting in Europe.[9]

None of those artists who have migrated from Europe in recent decades
has ranged so widely over the country for his material, drawing upon city
life, the beaches, the interior and the tropics. His colour, fine and subtle in
quality, is more French than Australian, and classical in its control. Although
he can be sombre in mood and occasionally dramatic, his work is for the
most part joyously full of the zest of living. There is a physical luxury of
form and colour in his best paintings that recalls the impressionists; and his
paintings, oddly enough, recapture in a contemporary idiom the sense of
visual adventure that animates the early work of the Heidelberg School.
Even when he paints the slum dwellings of Sydney there is a sense of
bounty: the tenement buildings are rich in colour, monumental in form, and
the people active and vigorous (132). It is a land filled not with old fears

145 WILLIAM DOBELL, *Portrait of Anne Hamer*, hardboard, 30 x 24,
1956, Dr Norman Behan

146 RUSSELL DRYSDALE, *Man and Woman, Melville Island*,
50 x 40, 1960, Mrs R. Drysdale

but new promise. His art is not, as it is in the case of so many migrants from Europe, a study in the nostalgia of exile.

Donald Friend (*b.* 1915), Russell Drysdale's close associate and companion for many years, was one of the most inventive and talented artists to become known in Australia during the war years. A magnificent draughtsman and the master of a fine, dry, facetious manner, he succeeded in

P

147 DONALD FRIEND, *Boy with Fetish*, panel, 20¼ x 24½,
c. 1946, Melbourne

assembling in his drawings, paintings and war diaries a splendid personal
record of the war years. He studied first with Dattilo Rubbo and Sydney
Long at the Royal Art Society's school, and later in London at the West-
minster School. In 1936 he held an exhibition at the Redfern Gallery,
London, before spending two years in Nigeria where he painted and acted
as adviser to Ogoga of Ikere. In 1941 he returned to Sydney with a series of
superb wash drawings and paintings of West Africans (147), and joined
the Army in 1942. His *Gunner's Diary* (1943) and *Painter's Journal* (1946)
record the experiences and reflections of the war years. In 1945 he was
made an official war artist. After his discharge from the Army, Friend
worked for a time in the Torres Strait area, then for a time at Merioola, a
picturesque old Victorian house in Edgecliff Road, Sydney, before settling
at Hill End, near Bathurst. At present he lives in Bali. As a painter
Friend is experimental in technique and style, brilliantly allusive, and never
dull; and his feeling for colour and decorative construction is of high quality.
But a facility, both of mind and hand, has hindered rather than helped the
full flowering of an art which, nevertheless, at its best reveals a combination
of pictorial intelligence, vitality and good taste unusual in Australian art.[10]

The post-impressionist student work of Purves Smith, Drysdale, Herman
and Friend developed, as it matured, realistic, satiric or colloquial trends
in marked contrast to the dry and brightly decorative post-impressionist

art of the 1920s and early 1930s. No better testimony can be found to the changed spirit of the times, to which, however, no one contributed more profoundly than Dobell.

William Dobell (1899-1970) was the son of Robert Dobell, a building contractor of Newcastle, New South Wales. His great skill in drawing revealed itself at an early age, and he was encouraged to develop it by John Walker, one of his teachers at Cooks Hill School. At seventeen he entered into articles with the Newcastle architect, Wallace L. Porter; but his interest lay in art, and in 1923 Dobell settled in Sydney where he attended Julian Ashton's evening classes while employed as a designer for Wunderlich Ltd, manufacturers of building materials. In 1929 he won the Society of Artists' Travelling Scholarship and went to London, where he studied at the Slade under Henry Tonks and Wilson Steer, and received private tuition in drawing from Sir William Orpen. In 1930 Dobell shared at the Slade second prize for drawing with a German student, and received first prize for figure painting. In 1930, too, he visited Holland to study the Dutch masters. Visits to Belgium and France followed where he also studied the work of modern masters. He found himself attracted among the old masters to Rembrandt above all, but also to Goya, Tintoretto, Mantegna and El Greco; and among the moderns, Daumier, Renoir, Van Gogh and Soutine began to exercise an influence. But, possessing a profound receptivity both to art and to life, Dobell was able to absorb and assimilate a wide range of influences without compromising the emergence of his own style. In 1933 his work was exhibited at the Royal Academy. He later exhibited with the New English Art Club, and in 1938 with the London Group.

Dobell's early paintings are executed entirely within the conventions of naturalism. The small landscape, *Village in Somerset* (1930, Dr G. Hallows) and *Canal Bruges* (1933, C. Gheysens) are intimate and tranquil in feeling; reticent colour schemes in grey, ochre and muted yellow heightened by small touches of red. Occasionally, as in *St Paul's from Waterloo Bridge* (1931), dramatic hatching in the manner of Van Gogh is noticeable, but more frequently the brushwork of his student days recalls both the fluency and the precision of Tonks.

The tranquil sensitivity of Dobell's early work is seen at its best in his little genre piece, *Boy at the Basin* (148). The brushwork is precise, the lighting soft, and the colours, though low in key, rich and resonant. The studied arrangement of the composition and its intimate setting owes much to the Dutch. With its fine impersonality, even texture and lovely colour it summarizes the achievement of Dobell's early years better perhaps than any other painting. It was singled out for praise by P. Konody, the critic on the *Observer*, when exhibited in the Academy Exhibition of 1933.[11]

About 1933 Dobell's painting acquired greater freedom of conception

148　WILLIAM DOBELL, *Boy at the Basin*, wood panel,
16⅛ x 13, 1932, Sydney

and more assurance in handling. The somewhat self-conscious air of his early work disappeared and he began to draw extensively upon life and personal experience, finding his material in odd corners and out-of-the-way situations. This new phase is heralded by his fine little *Woman in Café* (150). The handling is broad, preserving the immediacy of a sketch, and the subject realized with sensitivity, the large area of the dress with its warm shadows being counterpoised against the reds and yellow-greens he favoured so much in his early landscapes. The influence of Sickert is apparent; but there is an intuitive response to the subject which is Dobell's own, and quite unlike Sickert's flair and painterly assurance.

By 1936 the new free manner was fully fledged. But it was still used to record impressions. Indeed, a painting like *Park Lane* (1936, N. McEacharn), with its delightful evocation of an early spring day in London,

149 WILLIAM DOBELL, Finished oil study for *Portrait of an Artist*,
canvas, 48 x 32, 1943, Mr Warwick Fairfax. (The original, formerly
in the possession of Sir Edward Hayward, was severely damaged
by fire.)

150 WILLIAM DOBELL, *Woman in Café*, plywood, 9 x 9, 1933, Lady Murdoch

and the decorative charm of its terraces, street lamps and red chimney pots, owes much to impressionism. Likewise, many of his little genre scenes, such as *Woman Watching a Funeral* (1938, R. M. Crookston), and *Film Crowd Workers* (1937, C. Gheysens), are no more than incidents, closely observed and recorded without comment. Their handling is not dashing and assertive like Sickert's, but exploratory; and the subjects are observed off-guard; drawn into themselves by thought or mood. It is a kind of passive, introverted impressionism. The passive observation of life, however, did not wholly suit either the personality of the artist or his time. In life, Dobell has remained a modest and somewhat diffident person to all but his circle of close friends; a quiet man who can, none the less, hit back at the slightest hint of pretence or humbug with a cutting remark: and London in the midst of the economic depression of the 1930s was a different place from the London of Sir John Longstaff's day. Not surprisingly, therefore, Dobell's little slices of life began to acquire sharp edges; and he has left us a superb portrait gallery of London characters of the time. He began to paint women looking out of windows, maids and tired waitresses, film extras, charladies, costermongers at work and play, with a sense of kinship and affection; though there has never at any time been the slightest trace of sentiment in his nonchalant observations. On other occasions, however, his vision could be acidulous. The figure in the sketch for the *Duchess Disrobes* (1936, Sir E. W. Hayward) is like a great fat bird; a strange comment upon vanity. *Mrs South Kensington* (151) may be taken as an example of his satirical technique. It is a small, rapidly-painted impression in light pigment on a dark ground; the swirl of the brushwork portraying the pallid lips and flesh and narrow eyes has a venomous, ironic vigour. But he is rarely so savage. In *A Lady Waits* (152) there is little bitterness but a huge sense of the absurd. Indeed, Dobell's satire is but one aspect of his direct grasp upon life. Other paintings, such as his splendid interpretations of costermonger picnics, recall the robustness and jollity of Rowlandson.

The satirical paintings of 1937 are social comments, public utterances. Memorable though they are, it is not in those that we encounter Dobell at

his best, but in another group of paintings which includes *The Sleeping Greek* (1936, Sydney), *The Charlady* (1936, R. Pennicuick) and *The Irish Youth*, in which his native insight and sensitivity combine with the penetrating observation of the satires. Some indication of the development of Dobell's style may be obtained by comparing *The Sleeping Greek* with his early portrait *Consuelita* (1933, Sir E. W. Hayward). The firm contours of *Consuelita* are, in *The Sleeping Greek*, broken and softened by delicate modelling and hatched brushwork. The head is placed diagonally not vertically, as in *Consuelita*, and has become more a part of the pictorial composition and less an independent image.

151 WILLIAM DOBELL, *Mrs South Kensington*, oil on plywood, 14¼ x 12½, 1937, Sydney

The colour, too, has become warmer, and the light, smooth surfaces of the early picture have given way before deeper tones and modulated colours; the handling is freer, and the textures more painterly. *Consuelita* possesses an objective, impassive composure, *The Sleeping Greek* a sub-jective, palpable, moody composure. What is revealed is not only an increasing mastery of technique but a deepening interest in people. In his *Charlady*, for example, a study in scraping technique emerges as a portrait rich in characterization and understanding. Its technical virtuosity is masterly and that is not all. The painter has been able to approach his subject as an equal: no latent sense of superiority reveals itself, no air of patronage has come between artist and subject to cloud with sentiment the perceptive clarity and technical brilliance of the image. In such paintings the passive sensitivity of his early work is united with greater technical command and deepening powers of observation. *The Irish Youth* (153) is another masterly portrait of an anonymous individual encountered one day among the unemployed upon the Thames Embankment. There is a Hogarthian vitality in the painting of the emaciated head and the dull, questioning eyes. In these portraits Dobell reached a peak of perfection which, in characterization and vitality at least, he has not surpassed.

In or about 1937 Dobell painted *The Red Lady* (Sir Colin Anderson). It was inspired by his growing admiration for the portraits of Soutine and

is a landmark in his development. By contrast with the realistic immediacy of the portraits preceding it, *The Red Lady* is a return to organized composition. But the consciously controlled lines and volumes are not, as in *Consuelita*, used to attain impersonality and objective form but to achieve expressive power. The painting also reveals a new freedom in colour released by his interest in expressionism.

When Dobell returned to Sydney in 1939 both Sydney Ure Smith, the President of the Society of Artists, and Julian Ashton, his former teacher, then aged eighty-eight, praised his work enthusiastically. Its high quality was realized immediately by many artists and he acquired a small circle of discriminating patrons who began to buy his work and, in some cases, commission portraits. He was appointed to the staff of the East Sydney Technical College, was commissioned to design a mural for the Australian Pavilion at the Wellington Exhibition, became an exhibitor in the Society of Artists from 1939 and sent work to early exhibitions of the Contemporary Art Society.

After his return to Australia the satirical edge and swift brevity of statement that had characterized his London work of the later thirties declined. Dobell began to pay great attention to technique, widening and deepening the range of his tones, heightening the intensity of his colours, and experimenting with glazes; so that his paintings often achieved a jewel-like surface

152 WILLIAM DOBELL, A *Lady Waits*, board, 7⅛ x 9¼, 1937, Melbourne

and miniaturesque finesse of touch. A newly-found elegance began to appear in his first portrait commissions. In the portrait of *Jacqueline Crookston* (154), for example, the intimacy and curvilinear grace of the rococo appears: the interplay of line between girl, chair and dog is as delightful as any in his work; and the pale greens, reds, and soft yellows surrounding the figure herald his experiments with colour. Nevertheless, there is in this painting an element of tension and a noticeable attenuation of form present also in his conversation piece, *Mrs Blaxland and Toni* (1941, Mrs G. Blaxland). These incipient mannerist traits are much more prominent in his Bronzino-like *The Cypriot* (155) and *The Strapper*

153 **WILLIAM DOBELL,** *The Irish Youth,* canvas, 21½ x 17, 1938,
Dr D. R. Sheumack

154 WILLIAM DOBELL, *Jacqueline Crookston*, canvas,
13 x 10¼, 1940, Miss J. Crookston

(156), two of his greatest portraits. In *The Cypriot* Dobell created a most
effective counterbalance between form and content; between, that is, firm,
almost geometric organization of the volumes, and the alert air and uneasy
pose of the sitter. By contrast *The Strapper* is relaxed; but it, too, is given
monumental expression by the reduction of volumes to large simple units
and the skilled modelling of the surfaces. In these two paintings, as in so
many of his finest portraits, the figure is virtually anonymous and casually
dressed, the pose informal.

Despite Dobell's mannerist phase of the early forties, the influence of the
eighteenth century remained. It is present in his highly rococo *Carnival*
(1940, Teachers' College, Armidale), wherein he sought, not entirely with
success, to convey the atmosphere and colour of a Sydney surf carnival and

so faced once again the problem so well known to the Heidelberg painters, of rendering a great deal of detail in a high tonal key. It is present in his elegant *Portrait of a Boy* (1943, Mrs G. Blaxland), and in the Gainsborough-like *Elaine Haxton* (1941, Lady Lloyd Jones). It is also present in the rhythm and gusto of his *Tattooed Lady* (1941, R. M. Crookston), wherein he re-creates the brilliance, cheap sensuality and slightly ludicrous vulgarity of a side-show. In this last painting he achieved, by means of glazes and a *pointilliste* technique, a gem-like lustre of colour. The painting of tattooed flesh was a virtuoso feat which he demonstrated in a masterly fashion later in his *The Billy Boy* (141), one of the greatest of his war-time paintings.

In 1943 Dobell was commissioned by the Allied Works Council to paint pictures of the Council's war-time activities and was attached to the Civil Construction Corps for the purpose. What might be called the Australian bent of his genius then began to reveal itself fully. There had always been something characteristically Australian in his portraiture from the beginning; a direct, quizzical and somewhat deprecating approach to his subjects irrespective of rank and prestige. During the war it grew in strength and power. Paintings like *Brian Penton* (Sir Frank Packer), *The Billy Boy*, *Concrete Construction Worker* (both Australian War Memorial, Canberra) and *Professor L. F. Giblin* (University of Melbourne) constitute a gallery of recognizable Australian types unequalled in the history of the nation's art, and for painterly quality and brilliance of characterization unparalleled in twentieth-century portraiture. In these paintings a complete mastery of the traditional techniques of draughtsmanship and painting are united with a personal gift for characterization equally responsive to the vanity, ugliness, charm, stupidity, sensuality, beauty, obesity, vitality or arrogance of his sitters. On the whole it is a tough and unpleasant vision of humanity that he presents, but one, for all its implicit pessimism, never far short of the truth. It is not often in his work that any inner grace or spiritual beauty shines through the fatty imprisonment of the flesh. And though he renders the substance of flesh in his mature work with superb skill he does not paint it, as Titian and Renoir did, with deep sensual pleasure, but as if he were painting the skin of a grub not long out of the earth. If such a view of the surface of life is distressing to those who cherish a sentimental view of human nature it does perhaps explain the objectivity and clarity of a vision which makes it possible for Dobell to paint the arrogance of a statesman as naturally as he would paint the arrogance of a builder's labourer. In his ability to ignore the idealization so often associated with the portrayal of important personages Dobell reveals what is perhaps one of the better sides of the Australian character. By means of such insights he has been able to raise the art of portraiture in this country—during a century that has tended to ignore it—to the dignity of a great art. Australia, as we have seen, pro-

duced good portrait painters in Roberts and Lambert before Dobell, but they followed British practice and British habits of mind. Dobell has brought to his portraiture attitudes of mind that are his own. In achieving this he has not gone out in search of national character or local colour. Indeed, in seeking to depict men and women as they really are he is in no way unique, but the quality of his vision is Australian; as Rembrandt's is Dutch, Goya's Spanish, and Hogarth's English. In being Australian he is being himself. Thus he has done for Australian art what Hogarth did long ago for the art of England; he has shown that it is possible to attain a mastery of his craft and pursue it—despite the constrictions, intimidations and servility of a provincial society—without abasing himself before the false prophets of culture.

In January 1944 Dobell was awarded the Archibald Prize for the preceding year by the Trustees of the (National) Art Gallery of New South Wales for his *Portrait of an Artist* (149). This was a portrait of Joshua Smith, the friend and fellow-artist with whom he had shared a tent while serving in the Civil Construction Corps. Smith was a thin, bony man with prominent features and Dobell produced a portrait which, though not unsympathetic, adopted a manneristic attenuation of form and an expressionistic intensity of colour more vigorous and thoroughgoing than anything he had attempted previously. There was an expression partly of wonder and partly of self-pity upon the face but the figure sat erect with a natural if uneasy dignity. It was as if one of Drysdale's Albury stick-figures had suddenly blossomed in a burning bush and glowed with spiritual fire; and it was one of his finest paintings.

The award, however, aroused intense opposition and joined the battle between the ancients and moderns in New South Wales just as the foundation of the Academy had done in Victoria some years before. Two members of the Royal Art Society who had entered for the prize, Mary Edwards, a painter of picturesque South Sea Island exotica, and Joseph Wolinski, a conventional portrait painter, moved the Supreme Court of New South Wales to set aside the award on the ground that the painting was not a portrait as required under the terms of the Archibald award. This claim was worded as follows:

It is alleged that the picture is not a portrait but is a caricature of Joshua Smith, bearing a certain degree of resemblance to him, but having features distorted and exaggerated. Joshua Smith is a man of normal human aspect and proportion, and is not misshapen or deformed, but the picture is a representation of a person whose body, limbs, and features are grotesquely at variance with normal human aspect and proportions. It is apparent that the picture does not represent any attempt on the part of Dobell to make a likeness of Smith, but on the contrary, represents the result of an endeavour to depict him in a distorted and caricatured form.

155 WILLIAM DOBELL, *The Cypriot*, canvas, 48 x 48,
1940, Brisbane

The case was heard between 23 and 26 October 1944 in the Supreme Court
of New South Wales in Equity before Mr Justice Roper, Mr Garfield Barwick
appearing for the plaintiffs, Mr Kitto for the Trustees of the Art Gallery of
New South Wales and Mr Dwyer for William Dobell.

Mr J. S. MacDonald, the first witness for the plaintiffs, and formerly the
Director of the National Art Gallery of New South Wales (1928-36) and the
National Gallery of Victoria (1936-41), claimed that portraiture was a well-
defined category, as distinctive to art as a sonnet to literature. A portrait,
he said, should be a balanced likeness, objective in featural details and
proportions, though a certain amount of subjectivity was permissible. He
held little respect for the portraiture of recent times and asserted that the
last good English portrait painter was Sir Thomas Lawrence (1769-1830).
Questioned by his counsel, MacDonald asserted that the painting of Joshua
Smith was not a portrait but a 'pictorial defamation of character'. It was a
fantasy, a satirical caricature. When pressed in cross-examination, however,
MacDonald could provide no generally accepted definition of a portrait,
asserted that painters were not in the habit of reducing to formulae the

meanings of their art', and finally agreed that the question whether a picture was a portrait or not was a matter of the individual opinion of those considering it.

John Young, the second witness for the plaintiffs, a man who had done much in earlier life to champion the work of the first post-impressionists in Sydney, said that the portrait painter worked under specific limitations; a portrait was a compact between artist and sitter, and they created a work of art shared equally between them. He proceeded to describe Dobell's painting as a biological absurdity with sub-human proportions. The witness who followed Young, Dr Vivian Benjafield, was much more specific. 'I would say', he testified, 'that it represents the body of a man who had died in that position and had remained in that position for a period of some months and dried up'.

When Paul Haefliger (for Dobell and the Trustees), the art critic of the *Sydney Morning Herald*, was called to the box, he pointed out that old and modern masters alike have painted their portraits within distinguishable types arising from their personal styles. There was, for instance, a Leonardo type and a Picasso type of portrait. Portraits were also painted, he added, within the idiom of the school to which the artist belonged. Dobell was an expressionist; so, too, were Goya and Rembrandt. *The Red Vest*, today acknowledged as one of Cézanne's greatest paintings, contained more distortion than Dobell's *Joshua Smith*. Yet it can only be described as a portrait. Portraiture, Haefliger concluded, was a branch of art, and changes that take place in art also take place in portraiture. This was all very much to the point and Douglas Dundas, the head teacher of painting at the Sydney Technical College got even closer to the heart of the matter under dispute. He began by saying that in his view there were, generally speaking, two basic methods of portrait painting. The first method was to pose the sitter, set up the canvas and proceed to make a visual record of the shapes of light, shade and colour presented by the sitter to the artist's eye. This method, he said, was derived in large measure from Velasquez and Raeburn. It had had a great vogue in Australia, especially in Melbourne. The second method was through drawing in the constructive and not in the imitative sense, when the artist might work from drawings or from the sitter direct. And he continued:

The early Flemish artists did not work nearly so much by light and shade as the artists of the seventeenth century. The development towards visual facts, as revealed by light and shade, was a steady one from the time of Giotto onwards. Roughly the first one hundred or one hundred and fifty years of Italian painting after the beginning of the Renaissance was marked by paintings which relied less upon the extent of light and shade than upon the artist's conception of the form of his subject. Anyway there is a purer understanding of form in those works than there is in the later works where artists became enamoured of the

156 WILLIAM DOBELL, *Portrait of a Strapper,*
oil on canvas, 35½ x 25¾, 1941, Newcastle,
presented by Captain Neil McEacharn, 1960

effects of light and shàde, of the drama of light and shade as it fell upon their subject-matter.

The portrait painter has to bring about a co-ordination between many different elements. He has the sitter. He has, first of all, a blank canvas, and from those two elements, by his own skill, he has eventually to produce a work of art which will be known as a portrait. I would say that he has to consider the likeness of his sitter. By likeness I don't mean only a likeness to the features of the head of the sitter, but to his general physical bearing as well. If he feels that he wishes to stress certain characteristics, he will do so, but first of all he has to have all the problems of creating on this blank canvas an image—an image which will be satisfactory as a portrait and as a work of art, and to create that image he has to consider the physical fact of the sitter and the material facts of the canvas, paint and brushes, and the intellectual fact or factors of the

157 LLOYD REES, *Omega Pastoral*, canvas, 31¼ x 42⅝, 1950, Melbourne

design, by drawing or characterization, by tonal values of recession and of
envelopment of the sitter, his position in space with air surrounding him. He
has to consider the illumination of the picture and he has to consider the colour.
Now all these various elements are very difficult to combine satisfactorily in
the work of art. A great many portraits I think are painted without taking a
great deal of account of some at any rate of those elements. They may achieve
a certain likeness or resemblance to the sitter, but they will be lacking in that
profundity which comes to a work of art which is produced by a man who is
capable of co-ordinating all those different elements in his picture. Just getting
a likeness alone would not altogether constitute portraiture in my opinion.

Finally, Dobell himself was called to the box. *Joshua Smith*, he told his
counsel, was a serious portrait painting. He had known Smith for four or
five years, meeting him casually from time to time.

I did not then really know him. I respected him and I still respect him, but I
always regarded him as a rather diffident type of person and one who naturally
seems to call for people's sympathy, but when I worked with him as a camou-
flage labourer, I had to share the same camp with him for almost twelve months.
and I got to know his real character. I found that there was a determination
that amounted to stubbornness. . . .

Mr Dundas spoke of two methods of portrait painting. One was the light
and shade method; the other was the construction method. Mr Barwick seemed
to give the impression that the second method was the ethereal one which

needed no basic construction. You will find that it is the only one of the two that has a basic construction, because you have to know the figure and you have to draw the figure, no matter what the position is that the light is putting. At the Slade School we began drawing in the morning a figure of a person with the light on one side and to prevent us getting cheap imitation by light, another light was switched on, on the other side of the room later on, and off on the earlier part. This prevented us getting cheap light and shade effects as a camera does. We had to know the figure thoroughly. The first method is light and shade and you don't really have to know your figure. You copy the light and shade that is in front of you. If the light moves, that is just your hard luck.

. . . I selected a colour scheme for my picture. I just wanted to show a man in a warm night light setting—so I built up as a sculptor builds up any form, and I glazed my colours on to it, to obtain that. Had I used a dark colour, or a blue suit or dark brown suit for instance to put over the sculptural building up of the figure, it would have destroyed my form and my design in the picture. It would have made just a single head in the centre of the picture and would have lost my effect of light. That is the reason for the light colour.

[Both MacDonald and Young had maintained that colour was, strictly speaking, irrelevant to portraiture.]

Q. What particular influences are manifested in your painting?

A. My particular love in the art, as you may put it, is Rembrandt. I studied his methods in Holland and in London. I have had a close acquaintance with them—not only, I mean, copying his brush strokes or his technique . . . but his aims.

Q. We have heard various expressions of opinion as to how you would judge your own work. Is it modern work or academic work in your opinion?

A. I would say classic tradition. I do not like the word academic as applied to a great artist like Rembrandt . . . I was not called a modernist until I came to Australia. In London I was regarded amongst artists and art students as academic.

The hearing had obtained the widest publicity and made an artistic question a popularly debated issue throughout the country. A week later Mr Justice Roper announced a judgment which, because of its importance in the history of Australian art, needs to be quoted at some length.

After setting forth the nature of the suit, the terms of the will and the responsibilities of the Trustees of the National Gallery of New South Wales in regard to it, the judgment proceeded:

In this suit the award has been canvassed not upon the ground that the picture in respect of which it was made was not the best portrait but upon the ground that it was not a portrait at all. In my opinion, however, the question whether any competing picture is a portrait is as much a matter upon which the judgement of the Trustees is invoked as is that of whether it is the best portrait . . . the answer to that question depends on the formation of opinions by the observer to whom it is propounded. I think that the testator in this case has submitted that question to the Trustees of the Art Gallery for decision just as he has required them to decide which among competing entries is the best portrait. . . . In these circumstances I think that before this Court should inter-

fere in the administration of the trust it must be satisfied that as a matter of objective fact and not mere opinion the picture is not a portrait, so that the opinion formed by the Trustees to the contrary is founded upon a wrong basis of fact and is not truly an opinion upon the question to which the minds of the Trustees should have been directed.

If this is the proper test, as I think it is, it is not necessary to interpret the word 'portrait' in order to come to the conclusion that the suit fails, because the evidence is overwhelming, in my opinion, that at least there is a proper basis for forming an intelligent opinion that the picture in question is a portrait. . . .

. . . The word is used in a will which was made in 1916 and came into operation in 1919. In my opinion on the evidence there has been no change in its meaning up to the present time. Having heard the evidence of eight persons all highly qualified to express an opinion on the meaning of the word as it is understood by artists, I am satisfied that it has not among artists a technical meaning different from its meaning as an ordinary English word in current use among laymen. Even if it had been found that it had such a technical meaning, it has not been shown that the testator was a member of the class which uses the word in the technical sense. The word is an ordinary word of the English language and its meaning has to be ascertained accordingly. . . . With the assistance of dictionaries and the many works to which I have been referred by Counsel in this case, I think that the word 'portrait' as used in this will, incorporating in its meaning the limitations imposed by its context, means a pictorial representation of a person, painted by an artist. This definition connotes that some degree of likeness is essential and for the purpose of achieving it the inclusion of the face of the subject is desirable and perhaps essential.

The picture in question is characterized by some startling exaggerations and distortion clearly intended by the artist, his technique being too brilliant to admit of any other conclusion. It bears, nevertheless, a strong degree of likeness to the subject and is, I think, undoubtedly a pictorial representation of him. I find as a fact that it is a portrait, within the meaning of the word in this will and consequently the Trustees did not err in admitting it to the competition. . . .

Finally, I think that it is necessary to state my opinion on the claim that the picture cannot be included as a portrait because it is proper to classify it in another realm of art or work—as caricature according to the information or as fantasy according to a witness for the informant. It is, I think, unnecessary to consider whether the picture could be properly classed as a caricature or a fantasy. If it could be so classed that would only establish to my mind that the fields are not mutually exclusive because in my opinion it is in any event properly classed as a portrait. In the result I think this suit must be dismissed.[12]

Portrait or caricature: the fields were not mutually exclusive. Towards the end of his judgment Mr Justice Roper veered close, surely, to the heart of the matter, but did not state it: the portrait was a caricature and the caricature a portrait. For if the word 'caricature' has any meaning at all in normal English usage Dobell's painting of Joshua Smith was most certainly a caricature, but a caricature which was also a portrait of the highest artistic quality. But having regard for the state of artistic taste in Australia in 1944 and the specific circumstances of the case it is to be appreciated

that the judgment contained no such assertion while pointing to its pos-
sibility. To say that the painting was both caricature and portrait would
have been taken as equivocation, and satisfied the single-minded partisans
of neither side. As it stood the judgment succeeded in giving a legal sanction
to those who wanted the limitations of portraiture as an art form to be
interpreted with sufficient tolerance to enable an artist to work within it
according to the requirements of his personal style and the nature of his
genius. Consequently the judgment was rightly heralded as a significant
victory for the modern movement in Australia, regardless of whether Dobell
was a classic, academic or modern painter. As a result, expressionist paint-
ing acquired some status at law and the angry voices of the old prophets
for whom portraiture would always mean tonal matching in the manner
of Velasquez and Raeburn, Hall and Meldrum, were heard less in the land.
Indeed, the modern movements in Australia was well on the way towards
creating its own prophets and its own establishment.

Apart from Dobell, Australia produced during the 1940s one other por-
trait painter of note in the Tasmanian, Jack Carington Smith, who developed
a personal style of refined distinction from a grey, tonal, neo-Whistlerian
manner. Carington Smith studied first at East Sydney, and later at the
Royal Academy Schools, returning to Australia, like so many others, in 1939.
In his portraits painterly values and formal construction have always been
given pride of place.

The work of Dobell, Drysdale, Friend and Herman gave a special quality
to the art of war-time Sydney. Crowded with American servicemen, a
major base in the Pacific campaign, the life of the city was quickened by
the international urgency of events. Life was absurd: but it was also
exuberant and worth living. If the temper of the art was often deprecatory
and sardonic, that was but an aspect of its vigour and grasp upon life; and
it was not narrow in its sympathies. Its quality is also to be found both in
the elegant and yet uproarious, piquant and dexterous art of Cedric Flower
(b. 1920), and in the fine, decorative and colourful work of Elaine Haxton.

Neo-Romanticism in Sydney

The war years brought to Sydney not only a deeper interest in the
portrayal of contemporary life; it also brought a renewed interest in the
masterpieces of the past. This interest fed the stream of neo-romantic art
that flowed so freely through the decade. It must be stressed that the ways
in which Australian artists have received and assimilated the European
tradition have never been closely examined. Certainly, Australian art has
repeated in many ways the experience of other nations. But transmission,
like invention, is a personal and selective process carried on largely by
artists and teachers. The response to an old master, for example, however

158 JEAN BELLETTE, *Electra*, paper on hardboard,
23½ x 29¾, 1944, Sydney

universally fashionable at any given time, will differ in impact and diffusion
from one country to another. What an artist or a nation borrows is as much
a part of personal or national character as what it creates or rejects.

Some aspects of the process we have examined: the influence of Velasquez
and Raeburn in Melbourne, diffused by Hall and Meldrum; the influence of
the rococo, more literary and less influential, diffused by Norman Lindsay;
the influence of Rembrandt and Goya upon Dobell—to name only three.
During the war years many artists in Sydney found help and inspiration in
the primitive and formative phases of Western art in both its Christian and
classical manifestations. Archaic Greek art and the *quattrocento*, Byzantine
and Medieval art excited them as they sought to endow their own work
with the new authority of the primitive and monumental that had replaced
the older authority of the academic and naturalistic. This return to tradition,
despite the considerable use it made of classical forms, was at heart
romantic. Early evidence of the new interests is to be found in a number
of short appreciative articles written by Jean Bellette and Paul Haefliger
during 1941 and 1942 for *Art in Australia*. Miss Bellette wrote on the
fifteenth-century Suabian wood-carvings purchased by the Felton Bequest
in 1941, on Masaccio, Piero della Francesca, and Maillol, Haefliger upon
Giotto and Titian. Both artists brought a warm, sensuously romantic ap-
proach reminiscent of Elie Faure, to their material. These articles served to

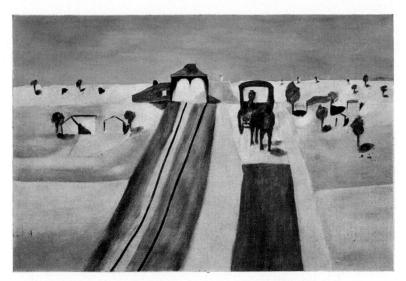

159 SIDNEY NOLAN, *Kyata*, synthetic enamel on hardboard, 24 x 36,
c. 1943, in the possession of Mr John Sinclair

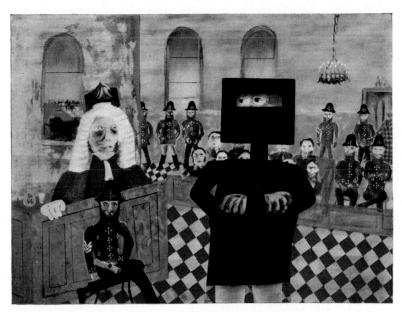

160 SIDNEY NOLAN, *The Trial of Ned Kelly*, synthetic enamel on
hardboard, 36 x 48, 1946-47, Mr and Mrs John Reed

introduce the role both artists, man and wife, were to play in painting and criticism in Sydney during the 1940s and early 1950s.

In the art of Jean Bellette, as Dr Hoff has put it, classic form is instilled 'with a decidedly poetic and romantic feeling'.[13] The classical problem of composing figures in a landscape occupied her attention for many years, and she sought to banish the particular from her vision as firmly as any neo-classical painter of the eighteenth century, but its depth and gravity is romantic. The atmosphere of impending tragedy that broods over her paintings does not depend upon literary allusions which she expressly avoids, but upon the way she conceives and relates her figures to their ominous settings (158). Monumental, generalized in the classical manner, they are held together only by formal order and assert their existence by the loneliness that clings to them like the faded aureole of a god and gives them their pathetic dignity. 'I have tried', she has written concerning her work, 'to paint groups of figures in landscape, using mythology as a pretext; my main preoccupation was to try to order space and colours in a certain way, so that they would suggest to me some atmosphere I recognized, possibly a place I had seen . . .'.[14] In some respects her work recalls that of Henry Moore in the way she achieves emotional tension by using massive, classical forms to express the isolatedness of the individual. Her work, too, may be usefully contrasted and compared with that of Drysdale. Both artists make use of monumental figures and austere landscapes; both use a restricted palette and deep tones. But Drysdale's landscapes are constructed from his experience of the actual. They seek the universal by elevating the particular. Jean Bellette's landscapes are universal from the beginning, constructed out of the classical landscapes of art itself, elemental settings for timeless dramas of the heart. Certainly, stray wisps of her own memories have floated into them and she has made them her own, but the personal character of things can no longer be seen in the melancholy twilight that, *sub specie aeternitatis*, blurs and softens her human monuments.

The neo-romantic trend of the early post-war years is also to be seen at its height in the splendidly controlled but sombre pastels and paintings of Desiderius Orban. The element of mystery in his work, never forced or sentimental, is the gift of a style precisely tuned to a temperament (161). The paintings—usually small and jewel-like in colour—of David Strachan (1919-70), who studied first with Bell and later in Paris, were touched at times with a *naïveté* in homage, one felt, to early Italian masters like Piero di Cosimo. They are most typical of the time (162). So, too, is the draughtsmanship of Francis Lymburner: broad, fluent and romantic, encompassing all things within lyrical arabesques, dark and swift-running (163). In the work of such artists temperament and style came wonderfully together.[15]

Although Lloyd Rees (*b.* 1895) belongs to an earlier generation and has

not been subjected to quite the same influence, in art or thought, as the circle of painters around Jean Bellette and Paul Haefliger, his paintings are nevertheless wholly characteristic of the neo-romantic taste. His art matured slowly. It began with impressionist pen drawings reminiscent of Hilder and developed into a style almost obsessive in its close analysis of geological structure and surface vegetation. On these foundations Rees erected a handsome, conservative style with a restricted palette, broad and dark, of

161 DESIDERIUS ORBAN, *Rueil, France,* canvas, 19¾ x 25⅝, 1925, Sydney

brown, grey and green tonal masses (157). His compositions are always well built despite an interest in the portrayal of detail that has never left him, and his textures preserve the crisp precision of the Lambertian generation of the 1920s but his dark, evocative tonalism is the hall-mark of his romanticism.

In 1945 the neo-romantics formed 'The Sydney Group': Jean Bellette, Paul Haefliger, David Strachan, Francis Lymburner, Eric Wilson, Wallace Thornton, Wolfgang Cardamatis, Justin O'Brien, Geoffrey Graham and the sculptor, G. F. Lewers, exhibiting in the inaugural exhibition. In the years that followed the group was expanded to include other artists with established reputations, such as Drysdale, Nolan, Arthur Boyd, Friend, Passmore, Kmit and Gleeson; so that realistic comment, expressionism and abstract paintings came to figure in annual exhibitions predominantly neo-romantic in flavour. Despite the neo-romantic predispositions of its founders, the Sydney Group was concerned not so much with a point of view as with

162 DAVID STRACHAN, *Young Girl on a Terrace,* canvas, 16 x 24, 1946, the artist

quality; and it succeeded in establishing itself, with the assistance of the criticisms of Haefliger, as a prestige group at the expense of the older Society of Artists from which it drew several of its most prominent members. The later exhibitions of the Society revealed the Byzantinesque vogue of the late 1940s and early 1950s quite strongly together with the growing strength of abstract and non-figurative art.

Q

163 FRANCIS LYMBURNER, *Near Circular Quay*, pen and wash, 11⅛ x 7⅛, *c.* 1945, from *Fifty Drawings of Francis Lymburner*, 1946

The work of those artists who resided between 1945 and 1947 at Merioola also testifies to the neo-romanticism of this time. Although linked more by friendship, propinquity and shared interests than by a common attitude, the art of the Merioola group was, in general, neo-romantic, decorative and merrily eclectic. Persia, Byzantium, the Pacific, the colonial picturesque, costume, theatre and the ballet alike contributed to the Merioola merry-go-round of pattern and whimsical comment. Loudon Sainthill worked for a time there; so too did Donald Friend, Justin O'Brien, Jocelyn Rickards, Edgar Ritchard, Peter Kaiser and the sculptor, Arthur Fleischmann. They put on two shows late in 1947; the first at the Myer Gallery, Melbourne; the second at David Jones, Sydney, prior to the departure of most of the members overseas.

Melbourne's Angry Penguins

Following the break with the social realists, a new group of painters associated with John Reed and Max Harris and their journal, *Angry Penguins,* came into prominence in the exhibitions of the Contemporary Art Society. It included Sidney Nolan, Albert Tucker, Arthur Boyd and John Perceval. Although each artist developed a distinctive personal style they shared some attitudes and beliefs that distinguished them from any other group of artists in the country at the time.

In the first place they rejected all forms of academic training, irrespective of whether they were based upon the tonal naturalism taught at the Gallery School, or upon the post-impressionism favoured by Bell and Bell's pupils, Alan Sumner and Alan Warren, for example, or upon professional training in the abstract form of the post-cubist tradition. In this they differed from the leading contemporary painters of Sydney. Drysdale, Dobell, Herman, Friend, Bellette, Haefliger and Rees had all received professional training of some kind and maintained strong links with the art of the past, and most of them were drawn into the orbit of the Society of Artists which stood for a continuous tradition of professional practice in Australia going back to the days of Roberts and Ashton. In their break with tradition the Angry

Penguins group had more in common with the Sydney abstract and semi-abstract painters, but were not prepared like them to submit their art to intellectual principles of formal construction.

In the place of tradition the Angry Penguins painters laid the greatest emphasis upon vitality in art. All forms of training, they felt, were professionally inhibiting. Writing in 1944, Sidney Nolan remarked that 'A painting is generally the result of an underground disturbance; when the disturbance is an almost biblical moving of the bowels one can only trace the convolutions by oblique means. And in the end as with most things, one backs a hunch'.[16] This approach owed much, of course, to the cardinal importance given to 'pure psychic automatism' by the surrealists. Of importance, too, was the significance the group gave to the work of primitive and untutored painters. In December 1944 *Angry Penguins* published seven paintings by an unknown Australian primitive, 'H.D.' In his article on the work, Tucker stressed the advantage of the natural painter over those professionally trained. 'With the natural artist problems of style and technique matter little, the sustained intensity of his vision solves them for him.'[17] Closely associated with these views was the belief that spontaneity and creative activity should be given pride of place in the educational process itself. In the same issue of *Angry Penguins* Janet and Clive Nield, educational reformers (quoting D. H. Lawrence extensively), stressed the overwhelming significance of giving aesthetic education first place in the primary school.

Other local contemporary groups had, of course, stressed the importance of spontaneity in artistic creation, but none with such emphasis as the Angry Penguins. In another respect, too, they stood somewhat apart from other Australian contemporary artists. From the time of its first glimmerings in Sydney in 1913 the Australian contemporary movement found itself opposed to a tradition that was naturalistic, conservative and above all, nationalistic. Not surprisingly, the movement developed strong anti-nationalistic sentiment from the beginning. By contrast, however, the war years developed national feeling and national sentiment considerably. In literature the *Jindyworobak* group, championing an extreme form of nationalism, gained considerable support during the war years. The word was Aboriginal and meant 'to join', the leaders of the movement expressing the desire that Australian culture should draw extensively upon Aboriginal culture for its inspiration. They sought to 'link Australian thought with its natural environment', and 'treat as alien everything that owes its being directly to origins in other cultures—English cultures, Irish cultures, Dutch or American'.[18] Australian artists, they declared, should follow the tradition established by Streeton and Heysen.

Although the Angry Penguins were strongly opposed to such a conservative and self-consciously nationalistic outlook they did believe that Aus-

164 ALBERT TUCKER, *Images of Modern Evil*, wood panel,
14 x 21, 1944, the artist

tralian art could achieve distinctive and characteristic features. 'We do our-
selves believe', wrote John Reed and Max Harris in an *Angry Penguins*
editorial (September 1943), 'that Australian art is developing at an aston-
ishing rate and that its growth will inevitably (if that growth is not arti-
ficially stimulated) mature into a form of expression which will be unique
and in the truest sense of the word indigenous'. And Albert Tucker, com-
menting upon exhibitions of the work of Sidney Nolan and Danila Vassilieff
in the same issue of the journal, expressed the opinion that in their work 'we
glimpse for the first time since Roberts, McCubbin and the early Streeton,
the return to an authentic national vision on a higher and more independent
level'.[19] Let us consider now the work of the principal members of the group.

Albert Tucker (*b.* 1914) was in many respects the intellectual leader of
the group. Possessed of great, almost ruthless, independence of mind and
considerable mental courage, Tucker succeeded in fashioning a distinctive
style, vital, edgy and tough, from his personal involvement in the art and
left-wing politics of Melbourne during the years around 1940. His earliest
work, painted between 1936 and 1939, consisted mainly of street scenes and
portraits in the post-impressionist manner of George Bell with whom he
studied for a very short period. The influence of de Chirico, surrealism and
T. S. Eliot's poetry appeared in such paintings as *The Philosopher* (1939)
and *The Futile City* (131). Then followed a period in which social realism
and German expressionism together made a strong impact: typical are his
Spring in Fitzroy (1941) and his fine little *Children of Athens* series (1942).

Tucker's social realism was, from the beginning, more individualistic and

165 JOHN PERCEVAL, *The Merry-go-round*, cheesecloth on cardboard,
24½ x 16, 1943, the artist

anarchic than the social realism of Counihan, Bergner and O'Connor,
deriving much of its aggressive vitality from German expressionists like
Beckmann. Indeed, Tucker was probably the first Australian artist to turn
to the German expressionists for inspiration, Australian expressionism de-
riving for the most part from French or French-inspired sources, such as
Van Gogh, Soutine, Chagall and Rouault. In 1943, following his ideological
break with social realism, Tucker began to paint a series of pictures entitled
Images of Modern Evil (164). This series marks the end of the formative
phase of his work and the emergence of a personal style. It made much use
of recurrent and obsessive symbols: inchoate protoplasmic forms, lip images,
electric light bulbs, city trams; pig-like and snarling monsters are juxtaposed
in night and nightmarish settings. Personal to the point of autobiography,
these paintings also record disgust and despair at the brutalization of the
person by the blind authority of the mass. The life of the modern city
becomes an allegory of evil: soulless, mechanical, stupid; peopled by crim-
inals, prostitutes, clowns and psychotics. (A group of expressionistic
portraits painted in 1946 was based upon the physiognomy of criminal

types.) Tucker returned at that period again and again to the theme of loneliness, here anticipating, among Australian artists, Dickerson and others; and during this period he also painted a number of distinguished expressionistic portraits of friends, notably Sidney Nolan and Arthur Boyd. In 1947 Tucker visited Japan for four months and, after returning to Melbourne, left for Europe later in the year. His work overseas is discussed in the following chapter.

Sidney Nolan, the best-known artist of the group, was born in Melbourne in 1917 into a family which, like Russell Drysdale's, had been settled in Australia for several generations. But where Drysdale's forebears were Scottish and members of the pioneering pastoral aristocracy, Nolan's were Irish and working-class. His grandfather was a policeman in the days of the Kelly gang; his father a tram-driver for the Melbourne and Metropolitan Tramways Board.

After completing his education at a Victorian State School, Nolan became an enthusiastic racing cyclist and worked at various odd jobs, picking asparagus, cooking hamburgers, mining gold and so forth. Then in 1938, following upon some art school training and work in commercial art during the mid-1930s, he turned to painting, becoming a member of a confraternity of Bohemians and artists who inhabited a ramshackle, Chinese-owned, tenement house situated behind the Museum, State Library and National Gallery of Victoria building in Swanston Street. In the circle which included Boyd, Tucker, and Perceval, Nolan began to paint pictures, clear, bright and primitively vivacious, with something of the gaiety and charm of Raoul Dufy about them. Subjects were taken direct from life and personal experience: swimmers in the St Kilda baths, street scenes, Luna Park, large studies of heads in a flattish, childlike manner.

It is false, however, to think of Nolan as an artist working outside of tradition, a bush primitive. True, his work possessed from the beginning a remarkable directness of statement, a superb sense of space, a bright freshness of feeling and an unusual capacity for creating a memorable image. But it was not the product of an 'innocent' eye, and can only be understood in the light of what he gained from the School of Paris, from literature, and from the highly explosive local situation in which his art emerged. Such paintings as *Woman and Tree* (1941) reveal what he gained from Picasso's 1932 series of nudes in flowing arabesque; and he himself acknowledged an indebtedness to Henri Rousseau. Meanwhile he was reading widely: Rimbaud, the French symbolists, Blake. In a sense, too, Nolan's early paintings were programmatic with much of dada about them, designed, in their impertinent simplicity, to shock the art-loving public out of its wits. *Boy and the Moon*, exhibited in the second exhibition of the Contemporary Art Society (1940) consisted entirely of a great yellow blob against a deep raw

blue background. Attacks upon the exhibition in the Press singled out this painting both in Melbourne and Sydney to attack contemporary art in general, for it cocked a jaunty and colourful snook at conventional art. It irritated the local post-impressionists as much as it irritated the latter-day followers of Roberts and Streeton. Artists like Bell, Herman and Lawlor, who still sought for traditional craftsmanship and formal design, strongly opposed exhibiting the painting in the 1940 exhibition of the Society. But it was John Reed and the group of laymen and young artists committed to expressive vitality above all else who carried the day.

Nolan became a close friend of Reed and his wife, Sunday, and spent much time with them during the early 1940s. They bought the greater part of his paintings, helped him in many ways, and played a most significant role in Nolan's growth and development as an artist. In 1939 Serge Lifar, who had come to Australia with the De Basil Ballet, commissioned Nolan to design the sets and costumes for his ballet, *Icare*. Lifar had been impressed by a painting of Nolan's inspired by lines from Blake. Then in 1942 Nolan entered upon service in the Army and began to paint a series of landscapes while stationed at Dimboola, in the Wimmera District of Victoria (159). Nolan's Wimmera paintings did not make so decisive a break with the local *plein-air* tradition as Drysdale's Albury landscapes had done the year before. He still sought, as the Heidelberg painters had done long before to create a direct and vivid impression of the thing seen. His landscapes were, of course, more startling, rudimentary and immediate, but the colour and the approach to the subject remained essentially visual: a remarkable short-hand poetry of the eye; but something of the hand and vision of older men still lingered. Even in the landscapes of his Kelly paintings (1945-47) there are echoes of the Australian *plein-air* landscapists.

By 1944 Nolan's work was beginning to receive favourable critical attention beyond the Angry Penguins circle. The first critic of standing to react wholeheartedly to his work was Paul Haefliger. In December 1944 Haefliger commented upon Nolan's splendid feeling for spacing and happy colour combinations:

He is a gay adventurer, and lives, in his paintings, entirely upon his sensations. He can be very good and also the reverse. He plagiarizes when he follows too closely in the footsteps of Picasso. . . . But he is also, on occasion, most original and certain of his passages are of rare subtlety. He appears possessed by a light-heartedness which seems to deny real seriousness, but follows the way of his whimsical nature. It scarcely matters; his lyrical impulse, his natural talent, assure moments of realization which are as spontaneous a delight as anything in Australian art.[20]

After Nolan left the Army in 1945 he was associated for a time with the publishing firm of Reed and Harris, illustrated a number of books of poetry

and fiction and led an active literary life. Then, about 1945, he read J. J. Kenneally's *The Inner History of the Kelly Gang* and a transcript of the Kelly trial. Encouraged by Sunday Reed, he decided to paint a series of pictures based upon the exploits of the gang (160). Following a hitch-hiking tour of the Kelly country in northern Victoria with Max Harris, he painted the whole series in rapid succession. There had been a good deal of talk about the role of myth in art among the Angry Penguins. As early as 1942 Tucker had discussed in a political context the connexion between myth and art in his article, *Art, Myth and Society*. Arthur Boyd was already developing a personal mythology out of his interest in Brueghel and Bosch; introducing rams, crocodiles and curious lusting dwarfs into his Australian landscapes. Having regard for their interest in 'an authentic national vision' expressed in contemporary idiom, it is not surprising that an attempt to depict a national myth should emerge within the group at this stage.

In turning to Kelly—criminal or no criminal—Nolan turned to a folk-hero still lively enough, as Max Harris has put it, in the minds of 'the St Kilda lads, *and* the countryman *and* the pub raconteur'.[21] Man and myth, Ned Kelly maintains too lively an existence in the Australian imagination to be honestly denied: and it is a measure of Nolan's genius that he should create a Kelly of just the right size, neither a grandiose hero figure nor a proletarian outsider filled with self-righteousness and self-pity, but a kind of absurd relative, an eccentric brother, a joking saint who appears at odd moments merely to assert his eternal, if subterranean, existence in the Australian mind.

The paintings, themselves, bright and colourful, with that light and dexterous lyrical grace so characteristic of Nolan are executed in a kind of sham folk-art style indebted, as the artist himself has said, to 'Rousseau and sunlight'. The wit is eager, the spacing delightful and the mock-heroic sentiment disarmingly charming. But the paintings are not, like Dobell's best portraits, outstanding achievements by any standard and have been praised, perhaps, beyond their true worth. They do, however, represent none the less a significant achievement. Nolan revealed in these works that it was possible to create a witty, decorative and sophisticated art by turning to local history for his sources of inspiration.

In 1947 Nolan spent a year roaming in Queensland and lived for a time on Fraser Island, where he painted out-back and tropical landscapes, and a series based on the story of Mrs Fraser, a Scottish woman, who was shipwrecked on the Barrier Reef in 1836, and lived for a time among the Aboriginals. Then in 1948 he married Cynthia Hansen, John Reed's sister, and settled in Sydney. During the next two years he concerned himself with paintings based on Australian history and legend: Ned Kelly, Mrs Fraser, paintings on glass of the Eureka Stockade and landscapes based on travels

in Central Australia. His work during the 1950s is discussed in the following chapter.[22]

Arthur Boyd (*b*. 1920), the third member of the group, was born into a family long associated with the arts in Australia. His grandfather, Arthur Merric Boyd (1862-1940), was a landscape painter who was born in Dunedin, New Zealand, and came to Australia in 1886 where he married Emma a'Beckett, the granddaughter of Sir William a'Beckett (1806-69), the first Chief Justice of Victoria. After travelling in England and the Continent, A. M. Boyd and his wife settled in Brighton, Victoria, where they painted landscapes and seascapes. Both exhibited at the Royal Academy and their work was included in the 'Exhibition of Australian Art in London', held at the Grafton Galleries in 1898. One of their sons, Penleigh Boyd, became a talented landscape painter who worked in a lyrical and atmospheric manner comparable with the early paintings of Gruner. Following his return from Army service in France, he became one of the best-known landscape painters in the country. In 1923, as we have seen, he brought out to Australia an important collection of European paintings, but was killed in a motor accident the same year. A second son, Martin Boyd, remained in England after service with the R.F.C. and became a well-known novelist. A third, Merric Boyd, Arthur Boyd's father, also remained in England for a time after the war to study pottery and kiln construction in Staffordshire and established a pottery at Murrumbeena, Victoria, upon his return in 1919.[23]

At an early age Arthur Boyd gained instruction in the art of ceramics from his father and was taught to paint landscapes in the Heidelberg tradition by his grandfather, but he did not receive formal training in art or technical schools. The Boyd family was a devout one, and Mrs Boyd brought up her children in an atmosphere in which art and religion occupied pride of place. In this family the desire to be an artist was not regarded as an eccentricity but as the acceptance of a calling with rights and responsibilities. Behind the art of Arthur Boyd and his brother David (*b*. 1924), there lies a family tradition of art, craftsmanship and Christian humanism.

During the later 1930s Arthur Boyd came into contact with the modern movement from reproductions and books available at Gino Nibbi's Leonardo Book Shop. Rouault, Van Gogh, Gauguin and Christopher Wood left their impression. About 1938 he made a set of illustrations in the style of Rouault to *The Brothers Karamazov*. Dostoevsky's tragic view of life and his concern with the elemental passions helped to liberate corresponding qualities in Boyd's own imagination. In 1939 Boyd joined the Army Survey Corps where he met John Perceval who later married his sister, Mary. Albert Tucker brought Boyd and Perceval into touch with the Contemporary Art Society, the two painters exhibiting work in the C.A.S. 1942 Annual Exhibition and the Anti-Fascist Exhibition that followed a few months later. The influence

of the social realist painters, Josl Bergner especially, exercised a deep influence upon both painters at that time.

In *Progression* (1941, Mr and Mrs John Reed), a characteristic feature of Arthur Boyd's work emerged for the first time: a tension between distorted and grotesque forms and the tenderness with which they are expressed. There is here already an identification of artist and theme, a humanism all pathos, that reaches beneath the levels of sentiment and political assertion. Following his social realist phase Boyd turned, about 1943-44, to paintings that embodied figures in landscapes. He continued to use a dark, restricted palette, but adopted freer and more expressive brushwork, breaking his canvases into textured expressive surfaces. These figured landscapes afford a parallel with those Albury landscapes painted by Drysdale in 1941. Boyd's work derived little if anything from Drysdale directly; but the publication of a large number of Drysdale's early landscapes in *Australian Present Day Art* in 1943 made his work, and a new orientation to Australian landscape, widely known throughout the country. Both Drysdale and Boyd moved from the light-toned, blue and gold palette and air of optimism traditional since the Heidelberg days towards a dark palette and pessimism. Surrealism and expressionism contributed to the emergence of both styles. But Drysdale's work clung to a more realistic path and was predisposed to the heroic and classical; Boyd's was more personal and allegoric. There is a turbulence and violence about his figured landscapes quite different from Drysdale's ordered composition. Boyd's scruffy bushland of grass trees and stunted eucalypt harks back to early colonial work, but the approach is new. The bush is a dark, primordial wood inhabited by those dwarfs and demons that once populated the medieval imagination, a St Anthony's wilderness full of strange devils. They sprout up from the earth, ride on monstrous animals, copulate, or crouch in loneliness, grief and despair. It is a vision of life heightened to a pitch of agonizing energy in which generations pass like generations of flies. It is curious how Boyd's work, like Drysdale's, testifies to the continuity of thought. In Drysdale the Australian landscape became once again what it was for Barron Field and several generations of pioneers, a 'barren wood', stark and intractable: Boyd's imagination recovered an old medieval vision of antipodes that had survived the rationalism of two centuries and the abstractions of a third. When, in 1793, Captain John Hunter, the second Governor of New South Wales, described in the language of the Enlightenment the novel forms of life he had met with in Australia, he anticipated curiously the surrealist monsters that confront us in Boyd's bush paintings and ceramic sculpture:

It would appear from the great similarity in some part or other of the different quadrupeds which we find here, that there is a promiscuous intercourse between

166 ARTHUR BOYD, *David and Saul*, canvas, 35 x 36¾,
c. 1946, Dr A. M. McBriar

the different sexes of all those different animals. The same observation might be made also on the fishes of the sea, on the fowls of the air, and I may add, the trees of the forest.[24]

In Boyd's paintings and ceramics this ancient vision of lusting antipodean monsters appears in a contemporary idiom.

In 1945 Arthur Boyd and John Perceval turned to a study of the masters of the past, especially to Bosch and Brueghel, in the desire to widen their artistic vocabulary and learn more about expression and composition. Mr Franz Philipp has pointed out how Brueghel's influence enabled Boyd to express the monstrous horrors of the war-time concentration camps with complete detachment.[25] For some years after 1945 religious themes occupied a prominent place in his work. In such paintings as *The Mockers* and *The Mourners* (1945-46), a religious subject-matter was given contemporary pertinence and universal significance. A little later Boyd turned to an intense and prolonged study of Rembrandt, a study that has since entered deeply into the mood and spiritual texture of his own work (166). The religious paintings culminated in a series of murals for his uncle, Martin Boyd, the novelist, painted in 1948 at 'The Grange', Harkaway.

While occupied with his religious paintings, he continued to paint his

own highly individual interpretations of the Australian scene. Many were executed in an egg-tempera technique which provided him with rich, enamel-like colours and fine tonal transitions. Some years before Tucker had introduced Boyd to Max Doerner's *Materials of the Artists and Their Use in Painting* (1934), which stimulated his interest in painting techniques and led to his decision to grind and prepare his own pigments.

In 1944 Boyd, Perceval and Peter Herbst, a University friend, founded the Murrumbeena pottery; and, during the later 1940s and early 1950s, both artists turned to pottery and ceramic sculpture with highly rewarding results. Ceramics, long practised in the Boyd *ménage*, provided both artists, after their release from the Army, not only with some economic support for themselves and their families but a new medium which they mastered with skill and imagination. During the early 1950s Arthur Boyd produced some of his finest and most memorable works in ceramic sculpture.

John Perceval (*b.* 1923), the youngest member of the Angry Penguins circle, began to paint from prints of Van Gogh and other modern masters during an attack of poliomyelitis. Closely associated with Arthur Boyd from the beginning, both artists have developed in a partnership of interests and influences. But Perceval has always been an artist in his own right; never at any time a mere disciple of Boyd. His first paintings, exhibited in the 1942 Exhibition of the Contemporary Art Society and the Anti-Fascist Exhibition which followed, were large in scale, combining social realist themes with forceful expressive techniques.[26] At that time he was strongly influenced by Orozco and Rivera. His paintings occupied themselves, at the beginning, with the problem of the individual in society.

The early work consisted of broad, massively constructed tonal paintings, but in 1943 he turned to a more painterly technique using a wider range of colour and more expressive brushwork. In night scenes, spiritually akin to Tucker's work at this time, boys with cats, and jack-in-the-box paintings, the confrontation of innocence and evil were symbolically presented (165). Later Perceval worked with Arthur Boyd, painting in tempera and resin, when both artists were occupied with the problem of painting crowd scenes in landscapes and with the work of Bosch and Brueghel.

After the foundation of the Murrumbeena pottery, Perceval turned his attention increasingly to pottery and, for a time, ceased to paint. His most important achievements, both in ceramic sculpture and in painting, belong to the 1950s and are discussed in the following chapter.

By 1947 the Angry Penguins had, as a group, virtually ceased to exist. The last *Angry Penguins Broadsheet* appeared in 1946 and, late in 1947, the Melbourne Section of the Contemporary Art Society collapsed. In 1947 Tucker left for Europe and Nolan spent a nomadic year in Queensland. Boyd and Perceval became increasingly involved in the development of the

Murrumbeena pottery. But though the group ceased to exist, the individuals continued to be as active as ever.

Australian society discovered contemporary art just when it had to face the challenge of war. The unusual degree of vitality which emerged is a clear indication of the vitality of the nation when forced to rely upon its own resources. By 1947, however, with the war over and the battle for the recognition of contemporary art won, there are indications of a slackening of the ebullient vitality of the war years. Peace, and the acceptance of the contemporary idiom in art, brought its own problems. After years of comparative isolation, most practising artists wanted to get away to Europe if only for a time, and a new generation of artists had not yet emerged. It was still, delayed by the war, in the art schools.

Peace, too, brought a marked change from the expressive extroversion of the war years. Art became, in the hands of the most creative, a more private matter, concerned far more with the individual than with society. Many were drawn to religion and became fascinated by medieval styles of one kind or another; others, like Nolan and Boyd—black swans upon alien waters—sought identification by turning to myths and legends which had already for many years provided Australian society with a sense of its own independence among the nations. But ten years of peace brought the triumph neither of religion nor of nationalism in the visual arts, but the victory of those informal kinds of abstraction which flowed for the most part from contemporary American experience and gave sanctity to nothing but the physical activity of painting itself.

NOTES

1 *AA*, March-May 1941, p. 9

2 On the Ern Malley hoax *see AE*, vii, 66; and *Ern Malley's Poems* (int. by M. Harris), Melbourne, 1961

3 *Angry Penguins*, iv (1943), p. 53

4 *AA*, iii, 76 (August 1939), p. 18

5 On Purves Smith *see also Australian Present Day Art* (ed. S. Ure Smith), Sydney, 1943, pp. 109-12; 1960 Acquisitions, Art. Gall. of N.S.W., pp. 28-9; 1960-61 Acquisitions, Queensland Art Gallery

6 'In a Dry Season' in *The Prose Works of Henry Lawson*, Sydney, 1935, p. 61

7 'The Union Buries its Dead', *op. cit.*, p. 59

8 *See also Russell Drysdale, a Retrospective Exhibition of Paintings from 1937 to 1960*, Sydney, 1960, which contains detailed biographical notes and an extensive bibliography

9 On Herman *see also* DANIEL THOMAS, *Sali Herman*, Melbourne, 1962; and B. SMITH, 'The Art of Sali Herman, *Meanjin*, vii (1948), 172-6

10 On Friend *see also Australian Present Day Art* (1943), Sydney, 1943, p. 70; and *Present Day Art in Australia* (ed. S. Ure Smith), Sydney, 1945, p. 33

11 *See* UTHER BARKER, 'The Boy at the Basin', *AA*, iii, 76 (August 1939), pp. 46-8

[12] This summary is derived from a typescript of the evidence given in the Supreme Court in Equity, New South Wales, H.M. Attorney-General for the State of New South Wales *v.* The Trustees of the National Art Gallery of New South Wales and William Dobell, in the library of the Art Gallery of New South Wales; on Dobell *see also The Art of William Dobell* (ed. S. Ure Smith), Sydney, 1946; *CAO*, pp. 55-6.

[13] U. HOFF, 'The Art of Jean Bellette', *Meanjin*, xi (1952), 358-60

[14] Quoted by DR HOFF, art. cit., p. 359

[15] On Lymburner *see also Fifty Drawings by Francis Lymburner*, Sydney, 1946; D. CLARKE, 'The Art of Francis Lymburner', *Meanjin*, ix (1950), no. 2

[16] *Angry Penguins*, Autumn 1944, p. 104

[17] *Angry Penguins*, December 1944, p. 25

[18] VICTOR KENNEDY, *Flaunted Banners*, Adelaide, 1941, p. 40

[19] A. TUCKER, 'Two Melbourne Exhibitions of Paintings', *Angry Penguins*, September 1943

[20] P. HAEFLIGER, 'The Contemporary Art Society Exhibition', *Angry Penguins*, December 1944, p. 94

[21] 'The Young Master', *Nation*, 2 July 1960, p. 12

[22] On Nolan *see also Catalogue to the Exhibition of Paintings from 1947 to 1957*, Whitechapel Art Gallery, London, June 1957, and *Sidney Nolan*, London, 1961

[23] *See* J. YULE, 'Merric Boyd', *Modern Art News* (Melbourne), i (1959), 15

[24] J. HUNTER, *An Historical Journal of the Transactions at Port Jackson and Norfolk Island*, London, 1793, p. 68

[25] F. PHILIPP, *Present Opinion*, ii, 11, 1947. I am also indebted here to U. HOFF, 'The Paintings of Arthur Boyd', *Meanjin*, xvii (1958), 143-7; *see also* F. PHILIPP, *Arthur Boyd*, London, 1967.

[26] On Perceval's early work *see* JOHN REED, 'Introduction to John Perceval', *Angry Penguins*, September 1943; and M. GARLICK, John Perceval, Hon. B.A. essay, School of Fine Arts, University of Melbourne, 1961

CHAPTER NINE

FIGURATIVE AND NON-FIGURATIVE
1950 - 60

*It sets out to show the direction in which abstract art is
heading in that country. . . . It is heading, as elsewhere,
right away from the visual image to the point where all that
is left is a gesture.*

LAURIE THOMAS, reviewing the *British Abstract Painting*
exhibition. The *Sun* (Sydney), 17 March 1959

*We want to say, finally, that we are more directly concerned
with our own art, more involved in it, than in anything else.
This is not escapism. It is simply a recognition that the first
loyalty of an artist is to his art. Today that loyalty requires,
beyond all else, the defence of the image.*

The Antipodean Manifesto, August 1959

AFTER the war Australian society entered a new phase. A series of good
seasons, a comprehensive immigration policy, rapid industrial growth and
expanding overseas markets had created by 1950 a society still small in
numbers but rich in material wealth. The first post-war decade (1945-55)
was not, however, a period of great vitality in Australian painting. Although
some of the leading painters of the contemporary movement, Drysdale,
Nolan and Arthur Boyd, for example, were widening and deepening the
range of their experience and maturing as artists, the initial impetus of the
movement itself was spent. The Melbourne branch of the Contemporary
Art Society collapsed in 1947, its first revolutionary phase over; the Sydney
branch was sustained largely by a faithful circle of abstract painters and
sculptors, but its influence was marginal. The more successful painters
graduated to the Society of Artists and within the C.A.S. itself little was
done to encourage discussion and controversy. There was a tendency to
assume that the problems of contemporary art had been solved, that the
society's business was now primarily to educate laymen. Emphasis upon
lay education in the arts was widespread, and sundry bodies arose to
perform the task. In rural areas the Council for the Encouragement of Music
and the Arts, Adult Education, and travelling exhibitions organized by
State galleries were active. In the cities, societies on the American model,
designed to stimulate interest in the collections and activities of the State
art galleries, were formed, first in Melbourne, then in most other capitals.
Such activities widened public appreciation of the arts considerably, but

167 JUSTIN O'BRIEN, *The Virgin Enthroned* (central panel of a triptych), canvas, 44½ x 32, 1951, Melbourne

appreciation was often thin and superficial. There was a dearth of discussion about fundamentals, little real clash of opinions. Serious art publication virtually ceased in the years after the war. *Art in Australia,* a war casualty, had ceased publication as early as 1942, *Angry Penguins* and its *Broadsheet* in 1946. For two years (1947-49) the Victorian Artists' Society, with their *Australian Artist,* bravely attempted to provide a journal, under the editorship of R. Haughton James and others. Books fared no better. From the death of Sydney Ure Smith in 1949 until the appearance of Kym Bonython's *Modern Australian Painting and Sculpture* (1960), no books of any great consequence dealing with contemporary Australian painting appeared.

Art ceased to be treated in the Press as it had been treated prior to and during the war, as a controversial matter and was featured increasingly, especially in Sydney, as social news and gossip. Paintings were now very rarely reproduced for their own sake, but appeared vicariously behind the heads and hats seen at exhibition openings. Art was rarely considered to be a criticism of life or even of other art and was thought of as culture, an adjunct to 'gracious' living. In Sydney the National Gallery Society became well known for its buffet banquets and candlelight concerts in which the consumption of art was subordinated to the public consumption of food.

The standard of art criticism in the Press continued to be poor. Inadequately paid, committed more to cliques than to principles and written, not as in highly civilized countries by professionals trained to their discipline, but for the most part by ageing painters soured by lack of recognition or very vocal young ones clamouring for it, what passed for criticism was, like the life of Hobbes's first men, 'nasty, brutish and short', given more to taunts and sneers than to enjoyment; hopelessly vitiated by jealousy, hidden loyalties and personal vendettas. Few critics, if any, ever ventured from the shallows of their Press columns into the deeper waters of criticism. None made important contributions to the criticism of European masters, past or present. Exhibitions from abroad were never really criticized, nor welcomed as a chance to test local standards of judgement upon different material. At the very sight of anything from over the water, local art critics were to be seen genuflecting everywhere. The 'cultural cringe'[1] became an occupational disease, a permanent stoop, among the confraternity. Australian art, at least, was better than its critics.

Material wealth and the desire for culture also fostered the art prize. Many local government bodies, in country towns or city suburbs, prompted by citizens anxious to bring a measure of sweetness and light to their localities, provided moneys for annual art prizes. In the cities the new affluence promoted the growth of dealers' galleries and the consequent increase of one-man exhibitions at the expense of the older group or Salon-type exhibitions of the established societies. During the 1950s the annual

exhibitions of such societies as the Royal Art Society, the Society of Artists, the Victorian Artists' Society and the Contemporary Art Society became of less significance than they had been in preceding decades. Young artists found it easier than ever before to arrange one-man shows of their work. The private gallery prepared the way for professional dealing in contemporary Australian art, which became increasingly prominent during the later 1950s.

Beneath the stale froth of culture, art pursued its way more or less concealed. Younger artists turned steadily away from all forms of realism; and contemporary life, if portrayed at all, was usually accompanied by an air of wistfulness. The surface of life was no longer interesting; some of the most creative writers and artists of the decade turned to the consolations of religion. For the first time religious painting flourished in the country. The desire to revive religious art was international in its ramifications and due in no small measure to Catholic intellectuals seeking a religious art suited to the spiritual needs of the century. The work in France of the Dominicans, Père Régamy and Père Couturier, through their journal, *Art sacré*, has been of great importance in this regard. But the mood and temper of the time were propitious. Hiroshima and the nuclear arms race that followed, the intransigent power politics of communism and the cold war, the debauchery of intellectual, moral and cultural standards by commercial mass communication in the West, eroded faith in scientific progress and materialistic thought. Those who respected themselves and others withdrew if not into religion, then into the practice of art itself. The artists most honoured by the young, like Godfrey Miller, John Passmore and Ian Fairweather in Sydney and Roger Kemp in Melbourne, lived in comparative seclusion; men alone with their art. They became the local forerunners of the non-figurative revolution which transformed art in Sydney fifteen years ago and has spread throughout the country since.

The Revival of Religious Painting

In Sydney the revival of religious painting centred upon the work of Justin O'Brien (*b.* 1917), who studied and taught painting in Sydney prior to serving in the Army. Taken prisoner in Greece, he began to paint again as a prisoner of war in an Austrian fort on the Vistula, finding a new source of inspiration in Byzantine art. After returning to Australia at the end of the war he held a joint exhibition with Jesse Martin at the Macquarie Galleries in 1944. His work at that stage was still immature and somewhat self-consciously designed; but the burning depth of colour, solemnity and hieratical splendour of Byzantine art had left a permanent impression. O'Brien's art, however, does not belong in spirit to the severe 'expressionistic' Syrian Byzantine but to the delicate transitional art of the Sienese

trecento. It is a religious art softened by opulent colour, elegant arabesque and sometimes a touch of folk whimsy; owing more to Persia and Matisse than to Rouault and the 'dark night of the soul'; an art devout in its good taste but not militant with evangelical intensity (167).

O'Brien's paintings did much to promote a richly colouristic and neo-Byzantine type of decorative art very popular in Sydney during the late 1940s and early 1950s. Medieval Christian art, Persian and Indian painting and the décor of the Russian ballet all contributed to the mode. Some of the best work of this kind was produced by Loudon Sainthill, a talented theatre designer with a refined yet generous feeling for colour. The Byzantinesque trend was, in a sense, a late development of the neo-romanticism inaugurated by Jean Bellette and Paul Haefliger during the war years. O'Brien's work, especially that based on secular subject matter, reveals the continuing influence of Bellette. In such paintings slender, effeminate nudes rendered in graceful arabesques inhabit a wonderland of magic colour. Jeff Smart (*b.* 1921), a South Australian who later settled in Sydney, has also painted a good deal in this mode.

Neo-Byzantinism was augmented for a season or two in the work of Michael Kmit (*b.* 1910), a native of the Western Ukraine who studied and taught at the Fine Arts Academy in Cracow and worked in Italy, Paris and Vienna before arriving in Australia in 1950. Kmit's Byzantinism was freer and more expressionistic than O'Brien's, and though rapid and uneven in execution could rise at times to work of unusual beauty and distinction (168), as in his fine painting, *The Evangelist John Mark*, which was awarded the Blake Prize for 1953.

In Sydney the interest in a contemporary religious art was sufficiently widespread by 1951 to make possible the establishment of an annual prize and exhibition devoted to religious painting. The idea came originally from Mr Richard Morley, who believed that an annual prize for a religious painting similar to those awarded in many European countries would stimulate both art and religious life in Australia.

William Blake's name was chosen because it was felt that his intensely personal art and religious life would transcend the denominational problem and suggest the type of religious art the committee wished to champion. The catalogue of the first exhibition (1951) pointed out that the award was unique in that two standards were involved—one artistic and the other religious.

We ask of all work that it should be both religious and beautiful. It must be religious in the sense that it has its inspiration in a mind that is not only capable of seeing the inner spiritual meaning of its subject but also the ability to convey that essentially universal reaction to others. It must be beautiful, not in any slavish, photographic way, merely copying nature, but in the sense that by a

168 MICHAEL KMIT, *The Three Wise Men*, canvas,
31 x 25, 1954, Melbourne

new creation the artist has produced that 'something' which, being seen, pleases
—pleasing the whole man, his senses as they ought to be pleased and his mind
as it ought to be pleased.

Many artists found the challenge to interpret traditional religious themes
in a contemporary idiom salutary, and the awards were made, for the most
part, with good judgement and maintained from year to year a reasonably
wide range of sympathies. Justin O'Brien, not inappropriately, won the first
Blake Prize with a splendid *Virgin Enthroned* (167); and Frank Hinder
won the second, with his *Flight into Egypt* (1952), an interesting essay in
dynamic symmetry, if not in religious experience. As the years passed and
critical values changed, the judges of the award became increasingly
tolerant of abstract forms of expression. But they set their face from the
beginning against any use of religious themes in the criticism of contem-
porary society. Arthur Boyd's magnificent paintings, *The Golden Calf* and
The Mockers, exhibited in 1951, for all their beauty of paint and vitality of
expression, cut too close to the bone of the affluent decade. In the minds

of most of the judges it is clear that religious experience was identified with personal illumination, ritual piety and the sacraments. The prize symbolized not only the religious aspirations of the decade but also its quietism.

The rapid movement in Sydney towards a predominantly non-figurative style in painting, which is discussed later in this chapter, created problems for the Blake Committee. It was committed to support innovation: but it was doubtful to what extent a purely non-figurative art could be deemed religious. 'Religious art must be didactic' asserted the foreword to the 1957 catalogue, 'and it must relate to specific theological truths which have their reality quite apart from the mind of the artist'. How far could a purely non-figurative art be didactic and reveal specific theological truths possessing a reality apart from the mind of the artist? Was the Committee obliged to see God in every artist's burning bush of colour? To what extent was the non-figurative painter an iconoclast helping to destroy the traditional imagery of the Church? To what extent was he glorifying in his own creative power rather than glorifying God? On the other hand, did the new informal modes of abstraction reveal the personal but none the less genuine spiritual experiences of the artists who painted them? Such questions were not easily answered. The judges of the award, however, increasingly favoured abstract work until, in February 1961, Stanislaus Rapotec was awarded the Blake Prize for his *Meditating on Good Friday*, an entirely non-figurative painting.

The Recognition of Australian Art Abroad, 1950–60

Exhibitions of Australian art, such as the Grafton Galleries exhibition of 1898 and the Burlington House exhibition of 1923, had been shown in London from time to time; Australian artists had exhibited continually at the Royal Academy and the Paris Salons from the end of the nineteenth century; but before 1950 critics overseas assumed and often had good reason to assume, that Australian art was for the most part a provincial expression of British art, the inspiration second-hand, the quality second-rate. During the 1950s, however, exhibitions of work by Drysdale, Nolan and Tucker gradually produced a revision of these assumptions. It was observed that Australian art possessed qualities of its own, that it was drawing not only upon European art but also upon Australian experience and attitudes, and upon Australian history. It is not surprising that the recognition of Australian art overseas was long delayed. The men who created the Australian school of painting towards the end of the last century revealed themselves as soon as they left the country to be colonials at heart. They not only failed to make any creative contribution to twentieth-century European art; they also failed in Europe to maintain the level of their youthful achievements. The local tradition was too young, too thin, too ill-nourished, too little-loved to survive the rigour of the sea voyage. It was difficult for the Heidelberg

169 GODFREY MILLER, *Unity in Blue*, canvas, 26 x 33, completed 1952,
Sydney, gift of the Society of Women Artists

expatriates and their numerous followers to appreciate that the standards of the Academy and the Paris Salons were not as firmly based and as international as they appeared. The second phase of Australian art which began about 1939, however, brought forth qualities of the Australian mind and imagination tough enough to survive in other soil. Though nourished upon European art, the work of Drysdale, Nolan and Tucker was embedded firmly enough in Australian interests and attitudes to maintain distinctiveness from European art in general. By maintaining their Australianness, and at times asserting it, they provided their art with room to breathe and develop in its own fashion.

The story begins in 1949. In December of that year John Reed, with the assistance of Peter Bellew, who had joined the art section of the U.N.E.S.C.O. executive, arranged an exhibition of Nolan's Ned Kelly paintings at the U.N.E.S.C.O. headquarters in Paris. The introduction to the catalogue was written by Jean Cassou, who had previously declined Reed's request to exhibit the paintings at the *Musée National d'Art Moderne*. The exhibition, however, was not reviewed, and received little attention. In the

170 JOHN PASSMORE, *Night in Harbour*, gouache on newspaper, 23½ x 32¾, 1956, Colonel Aubrey Gibson

following year the paintings were displayed by Gino Nibbi, who had returned to Italy, in his bookshop and gallery in Rome. Meanwhile, Sir Kenneth Clark, who had been acting as an adviser on major purchases for the National Gallery of Victoria, was invited to visit Australia by the Felton Bequest Committee. Joseph Burke, who had been appointed as the first Herald Professor of Fine Arts in the University of Melbourne in 1947, assisted Clark in the preparation of his itinerary, advising him, among other things, not to miss seeing something of Nolan's work, 'the most imaginative and original painter whose work I have seen in Australia'.[2] Clark arrived in January 1949, met Nolan and Drysdale in Sydney and was impressed by the work of both artists. 'I would not have accepted those upside down birds and flying harvesters', he has since written of Nolan's work, 'if my eye had not been held by vivid communication of every touch, and by the truth of tone which is the surest sign of a natural painter'.[3] Clark also advised Drysdale to hold an exhibition in London, and became a good friend of Australian art following his return to England.

In November 1950 Drysdale held an exhibition at the Leicester Galleries

in London. It met with fair success, the image of Australian outback life which he had fashioned during the war years making its first impact upon English art criticism. A painting entitled *War Memorial* was purchased by the Tate Gallery from the exhibition. At the Redfern Gallery, a couple of months later, Nolan held an exhibition of Central Australian landscapes painted from experience gained flying over the continent during 1949-50. Although it did not receive a great deal of attention the Tate bought a painting and the exhibition did something to complement and reinforce the new image of the outback beginning to crystallize in British art criticism.

Nolan had arrived the previous year. He settled for a time in Cambridge and then travelled during the winter of 1950-51 through France, Spain, Portugal and Italy. Upon his return to Australia he held an exhibition of small paintings at the Macquarie Galleries, Sydney, based upon his Mediterranean experiences, in which his visual wit, his fantasy, and his technical ingenuity were delightfully combined. Bird-like in the darting immediacy of his images, Nolan was less committed to an Australian iconography than Drysdale, making art out of his experience regardless of place.

Back in Australia, Nolan continued to work with immense energy. Commissioned by the Brisbane *Courier-Mail* in 1952 to make drawings in the drought areas of Central Australia, he visited the interior at a time when the Northern Territory, due to the failure of the monsoonal rains of 1952, was experiencing one of the most severe droughts in its history. In that summer an estimated 1,000,000 head of cattle valued at £25,000,000 died. Nolan painted with brutal realism and a sharp-edged economy of statement the cadavers of animals he had seen contorted in death by starvation and shrivelled by the sun. They were exhibited at the Stanley Coe Gallery, Melbourne, in March, and David Jones's Gallery, Sydney, in July 1952. Some of these drought paintings were shown in a second exhibition held at the Redfern Gallery in London in October 1952.

Australian contemporary work then began to appear more frequently in overseas exhibitions. In 1952 Australia was represented at the Carnegie International Exhibition of Contemporary Art by work from Dobell, Drysdale, Nolan and Friend. In June 1953 the Arts Council of Great Britain arranged a small exhibition of contemporary Australian painting at the New Burlington Galleries, London, on the occasion of the Coronation. It included paintings by Dobell, Drysdale, Nolan, Rees, Friend, O'Brien, Bellette, Constance Stokes, Arthur Boyd, Miller, Hinder and Balson. 'Australian painters', wrote *The Times* art critic reviewing the show, 'were anxious to produce a genuine national style, but also made every effort to keep up with the latest international art movements'.[4] The exotic element in the work attracted the critic most strongly. Nolan was 'the strongest and most curious'[5] of the artists showing; his works were 'suffused with a kind of pictorial folk-lore that has

vanished from serious painting in Europe'[6] and 'painted in a sham-naïve manner derived from European and other Sunday painters'.[7] Drysdale's darker vision was not so much admired. He was, said the *Sunday Times* critic, turning 'Australian landscape into a transcript from Ezekiel and Australian womanhood into a set of low-spirited frumps'.[8] The Australian Immigration Department held similar objections. Quality not obviously Australian was less noticed in the exhibition. Nothing more was found in Dobell's art than 'an engaging broad humour', and the two 'brave' abstractionists were treated rather patronizingly.[9] *The Times* review was representative of London critical opinion of Australian art at that time. Exotica, raw-boned and vigorous, appealed; Australia was thought of as a land culturally primitive, whose most talented artists, appropriately enough, worked in a primitivistic manner, painting deserts, banditti and tough bushmen. Nolan's paintings from the exhibition were sent on later to the 1954 Biennale.

Albert Tucker's work attracted some attention on the Continent before it became known in London and New York. After leaving Melbourne he lived in London from October 1947 until March 1948. But at that time his expressionistic urban imagery fell into no readily recognizable Australian form. From 1948 until 1950 he lived in Paris (where the work of Dubuffet exercised an influence), and during 1951 in Germany, holding his first one-man show abroad in the Kunstzaal van Lier, Amsterdam, in that year. During the winter of 1951 and the spring of 1952 he was back in Paris, where he held a show at the Galerie Huit. Then in 1952 he lived most of the time at Noli in the Italian Riviera. Until this time he had continued to develop the expressive urban imagery he had begun in Melbourne in 1943, but under the impact of French and German contemporary art, his forms became more abstracted and dissociated, and his colours more dense and complex. At Noli, however, he turned to a series of religious paintings: among them are some of his finest works, such as his stark and monumental *Judas* (171). Many of these paintings were exhibited in his first exhibition in Rome, which was held in 1953 at the Galleria di Quattro Venti. In Rome, where he lived from 1954 until 1956, Tucker's work first began to attract more than passing critical attention, and in 1956 he received a personal invitation to submit work to the Venice Biennale. About 1954 he had begun to turn to Australian frontier images of explorers, bushrangers and the desert. Tucker's frontier, however, possessed neither the folksy charm of Nolan's, the pathetic heroism of Drysdale's, nor the monstrous tumult of Arthur Boyd's. It was tough, scarred, residual and humourless, and had absorbed into its leathery textures a good deal of *art brut* and the abstract art of Italian painters like Alberto Burri working with polyvinyl acetate in low tones and heavy textures. His 'machines link outpost and capital

R

with more certainty than other Commonwealth artists', wrote Lawrence Alloway.[10] In Rome, and later in New York, the recognition of Australian art as a distinctive style based on frontier imagery has been due in large measure to Tucker's art. Late in 1956 he returned to London. During the following three years his art became known to critics in London and New York, where the Museum of Modern Art and the Guggenheim Museum purchased examples of his work.

Meanwhile Sidney Nolan had, in 1954, returned to Europe as a delegate for Australian documentary films at the Venice Film Festival, where *Back of Beyond*, produced by John Heyer (with whom Nolan had worked in Central Australia the year previously) won the *Grand Prix*. Then, after showing a group of his paintings at Venice and acting as Australian Commissioner at the Venice Biennale, he travelled in southern Italy, painting landscapes and compositions featuring the iron folk-art crucifixes which fascinated him at the time. In June he held a joint exhibition with Albert Tucker at the International Press Club in Rome, both artists exhibiting Australian desert and frontier paintings which attracted critical attention. Back in London in 1955, Nolan painted a new series of Ned Kelly paintings, exhibiting them with Italian crucifix themes at the Redfern in May 1955. Kelly had then become a familiar figure to London critics. John Russell, of *The Times*, spoke with great warmth about '. . . tender, brutal, universal Ned . . . the eyeslits of his steel helmet, sometimes alight with the joy of life, at times crimson with the threat of death'.[11] Nolan, however, now began to turn his attention from frontier to classical myth. Towards the end of the year, with Robert Graves's book on the Greek myths in his mind, he went

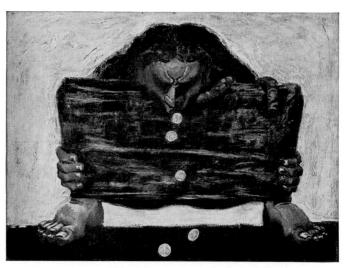

171 ALBERT TUCKER, *Judas*, hardboard, 38 x 51½,
1955, the artist

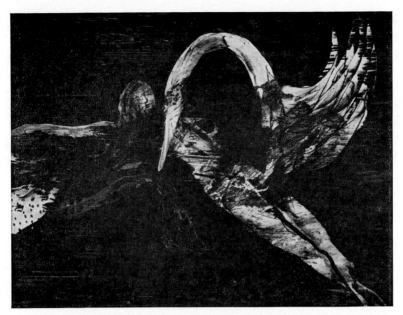

172 SIDNEY NOLAN, *Leda and the Swan*, polyvinyl acetate
on hardboard, 48 x 60, 1958, Sydney

off to paint landscapes in the island of Hydra where he lived from 1955 to
1956. From 1954 to 1956 he maintained contact with Australia by a series
of exhibitions based mainly on Mediterranean themes held at the Mac-
quarie Galleries, Sydney, in September 1954; at the Johnstone Gallery, Bris-
bane, in December 1954; and at the Macquarie Galleries, Sydney, in March
1955 and October 1956. During 1956-57 he moved about a good deal; from
Greece to Italy on an Italian Government Scholarship, thence back to
London for some months. Then, during a brief return visit to Australia, he
was able to visit Greece, Turkey, India, Cambodia, Mexico and America,
before returning to London for a large retrospective exhibition of his work
held in the Whitechapel Gallery, London, during June and July 1957. This,
the most important exhibition of his work yet held, covering the ten years
from 1947 to 1957, was received with great enthusiasm by London critics.
Nolan's work at the Whitechapel came to be accepted in its own right as
painting rather than as exotica.

During the late 1950s and early 1960s, Nolan became one of the best-
known painters at work in England. In June 1960 he held an exhibition of
paintings in the Matthiesen Gallery based on the Leda and swan myth
which had been inspired by his reading of Graves, an unpublished poem by
Alwyn Lee, and his experiences in Greece (172). This movement into
classical myth was a natural and normal development in Nolan's art, for his
art has never been limited by a national mythology. Writing on this point,

Sir Kenneth Clark has suggested that the element of myth in Nolan's art need not be over-emphasized: 'though he has drawn his strength from a locality he is able to transcend it, the local becoming universal'.[12]

In June 1961 a large exhibition of contemporary Australian art was shown at the Whitechapel Gallery and was most favourably received. Many critics recognized a distinctive quality in the work at large. The consideration of this exhibition and its importance lies beyond the scope of this chapter, but as we shall see later it proved to be a landmark. Australian artists became aware that they confronted a new situation. For the first time a receptive audience for their work began to appear overseas, mainly in England. The 1960s witnessed the emergence of two markets for Australian painting: one in England and one in Australia. In consequence Australian expressionism came to repeat, in some degree, the cycle of genesis, exodus and leviticus traced out previously by the impressionism it had replaced: a formative and rebellious local beginning, an expatriate phase of widened horizons and deepened ambitions, and finally a home-coming phase that was cast in a rather doctrinaire mould in which conventional, 'avant-garde' wisdom from the recent past was promulgated with an air of authority among students. In such wise the 1960s were to witness the end of the second cycle of innovation in Australian art.

The Growth of Abstract and Non-Figurative Painting

In 1950 abstract painting was still primarily geometric and constructivist in character in Sydney and pursued a path distinctive from the more fashionable neo-romantic painters around Paul Haefliger. New thought and experiment was, to begin with, more apparent among the sculptors than the painters. In February 1951 a Society of Sculptors and Associates was formed, with Lyndon Dadswell, the best-known sculptor and teacher of sculpture in the city, as its President. Dadswell advocated research, experiment and thought. For him the conventional divisions between architecture, sculpture and painting were becoming increasingly meaningless, and the new Society included architects and painters among its associates. It arranged Australia's first open-air exhibition of sculpture in the Botanic Gardens, Sydney, in November 1951 and helped to stimulate abstract experiment in the kindred arts. One of the younger members of the Society, Robert Klippel (b. 1920), who had returned to Sydney in 1950 after studying at the Slade, helped to arouse interest in open-form work and influenced some younger painters.

Of considerably more importance, however, was the work and example of Godfrey Miller (1893-1964), a New Zealander who had studied at the Slade and was then living in Sydney. His had been a lifetime of research into problems introduced by Cézanne, Seurat, Matisse and others, but for him never fully explored. Miller had set himself to capture a feeling for the

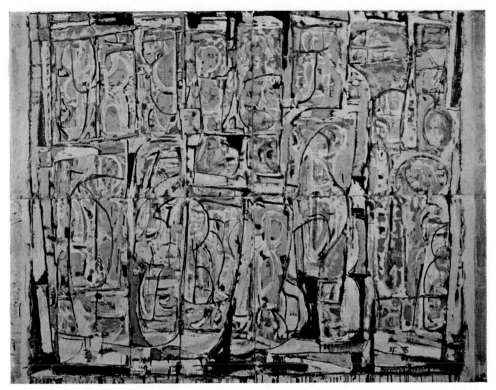

173 IAN FAIRWEATHER, *Monastery*, polyvinyl acetate on cardboard,
56¼ x 72½, 1960-61, The Rudy Komon Gallery

essence of things in the flux of changing appearances: to find a pictorial
technique capable of celebrating both permanence and change at the same
time. Few Australian painters have possessed either the technical facility or
the philosophical temperament to approach such problems, let alone pursue
them single-mindedly through the course of a lifetime. His mature paintings
were completed gradually, often over a period of many years. Natural ap-
pearances are never entirely eradicated, being held as it were in flight
between intricate, interpenetrating grids. The tiny faceted mosaics of colour
bear some reference to Seurat's *pointillisme*, but the visual and emotional
effect are quite different. Miller's paintings are not attempts to impose order
upon appearance, but allegories of a universe in which form and colour are
continuously created and destroyed by energy and light (169). That Miller
approached painting in the manner of a mystic is not altogether unusual:
what is exciting is the fact that his mysticism worked as painting, that he
found truly pictorial equivalents for his vision of cosmic unity. Although he
was probably the finest abstract painter at work in Australia in the early
sixties, his intricate technique was not readily transmitted but the inspiration
of his art and his teaching has been widespread and profound.

The greatest single influence upon painting in Sydney during the first half of the 1950s was, however, John Passmore (*b.* 1904), a contemporary of Dobell at Julian Ashton's School, who left for study in Europe in 1933 and did not return until 1950. Passmore also developed a masterly style derived from a lifelong interest in Cézanne. In his work abstract construction, a mastery of tone, an unusually subtle feeling for colour, and feeling, too, for the hidden poetry of nature are combined with a firm grasp upon life (170). Although, like Miller, something of a recluse, Passmore became for the 1950s in Australia, through his work and his teaching, the painter's painter. Rich ambiguities of space, form and atmosphere lie hidden in the firm, painterly thrust of his work; and it is not surprising that it was of first importance for the post-war generation of art students.

The art of Ian Fairweather (*b.* 1890), though based, like that of Passmore, upon the figure, has also moved increasingly towards abstraction during the post-war years. But it looks back more to Modigliani than to Cézanne, being grounded upon the interrelation of flowing arabesques, and has been enriched by contact with Chinese, Indonesian and Australian Aboriginal art (173). Fairweather served in the British Army during the First World War, after studying forestry in London and Edinburgh, and art at the Slade. He first came to Australia in the early 1930s, after painting in China and Indonesia. He has lived for several years in Melbourne, and also in tropical Australia. Peripatetic, eccentric and picturesque in his habits, Fairweather has left colourful tales behind him in his wanderings which have endowed his paintings with an associational charm. But the best of them can stand on their own. A master of fluent design full of springing energy and fine colour, Fairweather is one of the most inventive, personal and original of the semi-abstract painters at work in Australia today. It is only upon occasion that his fluency produces designs that are flaccid and repetitive.

The influence of Dadswell, Miller, Passmore and Fairweather lay in the direction of abstraction. So, all things considered, did the exhibition, 'French Painting Today', arranged by the French and Australian Governments, which toured the capital cities between January and September 1953. This was the most important exhibition held in the country since the Murdoch exhibition of 'French and British Modern Art' of 1939. Apart from the work of well-known artists like Braque, Chagall, Derain, Dufy, Ernst, Matisse, Picasso, Rouault, Utrillo and Vlaminck, original work of painters who had become known since the war became available to artists in the country for the first time. André Marchand's Picassoesque *Le Printemps*, with its lustrous colour, sonorous blacks and lively, spiky line was the most discussed painting; but the work of artists like Manessier, de Staël, Soulages, Vieira da Silva and Hans Hartung exercised a more lasting effect upon the work of younger artists.

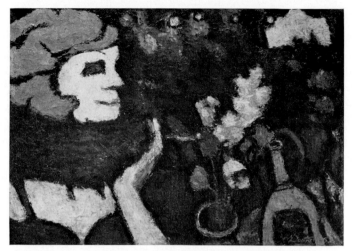

174 CHARLES DOUTNEY, *Night Club*, canvas, 19½ x 27,
1952, Mr Hal Missingham

The exhibition was of special importance to the group of ex-servicemen who studied art under the Commonwealth Post-War Reconstruction Training Scheme. These artists, who came to exercise a great influence upon Australian art during the later 1950s, were divided between the claims of figurative and non-figurative art. In Sydney Charles Doutney, Bob Dickerson and Jon Molvig continued to work in figurative modes while such painters as Roy Fluke, John Coburn, Anthony Tuckson and Stan de Teliga sought to explore the newer post-war forms of abstraction. In Melbourne John Brack, Clifton Pugh and David Boyd developed their own styles of figurative painting.

Among the figurative painters of Sydney, Charles Doutney (1908-57) was somewhat older than most of the C.R.T.S. art students and had seen a good deal of life before the war. In a sense his work belongs spiritually to the realistic and expressive comment of the war years. But Doutney was not only, like Dobell, whose work he much admired, a keen and creative observer of life; he was also an artist of the finest perception. His best paintings possess a quiet authority of statement and an unusual beauty of colour and mood (174). He succeeded in carrying out an admirable series of paintings of Sydney life, especially the life of King's Cross which he knew so well, before an illness contracted in New Guinea claimed him. With his death, Australia lost one of its most talented post-war artists.[13]

Bob Dickerson (*b.* 1924) was a professional boxer before joining the R.A.A.F., and only settled to painting when he was stationed in Indonesia after the war. Today he is probably the best-known figurative painter at work in Sydney, and the only important artist of his generation in the city

who remained immune to the mass-conversion to non-figurative painting which took place in Sydney during 1956 and 1957. He has developed his art out of a flat, posterish and naïve manner of painting. Like Sidney Nolan, however, Dickerson has a natural feeling for weight of tone and disposition of shape and mass, so that his paintings are usually constructed with distinction. From a limited technical vocabulary he has constructed a repertoire of cubic and expressive forms which he handles with great skill. It is a personal language with which he comments upon the human situation (175). 'I feel', he has written, 'we should try to paint the life we see around us—people and the way they feel about living today'.[14] It is a melancholy and pathetic vision of lonely and isolated people made tolerable by a certain amount of sentiment. Yet behind his image of tired men on park benches, furtive little clerks and touts and wide-eyed children lies the menacing allegory of universal isolation. His people are like A. D. Hope's wandering islands: no communication between them is possible.

> You cannot build bridges between the wandering islands;
> The Mind has no neighbours, and the unteachable heart
> Announces its armistice time after time, but spends
> Its love to draw them closer and closer apart.[15]

Dickerson's emphasis upon the isolation of the individual is a feature of the figurative painting of the post-war years. The element of wit, sardonic humour and the comments upon manners, so evident during the early 1940s in the work of such artists as Purves Smith, Dobell, Drysdale, Herman, Friend, Haxton and Flower, gave way during the post-war years to a new seriousness. People in their social roles, the comedy of manners, ceased to be interesting: attention turned once again to the individual isolated and yet encircled by an alien environment. The change in emphasis was already well in evidence during the later years of the war. In the paintings of Jean Bellette, Russell Drysdale and Albert Tucker, to name only three, the individual is figured standing out against society or nature; but the conception is still heroic. Dickerson and his contemporaries, notably John Brack and Charles Blackman, possess no such generous faith in the resources of the individual. People, in the mass or as individuals, are pathetic creatures at the mercy of forces beyond their control. This point of view is present both in the acidulous classicism of John Brack and the poignant romanticism of Charles Blackman.

John Brack (*b.* 1920), studied as a part-time student for two years (1938-40) before the war, and after service in the Army, for two years after the war as a full-time student at the National Gallery School (1948-49). Intellectual in attitude, well read, dry in manner, and no respecter of persons, Brack is something of a phenomenon among Australian artists. T. E. Hulme and Wyndham Lewis would have appreciated his art and

175 ROBERT DICKERSON, *Tired Man*, synthetic enamel
on hardboard, 54 x 60, 1957, Melbourne

176 JOHN BRACK, *Five o'clock Collins Street*, canvas, 45 x 64,
1955, Melbourne

disposition better than his own countrymen, for in a country whose artists have always tended towards romanticisms of some kind or other, Brack has become the leading anti-romantic, rejecting both the national romanticism of the frontier and the international romanticism of abstract expressionism. He is strongly opposed to the idea of creating a national style, regarding it as an anachronism, but also believes that the widespread desire to 'purify' painting by the abolition of subject-matter and image can only lead to ultimate sterility. Meanwhile, he maintains, the image remains 'impure and fecund'. In his own work he has sought for inspiration in the people he sees around him (176). 'I prefer to paint people simply because I find them more interesting than anything else.'[16] There is, however, nothing cosy about what he paints. His line is sharp, like a surgeon's scalpel, and just as cutting; and his colour can be as merciless as a sodium flare. There is nothing kindly in the way he depicts people with their masks off, but his art is a brave and timely reassertion of Matthew Arnold's belief in art as the criticism of society.

By contrast with Brack the art of Charles Blackman (b. 1928) is more personal. Blackman is a painter of women but not of flesh; a kind of belated reply to Norman Lindsay's pseudo-classical eroticism, an artist seeking to penetrate a feminine world of private sensations, hopes and fears (177). Blackman studied drawing at East Sydney and painting under Hayward Veal, a pupil of Max Meldrum. In 1950 he settled in Melbourne where he held his first exhibition in 1952 and helped to re-establish the Melbourne Contemporary Art Society the following year. Blackman is a skilled illusionist who owes not a little of his dramatic power to his Meldrum training. By combining tonal illusionism with forceful rudimentary images and rich, resonant colour, Blackman has created a personal art form of great beauty and poignant expressive power.

In the work of such artists as Doutney, Dickerson, Brack and Blackman the figurative tradition in Australian art survived with vigour into the 1950s. But in Sydney, especially, the desire to experiment with the new post-war form of abstract art current in Europe and America developed rapidly after the French exhibition of 1953. Significantly enough, the 1954 exhibition of the Sydney Group, the citadel of neo-romanticism for almost ten years, revealed the growing strength of abstract art in the work displayed by Passmore, Miller, Eric Smith, Michael Kmit and Ralph Balson. Furthermore, the hard-edged, geometric forms of abstract art gave way before forms freely fragmented and reconstructed into expressionistic rather than formal constructions.

During the early 1950s, art critics in Sydney gave only qualified support to abstract art. James Gleeson, for example, reviewing a joint exhibition of work by Ralph Balson and Robert Klippel, said: 'Generally speaking, ab-

177 CHARLES BLACKMAN, *Girl with Flowers*, hardboard, 47 x 41,
1959, Mrs Edith Kirwan

stract art offers an experience that is confined within very narrow frontiers. It has no content. We cannot relate it to ordinary life. The experience exists as a thing in itself, isolated in the art gallery by the moment of sensation'.[17] Even three years later Paul Haefliger, the critic of the *Sydney Morning Herald,* was still critical of abstract art as a mature form of expression. In March 1955, reviewing an exhibition of the Contemporary Art Society, he wrote:

The problem of abstract art as a means of expression for the younger generation seems formidable. Indeed, the fact that abstract art has conquered the world appears the best argument for not continuing it, since the cubist masters have exhausted most of its possibilities. If there are any aspects left in which to

specialize Paris is exploring them—and not too happily. For our own young painters abstract art offers a splendid means to master composition. Apart from this it can only be a restatement, and as such, lacking in vitality.

At that time Haefliger, still oblivious of the American contribution, was thinking of Paris as the centre of abstract art. Yet taste was changing. Gleeson, despite his reservations, reacted sympathetically to the Balson, Klippel exhibition; and Haefliger was about to become a full-blooded champion of abstract expressionism.

By 1955 a new spirit of inquiry and discussion, a new curiosity about events abroad, stimulated by a younger generation of post-war artists and art students, began to reanimate the Contemporary Art Society in Sydney. It was given leadership and definition by Elwyn Lynn (*b*. 1917), a schoolmaster and philosophy graduate with an interest in aesthetics, who had begun to paint in the later 1940s. Elected to the executive of the Society in 1955 and appointed editor of its *Broadsheet*, Lynn revived an interest in events overseas, promoted discussion, printed useful news and began a continuous questioning of the assumptions (especially the neo-romantic assumptions) of local Sydney critics. In the *Broadsheet* of March 1955 he was discussing the emotional element in American abstract expressionism; in April, how French and American action painters were reacting against commercialized abstraction. During 1956 and 1957 the C.A.S. *Broadsheet* discussed continuously abstract expressionism, tachism and action painting. This interest in the new developments in abstract art was assisted by several exhibitions from abroad, held between 1956 and 1959, such as the 'Exhibition of Modern German Graphic Art' (1956), 'Italian Art of the Twentieth Century' (1956), 'Contemporary Canadian Painting' (1957), 'British Abstract Painting' (1958-59), 'Contemporary Japanese Art' (1958-59) and 'Recent Painting: Seven British Artists'. Some visitors from the United States, Dr Grace McCann Morley (1956), Professor Dorothy Cogswell (1957) and the Australian, Mary Cecil Allen (1960), for example, helped to make the American contribution to post-war painting better known.

Meanwhile, in Melbourne, the interest in abstract art, both geometric and informal, was increasing. Roger Kemp (*b*. 1908), who had been trained at the Royal Melbourne Technical College and at the Gallery School, had already been working in a semi-abstract style for many years. He developed a personal style owing something to Italian futurism and sought, like Godfrey Miller, pictorial forms expressive of the relation between humankind and the cosmic order.

Kemp's art exercised a considerable influence upon the work of Leonard French (*b*. 1928), who turned to a more abstract manner following a year or so abroad during 1949-50. French is a painter of power and vigour whose

178 LEONARD FRENCH, *The Burial,* synthetic enamel and gold leaf on
hessian-covered hardboard, 60 x 72, 1960, The Rudy Komon Gallery

massive constructions are held in control by a hard-edged geometry of
form owing not a little to Léger, Delaunay and Manessier. He has produced
some fine murals. In recent years the personal language of symbolic forms
with which he invests his constructions has been simplified and clarified,
his compositions are more controlled, and his colour has become richer,
denser and more flexible (178). Avoiding the accidentalism of abstract
expressionism, French has evolved a sonorous and monumental art, richly
decorative in the best sense, and capable of expressing a wide range of
feeling. At the root of his art lies a craftsman's interest in materials and
techniques. His themes of recent years have revealed an increasingly
religious cast of thought. Given the opportunity, he could become, perhaps,
an ecclesiastical decorator of great distinction.

Somewhat apart in manner from French (around 1955) were a small
number of young artists and art students who, independently of events in
Sydney, had begun to experiment with the accidental, informal and romantic
aspects of abstract painting. The most important of these were Donald
Laycock, John Howley and Ian Sime. Both Laycock (*b.* 1931) and Howley
(*b.* 1932) had studied at the Gallery School, the latter also for short periods
at the Royal Melbourne Technical College and with George Bell. Both

artists became interested in the work of Roberto Matta, Jackson Pollock and Max Ernst. Laycock developed a rhythmical linear and part-accidentalist style, building his pictures into richly textured masses of colour, in a desire to create pictorial analogies for the dispersion of energy and the creation of matter (180). He was, if not the first, certainly one of the first among local artists to develop a coherent personal style from the abstract expressionist mode of invention. Howley developed a freer, more informal and plastic style.

Ian Sime (*b.* 1924), like Laycock and Howley, has sought to develop an art which avoids the conscious control of thought. As Miss Erica McGilchrist wrote:

He regards the act of painting as an extension of the creative forces of nature operating through man; and just as nature, within the framework of certain fundamental laws produces a mountain or a toadstool or a sparrow, so the artist, out of the principles of design, produces a painting. In both cases, the questions, 'What is it? What does it mean?' come close to destroying the capacity of the observer to be emotionally affected by the object. The painting like the sparrow, should be accepted for its own sake simply as another created thing.[18]

Sime's distrust and contempt for the operation of the intellect in painting and his supreme faith in subconscious processes is shared widely by many of his generation. His style, which has emerged, in part, from an organic surrealist heritage reminiscent of Masson, possesses an explosive and disjunctive vitality (179). In his *Animist Paintings*, exhibited in 1956, he sought to produce works independently of volition and premeditated meaning 'acts' of nature.

It was in Sydney, however, that the movement towards informal abstraction gathered the greatest momentum. It centred upon members of the Contemporary Art Society, John Passmore and his pupils. In February 1955 one of them, John Olsen (*b.* 1928), held his first show at the Macquarie Galleries. The paintings were semi-abstract, with masses and planes of colour chunky and Cézannesque, revealing his teacher's influence. Robert Klippel, the sculptor and a friend of Olsen, stressed the importance of becoming more involved with the act of painting. 'Painting of the bloodstream'[19] they called it. Later, in August 1955, Olsen moved down to Melbourne and mingled with a group of artists that included John Howley, Donald Laycock, Lawrence Daws and Leonard French. His work began to move firmly in the direction of abstract expressionism. Soulages was clearly an influence at that time; but some paintings by John Howley were also germinal to his later development. In April 1956 he returned to Sydney and in December organized with Klippel an exhibition at the Macquarie Galleries called 'Direction 1', which included work by Passmore, Olsen, Klippel, Eric Smith and William Rose. It launched abstract expressionism on the scene in Sydney and the new mode was quickly accepted by the critics.

179 IAN SIME, *Painting*, hardboard, 36 x 48, 1955,
Mr and Mrs John Reed

Events moved rapidly. In October 1956 the Orient Line, with the
assistance of the Art Gallery Society of New South Wales, organized an
exhibition of Contemporary Australian Paintings for display on the s.s.
Orcades in the ports of Auckland, Honolulu, Vancouver and San Francisco.
It gave special prominence to the new trends. Work by the better-known
figurative painters: Drysdale, Nolan, Arthur Boyd, Herman, Brack, Orban,
O'Brien and Friend was included; but the emphasis lay upon abstract and
semi-abstract work. It contained the work both of the older generation of
geometric abstractionists and constructivists, such as Miller, Passmore,
Kemp and Balson, and the younger generation, such as Lawrence Daws,
William Rose and Leonard French. It also included work by the abstract
expressionists Olsen, Howley and Laycock.

The Sydney critics praised the exhibition lavishly. Haefliger, whose praise
of abstraction had hitherto been guarded and qualified, found the exhibition
extremely exciting. 'Once again', he wrote, 'Australian art has sprung to life
in this most important of all exhibitions'.[20] Its importance, he asserted, could
not be overestimated. 'Painters with diverging interests have suddenly cast
aside their former manner of expression and, so to speak, jumped into the
maelstrom of abstract expressionism.' Gleeson, who travelled with the
exhibition to lecture, was equally enthusiastic. It was, he exclaimed in his
newspaper review of the exhibition, 'a honey of a show';[21] and in his fore-
word to the catalogue asserted that: 'European . . . art is an organic thing,

180 DONALD LAYCOCK, *As it was in the Beginning*, hardboard, 48 x 36, 1955-56, Colonel Aubrey Gibson

subject to immutable laws that cannot be artificially checked. . . . It must follow the current of History. It is not unlike a Calder mobile that takes its form from the pressures and tensions of History'. On his return he emphasized that the artists who aroused the greatest interest on the West Coast were 'those committed to the extreme forms of abstraction or abstract expressionism'.[22]

With Sydney critics thus enjoining artists to jump into the maelstrom, or on to the band-wagon of abstract expressionism in order to follow the current of History with a capital H (the metaphors varied), it is not surprising that the victory of the new mode and its variants was swift and surprisingly complete. John Olsen, personable, sensitive and poetic, was hailed as a master over night. Early in 1957, supported by a generous patron, he left for Europe. During his visit abroad he exhibited at the Salon de Mai, in the exhibition 'L'Oeil Neuf', Paris, and the Atelier 17 exhibition held at Basle. In August 1958 he sent an exhibition back to the Macquarie Galleries. 'He is the complete artist', wrote Mr Laurie Thomas, the acting critic of the *Sun*, 'sensitive, intelligent, strong and courageous . . . but still the artist who responds to his intuitions. . . . He is probing into the depths of human nature, seeking the basic images which have satisfied mankind, for some reason or other from the beginning'.[23] The enthusiasm, though somewhat generous, was genuine enough. Olsen returned to Sydney, in February 1960, after travelling in Spain and living for a time in Majorca.

Like most abstract expressionists, John Olsen seeks to discover form and image in the actual process of painting (181). The poetry of Dylan Thomas and the sea-port paintings of John Passmore have deeply influenced his art. Pictorial animism, the possibility of automatic painting, has appealed to him, as it has to Ian Sime. 'The thing which I always endeavour to express is an animistic quality—a certain mystical throbbing throughout nature.'[24] He has abandoned painting landscapes from a fixed position which seems, he has said, to be quite out of keeping with present modes of travel and our changing conceptions of the universe.

The recognition of other painters experimenting in the new abstract mode followed upon Olsen's dramatic acceptance. In February 1957 Elwyn Lynn (182) won the Blake Prize with his *Betrayal* (Melbourne), an expressive abstract painting in which an affection for André Marchand still lingered. Later in the year he won prizes at Mosman and Bathurst. In August 1958 he exhibited a series of paintings at the Museum of Modern Art in Melbourne based upon *The Rime of the Ancient Mariner*, in the belief that abstract expressionism could communicate, symbolically, emotional states that were otherwise incommunicable.

The rise of Thomas Gleghorn (*b.* 1925) was more mercurial (185). He had studied art at Newcastle with advice and encouragement from Dobell,

181 JOHN OLSEN, *Digger Landscape*, charcoal and
gouache on paper, 27 x 20, 1960, Mr Daniel
Thomas

but in 1957 was still virtually unknown. Then he won the Rockdale Art
Prize, and in 1958 the Blake *Christus* prize, and prizes at Bathurst, Tumut,
Mosman and Muswellbrook. In June 1958 he painted several abstracts of the
Nullarbor desert, and has concerned himself a good deal in recent years
with applying abstract expressionist methods to his experience of landscape.

John Coburn (*b.* 1925) has developed a firm, flat-surface style built upon
simple organic forms about which sonorous colours glow and play. His work
owes something to Manessier and Pre-Colombian art; and he is one of the
very few painters in Sydney who has succeeded in endowing non-figurative
work with genuine religious feeling (183).

Eric Smith (*b.* 1919), who worked with some success for several years
in a neo-Byzantine expressionistic manner and produced some notable
religious paintings in that mode, has endeavoured to convey religious feeling
in abstract work with less success. The art of Carl Plate (*b.* 1909) has
developed more slowly and is more urbane. It possesses a genuine feeling
for nature, at times a note of wit, and always a sense of good taste (184).

182 ELWYN LYNN, *1960*, canvas, 72 x 72, 1960, Museum of Modern
Art of Australia, Melbourne

Among women in Sydney, Margo Lewers (*b.* 1908) is one of the most
accomplished artists working with abstract form (186). Her interest in
abstraction dates from a visit to England in 1933 with her husband, the
sculptor, Gerald Lewers, when she became acquainted with the work of
the artists associated with the Unit One group (1934, Mayor Gallery), such
as Nicholson, Hepworth and Moore. During the 1950s her work moved from
a geometric to a more informal mode of abstraction and she produced work
of distinction in mosaic and tile. In Melbourne both Erica McGilchrist and
Dawn Sime produced competent abstract paintings during the 1950s.

By 1960 non-figurative painting had spread pretty generally throughout
Australia from Perth to Sydney, from Brisbane to Hobart, and from the
Museum of Modern Art to the secondary schools. In Australia, as in most
other countries, it has brought with it an increasing preoccupation with the

183 JOHN COBURN, *Litany*, hardboard,
36 x 24, 1958, Sydney

processes and materials of art. In a very real sense art has become more materialistic, less concerned with image and idea, and more concerned with the creation, deliberately or adventitiously, of novel surfaces, edges and textures. This obsession with surface has been accompanied by an equal and opposite obsession with the nature of space, and both obsessions by a growing intolerance of figurative painting. Abstract expressionism became, furthermore, an exclusivist doctrine. It was, its champions maintained, the only international art. It was the mainstream into which all contemporary expression was to be channelled. Its advocates became the dupes of the historicist fallacy. Abstract expressionism, they said, was the Instrument of History and there was nothing anyone could do about it. Its champions developed, like communists, a smug satisfaction in the inevitable triumph of their cause.

Innovation, however, is one thing, and quality another. Oddly enough,

184 CARL PLATE, *Paradox of Sequence*, hardboard,
48 x 36, 1958-61, the artist

during the time when the swing to abstract art was gathering such momen-
tum, William Dobell was preparing the sketches and studies for his portrait
of Mary Gilmore, one of the finest and most representative of his paintings.
After the Archibald Prize controversy and court case of 1943-44 Dobell's art,
despite many fine portraits such as his *Mrs Frank Clune*, entered upon a
period of uncertainty. He was not the kind of artist to take easily to the
painting of commissioned portraits, except when the subjects interested him
personally. Much of his work after 1945 was unequal and uneven, reflecting
perhaps, something of the general uncertainty which many artists felt during
the years following the war. His New Guinea paintings, based on visits made
in 1949 and 1950, are often of great beauty but are not to be numbered
among his best works. He was not able to bring to his paintings of the native
peoples of New Guinea the kind of insights which give such authority to

185 THOMAS CLEGHORN, *The Passion*, hardboard,
53½ x 24, 1958, Mrs Bernard Smith

186 MARGO LEWERS, *Irregular Shapes*, hardboard, 48 x 84,
1961, the artist

his portrayal of the members of his own race. Indeed, they rarely reach
beyond the picturesque.

Dobell found Dame Mary Gilmore a congenial subject to paint. The
portrait (128) returns in some ways to his mannerist phase of the early
1940s, of which *The Cypriot* is the most notable example. The subject
seated in an alert and slightly tensed position, as though about to rise from
her chair, is presented with great distinction, being composed in a pyramidal
form of strength and dignity. The cool luminous blues and greens, of
costume and background, serve as delicate foils to the fine, warm leathery
texture of the head, and the painting of lace and hair has been accom-
plished with Dobell's mature technical mastery. The work as a whole
endows his subject with an air of spiritual grandeur, a startling vitality of
presence and, most justly, a queenly magnificence: the tribute of an artist
to a poet.

The Survival of Figurative Painting in Melbourne, 1956-59

In Sydney the strength of figurative painting was sapped by a decade of
neo-romanticism, Byzantinesque exoticism and genteel taste. Abstract ex-
pressionism brought new vigour, new life and a new cause to be fought for,
to a rather stuffy art world. But in the process a good deal of Sydney's art
began to look like a provincial expression of American painting: aesthetic-
ally, the city was ambitious to become, it seemed, a kind of south-western
suburb of San Francisco. By 1957 Bob Dickerson was the only painter of
real quality among the post-war generation who was working entirely within
the figurative mode. In Melbourne, however, figurative painting survived
with vigour; maintained a critical edge upon life, and drew strength from
a local tradition, still held in respect, that reached back to the Heidelberg
School. In November 1956, a month after the s.s. *Orcades* had sailed for

s

San Francisco with its exhibition, John Brack exhibited his *Racecourse Series* of paintings at the Peter Bray Gallery, Melbourne: the direct comments of an acidulous eye upon an everyday facet of local life. Such ordered and forthright statements about contemporary life would have found little favour in Sydney; in Melbourne they aroused the interest of critics and public alike.

In the same month John Perceval held his first exhibition of paintings after having worked for several years in ceramics. It was an unusual return. The new paintings were quite different from the work of his Angry Penguin years. The subjects chosen were drawn from Williamstown, Melbourne's oldest port, and Gaffney's Creek, an old mining town (where Perceval painted with Boyd); and the artist, like Hans Heysen working at Ambleside, revealed an affection for the scenes he painted. This first exhibition following his return to painting was not, however, entirely successful. The speed with which he worked resulted in the production of many paintings that fell midway between mere paint and visual illusion. But as he developed his new manner, Perceval began to invent a truly novel interpretation of Australian bushland landscape. Radiant with high colour, it broke completely with the landscape of dry, open spaces, strange creatures, and tough heroes which Drysdale, Nolan, Arthur Boyd and Tucker have made so well known during the past twenty years. Just as their work may be viewed as a reinterpretation of ideas and feelings about Australian nature first quickened in colonial days, so Perceval's landscapes may be viewed as the products of an emotional attitude akin to that which produced the landscapes of the Heidelberg School. For Perceval's paintings are also visual and optimistic interpretations of the Australian countryside, full of the joy of life; but unlike the Heidelberg landscapes the imagery emerges vicariously from a tumult of pure colour and deeply corrugated, heavily impasted paint. It is a kind of action painting controlled by visual intuition rather than by non-visual and subconscious processes of the mind. In the act of painting before nature, *alla prima*, at high speed and pressure, drawing visual sensations not from one point of view but from all sides, a total impression drawn from new visual coherences, half-accidental, half-willed was found to emerge from the thickening and spreading paint (187). The approach has something in common with the later work of Van Gogh: but Van Gogh's method, even at its most expressionistic and exultant, was controlled by a repetitive act of emotive brushing derived from *pointillisme*. It created a deliberate, and more or less regular, textured weft over the canvas. Perceval's painting is far less controlled by systematic and repetitive brushwork or palette-knife work. It is a more random affair from which visual equivalences emerge, instead of being consciously asserted, from the painting process. In switching his attention from conceptual images to the pictorial problems of visual

187 JOHN PERCEVAL, *River Foam*, hardboard, 30 x 36,
1960, Miss D. Dyason and Mesdames M. Campbell,
C. McComas, J. Davies and E. Falloon

perception, Perceval has returned to one of the central problems of painting. His new approach could be of great significance for the future of Australian painting.

The work of Clifton Pugh (*b.* 1924) also testifies to the survival of figurative painting in Melbourne during the later 1950s. A C.R.T.S. trainee who had seen service against the Japanese in New Guinea, Pugh's personal style did not begin to emerge until about 1954. In 1955 and 1956 he exhibited with the 'Group of 4', which included Lawrence Daws, John Howley and Donald Laycock. Pugh has developed an imaginative and expressive portrait style, but he is just as well known for his landscapes which reveal his early interest in expressionism, his firm sense of design and his sustained interest in the appearance and structure of the visible world. But it is the savage and ruthless dichotomy beneath the surface of life, the hunter and the hunted, upon which his art is centred. Pugh sees nature as Thyestes devouring his own children: life battening upon life in an eternal cycle. Occasionally the more tender emotions appear, as in his *World of Shane and Dailan* (188), an admirable contemporary interpretation of a theme which has appealed to Australian writers and artists since colonial days.

In Melbourne the figurative tradition also found two able champions in the poetic humanism of Charles Blackman and the tragic vision of Arthur Boyd: Blackman with his *Alice in Wonderland* and *The Sleeping Beauty*

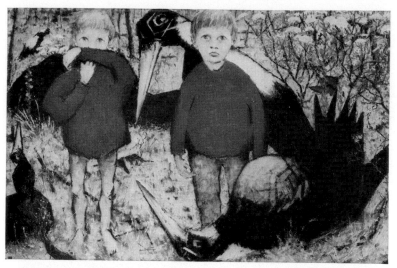

188　CLIFTON PUGH, *The World of Shane and Dailan,* synthetic
enamel on hardboard, 36 x 54, 1957, Adelaide

series, and Boyd with his memorable *Love, Marriage and Death of a Half
Caste* series of allegorical paintings first exhibited at the Australian Galleries,
Melbourne, in April 1958. These last were probably the most important
series of subject pictures painted in Australia during the 1950s (189). They
grew from observations made during a trip from Alice Springs to Arltunga
in 1951, when Boyd became acutely aware of the dereliction and poverty
of half-castes in Central Australia, and the great human problem involved.
The paintings, however, do not refer to an actual event and recall few
remembered observations: they are conceived as in a dream, a dream that
owes something to Chagall, Rembrandt, surrealism and Boyd's circle of
painter friends. Like John Brack's annotations on urban life, Boyd's paint-
ings are a brilliant vindication of the role of the artist as a critic of society.
Not that Boyd has a programme or a solution to expound. As Dr Hoff, who
has discussed the paintings in detail, concludes:

There is no real end to the series; its importance lies in the individual situations
in which Boyd appeals above all to our sense of sympathy. He leaves no message,
offers no solution; but he presents problems inherent in the aborigine situation
in a manner in which contemporary formal trends, and Boyd's own tradition of
poetic representation, combine to a successful climax of nearly twenty years of
artistic endeavour.[25]

In these paintings Boyd succeeded better, perhaps, than any other member
of the original Angry Penguin circle in elevating an Australian theme to
a universal level, endowing it with a breadth of reference and feeling beyond
the limits of nation or region.

In Melbourne the figurative image also survived in the work of David

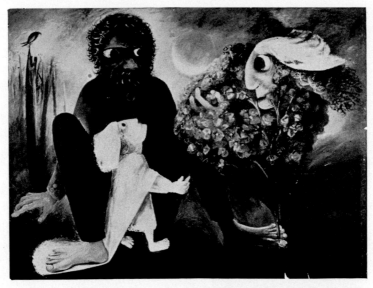

189 ARTHUR BOYD, *Groom Waiting for his Bride to Grow Up*, hardboard, 54 x 72, 1958, Mr W. A. K. a'Beckett

Boyd, who grew up under the influence of his elder brother, but developed a talent and imagination of his own. There is, as might be expected, a certain kinship in the response of both brothers to art and life. David first studied music at the Melbourne Conservatorium, and was trained in pottery and clay modelling in the family circle. After the war he also studied painting as a C.R.T.S. student at the National Gallery School and proceeded abroad where he worked and studied for five years (1950-55), mainly in the south of France and England. Upon his return he and his wife, Hermia, became well known throughout Australia for their pottery. Like his brother Arthur and brother-in-law John Perceval, David Boyd has also worked a good deal in ceramic sculpture. He held a one-man show of this branch of his work in Melbourne in 1957. In the same year he turned seriously for the first time to painting, beginning a series on the theme of Australian exploration. In 1959 he began a series based on the pathetic history of the Tasmanian Aboriginals. These early explorer and Tasmanian paintings are romantically conceived; the figures crowd upon the canvas grotesquely, and often possess a touch of the comic. All this was indubitably Boydian. But David Boyd's work is no mere imitation of his brother's. Arthur Boyd's *Love, Marriage and Death of a Half-Caste* paintings evoke a profound pathos. His morality, as Pater said of Botticelli, is all sympathy. His apprehension of tragedy is indirect. It is muffled by allegory and enters into the spirit of suffering without bitterness. David Boyd's work is more direct. He seeks his symbolism in historical events. In his later works his paintings are more highly

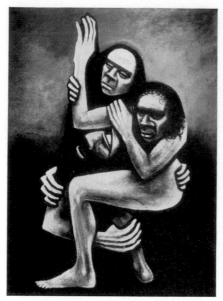

190 DAVID BOYD, *Truganini
and the Sealer*, hardboard, 48 x 36,
1959, the artist

modelled, more cubic and sculpturesque, less painterly and fluent than his brother's. Even in the early paintings of his explorer series, however, he revealed a clamorous vitality which was not the mark of a copyist. He was searching for a repertoire of images capable of expressing, within the nature and limitations of painting, moral issues of some complexity. In the later paintings produced during 1959 and 1960, the anecdotal element of the early work has been suppressed: the forms are cubic, simple and massive, an element of classicism entering in to the expression. In the process of creating the series, the Tasmanian tragedy has grown into a universal expression of the conflict between white and coloured. The paintings belong to the world of Notting Hill riots, Little Rock, Sharpeville and the trial of Albert Namatjira. They are concerned with human conflict, guilt, love, compassion and forgiveness; and what they express they express as paintings, not as literature or propaganda. The image of Truganini (190), raped and dead, clinging to her sealer-lover in a timeless agony of hate and love, is an inverted image containing a dark truth which Dante (who placed purgatory down here in the southern hemisphere) would have understood. In such ways it is still possible for an artist to express the moral conscience of his time and assert his own freedom and the dignity of painting as one of the liberal arts (191).

The Melbourne Reaction against Abstraction

The conversion of artists and critics in Sydney to abstract expressionism was accomplished, as we have seen, with the enthusiasm, speed and efficiency of a modern evangelical crusade. Conversion brought with it a fanatical devotion to the principles of abstract art and a rising intolerance of figurative painting. The rivalry, always present between Sydney and Melbourne, where figurative painting persisted with vigour, grew sharper and more bitter. When, in October 1958, Arthur Boyd exhibited his *Love, Marriage and Death of a Half-Caste* series of paintings in Sydney, it was subjected to the most trenchant attacks. They were, it was said, bad paintings: the artist had mistaken an idea for a painting.[26] Ideas in art had

191 DAVID BOYD, *Conflict*, hardboard, 48 x 36, 1959,
Monash University

become the unforgivable sin. When, a month later, David Boyd exhibited
some of his explorer series, he was accused outright in the Press of plagiar-
izing his brother.[27] To imitate Dubuffet, or Pollock, or Tapies from the glossy
magazines was to be universal and progressive; to follow and add to a
family tradition, like the Brueghels and the Le Nains, was to plagiarize!
When, in February 1959, John Reed's pioneering collection of contemporary

Australian painting, which included early works by Atyeo, Lawlor, Fair-weather, Nolan, Tucker, Boyd, Perceval, Gleeson, Bergner, Counihan and Vassilieff, was exhibited in Sydney, the *Sydney Morning Herald* critic asserted that most of the collection possessed 'a decadent, inbred "hill-billy flavour" of tenth-rate German expressionism mixed with a dash of Picasso and at times reverting to the Australian primitive school'.[28] Under the pressure of the issues involved local criticism had degenerated into a slanging match. A reaction was bound to follow. Not surprisingly, it came from Melbourne. It had been foreshadowed by a statement made by Eric Westbrook, the Director of the National Gallery of Victoria, at a Council of Adult Education Summer School held at Albury in January 1958, in which he sweepingly condemned the more extreme forms of *avant-garde* painting:

Most of the pictures painted today were unintelligible nonsense. . . . If an artist were to kick a hole in his canvas and then exhibit this as a new work there would be some people who would say this was advancing the frontiers of art. Some of the public today think that any change or novelty necessarily means progress in painting.[29]

These comments were followed independently, a year later, by the forma-tion of a group called the Antipodeans which contained seven artist mem-bers: Charles Blackman, Arthur Boyd, David Boyd, John Brack, Bob Dickerson (the only Sydney painter in the group), John Perceval and Clifton Pugh. The formation of the group was a reaction not so much against abstract art as one of the long-proven forms of contemporary expression as against the clamorous pretensions of the multitude of new converts to abstract expressionism and its varieties then rising upon all sides. The manifesto which the Antipodeans published in the catalogue of their exhibition, held at the Victorian Artists' Society rooms in August 1959, is best understood as a formal protest against the mass conversion to abstract expressionism of artists and critics.[30] Certainly, none of the members of the group was incapable of appreciating the aesthetic merits of abstract art. All of them had numbered abstract painters among their friends and asso-ciates. Pugh, for example, had been associated with Laycock and Howley in the 'Group of 4' exhibition. But with non-figurative art suddenly emerging as a mass movement arrogant and intolerant of all other forms, and one to which Press critics were becoming increasingly committed without much discrimination, it was felt that a trenchant defence of figurative painting was needed.

The manifesto began by identifying the group with the contemporary movement: 'Let it be said in the first place that we have all played a part in that movement which has sought for a better understanding of the work of contemporary artists both here and abroad'. But it proceeded to criticize

the tendency of abstract painting to reduce all art to pattern and private gesture:

Modern art has liberated the artist from his bondage to the world of natural appearances; it has not imposed upon him the need to withdraw from life. The widespread desire, as it is claimed, to 'purify' painting has led many artists to claim that they have invented a new language. We see no evidence at all of the emergence of such a new language nor any likelihood of its appearance. Painting for us is more than paint.

The manifesto took its central stand upon the cardinal importance of the image in painting, which was defined without equivocation.

Art is for the artist, his speech, his way of communication. And the image, the recognizable shape, the meaningful symbol, is the basic unit of his language. Lines, shapes and colours, though they may be beautiful and expressive, are by no means images. For us the image is a figured shape or symbol fashioned by the artist from his perceptions and imaginative experience. It is born of past experience and refers back to past experience—and it communicates. It communicates because it has the capacity to refer to experiences that the artist shares with his audience.

Art is willed. No matter how much the artist may draw upon the instinctive and unconscious levels of his experience, a work of art remains a purposive act, a humanization of nature. The artist's purpose achieves vitality and power in his images. Take the great black bull of Lascaux, for example, an old beast and a powerful one, who has watched over the birth of many arts and many mythologies. He is endowed with a vitality which is an emblem of life itself. Destroy the living power of the image and you have humbled and humiliated the artist, have made him a blind and powerless Samson fit only to grind the corn of Philistines.

As Antipodeans we accept the image as representing some form of acceptance of and involvement in life. For the image has always been concerned with life, whether of the flesh or of the spirit. Art cannot live much longer feeding upon the disillusions of the generation of 1914. Today dada is as dead as the dodo and it is time we buried this antique hobby-horse of our fathers.

The Antipodeans asserted their right to draw upon the life and forms of nature about them for their art whilst explicitly denying any attempt to create a national style. Their attitude to myth has been much misunderstood. The Antipodean manifesto asserted the right of the artist not to invent myths of his own but rather to make use of myth in a creative way.

In the growth and transformation of its myths a society achieves its own sense of identity. In this process the artist may play a creative and liberating role. The ways in which a society images its own feelings and attitudes in myth provides him with one of the deepest sources of art.

The manifesto was critical of the restraints placed upon artists by the advocates of social realism, and concluded with a specific denial of any delimiting patriotic or regional preoccupations. 'Our final obligation is

neither to place nor nation. So far as we are concerned the society of man is indivisible and we are in it.'

The Antipodean exhibition and manifesto aroused a good deal of discussion and controversy in Melbourne and throughout Australia. Critics were either cautious or antagonistic. Willing enough to accept the work of the artists as individuals, they interpreted any collective criticism of non-figurative painting as a sign of conservatism and reaction. Many sought, despite the assertions of the manifesto to the contrary, to interpret it as a nationalistic *pronunciamento* preoccupied with what was quite mistakenly called regional painting or, more contemptuously, 'Australiana'. The Antipodean Exhibition itself asserted a position, like the 9 × 5 Exhibition of 1889, the synchromies exhibition of 1919 and Direction 1 of 1956.

Although the Antipodeans were not overtly nationalistic in outlook their exhibition did represent, among other things, an attempt to defend an indigenous tradition against the uncritical acceptance of currently fashionable overseas modes. In one sense the formation of the group may be seen as a part of a growing uneasiness among many Australians at the prospect of being swamped culturally by what Arthur Koestler has called 'coca-colonization'. Similar uneasiness was also expressed in the lectures and writings of Robin Boyd, the architect son of Penleigh Boyd and cousin of the artists, especially in his book *The Australian Ugliness* (1960), which proffered a trenchant criticism of modern vulgarities in contemporary Australian design that were also being justified in the name of progress. At a philosophical level, the essays entitled *The End of Modernity* (1959), by the poet, James McAuley, were also a reaction against the slothful acceptance of the *avant-garde* at any price. McAuley recalled the protests made by Plato and St Augustine against 'the degradation of *rhetoric*, the art of verbal communication, into *sophistic*, the art of verbal gratification and display'.[31] Arguing that greater use be made of contemporary art for ecclesiastical purposes he advised the clergy: 'Do not believe that artists are not interested in prescribed subjects, set themes, art for use's sake: consciously or not, they know very well that their art is dying of boredom and sterility for lack of use and meaning. No artist really wants to spend his days spinning irrelevant artifacts out of his navel'.[32]

'Irrelevant artifacts', however, *were* sought eagerly by a number of local Sydney artists a few months after McAuley's book appeared. The Antipodean Manifesto had been somewhat precipitate in declaring dada as dead as the dodo. In October 1959, as neo-dada it fluttered, albeit a little wearily, into Potts Point. (Barry Humphries, the actor and mimic, had already held three one-man neo-dada shows, one at Melbourne University in 1952, another at the Victorian Artists' Society (1958) and a third at the Museum of Modern Art.) The Sydney exhibition, which was called *Muffled*

Drums, was arranged by Elwyn Lynn, Henry Salkauskas, John Coburn, John Ogburn and Oscar Edwards at Terry Clune's Gallery. It sought to be funny and ridicule the local art establishment of art gallery officials and critics. The show included Victorian paintings with rockets glued on; the *Vaucluse Venus*, an early art love unearthed; the Antipodean invasion, drawn upside down on a military map; and an old photograph of a lady (who had been given a Nolan-Kelly helmet) and a child, which was entitled *Someone had to be Picasso's Mother*. It was good, clean fun and the place was packed to the doors. But it was all a trifle *retardataire*.[33]

Significantly enough, the Muffled Drummers had their fun and made their points by means of visual images. The image which the abstract expressionists had so confidently swept out of the door instantly flew back in again through the window as neo-dada, and has been hovering about metamorphosed like a spritely god ever since, his shy theophany glimpsed at times as through a veil in the curious wiggles of John Olsen's recent paintings; or as ravens and screeching cockatoos in the work of Albert Tucker; or as an enormous white swan looking slightly lost and a little distrait in the *Leda and the Swan* paintings of Sidney Nolan.

The visual image was not to be put down easily. Nevertheless, it is to be stressed that as the 1950s drew to a close in Australia, most of the younger painters of the post-war generation were experimenting with some form of abstract painting which they felt suited their temperament.

NOTES

[1] *See* A. A. PHILLIPS, 'The Cultural Cringe' in *The Australian Tradition*, Melbourne, 1958, pp. 89-95

[2] J. T. A. Burke to Sir Kenneth Clark, *in litt.* 24 September 1948

[3] The *Observer* (London), 12 June 1960, p. 17

[4] Reported in the *Sydney Morning Herald*, 20 June 1953

[5] *The Times* (London), 24 July 1953

[6] The *Sunday Times* (London), 2 August 1953

[7] *The Times* (London), 24 July 1953

[8] The *Sunday Times* (London), 2 August 1953

[9] *ibid.*

[10] *Art News*, New York, Summer 1957, 62, 83. On Tucker *see also* 1960 Acquisitions, Art Gallery of N.S.W., pp. 30-1

[11] *The Times* (London), May 1955

[12] The *Observer* (London), 12 June 1960, p. 17

[13] On Doutney *see also* B. SMITH, 'Notes on the Life and Art of Charles Doutney', *Meanjin*, xvi (1957), 420-4

[14] *Modern Australian Painting and Sculpture* (Bonython), Adelaide, 1960, p. 15

[15] A. D. HOPE, *The Wandering Islands*, 1955, p. 15

[16] *Modern Australian Painting and Sculpture*, p. 43

[17] The *Sun* (Sydney), 21 May 1952

[18] *Modern Australian Art* (Museum of Modern Art, Melbourne), 1958, p. 52

[19] *in litt.* 26 March 1961

[20] The *Sydney Morning Herald*, 3 October 1956

[21] The *Sun* (Sydney), 1 December 1956

[22] *ibid.*

[23] L. THOMAS, The *Sun* (Sydney), 6 August 1958

[24] Statement in the catalogue of the s.s. *Orcades*, Pacific Loan Exhibition, 1956

[25] U. HOFF, 'The Paintings of Arthur Boyd', *Meanjin*, xvii (1958), 143-7

[26] L. THOMAS, The *Sun* (Sydney), 1 October 1958

[27] L. THOMAS, The *Sun* (Sydney), 20 November 1958

[28] The *Sydney Morning Herald*, 18 February 1959

[29] The *Albury Mail*, 6 January 1958

[30] The final draft of the manifesto was written by the present author, the only non-artist member of the group, in close collaboration with the artists and from discussions held between February and May 1959.

[31] *op. cit.*, p. 73

[32] *op. cit.*, pp. 106-7

[33] *See also Modern Art News* (Melbourne), no. 2 (1959), 10

THE ART SCENE IN THE 1960s

There are two types of cultural provincialism: unawareness and over-awareness of the 'centre', a hedged complacent identity and a loss of it in a desperate chase to keep up with the Joneses of the international art scene.
FRANZ PHILIPP, in the Preface to his *Arthur Boyd*, 1967

Towards a Metropolitan Situation

AUSTRALIAN art from the beginning has been given shape and direction by artists born or trained overseas. Martens, Buvelot and Ashton, to name but three, are crucial for the nineteenth century. From 1880 an increasing number of artists who were native-born or arrived in their youth first trained in the local art schools and completed their training in London and Paris. This was typical of the artists who, between 1885 and 1914, established Australian painting as a distinctive tradition. Incoming trained professionals, outgoing students in search of further study abroad; this is the traditional Australian situation, though, of course, the proportions have varied greatly from time to time. The attempts made by some critics during the early 1960s to explain the characteristic features of Australian painting as the result of isolation from European traditions will not bear a close examination.[1] From the beginning it has been the product of a perennial commutation between the northern and southern hemispheres. It still is.

It is not isolation but the curious effect of distance from its European metropolitan sources combined with the constant though by no means unchanging effect of the physical and social environment which has given Australian art its own character. The Aboriginal art of Australia, it might well be argued, is an art which has evolved in isolation from the rest of world art. But the European art of Australia has continued to be a provincial art carried on for almost two centuries now in a south-east Asian situation far from such metropolitan sources as London, Paris and, more recently, New York.

Distance has caused a time-lag in the reception, absorption and florescence of styles generated in those distant metropolitan centres. Innovatory styles first appear in Australia when they are ceasing to be innovatory at their source. The innovations have been brought to the country by newcomers or returning artists who have acted as messengers of the new. But messengers are not *ipso facto* creators: they carry the new; they do not

333

create it. In Australia the finest art has not arisen from the art of the messengers shortly after setting foot in the country. It has arisen not at the immediate point of impact of the novel metropolitan style upon the slower-moving provincial style but later, when the innovation has found a creative point of accommodation with the sluggish, provincial tradition which, though out of date by the standards of its metropolitan sources, has put down its roots in the environment of the country.

During the 1960s, however, there were indications that Australia's provincial situation, though continuing to prevail, was being transformed. By 1970 there were indications that Australia was beginning to create nascent metropolitan situations of its own in its main capital cities. The distinction being made here between a metropolis and a province will need to be clarified. A metropolis creates a cosmopolitan urban situation by drawing upon many other centres and regions for its own growing population and creates a cultural dynamic from the urban environment so created. That dynamic *depends* less and less for the creation of its art and its standards upon other centres. It draws its raw material from many places but its energy, and the nature of its originality, depends upon the energy of the metropolis itself. In its maturity the styles and the standards of the metropolis are admired and imitated by the cultural provinces that have become dependent upon it.

The emergence of a metropolitan situation in Australia would appear to be due to three main factors: first, the migration policy inaugurated at the end of the Second World War has begun the creation, slowly at first but now at an increasing rate, of cosmopolitan art communities in the main capital cities of the country; second, improved travel facilities, especially by air, have increased the movement of artists, critics and information between one country and another; third, the emergence of provincial communities and popular tastes within the country that look to the metropolis for standards and styles, on the one hand, but also make use of art, to a greater extent than the metropolis, as a means toward regional and national self-identification.

Australia's first wave of migrant artists this century began to arrive from Hitler's Europe during the late 1930s. Desiderius Orban, from Budapest, established an important art school in Sydney whence he disseminated his conviction that only an education based upon creative art could eliminate the twin evils of the age, fear of freedom and fear of responsibility. Sali Herman, from Zurich, did much—though it was only a side product of his aesthetic intentions—to teach Sydneysiders to enjoy the beauty of their terrace dwellings which they were disposed to reject as slums.

And there was Ludwig Hirschfeld-Mack (1893-1965), at first a student and then a teacher at the Bauhaus, Weimar, from 1920 to 1925, where he

conducted notable experiments in colour theory and music. Mack later taught art at Frankfurt, Kiel and Dulwich prior to taking an appointment in 1940 at Geelong Grammar School, Victoria, where he spent the last fifteen years of his influential teaching career. From his example Bauhaus methods and ideals began to percolate slowly into art educational techniques in Victoria (194).

They were the first of many. As the Iron Curtain fell across Europe from Lubeck to Trieste in the postwar years, artists began arriving in Australia from eastern Europe. From Poland came Josef Stanislaw Ostoja-Kotkowski (b. 1922), who had studied in Warsaw and Düsseldorf before settling in Adelaide in 1949. It was Ostoja-Kotkowski who

192 MAXIMILIAN FEUERRING, *Conquerors of Space*, canvas, 36 x 48, 1965, Mr Herbert Lewis

pioneered kinetic art in Australia (195). From Poland, too, a year later, came Maximilian Feuerring (b. 1896) who studied in Berlin, Florence and Rome, and has brought a resilient, experimental approach to his art and teaching (192). In 1961 he represented Australia at the São Paolo Bienal. Michael Kmit, born in the Western Ukraine, also arrived in 1950, as did the Dutkiewicz brothers, Ludwig (b. 1921) and Wladyslaw (b. 1918). Ludwig had studied at Lvov; Wladyslaw at Cracow. Both played a leading part in the contemporary art movement in Adelaide during the 1950s. Stanislav Halpern (1919-70), another Pole, established himself first as a potter in Melbourne and later worked as an abstract expressionist painter in Paris in the 1960s.

During the early 1950s a talented group of artists from the Baltic settled in Australia, several of whom contributed to the revival of the graphic arts. From Lithuania came Henry Salkauskas (b. 1925) who had studied in Paris and Freiburg prior to settling in Sydney, where he became known for his abstract expressionist paintings, particularly in water-colour; and also the printmaker, Vaclovas Ratas (b. 1910), who had been the curator at the Curlionis Museum, Kaunus, and had taught in Augsburg, Germany. From Kaunus, too, came Adolphas Vaicaitis (b. 1915), the graphic artist who had once been an artistic supervisor in the State Publishing House of Kaunus.

Eva Kubbos studied art in Berlin for five years before migrating to Australia in 1952, where she has become widely known for her graphics and water-colours. From Latvia came Ojars Bisenieks (*b.* 1924) in 1948, Karlis Mednis (*b.* 1910) in 1949, Reinis Zusters (*b.* 1918) and Jan Senbergs (*b.* 1939) in 1950, Uldis Abolins (*b.* 1923) in 1951; and from Esthonia in 1949, Edgar Aavik (*b.* 1913).

In 1953 the migrant artists from the Baltic then resident in Sydney established a group, *Six Directions*, devoted mainly to abstract painting. It held its first exhibition in the Bissietta Gallery. The members included Aavik, Abolins, Salkauskas, Bissietta, August Molder, Dzems Krivs and Jurgis Miksevicius. And in the same year in Melbourne a group of Latvian painters established the *Blue Brush Group*. It included Bisenieks and Karlis Mednis, together with Gunars Jurgans, Gunars Salins, Leo Svikers, Karlis Trumpis and Erna Vilks, and held regular exhibitions until 1963.

From Austria, in 1947, came Louis Kahan (*b.* 1905), a talented portrait draughtsman, painter and stage designer; in 1951, Judy Cassab (*b.* 1920), an artist of Hun-

193 JUDY CASSAB, *Moon Reflections*, acrylic and oil on hardboard, 50½ x 24, 1969, Bendigo Art Gallery

garian parentage who had studied in Budapest and Prague, and established a reputation in Sydney both as a portraitist and a painter of abstracts (193); and Leonard Hessing (*b.* 1931), who had worked under Léger in Paris before ariving in Sydney in 1951, where he became a leading figure among Sydney abstract expressionist artists in the early 1960s. Anton Holzner (*b.* 1926), who had studied at Innsbruck and Linz prior to settling in Adelaide in 1955, is a tonal abstractionist of fine sensibility. Franz Kempf (*b.* 1926), another Austrian, studied under Donati and Kokoschka, prior

194 LUDWIG HIRSCHFELD-MACK,
Growing, water-colour, 11⅜ x 7¾, 1940,
Mrs Hirschfeld-Mack

195 JOSEF STANISLAW
OSTOJA-KOTKOWSKI, *Sun-
set,* collage on hardboard,
47 x 47, 1967, National Col-
lection, Canberra

to arriving in Adelaide to teach painting and print-making at the South Australian School of Art.

From Germany in 1955 came Udo Sellbach (*b.* 1927), who had studied painting and graphics in Cologne, to teach graphics first in the South Australian School of Art and later at the Royal Melbourne Technical College. Sellbach has played a significant role both in the revival of print-making and in the recognition of colour painting in Australia. Joe Rose (*b.* 1915), who studied in Berlin, arrived in Sydney in 1957 and is known for his abstract expressionist paintings.

From Holland in 1949 came Gerard Ebeli; in 1951 Alfred Calkoen (*b.* 1917), who has taught art as an occupational therapy to adults and children in Melbourne; in 1952 Jan Riske (*b.* 1933), who has produced abstract reliefs on an enormous scale and who helped to create the Baroque Abstractionist Group on a return visit to Holland between 1962 and 1965; in 1958 Ernest van Hattum (*b.* 1920), who had studied in Antwerp and, by his industry and energy, turned the Mildura Art Centre into a centre of national importance for contemporary sculpture.

From Spain in 1962, at a time when the modern Spanish School was much discussed, came Ignacio Mármol (*b.* 1934), a texture painter of distinction.

Britain and the Commonwealth contributed fewer artist migrants during the 1950s than might have been expected. Peter Laverty (*b.* 1926), trained at the Winchester School of Art, arrived in 1949, to teach and later become Principal of the National Art School, Sydney, the largest, if not the most forward-looking, art school in the country. Roy Churcher (*b.* 1933), trained at the Sutton School of Art and at the Slade, arrived in 1957 and became an influential teacher in Brisbane. Gareth Jones-Roberts (*b.* 1935), a grandson of the Welsh poet, Owen Parry Owen, arrived in Melbourne in 1949 and has produced a series of resplendent semi-abstract paintings inspired by the sea and surf (196). Alun Leach-Jones (*b.* 1937), who studied at the Liverpool College of Art, has produced work of unusual interest related to colour-field painting since his arrival in Melbourne. Michael Shaw (*b.* 1937), who had studied at the Royal College of Art, and arrived in 1963, is of importance for the appearance of pop art in Sydney, during the mid-1960s. Melvyn Ramsden's brief residence in Melbourne during 1963 was significant for the emergence of the first attempts at colour painting there. Tate Adams (*b.* 1922), a print-maker, came to Melbourne from Eire in 1951, and established an important print gallery there in 1966.

From the United States in 1959 came Charles Reddington (*b.* 1929), who had been trained in the Chicago School of Art and was influential in the acceptance of abstract expressionism in Australia before his return to the United States. Gordon Samstag (*b.* 1906), an able exponent of texture painting and collage, and formerly a teacher at the Art Students' League,

196 GARETH JONES-ROBERTS, *Totem for a Summer Sun*,
oil on canvas, 66 x 66, 1968, Mavis Chapman

New York, has taught in Melbourne and Adelaide since his arrival in 1962

No Asian artist has yet been provided with an opportunity to make a significant contribution to Australian art, though the country is closer to Asia than Europe. This is due to the immigration laws.[2]

Migration during the post-war years also made its effects felt in art criticism and history—reducing the chauvinism of the 1920s. Paul Haefliger, born in Hamburg, brought, as noted above, an awareness of European values to his art criticisms for the *Sydney Morning Herald* between 1942 and 1957. Of more lasting importance are the writings and teachings of Ursula Hoff (*b.* 1909), a pupil in Hamburg of Erwin Panofsky, who arrived in Australia in 1939, and Franz Philipp (1912-70), who had studied under Julius von Schlosser in Vienna. The study of the art of continental Europe in Australia begins with the work and teaching of Hoff and Philipp. The appointment of Joseph Burke (*b.* 1913), a specialist in English eighteenth century art, to the Herald Chair of Fine Arts in the University of Melbourne inaugurated the academic study of art in Australia. A valuable association between the University of Melbourne and the National Gallery

T

of Victoria has raised the level of Fine Art scholarship in Australia. Brisbane has benefited from the art criticism of Dr Gertrude Langer who studied at Vienna under Strzygowski and in Paris under Focillon. Dr George Berger, another product of the Vienna school, has contributed to art criticism, particularly for the Jewish press, since his arrival in Sydney in 1939. Dr Hedi Spiegel, also of Vienna, has contributed to the knowledge of Melanesian art. Art dealing, too, has been stimulated by the initiative of migrants. Rudy Komon, who arrived from Czechoslovakia in 1953, brought methods of promoting and supporting artists new to the local scene to his advocacy of such fine artists as Leonard French, Bob Dickerson and Fred Williams. Georges Mora, a Parisian who settled in Melbourne in the same year, has become an influential patron of, and dealer in, *avant-garde* art.

None of the migrants listed above came to Australia with an international reputation; only a few were widely known in their native country prior to their departure. In this the Australian situation differs from the American experience. America, during the same period, received such famous artists as Yves Tanguy, Max Beckmann, Max Ernst, Amedée Ozenfant, Salvador Dali, Sebastian Matta. The preponderance of migrants to Australia came from eastern and central Europe and most had developed a sympathetic knowledge of *avant-garde* art, especially expressionism, prior to their arrival.

What was the effect of this migrant in-flow? It seems clear that the migrants helped to reinforce quite strongly during the 1950s and early 1960s that bent towards expressionism which had already begun to emerge in a figurative and realistic context during the early war years in the work of artists such as Dobell, Drysdale, Tucker, Nolan and Arthur Boyd.

The new migrants, however, were interested neither in realism nor the incipient nationalism present in the work of these artists. Social realism, particularly, was synonymous with the political and bureaucratic tyrannies from which they had fled, and the very concept of nationalism had taken on in their own experience grotesque pathological qualities under Hitler, Stalin and their satraps.

With one or two important exceptions such as Stanislaw Ostoja-Kotkowski, who pioneered kinetic art in Adelaide and Melbourne, the post-war migrant artists did not establish themselves as leaders of *avant-garde* movements. Leadership remained with the native-born. But the migrant artists did much to change the climate of aesthetic opinion during the 1950s and 1960s. By taking up teaching posts at many levels—in general education, in public and private art schools, in adult education—they were able to educate a generation of Australians towards a more tolerant view of modern art, particularly abstract art. Furthermore, their own art appears on balance to have contributed strongly towards reinforcing expressionism as the pre-

dominant modern style in Australia between 1940 and 1965, and directing the general movement of that style towards abstraction.

The movement towards a metropolitan situation in the capital cities during the 1960s was stimulated not only by migration but also by increased mobility. More Australian artists were moving about the world than ever before by 1970. Most, on their first overseas visit, made for London, not from any conviction that it was the art centre of the world but because the right to enter and work there was still easier than in any other great centre. The desire to study and work in Paris declined markedly. By 1965 most young Australian artists would have preferred to work in New York than anywhere else, but living costs and the lack of scholarships or work permits prohibited most. There was a slight improvement during the decade in the number of scholarships available to art students for study abroad but it was not comparable to the increased wealth of the country. State and Commonwealth Governments showed little interest, the improvements coming almost entirely from the private sector of the economy, and from foreign countries and business houses with Australian ties. The more important included the Helena Rubinstein Travelling Scholarship, the Fellowships awarded by the Harkness and the Ford Foundations of America, by the shipping lines, Flotta Lauro and Lloyd Triestino, the English Speaking Union, the Churchill Fellowships, and the Anthea Dyason Trust. In 1967 the University of Sydney purchased a studio for the use of Australian artists at the Cité des Arts, Paris, and a second studio was later purchased by the friends of Moya Dyring in 1969, and dedicated to her memory.

There was a complementary movement into the country on short-term visits of well-known critics and, towards the end of the decade, practising artists. In 1963 Sir Herbert Read visited Australia to attend a U.N.E.S.C.O. Seminar on Art Education held in Canberra and spoke to mass audiences throughout the country. In 1964 James Johnson Sweeney was invited from Houston to judge the Georges Invitation Art Prize. This was followed by invitations to the English critics, John Russell (1965), Robert Melville (1966) and Patrick Heron (1967) to judge the Wardle Invitation Art Prize, of Perth. In 1968 the Carnegie Corporation and the University of Sydney sponsored a visit from the American critic, Clement Greenberg; and in 1969 the Italian artist, Enrico Baj, the American sculptor, Richard Stankiewicz, and the Bulgarian artist, Christo, visited Australia. Baj was a visitor, but Stankiewicz worked for three months in the country before returning to the United States; Christo wrapped up a large section of the cliff-face at Little Bay, south of Sydney, with the aid of art students.

Immigration, greater mobility among artists, the increased number of visitors, a wider public for the international art magazines, the emphasis

given in local criticism to *avant-garde* work, and some important exhibitions from abroad, for example, Contemporary Trends in Dutch Painting (1961), Italian Painting (1963), The Michener Collection of American Painting (1964), Two Decades of American Painting (1966), all helped to transform the Australian art scene during the 1960s from a situation essentially provincial at the beginning of the decade to an emergent metropolitan situation by 1970. Sydney and Melbourne began to develop communities directed towards *avant-garde* art and susceptible to drives and pressures similar to those operating in Milan, Tokyo, Chicago, San Francisco, Amsterdam and Los Angeles. Though it could not be claimed that work of major international importance for the development of international contemporary art was being created, the climate of thought and experiment was directed towards international aesthetic issues and artistic problems, away from a concern with regional culture.

The Appreciation of Art and the Australian Community

The movement towards a metropolitan situation with many overseas links has coincided with a widening appreciation of art within the community. This appreciation is not exclusively aesthetic. Art has become, as never before in the nation's history, an investment, a status and culture symbol, a means toward regional and national self-identification. And the effect of these forms of appreciation which are grounded deeply in the changing social needs of the community has tended on balance to act as a counter-vailing tendency to the growth of metropolitan internationalism in Australia.

The introduction of sophisticated Continental techniques in art dealing greatly promoted interest in art as an investment and as a culture symbol. The private dealers have largely taken the initiative from the State galleries in the formation of public taste. The galleries have suffered from inadequate housing, lack of purchasing funds, and a fully-developed curatorial profession. The dealers have been in a better position to take advantage of Australia's increased affluence, to adopt and adapt to a taste-making structure radically different from that of the nineteenth century to which the public galleries tend to be still administratively structured.[3] Professional dealing has also greatly diminished the importance of the artists' societies. The Victorian Artists' Society has survived due to a few artists who have been loyal to the local traditions which it embodies. In Sydney the Society of Artists, founded in 1895 by Tom Roberts, held its last exhibition in 1965, having no longer, in the minds of its existing members, a useful role to play. The Contemporary Art Society survives primarily as a forum for the young and the less well known.

By the 1960s the art dealers with their more sophisticated techniques

had largely taken over the role of taste-makers to the community, by means of the one-man show and the mixed exhibition of sponsored artists. A few have acted as pilot galleries. The Rudy Komon Gallery, for example, is closely linked with the public recognition of Leonard French, Bob Dickerson and Fred Williams. Gallery A, at first in Melbourne and then in Sydney, has consistently supported abstract art in a variety of modes. But most dealers have been prepared to compete for well-known names, and many artists, in order to keep their options open, have tended to spread their favours among the more prestigious galleries. Australian dealers have certainly acted with an initiative which has widened and deepened the market for art and has spread its appreciation throughout a wider section of the community than ever before. But selling has been their business. Most have avoided involvement in the issues which concern artists deeply. The commercialization of the art scene during the 1960s to a degree never witnessed before in Australia has aroused wide concern—most notably in the art of Michael Brown and the criticisms of Donald Brook. And it has seen the emergence of galleries of a rather new type. Central Street, Sydney, was established in 1966 by a group of young artists to promote their own form of *avant-garde* art; the Pinacotheca, Melbourne (estd 1967), is now run on a membership basis to alleviate the tyranny of sales. Late in 1970 a group of young Sydney artists with similar intentions formed the Inhibodress co-operative.

Art dealing is linked with the art prize in the creation of reputations. There are now over one hundred annual prizes available throughout the country. They are of two principal kinds. First, prizes which have been established by suburban or rural communities to promote civic interest in art and, in many cases, form the nucleus of a local art collection. Second, prizes financed by city-based industrial organizations with a public relations interest in the cultural field. The first type usually provides more modest awards and attracts less well-known artists; the second type provides higher prizes and is therefore more prestigious. New talent is thus often given its first recognition in the country and its final accolade in the city. At the top of the art-prize hierarchy during the 1960s were such prizes as the Helena Rubinstein Prize (estd 1958 and of great significance in the early 1960s), the Georges Invitation Art Prize (estd 1963), and the Transfield Prize (estd 1961). Many dealers will undertake to send works regularly to art-prize competitions—awards being noted in the artist's biography printed in the catalogues of one-man shows.

The judges of art prizes are recruited frequently from the ranks of art critics, gallery directors and curators, lecturers in Fine Art, occasionally art gallery trustees—it is really a matter of personal reputation. Because of the frequency with which critics are chosen to judge there tends to be, in the

long run, a high correlation between critical approval of an artist's work and his capacity to win prizes. The choice of the judge, however, resides with the civic or industrial sponsor of the prize, so that it may fairly be said that the art-prize, art-dealing structure within which reputations are largely made is broadly democratic and based ultimately upon civic and industrial aspirations. Apart from the dealers, the most influential taste-makers operating within the structure are those who are able to combine frequently such roles as artist, dealer, critic, judge, curator and lecturer. Critic-judge and curator-judge conflations are the most common, and the artist-critic-curator-lecturer-judge conflation is by no means unknown. No taste-maker of the 1960s, however, succeeded in combining the roles of artist, dealer, critic, judge, curator and lecturer.

Well-established artists tend to avoid salon-type exhibitions and art-prize competitions, since they have little to gain from either. They prefer one-man shows and the comprehensive retrospective. Such artists stand to gain less and less from newspaper criticism which is becoming increasingly oriented towards the promotion of the young and the *avant-garde*. Many established artists have found it preferable to live overseas in older estab-lished, more civilized communities. Living abroad has provided them with a new art market in their adopted country while they have been able to retain connections through their dealer with the more lucrative home market. Their adopted country has usually been able to provide, if not more sympathetic, at least less abrasive criticism than that available at home.

No great quantity of European old masters has ever been brought into the country to enrich either public or private collections, so that art dealing in this field is non-existent—though overseas agents grope about profitably for odd pieces of Victoriana. A few dealers in Sydney and Melbourne interest themselves in Colonial and Heidelberg School art, where values are established and the market firm and rising. They attract the conservative investor who often comes from the established professions, particularly medicine. But by far the greater part of art dealing is concerned with Australian work executed since the Second World War by artists whose reputations are well established. Distance, in the form of high freight costs, together with customs and sales tax imposts, protect the local market from overseas competition. Efforts by some dealers to import expensive con-temporary work has not met with much success, though the number of one-man shows by artists from abroad is increasing slowly.

The Australian art market is still, therefore, rather provincial, being limited both to twentieth century work and to established local reputations. To this extent it acts as a brake upon the movement towards a metropolitan situation.

The appreciation of art within Australia was greatly stimulated, albeit

indirectly, by the favourable reception of Australian painting in England. Australians have never been prepared to place much confidence in their own art critics. This may be due, as has been on occasion asserted, to a sense of national inferiority, but it must be recognized that no Australian critic has become internationally known for his critical writings or the discernment of his judgements. The desire, therefore, of many Australian artists to live, work and exhibit abroad, to submit their work to more sophisticated standards of criticism, is but another aspect of the search for metropolitan—and international—standards. Furthermore, the transformation, after the Second World War, of the Venice Biennale into an international festival of contemporary art, stimulated the desire in Australian art circles that Australian artists should be exhibited in international company and submitted to international standards.

From 1950 onwards the Commonwealth Government was requested constantly by art societies and other bodies to ensure that Australia was represented at each successive Biennale, but without much success. Certainly Australian exhibits were shown in 1954, 1958 and 1960; but the selections revealed little appreciation of the nature and style of an international exhibition of contemporary art and were largely ignored by the critics. The Commonwealth Art Advisory Board which made the decisions in such matters was a highly conservative body and reflected the Prime Minister's own taste. At the Commonwealth level Australia was more interested in using its art to sustain Australia's imperial connection. No exhibits of Australian work have been shown at Venice since 1960.

In the circumstances it is not surprising that the recognition of Australian art abroad was attempted not in Venice but in Britain. As we have already noted above, the crucial exhibition in this connection, the one which aroused widespread public and critical interest in Australian art, was Sidney Nolan's Retrospective organized by Bryan Robertson at the Whitechapel Gallery, London, in 1957.

Nolan's work was first admired for its exotic subject-matter. This becomes clear from a reading of the critical reviews of the time, but the initial appeal of the subject-matter led to a greater interest in the formal aspects of the work—a phenomenon common to the reception of exotica. Nolan's success prompted among others the desire to live and exhibit in London. One of the principal interests of the Antipodean group of painters in Melbourne was the possibility of a London group show. All highly-talented figurative painters, they were experiencing at that time the growing pressure of abstract-oriented *avant-garde* criticism. They wished to submit their work to a wider and better informed range of criticism than was available to them in Australia. Their initial inquiries concerning a group show in London was one of the factors which led to Mr Bryan Robertson's visit to

Australia in 1960 in order to select a representative exhibition of Recent Australian Painting for exhibition at the Whitechapel Gallery. That exhibition was very well received but its attempt to select the best of what was available over the whole field ensured, unfortunately, that it would be promoted and viewed as an exhibition of *Australian* art. In consequence many futile attempts were made at the time to define the essential nature of Australian art. Mr Robertson himself said that it consisted in 'a natural and instinctive feeling for the sensuality and the plasticity of paint';[4] for Mr Robert Hughes it was rather an 'acute awareness of the dark side of experience . . . a ritual in the dark'.[5] Whilst such attempts at a general definition revealed insights into some of the aesthetic issues and problems which occupied Australian artists at that time (1961), they grossly over-simplified a complex and varied situation. The decision to make the Whitechapel Exhibition a comprehensive show of Australian 'bests' arose, doubtless, from a natural desire to be fair to the whole field, but it was a naïve manner of introducing an unknown art to the English public. The 'ifs' of history are mostly idle speculation, but had the Antipodeans succeeded with their original intention of presenting their own work in London in their own way, there can be little doubt that the controversy which would have followed, not to speak of the uproar from Sydney, would have resulted in a second Australian exhibition in London of contemporary work of a substantially different type. Furthermore, the issues aroused by the two exhibitions would have centred upon the nature of the image in painting, an issue much discussed at that time both in Australia and overseas. For it was this question, and not any desire for a national art, about which the Antipodeans were centrally concerned, as a careful reading of their Manifesto will reveal. But in the event the Whitechapel Exhibition presented Australian art under a national banner, implied a spurious unity where little existed, and an increasing number of English critics soon came to view the Australian intrusion as an exercise in cultural nationalism. The large survey of Australian Painting officially sponsored by the Commonwealth Government at the Tate Gallery in the following year substantiated their misgivings. Selected by the members of the Art Advisory Board and provided with a foreword by the Prime Minister it bore all the hallmarks of national pride and cultural politics. It was selected with less discernment than the Whitechapel Exhibition and as an historical survey was amateurish. It received a polite but cautious reception from all but the most forthright of the critics, and helped to create a temporary vogue for Australian painting which was followed by a distaste for it that only a few good artists, who did not require the prop of nationalism, survived.

Although it is notoriously difficult to generalize about a large field of varied critical opinion, a close examination of the record will indicate that it

was the figurative expressionists who aroused the greatest interest among English critics. The desire of the Antipodeans to be brought to the bar of international criticism was vindicated. Distinguished critics from Sir Kenneth Clark to Clement Greenberg have discerned originality and quality in Antipodean-type painting. This consensus among the informed cannot be dismissed as a conspiracy. It is simpler to assume that the judgements were made in good faith and that around 1960 it was in the field of figurative expressionism that quality in Australian art tended particularly, if not exclusively, to lie.

This critical consensus did not take long to reflect itself in prices. The vogue for Australan art, fitful and precarious enough in London, exercised a major effect upon the Australian art market. Art became news and an exciting new form of investment. Works by figurative expressionists such as Dobell, Drysdale, Nolan and Arthur Boyd achieved prices unheard of before for Australian work. The approval of State and Society was not long delayed. The alienated dissidents and conscripts of the Second World War began to receive Birthday and New Year honours. For many, the cycle of alienation, reconciliation and accommodation was complete.

Now, as will be seen later, the most talented, energetic and critical of the art-student generation of the later fifties and early sixties rejected both Antipodean-type painting and abstract expressionism almost to a man, a rejection later reinforced by the aesthetic responses of the new critics of the 1960s. But as this rejection asserted itself among the taste-making *élite* of Sydney and Melbourne, figurative expressionism, the *avant-garde* art of the 1940s, began to be absorbed within the popular traditional art of Australia.

Expressionism in Australia, being a romantic art, had no great difficulty in establishing links with popular culture. Sidney Nolan, Donald Friend, Albert Tucker, Arthur Boyd, the collector John Reed, and others, have taken great interest in the naïve painting of Australia, both in its contemporary and in its colonial forms. Several of them, too, were able to enjoy the achievements of the best of the Heidelberg School. This gave them a stake in the popular culture from the beginning. Their own art was not, of course, naïve, any more than the paintings of Chagall or the music of Bartók, but it contained primitivistic elements.

If folk art is defined narrowly as traditional peasant art then there is no true folk art in Australia, which has never possessed a traditional peasantry. Yet there is no reason why folk art should be so narrowly defined. Art styles and their appreciation cannot be separated from life styles; and of course all life styles in Australia are not similar. The presence in Australia of naïve artists is but one indication that it is possible to have creative art proceed-

ing at some distance from the *avant-garde* art of the metropolitan centres—
a distance to be measured not only in space, but also in time and attitudes.
There has existed in Australia from its convict beginnings an audience for
folk song and folk ballad. Here tradition tends to be conservative but is
not static: it not only remembers, it also makes. And the potential audience
for a folk-type art and a folk-type culture is to be clearly distinguished
from the metropolitan *avant-garde,* for folk art is not a contemporary ex-
pression of international aesthetic values but a means of achieving a sense
of community and national identity through music, poetry and painting.
The emergence of the advanced industrial society with its flood of industrial
artifacts has not obliterated this audience. For the folk art audience views
such artifacts not as art but as furniture, useful adjuncts to daily living, not
as symbols of community and nationality. The audience for folk art, there-
fore, is not to be identified with the sophisticated audience for pop art
which seeks to identify aesthetically industrial technology and popular
culture. Nor is it to be confused with those whose enfeebled aesthetic
responses are satisfied by the popular reproductions available in the furni-
ture departments of retail stores. Between the internationalism of furniture-
store art and the internationalism of the *avant-garde* lies a growing audience
which seeks from art not pure aesthetic response but a sense of personal
and national identity. Less mobile than the *avant-garde élite*, more sluggish
in its aesthetic responses, yet not entirely visually illiterate, its presence
reveals the effect of art as a civilizer within the philistine core of Australian
society. 'Where there is no creation there is also no mimesis.'[6]

Now as Australian expressionism came to be rejected by the younger
artists and critics of the 1960s it began to exercise a wider appeal upon
provincial and folk taste. This is not surprising since, as we have noted
above, much Australian expressionism was itself compounded of folk art
elements, popular myth, popular naïve painting and child art. This broaden-
ing of appeal is revealed not only in the high prices achieved on the local
art market, but also in the tendency of expressionist art to furnish proto-
types for the popular art which has increased with the spread of cultural
awareness into suburbs, country towns and regional areas. As the *avant-
garde* turned its face away from regional and national interests a new kind
of artist has emerged during the 1960s to fill the resultant cultural vacuum.
Artists such as Ray Crooke, Gil Jamieson, Jacqueline Hick, Douglas Stubbs,
Sam Fullbrook and Pro Hart have cultivated relatively *retardataire* modes
of painting to good purpose. Crooke working in a quiet, lyrical, post-
impressionist manner faintly evocative of Gauguin and the South Seas has
created a new visual image of the tropical north (197); Gil Jamieson,
working in a coarse and wiry, expressionistic mode, as tough and rhythmical
as a bush ballad, has sought to capture the spirit of the Queensland outback

197 RAY CROOKE, *Sunrise, Albion Hotel, Normanton,*
oil on masonite, 30 x 47⅞, 1961, Brisbane

(198); Sam Fullbrook, the lyrist among these painters, realizes images, in soft muted tones, evocative of the land (199). 'I aim to paint' he has said 'good pictures that children will love'.[7] Pro Hart paints incidents and scenes related to the Broken Hill district, as does, in a more naïve manner, the painter Sam Byrne (200). Jacqueline Hick paints figurative compositions, in a broad, expressive style, drawn from scenes of daily life (201). All these painters have drawn something, either in style or attitude, from expres-

198 GIL JAMIESON, *Stockman with Saddle and Dog,*
hardboard, 48 x 72, 1970, the artist

199 SAM FULLBROOK, *Two Aeroplanes, Warana,*
oil on canvas, 24 x 33, 1965, Perth

sionism. Such painters are representative of the best of a great deal of
pictorial activity to be seen in the work submitted to suburban and rural
art-prize competitions or such traditional prizes as the annual Archibald,
Wynne and Sulman prizes of the Art Gallery of New South Wales, which
attract a great deal of popular art. The later work of Albert Tucker,[8] too,
appears to be directed increasingly towards a folk, rather than a metro-
politan, response (202). What has occurred and is occurring exemplifies the

200 SAM BYRNE, *Rabbit Plague, Thackaringa, 1886,* hardboard,
16 x 32, 1962, The Rudy Komon Gallery

201 JACQUELINE HICK, *Darker People*, oil on masonite,
47 x 65¾, 1962, Adelaide

reception theory of folk art which asserts that the true sources of folk art are to be found in the élitist art of former generations.[9]

It needs to be stressed that the emergence of one group dedicated to experiment, to internationalism, to a metropolitan-type culture and another

202 ALBERT TUCKER, *The Gamblers*, oil on hardboard,
36 x 48, 1965, Hobart

group seeking national identity through art are both based upon real-life situations. The one based upon a young, urbanized and—in Riesman's phrase—other-directed,[10] highly mobile *élite* group, the other upon older, suburban and rural groups, the members of which expect to live out their lives in Australia, draw some cultural sustenance and a sense of identity from its legends and history and make, at most, one visit overseas during a lifetime. The emergence of these two kinds of art, reflecting two kinds of life, *both* lived above the level of sheer visual illiteracy testifies both to the growth of civilization in Australia and to a stratification of the artistic culture grounded in different living conditions and different cultural aspirations.

NOTES

[1] For example, 'What pressures, then, have formed Australian sensibility? The first that springs to mind is our complete isolation from most of what happens now in world art'. Introd. to Cat. *Recent Australian Painting 1961*, Whitechapel Gallery, London, 1961. These views were echoed by several English critics during the early 1960s. See my 'The Myth of Isolation', *Australian Painting Today*, St Lucia, Brisbane, 1962.

[2] This is almost certainly due to the severe restrictions placed upon immigration from Asia by the Commonwealth Government since Federation. It is probably the chief factor making for the preservation of provincialism in the arts in Australia.

[3] The prominent exceptions have been the National Gallery of Victoria and the National Gallery Society of Victoria which, particularly since the opening of the new premises on St Kilda Road in 1968, have succeeded in attracting a mass audience to an appreciation of the visual arts.

[4] *Recent Australian Painting 1961*, Whitechapel Gallery, London, June-July 1961, p. 8

[5] *ibid.*, pp. 20-1

[6] A. J. TOYNBEE, *A Study of History*, London, 1939, iv, 5

[7] *Present Day Art in Australia* (ed. M. Horton), Sydney, 1969, p. 74

[8] On Tucker's work in the 1960s *see* R. HUGHES, 'Albert Tucker' *Art and Australia*, February 1964; and C. UHL. *Albert Tucker*, Melbourne, 1969

[9] The reception theory of folk art is to be traced in the writings of A. Riegel, M. Haberlandt, B. Berenson and others. *See* the comprehensive article on folk art in *Encyclopaedia of World Art*, v, 451-506; also A. HAUSER, *Philosophy of Art History*, London, 1959, pp. 279-365.

[10] D. RIESMAN, *The Lonely Crowd*, New Haven, 1950

THE EXPRESSIVE AND SYMBOLIC STYLES OF THE 1960s

*On the other hand, there were mornings when the mere
physical pains throbbed higher, to break into life, or live paint.
He dabbed and scratched frantically. He reached out and
drew his brush across the hard surface in a broad blaze of
conviction and watched the last few drops of fulfilment spurt
and trickle and set for ever. He was learning to paint; but as
he tottered on the crude block groping for some more
persuasive way in which to declare his beliefs, it seemed
that he might never master the razor-edge where simplicity
unites with subtlety.*

PATRICK WHITE, *The Vivisector*, 1970, p. 591

Abstract Expressionism

BY 1960 figurative expressionism had long ceased to be an *avant-garde* style
in Australia; indeed during the later 1940s it was beginning to lose its
impact in the art schools which had been augmented by ex-servicemen
taking rehabilitation courses after the Second World War. Throughout the
1950s there was a general movement both from figuration and cubist styliza-
tion towards looser and freer form. The inspiration of the movement,
especially at the beginning, was based primarily upon French sources. Paul
Haefliger, the most influential critic of the 1950s, was oriented towards
French painting. Several of the artists who were to play a major role in the
emergence of abstract expressionism in Australia were confronted by the
comprehensive *French Painting Today* Exhibition which toured Australia
in 1953, at an important formative stage in the development of their own
work. It was the first post-war generation of art students which provided
the driving force towards the new abstraction; few, if any, who contributed
to the formation of the new style had travelled abroad before 1960. Original
works by the first wave of American abstract expressionists were not shown
in Australia prior to the 1960s, and were unknown to them.

In consequence Australian abstract expressionism bears a closer family
resemblance to European *art informel* than it does to American abstract
expressionism, so that the latter term is rather misleading as an implicit
indication of the source of the style. But since it has become the general
term, among English speakers, for the whole international style under dis-
cussion it is best that it should be preserved in this context. But it should

be borne in mind that the Australian variant of abstract expressionism evolved against a background provided by the work of such artists as Manessier, Singier, Poliakoff, de Stael, Klee, Hartung, Soulages, Wols, Vieira da Silva and Mathieu than against the work of such Americans as Pollock, Gorky, de Kooning, Guston, Still, Marca-Relli and Kline. Of course something of the American developments came through via the magazines. Robert Klippel, the sculptor, came back to Sydney in 1950 with accounts of the work of the French-Canadian painter, Riopelle, whom he had met in Paris. In Melbourne, as we have noted above, Howley and Laycock were interested as students in the work of Matta and Pollock.

And there was something about the new style which possessed local roots. As we have seen, it first appeared as a going concern in the work of a new generation of Sydney artists just emerging from the art schools, and the contemporaneous practices of the schools is inextricably mixed with their innovations. The dynamic of the style in general arose in the search for personal styles; the influence of overseas magazines or of influential artists returning to Australia were side issues. Certainly John Passmore who returned in 1950 from seventeen years abroad, largely in England, was of the greatest importance in the evolution of the style: but Passmore worried out his movement towards free form within the exacting personal discipline of his own art and in concert with his students, such as John Olsen.

The linear abstract expressionists: This was the time when John Olsen in his work, enthusiasms, personality and life-style gave a new energy and character to Sydney painting. During the later 1950s he became increasingly committed to the act of painting as a total experience. He sought to make of his paintings enactments of passionate experience, records of a personal encounter of the whole man with his environment, a palimpsest of moods, memories and physical sensations, revived and relived in the act of painting. Of painting Sydney harbour he remarked, 'It's all there—everything—the seaport, ships coming in and out, the dawn, the sun, the great cranes, men working, traffic, movement—everything—*I want to get it all down*'.[1]

In the mid-fifties he had read Dylan Thomas's *Under Milk Wood* and it suggested the possibility of a new direction; to offer up his work as a totality of random sensations, passionately experienced, emanating from and inspired by a whole urban environment. In Australian literature Patrick White had achieved something like that before in his early novel, *Happy Valley*, and behind them all, of course, White, Thomas and Olsen lay, distantly, the overtowering genius of James Joyce. Not that there was much that could be called literary in Olsen: it was the sense of abundance, vitality and acceptance which linked him to these writers. Speaking of one of the paintings inspired by his new approach he said:

I feel in paintings like 'Dylan's Country' that one gets a feeling of landscape as a totality as opposed to the Renaissance ideal 'here I stand, where I look is landscape'.... Questions come to mind. What is it like to get a totality of the Riverina, the Dead Heart and other parts of our wonderful landscape—to travel through, to feel the rise and fall of hill and plain, to circumvent, to come back where I have gone before? I cannot help thinking of Klee's lead when he said 'The line goes for a holiday'.[2]

In his mature work Olsen's line goes for a ragged, hitch-hiking sort of holiday across great bursts and blotches of colour. Line enabled him to express, against the moods, intimations and expectancies of those vibrant-coloured grounds, his intuitive grasp of the energy, vulgarity and vitality of Australian life (203).

In Paris he had met Alan Davie, a pioneer of abstract expressionism in Britain, and began to take an interest in theories about archetypal imagery. In Paris too, via Atelier 17, he met members of the Cobra group, and later travelled to Spain with Corneille on his motor scooter. It was the example of the Cobra group, doubtless, which helped to reinforce Olsen's desire to record the energy and spirit of the everyday world in a thick, lively and turgid calligraphy. Dubuffet, too, revealed how gross, child-like, and monstrous figurations could be realized with great pictorial force while yet linked to the concept of total plastic unity. And it was Dubuffet and the Spanish painters, Tapies and Canogar, who led him, by their work, to experiment with thick pastes and serrated, incised textures—a manner which he later modified towards a more tenuous, open, calligraphic style.

Robert Hughes has written:

In his celebration of vitality, Olsen has invented one of the few original schemata for Australian landscape since 1885. In its worse moments, his work can be disorderly, often over-sweet, incoherent and too dependent . . . on the personality behind it. But at its best, it stands honourably in the company of Roberts's Heidelberg studies, Streeton's *Fire's On!*, *Lapstone Tunnel*, and Nolan's Wimmera landscapes. He has developed an art robust enough to face the breadth of the street.[3]

The influence of Olsen's work and personality did much to endow abstract expressionism as practised in Australia with a life and character of its own, features by means of which it may be distinguished from the abstract expressionism of other countries. There was, for example, the strong committal of Olsen and of many of his friends and associates to landscape not as scenery but as environment, a mingling in harmony and discord, in vulgarity and beauty, of the animal, vegetable and human—an ecology of the *genius loci,* the sullen, brooding, spirit of place, embattled and barricaded against time. And there was also the curious pictorial dialectic

203 JOHN OLSEN, *Spring in the You Beaut Country*, oil, 72 x 48,
1961, the artist

204 LEONARD HESSING, *Charred Memories,* oil on
canvas, 58 x 48, 1960, Sydney

established between the ragged blotches of thrusting colour held more by
a chromatic of tone than a chromatic of hue, and the wayward, drunken,
sensuous, erratic line. Both find parallels and antecedents of a sort in
tachism and in cobra painting, but the synthesis achieved possesses the
quality of a personal creation.

The abstract expressionists, though drawn strongly by the pull of land-
scape and environment—Gleghorn worked in the Nullarbor Plain, Daryl
Hill in the salt-lake district of Western Australia, Ross Morrow in northern
Australia—were also drawn by the compelling desire to make their paint-
ings a personal encounter with the inner self. So that the images which they
create in the liberating act of painting are ambiguous—hybrids born of the
inner and the outer world. Some like Ross Morrow (*b.* 1932) placed much
emphasis upon the external image, while yet personalizing it into strange
forms, and became almost figurative painters—abstract impressionists;
or, like Carl Plate, placed an emphasis upon the landscape of mind,
'to expose a glint of the unknown', to make the non-visual visual (184); or,
like Leonard Hessing (*b.* 1931), sought to hold a delicate balance between

U

205 CHARLES REDDING-
TON, *Coromandel Valley*,
canvas, 73 x 71, 1963, Ampol
Exploration Ltd

206 STANISLAUS RAPOTEC, *Athene*,
polyvinyl acetate on hardboard, 72 x 54,
1969, Mr Elliot Aldrich

the inner and the outer, man and
the environment, past and present,
by means of vestigial, totemic
presences, mandalas and tribal
wounds (204); in others, like
Charles Reddington (205) and the
early Brett Whiteley, the landscape
is sex and flesh, hot colour and
writhing sensuous bodies, com-
pacted and interlocked—the im-
patient vitality of the desert: still
others, like Stanislaus Rapotec (*b.*
1912), developed the sweep and
force of the brush in order to ex-
hibit states of extreme tension,
ploughing up elephantine furrows
of black pigment across fitful and
livid flares of yellow, in order to
testify to the reality of evil and the
sublimity of the act of creation
(206).

What excited them all was the

sense of discovery made possible by the new informal techniques by means of which they might give birth to a new, personal symbology; a language not premeditated but generated out of the very act of drawing and painting. Drawing was for many the vital path into this magical world. It was to be regarded not as a mental but as a physical, almost involuntary act. 'When I draw', wrote Hector Gilliland who drew darkly massive and yet lyrical structures on light grounds, reminiscent of Soulages and Kline, 'I need to begin with a sensuous awareness of physical activity' (207). For him drawing was

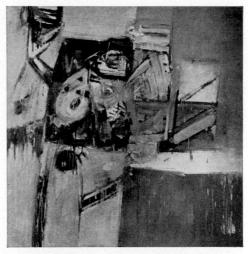

207 HECTOR GILLILAND, *Untitled*, oil on hardboard, 48 x 48, 1964, Maitland City Collection

emergent form. 'The tree draws its growth and the spider its web.'[4] Drawing was not a concept to be realized but a quest for the unknown. 'Art', wrote Frank Hodgkinson, 'is an act of divination by entrails, not a careful record of the obviously seen. . . . I find it necessary to sleepwalk a little'.[5]

The pure act of drawing was celebrated, at this time, most ecstatically in the enormous arabesques of Peter Upward; great, black furrows on white empty grounds which referred to nothing beyond the act—creativity admiring, like Narcissus, its own beauty (208). Henry Salkauskas (*b.* 1925), a superb water-colourist, located the creative source of the gesture beyond

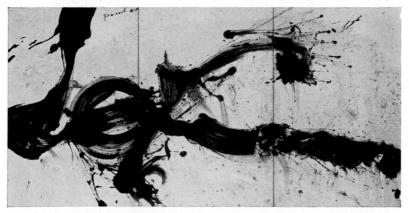

208 PETER UPWARD, *June Celebration*, polyvinyl acetate on hardboard, 84 x 162 (in three sections), 1960, The Rudy Komon Gallery

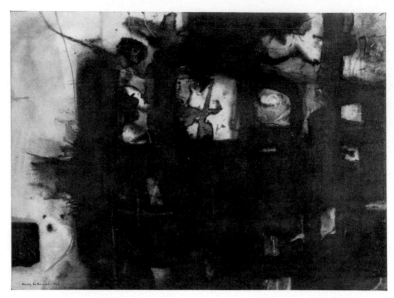

209 HENRY SALKAUSKAS, *Landscape Striped by Moonlight
and Shadow*, water-colour, 22⅝ x 30⅞, 1963, Adelaide

the gesture itself. Line was for him the language by means of which the
tale of creation could be symbolically told (209). 'Lines moving as lines
or as masses represent', wrote Salkauskas, 'creativity ruminating over or
being ecstatic about water, earth, sky and cities; but it is the rumination
and ecstasy that I want to put down'.[6] In the work of Jan Riske (*b.* 1933),
line took on a baroque exuberance, in massively scaled relief paintings, that
also linked the linear abstractionists with the aesthetics of texture painting.
Because of the great importance given to line as a discoverer of hidden
symbols much of the abstract expressionist work produced in Australia at
this time is at heart linear, calligraphic, despite the massive painterly build-
up finally achieved. It is a feature of the work of the Victoria Street Group
which included Olsen, Rapotec, Upward and Rose, and a distinctly linear
emphasis is to be found in the work of artists as otherwise diverse as
Leonard Hessing, Thomas Gleghorn, Daryl Hill, Ross Morrow, Eva Kubbos,
Hector Gilliland, Margo Lewers, Henry Salkauskas, John Passmore, Eric
Smith and Nancy Borlase.[7]

 William Rose stands somewhat apart from this group of linear abstract
expressionists. Although closely associated with Olsen and Eric Smith in
the Direction I exhibition of 1956, which is important for the emergence
of the Australian variety of abstract expressionism, Rose is only with some
difficulty classified as an abstract expressionist. For his work obviously
owes much to the post-war development of the cubist tradition by painters
such as Vieira da Silva, Hartung, Bissière and others (212). And yet by

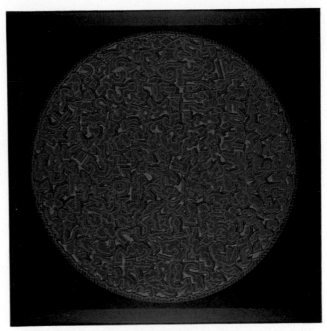

210 ALUN LEACH-JONES, *Noumenon XXXII Red
Square,* acrylic on cotton canvas, 66 x 66, 1969,
National Collection, Canberra

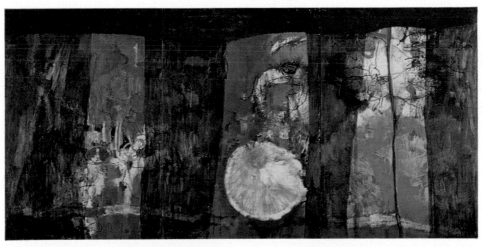

211 FRANK HODGKINSON, *Time of the Last Cicada,* canvas, 70½ x 144,
1963, The Union, University of New South Wales

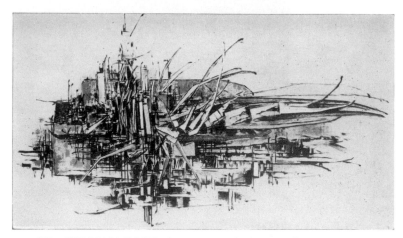

212 WILLIAM ROSE, *Construction in Space,* oil on canvas on
synthetic panel, 38½ x 67¼, 1959, Brisbane

1962 Rose was aware that his work was freeing itself from geometric form
and 'flowing out in a more expressive manner'. He placed great importance
upon the first mark on the canvas and the part-conscious, part-unconscious
feed-back process which it launched upon the artist, the human element
intervening as a finely-established relationship between the structural and
the lyrical. Such fine relationships in his view endowed paintings with an
almost living quality. Such an art seems far indeed from any regional in-
terests. Yet Rose like many of his contemporaries appears to have felt
the continuing pull of place. 'Because', he wrote, 'of some national revolu-
tion which has taken place in Australia, we are, I feel, at the point where
we cannot approach our painting in the general manner, the international
manner—unless we do create a national culture, we are virtually lost'.[8]

The tonal abstract expressionists: In other artists, however, the use of line,
though often of seminal importance in the execution of the painting, does
not dominate the finished product. Often this is no more than an indication
of a difference in personal approach and temperament. It is, however,
possible to glimpse within the history of abstract expressionism, both in
Australia and abroad, a kind of classic movement from linear to painterly,
a movement hidden by the great diversity of individual talent working in
both modes during the 1950s and 1960s. But from the recognition of Pollock
to the recognition of Tapies, the mainstream seems to move from line to
mass, and from an emphasis on art as action, to art as object. The revival of
collage in assemblage, the use of high pastes by Dubuffet, the emphasis
placed upon texture and material by Alberto Burri and Tapies, all helped
to move interest from the act of painting to the pictorial object. The desire

so frequently expressed by the abstract expressionists that the painting should act totally upon the viewer, that is to say simultaneously, rather than be viewed as a record of sequential events, gave mass, tone and texture a new importance.

The work of Carl Plate occupies a central, almost classical position between the linearists and the tonalists (184). Tone is the architectonic base of his work. Line is reduced largely to crisp edges which articulate a shallow space and maintain the surface tension across the pictorial structure. Colour is muted to greys, pale blues and olive greens, with an occasional warm accent. By these means Plate seeks to figure forth in plastic form his intimations of the non-visible. And in his work, as in that of Rose, the French heritage is notably present; behind him there stand such artists as Braque, the later Matisse, Hans Arp even, in the feeling for weight and placement, in the delicate confrontation and articulation of the elements of the composition.[9]

The paintings of John Coburn may also be placed under the broad classification of tonal abstract expressionism. For despite the commanding sonority and resonance of their colour it is by means of tone that he constructs their pervasive harmonies and the transcendent space which inhabits them. His mood is *adagio* (183) to Plate's *andante capriccioso* (184), but his art, for all its poise, is firmly linked to a central concept of abstract expressionism, namely that the act of painting summons the forgotten, illuminates the unknown. Coburn's art, like Proust's, is recollection heightened by feeling, experience recovered. 'I seek images', Coburn has written, 'that . . . I knew as a child, blackened tree trunks after a bushfire, a flight of screeching pink galahs over a dry creek bed'. He seeks, as he says, but rarely knows that which he is seeking. 'I usually discover what the paintings are "about" only after I have finished them.'[10] In Coburn discovery mingles with faith: the realization of meaning in the pictorial process of creation acts like a sanctification, a solemn benediction. And in Coburn, too, the School of Paris asserts its latent but potent presence. The heritage of Picasso, Gris, Manessier, Singier, Poliakov subtly manifests itself in his work without weakening its authenticity or originality.

Tonal abstract expressionism is a manner within a style and has no clearly definable limits; many artists move between a linear and tonal manner as mood or subject suggests. It would be difficult to classify the delicate paintings of Robert Grieve, that owe so much to his love and understanding of Japanese art, as linear or tonal (213). Guy Warren will utilize a line deftly to bring movement and depth into paintings in which colour sings with a lyrical purity as it floats in pools of pale liquid space, but tone still holds the image within its limits. In Warren's work abstract expressionism verges upon the edge of colour-field painting. Anton Holzner,

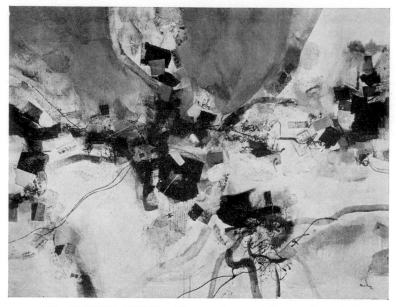

213 ROBERT GRIEVE, *Ukiyoe Theme,* collage and acrylic,
36 x 48, 1965, Sydney, gift of Mr Patrick White

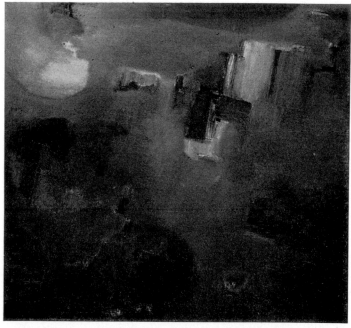

214 ANTON HOLZNER, *Blackwood, July 1965,* oil on canvas,
46 x 48, 1965, the artist

however, by means of tenuous veils of grey or brown, has achieved a lyricism comparable to Grieve and Warren (albeit more austere) by tonal means alone (214).

In the work of Franz Kempf tone affirms structure and expresses mood in paintings and graphics both lyrical and urbane. A student at Kokoschka's school in Salzburg, he owes much to Klee and Chagall, and came to abstract expressionism through an appreciation of the work of Conrad Marca-Relli and those Italian masters of lyrical abstraction, Alfro Baldasella and Giuseppe Santomaso. It is by means of tone largely that Kempf has commuted with tradition, with the Venetians and Rembrandt, while keeping his options open towards the present. As George Berger has put it: 'He searches for ways to retain great values of the past for the proletarian revolution which is afoot in the arts, and builds slender bridges for his own use between compliance with demands of the moment and traditional values'.[11]

Iconomorphic expression: Abstract expressionism is essentially an image-fashioning art by means of which the act of painting becomes a kind of invocation, a summoning up of expressive content, of a personal language from the flowing pictorial surface. Should the process result in the conception of recognizable images the offending images are usually suppressed. Many artists, however, who have involved themselves deeply with the methods of abstract expressionism, De Kooning, Appel, Corneille, Jorn, Enrico Baj, Dubuffet, Saura, Diebenkorn, to name but a few, have been unwilling to abort the foetus of figuration when it rose unexpectedly from the marriage of mind and paint. For although it is true that representation may at times proscribe the free creative process, the free creative process by its very nature is unable to proscribe representation. Now in order to avoid emergent figurations becoming realistic stereotypes artists have made use of many devices. One is the use of visual ambiguity, by means of which a figure may suggest now this reference, now that. Another is the use of conflation, whereby the artist draws upon the repertoire of images contained in his earlier work, and presents a familiar motif in a new context, so that something of the former connotations is carried on into the new work. Conflation in this sense is a special kind of ambiguity in sequential depth derived from the artist's *oeuvre*. A third method is the creation of hybrid or monstrous forms from the commingling of parts of realistic images, a method traditional to the mythical imagination. There has arisen as a result of this a semi-figurative type of expressionism which has been much practised throughout the world during the past two decades. It is sometimes called metamorphic painting, but metamorphosis suggests a physical change, a change of substance. What is at issue here, however, is

not the physical or chemical changes which may indeed take place during the pictorial process—between different materials, for example—but the nature of the process by means of which the images are changed. And since the images are discovered in the actual process of painting, growing and emerging more from the physical activity of the artist than from conscious thought control, the term *iconomorphic* is a better description. An iconomorphic image is an image which grows out of the pictorial process, but was not the purpose which set the process in motion—as an icon is.

There are many different varieties of iconomorphic expression, and it follows that the proportionate use of intention to accident will vary from artist to artist. But all iconomorphic painters are prepared to make creative use of accident and preserve in some measure elements of figuration. They are thus to be distinguished from non-figurative painters on the one hand, and the painters of realistic imagery on the other.

One of the varieties of iconomorphic expression by means of which painters have commuted between figurative and abstract expressionism, either in moving away from or towards non-figuration, has taken the form of a labyrinth. There are, of course, many traditional prototypes, perhaps the best known being the animal-interlace style of Hiberno-Saxon art. The labyrinthine surface appears to have become attractive to many artists in recent times because it not only held out one possible solution to the conflicting claims of the figured motif and the abstract form, but also because it held out a possible solution to the competing claims of the tense, dynamic, gradated surfaces of action painting and the relaxed, motionless surfaces of texture painting. By means of the labyrinth structural accents could be reduced to an even pattern which would stress the *total* painting, not its parts. Modern artists who have made notable use of the labyrinth include, in America, Jackson Pollock and Mark Tobey—as their work moved from figuration towards abstraction; in Europe, Pierre Alechinsky, a member of the Cobra group, and Jean Dubuffet (between 1962 and 1966) in the series of paintings which he called *L'Hourloupe*.

Fairweather is the Australian master of the labyrinth (173). In his hand it is not a compromise but an eloquent and highly personal crystallization of his aesthetic and metaphysic, a genuine union—won from a lifetime of experience of East and West. He confines himself usually to the ochrous colours of the earth and of primitive art; the interlacing lines are relaxed and slow-moving; and the figures which emerge possess an anonymous primeval solemnity.

Rodney Milgate (*b.* 1934) has also made considerable use of the labyrinthine mode (215). Design becomes an intricate pattern of interlace, the effect almost random, a play upon intention and spontaneity. Indebted to Fairweather, Milgate's paintings have more in common with Tobey and

Alechinsky. Desiderius Orban has also adopted in some of his work of the 1960s a labyrinthine network of fine lines upon dark grounds.

All three artists, Fairweather, Orban and Milgate, have, like Mark Tobey, been influenced by Eastern philosophies, such as Zen Buddhism; and the labryinthine mode may be seen as an aesthetic form suited to the expression of cyclic, purificatory, meditative views of human existence, suited too, of course, to express the enigma of meaning.

Visually at least Warren Knight's script imagery has something in common with the labyrinthine mode in its even-grained and totally-worked surface. But Knight is concerned with the development of a concrete poetry in which script and image conjoin. Before his work we feel in the presence of meaning without a knowledge of the

215 RODNEY MILGATE, *Landscape*, encaustic oil on hardboard, 71 x 48, 1966, Newcastle

language. The labyrinth has become a semantic puzzle. It is a form of art that may well become more prominent during the 1970s.

Texture painting: In 1912 Picasso and Braque began to paste strips of paper, newspaper clippings and wallpaper to their paintings. So began cubist collage. Collage helped to emphasize the painting as an object, particularly the objective reality of the surface. Instead of considering the surface as a field upon which to establish an illusive space, the artist could allow the surface by means of its own physical nature to yield its own references, illusions, metaphors. Klee, in 1918, extended the evocative possibility of the surface, using glue, paste and gauze, for effects of texture and colour; Kurt Schwitters, in 1920, invented his *merz*, which made an inventive use of litter and discarded objects glued to the surface of the canvas; Max Ernst, in 1925, developed a free use of grained surfaces which he called *frottages*.

These early interests in surfaces, grounds and textures were taken up by a number of European artists working in the tradition of *art informel* in the post-war years. In 1945 Jean Fautrier exhibited his *Otages* in Paris, viscid

islands of impasted paint laid thickly with a knife upon thinner grounds. Shortly afterwards Jean Dubuffet incorporated Fautrier's high paste techniques into his own *art brut*. Then in the early 1950s the Italian Alberto Burri, working with old rags and sacking, created objects with a haunting, tragic presence, and the Spaniard, Tapies, with plaster, glue and sand, and by hollowing, scouring, and incising his thick reliefs, showed how it was possible for 'inert matter . . . to speak with incomparable expressive force'.[12]

Texture or matter painting, as it was also called, came into international prominence when Jean Fautrier won the major prize of the Venice Biennale in 1960. By that time, however, Tapies and a group of Spanish painters, notably Cuixart, Feito, Lucio and Saurez, had developed a strong Spanish School of texture painting. In the early 1960s Spanish exhibitions were held in New York, London and many other European centres: and texture painting was much discussed and experimented with in *avant-garde* circles throughout the world.

Elwyn Lynn introduced texture painting to Sydney in an exhibition held at the Macquarie Galleries in 1960. Texture became the basis upon which he built his own mature manner, and he carried the style to a point of perfection not excelled by any Australian painter. He had already played an important role in introducing some knowledge of the crucial American contribution to abstract expressionism, and his first notable works, such as the *Ancient Mariner* series, possess the linear urgency common to much of the abstract expressionist work in Sydney at that time. But he had been deeply impressed by Suzanne Langer's account of art as the symbolic representation of feeling and was in search of means whereby it would be possible to make the work a total and non-discursive symbol. Abstract expressionism with its emphasis upon action and the pictorial handwriting of the artist was not ideally suited to the poised, motionless totality he was seeking.

Lynn visited the Venice Biennale in 1958, whilst studying abroad, and was greatly impressed by the Wols retrospective and the work of the Spaniards Tapies, Feito, Cuixart, Millares, Saura and others. With his interest deeply aroused he made a close study of the whole movement— Dubuffet and Fautrier, Burri, and the German matter painters, Gerhardt Hoehme, Bernard Schultze, Hans Plaschek and Emile Schumaker. Lynn's own first essays in texture painting were thus informed by his awareness of the work of the school as a whole, not of Tapies only, to whom he is so often compared.

There is much, of course, that distinguishes one texture painter from another, but the distinctions are not often made, for the movement as a whole has not yet been carefully studied. Tapies, for example, executes wall-like surfaces of a startling immediacy; we are confronted almost

216 ELWYN LYNN, *Battle Plan,* polyvinyl acetate acrylic
and sand on canvas, 50 x 50, 1966, Sydney

brutally with what Patrick McCaughey has called an 'irreducible imman-
ence'. Lynn's paintings are not often about walls, his surfaces assert their
total physical presence, yet a shadowy symbolic presence, an *alter ego* of
the material, is contained within it (216). He is a romantic and lyrist
among matter painters: earth, sea and sky, the waves and tides, cities
remembered or seen from the air emerge precariously from the raddled
and blistered surfaces. It is an iconomorphic art in which the image is
enticed almost furtively from the material and never asserts its independ-
ence, for the image is invariably coterminous with the surface; that is to
say, a total image, still, and self-contained suggesting meditation and en-
durance. 'If, as André Malraux says, art is the defiance of mortality, then
I should like to achieve this through work which recalls something of the
dark paintings of Goya, of steles, of ancient maps and walls.'[13]

Frank Hodgkinson (*b.* 1911) was the other outstanding painter whose
work came to maturity around 1960 under the influence of the Spanish
School. Behind him lay a thorough academic training. He studied at the
Royal Art Society School, under Dattilo Rubbo, at the East Sydney Tech-
nical College, and finally at the London Central School under Bernard
Meninsky. During the Second World War he served in the army in Syria

and New Guinea and worked later as a war artist in Borneo. Then after
the war he went back to Europe, painting in London and Paris until 1952.
During the 1950s his work, in the manner of the time, remained figurative
with a leaning towards the neo-romantic. But towards the end of the decade
he moved towards a more plastic, painterly abstraction. In 1958 he won the
first Helena Rubinstein prize, left Australia and settled at Deja, in Majorca,
where he worked with Paul Haefliger and John Olsen. There he came under
the influence of the work of the Spanish painters: particularly the *El Paso*
group of Madrid, which included Canogar, Viola, Saura, Saurez, Millares
and Feito. Working in close association with several of these painters be-
tween 1959 and 1961 Hodgkinson thickened his pastes and textures, but
continued to seek a telling, dynamic image in the act of painting. 'I like to
build a surface', he has written, 'dig into it, penetrate behind the veil of
reality, open it up to reveal new sensations of space, then enter and explore
it. With every advance from the known to the unknown the mystery in-
creases. It's a wrestle to extract the mystery, to find the essence of its
ecstatic silence'.[14] He works with more colour than Lynn, gives his images
a greater dynamic thrust and a brooding animistic presence: but he, too,
seeks for a still point, a sense of potent silence.

Spain possessed him, became his second country, and brought out the
best in him. Much of his work is a celebration of this devotion to Spain.[15]

The international significance given to the Spanish School at this time
aroused an interest in Spanish painting in Australia. The Felton Bequest of
the National Gallery of Victoria purchased works by Tapies and Saura in
1961. In 1962 Jaime del Poso and Jose Guevara exhibited, and Juan Almoril
and Ignacio Marmol settled in Australia.

Like Olsen and Lynn, Hodgkinson is an iconomorphic expressionist,
allowing the material to suggest and have its way, not proscribing figura-
tion where it emerges naturally as an aspect of material and process. And
like them, too, his finest achievements, which are among the masterpieces
of Australian expressionism, have been inspired by landscape.

In the work of Lynn landscape is evoked in a mode which is almost
heraldic. There is a leaning towards symmetry and simplicity which endows
the work with something of the quality of emblematic painting. In this,
though not in other ways, his work has an affinity with that of Leonard
French. In Hodgkinson the landscape elements are so closely incorporated
within the ground that they arise more as a presence, a mood, than as an
iconic symbol (211).

William Peascod (*b*. 1920) is a texture painter who uses thick pastes and
relief forms to represent landscape from unusual vantage points but in a
naturalistic manner so muted that it takes on the qualities of abstract art
(217). But he, as he has said, is a romantic at heart, who seeks the delicate

217 WILLIAM PEASCOD, *Opal Diggings*, oil and mixed media
on masonite, 48 x 72, 1962-63, Adelaide

beauty that may rise from the wild, the lonely, the crude and the de-stroyed.[16] Much of his work is associated with the mining environment of Wollongong where he has lived and worked and with his experiences in coal-mines as a mining engineer in England during a period of fifteen years.

In Melbourne Peter Clarke (*b.* 1935) pioneered texture painting and the new sensibility of the Spanish School. His early work, shown at Gallery A in 1959, was semi-abstract in character, drawing upon nature, Christian and classical myth for its evocative, emblematic symbolism. In this he had some-thing in common at that time with the circle around Leonard French. But during 1961 and 1962 he travelled in Europe and worked in Spain, where he discovered a new delight in collage and the surface of paintings. By 1965 he was thoroughly involved in texture painting, using earthy colours, rags, and thickened, scoriated surfaces (220). In more recent work (1969-70) he has saturated his grounds (built up and granulated with marble dust) with colour. In his development he has moved steadily towards the presen-tation of the painting as object. Yet he recognizes a duality at the heart of the matter: 'the sensuous response to texture and colour and their shift from tangible surfaces to ambiguous spaces'.[17] That which is going on visually *before* the surface is what now interests Clarke. Thus texture painting has merged with the current interest in optical and dimensional ambiguities.

The Emblematic Symbolists

Although the view that Sydney was the centre of abstract expressionism

218 RICHARD LARTER, *Sliding Easy*, oil on hardboard,
48 x 72, 1970, National Collection, Canberra

219 JAMES CLIFFORD, *Cinematic Landscape*, polyvinyl
acetate on cotton canvas on shaped support, 48 x 48,
1968, the artist

220 PETER CLARKE, *Puerta del Sol*, polyvinyl acetate,
stone dust and pigment on hardboard, 48 x 69,
1964, National Collection, Canberra

and Melbourne the centre of figurative expressionism during the 1950s is frequently criticized, it is broadly true. Apart from Bob Dickerson no new figurative painter of originality arose in Sydney during the 1950s, and in Melbourne, despite the early interest of John Howley and Donald Laycock, abstract expressionism never really got under way. In that city the effective *avant-garde* consisted of two groups both of whom were opposed to the informalism of abstract expressionism, the Antipodeans, who have been discussed above, and some talented symbolist painters who opposed both the figurative and regional interests of the Antipodeans on the one hand, and the informality of abstract expressionist techniques on the other.

Although these symbolists did not form themselves into a programmatic group they were linked by similar aesthetic interests and ties of personal friendship. A community of ideas and attitudes emerged which was distinct from both abstract expressionist and Antipodean painting. The central figure among these painters was Leonard French (*b.* 1928), one of the most highly original and creative talents in contemporary Australian painting.

French was born and grew up in the industrial suburb of Brunswick, Melbourne. He worked for a time on farms after leaving school and, at sixteen, was apprenticed to a signwriter, from whom he learned to gild, glaze and design on a mural scale. At night he attended evening classes at the Melbourne Technical College. In 1948, at the age of nineteen, he obtained his first commission, two murals for the Congregational Church, Brunswick, which he called *Fresco to the War Dead* and *One World*. In both the influence of the social realist manner of Orozco is present.

In 1949 he worked his passage to England and lived for a time at the

Abbey, New Barnet, where Alan Davie, the Scottish painter, was also living. In London he also met the Irish painter, Gerard Dillon, and travelled later in Eire and the Netherlands. French's later interest in Celtic art may have been stimulated by contact with Dillon and Davie. Dillon, around 1949, turned from a folk art manner reminiscent of Christopher Wood to an iconic, aedicular manner inspired by such crosses as those of Kells and Monasterboice. Davie was then producing jewellery strongly influenced by Celtic motifs.

The impact of Celtic art did not appear, however, until years later in French's art. During his time abroad it was the work of the Belgian painter, Constant Permeke, and the Franco-Belgian, Marcel Gromaire, that impressed him. The heavy, gravid style of Permeke, the feeling for mass and weight of Gromaire, their links with folk art, their mural and tapestry designs, their expressive realism, were significant for French's development during the early 1950s.

Nolan had exhibited his first Ned Kelly paintings at the Velasquez Galleries, Melbourne, in 1948, the year before French left for London. Whilst he was abroad Nolan painted the Eureka series, exhibited at the Macquarie Galleries, Sydney, in June 1949. On his return to Melbourne in 1950 French found that the painting *en serie,* of national myth and legend, and events of colonial history were being much discussed in Melbourne art circles. He firmly rejected the national mythos of Nolan's Kelly series, but was impressed by the universal truths embodied in Greek myth. A series of paintings based upon the *Iliad* were exhibited at the Peter Bray Gallery, Melbourne, in 1952. French had become interested in the problem of the hero, and its depiction in painting: the heroic will, the heroic stance, the heroic fallibility, the heroic myth. Much of his reading—Homer, Joyce (Dillon read *Finnegan's Wake* to him in Ireland), Faulkner, *Moby Dick,* the book of Genesis, and Waugh's biography of the Jesuit recusant martyr, Edmund Campion, was connected with this interest.

In 1955 he mounted a large exhibition at the Victorian Artists' Society Galleries based on the *Odyssey.* His work had become more geometric. Large mechanized forms appeared in which an interest in Léger was revealed. There was also a new purity of colour, revealing an interest in the colour theory of Delaunay. The work was sheer, static and flat, with a tautness of line and stridency of colour sharply in contrast to the soft edges and painterly surfaces to which Sydney painters were turning at that time. In 1956 he painted the *Legend of Sinbad* for an expresso bar in Bourke Street, Melbourne, and later in the year began a mural in the Beaurepaire Physical Education Centre of the University of Melbourne. From 1956 to 1960 he was exhibitions officer for the National Gallery of Victoria and in 1960 won a scholarship to visit Indonesia, India, China and Japan.

Through the later 1950s French wrestled with the problem of form and expression. He had difficulty in relating his basic geometry, the circles and hemispheres, squares and crosses which he had adopted as the structural grammar of his art, to the complex burden of meaning which he was calling upon them to bear. The problem reached a height in the work which he exhibited at the Museum of Modern Art, Melbourne, in 1958, heavy, mechanical and crowded forms, impressive in bulk but rather forbidding in colour and over-consciously designed. The problem of meaning and form had reached a condition of unresolved tension.

The crisis was resolved during the early 1960s. The strident hot, impersonal colour, the over-conscious design, gradually disappeared. In their place emerged an art possessing greater formal and expressive subtlety. His colour technique had developed greater resources. He studied enamelling techniques, built his colour glaze upon glaze, adding and modulating as the work suggested. In the end it achieved a lambent luminosity and sonorous intensity rarely seen before in Australian painting. The self-conscious air of the early compositions disappeared. He had profited from the spontaneous and involuntary modes of working then much discussed by the abstract expressionists. 'I don't really know what I am going to paint', he remarked in an interview, 'it has to grow up in the process of one colour on top of another'.[18]

With his *Genesis* paintings of 1960 his work reached its early maturity. French had begun to control his repertoire of geometric devices: circle and hemisphere, square and rectangle, plant and fish-form, within superimposed and interlacing registers; accentuating, subordinating and concatenating the schema into a massive pictorial unity. Behind it lay, like a distant bell heard at night across water, the ancient beauty of Celtic art—the enamels of Sutton Hoo, the splendour of Carolingian reliquaries—transformed by cubism and a highly original temperament.

His painting the *Wake* (221) of 1960 will serve to illustrate French's manner of working. For many of his paintings he has preserved verbal jottings put down as an aid, rather than as a specification for composing. The paintings are not illustrations to the notes, for the painting itself develops, as the artist has said in the remark quoted above, its own dynamic. But they do provide insights as to his intention.

For the *Wake* the artist has preserved the following notes:

Luna Park—the carnival—the ferris wheel—man crucified, becoming the spokes of a wheel—his body a prismatized window of light—the woman watches and mourns above. Border of neon lights. At the base the clowns—the watchers— wooden clowns who turn their heads while balls come from their mouths.[19]

The design is a complex essay in radial and axial symmetry; and in his use

221 LEONARD FRENCH, *The Wake*, enamel on hessian-covered hardboard, 90 x 48, 1960, Alfonso Osorio

of symmetry and modular units French may be compared to Vasarely, whose work he admires. But French's units are signs in a device which link past and present. Like James Joyce he would bring all history to one timeless day. The wheel at Luna Park is also the turning wheel of martyrdom, the rose window of a cathedral; the neon lights could also be the studs of a portable altar-piece or symbols of the Passion; the clowns with their conical hats are at once mourners, laughers and inquisitors. French is not a literary painter; the structure does not depend upon a meaning. Yet he does not abort meaning. Meaning plays across the shapes like a hovering, transcendent spirit —conflated, ambiguous, transient— and the shapes remain. For French geometry is coloured and burnished by history.

It has been suggested that Leonard French's art is somewhat exceptional to the Australian scene. It certainly is exceptional in some aspects of its quality. No one has brought the techniques of gilding, enamelling and glazing to such a point of beauty and eloquence. And, like few of his generation, he has been prepared to make art objects that are frankly beautiful. 'It seems to me that if you want to say something you've got to love it enough. You've got to have respect and it's got to be built in a sense into a beautiful thing.'[20] In both these ways he has been exceptional.

Yet there is much that links him with Australian traditions. His concern with the heroic, for example. The heroic has been a concern of Australian artists since the 1890s. Roberts and Streeton turned from impressionism to depict shearers, stockmen, railway gangers, the 'unsung' heroes of Australian labour. Lambert's vision of the Anzacs, his Palestinian paintings of the Australian Light Horse are as pure, virginal and unquestioning as the war poems of Rupert Brooke. Nolan was the first to gently question the un-

222 G E O R G E HAYNES, *Ra,* acrylic on canvas, 64 x 64, 1970, The Skinner Galleries, Perth

223 ROBERT JUNIPER, *Day Dawn,* oil and acrylic on canvas, 34 x 52, 1971, The Skinner Galleries, Perth

sullied innocence of these heroes of mateship, by the whimsy and parody he brought to his portrayal of Ned Kelly. For Tucker, the Australian hero becomes monstrous, malignant, residual, a man soured, hardened, and made evil in his successful struggle to survive—a polluter and despoiler of himself and nature. Heroism here is the egotistical will that seeks to change others but remains unchanged.

French escaped from these national preoccupations into universal myth. But so have other Australian artists of his generation. Arthur Boyd, for example, in his pastels and lithographs devoted to the life of St Francis, and the painting cycle devoted to that bizarre anti-hero, Nebuchadnezzar, in his madness. James Gleeson has for many years concerned himself with the problem of the hero in a universal context, a fascinating theme to emerge from surrealism. The nature of the heroic has continued to fascinate many of the best Australian painters for eighty years. Painting has been made to serve a 'non-aesthetic' purpose—a search for national and personal identity. The heroes of Roberts and Lambert are still the noble frontiersmen, the innocent white savages, of colonial days—Australian nature's children. Nolan's Kelly, as Robert Hughes has noted, is Camusian, existential, absurd; a communal hero turned inside out, made personal, and placed beyond morality. But for French the absurdity is not beyond the moral imperative but within it. From Homer, it would seem, he gained more than a story for his Campion is neither Christian nor Camusian, but Greek. Campion's mission is just, his duty unequivocal; the absurdity is that it is he who must be consumed by it. Greek, and Dionysiac Greek at that, in Nietszche's sense. The heroic will and the artistic will are identified; and so, too, are vanity and duty. In the *Crusader,* Campion's recognition of his forthcoming martyrdom is united with the image of a crusading knight preparing for a tournament, gaily bedecked and proud.

In *Tongues of Fire* Campion is the superman of moral action who binds the populace by the miracles he can perform. French sees heroism as a cyclic, vegetative phenomenon of which Christ, Campion and the creative artist are but human exemplars. In the *Trial,* a magnificent painting, Justice is seen as one of the more theatrical performances provided by nature. In *Landscape with Helmets* the emblems of the Dionysiac will are reconciled with nature, which is really the field of Mars. One might compare all three paintings with Nietszche's comment: 'not only does the bond between man and man come to be forged once more by the magic of the Dionysiac rite, but nature herself, long alienated or subjugated, rises again to celebrate the reconciliation with her prodigal son, man. . . . The chariot of Dionysos is bedecked with flowers. . . .'[21] In *Death of a Martyr* the dead fish, symbolizing the anonymous death of Indian peasants, is exalted above the pageantry and publicity of the death of Christ, the martyr. The martyr is seen here as

one who prepares a good press against the occasion of his dramatic exit. But the emotional tone maintained is too cool for satire, or even irony. In *Death Full of Wounds* legend is shown to emerge as an hypnotic power released by a dramatic, heroic death. All nature is brought into this vision of the dying hero. Even the sun—after the fashion of an Egyptian solar creation myth from the Book of the Dead—sprouts roots as it sinks into the earth at night, only to burst its winding sheet in the morning and be born again. For Apollo must co-operate with Dionysos, and be subsumed by his creative principle.

All this suggests an affinity with Nietszche. Furthermore the problem of the hero is not only figured forth at the discursive level of symbols. It is a parable which illuminates the creative process itself. The artist's will battles with the mechanical. The circle must sprout like the sun in the night to fructify the dead earth in the morning. French does not create a self-contained geometry, a sacred geometry, or a geometry of fear, but a geometry able to bear the burden of history. Because he is an artist he personifies objects, creates them after his own nature, being himself a person and not an object.

There is, too, in French's art a deliberate clumsiness, a heavy, gravid quality which links his work with folk art, possessing a kind of presence which other Australian artists have sought. Leonard French does not reveal, as Nolan and Olsen do, the overt signs of an interest in child art or folk art, but a similar inspiration is there. In this connection it may be noted that it was he who brought the work of the naïve painter of Broken Hill, Sam Byrne, to the attention of his dealer, Rudy Komon. And a comparison between Nolan's Kelly clutching his pistol in the painting *Glenrowan* and French's Campion clutching his cross in the *Crusader* reveals some fascinating similarities, suggesting that even universal heroes take on a local colour when the tale is retold—that the sun has roots.

This drift towards a folk style or, if you prefer, a sham folk style, is a recurrent trait of Australian figurative expressionist painting between 1940 and the present day. It appears in the work of Drysdale, Nolan, Tucker, the Boyds, French, and many less well-known painters. It may be seen as one possible way in which local *avant-garde* modes have sought for roots in a popular culture in search of its own national identity. Although Australian artists have frequently expressed their disgust at the mores of Australian society which most of them find intolerant, prudish, puritanical and philistine, few have achieved what might be described as a total and aesthetically successful alienation from it. In this perhaps they have revealed their rugged provincialism and their difference from the international *avant-garde* which has cut itself off far more ruthlessly from social or national identifications.

V

Closely associated with this drift from 'high' art towards a nascent, emergent folk art is the fact that the best contemporary art of Australia has not, to any marked degree, been reductive. Mies van der Rohe's well-known dictum, 'less is more', does not apply at all neatly to the Australian situation. Those Australian artists who have achieved the greatest recognition both at home and abroad, for whom there exists a broadly-based consensus as to the quality of their work, have not been simplifiers, reducers, primary-structure men. They have moved in the direction of complexity rather than formal simplicity. It is arguable of course that this consensus as to quality is not soundly based, that the canon will have to be revised. But it seems more likely that quality in art emerges in different ways in young, provincial, conservative societies. That in such cases the artist is less alienated than the artists of advanced metropolitan societies and in some measure still the voice of his tribe.[22]

Leonard French's art has exercised a pervasive and almost indefinable influence upon art in Melbourne. Perhaps the most that can be said is that there are several artists active in Melbourne who work in modes cognate to those of French. Some, no doubt, have been directly influenced by him;

224 LEONARD CRAWFORD, *Captive Phoenix*, oil on hardboard, 55 x 37, 1960, The Rudy Komon Gallery

others have found themselves as artists in a climate of artistic practice which has been responsive to emblematic symbolism.

The work of these artists is distinguished by strong formal structures. Their work lies closer to the cubist and constructivist traditions than either the abstract expressionists or the Antipodeans. Although their interest in symbolism distinguishes them from hard-edge painting, their use of firm structures provided a bridge to the reductive geometry of the later 1960s. They differ from the Antipodeans in that, like French, they rejected both local themes and naturalistic techniques. They are painters of portents, totems, presences and memories.

The *Captive Phoenix* (224) of Leonard Crawford (*b.* 1920) is a characteristic example of an artist

225 ROGER KEMP, *Balance,* acrylic on paper, 60 x 72,
1969, the artist

working within the ambience of French: space is either non-existent or
shallow; the totality of the surface pattern from edge to edge is an important
factor of the design; colours are strong, resonant and unmodulated, and a
firm *cloissoniste* binding line enhances and divides colour areas. Of course
not all emblematic symbolist work, nor all of Leonard Crawford's work, is
quite like this, but it is typical.

Roger Kemp (*b.* 1908), who influenced French's early development in
the 1950s, works like him within a world of recurring symbols, addressing
himself to the cosmic predicament of man. His paintings are more dynamic
than those of French and more tense. He paints within a limited range of
colour, primaries mainly, muted and greyed with occasional flashes of light,
as befits his perennial subject-matter. The interlocking, angular facets, by
means of which he defines space, recall futurist devices for establishing
pictorial tension. But Kemp is not concerned as the Futurists were with
symbolizing the pressures of city and society. For him force is a transcen-
dental metaphor and he offers his theme—the great mystery of man trans-
fixed in his loneliness among the stellar spaces—over and over again like a
sacrament or a solemn monody upon the clanging wheel of time (225).

226 JAN SENBERGS, *Night Travellers*, enamel on hardboard,
48 x 54, 1964, The Rudy Komon Gallery

Jan Senbergs (*b.* 1939), a former pupil of French at the Melbourne
School of Printing and Graphic Arts, has created sinister and foreboding
emblems of the modern industrial city. Inspired by Gaudi's architecture,
and working in enamel and in seriograph, he has created a personal pic-
torial language. Clusters of dark, domical shapes conflate man, houses,
factories and machines into depressing technomorphs. They may be read
as dreary emblems of humankind polluted materially and spiritually by the
advanced technological society (226).

For George Johnson it is not society but organic life, especially the
vegetal and subterranean life of the earth which assumes monstrous, techno-
morphic form (227). Space and growth is reduced to mechanistic counter-
change patterns somewhat reminiscent of the art of Capogrossi. In the
paintings of the emblematic symbolists it is the burden of human history,
or biological time, or the immensity of the cosmos which presses in upon
the very act of painting. Richard Crichton (*b.* 1935) has sought the presence
of the totemic, the monumental in the commonplace objects of the country-
side or the studio. His *Sentinel* (228) is a kind of homage to seamen in the
Port Campbell area.[23] Lawrence Daws (*b.* 1927) who trained in Melbourne,
adopts a freer, more painterly and expressive technique than most of the
emblematic symbolists. He suspends enormous mandalas in the crimson air
of ancient landscapes like marks of Cain burnt on to the brow of the desert,

signifying fratricidal guilt (229). Donald Laycock turning from his earlier abstract expressionist manner has painted effigies of Assyrian and Egyptian kings that are more meditations upon fame, time, myth and history than portraits. They are for Laycock the images of men who once lived 'in harmony with time', not seeking as we do to outstrip time. In still more recent work he has turned to simple things, such as fruits and flowers, to endow them with a magical presence (230). Colour is built layer upon layer until it becomes lambent and liquescent, and simple things float and glow like spectres. It is a search for the immutable in the eye of perishing form (that old Platonic quest) 'a feeling of timelessness . . . something transcendental to the moment'.[24] Guy Stuart (b. 1942) clings just as closely as Lay-

227 GEORGE JOHNSON, *Totem*, enamel on hardboard, 72 x 48, 1963, Melbourne

228 RICHARD CRICHTON, *Sentinel,* poly-vinyl acetate on hardboard, 60 x 72, 1965, Mertz Collection, U.S.A.

229 LAWRENCE DAWS, *Mandala I*, canvas, 54 x 54,
1962, Mr Kym Bonython

230 DONALD LAYCOCK, *Riot*, oil on
canvas, 62 x 59½, 1968, National Collection,
Canberra

cock to the mundane, and he, too, transmutes objects in his case by rhythm, repetition and light, into transcendent images, radiant celebrations of transience. For Stuart the artistic event rescues the object from the anonymity of time (231). Asher Bilu (*b*. 1936) is also concerned with the emergence of events from the anonymous continuum of time. In his recent work the creation myth is re-enacted at a level more mystical than the chthonic, creation myths of Leonard French. For him creation begins in the coldness of chaos, not the warmth of the earth. Spheres gyrate in a menacing twilight against a black void. The Sons of

231 GUY STUART, *Sound Sweep Wall*, oil on two
separate canvases, 89 x 123, 1968, National
Collection, Canberra

Light are locked once again, it seems, in an apocalyptic battle with the
Sons of Darkness on the limitless plains of Time (232). In Melbourne

232 ASHER BILU, *Graphite*, mixed media on hardboard,
36 x 36, 1970, Mrs G. Scheinberg

such meditations as these have even intruded into optical and colour field-painting. Alun Leach-Jones (*b.* 1937) has produced a commanding series of circular paintings, which he calls *Noumenons,* that is to say objects of pure intellection, a *painter's* concepts—at once optically active and thus phenomenal, and emblematically durable and thus intellectual—parables about the transience of sensation and the durability of images coaxed from a severe, reductive art (210).

The hero, of course, is embedded in time, a man enlarged by time and death. In Melbourne it would appear that that concern with the hero and heroic myth which occupied so many good painters during the 1950s has turned in the 1960s to a different and yet associated concern with time, change and eternity. In both cases there is to be observed a continuing, almost stubborn refusal to treat the work of art, positivistically and materialistically, as pure object. The rim of vision has turned more rapidly than the axle of environment: but both have moved.

NOTES

[1] v. spate, *John Olsen,* Melbourne, 1963, p. 1
[2] *ibid.,* p. 7
[3] r. hughes, *The Art of Australia,* Hardmondsworth, Middlesex, 1970, p. 267
[4] e. lynn, *Contemporary Drawing,* Melbourne, 1963, p. 20
[5] r. hughes, *op. cit.,* p. 274
[6] e. lynn, *op. cit.,* p. 23
[7] *See* e. lynn, 'Avant Garde Painting in Sydney', *Meanjin,* 3, 1961, pp. 302-6
[8] Hazel De Berg transcript of an interview with the artist, N.L.A., Canberra
[9] On Plate, *see also* e. lynn, 'Carl Plate', *Art and Australia,* September 1969, pp. 144-52
[10] j. reed, *New Painting 1952-62,* Melbourne, 1963, p. 12
[11] g. berger, *Franz Kempf,* Adelaide, 1970
[12] Quoted by w. haftmann, *Painting in the Twentieth Century,* i, 362
[13] j. reed, *op. cit.,* p. 17
[14] r. hughes, *op. cit.,* p. 274 and e. lynn, *op. cit.,* p. 12
[15] *See* p. hutchings, 'Hodgkinson and Lorca', *Art and Australia,* March 1968
[16] *Present Day Art in Australia* (ed. M. Horton), Sydney, 1969, p. 162
[17] In his exhibition Catalogue, Gallery A, Sydney, July 1969
[18] Interview with L. Thomas, the *Australian,* May 1967
[19] Quoted from *The Campion Paintings* (introd. V. Buckley), Melbourne, 1962, p. 34
[20] Interview with L. Thomas, cited above
[21] f. nietszche, *The Birth of Tragedy* (trans. F. Golding), New York, 1956, p. 23
[22] On French *see also* b. hannan, *Art and Australia,* August 1963, pp. 74-83 (the best article on French)
[23] De Berg transcript of an interview with the artist, N.L.A., Canberra
[24] *ibid.*

POP ART AND THE TRADITIONAL GENRES 1960-70

I am the sort of person who might paint with hens-teeth if only a hen with teeth were left lying around the place. Thus I am an Imitation Realist.

DAY (ROSS) CROTHALL, Catalogue, Annandale Imitation Realist Exhibition, Museum of Modern Art of Australia, Melbourne, February 1962

Pop, Satire and Sex

BOTH abstract expressionism and emblematic symbolism were highly individualistic styles: the artist fulfilled his social role simply by making his art a vehicle of personal expression. This romantic attitude was seriously challenged in England and the United States by the emergence of Pop art during the mid-1950s. Pop art sought to close the gap between Fine Art and everyday life ('I work', said Rauschenberg, one of the most able American exponents of Pop art, 'in the gap between life and art'). Pop turned to modern industry and commerce for its imagery and inspiration: to cigarette packaging, the pin-up girls of play-boy magazines, bill-board posters, the labels on canned goods, and so forth.

Pop art did not make ground readily in Australia. It was not taken up, as hard-edge painting was, by a group of artists returning home from study abroad: it found no champion among local dealers; the public galleries revealed less interest in Pop art than in other forms of *avant-garde* art. Its impact upon Australian art during the 1960s, though not insignificant, was tangential, diffused among many personal styles. Its contribution to Australian art, like surrealism before it, has been oblique. It never developed into a programmatic, evangelizing style.

Why Pop art has not readily 'taken' in Australia is not easily distinguished and requires a closer investigation than is possible here. But three reasons seem to be significant.

In the first place, Pop art was a highly sophisticated reaction to advanced forms of urban culture. Although Australia possesses a higher proportion of city-dwellers to most other countries, it has not developed the *high-density* urban concentrations of the United States and Europe. The typical Australian city-dweller lives in the suburbs of his city, never far from the beach

or bushland, or both. His environment is suburban; and his sensibility is influenced by the suburb's historic and traditional emphasis upon nature and the romantic. The primary social factor behind the emergence of Pop, an overwhelmingly *urban* environment, has operated more weakly in Australia than in the United States, Britain or the Continent of Europe.

Secondly, Pop art though not at heart an anti-abstract movement (for there is much in the popular commercial culture which derives directly from abstract art) developed in practice in the United States, Britain, France and Italy as a strong counter-current to abstract expressionism, because of the nature of so much of its source material. For popular commercial art makes extensive use of figurative imagery in order to attract and entice, since its primary object is the merchandizing of goods and services. It was Pop art in England and the United States which gave new vigour to the challenge to non-figurative painting during the late 1950s and early 1960s. In Australia, however, the issue between figurative and non-figurative painting was joined largely in the debate between the abstract expressionists and the Antipodeans; that is, within an expressionistic and romantic context. The iconomorphich image compounded of mythic, legendary and landscape elements was of greater significance for the artists of the 1950s than brand labels, pin-ups and plastic toys. Pop was never presented in Australia as a possible alternative to abstract painting; the issue had been fought out on other grounds. In Australia Pop art lacked an important *raison d'être*.

Finally, it must be stressed that neither Australian artists nor the Australian public responded sympathetically to the mood of Pop art. Dealers, collectors, critics, the public galleries, all appear to have been much too firmly committed to the view that art was a highly serious activity and on no account to be mocked, to be able to respond readily to Pop satire and Pop irony. In Australia Pop art appeared in contexts associated with the ebb-tide of abstract expressionism: junk art, Sepik art, revived neo-dada, erotic art and so forth. But it did not emerge vigorously from these contexts. Australians did not warm to the sophistication of Pop art.

In the United States and England Pop artists took the images of commercial art from their real life contexts, that is to say, from their promotional and advertising contexts. The new aesthetic context transmuted the old slogans. Brand names no longer displayed in order to sell acquired a poker-faced air, because mute witnesses in a dead-pan way to the *tone* of the culture from which they had been extruded. Certainly, each Pop artist developed a personal colour in his aesthetic deployment of commercial imagery—the spectrum of attitudes ranges from disgust with industrial technology to a rapturous celebration of it: the prevailing note, however, was not satire but irony. Pop images are old images in new set-

tings, imitations of imitations. They no longer propose: buy this, buy that; love this, love that, but are submitted instead, in the new context, to an audience trained to react to the aesthetic presence of a work while insulated or distanced from the raw commercial message. But in Australia the aesthetic irony of Pop was not much appreciated by the art-loving public.

The swing from a personal, expressive art which directed attention towards the artist to a cool art like Pop which directed attention away from the artist towards the anonymous popular imagery of modern society, imposed great strains upon many Australian artists who, around 1960, sought to make the change. The early career of Brett Whiteley, for example, reveals many of the stresses imposed by the conflicting positions of abstract expressionism and Pop painting.

Whiteley (b. 1939) was awarded the first prize in the young painters' section at the Bathurst show at the age of seventeen. At twenty-one, following three years study at Julian Ashton's, he gained an Italian Travelling Scholarship and (after some months in Italy) reached London in 1960 at the height of the brief vogue for Australian art. His work gained instant recognition from the moment it appeared in the *Recent Australian Painting* exhibition at the Whitechapel Gallery in June 1961. It was purchased by the Tate, the Contemporary Art Society and the Victoria and Albert Museum. In the next few months he exhibited in group shows in Germany, Amsterdam and Paris, rounding off the year by winning the International Prize at the *Biennale des Jeunes*, Paris, and representing Australia at a Young Painters' Convention organized in Paris by U.N.E.S.C.O. Since 1961 his work has been showing constantly on the international circuit and is widely known.

Whiteley's early manner, revealed in his first one-man show held at the Matthiesen Gallery, London, in 1962, is cast in an abstract expressionist mould. A palette of ochres, creamy whites, and red-browns recalled faintly the work of Drysdale, though much more abstracted, and a touch of Arshile Gorky. But the temperature of Whiteley's hot-brown Australia was increased several degrees by the presence of fatty, tumescent forms poking about the rocks adventurously in a kind of primordial tumble. Erotic landscapes of this kind were being shown in Sydney at this time by Charles Reddington, Robert Hughes and others. The sexed-and-fleshed landscape is a mode which has continued to fascinate Whiteley, but into it he has added increasingly, in recent years, images of violence and death.

Whiteley is an uncommonly good draughtsman with a splendid feeling for space, placement and accent; indeed his natural gifts have much in common with those of Toulouse-Lautrec, but a tormenting ambition to attain a profundity which is obviously not for him lies at the source of his failure. It is in his drawings and graphics of animals that his natural

233 BRETT WHITELEY, *Drawing of an Ape*, pencil and charcoal on paper, 47¾ x 41¼, purchased 1966, Melbourne

abilities have been allowed to flow most easily, and these constitute his most lyrical and personal statements (233).

In Britain, and later in America, Whiteley was exposed to the powerful and conflicting pressures of abstract expressionism and Pop art, and his search for a personal style has developed into an increasingly desperate attempt, common to so many of his contemporaries, to forge a personal manner from these warring modes: the one hot and personal, the other cool and detached. An incapacity for detachment, for distinguishing between the work and the self, reduces his more ambitious work, again and again, to visual melodrama. The personal moment is grasped greedily and desperately, like a man drowning, as if it were possible simply by experiencing life in moments of ecstatic sensation to solve the problems of art. Manifestly, on Whiteley's showing, it is not. For all its hot-rod immediacy, his art remains eclectic, gulped and vomited forth in a simulated expressive frenzy. It is not at all surprising that violence is a continuing theme, since the act of creation appears in Whiteley like an assault or rape upon the temperament. For all its high-minded and anguished attempt to express the revolt of youth and Bob Dylan's world, it remains an egocentric art, pseudo-profound and self-pitying. Yet there is at least a kind of moral grandeur about the aesthetic failure: a desperate attempt with an inadequate personal and stylistic equipment, to conjure up an art which might not look trivial before the great issues of the day.[1]

Imitation Realism

Whiteley did not encounter Pop art until he left Australia. When it did appear on the local scene Pop was but one component of the art of a new group of satirists. In Sydney in 1962 three young artists, Ross Crothall (*b.* 1934), Colin Lanceley (*b.* 1938) and Michael Brown (*b.* 1938), preparing themselves for their first group exhibition, adopted the name (in high-spirited banter) of Imitation Realists. Crothall appears to have formed the

group and produced the first 'imitation realist' works late in 1960, to be joined, early in 1961, by Brown and later by Lanceley. The group held its first show at the Museum of Modern Art, Melbourne, in February 1962, adopting the name, *Annandale Imitation Realists,* after the Sydney suburb where they were then working. In May 1962 they held a second show at the Komon Gallery, Paddington, when they called themselves *Subterranean Imitation Realists, formerly of Annandale.*

The imitation realists drew more upon dada, junk, assemblage and the Duchamp tradition than upon Pop art. Their art arose in the international climate of interest stimulated by the Museum of Modern Art's comprehensive *Art of Assemblage* exhibition of 1961. Lanceley has claimed that the whole thing developed out of games they played together. One was called aesthetic chess. 'We pulled things out of our pockets, e.g. keyrings and other garbage, we laid them about. There were certain rules—each of us had to agree that every new move improved the design.'[2] In the spirit of the time they embraced a mixed media approach wholeheartedly. Discarded objects, bric-a-brac of all kinds were combined in bright plastic paints, posterish colours and matt textures. It was their flat, bland colour and their free use of commercial junk which linked them, somewhat precariously, to Pop art though they do not appear at the time to have been aware of what the English and American Pop artists were doing.

Their outlandish assemblages were put to a satirical purpose. They sought both to celebrate and oppose the shoddy vulgarity of Sydney.[3] By adopting a satirical stance they set themselves apart both from the Sydney abstract expressionists and the cooler exponents of Pop art abroad. In putting junk art and mixed-media to a satirical use they were foreshadowed by the Muffled Drums affair (pp. 330-1), and there were other local links. The style of the imitation realists combined a dada delight in *objet trouvé* with the post-Cobra manner of John Olsen's later neo-figurative style. Swirly labyrinths of fat pigment pullulated from children's drawings and Sepik art then coming into vogue on the Sydney and Melbourne art markets. Brown had worked on a film about New Guinea and was fascinated by the way in which Melanesian artists substituted bottle tops for cowrie shells when they were in short supply. The three artists worked jointly on paintings and placed great importance upon the presentation of their work, seeking to display it not as the work of three individuals but as a totality, a complete aesthetic environment. Whilst they owed much in style to him, they gave a sour satirical twist to John Olsen's colourful apotheosis of Sydney life.

It is to be stressed, however, that although Crothall, Brown and Lanceley exhibited as a group and displayed their work as a total environment there was no serious attempt to announce a corporate position. The pull of in-

dividualism was too great. Each artist contributed a personal statement to the catalogues of the two group exhibitions. Crothall asserted that he did not believe in catalogues, Lanceley that he was opposed to pronunciamentos, and Brown that none of them knew what imitation realism meant.[4] The note sounded was dadaist, anarchic—a Manifesto against Manifestoes —with the Antipodean Manifesto possibly in mind.

Their link with the aesthetics both of Assemblage and Pop is made clear in a statement by Crothall:

There is no conscious bad taste, no anti-art. There is no junk or incongruous materials that are not part of the creative transformation . . . I would wish to be unaware of Art—as I sometimes am. It is only the free creative spirit which can disclose the values of experience, which are significant. As an artist I look to the other world, the one outside of Art, for there is little to sustain me within the frame of reference of Art. And perhaps Imitation Realism is an Eloquent Testament to the absurdity of an economic order based on chaos, waste, ugliness and misery, and an ultra-modern display at that.[5]

Having announced their arrival upon the scene with a group gesture of defiance the imitation realists began to move each in his own direction. Crothall turned increasingly to writing and left the country. Lanceley, disappointed with painting, turned to assemblage and in 1964 won the Helena Rubinstein Travelling Scholarship for Painting with a group of free-standing constructions made largely from wooden moulds for casting machine parts. They were designed to stand against a wall. In London, whence his scholarship took him, he continued experimenting with assemblages and with combines of painting and object. He attached coloured objects to coloured surfaces, so that the perception of space *before* the surface replaced the perception of illusory depth of traditional painting. Such visual problems led him to shape edges and bend surfaces in seeking a total aesthetic integration in front of the surface. Lanceley rejected the satirical approach of his imitation realist apprenticeship but continued to work within the surrealist tradition: he admired Miro and Ernst. He rejected the doctrines of the minimalists and sought to fashion a personal visual language to express his ideas. Thus emerged the *Miraculous Mandarin* prints executed in homage to Bartók, which dwell upon the conflict between totalitarianism and liberal humanism.[6] Lanceley's art is, in short, still firmly grounded upon the aesthetic issues that occupied artists at the beginning of the 1960s. His is yet another variety of iconomorphism—locating his aesthetic interests and problems in ambiguities of space and image (234). But his recent work (1970) has yielded diminishing returns. Stains of sweet colour upon pale scalloped surfaces make one suspect that, for him at least, the enticing no-man's-land between painting and sculpture lies at no great distance from the land of the sugar-plum fairies.

234 COLIN LANCELEY, *Hot Monument,* oil on
undulating canvas and wood appendages,
41 x 62 x 9½, 1969, Sydney

Michael Brown, the third member of the imitation realist trio and the best of them, did not turn away from satire. He mixed satire, humour, buffoonery and parody with colour and shape in an uproarious art which celebrated the gratuitous act of creation without thought of the consequence. Brown has come closer than any Australian artist to the scarifying nonsense of dada which seeks to destroy the conventional boundaries dividing art from life. It is true, of course, that an element of playful fun had been present in Sydney art for years—for example, in Donald Friend's burlesques and Cedric Flower's parodies of colonial life. But in such art the proprieties were always maintained; nothing was pressed beyond good taste—as Sydney understood it. But when Michael Brown walked out of the Sydney art scene he banged his doors loudly behind him. No one was spared: artists, critics, dealers, art-lovers, all were ridiculed unmercifully and parodied gaily and uproariously. So, too, were the contemporary styles: there was a Hard-Edge Brown, an Op Brown, a Pop Brown, and a collage Brown as well as a primitive Brown. The going styles sat lightly upon him; nothing was to be taken too seriously. The advertising world, especially its exploitation of sex and beauty, was burlesqued. He rejected all indirection and ambiguity, asserting that his paintings were to be taken quite literally at their face value. And in order to ensure that his pictures were not misunderstood he wrote his opinions into texts woven into his paintings, creating a total design like a medieval illuminated manuscript. But Brown's forthright views, the free use of erotica in text and image, offended many, and in the end aroused the Sydney Vice Squad to action.

Yet it is clear that Brown did not want his paintings to be read like a book, or taken too seriously for their 'meanings' alone. The texts and the

images were part of a total pattern conceived as a creative act, a happening, entered into with no other intention than the assertion of the artist's total freedom to make that which he wished at the time to make.

Not surprisingly his art was misrepresented and misunderstood. Several critics, predisposed to be friendly, but committed to an aesthetic which favoured non-figurative art and distrustful of any art which—even implicitly—commented upon society, attempted to deny the presence of any satire in Brown's art. The abstract expressionists then dominant in Sydney after battling for years for recognition were disturbed by this apparently brash assertion of figuration and morality via the back door of gratuitous creativity. The public, to the extent that it was represented by the police and the judiciary, interpreted it all simplistically. It was quite obvious that they saw Brown as nothing more than a young man out to gain a reputation for himself in the art world by exhibiting a few indecent paintings.

Michael Brown's art is exemplified by his *Mary Lou*, a collage featuring a female figure with a celluloid doll's arms and plastic ducks for breasts, a coat-hanger for a nose, and guitars for legs. It is surrounded by colourful cutouts of nude and semi-nude girls taken from the beauty and sex magazines. Brown explained that he had tried to be deliberately funny in designing *Mary Lou*. 'She epitomises', he explained, 'the totally synthetic woman . . . completely taken in by the modern idea of beauty and modern aids to beauty. She's left without any human personality of her own—a Machine Woman'.[7] Brown developed a great affection for the work. He exhibited it in the first Imitation Realist Exhibition (Museum of Modern Art, Melbourne, 1962)—where it was the most highly-priced work—and subsequently worked on it from time to time throughout 1962 and 1963, removing details which did not contribute to the central idea. Thus changed it was shown as *Mary Lou as Miss Universe* in the Contemporary Art Exhibition of 1963 (237). Then it was introduced into the *Australian Painting Today* exhibition, a prestigious showing of Australian talent, for which financial support was then being sought from the Commonwealth Art Advisory Board, to enable it to circulate in Europe. But Mr Douglas Pratt, one of the members of the Board, considered Brown's picture 'completely disgusting'. 'When one sees groups of schoolgirls gathered around a work like this just sniggering', he wrote in a letter to the *Sydney Morning Herald*, 'it's about time someone made a protest . . . I will not be a party to public money being spent on sending this sort of work around the world'.[8] Meanwhile Mr Laurie Thomas, the organizer of the exhibition, rejected the picture from the Exhibition on the ground that it was not up to standard—Brown, in his view, having altered it for the worse.

Having had his dadaist send-up of the commercial prostitution of beauty rejected by Mr Thomas on aesthetic grounds and by Mr Pratt on moral

grounds—and receiving little support from his fellow artists—Brown next turned a mordant eye upon the Sydney art scene. In April 1964 he fabricated a kite-like shape called *Sydney February 15, 1964,* and suspended it from the ceiling of the Blaxland Galleries in the *Young Contemporaries Exhibition* organized by the Contemporary Art Society. It was valued at forty guineas and upon it he wrote:

To say that Sydney art is sick would be misleading, as sickness tends to imply a deviation from a customary state of good health. Present-day mainstream Sydney art should not be likened to a diseased organism but to the disease itself—it is a kind of cancer which won't stop flourishing until, inevitably, it eats the heart out of its own futile existence.[9]

He proceeded to make it abundantly clear that in his view a small amount of talent in Sydney was surrounded by a flood of mediocrity which was publicized, propagandized and merchandised by a cynical conspiracy between avaricious dealers and a band-waggoning press. 'The cultural atmosphere thus generated is one in which even talent must suffocate and art must surely die.'[10] Brown's kite aroused some heat among members of the Contemporary Art Society, particularly among those he had singled out for special criticism. But both Elwyn Lynn and the Melbourne patron of contemporary art, Georges Mora, expressed the view that the kite was a happening—a view later confirmed by the artist himself . . .:

in writing the words I felt no more committed to them than Lichtenstein would feel in writing the words in his comic strips. When the painting is hanging up in a gallery I feel as free as any other spectator to condemn or condone the opinions expressed. I must say that I believe my words were very sugary compared with what *could* be validly written. A really good survey of Sydney art would be unprintable.[11]

Brown worked for some time in comparative isolation and in November 1965 held a one-man show at Gallery A. In reviewing it for the *Australian,* Elwyn Lynn wrote:

Mike Brown's show is a technicolour *Walpurgisnacht*: gaudy ribbons of paint writhe, whorl and cavort; nudes drop freely through the air like manna; the cluster and tumble of hard-edge shapes give optical shocks. . . . The senses reel before the unrelenting fierceness of colour and form; the moral senses stagger somewhat, too, because Mr. Brown has an assortment of messages written in an engaging cursive, expressive hand and made emphatic by words from Lady Chat and other literary sources unknown to me.

Shortly before the show closed it was visited by members of the Sydney Vice Squad and the artist was later charged under the New South Wales

235 JANET DAWSON, *St George and the Dragon*, canvas,
66 x 78, 1964, Mrs J. Lewis

236 JEFFREY SMART, *Approach to a City*, oil on canvas,
25½ x 31, 1969. Mr Clive Evatt jnr

Obscene and Indecent Publications Act, 1901, with exhibiting indecent paintings. Brown's dealer, Mr Max Hutchison, was also charged and, at a hearing which antedated that of Brown, pleaded guilty. This had the effect of isolating Brown. The charge against the artist was heard in the Paddington Court of Petty Sessions before the Stipendiary Magistrate, Mr G. A. Locke, on 28 and 29 November 1966. He found the paintings grossly indecent and sentenced Brown to three months imprisonment with hard labour. An application to appeal against the sentence came before Mr Judge Levine in the Sydney Quarter Sessions on 5 June 1967. In a reserved decision the judge dismissed the appeal and confirmed the conviction but revoked the gaol sentence, imposing a $20 fine and a good behaviour bond. The judge expressed the opinion that 'Brown was a man of good character and it seemed unlikely that he would again commit an offence under the Obscene and Indecent Publications Act'.[12]

237 MIKE BROWN, *Mary Lou as Miss Universe,* mixed media on plywood, 84 x 48, 1964, destroyed by artist in 1970

Both Magistrate Locke and Judge Levine viewed the paintings as indecent because, in their view, they offended 'the current sense of morality'. It was decided on the evidence that they were addressed to the public at large (which was not so) and that indecency was proven if it could be plausibly asserted that the paintings were such as might offend the most conventionally-minded members of the public in a matter of sex.[13] The fact that the paintings were shown in an art gallery, were directed to a specialized audience and assumed for these reasons, a specialized kind of reaction, that is to say an aesthetic reaction, was given little weight. The Australian law came down once again, as it had done so often before, on the side of the wowsers. It was far more concerned with protecting the conventional mind from embarrassment than providing the creative mind with freedom to act. To the artist it held out the veiled threat of more drastic action

W

should he again embarrass conventional people by his art. Brown paid his fine and left the city for the Blue Mountains where he stayed for a time and then departed for the freer air of New Zealand.

The isolation, harassment and conviction of Michael Brown was not an isolated case. Two years before the February 1964 issue of the satirical magazine *OZ* had been found by Magistrate G. A. Locke to breach the New South Wales Obscene and Indecent Publications Act, 1901. *OZ* was a first-class satirical magazine with style, and a scarifying sense of humour. Its moral and social effect upon any of the citizens of Sydney who chose to read it could have been nothing but beneficial. Indeed the defence assembled a formidable array of intellectual and literary opinion to testify to the magazine's literary merit and social value. But it made no difference. The magistrate pointed out that such informed opinion was probably irrelevant and doubtfully admissible. It was for the court to decide. And decide it did. The editors of *OZ*, Richard Neville and Richard Walsh, were sentenced to six months gaol with hard labour and the artist, Martin Sharp, to four. An appeal against the conviction was later successful, but the real damage was done. It had been made quite clear that the law in New South Wales would not permit a free-ranging, satirical art to flourish. The Establishment was not to be mocked. Confronted with such intimidation it is not surprising that the satire and irony of Pop art did not mature in Sydney.

One of the items found to be obscene in the February 1964 issue of *OZ* was a story entitled the *Gas Lash* by the artist Martin Sharp. It told in their own colloquial language how a pack of surfies gate-crashed a suburban house-party and proceeded to bash the guests, defoul the hostess and rape her daughter. The story was based upon fact—and not unusual. One witness, Alex Carr, pointed to the similarity of Sharp's method to that used by Hogarth in publishing the *Rake's Progress* and the *Harlot's Progress*. It was a perceptive comparison, but had no perceptible effect upon the magistrate when framing his judgment. After a few more issues and the threat of a major libel suit *OZ* closed down. Neville and Sharp left for London where they established a London version of the magazine. The persisting provincialism of Sydney cultural life during the 1960s is revealed by the ways in which it encouraged its most intelligent satirists to become expatriates.

After five years in London Martin Sharp returned to Sydney in 1970 and set up a stimulating exhibition notable for its bite and wit in the old Clune Galleries, Macleay Street. The image of Van Gogh ran through the exhibition. 'The more I know of him', Sharp has said, 'the more I come to feel he was a saint'.[14] One of the refreshing features of the exhibition was Sharp's use of collage, to suggest new settings, and new connotations. With Sharp the spirit of dada moves from form towards meaning, like a cat among the

238 MARTIN SHARP, *Billy Boy visits Saint-Rémy*, collage,
20 x 30, 1970, Mrs Thelma Clune

iconographical pigeons of traditional art. One of his methods is to cut up reproductions of masterpieces and mix up the images. A fine example consists of a mixture of Dobell and Van Gogh (238). Here the gargantuan child-brain of Australia (which the Australian law protects so fondly from corruption by artists), unforgettably rendered by Dobell in his *Billy Boy*, is depicted wandering mindlessly among Van Gogh's stars.

Martin Sharp's fellow-artist on the Sydney *OZ* was Garry Shead. As a student at the National Art School during the early 1960s he had been impressed by the new mood of discontent expressed in the imitation realist exhibitions of 1962. Shead's paintings reject the aestheticism so typical of Sydney art and form a link with the work of Whiteley and Brown. But he does not bring his work to a point of personal crisis as Whiteley does, and his colour is more sombre, more tonal, more attracted to the physical movement of paint, than Michael Brown's. Both in mood and in paint quality he is indebted to Francis Bacon, and possesses a feeling for local tradition (unusual among artists of his generation) which links him with Dobell, Nolan and Perceval. All this separates his style sharply from the bright, 'commercial' palette of Pop art. The mood of Shead's work, too, differs from Pop. It is not an urban-based satire employing wit, shock and visual banality, but a sullen, sluggish evocation of moral corruption in sylvan, suburban settings (239). Craig MacGregor, in a perceptive catalogue comment, presents Shead as a painter-celebrant of the Sydney North-Shore

239 GARRY SHEAD, *Wahroonga Lady in her Naked Lunch,*
oil and collage on canvas over board, 42 x 71, 1965,
Mr Frank Watters

life-style: 'the whisky-and-soda, two-car, three-dachshund, one-kid section
of Sydney suburbia'.[15] Shead is a great admirer of D. H. Lawrence and one
can find in his paintings a smouldering Laurentian disgust at love mocked
and debauched by the 'progressive' values of a corrupt society. Many of his
paintings contribute to the *Et in Arcadia* theme which has for so many
centuries haunted the western tradition. They do not come readily to him
and indicate a slow development towards a mature style. But a sense of
quality is there.

Pop Art

Australian art is largely landscape art: within the category of landscape
the distinctive tradition has evolved. Pop art directed Australian figurative
painters towards the city and city life. Such themes had been foreshadowed
during the 1950s in the work of the Antipodean painters, John Brack and
Bob Dickerson. But they were exceptional. Most of the painters of the
1950s, both figurative and abstract, continued to draw their inspiration
from the landscape. Brack and Dickerson were preoccupied with the isolat-
ing and alienating features of city life. The new artists of the 1960s in-
fluenced by Pop rejected such contemplative attitudes; and they rejected,
too, those high-minded meditations upon the condition of man, history and
the cosmos, which characterize the work of the Melbourne emblematic
symbolists. Sex, violence and satire are the prevailing features of the figura-
tive art of the 1960s. This we have already seen in our consideration of the
work of Brett Whiteley, Michael Brown and Martin Sharp. Typical of the
early 1960s is the work of Gareth Sansom (*b.* 1939). In his show at the

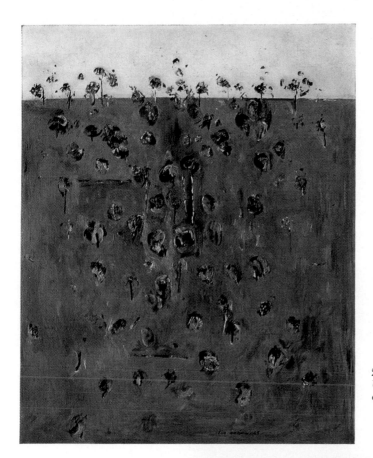

240 FRED WILLIAMS,
Upwey Landscape, oil on
canvas, 72 x 58, 1966,
National Collection,
Canberra

241 SYDNEY BALL, *Canto
No. XXIV*, acrylic on canvas,
69⅛ x 69⅛, 1966, Adelaide

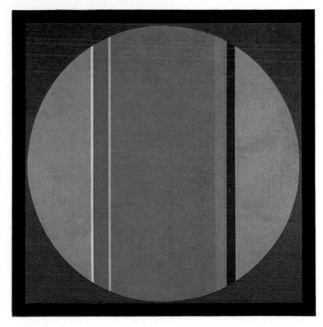

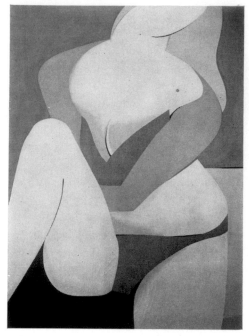

242 PETER POWDITCH, *Bathing Girl I*,
canvas, 40 x 30, 1969, the artist

South Yarra Gallery in April 1965 he took for his subject the lives and intimacies of pederasts and transvestites, expressed in bright colour, collages and sundry Pop devices. Sansom's emotive brushing linked him with the abstract expressionists. But the artists of the later 1960s who continued to display an interest in erotic themes reacted to the impact of hard-edge and minimal art. They simplified and flattened their imagery, used bright, matt, posterish colour, and the broad, tonal simplifications of colour printing. In such work the satirical bite of the early 1960s is diminished. The mood is cool and bland like the contemporaneous hard-edged, abstract painting. The work of Peter Powditch (242) (*b.* 1942), Alan Oldfield (*b.* 1943) and Kym Faehse (*b.* 1948) testifies to this conjunction of Pop art, erotic themes, and the hard-edge style.

Richard Larter (*b.* 1929) is, however, probably the most original talent to emerge in Australia in recent years within the context of Pop and erotic art. Larter studied at St Martin's School, London, just after the Second World War, drawing plaster casts incessantly because he then held, as he has said, a fundamentalist attitude to art—believing that if one desired to be an artist one should first learn to draw accurately. As he saw it British painting in the later 1940s offered the choice between the kitchen sinkers and the provincialists, between Bratby and Piper—and neither appealed. He left for Algiers, living for a time in Bou Saada. When he returned to England he was deeply affected, like many of his generation, by American abstract expressionism. In 1957, however, disillusioned with abstract painting he returned for a time to academic drawing, and began to evolve a personal kind of Pop art. By 1962 his work was beginning to attract some attention in Paris, but suffering from illness and the cold English winters, he remembered Algiers and migrated to Australia in 1962.

Larter draws prolifically, cutting up his sketches and arranging them on a floor or table until he hits upon something worth keeping; the use of both deliberation and accident being a feature of his method. In painting, in

place of a brush, he uses a wide range of hypodermic needles, filling syringes with chosen colours and pressing out a calligraphy of continuous lines, varied in weight and flow at will. Collage is used freely, oil paint avoided, being replaced by polyvinyl acetate and epoxy resins.

Larter does not take his stand in the urbane, nonchalant, ironic world of Pop art. He finds his source in a more primitive energy (218). He would, as he has said, affirm life, say his yea to it. For this reason as much as any the female figure, naked (to preserve Sir Kenneth Clark's inspired distinction) rather than nude, is as much a personal symbol for him as it was for Norman Lindsay. But he rejects all classical stances and postures, posing his women in bizarre, grotesque, often obscene attitudes. He takes, one feels, like St Augustine, a mordantly realistic view of human life, but rejects the saint's low appreciation of it. Life, if absurd, is also real. Larter's women, it must be stressed, however, are not for him the prime bearers of mood or meaning. 'The figure', he has said, 'is a splash in the middle of the hardboard'.[16] It is to be seen rather as a high point in his overall calligraphy. The female figure occupies a place in his art not altogether dissimilar from the place of animals in the animal-and-interlace art of the Celts. Larter was, as noted above, inspired in youth by Arabic calligraphy, but strongly prefers western to eastern calligraphic styles. Asian calligraphy, he claims, does not possess the emotional content of the Indo-European. For him the graffiti found upon the walls in Paris and Pompeii contain more basic humanity than any Eastern art.

As we have seen, Pop art first emerged in Australia among the imitation realists in a context of satire and individual, romantic protest. It did not cloak itself with the protective irony of international Pop art and clashed sharply with local Establishment values.

Fragments from imitation realism and Pop are to be found from time to time in the work of James Clifford (b. 1938), for he works vicariously across the current styles, like the neo-modernists associated with Central Street, picking up what is of interest to him in a wilfully eclectic manner without becoming entangled within the formal development of any one style. Such eclecticism, in which a painter selects a style as a more traditional painter might select a subject and then pass on to something quite different, is characteristic of an increasing number of Australian painters during the 1960s. The work of Watkins, Brown, Schlicht, Oldfield and Woods is all of interest here. In his *Cinematic Landscape* (1968) Clifford mixes figurative and non-figurative concerns with an easy nonchalance. Film technique is used to create the impression of fast movement through a varying landscape; but the visual paradox about keeping the surface while suggesting depth, for long so important to modern painting, is maintained (219).

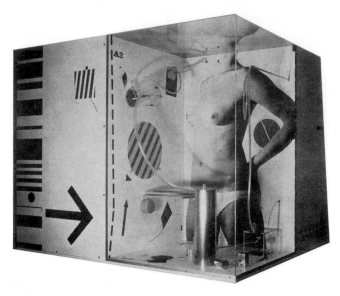

243 KEN REINHARD, *Press Button B,* mixed media,
36 x 60 x 36, 1967, the artist

It is in the work of Ken Reinhard that the irony of international Pop art first asserted itself locally. The growth of his style may be traced from an early abstract expressionist manner, akin to Hessing and Hill, towards a more figurative style in which, by 1963, a confrontation 'figure and machine' theme had begun to emerge. His first one-man show, held at the Macquarie Galleries in 1964, presents a struggle for a personal style and drew eclectically upon a number of current interests: assemblage, optical painting, Pop. The figure and machine theme was now asserted more vigorously; but the approach was still, after the fashion of the imitation realists, satirical.

In his mature work, however, satire gives way to a drier, more objective tone (243). Reinhard now constructs his two-dimensional and three-dimensional objects from modern synthetic materials which provide him with the smoothest of surfaces and the sharpest of edges. To these he applies macro-photographs and signs such as arrows and broken lines, or algebraic equations. The smooth world of modern and commercial design is magically evoked, but the appearance is deceptive. The apparent efficiency has no point. The arrows are gratuitous, pointing to the obvious or to nothing. The algebraic equations are either true or false, yet in either case in their aesthetic setting, equally absurd. The perspective is wilful, arbitrary. The carefully calibrated instruments, the glass tubes carrying their fluids so busily and industriously about as if saving someone from death, are there to be admired only for their cold, impersonal beauty. For Vitruvius and Leonardo man was the centre of the cosmos, the measure of

all things. In Reinhard man appears in the new, smooth, modern world of his making as a soft and vulnerable feminine object lost among scientific hardware and 'basic research'.

The only other painter to capture the cool irony of the best international Pop art is Robert Boynes, who paints images possessed of a cool beauty touched but not destroyed by notions from minimal art. Although contemporary and urban they are born of fragile events and an awareness of the unusual in the commonplace, and are often so apt that they become emblems of a life style. Boynes works in the area between the nonchalance and give-away air of Pop, and the concern with time and process of the emblematic symbolists. He succeeds in getting the present day into his art without adopting shock tactics or playing up trivialities. He is certainly one of the most impressive young artists to emerge in the 1960s (244).

Figurative Expressionism in the 1960s

Pop art invigorated figurative painting during the 1960s. Cool, detached, allusive, sophisticated, Pop provided a possible alternative to non-figurative hard-edge painting. Even when they did not imitate Pop mannerisms, the best painters of the 1960s who chose to work in figurative modes, such as John Brack and Jeffrey Smart, adopted a cool, ironic tone comparable to Pop art.

Figurative expressionism, however, the style within which the finest Australian painting of the 1940s and 1950s was mostly produced, failed in Sydney and Melbourne after 1960 to sustain much work of originality. During the 1960s expressionism, both figurative and abstract, became an increasingly tired, overworked style. The best-known names were no longer producing the best work. The paintings of the last ten years of Sir William Dobell's life—he was knighted in 1966 and died in 1970, a myth in his country and a legend in his hometown—are not to be compared with his great portraits of the forties and fifties. Sidney Nolan travelled widely about the world from his work-base in Putney, London, as productive as ever, painting his travels and mixing his images both old and new, then dissolving them back into their landscape settings—but it all became increasingly predictable. Ned Kelly

244 ROBERT BOYNES, *Eternal Roll-Up*, acrylic on canvas, 71⅞ x 71¾, 1969, Adelaide

having imitated Christ became an Anzac digger and joined the Returned Servicemen's League—not the most spiritual of transfigurations. Nolan's paintings of the 1960s tend to be ambitious, large in scale and painted for occasions—the refreshing immediacy and involvement of his early work is no longer there. Others declined into romantic sentimentality. Among the Antipodean painters only Arthur Boyd and John Brack developed beyond their work of the 1950s. Boyd in his *St Francis* and *Nebuchadnezzar* cycles attained a mastery of means and an eloquence of expression beyond anything he had achieved previously. John Brack emerged as a master of contemporary realism. For his Gallery A exhibition of 1965 he took as his theme the window of an old surgical supply shop. The imagery was deliberately banal if not positively ugly: artificial limbs, scalpels, knives, scissors, wheel-chairs, stuffed dummies. They glowed in a sour radiance. And Brack painted himself looking in at it all—the artist with a vision of no comfort, the surgeon who cannot heal. For Brack man is always alone, always inadequate, and lives out his life affecting the most ridiculous pretensions in a world in which only hypocrites and self-confident fools succeed. His cool, flat, crisp-edged style and his urban-based imagery had much in common with the *avant-garde* of the sixties; but his pessimistic humanism and his sense of tradition are his own.

There were one or two other wayward achievements which owed nothing to the *Zeitgeist* of the sixties. The skill and piercing lyrical clarity of Francis Lymburner's late paintings; the masterly romantic classicism of Jean Bellette. But both Lymburner and Bellette reached the maturity of their 'late manner' abroad. In Australia it would have been much more difficult.

Why did so many figurative expressionists fail in the 1960s? The turning wheel of fashion is not the complete answer. During the decade many ageing expressionists in Sydney and Melbourne found it increasingly easy to sell their paintings but increasingly difficult to win critical acclaim for them. For the new critics who set the tone of the decade championed most things new with the finesse of television salesmen, while casting a jaundiced eye upon anything painted in a *retardataire* mode. But the dealers championed the ageing and sold their works successfully, despite the criticism. Flattered by the prices paid by collectors seeking well-known names as a sound investment and encouraged by the news media to see themselves as romantic art heroes (every man his own Van Gogh) many succumbed to the distractions of social life, and the debilitating effects of success and senescence. They were not so much the servants of art as the servants of their own reputations. Something similar happened, though on a smaller scale, during the 1920s, to the ageing painters of the Australian impressionist school.

Only two new figurative painters of talent appeared in Sydney during the 1960s: Kevin Connor (*b.* 1932) and Keith Looby. Connor's style was

formed during his years abroad between 1954 and 1957; his first one-man show being held in Sydney and Melbourne in 1962. Despite a very real painterly gift Connor's work reveals the problem of the artist who chooses to work within a tired style. He is patently eclectic, owing much to Francis Bacon and something to Whiteley, Nolan, Dickerson and Blackman. Some city-scapes, reminiscent of Kokoschka, are among his most successful paintings.

By contrast Keith Looby (*b*. 1940) ploughs his own furrow. His work owes nothing to his Australian contemporaries and its affinity with the Italian graphic artist, Alberico Morena, is accidental. Yet he absorbed much during his *wanderjahre* between 1960 and 1967 when he lived mainly in Italy. Looby usually avoids painterly methods, his expressionism residing in forceful, grotesque drawing. In his paintings, which are often large, tiny ape-like people frisk and tumble together like the damned in the Camposanto fresco.

It is a vision, mocking and pessimistic of humankind treading the monkey-wheel of existence. Looby was the only figurative artist with a talent tough and eccentric enough to develop in the hostile climate of Sydney art criticism in the 1960s with its strong non-figurative bias. Overemphatic statement, a weakness common to young artists in revolt against preciosity, mars much of his present work and the best is probably still to come. In recent work he has adopted a broader, more energetic, handling (245). Such odd talents are important in any country. They help to preserve that plural situation (in which more than one style flourishes at one time) so important for originality; keeping the options open against the apocalyptic orthodoxy of the new.

In the smaller centres the gradual failure of expressionism was less noticeable: in Brisbane, for example, provincial even by Australian standards, where the Art Gallery of Queensland, in its impoverished and out-of-date condition, could not be compared favourably with many of the active little galleries in Victorian country towns. In Brisbane there was a kind of late flowering of figurative expressionism in the work of Jon Molvig (1923-70) and his associates.

Molvig was born in Newcastle in 1923. Like Clifton Pugh he turned seriously to painting following war service, taking the rehabilitation course at Sydney from 1946 to 1948. And like Pugh he became known as a portraitist and landscape painter. But his art is more violent, more savage and sombre than Pugh's; more closely related to German expressionism, far more dissociated than Pugh's from the colour and naturalism of the Heidelberg School. His link with the European expressionist tradition through Nolde, Kirchner, Kokoschka and Soutine was probably developed during his four years of study abroad (1949-51); though expressionism did not

245 KEITH LOOBY, *Emoh Ruo String Septet,* mixed
media on canvas, 84 x 108, 1969, the artist

come to dominate his work until the mid-1950s. Molvig continued in Australia that tradition of expressionist portraiture introduced by Sir William Dobell (he was like Dobell, born in Newcastle) and gained something from Dobell's example. But his portraits are not at all like Dobell's. Molvig depends more upon a muscular, rhythmical and painterly line and far less than Dobell upon drawing. His colour, too, a preference for flaring reds and acid greens, often blazing from sombre settings, is quite different. Furthermore, Molvig worked with a harsh, egocentric, autographic energy markedly different from Dobell's whimsical, humane and observant characterizations. Yet none excelled Molvig in the power of his portraiture during the 1960s when Dobell's powers were waning—and there never was in his work, as there was from time to time in the portraits of Clifton Pugh and Judy Cassab—an unresolved dichotomy of style between the painting of the sitter and the painting of the setting. Molvig's contribution to figure and landscape painting are also considerable. His *Ballad to a Dead Stockman* owes something to Nolan, but the grimmer, more desperate mood is his own (246). His *Eden Industrial* series is a comment upon humanity mechanized. Adam and Eve are presented as mechanomorphic symbols of the technological millenium. Here he has something in common with such emblematic symbolists as Jan Senbergs and George Johnson. Although Molvig was the master of a very free painterly method he was opposed to abstract expressionism. 'Unfortunately', he said in an interview, 'too many people just splash paint around and they quite often, many of them, admit

246 JON MOLVIG, *Ballad of a Dead Stockman, No. 2*, oil on
hardboard, 45 x 72½, 1959, Sydney

they can't draw or paint, they can just liberate paint. This is not art to me'.[17]
Two artists of ability were associated with Molvig in Brisbane, Andrew
Sibley and Gordon Shepherdson.

Sibley (*b.* 1933) studied first at East Sydney and in England (1952-55);
then lived in Papua for two years (1958-59) before he became associated
with Molvig in Brisbane during the early 1960s. Sibley is not interested in
pure landscape. He sees himself as
a painter committed to the human
figure which for him is an inter-
national symbol. His best work is
intensely lyrical. An expressive cal-
ligraphy is associated with lambent,
floating colour (247). He tends to
paint *en serie*: one series was con-
cerned with the lives of outback
children, another with cane-cutters,
a third with young lovers.

Like Molvig, Sibley is a critic of
abstract art. In his view Sydney
abstract expressionist painting is
marvellous at a first viewing, dis-
appointing at a second, and hard
to remember. Interested in politics,

247 ANDREW SIBLEY, *Advance No. 2*,
acrylic on pineboard, 42 x 36, 1970, the
artist

he criticizes the indifference shown by the abstract expressionists to politics. For him art 'must become a part of the way of life of the people'.[18] It is not at all surprising to find that Sibley's art has been very severely criticized by the new critics of the 1960s sympathetic to the new forms of abstract art, such as hard-edge and colour-field painting.

Gordon Shepherdson (b. 1934), Molvig's other talented associate, tried a variety of jobs before he took seriously to painting. For four years he worked in an abbatoir. 'I got to know cattle very well, how they look and how they feel, how they felt when they died, and how they felt when they were on the bar.'[19] He has painted a series of slaughterhouse paintings and more recently a series on housewives 'and their endeavours to find a certain amount of escape outside their daily environment'.[20]

In Queensland Sam Fullbrook has brought a lyrical form of expressionism to his portraiture and Gil Jamieson a rugged, extroverted mode of the style to his paintings of country life—a kind of folksy expressionism (198).

In Queensland, then, in a community more philistine than most, a number of talented painters have sought to keep in direct touch with daily life—without a complicated aesthetic to explain it. Here, too, a kind of Merioola neo-romanticism typical of Sydney in the later 1940s has been given new life and a certain vigour by being applied to subjects characteristic of the tropics. It is to be seen, at its best, in the decorative figure-and-landscape subjects of Margaret Olley and Ray Crooke (197).

The Tasmanian artist, Tony Woods (b. 1940), has cultivated a sensitive figurative style from the use of pure line. His psychologically expressive drawings are made upon stained grounds which set the mood—often a sense of disquiet (248). Woods works, as Klimt and Schiele once did, in that half-world of unstable and slightly sinister human relationships; and it is not surprising to find, as one does, a sustained interest here in the poetry of Lautréamont and Rimbaud. More recently Woods has widened his range to include both figurative and non-figurative modes with a growing interest in the nature of illusion and the mimetic status of the pictorial image.

In South Australia both the Germanic and the French[21] forms of expressionism have survived with some vigour. The work of Geoffrey Proud (b. 1946), though more reductive than that of Tony Woods, also possesses an affinity with the calligraphic modes of Continental expressionism. The work of Vytas Kapociunas, who was born in Kaunas in 1943 and arrived in Australia in 1949, recaptures the energy and the sense of personal urgency and intensity which inhabit the work of Emile Nolde. His high colour and biomorphic form reveal a kinship with psychedelic art and he claims to be seeking an effect akin to that of hallucinogenic drugs—the power to distort time, emotion and space.[22] Painters like Proud and Kapociunas cannot be

dismissed or ignored as *retarda-taire*. To do so is to assume that quality lies always with the *avant-garde*; a unilinear view not at all borne out by a study of quality in Australian art. In Australia the best has usually been a little out of date.

Painters in the French Tradition: Few Australian artists prior to 1960 drew deeply upon the pre-cubist tradition of twentieth-century French art—seen at its best in the work of Bonnard and Matisse. The preference has been for the Germanic forms of expressionism, for romantic and metaphysical forms of abstraction, and for surrealism and its derivatives. But in recent years a few Australian artists have begun to turn to early twentieth-century French painting (with its post-

248 TONY WOODS, '67, acrylic on hardboard, 54 x 45, 1967, Mrs J. K. Purves

classical feeling for space and structure and its magnificently frank acceptance of colour) not in any nostalgic or historicist mood, but in order to find a way through the present dilemma of painting. For there certainly is a dilemma: either to continue painting or desert it for some associated art, in the pessimistic belief that painting is no longer providing an arena within which original, creative work can be performed. Two Adelaide painters, Robin Wallace-Crabbe (*b.* 1938) and Brian Seidel (*b.* 1928), have drawn with value upon the art of the Nabis and the Fauves.

The master behind the art of Robin Wallace-Crabbe is Matisse. Lovers or solitary nudes inhabit interiors painted in flattish, opaque colour. There is a nice discrimination between positive and negative volume—and the feeling of something held in reserve (251). The discreet, sensuous presence of these paintings may be contrasted with the wit and vulgarity with which Peter Powditch paints his nudes. Technically they have something in common.

For Brian Seidel, Bonnard has been the guide and inspiration. The nude in an interior has been of importance to him also, but his work is more emphatic than Wallace-Crabbe's, relies less upon subtleties of shape and colour, being pinned a little precariously between naturalism and abstract form.

This interest in early twentieth-century French art is not limited to

249 DALE HICKEY, *Untitled,* liquitex on cotton duck, 68⅝ x 68⅝, 1967-68, Melbourne

250 JAMES DOOLIN, *Artificial Landscape,* 67-5, acrylic on canvas, 51 x 40⅛, 1967, Melbourne

Adelaide or to figurative and semi-abstract art. Several of the colour painters, to be discussed in the next section, are indebted to Matisse and the Fauves tradition.

The Continued Pursuit of Appearances—The Country: If expressionism continues to produce work of quality in the smaller centres so too does naturalism. In Western Australia, smaller in population, more isolated than Queensland, but with an economy like hers stimulated by new mineral wealth, older modes of painting have persisted. Here landscape painting styles owing something to naturalism and post-

251 ROBIN WALLACE-CRABBE, *Family Before a Mirror,* acrylic on canvas, 48 x 44, 1967, Mr J. Kirsner

impressionism have been used by artists seeking to express their sense of involvement in their local rural or semi-suburban environment. Robert Juniper (*b.* 1929) has painted in delicate, pale, sun-drenched colour and in large, decorative forms, his deep affection for the burnt hills of his native country. They possess a deeper, spiritual affinity with the landscapes of Streeton, Blamire Young, and Heysen than with the work of any European landscape painter (223). George Haynes (*b.* 1938), an English artist born in Kenya and a former student of Chelsea Art School who arrived in Perth in 1962, has celebrated the brilliant sunshine and unpolluted air of the West in radiant, ebullient paintings of a type no longer painted, nor much admired, in eastern Australia (222). Guy Grey Smith (*b.* 1916) has painted crisp, bright, stylized interpretations of the desert and the sea. These artists have captured again something of that lyrical involvement in landscape which once inspired the best paintings of the Heidelberg School. Such painting, though not *avant-garde,* has achieved a living relationship with the community from which it has sprung: a relationship which often induces better work than the pursuit of fashion.

The most original contribution to Australian landscape made during the decade, and one of the most original of the century in Australia, was, however, achieved not in the West but in Melbourne. There Fred Williams (*b.* 1927) succeeded in working within the naturalistic tradition and in making a creative contribution to it—a rare achievement for any landscape painter in the twentieth century—when so little pure water seemed to be left in the old wells of appearance. Williams came first to note as a graphic

artist, particularly for his mastery of etching, attained during a long apprenticeship first at the National Gallery School, Melbourne, and later (between 1951 and 1956) at the Chelsea Art School and the London Central School of Arts.

Williams seems to have taken up the problems of Australian landscape painting where Tom Roberts left off in the 1920s; an old man in his seventies painting saplings in Sherbrooke Forest. He uses a palette which has long been associated with the Australian landscape: ochres, russets, pale olive greens, pale blues, and dull brick reds. His surfaces are rich and opulent, varying from thin, transparent stains to creamy, impasted accents; the colour finely modulated and grained, seen as though bleached by veils of dust or heat-haze. The horizon line is often placed near the top of the picture or is not there at all, so that the landscape is seen as if from the air. Williams does not seek to convey an impression of a particular place but a region, or something about the character of bushland more general still (240). He usually begins a painting from notes made as drawings, water-colours or etchings upon field excursions undertaken some months before he begins. A painting will usually take about a year to paint, so he works on groups of ten to twenty at a time. His knowledge of other media has influenced his style in painting. A preference for sugar aquatint, for example, has suggested some organic forms present in his landscapes. There is much about his compositions which are reminiscent of music. Trees spread themselves across scoriated surfaces like notes on a musical score; the slower and heavier rhythms are in the lower parts of the painting, the more rapid and scintillating dance about the horizon line like a descant. In Williams, we might say, landscape aspires to the condition of music.

But it also aspires to the evocation of place. Williams is aware of a bond between his art and his environment, being most at home as an artist, most creative, in his own country. 'Wherever I've gone I've felt that I could be quite at home there if I'd been born there, like in France or Italy.'[23] He sees culture, that is to say, as something to be created rather than as something to be taken and eaten.

The Continued Pursuit of Appearances—The City: One of the reasons, as we have noted, for the failure of Pop art in Australia may be the predominantly suburban character of Australian society. During the 1960s, however, the values and presuppositions of suburban romanticism were challenged seriously for the first time. The fitful appearance of Pop art was itself a sign of this. More important was the success, at least among painters and critics, of colour painting during the later years of the decade—to be discussed later. For this style was strongly oriented towards the urban culture of New York whence it originated—and its exponents and cham-

252 LOUIS JAMES, *It's Hot in Town,* oil on canvas,
72 x 60, 1966, Adelaide

pions rejected, or sought to minimize, influences arising from the local
environment, especially the rural environment. Hard-edge was an urban
art and sought an urbane presence: cool, impersonal, in a sense, classical.
The recognition of hard-edge may be taken as a sign of the emergence of
an urban and nascent metropolitan culture in Australia. But there were also
painters who preferred to work in figurative and semi-figurative modes,
and took for their subject-matter the city environment with its human
problems and its delights. The two most important were Jeffrey Smart and
Louis James.

Smart studied first in Adelaide and later in Paris. During the 1960s he
lived a good deal abroad, mostly in Rome. There he perfected a close-focus,
crisp-edged style which also possesses classical finesse of composition. The
fifteenth century, Piero della Francesca especially, has obviously inspired
him. And though, at a first glance, his style resembles that of the North
Americans, Andrew Wyeth and Alex Colville, his vision lacks their senti-
ment and domesticity. There is a terror in his precision reminiscent of
de Chirico. Painting in one of the most ancient of great continuing cities,
Smart has taken for his theme the predicament of life in the modern city.

Few living artists have visualized the psychological problems of urbanization with such power. He sees the modern city as a prison without walls which traps and devitalizes its inhabitants as it responds inhumanly to the new forces of technology (236).

Yet for all its classical balance Jeffrey Smart's art presents a romantic and partial view of the modern city. Neither Los Angeles, nor Sydney, nor modern Rome—one objects—is quite like that, where there is community for those who belong, even though troubled. It is rather, one feels, the vision of a city seen by a Dick Whittington who will never become Lord Mayor of London, of a stranger within the gates. The suburbs of Adelaide still cling to it. Yet the loneliness is no less authentic for being more in the heart than in the city; and the achievement, though romantic is, nevertheless, real.

By contrast Louis James accepts the modern city for what it is. Sydney has become his subject: the motels, drive-ins, discotheques, beaches and airports, especially the adolescents and the swinging students at play. Little groups huddle gregariously together under the bright lights and the mod. decor (252). In his ready acceptance of the modern city James is close to the spirit of Pop art—but he avoids its ironies. Instead he celebrates modern city life, accepting it as different but real, avoiding the pessimism of Smart.

NOTES

[1] On Whiteley *see also* R. HUGHES, *The Art of Australia*, pp. 297-8 and S. McGRATH, 'Profile: Brett Whiteley, *Art and Australia*, June 1967, pp. 368-73
[2] In an interview, *Other Voices*, August 1970, p. 36
[3] *ibid.*, p. 37
[4] Catalogue to *Subterranean Imitation Realists* exhibition, Komon Gallery, Sydney, May 1962
[5] *ibid.*
[6] Interview in *Other Voices*, August 1970, p. 40
[7] *C.A.S. Broadsheet* (Victoria), February 1964, p. 1
[8] In a letter to the editor, *Sydney Morning Herald*, 6 January 1964
[9] Quoted in the *Daily Mirror*, Sydney, 16 April 1964
[10] *ibid.*
[11] *C.A.S. Broadsheet (N.S.W.)*, May 1964, pp. 7-8
[12] In the Court of Quarter Sessions, Sydney, 26 July 1967
[13] *ibid.* 'I have considered the parts complained of in relation to the whole and in the end it suffices for me to say that for all the good intentions which may have been in the minds of the artist and the Gallery Director, in fact in a public gallery for the view of any ordinary member of the community the indecent elements were the subjects of a display not justified in the circumstances.'
[14] Interview with M. Jones, *Sydney Morning Herald*, 16 May 1970
[15] In the catalogue, Garry Shead exhibition, Watters Gallery, June 1966
[16] De Berg transcripts, N.L.A., Canberra, Larter
[17] De Berg transcripts, N.L.A., Canberra, Molvig
[18] De Berg transcripts, N.L.A., Canberra, Sibley
[19] De Berg transcripts, N.L.A., Canberra, Shepherdson
[20] *Present Day Art in Australia* (ed. M. Horton), Sydney, 1969, p. 198
[21] On the French origins of expressionism *see* D. E. GORDON, 'On the Origin of the Word Expressionism', *Journal of the Warburg and Courtauld Institutes*, XXIX, 368-85
[22] N. BENKO, *Art and Artists of South Australia* (Adelaide, 1969), p. 861
[23] De Berg transcripts, N.L.A., Canberra, Williams

253 TONY McGILLICK, *Cuba SI*, acrylic on canvas in
four segments, 95½ x 92, 1968, the artist

254 DICK WATKINS, *Un-
titled*, acrylic on canvas,
72 x 61, 1968, Mr John A.
White, Sydney

COLOUR PAINTING 1965-70

It is obvious that colour is now the only direction in which painting can travel.

PATRICK HERON, *Art International*, February 1963

DURING 1966 the twenty-five years dominance of expressionist painting both in its figurative and abstract forms, together with the symbolic modes associated with it, gradually came to an end. It was challenged successfully by a new non-figurative style, different aspects of which have been given different names: hard-edge, post-painterly abstraction, the new abstraction, colour-field painting, colour-form painting, colour painting. The term colour painting will be employed here to describe the style in general since it best describes its fundamental intention: to exploit the visual and aesthetic qualities of flat, unmodulated colour dissociated from all other considerations. In its purest manifestations colour painting avoids all referential overtones. The painting is regarded as a coloured object and nothing else. It also avoids all formal devices that might compromise or compete with colour such as tone, line, or the illusion of spatial depth. In a sense, of course, all painting is colour painting; but those are the ways in which colour painting, in the present sense, differs from traditional painting.

Needless to say colour painting is never met with in an absolutely pure form since it is not possible to remove entirely all the pictorial elements associated with colour. Nevertheless the new style owes its energy and development to the *ideal* of painting only with colour.

The new style was first developed in the United States and was due largely to the confluence of two major streams of abstract art, constructivism and abstract expressionism. To constructivism it owed an experimental concern with colour. Two names are of particular importance here, Josef Albers and Victor Vasarely. Albers, first a student and then a teacher at the Bauhaus, taught to good effect in the United States and developed a new interest in colour interaction. Vasarely, exposed to Bauhaus teaching as a youth in Budapest, became a champion of an experimental approach to colour and light during his long sojourn in Paris, and did much to develop experiment in optical, modular, multiple and kinetic art. To these men, and the revived constructivist tradition which they embodied, colour painting

owes its interest in colour interaction and optical colour. The interest in experiment, it may be noted, was also associated with the growing influence of behaviourist psychology, in marked contrast to the expressionists' interest in psychoanalysis.

To abstract expressionism colour painting owed above all the idea that the work should be treated by the beholder as a totality, the colour image flowing out, as it were, from the support and enfolding him with its colourful presence. Gestalt was here the appropriate psychology. The influential painters were Americans: Clifford Still, Mark Rothko, Barnett Newman and Ad Reinhardt. Through their influence the surface busyness of abstract expressionist painting was quietened. Flowing spaces and folds of colour emerged.

A truly non-figurative constructivist tradition cannot be said to have existed in Australia prior to 1965. The artists of the 1930s who made contact with constructivism, John Power, Grace Crowley, Frank Hinder and Rah Fizelle, preferred a semi-abstract manner or turned later, like Frank Balson, to painterly abstraction. The promise of an Australian non-figurative constructivism present in *Exhibition 1* held at David Jones, Sydney, in August 1939 was overwhelmed by the arrival of surrealism and expressionism upon the art scene that same year. And in Australia abstract expressionism was rarely non-figurative in a fundamental sense. It often contained symbolic references, usually to landscape.

The colour painters of the later 1960s were, therefore, the first group of Australian artists to work consistently over a continuous period with an uncompromisingly non-figurative style. In other ways, too, they mark an important break with the local past. Most of them painted as if they believed that the work of art should be seen as a self-contained object and not as a vehicle of expression, and many, but certainly not all, have espoused this view. Colour for itself alone, separated from compositional systems introducing an hierarchy of dominant and subordinate parts, and also separated from tonal values, was the real concern of painting. In this latter respect the colour painters have made the greatest break of all with local tradition. Before 1965 all painting in Australia of consequence was linked by a continuous chain with that tonal manner of painting which had been handed down from one generation to the next, mainly through the art schools. In Australia, prior to Buvelot, it was a *chiaroscuro* tonalism, after him it was the more sophisticated tonalism of values developed by the French painters of the nineteenth century. In rejecting tone the colour painters insisted that *ideally* colours should be flat, untextured, unmodulated, and should not suggest spatial depth.

They also abandoned the belief, long cherished by surrealists and abstract expressionists, that the picture-making process should incorporate the

x

accidental and be extended where possible beyond the rational control of
the mind. They saw painting as a problem-solving activity, in which there
might be trial and error, but these were not to be displayed in the final
product. That should demonstrate without fumbling and indecision a clean,
efficient solution. Paintings were often planned as one of a series, thus
making the total exhibition, or large segments of it, important units of
which the individual paintings were but parts. This has been called *serial
art*. The term has also been used to describe individual paintings made up
of elements equal in size, shape, colour, etc., thus avoiding centralized and
hierarchical forms of composition.

Colour painting was first championed in Sydney by a group of young
artists who studied abroad, mainly in England, during the late 1950s and
early 1960s and returned to Australia around 1965. It emerged in Melbourne
about the same time, but there its appearance was more diffuse, and the
influence of James Doolin, the American painter, significant. Because the
style was introduced from abroad swiftly and successfully, so that by 1970
it had become the normal style for a new generation of artists, it effected a
sharper break with localized traditions than that which accompanied the
acceptance of surrealism and expressionism (both figurative and abstract)
—movements introduced into Australia largely by young artists before they
had first travelled abroad.

The course of colour painting in Australia since 1965 may best be con-
sidered under three main modes of the style: hard-edge painting, optical
painting, and colour-field painting. It must be remembered, however, that
elements of all three modes are not infrequently to be found in the one
painting.

A *hard-edge* painting consists of areas of flat, unvarying colour. Although
colour is not always pure, it may be tinted or toned, the colour relationships,
not the tonal relationships, are the concern of the painter. Where colours
meet in a good hard-edge painting the edge is as fine as a sharp knife-blade.
Edges are usually straight or simply curved, so that hard-edge painting has
a geometric clarity. But it is the elements of geometry, lines and curves,
not geometric figures such as rectangles and circles, which are the true
linear components of mature hard-edge painting. The avoidance of discrete
geometrical figures or other self-contained motifs gives a relaxed, open face
to the work. Hierarchical composition which makes use of dominants and
subordinates is avoided. Construction is often by simple addition, blocks,
segments or bands of colour arranged across the surface to the edges on
all sides. As a result of such methods the traditional role of the framing
edge of a painting, an open window looking upon an illusory pictorial
space, is destroyed. This destruction is stressed by the fact that hard-edge
paintings are usually not framed and the coloured areas continued round

the edge of the stretcher at right-angles to the main surface. Such a device stresses the nature of the painting as an object.

An important device which has developed from the aesthetic precepts of hard-edge painting is the shaped or moulded canvas. In recent times, especially since the development of naturalism, painters have largely confined themselves to the rectangular-shaped canvas. In naturalistic painting the rectangular frame functions as a window or stage proscenium opening into an illusory world. The iconic painters of Byzantine and Gothic times, and the great architectural decorators of the baroque and the rococo employed a wider variety of shapes as frames. Colour painters began to make use of novel shapes in order to avoid the traditional associations of the rectangular canvas with naturalism, and in so doing stressed the painting as an object. They also began to investigate more closely than hitherto the effect of the shape of the frame on the development of the internal arrangement of the painting—a process which has been called 'deductive structure'.[1] Furthermore, by making use of moulded and projecting canvases many artists sought to investigate the perceptual and aesthetic issues which lie in the area between traditional painting and traditional sculpture. It was the American hard-edge painters, Frank Stella particularly, who pioneered the modern shaped canvas.

Optical painting has grown largely out of the conditions set by hard-edge painting, although it does not always conform to these conditions. It makes use of the fact that both shapes and colours in certain arrangements are capable of optical illusion—that what can be shown to be physically there upon the canvas is not necessarily what is seen by the eye. Like hard-edge, optical painting avoids hierarchical composition and utilizes sharp, crisp edges. But unlike hard-edge it makes great use of self-contained geometric units, such as squares, circles and their derivatives in projection. Such units are usually small and used in quantity in order to create a chequered or other evenly patterned surface which is optically 'active'. In other words optical painting creates surfaces which are visually unstable, breaking from one visual structure into another as the eye of the beholder accommodates or tires to the pattern. In developed forms it can create the effects of vertigo.

Colour-field painting in its mature form avoids the linear elements present in hard-edge and optical painting and the unstable visual surfaces of the latter. It creates fields of intense colour, poured, painted in layers, or sprayed on to the support, which is often raw, unprimed canvas or similar material. Such techniques create stained effects and soft melting surfaces. At its best colour-field painting creates a dense, translucent *volume* of colour visually, rather than a coloured surface. Painting into the surface by staining does something to eliminate figure-ground relationships, a

traditional recession effect which colour-field painters seek to avoid. The problem of creating sky-type effects unintentionally behind the surface is always present. Colour-field painting seeks rather to create the illusion of a coloured volume operating in front of or about the surface plane. The painters largely responsible for its development are all Americans, the most notable being Mark Rothko, Morris Louis and Jules Olitski.

Although, like most *avant-garde* styles of the twentieth century, colour painting is a rejective art which seeks to eliminate all that which is considered not to be *essential* to the art of painting, many colour painters have been driven by the implications of their own work to the conclusion that illusory effects are native to painting and cannot be entirely eliminated. Since a painting is something seen paintings will always possess an optical as well as a physical surface. Research into optical effects has broken down considerably the former sanctity with which earlier twentieth-century artists were inclined to hold the 'integrity of the picture plane'. Many painters have become increasingly interested in the kinds of illusion, both optical and perspectival, possible within the terms of reference—flat, unmodulated colour—of colour painting. The shaped canvas has been an important factor in this new development and the American painter, Ron Davis, particularly inventive.

The Beginnings of Colour Painting in Australia

Colour painting first began to appear rather hesitantly upon the Australian scene around 1963. Two artists are of special importance for its appearance, Dick Watkins in Sydney and Janet Dawson in Melbourne.

Dick Watkins (*b.* 1937) studied first at East Sydney and then at Ashton's where he made contact with Brett Whiteley. Art student interests, Watkins has recalled, during the later 1950s were manifestly eclectic. The idols changed every month.[2] That, of course, is not uncommon among students at any time, but in Watkins's case the desire for continuous experiment with new styles and the styles of the recent past has remained with him.

In 1959 he left for England, lived for a time in Earl's Court, then hitch-hiked around Europe before returning to Sydney via New York in 1961. After returning he worked within the ambience of the prevailing abstract expressionism and texture painting. But 1963 found him experimenting tirelessly in new directions. His *One-Tree Plain* shown in the Wynne Prize in January, a collage with hints of landscape, was still predominantly expressionist, but his art was moving towards reduction. This was achieved in *Moscow* (257) exhibited in the *Young Contemporaries Exhibition* in April, an important landmark in the development of his style. It consisted of a blue-green cross above a red square painted upon similarly shaped

255 ROLLIN SCHLICHT, *La Noce*, acrylic on linen, 68 x 76½,
1970, University of Melbourne

256 TREVOR VICKERS, *Flat Cube with Blue Centre*, acrylic
on canvas, 69 x 96, 1970, the artist, by courtesy of the
Pinacotheca Gallery, Melbourne

257 DICK WATKINS, *Moscow*, enamel on hardboard with assembled elements, 71 x 47, 1963, National Collection, Canberra

pieces of masonite that had been attached to the middle of a rectangular support, the surface of which was thickly worked with white paint. *Moscow* was a significant move away from expressionism, though some features such as expressive brushing were present. The painting recalls suprematist compositions painted by Malevitch in 1913 and was neo-constructivist rather than hard-edge. But Watkins was moving towards hard-edge painting. The paintings which he exhibited in the Blaxland Gallery *Survey Three* exhibition in June 1963 abandoned the discrete, geometric figures of *Moscow* (and their inevitable symbolic associations) in favour of colour perception experiments with colour stripes and timber slats fastened to hardboard, in the manner of Victor Pasmore. By October he had abandoned largely the relief effects of these 'structurist' paintings and, in his first one-man show at Barry Stern's Gallery, exhibited vertical colour stripes on white grounds, reminiscent of the American painter, Gene Davis. These were probably the first hard-edge paintings to be exhibited by an Australian artist in Australia.

Having arrived at hard-edge, however, Watkins did not stay with it. Each one of the group of paintings which he submitted to the Helena Rubinstein Prize in November 1963 was deliberately painted in a different style. And in the following year he experimented with Pop elements and figures treated as colour areas. From all this it becomes clear that Watkins was not in pursuit of a personal style, but was exploiting styles relevant to the pursuit of his central interest—colour. Or, as he put it: 'The problem as I see it is how to use colour in the most vibrant sorts of combinations. I think colour is the most exciting element in painting to-day'.[3]

In Melbourne Janet Dawson (*b.* 1935) was also something of a pioneer of colour painting. Her training, for a contemporary Australian artist, was unusually long. After four years at the National Gallery School, Melbourne,

she was awarded the Travelling Scholarship and proceeded to the Slade for two years. Then she travelled and painted in France and Italy between 1959 and 1961 before returning to Melbourne. There she established an influential workshop at Gallery A in South Yarra, working there from 1962 to 1964.

Janet Dawson's work exercised an *avant-garde* influence upon Melbourne painting in those years. Her work owed little to constructivism or hard-edge painting but was oriented towards pure colour often painted with broad, curvilinear strokes and suffused edges. Although the ideas which prompted the paintings were often based upon myths and stories of personal interest to her,[4] the paintings which resulted were highly abstracted from them and concerned almost exclusively with the organization of pure colour, radiant and flat, upon a spacious surface (235). Her work foreshadows the colour painting of the later 1960s in its virtual elimination of tone, expressionistic brush work and self-contained figurative motifs, her concern being with the unification of pure colour and shape in space. After moving to Sydney she became interested first in hard-edge, occupying herself with modular and illusionist problems, and later, colour-field painting, employing monochromatic brushed effects on oval grounds.

The work of Dick Watkins and Janet Dawson around 1963 foreshadowed colour painting but it did not become a force in Australian art until the establishment of the Central Street Gallery in Sydney in April 1966 by three artists committed to the new style: Tony McGillick, John White and Harald Noritis. This gallery, in some respects a co-operative venture, was established to disseminate a knowledge of the new style among the public and to sell colour paintings. It also functioned to bring artists of like interests together.

Behind the formation of Central Street lay the taste and attitudes of a new generation. In Sydney, colour painting became the *avant-garde* style embraced and championed by the student generation born around 1940. Most of those influential in promoting the style had studied either at East Sydney or Ashton's during the later 1950s, and proceeded to England for further study and experience during the early 1960s. The group included: Michael Johnson (*b*. 1938), Wendy Paramor (*b*. 1938), Vernon Treweeke (*b.* 1939), Ron Robertson Swan (*b.* 1941), Tony McGillick (*b.* 1941) and Tony Coleing (*b.* 1942).

When these artists were students in Sydney abstract expressionism was the prevailing local style. When they were in London Australian art, above all figurative expressionism, became high fashion as a result of the success of Sidney Nolan and the 1961 *Recent Australian Painting* exhibition at the Whitechapel Gallery. The vogue for Australian art helped them. Some gained invitations to participate in influential group shows, such as the

Young Contemporaries exhibitions held at the Royal Society of British Artists Galleries, London; others were included in exhibitions of Australian art organized in London, such as those held at Folkestone and Frankfurt; still others gained teaching posts in English art schools. Gaining recognition (at least of some sort) was not the problem it had been for expatriate Australian artists in the early years of the century. More was expected of a young Australian artist in London in 1960 than in 1900; and the change was due mostly to the quality of the work of the preceding generation, the figurative expressionists.

But for the student group expressionism was the tiring style of an Establishment. During their London years they rejected it one after another and turned, like their English contemporaries, towards American art for inspiration. They read the *avant-garde* art journals of the time, particularly the American *Artforum,* and welcomed the publication of Josef Albers's highly influential *Interaction of Colour* in 1963 with enthusiasm. Most remained for at least three or four years in England, returning to Sydney in the mid-1960s, Wendy Paramor as early as 1963, Ron Robertson Swan not until 1968.

The impact upon Sydney art and taste of this homecoming student group is not the whole story. Apart from the presence and example of Watkins, there was also a small group of young migrant artists of importance. They were all slightly older than the returning natives and did not take seriously to painting until their arrival in Australia. This group included Harald Noritis (*b.* 1928 in Riga), Joseph Szabo (*b.* 1932 in Budapest), David Aspden (*b.* 1935 in Bolton, Lancashire) and Gunter Christmann (*b.* 1936 in Berlin). And apart from these there are three other artists who must be mentioned: John White (*b.* 1930 in Auckland) who had studied in England in the early 1950s; Rollin Schlicht (*b.* 1937 in the Gilbert Islands) who had studied art and architecture in London and arrived in Sydney in 1966, and Col Jordan (*b.* 1935 in Sydney).

The reception of colour painting in Sydney was due then to a new generation of artists, mostly in their late twenties and early thirties in the years between 1965 and 1970, the period within which the style was established. All of them had gained their basic training as artists either in Sydney or London, or both.

There were two travelling shows which provided these artists with stimulating information about American colour painting; the James A. Michener collection, which toured Australia in 1964 and the *Two Decades of American Art* of 1967 (discussed below). Neither, however, was an important source for the beginnings of colour painting in Australia, and their influence can be easily over-stressed.

In Melbourne the biographical pattern was not markedly different—though there were differences. As in Sydney, colour painting was intro-

duced by a new student generation, part migrant, part native-born. In 1965, an important year for the appearance of the new style in both capitals, their average age would have been about twenty-five. But the spectacle of a group of native-born homecomers acting out the role of messengers-of-the-new was less in evidence.

For Melbourne found it more difficult to get its most enterprising and creative students overseas during the 1950s; and those who did manage to get away remained for shorter periods. In Melbourne students and young artists who wished to move from an immature, and increasingly distasteful, expressionist student style towards hard-edge had to perform the transition in full view in their home-town and not in the anonymity of London. It was thus more difficult for them to adopt a missionary stance. In many respects the whole situation in Melbourne was much more open and diffuse. No taste-making institution comparable to Central Street emerged, nor was the image, feigned or real, of an expressionist establishment so much in evidence.

There were good reasons for this. In Melbourne abstract expressionism never flourished as abundantly as in Sydney, and the leading Antipodean and Angry Penguin painters, who might well have played an Establishment role had they remained in the city, either emigrated to London, where they developed two markets for their work, or adopted the customary practice of ageing Australian artists and retired to a picturesque studio-homestead in the suburban bush. What opposition there was to colour painting in Melbourne came mostly from older critics, and even that was short-lived. But the growth of a market for colour painting, needless to say, was a much more gradual process in both capitals.

Although the new style first appeared in Melbourne, as we have seen, in the work of Janet Dawson and her pupils (such as Graeme Cohen, Richard Havyatt and Winston Thomas) at the Gallery A workshop, it was an American painter, James Doolin (*b.* 1932), trained at the Philadelphia School of Art, who was the most influential artist in developing an interest in colour painting in Melbourne. Among the most prominent of the many young Melbourne artists who turned to the new style around 1965 were Robert Rooney (*b.* 1937), Dale Hickey (*b.* 1937), Robert Jacks (*b.* 1943), Trevor Vickers (*b.* 1943), Mel Ramsden (*b.* 1944 in Nottingham), Garrey Foulkes (*b.* 1944) and Paul Partos (*b.* 1943 in Czechoslovakia).

The young colour painters of Sydney and Melbourne looked to America as the source of colour painting but none had been exposed to it as students in New York. Sydney Ball (*b.* 1933) of Adelaide, however, after completing his studies at the South Australian School of Art, proceeded to New York, where he worked at the Art Students' League under Theodore Stamos, and became acquainted with Mark Rothko, Willem de Kooning, Stephen Greene

and Robert Motherwell. Ball became a member of the New Edge Group, New York, which maintained connections with the German *avant-garde* group, *Zero*. Other Adelaide painters who turned to colour painting include David (*b.* 1914) and John (*b.* 1941) Dallwitz and Cecil Hardy (*b.* 1929). In Brisbane Neville Matthews worked with high pastes and textures before turning to colour painting; and in Perth the recent work of Miriam Stannage may be mentioned.

Early Hard-edge Painting in Adelaide and Melbourne

Some of the best and most confident Australian colour paintings are to be found, stylistically speaking, at an early phase in the development of the style. The works of Sydney Ball, James Doolin, Alun Leach-Jones and Dale Hickey, between 1966 and 1968, did not reveal that absence of internal, self-contained geometric figuration, that avoidance of hierarchical and tonal forms of composition and (apart from Hickey) that absence of symbolic reference which are among the important negative characteristics of mature hard-edge painting. They are less bland-faced, less wholly reliant upon flat, interacting colour, than mature hard-edge. Their work at that time occupied a position stylistically somewhere between the constructivist geometry of Auguste Herbin and the colour stripes of Kenneth Noland. They painted within an early and relatively undeveloped form of the style which has evolved like so many modern styles by shedding elements considered irrelevant to it. Yet early phases of a style often produce the best work, so that it need not surprise that the works of Ball, Doolin, Leach-Jones and Hickey between 1966 and 1968 include some of the most impressive colour paintings yet executed in Australia.

Sydney Ball regards himself as a hard-edge painter. He does not consider line, space, tone and light as elements which need compete with colour, but as elements which colour itself may generate if used aright. 'A colour', he has written, 'must be regarded as a structural unit, a spatial unity, a unit of light or direct sensation, with its own capacity to react aggressively against another colour. It may even have the capacity for motion'.[5]

Ball's student work contained subjective and figurative elements. But in New York from 1963 onwards he began an intense study of colour stimulated by seeing originals in quantity by several of the formative masters of colour painting: Matisse, Morris Louis, Rothko, Albers, Barnett Newman, Hans Hofmann and Kenneth Noland. He also became interested in the colour theories of Eugène Chevreul, Charles Blanc and O. N. Rood.

His earliest hard-edge paintings, exhibited in his first one-man show, held at the Westerly Gallery, New York, in 1964, took the form of vertical bands of colour (cf. Dick Watkins's first hard-edge paintings, p. 424)—the decisive

influence of Louis and Newman. They are, as Patrick McCaughey has noted, the most minimal of all Ball's work to date.[6] Later that year he exhibited the first paintings of the series by which he is best known, the *Cantos* in each of which a circle banded with colour is inscribed within a square or rectangle (241). This striking format provided him with an admirable means for developing a forward thrust of colour and also provided a balanced tensility. Yet though the colour was magnificently assured, flat and unmodulated, the total impact was supported by several features not peculiar to hard-edge painting but, on the other hand, traditional to earlier forms of abstract art such as orphism, constructivism and De Stijl. The self-contained circles, whether inscribed entirely within the internal space or attached to the framing edge, create figure-ground relationships, indeed this is one of the factors which gives such a thrust to the colour, quite apart from the vibrance engendered by optical interaction at the edges of the colour bands. The colour values, too, often contrast so strongly that one becomes aware of the tonal relationships contributing directly to the strength of the construction.

Nor does Ball see his *Cantos* as objects shorn of reference. They arose, he assures us, from past experiences: the effect of a tondo mount in a rectangular frame seen by chance in an old New York second-hand shop; Gaudi's architecture, the *Cantos* of Ezra Pound. And for the artist they possess a personal meaning. 'The circle containing the vertical bands of colours represents for me the Chinese symbol of infinity. The general epigraph to the *Cantos*, "In Great Praise", represents my affirmation to people, places and things experienced.'[7] Of course the *Cantos* could be seen as pure objects, but the colour is as confident and expressive as the trumpets before Jericho. Too expressive, in fact, to be contained without special pleading, within the minimalist criteria of doctrinal hard-edge.

Yet Ball chose to develop his art within the rejective disciplines of colour painting. His next series of paintings led him to a more minimal format. He began to make use of ribbons of colour shaped in the fashion of a Persian ogee arch. These he floated informally through fields of flat but strong colour. Matisse was, in part, the master behind it, and the chevrons of Noland no great distance away. The firm geometry of the *Cantos* was replaced by a plastic ease; centralized composition by relaxed, open form held to the framing edge. The Persian series, as they were called, came much closer to the principles of mature hard-edge painting but were not such an impressive body of work as the *Cantos*.

In the paintings which Ball exhibited at the Bonython Galleries in June 1969 he turned from informality to a tougher, rectilinear manner that avoided all imagist and referential features. The painting as object was now stressed, but the surface was not allowed to remain flat. Colour was

used as a structural and spatial unit. In *Banyan Wall*[8] the rectangular frame determines the rectangular structure of the coloured units. Space is achieved by that primitive device, overlapping, and strong primary and secondary colours are chosen to aid the spatial effect while yet asserting their own independence with the blocky simplicity of the shapes and the optical activity at the edges. The painting is symmetrical and, in a sense, classical. Between the yellow and blue, space is asserted with great clarity, but it is an airless, autonomous space, a sort of cubist space attained by means of the (reduced) compositional language of the High Renaissance. In *Strata Span* the irregular shape of the canvas determines the irregular shape of the units or *vice versa*. Space is created here, too, but it is ambiguous, achieved more by projection than by colour. The irregular shapes preclude a centralized structure, keeping activity at the edges and creating a sense of movement. Although the component parts are of un-equal size there is no effect of hierarchical composition, for by their shape and colour they are given great independence within the highly tensed, unstable unity of the whole painting. It is perhaps not too fanciful to describe the effect of the painting as somewhat akin to the uneasy tensions of Mannerist painting.[8]

Ball seems to be in such paintings out to make colour, and colour alone, achieve those effects of space, light, structure and movement, which are available to traditional painting with its more copious resources. Despite his early development from stripes (minimal) to *Cantos* (referential) the trajectory of Ball's development has in general conformed to that of the typical *avant-garde* painter; he has sought more with less, and this has certainly kept his art probing at colour problems and alive. But only in a few of his recent works such as *Strata Span* has he approached his American exemplars and worked wholly within the severe reductive discipline of hard-edge painting.

The important works painted in Melbourne by James Doolin during 1966 and 1967, when colour painting was being established there as an *avant-garde* style, possess a number of features in common with Sydney Ball's *Cantos* of 1964-66. Both painters used strong, symmetrical, internalized compositions with some grading of component parts. Both used strong tonal values in their colour to aid the thrust, structure and assertion of their paintings. Neither sought to avoid the referential. Doolin's *Artificial Land-scapes* of 1967 drew upon 'forms, images and systems from the man-made environment'.[9] All these features reveal Doolin, like Ball, working at this time in a transitional area between constructivism and hard-edge.

Yet there were important differences—and the differences reveal Doolin utilizing more of the possibilities of colour painting than Ball. Unlike Ball, who preferred sharp contrasts of colour, Doolin combined sharp contrasts

with fine gradations both within colour bands and between one band and the next—essentially a colour-field technique (250). He made greater use of small, repetitive elements, such as clusters of circles, and these smaller forms set up a greater amount of optical activity than is present in Ball's work. Although Doolin's paintings are not held within the minimalist discipline of mature hard-edge painting he does make intelligent use of the three main procedures developed by colour painting: hard-edge, optical activization and colour-field. Besides, his paintings are superbly well made.

The format used by Alun Leach-Jones for his *Noumenon* series of paintings, a circle within a square, is similar to Ball's *Cantos*. But within his circles Leach-Jones introduces a thick interlace of vermicular, organic forms like an exposed brain—a disconcerting reminder that the *Noumenons* are intended as images of pure intellection (210). A good deal of optical activity is developed within the circles between pattern and ground which establishes a vibrant presence in sharp contrast to the static geometry of circle and square. They are handsome, impressive paintings; but for the artist colour painting is clearly not an art to be confined to perceptual experience. He uses the modes of colour painting for conceptual and, as we have seen above (p. 386), even metaphysical purposes. Not that he is altogether unique in this, for it may be noted that there is a conceptual element in the work of all three artists we have just considered. The *Noumenons* of Leach-Jones, the *Cantos* of Ball and the *Artificial Landscapes* of Doolin all possess, among other things, a radiant *emblematic* quality, and may be interpreted as celebrations of transience—the material objects as transcendent symbols.

The paintings of Dale Hickey produced between 1967 and 1968, his finest to date, may be discussed within the context of early hard-edge painting, though he moves farther towards optical and serial painting than any of the three artists discussed above. In these paintings Hickey is early hard-edge in his use of discrete, geometrical figures and toned colour. He avoids the gradated compositions of Ball and Doolin, however, by keeping his geometric components small and arranging them in serial form. In *Untitled* (249) of 1968 blue circles are imposed upon an orange grid, the blue being broken into four tones and varied from circle to circle in a sequential rhythm, and the orange toned with green to create a visually-ambiguous coffered ground. With this formal device Hickey achieves a splendid interplay between visual and optical colour within a shallow space. These paintings are not only, in their own way, a kind of homage to Vasarely, a master of colour painting sadly neglected in Australia, they are among the most effective and satisfying colour paintings produced in Australia during the 1960s—an achievement assisted by not sticking too closely to the rejective rules of the flat-colour game.

Mature Hard-edge Painting in Sydney: Central Street Style

During 1966 the group of artists associated with the Central Street Gallery, Sydney, developed a local form of hard-edge painting which may be distinguished from the early or transitional forms discussed above. It has been called, appropriately, Central Street Style.[10] The important influences on its formation were Kenneth Noland, Frank Stella, Josef Albers, Elsworth Kelly and late Matisse. The only local influence of significance was Dick Watkins. A distinct English inflection is also present in much Central Street Painting. As we have noted above, most of the native-born artists associated with Central Street studied in England during the early 1960s. Here it was the work of English artists working within the ambience of American hard-edge such as Robin Denny, Michael Tyzak, Richard Smith, Roger Cook, Peter Coviello and others, who must be taken into account. The overall effect of the English versions of hard-edge seems to have been a preference for colours cool, muted, neutral and thin. It is likely that here we have the indirect influence of the ideas of Edwin Land, the physicist, whose research in colour vision suggested that the eye does not need as much information about colour as it normally receives. 'It can build colored worlds of its own out of informative materials that have always been supposed to be inherently drab and colorless.'[11]

A typical Central Street Painting of around 1966 maintained a flat, open surface. Colour edges and colour fields flowed easily to and from the framing edge. Although surfaces could be built up into quite complex structures hierarchical composing was avoided. Colour was more often 'artificial', that is, made up, rather than 'natural' or 'landscape' colour such as atmospheric blues and greens, which were suspect as possible mimetic stimulants. Central Street painters were more interested in colour problems than colour effects. It was a more minimal, more evolved, form of hard-edge painting than that which obtained in Melbourne and Adelaide around 1966.

The broad principles within which the Central Street painters chose to work was stated in the catalogue to the *Black and White Paintings and Sculptures* exhibition held at Central Street in May 1967.

The painters in this exhibition are better known as colorists and all share a heightened interest in color. Normally, color is perhaps the most conspicuous element in their work. Other than this primary concern with color, some affinities of sources, style and attitude will be recognised in this work. There is generally a preference for flat picture space, and 2-dimensionality, a non-tactile, non-gestural technique and a conceptional approach to composition which allows little room for schematic revision after the decisions have reached the canvas. These disciplines are to their advantage in focusing more acutely on the specific issues they choose to examine . . .

The significance of the Central Street artists is to be found, as Terry Smith has rightly argued, in the fact that they 'sought guarantees of goodness in their own art by taking on a style, by joining a mainstream'.[12] Curiously enough there have only been two real *avant-garde* groups in the whole history of Australian art: the group of young painters who introduced impressionism to Australia with their exhibition of 9 × 5 Impressions in 1889, and Central Street. It has been much more usual in Australia for new ideas in the visual arts to be accepted gradually as the result of the work of a *congeries* of individuals sharing some ideas and attitudes in common but much more ready when pressed to assert their differences than what they hold in common. In such a fashion post-impressionism, expressionism, surrealism and dada entered the country.

That is not to say, of course, that there were no individual differences among Central Street artists; indeed the *Black and White* show, mentioned above, pointed them up—that was partly its intention. As the catalogue put it: 'working without color the formal variety from painter to painter becomes clearer'. The way form was here distinguished from colour also indicates that Central Street style, though exhibiting many of the features of colour painting, is not to be identified with it at all points as practised abroad. For in mature hard-edge painting form is a function of colour, inseparable from it.

The artists associated with Central Street, as might be expected, modified their personal style in relation to the problems with which they became concerned in their own development as artists. Broadly speaking, it is possible to discern three main trends within Central Street style; first, the unitary or modular painters; second, the relational-colour painters; third, the neo-modernists.

Within the first group, the unitary or modular painters, it is possible to include much of the work of Tony McGillick, Joseph Szabo, Wendy Paramor and Vernon Treweeke.

Like many of his generation McGillick as a student was touched briefly by the influences of expressionist and Pop art. While in England he was strongly influenced by the work of Jasper Johns during 1964 and 1965. On returning to Australia through America he saw paintings by Stella and Kelly and became increasingly interested in hard-edge. Then late in 1966 he became interested in the possibilities of the shaped canvas and developed a sliced square as a module which could be arranged in a variety of ways. His development of the modular form may be compared and contrasted with that of such American artists as Michael Egan.

McGillick's modular canvases, usually painted by spraying with one colour, established autonomous colour fields and avoided hierarchical structures (253). The technical and, to some degree, the visual problems created

258 JOHN PEART, *Colour Square III*, polyvinyl acetate on cotton canvas, 66 x 66, 1968, the artist

259 GUNTER CHRISTMANN, *Dark Blue Painting*, acrylic on canvas, 68 x 66⅛, 1970, the artist

by the edges of colours upon one canvas were thus avoided. The independent, yet attached, modules stressed the autonomy of the colour fields, form arising from the physical limits of the modules rather than from the arbitrary limits of colour fields which generate line—an ever-present competing element with colour in hard-edge painting. McGillick wanted to insist upon the object quality, not the art quality, of his constructions. 'In making objects it's my concern to maintain the integrity of their objecthood.' For him art was a contextual concern which his objects might acquire outside his 'influence and interest'.[13]

McGillick's coloured modules took colour painting farther towards the minimal than anything achieved locally hitherto. Whereas artists like Ball and Doolin sought to make colour painting perform somewhat after the fashion of traditional painting and utilized judiciously effects of tone, space, symbolism and so forth, towards that end, McGillick moved towards reduction. Now since colour painting in relation to traditional painting was a more rejective, more minimal discipline it was certainly the more logical step. But it did not always produce better paintings.[14]

Unlike McGillick, Wendy Paramor has developed her unitary, modular art, within the single frame (260). In 1965 she gave up working in an abstract-expressionist manner, sometimes reminiscent of Whiteley, and turned to a modular mode, varying the units according to a numerical series. Her systems are simpler than the intricate systems of Lohse and Vasarely, the units being formed from freely-drawn organic curves. In recent work she has made more use of the unpainted canvas and become more minimal. In its studied avoidance of charm her work bears a similarity to that of McGillick.[15] Vernon Treweeke has preferred to use squares as units. Upon them he has painted, in rich, psychedelic colours, flower-like patterns in a neo-*art-nouveau* manner. In his use of the square module arranged in kaleidoscopic symmetry his work may be compared with that of the English artist, John Pearson.

The relational colour painters have centred their attention upon colour interaction, particularly the activity of adjacent colours at their edges; and have preferred to avoid the multiplication of self-contained, modular units, within the surface of the painting.

Harald Noritis, a co-founder of Central Street, developed an attractive minimal style in which close-valued colours, keyed to cool hues, met in easy, flowing curves. Spatial relations, gently ambiguous, and occasionally suggesting a landscape were the result. His paintings are probably the least doctrinaire and most lyrical of the Central Street group.

Col Jordan is a somewhat more robust painter who works with a wider range of hue than Noritis, both in two and three dimensions, usually with adjacent ribbons of colour. He is a relational painter, in the sense used

260 WENDY PARAMOR, *Libra,* acrylic, 48 x 48, 1967, the artist

here, in that he tends to assert the unity of the field rather than the individuality of the colour ribbons. He makes free use of the shaped canvas which does much to determine the internal structure of the work. Many of his paintings might be taken to demonstrate Michael Fried's principle of deductive structure. But not entirely.

For neither his internal shapes nor colours are bound entirely by deductive relationships. In the series called *Daedalus* the tyranny of the frame as structural determinant is challenged increasingly, the greater the distance from the edge, as forms and shapes arise which assert a kind of plastic freedom (261). Perhaps this is what Jordan meant when he said that these paintings were about paradox. 'A work is good to the extent that it reconciles irreconcilables. *Daedalus* is about directions, tied down and boxed by the stripes of its own identity.'[16] A strangely human image to fly from the tight, behaviourist world of stripe painting.

Some of the early paintings of Gunter Christmann are among the most minimal of the group. Both he and Joseph Szabo made paintings in the mid-1960s possessing a high degree of optical activity and then moved towards simplification—a feature of the development of the Central Street style (262). In Szabo's *Baboon* (263) the concern is with the edge rather than centre, with banded colour and the shaped canvas. Such painting is like a blazon; the colour relational and modular modes mingle to result in some of the most typical examples of Central Street style.

David Aspden's investigations in colour interaction during 1967 and 1968 took the form, as Jordan's did, of stripes and bands of colour taken from edge to edge of the support. But Aspden has preferred to work within the rectangular format, and there was a preference for broad, closely related, bands of colour; aggressive colour contrasts and high optical activity being carefully avoided. His work at this time was not ambitious and wore the air of investigation and experiment; and like Jordan he wrestled with the problem central to hard edge: the framing edge as determinate of internal structure (265).[17]

Most, though not all, the formal advances in modern painting have been advances in the use of colour, giving it more freedom from other pictorial

261 COL JORDAN, *Dynapac*, acrylic on canvas over hardboard, 59 x 62, 1968, the artist

elements. But the sources of colour painting possess a long history that goes back through the impressionists to Rubens and the Venetian school. And some artists have chosen to back-track a little rather than be pushed headlong forward. The term *neo-modernists* is here used to describe the work of Dick Watkins (254), Rollin Schlicht (255), and Alan Oldfield (264), three artists less prepared than most to restrict their work to precepts about surfaces and edges; and ready to experiment with earlier art, particularly the earlier twentieth-century styles that were preoccupied with colour.

Watkins has worked freely across the century in this way for some time, keeping his surfaces open yet complicated enough to avoid being trapped within the nihilistic *culs-de-sac* of minimal painting. So, too, more recently, has Schlicht, parodying the earlier styles, and keeping his own options for the future open. From a minimal, hard-edged manner at times reminiscent of Stella, he has moved towards a more ample and more relaxed style in which figurative elements, stainings, primings and bare canvas, abstract and organic form, are all used as befits the case. *La Noce* is a

262 GUNTER CHRISTMANN, *Composition No. 4*, oil on hardboard, 48 x 48, 1966, the artist

263　JOSEPH SZABO, *Baboon*, acrylic on canvas,
84 x 66 x 60, 1968, Central Street Gallery

fine example of this new freedom. Alan Oldfield, the youngest of this group, also ranges over the modern styles in an easy spirit of playful banter. His *Sexyvaganza* (1970) burlesqued Picasso's *Les Demoiselles d'Avignon*, and other paintings have taken on the 1920s and 1930s. Nor is it all mere art school form fun. *Ship of Fools*, while most convincing as pure form, is also a gentle parody of the sweet, white, Australian mind in its mindlessness. It owes something, fortunately, not only to Matisse and Hockney but also personal experience. All three painters have chosen to go back a little in order to go forward: it is but one of the several moves within colour painting away from the rejective principles which have largely determined its trajectory—and probably the most promising.

The work of John White, the other co-founder of the Central Street Gallery, is neither a modular nor a relational mode of hard-edge painting. Somewhat older than the others, his work reveals many of the features of early hard-edge, already discussed above, being characterized by strongly contrasted geometric figures, often segmented and asymmetrical, suggestive of tension and movement, and marked figure-ground relationships. Design becomes a more important constructive element than colour.

Mature Hard-edge Painting in Melbourne

In Melbourne the assertive form and projective colour which is characteristic of the early hard-edge paintings of Doolin, Leach-Jones and Hickey continues to be found in the work of the best painters working within the more minimal discipline of mature hard-edge. There was nothing in Melbourne quite like the reduced, relational and close-valued colour typical of

so much Central Street painting around 1966—apart from some paintings by Barry Foulkes.

Intense and strong colour, for example, is a feature of Trevor Vickers's work (256). He seeks the greatest possible independence for the parts within the total work—to go as it were to the visual limits of the Gestalt. In pursuit of this aim he paints and sprays to obtain intense, many-layered colour surfaces—or in Richard Smith's phrase, deep 'hedges of colour'— that are placed upon shaped-canvas components, and clamped together. In his use of components painted with one colour only, his work may be compared with that of Tony McGillick, but he does not confine himself to a modular shape and whereas McGillick's paintings tend to 'keep the surface' and are contained by the shape, Vickers's thrust forward visually to assert their presence upon the surrounding space. Indeed his deep, rich fields of colour give his paintings both an object quality and a commanding visual presence, gleaming like shields or armorial trophies.

Peter Booth is a romantic among hard-edgers. His chosen colours, brown, ochre, red and black, are related to personal experience. Not surprisingly he avoids the rigidity of taped edges, and his paintings though minimal possess a plastic quality. The shapes, deductively structured, are normally confined to rectangles within the rectangular frame and cling to the edges.

Modular hard-edge is represented in Melbourne by Paul Partos (b. 1943) and Robert Rooney (b. 1937). Partos, after a student expressionist phase, turned to a unitary hard-edge in which squares were sprayed to achieve illusive effects of tone and light. In some respects the effects he

264 ALAN OLDFIELD, *Ship of Fools*, acrylic and oil on canvas, 98 x 100, 1970, Perth

265 DAVID ASPDEN, *Norfolk 9*,
acrylic on canvas, 90 x 60, 1970, The
Rudy Komon Gallery

266 STEPHEN EARLE,
Point of View, acrylic on
canvas, 60 x 60, 1970,
Mr and Mrs Spencer
Simmons

achieved are akin to the vibrating textures created by the Italian, Getulio Alviani, with brushed aluminium. More recently, Partos has turned to open-form modules which make use of the wall on which the picture-object is hung as a negative space. His work in this field may be compared with that of the Californian, David Novros.

Robert Rooney works as if he were a naïve among serial painters creating continuous figure-ground relationships from everyday things like knitting patterns, blown up to an out-size scale. Such paintings wear the bland-faced, nonchalant air more common to Pop painting.

Optical Painting

Op art like Pop art has been rather neglected in Australia. This is curious because optical effects are a feature of colour painting rarely present in other styles. Those features which have become associated with colour painting and have received so much attention: deductive structure, the unitary field, modular composition and the integrity of the picture plane are more the product of formalist criticism and may be pursued in other painting styles. But retinal effects, the concern of optical art, are best achieved, within the field of painting, by means of pure, intense, unmodulated colour; that is to say, in colour painting.

The reason for the poor reception of optical painting in Australia is probably historical. It did not become an international fashion until 1965, though in Europe there is a continuous interest in the use of optical effects to achieve pictorial ends reaching back to the 1920s. 1965 was, as we have seen, the year in which many young Australian artists were beginning to work in hard-edge painting. Few at that time were prepared to make detailed studies of the intricate patterns and modular systems which created optically-charged surfaces, shimmering effects, after images, *moiré* patterns, and the like. The swirling spaces induced upon the retina by the chequered surfaces of the paintings of Bridget Riley, the British artist, were regarded by many as a passing fad. In Sydney, few artists were greatly interested in the creation of optical effects as they began to work within the rejective, formal discipline of hard-edge.

No doubt there were good reasons for the distrust. Optical painting launched a formidable challenge to formalist criticism from the unexpected quarter of visual perception. By demonstrating how flat colours could be charged with retinal effects sufficiently to make optical colour prevail over physical colour it questioned the central myth of formalist criticism, the so-called 'integrity of the picture plane'. Were phenomenal, retinal effects to be dismissed, like symbolic associations, as being not essential to painting? Yet the unstable optical colours were closer to that ideal of pure

Y1

sensational apprehension, devoid of associations, which was the formalist ideal, than any colours produced by traditional formalist means. To that extent optical colour might well have been embraced by formalist artists. But it was received with distrust. Perhaps the realization that optical colour was always a function of physical colour, unstable and transient, being dependent upon retinal fatigue and retinal accommodation, was discouraging.

The first exhibition given over entirely to optical painting was held in the Museum of Modern Art, Melbourne, in October 1965. It was the work of Frank Eidlitz who had received a Churchill Scholarship that year to study Visual Communications under Gyorgy Kepes at the Massachusetts Institute of Technology. The show had been commissioned by U.S.P.-Benson, a leading advertising agency, for the decoration of their new headquarters in South Melbourne. It was an impressive and highly professional exhibition which introduced to Australia, albeit indirectly, something of the visual achievement of Vasarely and his followers.[18]

The only other artist to work in some depth in the field of op art was Stanislaw Ostoja-Kotkowski, who is much better known for his work in electronic and kinetic art, when during the early 1960s, he was a solitary research worker among Australian painters in these areas. During 1966 and 1967 he worked creatively in the field of optical painting (195). But the art of Eidlitz and Ostoja-Kotkowski was pursued rather apart from the work of the hard-edge painters. If the latter had come to constitute by 1968, as Royston Harpur suggested, 'an intelligent Academy . . . in its beginnings, but very firmly established',[19] the optical paintings of Eidlitz and Ostoja-Kotkowski were certainly not considered to be a part of it.

In Melbourne, however, optical painting made more impression upon the development of hard-edge than in Sydney. Here artists worked with smaller units and a consequent higher amount of optical activity from the surface, as may be seen by comparing the work of Doolin, Leach-Jones, Hickey, Rooney and Jacks with their Sydney contemporaries. It is not until hard-edge gives way increasingly to colour-field painting in Sydney that optical colour effects are found in liberal use in Sydney.

Colour-field Painting

During 1965 and 1966 the colour painters of Sydney and Melbourne, though an *avant-garde* among artists, were little known to the public. But during the next two years as a result of exhibitions at Central Street and the writings of new critics, particularly Ross Lansell, Patrick McCaughey and Donald Brook, an audience for the new style gradually developed. Knowledge of colour painting was also improved by some important public events.

In 1967 an exhibition entitled *Aspects of New British Art* was brought to Australia by the British Council. It had been assembled by Jasia Reichardt for the Institute of Contemporary Art, London, and contained many examples of the work of contemporary British colour painters, including Bernard and Harold Cohen, John Hoyland, Bridget Riley and Peter Sedgley.

Between June and August 1967 a more influential exhibition, *Two Decades of American Painting*, assembled by Waldo Rasmussen for the International Council of the Museum of Modern Art, New York, attracted large crowds in Melbourne and Sydney. Although about half the show was given over to the abstract expressionists (then being shown adequately in Australia for the first time) a good selection of the masters of American colour painting was included: Albers, Gene Davis, Francis, Frankenthaler, Kelly, Louis, Newman, Noland, Poons, Reinhardt, Rothko, Stella and Still.

Then in May 1968 Clement Greenberg, the American critic, came to Australia for two months to lecture, and met artists throughout the country. Hard-edge—or as he preferred to call it—post-painterly abstraction, was a curious style in his view. All previous *avant-garde* styles contained in-built guarantees of quality. Not until their decline did the bad art begin to appear. But in the case of hard-edge the bad art appeared at the beginning of the style along with the good. It contained, he concluded, the elements of a style in decline from the beginning. He also pointed out that all *avant-garde* styles possess a limited life-span of, he suggested, about twelve years.[20] These ideas, together with Greenberg's preference for the work of the Australian figurative expressionists, and his cool but friendly reaction to local hard-edge dampened somewhat the missionary confidence of the champions of the new style. But Greenberg had much to say about the recent American developments in colour painting, especially colour-field, and gave special attention to the work of Jules Olitski.

Later in August 1968 the National Gallery of Victoria (as one of the events arranged to celebrate its entry into fine new quarters on St Kilda Road) organized a comprehensive exhibition of Australian colour painting, entitled the *Field*. It gave the widest possible publicity to the new style and was a courageous gesture. But it had side effects.

For one thing it forced the pace. In Australia colour painting was, effectively, but two years old; the exhibitors were young, mostly in their late twenties or early thirties and, though several had travelled, but a few years from art school. In America, where it had originated, the emergence of colour painting was a much slower process. Many of the artists responsible, men like Albers, Gene Davis, Rothko, Newman and Ad Reinhardt had been painting for over a quarter of a century. And the local painters were at the disadvantage of being carriers rather than originators of the style. It is not surprising, therefore, that the *Field* exhibition, in the matter of quality,

did not meet the expectations either of the participating artists themselves or the public. But it did draw attention to radical new thought and to the liveliest areas of experiment in local painting.

All these events drew attention to an aspect of the new style then little practised in Australia, colour-field painting. The painter most admired by artists in the *Aspects of New British Art* show was probably John Hoyland. Those who attracted the most attention in the *Two Decades of American Art* exhibition were probably Morris Louis and Ad Reinhardt. Greenberg had spoken much about Olitski. All these were essentially colour-field painters. Not that colour-field was unknown in Australia, but in 1968 there were few local practitioners. There was a reason for this. Colour painting came in as a hard, cool, classical, objective style opposed to the soft, romantic, subjectivism of abstract expressionism. In Australia most local colour painters were still painting *against* expressionism and so preferred the hard-edge and modular modes of the style. But colour painting was already by 1968 moving increasingly towards colour-field painting—a more personal and painterly mode of the style. There can be little doubt that this would have happened quite apart from external events as a result of the working out of the inherent pictorial logic of the style itself. Indeed there were already several artists who had exhibited in the *Field* exhibition who were best described as colour-field painters.

Michael Johnson, for example. He had been seven years in London and his work is closely associated with developments in British colour painting, by such painters as Michael Tyzak, Richard Smith and John Hoyland. Johnson's work has moved through a hard-edge phase in which he gradually reduced colour edges and colour contrasts in favour of shaped canvases and broad fields of unimpeded colour. He prefers to keep his colour cool, blues and blacks predominating. His shaped supports are usually rectangular and have the object of placing different colours in different planes, structurist fashion, after the manner of Biederman and Victor Pasmore. Although Johnson asserts the objective presence of the work, he allows his stained and sprayed surfaces to create the illusion of volumetric colour, being one of the first Australian artists to demonstrate the visual effects of unimpeded surfaces of fully saturated colour. His development should be compared with that of Tony McGillick.

Like Johnson, Robert Jacks prefers to work with a rectangular format and monochromatic fields of colour. By means of severe, symmetrical, and rectilinear structuring he stresses the framing edge and holds the surface from depth effects. Such structures make it possible for him to be considered a modular and serial painter. His work, too, may be compared with that of McGillick; but in Jacks's case the format structures the colour field without dominating it. So that he may be regarded as a colour-field

painter, but one for whom the preservation of the flat surface, and form as a function of frame, are matters of importance.

Yet, like Col Jordan, he presents us with a paradox. By using closely-related tones of one colour when painting the internal struts and edges of his pictures, he turns the frame, and not the field, into the illusory element of the painting. One is reminded of Marcel Duchamp's *Fresh Widow* of 1920 (a pun both on French window and the popular name of the guillotine *La Veuve*) in which the panes of a small window are covered with dark leather. As in the Duchamp, the frames of Jacks's paintings are no longer windows into the illusory pictorial worlds of post-Renaissance painting, nor are they windows which frame the autonomous pictorial worlds of cubism; they are nothing but magic casements opening on to perilous seas of pure colour in the forlorn fairy-land of minimal painting.

The colour-field paintings of Jacks are still closely related to the formal disciplines of hard-edge: colour is pinned down to prevent it asserting itself too freely as pure volume. In the work of John Peart (*b.* 1945) and Robert Hunter (*b.* 1947), somewhat younger men, the dominance of surface and edge is less in evidence. Their work in the *Field* show lay in the area of monochromatic and monotonal painting: fine relations of tone, or of close-valued colour, or of both, are used in their work to evoke sensations of space, volume and light.

John Peart's work belongs to the romantic, evocative side of mono-chromatic art. His work in the *Field* show may be compared with that of the American painters, Ralph Humphries and Robert Irwin. Such painters, while not ignoring problems of arrangement created by the sur-face, edges and corners of a painting, handle the formal rules of hard-edge lightly, and with a sense of ease. So, too, with Peart. There is indeed in his work an expressive centre; but it is more an expression of the medium than of the personality, to allow colour to create rhythm, space and volume. In 1967 he took part, in the company of Nigel Butterly, in a music-painting performance at the Sydney Town Hall, called *Interaction*, in which the music and painting developed on a partly improvisatory basis, each art influencing the other.

Since the *Field* exhibition Peart has moved away from monochromatic minimalism and has begun to complicate the surface of the painting. In *Bivouac*, which won the Transfield Prize late in 1968, colour was used more abundantly and the shaped corners assisted the illusion of atmospheric space instead of, as is usual in hard-edge painting, assisting the painting as object (258). Furthermore, the colours were evocative of atmosphere and light. The beauty of the painting was more accessible than the reductive aesthetic of hard-edge, and the Transfield award with its attendant publicity did much to make colour-field painting better known in Sydney.

In his more recent paintings of 1969 Peart has turned to large mono-chromatic fields of stained colour, in long rectangular formats, flecked with trails and specks of paint, the titles, such as *Taklamakan* and *Khajuraho,* being evocative of Asia and meditation. In these highly atmospheric paintings Peart has moved away from all the precepts of hard-edge and minimal painting.[21]

Robert Hunter, on the other hand, has remained within the conventions of minimal art. Like Kasimir Malevitch, who began it all in 1918 with his *White on White* series, and the many Americans and Italians who have followed his path, Hunter works with fine tonal discriminations upon white or almost white fields. Such paintings may appear empty at a first glance, the eye accommodating to the final tonal structures only after sustained attention. It is an exploration of one of the perceptual limits of painting, of which painting in black and near-black is the other.

One of the problems which confronts painters moving from hard-edge to colour-field painting is the decision to maintain the surface or allow it to be transformed visually into a volume of colour. Johnson, Peart and, to some extent, even Hunter are volumetric painters. Gunter Christmann has adopted a spray technique in his recent work which produces an intricate and multi-coloured surface of tiny dots, which are reminiscent of but much smaller than the divisionist dots of the neo-impressionists. The paintings may be compared with the work of Jules Olitski, but Christmann, unlike Olitski, does not work the surface in order to create a multicoloured volume, but a sparkling surface which asserts both the materiality of the pigment and the painting as an object (259).

Late in 1968 David Aspden turned from his relational hard-edge painting with colour bands towards colour-field. The earlier concern with reduced, muted, and closely-related colours gave way to brilliantly complicated surfaces (265). He employed bright, irregular shapes across an infrastructure of bands. By such means he created both a strong directional flow across the canvas and a shallow ambiguous space which did not, however, destroy the visual presence of the surface. The irregular units of the painting were kept large enough to maintain their independence from optical corrosion within the field, and plasticity was achieved by keeping the irregular edges of the units soft and ragged. There was something of Cezanne in the spatial device and something of the Fauves in the colour, but it was highly original work, keyed to the higher pitch made possible by acrylic paint and the principles of colour painting. Paintings like *Little Bay* and the *MacCruiskeen Colour Card* series are among the most exuberant expressions of the style yet painted in Australia.[22]

In the work of John Peart we may note colour-field painting being pressed towards an expression of the oriental mysteries. In the work of David

Aspden we may find it pressed perceptibly towards the expression of environment. 'They are not really abstract paintings', he remarked in an interview, 'because I think that they are strongly related to the things around us. . . . I'm still very interested in the landscape . . . it has become seascape, the headlands, the rocks, the movement, just a general feeling of space—tremendous space, tremendous sunsets'.[23]

The relation of Stephen Earle's paintings to the landscape environment is, if anything, even more close and intimate. A typical Earle colour-field painting combines features of hard-edge grids or bands of related or contrasted colours, with rich mottled surfaces of natural and environmental colour. His finest works possess a joyous, unaffected lyricism; a celebration of light and warmth, colour and space in a kind of colour-field impressionism. 'I am concerned', he has written, 'with the clarification of my notions about the concept of place . . . and with different levels of perception'.[24]

And upon another occasion:

. . . the only time I can really successfully paint is during summer because then I can have the doors at both ends of my studio open and the window open, and there's a complete feeling of freedom. It's not as though I was in the room, it's as though I were on a platform with the wind blowing. The breeze blows in one end and—there are not many birds round our area, but there are a few birds singing, cats playing on the roof outside, leaves, what little leaves there are, rustling; and this gives me a feeling of complete peace, and I try to get in harmony with all this, and I find that this is when I paint best.[25]

Was it not Horace who said that you can drive nature out the door with a pitchfork but she will come in through the window?

As the 1960s drew to an end colour painting in Sydney entered upon a painterly phase. Ron Robertson Swan, the painter and sculptor, was still primarily hard-edge when he exhibited in the *Field* exhibition in 1968. But late in 1969 he won the Transfield Prize with a most painterly painting, *Sydney Summer*. Combining hints from Newman, Kelly and Louis, he created a painting in which pure and intense, melting colour poured out visually on all sides—a joyous painting, and acceptable to a wide public. And by the end of 1970 large-scaled works, painterly and radiantly colourful had begun to appear in the Sydney dealers' galleries again, skating at times upon the rim of charm. To some it seemed as though Merioola had come again. The Calvinistic virtues which for a brief season had given such momentum to Central Street—energy, dogma and the fear of corruption by indolent forms of beauty—were on the wane. For in Sydney it is difficult to deny growth and the sun—nor perhaps natural. Now depth and volume of colour challenged flatness and the dominating edge; line disappeared in

luscious stain. Heinrich Wölfflin's propositions about the evolution of style, at least in this instance, still appeared to be relevant. In Melbourne, however, artists continued to work in the more linear modes of colour painting and there was a growing interest in conceptual art.

Colour painting is a style still very much alive in Australia and most who work within its disciplines are young with most of their lives as painters before them. The new style has already effected the strongest break with local tradition since the introduction of impressionism; and it has been a deeper break, since impressionism only reinterpreted the visual environment whereas colour painting, at least up to 1968, had largely abolished it from painting. It has done this because it has turned from using a style as something *given* within which to express a personality, interpret a landscape, or a mood, or whatever, to investigating, in strictly formal terms, the possibilities (for painting) of a style. This has brought a new seriousness to theory and practice, and the excitement of a new beginning.

Colour painting, as Jules Langster was at some pains to point out when he coined the name hard-edge,[26] has many of the features of classicism, in its distrust of an immersion in feeling, its emphasis on the objective side of painting, and of the work (within the discipline) as a well-made object. The new style brought a tough, conceptual clarity to an investigation of the visual and depictive problems concerned with colour and possessed a thoroughness and rigour not present in the emergence of earlier styles in Australia, which were used rather than investigated.

Deeply built into the development of colour painting itself as a style, however, was the rejective principle it had inherited from earlier *avant-garde* art. This principle arises from the primitivistic drive which has been present in Western art for over two centuries since, in fact, the triumph of romanticism. Despite an apparent surface classicism, colour painting has been moved from within by the same romantic dynamic which dominated abstract expressionism and the *avant-garde* styles before it. Like them colour painting has been required, in order to remain *avant-garde,* to attempt more with less.

But colour painting is a late-comer to the *avant-garde* situation: first announced at the beginning of the nineteenth century by the *Barbus* of Jacques Louis David's *atelier*. It inherited a highly minimal position. All was to be done, to the extent that it could be done, with flat colour in two dimensions. There was not much more within painting that could be rejected. The style has therefore produced, particularly in America, many artists working near the top of the white scale, and others near the bottom of the black, in monochromatic or monotonal painting, or both. And they *have* shown that even within these fine limits a considerable variety of painting is possible: painting as coloured object, painting as coloured space,

painting as expressive object, and so forth. But there is probably a limit to the number of times a painter can knock upon Malevitch's white door or Rodchenko's black one, and still come back with good painting. Such work begins to look increasingly like propositions about visual perception, or the demonstration of an aesthetic problem. They begin, as paintings, to look trivial.

In such a situation it is not surprising to find many painters concluding that painting is now an exhausted art, and turning to sculpture, or to process arts in which the performance is of much greater importance than any resultant objects—to become, as Fried has suggested, theatre.[27]

It may of course be true that painting is no longer relevant to modern society, and the art better abandoned. Certainly a great many of the paintings produced today would support this view. But for artists committed to painting it is a doomsday proposition; and can only be tested for its truth by those who are prepared to go on painting.

For those who do continue to paint, painting will remain a process which involves the use of materials. The potential of paint itself will change with technological developments, indeed much of the development of colour painting may be seen as the technical exploration of new materials, such as acrylics. And the pictorial process will continue to yield more or less durable objects—paintings. Painting is not a pure act of perception. One does not make a goat into a pig by looking at it as if it were a pig; and one does not, Duchamp notwithstanding, make an object, which might well be an art object, into a painting by looking at it as if it were a painting. Nor is painting an act of pure thought, as poetry possibly is. In the painting process, concept, percept and action are all involved. The tendency to reduce painting to pure acts of perception or conception is a further development of the rejective processes of primitivism by means of which an attempt is made to make the part work for the whole.

There are, of course, very strong presumptive reasons why artists should continue to make use, wherever they can, of the rejective principle. For there can be little doubt that the doctrine that less is more, though paradoxical, has helped to create the best art of our time. But the principle of rejection is now working to remove painting entirely from the scene.

Confronted with this situation many colour painters, as we have seen, are beginning to re-complicate the canvas, to act, that is, in opposition to the rejective principle. This is both a courageous and dangerous procedure, since others who have acted in this way at early situations along the *avant-garde* trajectory have found themselves left in a *retardataire* position, and the course of painting proceeding more vigorously elsewhere and from a more minimal position. But many have come to the view that opposition to the rejective principle is the only course left for those who wish to go

on painting, since the art has reached the position in which less will be neither more nor less, but nothing.

But they may be wrong. If good paintings can still be produced by the progressive rejection of 'inessentials' which has been so long a feature of *avant-garde* painting, then we shall see them during the 1970s.

Australian art, as a living tradition, has come into existence during the past eighty years. It has been created by artists of independent mind and imagination who have gained inspiration and knowledge of their craft from the European tradition and applied them to their personal situation as artists in Australia. Some were revolutionaries; some were reactionaries; and some, at different times of their lives, succeeded in being both. But most of them found themselves, at the most creative moments in their lives, involved in challenging the values of Australian society. But they had to come to terms with it, or else spend their lives abroad until old age or death. This was no easy matter, for Australian society rarely takes its artists seriously until they begin to exhibit the conventional ambitions. This is partly due to the fact that the uneducated Australian is indifferent to art; and the educated Australian, upon whom the role of patronage normally falls, is, as often as not, a second-rate European with such a strong feeling of inferiority that he is embarrassed by the accents of his own countrymen. Lacking a folk-tradition of long standing from one section of society, or a well-informed aristocratic patronage of the arts from the other, Australian artists have constructed what is national and distinctive in their art in the face of the anti-art values of their society. That is why good Australian art is so often tough-minded and sardonic: not because of the desert but because of the people.

Australian art is today, however, a going concern which is gaining respect and some distinction abroad. But if Australia is to continue to produce an art of international standing it will be an art that emerges from Australian experience and gives a critical edge to it; an art that both celebrates and scarifies; diverse in its interests; encompassing everything from social realism to colour painting within its ambience, while allowing the adherents of no doctrine to posture as an elect called by History to create the only true art of the time; an art combining tolerance with a lively clash of conflicting interests; an art contemptuous neither of ideas nor of intuition in the creative process; and an art which, at its best, can rise above the interests and limitations of the nation and the self.

NOTES

[1] *See* M. FRIED, *'Three American Painters: Kenneth Noland, Jules Olitski, Frank Stella'*, Fogg Art Museum, Harvard University, Cambridge, Massachusetts, April-May 1965
[2] De Berg transcripts, N.L.A., Canberra, Watkins, 1965
[3] *ibid.*; on Watkins's early paintings *see also* T. SMITH, *Honi Soit*, 12 June 1969
[4] De Berg transcripts, N.L.A., Canberra, J. Dawson, 1965

5 *C.A.S. Broadsheet South Australia,* July 1967, quoted by P. McCAUGHEY, *Australian Abstract Art,* Melbourne, 1960, p. 29

6 P. McCAUGHEY, 'Sydney Ball in the Sixties', *Art and Australia,* March 1970, p. 333. I am indebted to this interesting account of Ball's development though I differ from it on minor points.

7 *Present Day Art in Australia* (ed. M. Horton), Sydney, 1969, p. 19

8 *Banyan Wall* and *Strata Span* are illustrated in colour, *Art and Australia,* March 1970, p. 335 and front cover.

9 In a letter from J. Doolin quoted in his *Artificial Landscapes* exhibition, Central Street Gallery, Sydney, May 1970

10 By T. Smith in 'First Thoughts on a "Style of the Sixties" in Recent Painting', *Uphill,* no. 1, September 1969, Sydney. Smith lated abandoned the term (*Other Voices,* June 1970, p. 6) for Colour-Form. But the local name seems to be more appropriate for a local variant of hard-edge which is not relevant for other parts of Australia. Moreover, the term Colour-Form suggests an equal importance between the two elements that might describe, say De Stijl, better than the style here under discussion. Dr Berger's criticism of Colour-Form is to the point here (*Other Voices,* August 1970, p. 4) but I believe he errs in supposing a 1966 Christmann and a 1970 Christmann to belong to two quite different styles. As I have argued in this chapter, I believe such paintings to be examples of an early and later phase of one style, Colour Painting, the central concern of which is the investigation of the possibilities for painting of flat, unmodulated colour.

11 Quoted by John Coplans in 'John McLaughlin, Hard Edge and American Painting', *Artforum,* vol. 2, no. 7, p. 31. Land's article appeared in the *Scientific American,* May 1959.

12 T. SMITH, Color-Form Painting: Sydney 1965-70', *Other Voices,* June 1970, p. 14. I am indebted to this first account of the development of colour painting in Sydney.

13 *Present Day Art in Australia,* p. 134

14 For a more detailed account of McGillick's style *see* T. SMITH, *Honi Soit,* 12 June 1969

15 *See also* A. OLDFIELD, 'Wendy Paramor', *Other Voices,* August 1970, pp. 17-21

16 *Present Day Art in Australia,* p. 107

17 For a more detailed consideration of Aspden's work *see* T. SMITH, 'The Paintings of David Aspden', *Art International,* October 1970, pp. 50-3

18 *See* A. HEINTZ, 'Visual Communications—the New Force in Art', *Art and Australia,* March 1966, pp. 298-300

19 Catalogue of the *Field* exhibition, National Gallery of Victoria n. d. (1968), 'An Important Academy', pp. 92-3

20 CLEMENT GREENBERG, *Avant-Garde Attitudes,* Sydney, 1969

21 On Peart *see also* D. THOMAS, 'John Peart', *Art and Australia,* June 1969, p. 64 and G. CATALANO, 'The Recent Paintings of John Peart', *Other Voices,* August 1970, pp. 31-3

22 *See* the article by T. SMITH, *Art International,* October 1970, pp. 50-3

23 De Berg transcripts, N.L.A., Canberra, Aspden

24 *Present Day Art in Australia,* p. 62

25 De Berg transcripts, N.L.A., Canberra, Earle

26 JULES LANGSTER, *Four Abstract Classicists,* Los Angeles County Museum of Art, July 1959

27 M. FRIED, 'Art and Objecthood', *Artforum,* June 1967

LIST OF ILLUSTRATIONS

z

A NOTE ON BOOKS AND PERIODICALS

Many references to individual artists and special aspects of Australian art are listed at the end of relevant chapters. This note lists publications of a general value for the study of Australian art, and includes significant publications which have appeared since 1962 (when the first edition of this book was published).

Books General Surveys All students of Australian art are indebted to William Moore's *Story of Australian Art* (2 vols, Sydney 1934). the pioneering study. The present author's *Place, Taste and Tradition* (Sydney, 1945) owes much to Moore but seeks to relate Australian art to a background of European art and ideas. H. E. Badham's *Study of Australian Art* (Sydney, 1949) derives largely from Moore but contains useful biographical information on artists flourishing between 1934 and 1949. Robert Hughes's *The Art of Australia* (Harmondsworth, 1970) contains lively critical comment and is of special value for the art of the 1950s. It is a revision of a suppressed edition of 1966. Perceptive comments on selected paintings will be found in *Masterpieces of Australian Painting* by James Gleeson (Melbourne, 1969) and *National Gallery of Victoria: Painting, Drawing, Sculpture* by U. Hoff and M. Plant (Melbourne, 1968). Short surveys of Australian art, part-historical, part-critical, have often featured as introductions to catalogues of exhibitions of Australian art held overseas and locally, and provide a fascinating insight into changing valuations, for example: *The Exhibition of Australian Art in London* (1923), Sydney, 1923; the excellent *Art of Australia, 1788-1941*, edited by S. Ure Smith and published in 1941 for the Carnegie Corporation by the Museum of Modern Art, New York, for the exhibition assembled by Theodore Sizer in 1940 to tour the United States; the *Arts Festival* of the Olympic Games (Melbourne, 1956); the *Jubilee Exhibition of Australian Art* (1951); and the exhibition of *Recent Australian Painting* (Whitechapel Gallery, London, 1961). Note also the entry under Australian art in the *Oxford Companion to Art* (1970).

Special Surveys Early Artists of Australia by Rex and Thea Rienits (Sydney, 1963) is a detailed, artist by artist survey from about 1788 to about 1820. The present author's *European Vision and the South Pacific 1768-1850* (Oxford, 1960) (paperback edn, London, 1970) studies European art and ideas in their relation to the opening of the Pacific. *The Golden Age of Australian Painting, Impressionism and the Heidelberg School* by A. McCulloch (Melbourne, 1969) is devoted to the later nineteenth century. Note also titles in the National Gallery Booklets series published by the National Gallery of Victoria: for example, J. Gray, *Early Australian Paintings*; P. McCaughey, *Australian Abstract Art*; and the *Arts in Australia* series published by Longmans, Melbourne: for example, J. Reed, *New Painting 1952-62* (1963).

Biographical Information The first attempt at a dictionary of Australian artists is contained in Moore vol. ii, 155-234, and remains useful for artists before 1934. A. McCulloch's *Encyclopaedia of Australian Art* (London, 1968) is the only comprehensive dictionary and contains many valuable subject entries. J. Kroeger's *Renniks Australian Artists* (Adelaide, 1968) lists artists included in the collections

459

of twenty-five Australian public galleries. It is intended mainly as an investment guide. The *Australian Dictionary of Biography* (Melbourne, 1966-) contains excellent biographies of major artists. Three volumes have been published to date, making it complete to 1850, and holding entries A to C between 1851 and 1890. The above works may be supplemented by the *Catalogue of Australian Oil Paintings in the National Art Gallery of New South Wales, 1875-1952* (Sydney, 1953), and the subsequent catalogues of acquisitions published annually by that gallery. Other gallery catalogues can also be helpful. The only comprehensive biographical dictionary compiled on a state basis is Nancy Benko's *Art and Artists of South Australia* (Adelaide, 1969). Many popular and lavishly illustrated surveys of the works of artists currently in fashion usually include biographical notes: for example, *Modern Australian Painting and Sculpture* (ed. K. Bonython, Adelaide, 1960), useful for artists flourishing in the 1950s; *Present Day Art in Australia* (ed. M. Horton, introd. D. Thomas, Sydney, 1969); *Modern Australian Painting 1960-70* (ed. K. Bonython, introd. R. K. Luck, Adelaide, 1970). For biographical notes of the colour painters of the 1960s see the *Field* exhibition catalogue, National Gallery of Victoria, and the Central Street Gallery portfolio (1968).

J. Hetherington's *Australian Painters, Forty Profiles* (Melbourne, 1963) is a readable compilation based upon interviews.

Periodicals Prior to 1900 there were no periodicals devoted exclusively to the visual arts. The *Bulletin* (1880-), *Table Talk* (1885-1939), The *Australian Builder and Contractors' News* (1887-85), The *Australasian Art Review* (1889-1900) are all very useful sources of information. *Art and Architecture* (1904-12) and *The Salon* (1912-16), both published by the Institute of Architects of New South Wales, are important for the Edwardian period and *art nouveau*. *Art in Australia* (1916-42), founded and edited by Sydney Ure Smith until 1938, was the pioneering art journal. Well illustrated, it featured appreciation rather than independent or controversial criticism. *Manuscripts* (1931-35), edited by H. Tatlock Miller, an early *avant-garde* miscellany, included articles on design. *Angry Penguins* (Adelaide, 1940-42, Melbourne, 1943-46), *avant-garde* and controversial, is a basic source for the emergence of contemporary art in Australia. The literary quarterly *Meanjin* (1940-) carried critical articles on the visual arts until about 1965. *Art and Australia* (ed. M. Horton, 1963-), well illustrated and informative, is the current leading art quarterly. *Other Voices* (1970-), a new *avant-garde* magazine, is controversial and interested in art education.

Periodicals published under the auspices of art societies have appeared sporadically and contain much useful information. The most notable include *The Society of Artists' Book* (five annual issues, 1942-47), edited by S. Ure Smith; *The Australian Artist*, edited by R. Haughton James for the Victorian Artists' Society (1948-49) (this Society published its own journal from 1911 to 1919); and the *Broadsheet* of the Contemporary Art Society, N.S.W. Branch (1947-), edited by E. Lynn (1955-70), an important source of information and comment on contemporary art.

Books on Individual Artists (published since 1962) Earlier publications of importance are listed in the chapter notes and references to the artists concerned.

R. Mathew, *Charles Blackman* (Melbourne, 1965); T. Shapcott, *Focus on Charles Blackman* (St Lucia, Brisbane, 1967); F. Philipp, *Arthur Boyd* (London, 1967); J. Gleeson, *William Dobell* (London, 1964); G. Dutton, *Russell Drysdale* (London, 1964); V. Buckley, *The Campion Paintings* (Melbourne, 1962), paintings by Leonard French; R. Hughes, *Donald Friend* (Sydney, 1965); D. Thomas, *Sali Herman* (Melbourne, 1962); D. Dridan, *The Art of Hans Heysen* (Adelaide, 1966); B. Hilder, *The Heritage of J. J. Hilder* (Sydney, 1966); P. McCaughey, *Elwyn Lynn* (Adelaide, 1969); J. Henshaw, *Godfrey Miller* (Sydney, 1965); E. Lynn, *Sidney Nolan: Myth and Imagery* (London, 1967); N. Macainsh, *Clifton Pugh* (Melbourne, 1962); R. Hall, *Focus on Andrew Sibley* (Brisbane, 1968); A. Galbally, *Arthur Streeton* (Melbourne, 1969); C. Uhl, *Albert Tucker* (Melbourne, 1969).

INDEX

AA